KILLING THE MOONLIGHT

MODERNIST LATITUDES

MODERNIST LATITUDES

Jessica Berman and Paul Saint-Amour, Editors

Modernist Latitudes aims to capture the energy and ferment of modernist studies by continuing to open up the range of forms, locations, temporalities, and theoretical approaches encompassed by the field. The series celebrates the growing latitude ("scope for freedom of action or thought") that this broadening affords scholars of modernism, whether they are investigating little-known works or revisiting canonical ones. Modernist Latitudes will pay particular attention to the texts and contexts of those latitudes (Africa, Latin America, Australia, Asia, Southern Europe, and even the rural United States) that have long been misrecognized as ancillary to the canonical modernisms of the global North.

Barry McCrea, *In the Company of Strangers: Family and Narrative in Dickens, Conan Doyle, Joyce, and Proust,* 2011

Jessica Berman, *Modernist Commitments: Ethics, Politics, and Transnational Modernism,* 2011

JENNIFER SCAPPETTONE

KILLING THE MOONLIGHT

Modernism in Venice

COLUMBIA UNIVERSITY PRESS *New York*

Columbia University Press
Publishers Since 1893
New York Chichester, West Sussex

cup.columbia.edu
Copyright © 2014 Columbia University Press
All rights reserved

Library of Congress Cataloging-in-Publication Data

Scappettone, Jennifer.
Killing the moonlight : modernism in Venice / Jennifer Scappettone.
pages cm
Includes bibliographical references and index.
ISBN 978-0-231-16432-0 (cloth : alk. paper) — ISBN 978-0-231-53774-2 (ebook)
1. Venice (Italy)—In literature—History. 2. Literature, Modern—19th century—History
and criticism. 3. Literature, Modern—20th century—History and criticism.
4. Modernism (Literature) 5. Venice (Italy)—In art—History. 6. Modernism (Aesthetics)
I. Title. II. Title: Modernism in Venice.
PN56.3.V4S38 2014
809'.9335845311—dc23
2014000748

Columbia University Press gratefully acknowledges permission to reprint from the following:
Published works by Ezra Pound. Used by permission of New Directions Publishing Corporation.
Published material by Andrea Zanzotto. Used by permission of the heirs of Andrea Zanzotto.

Columbia University Press books are printed on permanent and durable acid-free paper.
This book is printed on paper with recycled content.
Printed in the United States of America

c 10 9 8 7 6 5 4 3 2 1

Jacket image: Peter Eisenman, *Presentation model including Cannaregio West and Le Corbusier's
Venice Hospital,* gold and pink paint over wood and cardboard, commissioned ca. 1978.
Canadian Center for Architecture, Montreal.
Jacket design: Noah Arlow

References to websites (URLs) were accurate at the time of writing.
Neither the author nor Columbia University Press is responsible for URLs
that may have expired or changed since the manuscript was prepared.

for Joshua, and for love

. . . quel che lo spettro con la sua voce bianca argomenta è che, se tutte le città e le lingue d'Europa sopravvivono ormai come fantasmi, solo a chi avrà saputo di questi farsi intimo e familiare, ricompitarne e mandarne a mente le scarne parole e le pietre, potrà forse un giorno riaprirsi quel varco, in cui bruscamente la storia—la vita—adempie le sue promesse.

. . . what the specter argues, with its choirboy-like voice, is that if all the cities and the languages of Europe now survive only as phantasms, then only to those who have learned to become intimate and familiar with these phantasms, reciting and committing to memory their discarnate words and stones, will that breach perhaps one day reopen in which history—life—abruptly fulfills its promises.

—Giorgio Agamben, "On the Uses and Disadvantages
of Living Among Specters"

CONTENTS

LIST OF ILLUSTRATIONS

ACKNOWLEDGMENTS

This project began as a convergence of questions surrounding modernist poetry, travel narrative in reverse (from the perspective of the "destination," Italy), and the moment of description in writing about works of art. In exploring all of these regions of study at once, the central term that emerged was Venice. I am immeasurably grateful to those with whom I was working at that moment, thirteen years ago, and from whom I have learned ever since: Charles Altieri, for his experimental criticism and pedagogy and his support for poet-scholars, and for advising me then, and always, to pursue critical fascination above all; Barbara Spackman, for her pioneering approaches to Italian studies, and for transporting so many marvelous authors into my sphere; and T.J. Clark, for his dazzling example in writing about history from the perspective of the present, and his crucial suggestion that it might be the city, rather than any particular author, who would be the protagonist of my project. Lyn Hejinian has been an essential ally through this project and many others—and our shared obsessions with Ruskin and James, and sense of their contemporaneity, sustained me over years of struggle with the magnitude of "material" to elucidate, or shadow. Anne Wagner and Anne Anlin Cheng were other vital sources of support in my years at Berkeley. I am grateful to the entire Department of English for splendid formative years of conversation, to

my fellow members of the editorial board at *Qui Parle* for models of curatorial risk and rigor, and to those in my cohort who kept me sane, especially Joel Nickels, Chris Chen, Julian Brolaski, Dennis Childs, and Liz Young. Earlier on, at the University of Virginia, Jessica Feldman, Paul Barolsky, Eric Lott, Sara Blair, Deborah McDowell, and Charles Wright provided models of creative interdisciplinary thinking in modern and historical studies.

It goes without saying that a study across disciplines and periods such as this one is indebted to the work of many authors, some of whom will necessarily remain uncited. I began to realize, years in, that I would not be able to fit many relevant works surrounding Venice into the argument if it were eventually to be printed, not to say legible—and I dare not attempt to name them all here, whether canonical or obscure, lest I exceed my word count yet again. (That I learned of feminist artist Carolee Schneemann's 1966 *Water Light/Water Needle*, a performance work inspired by and projected for Venice, only once production had been set into motion became paradigmatic.) I have therefore chosen to track fresh and coherent, if tortuous, lines of influence, rather than being encyclopedic—even if it means that "I mourn for them all as I remount the stream, . . . the missing links, the mocking shadows." In addition to those that I cite repeatedly, works of scholarship by Sergio Bettini, Tony Tanner, Margaret Plant, Margaret Doody, and the entire community represented by "News on the Rialto" were also key to the book's development.

I am fortunate to have received so much decisive feedback on this manuscript from my colleagues at the University of Chicago. I am grateful to those who read the entire manuscript (in tandem with other demanding projects) and offered invaluable advice, especially to Beth Helsinger, Lisa Ruddick, and Raùl Coronado. I am particularly indebted to Maud Ellmann, Jim Chandler, and Bill Brown, without whose perspicuous scholarship, commentary, and advocacy this book would not be what it is today. For their camaraderie, example, and support of my strategically circuitous approach to the scholarly genre (and those of others), I offer special thanks to John Wilkinson, Frances Ferguson, Chicu Reddy, and Lauren Berlant.

I am also thankful for the friends and interlocutors who read pieces of this manuscript, or spurred related investigations of various kinds, and whose dialogue sustained me through an infinite inquiry—especially Marinella Caputo, Judith Goldman, David Buuck, Nathanaël Stephens, Patrick Barron, Andrea Raos, Marjorie Perloff, Juliana Spahr, Joshua Clover, and Simon Verity. David Lobenstine's lucid commentary in the process of cutting and restructuring in the final minutes of the eleventh hour was a salve. And my Venetian and Veneto friends made this project so much more than

an analysis. Thanks especially to Rosella Mamoli Zorzi, Marino Zorzi, and Enrico Palandri for their guidance and generosity, to Simone Bottazzin for his camaraderie and help at the Guggenheim Collection, to Giovanna Frene for our treasured road trip to meet Andrea Zanzotto in Pieve di Soligo, and to Arianna Silvestrini and Andrea Zorzi for their enthusiasm and friendship— and for helping me to salvage my hard drive when, weeks from a major deadline, a wave of the Giudecca Canal filled my laptop with salt. Thanks above all to Giorgio Agamben and Valeria Piazza for lending me their perch above the Sotoportego del Casin dei Nobili during my first summer in Venice; I will be reading the books to which Giorgio led me then for the rest of my life. I also want to thank the poetry community at large, in both the United States and Italy, for sustaining me intellectually and passionally through these years, and for the evolving discussions that always make "history" new.

I am also grateful to those who invited me to speak about the project when it was in progress, at the University of Leeds, UC Berkeley, the University of Michigan, Harvard, the University of Catania, the University of Pennsylvania, the American Academy in Rome, Carnegie Mellon University, New York University, Boise State University, and Columbia University. Special thanks to Francis O'Gorman; Sara Blair and Jonathan Freedman; Ara Merjian; Carla Billitteri and Benjamin Friedlander; Al Filreis; Corey Brennan, Karl Kirchwey, and Chris Celenza; Melissa Ragona and John Carson; Paolo Valesio and Patrizio Ceccagnoli; Martin Corless-Smith; and Ernest Ialongo.

Patricia Yaeger and Oren Izenberg were generous enough to solicit the fragments of this book that were published in *PMLA* ("Utopia Interrupted: Archipelago as Sociolyric Structure in *A Draft of XXX Cantos*") and *Modern Philology* ("'Più mOndo i: tUtti!': Traffics of Historicism in Jackson Mac Low's Contemporary Lyricism") in 2007; without their encouragement, I would have, out of inclination, held on obsessively to all of the chapters until the entire manuscript was complete. Above all, in this regard, I wish to thank Philip Leventhal for soliciting this manuscript years ago, and for his support in helping me produce the book, to the degree possible, in a form approaching its ideal state—as well as Jessica Berman and Paul Saint-Amour, co-editors of the Modernist Latitudes series, for their advocacy and crucial recommendations on sculpting the final product.

This project has been supported by a range of fellowships, without which I could never have undertaken a project of this scale: by multiple years of fellowships from the Department of English, the Division of the Humanities, and the Regents at the University of California at Berkeley, and an enriching year in residence at the Doreen B. Townsend Center for the Humanities; by

Phi Beta Kappa; by a Mellon Post-Doctoral Fellowship at the Wesleyan Center for the Humanities under the collaborative directorship of Henry Abelove; by sabbatical support for junior faculty from the Humanities Division at the University of Chicago; and most recently, by the Andrew W. Mellon Post-Doctoral Rome Prize in Modern Italian Studies at the American Academy in Rome, a community that will provide intellectual sustenance for years to come. The Gladys Krieble Delmas Foundation has been extraordinarily generous through more than a decade of research, providing multiple fellowships, and ultimately, a decisive subvention for the book. The Division of the Humanities at the University of Chicago also supplied an essential subvention that permitted me to include a significant number of illustrations. Josephine Miles provided prior years of shelter, thanks to her utopian vision of a Berkeley Center for Writers. Finally, without a merit scholarship provided by William G. Pannill to the University of Virginia's Jefferson Scholars Program, I would not have had the gift of such an excellent and focused university education—nor would I have had the formative work experiences in Italy that provided the kernel of this book. Gratitude is too little a word for such a fundamental intervention.

This book has benefited from many hours of library research, particularly at the Biblioteca Querini Stampalia, the Biblioteca Marciana, the Fondazione Cini, the library at the Guggenheim Collection in Venice, the Archives of the Biennial of Venice (ASAC), the University of Chicago Special Collections Research Center, the Beinecke Library at Yale, the Wertheim Study at the New York Public Library, and the Ruskin Library at the University of Lancaster. Thanks to the librarians, and especially to Stephen Wildman in Lancaster, for keeping these precious materials accessible to scholars. Thanks as well to the staff of the Visual Resources Center at the University of Chicago, and to that of the Newberry Library, who assisted in the production of images.

Several research assistants lent their time, enthusiasm, and meticulous eyes for detail to this project over the years: many thanks to Jia Angeli Carla Tolentino, David Gutherz, and Stephanie Anderson.

The loss of Emma Bee Bernstein, felt by so many, hovers over these lines.

This book is for Joshua Stein, my companion in the discovery of cities—joy and sustenance in the years when the myriad paths of thinking converged. But my biggest debt of all is to Richard and Theresa Scappettone, who taught me to love and instilled in me the love for Italy that is the very core of this book.

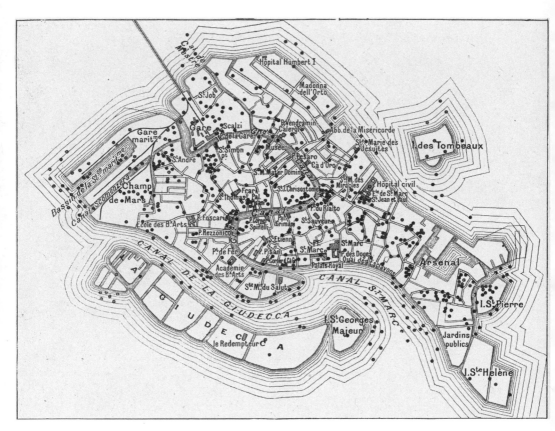

"The bombardment of Venice: locations of bombs dropped by Austro-German aircraft" during the First World War, *L'Illustration*, issue 294, no. 3967 (March 15, 1919). Shows the fish-shaped historical center of Venice, with the railway station and port at Santa Marta along the western edge, the Giudecca and the Island of San Giorgio Maggiore to the south, and the cemetery Island of San Michele to the northeast.

KILLING THE MOONLIGHT

INTRODUCTION: VENETIAN MODERNITY
A TROUBLED PRESENT

Pure ingenuity could not devise
Such a nightingale.
—Robert Duncan, "The Venice Poem"

non ho mai pensato che nella vita, per procedure, si debba necessariamente andare in linea retta

I have never thought that, to move forward in life, one necessarily has to go in a straight line
—Marco Paolini, *Il Milione: Quaderno veneziano*

Venice as Construction:
Within and Against the Modern

You might just pass by this installation, were it not part of the group show at the 52nd Biennale (figure I.1). Were it not titled *Venice Fountains,* you might mistake it for an unkempt corridor between exhibits in the city's Public Gardens. In an oblong gallery behind the Fascist façade of the Italian Pavilion, two cruddy industrial sinks face each other, their flows noisily rerouted: each faucet has been outfitted with a tube that, looping up and back, feeds an anonymous death mask sloppily cast and hung by wire to face the wall. Water spurts backwards through the mouths of the masks, one white and one blood-red, and down each drain, ending up—when it does not spray the floor—in a "Homer's All-Purpose Bucket." Bruce Nauman's sculptural assemblage gives mordant body to the trope of the mask that circulates through the cultural legacy of Venice, while disfiguring the souvenir Carnival masks that beleaguer the city's shopwindows: the effect of these "fountains" is vaguely seedy, as if the fluid were being recycled through a couple of implicit bodies. The piece recalls Nauman's parodic "spitting image" of 1966–67—the photographic *Self-Portrait as a Fountain*—but only in the way it invites you to imagine your own organs occupying these hollows.

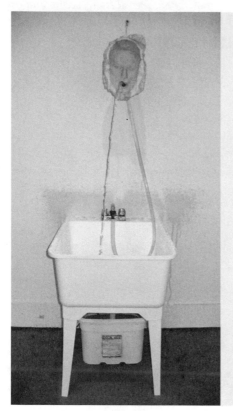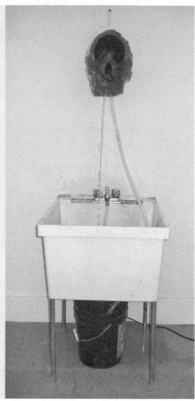

FIGURE I.1. Bruce Nauman, *Venice Fountains*, two views of the installation featured in a group show at the Italian Pavilion for the 52nd Venice Biennial, *Pensa con i sensi/Senti con la mente* (Think with the Senses/Feel with the Mind), curated by Robert Storr, 2007. Mixed media, two parts: two sinks, two plaster casts and two buckets (one white, one red), and tubes. Astrup Fearnley Collection, Oslo, Norway.
© 2013 Bruce Nauman/Artists Rights Society (ARS), New York; image courtesy of Sperone Westwater, New York.

Though it cites the figural tradition, Nauman's installation engages above all the distressed ecology of the city in which it stands. Evoking monumental Roman feats of hydraulic engineering, the sculptor delivers instead a mere dampening—alluding via circumlocution to Venetian decline. *Venice Fountains* serves as a punning riposte to two centuries of Romantic tropes that saturate the literature, art, and political life of the sinking city—a place defined as much by its reinscription as a topos as by its actual presence on swamplands and sea. Nauman's mundane act of plumbing competes aggressively with a slough of clichés inherited from the nineteenth century that

render Venice as a glittering maritime panorama: the eternal playground of poets and residual aristocrats in their gondolas floating on moonlit waters, or the lingering repository of a decadent, labyrinthine, feminine, "Oriental" mystique-for-sale—all of which amounts to Venetian "ambience." By deflecting these tropes, *Venice Fountains* helps us to regard Venice instead as a living city, one whose daily life must negotiate constantly with its grand legacy, and with current projections of death and decline.

In the pages that follow, I track the material and ideological pressures that modernity has placed over the past 150 years on the ever-present legacy of Romantic Venice—and the distinctive strains of aesthetic invention that resulted from the clash. Whether seduced by Venetian clichés or repulsed by them, many post-Romantic artists found a motive for innovation in Venice; they located vitally material forms of historical duration in the cityscape, forms that eluded both romantic kitsch and monumental classicism. As Nauman's dampening of the Biennale gallery suggests, the amphibious Venetian landscape persists as a provocation to this day. By reintroducing fluid to a modernist sculptural tradition associated with dry, hard geometry (and by citing the canonical gesture of abstracting form from its material context, Marcel Duchamp's 1917 *Fountain*), Nauman exposes not only the disjunction between aesthetic fantasy and fact in the city of lagoons, but the unruly currents of artistic production roused by that disjunction as well.[1]

Though water is everywhere, Venice is not, like Rome, a city of imposing fountains, but a city of wells; water pressure is too precious in a city of reclaimed marshes—and too difficult to control. Nauman's slapdash hydraulics form a grim reminder of the great flood of November 4, 1966, when disaster struck the Venetian lagoon—and with it, the "rare and unusuall accident[e]" of a city that has come to stand as modernity's most voluptuous urban other.[2] That day, the city that John Ruskin represented as "the very centre of the struggle" between "the glacier torrent and the lava stream" of geological and cultural influences from the North and South suffered the consequences of being a geographical crossroads.[3] A southeasterly storm at full moon, aggravated by *scirocco* winds from Saharan Africa, caused three Alpine rivers that drain into the lagoon to break their banks, disrupting the tide cycle and triggering a deluge that reached nearly two meters, flooding the city center and surrounding islands for twenty-four hours (figure I.2). The flood ruptured centuries-old seawalls, trapped residents in apartments and on roofs, and destroyed homes, crops, gardens, businesses, and priceless works of art. Sixteen thousand ground-floor residences were deserted; five thousand Venetians were left homeless. The flood was eventually understood

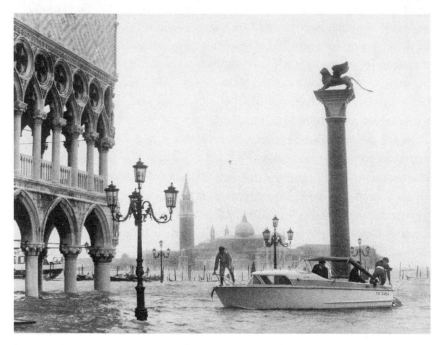

FIGURE I.2. *Acqua alta* of 1.94 meters seen from St. Mark's Square, November 4, 1966:
View of the *molo* and Column of St. Mark, the Bacino di San Marco, and the Island of
San Giorgio Maggiore.
Fondo Archivio Storico Comunale della Celestia, Comune di Venezia.

as a key trigger for the city's notorious population decline. Though floods
and *acque alte* ("high waters") had been on the rise in Venice since the sixth
century, none had been so severe.[4] The event was a "painful constatation," as
the *Gazzettino di Venezia* worded it,[5] registering "the uniqueness of a truly
precarious situation and of a tragic insecurity": a threat of mortal danger that
was not exceptional, but chronic.[6]

In 1969, UNESCO issued a comprehensive report on city conditions that
declared a state of emergency. The report translated the urgency of the cri-
sis into historical terms by comparing the environmental threat to Venice
to that of the pan-European forces of the 1508 League of Cambrai (which
signaled the end of Venice's political domination), though specifying that
this adversary was far more insidious and pernicious.[7] The report provoked
the founding of more than fifty local, national, and international commis-
sions to research and redress the damage. Awareness of the art capital's fragil-
ity ricocheted across the globe, thereby exploding a preservation effort that

had begun with Ruskin's 1851 *The Stones of Venice*. The flood rationalized the notion of Venetian decline, which had long before descended to the status of a cliché, and made it clear that the city's future was definitively endangered. However, even as it bolstered charities devoted to the restoration of artworks, the UNESCO report indicated the need for overhauled initiatives to regard the city systemically—not as a "museum-city," but as a "*capolavoro attuale*," or "current masterpiece."[8] Yet recognition of the "actuality" or present tense of Venice has always been a vexed project. To "see" Venice we must dig through two centuries of literature that has rendered this place the apparent antithesis to any contemporary form of life.

The volatile reality of Venice's topography, and its constatation as fact through tragedy, stand in contrast to received notions of Venetian timelessness (and similarly, contrast timelessness's double, eternal decay). Venice is an archipelago that sits in a lagoon, the gradual consolidation of a loose association of island settlements (figure 1.3).[9] A Venetian chronicle of the sixteenth century recounts that the city was "founded upon Quagmires, and planted uppon such unfirme moorish and spungie foundations" out of necessity; popular tradition claims that the islands were settled by noble mainland Romans fleeing the invading Huns, desperate for whatever hostile land they could find, and built up through centuries of collaboration with environmental flux, "euery day altering and chaunging according to the tides of the sea."[10] Though dissociated from the mainland (a key component of its legend), Venice is protected from the Adriatic Sea by a series of barrier islands, and its wetlands, the most extensive in Europe, were once abundant with mudflats that helped to disperse rising tides. Venetians have shaped this unstable ecosystem for at least twelve centuries, creating a delicate equilibrium: they maintained canals for irrigation and drained mudflats for agriculture and construction; they diverted the Brenta, Piave, Adige, and other rivers to prevent the protective lagoon shallows from being silted in (from the fourteenth through seventeenth centuries); they excavated shipping channels and built various types of barriers to stop river overflow (from the fourteenth century forward); and they erected *murazzi*, or seawalls (finishing only a few years before Napoleon overtook the Venetian Republic in 1797).[11] However, over the course of the nineteenth and twentieth centuries, massive infrastructural projects connecting Venice to terra firma and establishing an industrial port (at Marghera, a toponym popularly held to derive from the Venetian dialect for "*el mar ghe gera*," "the sea that was") pushed this evolutionary compromise between humans and environment beyond viable limits, and inverted the problem faced during the early modern period: the sea now threatens to overtake the archipelago.

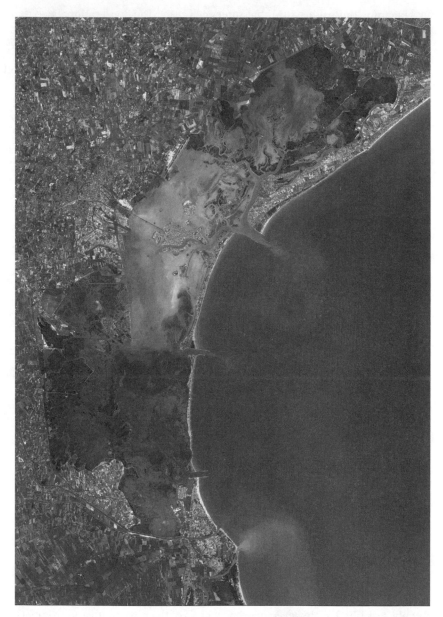

FIGURE 1.3/PLATE A. Image of Venice from the Advanced Spaceborne Thermal Emission and Reflection Radiometer on the Terra satellite, acquired in December 2001, and showing the saltwater lagoon that lies between the mouths of the Po, Adige, and Brenta Rivers (to the south) and Piave (to the north), with the fish-shaped historical complex just west of the Lido barrier island. False-color enhancements bring out the details of water and vegetation.

Courtesy of NASA.

Research commissions formed after 1966 raised many points of debate, but the consensus charged that radical changes in water levels were caused not by nature but by "modern man": not by climatic conditions intrinsic to the lagoon, but by pollution, dumping, farming, and industry at the city's periphery.[12] Since the 1920s, manufacturing outfits along the coast had been withdrawing excessive amounts of groundwater from wells, compressing the geological structure and causing the entire city to sink; fish farming and industrial and urban infill for sea and air ports had reduced the wetlands' size by thousands of hectares, altering tidal patterns; and waves from motorboat traffic were wearing away stone foundations and the banks of smaller canals, while the excavation of industrial channels for petrochemical operations— including one generated by dredging 25,000 meters of lagoon to allow oil tankers to pass between the Lido and Port Marghera—had radically destabilized lagoon foundations and currents.[13] Venice sank more than twenty-three centimeters over the course of the twentieth century, and the incidence of normal flooding events increased tenfold.[14]

The escalating reality of Venice's vulnerability gradually exposed the fallacy of the city's Romantic mythos: it was not isolated from the conditions and costs of modernity. Contemporary artists attentive to the life of the city over time have been eager to expose this reality, engaging Venice not as a mythical refuge from modernity but as a portent of its failures. Giorgio Lotti's shocking documentary photographic sequence *Venezia muore* (Venice Is Dying; published in book form in 1970) exposed the lagoon's neglect by juxtaposing captionless details of a dilapidated architectural heritage with views of smoking oil tankers, industrial coasts laden with garbage, and labor protests against working conditions called out as deadly on picket signs—rendering the city's storied "death" an undertaking in the present tense (figure I.4). *Morte a Venezia* (Death in Venice), Luchino Visconti's 1971 filmic adaptation of Thomas Mann's novella, invoked the literary tradition more directly by implicitly extending Mann's allegory of demise to the contemporary environmental context—a reality made poignant from the opening sequence, in which a tourist steamer's black smoke stains the dawn sky, its piercing horn blare disrupting both the tender Romantic soundtrack of Mahler and the slumber of Aschenbach. By framing the myth of Venetian decadence that underpins *Der Tod in Venedig* with signs of the military-industrial development that led to the apocalyptic flood, Visconti illuminates the ongoing historical reality behind Mann's allegorical treatment of Venice as a locus of death—itself the culmination of a long history of engagement with the city in the Northern European cultural imagination. Composer Luigi Nono answered to this

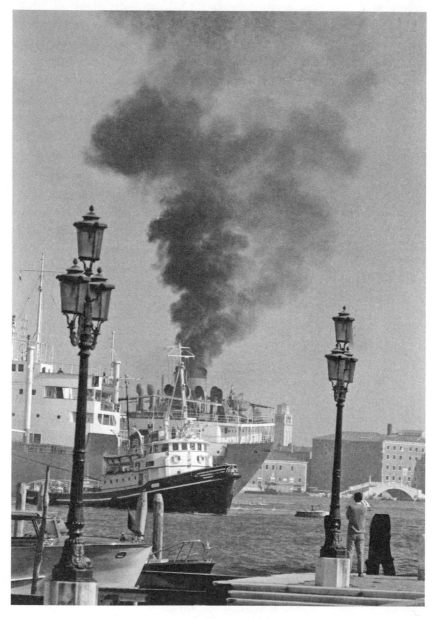

FIGURE I.4. Giorgio Lotti, "Oil Tanker at San Giorgio Maggiore," photograph from the book *Venezia muore* (Venice Is Dying), Il Diaframma, 1970.
© Giorgio Lotti. Reproduced by permission of the artist.

cultural tradition more pointedly in 1978 when testifying to the realities of small industry in the lagoon and of the sixty thousand workers that were commuting daily to Mestre and Marghera: "there's an external Venice, a city of tourists and intellectuals, the Venice of Thomas Mann and Visconti, Venice by night, . . . the Grand Canal, etc.—a place designed for consumption. There's another city that doesn't live off of tourism. . . . a way of life largely camouflaged from cultural Venice. There are powerful economic forces maintaining Venice as a historic center and cultural museum, and this is the real death of Venice."[15] Rob Pruitt's 2005 installation for the François Pinault Foundation at the Palazzo Grassi, *Art Idea #97: Write Captions on the Glass for the View Outside Your Window*, continues to purge fantasies surrounding the city as it filters the view across the Grand Canal to Ca' Rezzonico (the Baroque palace where Whistler, Boldoni, and Sargent are said to have worked and where Robert Browning died) with a ruthlessly exact index of the weight of eleven industrial byproducts found in that celebrated body of water: the window caption forces viewers to apprehend the "4,040 kg Arsenic," "900 tons Mercury," "145 tons Polychlorinated biphenyls (PCBs)," and so on, in the canal water beyond. These postdiluvian works shirk the mythical treatment of Venice, simultaneously exploiting the fact that its antiquated environs render the global costs of modernity particularly vivid and agonizing.

When the damage inflicted by Port Marghera begins to show in the postwar period and modern notions of progress in turn become obsolete, the city of lagoons—being as perennially open to industrial contaminants as it has been to organic influx—can be seen to host a discomfiting marriage of its famed stones with the detritus of modernizing campaigns. In a 1976 essay provocatively titled "Venice, Perhaps," the poet Andrea Zanzotto (a Veneto native) overturns centuries of romanticization by bringing this coagulation of primordial beauty and postindustrial sludge to the fore. In Zanzotto's postutopian handling, this corner of the Adriatic reveals its status as "a poor well, clotted . . . with sewage"—"where the purest mother-of-pearl fuses with the equivocal iridium of industrial dejecta."[16] While rendering the costs of modernization trenchantly clear, the lagoon's contents also literalize the challenge of reconciling this fabled cityscape with an incommensurable ambient temporality, or of "framing certain fundamental exigencies of today's rhythms and production with something that is too far past—to be conserved—or too far in the future—to be reinvented."[17]

And yet it would be a mistake to view these contemporary deflations of myth as altogether new. Efforts to pull back Romantic veils and expose the "actual" Venice have a history of their own. The comprehensive modernization

of Venice was imagined in 1910, when F.T. Marinetti and comrades launched a reputed 800,000 copies of the leaflet "Contro Venezia passatista" (Against Passéist Venice) from the Clock Tower of St. Mark's Square upon crowds returning from resorts on the Lido. With this early manifesto, Futurism defined its own mission to "kill the moonlight" of Romanticism and Symbolism in unprecedentedly concrete terms: the document called on the Venetians to destroy the cherished curves of their falling city—filling in the canals of the passéist "sewer" with its decrepit palaces—and to erect the imposing geometry of an industrial port lit by electricity in their place.[18] While the city declined to comply with the artists' overblown scheme, contemporary Venice embodies the Futurist vision in part: the hybrid reservoir that Zanzotto describes, natural and postindustrial, can be read as uncanny kin to the "[f]air factory drain" out of which Futurism was born.[19]

Whether lodged conceptually in the distant past or the distant future, Venice has stood since the dawn of modernity as an anachronism in the cultural imagination. It resists any uniform present tense and, in turn, any twentieth-century effort to mold it into a more rational urban form. The Futurists launched their founding call to "kill the moonlight" of Romanticism in April of 1909, but the swarms of tourists who crowd the *calli* from the railway station to St. Mark's Square all summer, seeking the moonlit locus of popular imagery, literature, and song from Antonio Lamberti's 1788 "La biondina in gondoleta" to Madonna's 1984 video for "Like a Virgin," continue to require that Venice hover as an untouched refuge of the past, frozen in time.[20] As we will see, these desires, though opposing, are equally phantasmatic.

Killing the Moonlight accounts for this unrelenting conflict by reconstituting a chronically split object that lacks presence in global modernist studies in anything but fractured form: the paradoxical project of Venetian modernity on the one hand (of the city's piecemeal modernization and the transformations of consciousness that attend it) and of modernism in Venice on the other (or the socio-aesthetic struggle accompanying these transformations, whether in support of or against them). Being both hostile to the designs of modern planning and incompletely obsolete, Venice is a radically anachronistic city—not in the simple sense of the word, though that would suit the tourist's nostalgia for an asylum out of time, but in the sense that its urban fabric retains remnants of incommensurable historical epochs. As such, the city aggravates twentieth-century schemes to isolate the present and future from their precedents—while continuing to elude any instrumental narrative of history that would settle the meaning of the city's past or determine the trajectory of its future. In Venetian incarnations of modernism, residual traces of culture (and nature) that have

allegedly been overcome resurface unpredictably, forcing authors of the pro-
gressing future into digressive advances as they struggle ardently to mourn,
dismiss, or assimilate what is being left behind.

While it is essential not to disavow Venice's role in modernization—alter-
nately, as victim and as complicit party—the historic city of lagoons has rep-
resented a rebuke to modernity for artists and intellectuals since the dawn
of Enlightenment. This aggregation of elaborated islands and the literary
traces that accrue to them resists the modern, both formally and symboli-
cally; it has thus become a point of obsession for those seeking to delineate
and explore the conceptual borders of modernism, both early and late. It was
in relation to the 1980 Venice Biennial—the world's first freestanding inter-
national architecture exhibition, credited with introducing postmodernism
to a broad, nonspecialist audience for the first time—that Jürgen Habermas
was compelled to define and defend the rationalism of aesthetic modernity.
Anachronistic Venice formed an apt environment for an exhibition that rep-
resented the "sacrifice" of the modern tradition, as Habermas would lament.
Titled *The Presence of the Past* and installed in the historic Arsenal, which was
emptied of armaments, remodeled, and opened dramatically to the public for
the first time in its eight-hundred-year history, the biennial curated by Paolo
Portoghesi emblematized the dawning of a movement that would rummage
through the spectral forms of history. Its central exhibit featured a *Strada
Novissima* (Latest Street) of twenty façade fantasies constructed to scale
in wood, papier-mâché, and plaster, with leading architects, from Venturi,
Rauch, and Scott-Brown to Hans Hollein, offering wildly synchronic pas-
tiches of historical shapes and styles (figure I.5). Habermas opened his semi-
nal acceptance speech for the Adorno Prize with a poignant suspicion of this
"avant-garde of reversed fronts" that "sacrificed the tradition of modernity
in order to make room for a new historicism."[21] On this occasion, Habermas
famously set himself against the Frankfurt School's critique of Enlighten-
ment—whose writings against rationalist, triumphalist historicism clarify the
renewed pull of Venice on a postwar generation of intellectuals. Against the
new historicism on display in Venice, Habermas identified in the modern
impulse "the longing for an undefiled, immaculate and stable present."[22]

It was not by chance that both Marinetti in 1910 (at the dawn of modernism)
and Habermas in 1980 (at the dawn of postmodernism) were drawn to define
the modern through and against Venice. Modernism had always been subject
to stress in this place—a city that offers, in the words of architectural historian
and theorist Manfredo Tafuri, "a subtle challenge that affects the very presup-
positions of modernity."[23] Any quest to usher the city of lagoons into a purely

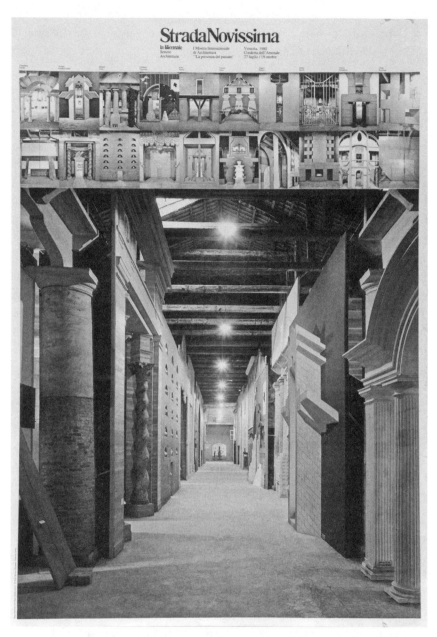

FIGURE I.5. "*Strada Novissima*," poster advertising 1st Venice International Biennial of Architecture exhibit, *The Presence of the Past*, curated by Paolo Portoghesi, with views of twenty façade designs and of full-scale installation at the Venetian Arsenal, 1980.
© La Biennale di Venezia, ASAC.

present tense or even to harmonize its histories is frustrated by the mediation of centuries of inscription, on the one hand, and, on the other, by structural features of the cityscape itself: a topographical ambiguity or "amphibiousness" that retains natural features associated with the primordial, and an architectonic obliquity that thwarts any Cartesian viewpoint or rationale.

That subtle challenge is embedded in the physical constitution of the archipelago itself. As a complex that seems to float in the margin between Europe and Asia, removed by a lagoon from the routine realities of terra firma, and thereby conjoined to the unknown, Venice has long represented a site of estrangement. Identified as the plural *Venetiae* on early maps, it was once a loose configuration of island-cells, or *insule*, rendered a totality by the consolidation of marshes between the last centuries of the first millennium and the fourteenth century. In 1560, Francesco Sansovino described the transition between city zones, or "*contrade*," as a continual process of adaptation and defamiliarization: "Venice shows itself not to be only one, but many cities, separated and all conjoined at once . . . in such a manner that exiting one quarter and entering another you will say without a doubt that you are exiting one city and entering another, with the infinite ease of the inhabitants and the stupefaction of foreigners."[24] In the discontinuous texture of superimposed canals and *calli* (alleyways for pedestrians, which were always less important than waterways), we still encounter seams between the sixty-odd island parishes that were never rationally planned or aligned, even as reclamation filled in the liquid divisions. Though the archipelago was connected to the mainland by rail in the mid-nineteenth century and by an automobile bridge in the 1930s, the paradoxical harmony among discordant nuclei still conditions any motion through the Venice of today. What Sansovino described as a simultaneous sense of naturalization and alienation still animates the navigation of the various pathways so specific to Venice that they founded their own terms—*calli* (walking streets), *rii* (the small canals forming the city's capillary network), *campi* and *campielli* (grassy plazas around wells for fresh water), *corti* (courtyard-like spaces between palaces), *sotopòrteghi* (public passageways carved out of existent buildings), *fondamente* (walkways lining canal banks), *rami* (alley subdivisions or dead ends), and so on. The discordant harmony of Venice has inspired countless polemics and eulogies, the past century and a half of which this book attempts to track.

This complex of *insule* defies the modern conception of the city as "Centralization itself," as Baron von Haussmann affirmed of his Paris, having been granted the mythical mandate by Napoleon III in 1853 for the imperial capital's spatial elaboration as "the head and heart of France."[25] Haussmann's

re-creation of the vistas and circulatory functions of Imperial and papal Renaissance Rome set a blueprint to be emulated worldwide, from Chicago to modern Rome itself. The Italian capital had similar designs on Venice: the year after Italian unification, Victor Emmanuel II devoted special funds to the creation of a curved boulevard of sorts lined with shops in his name, opened in 1871; and in accordance with Mussolini's 1934 injunction that "Venice must recover the roads of its traffic, the roads that gave her power and Glory," the broad and arrogantly named Riva dell'Impero was built out from Castello, unveiled in 1937. The archipelago as a whole remained largely aloof to the capital's designs, however. There were structural as well as cultural impediments: while the medieval mazes of Paris, London, or Dublin are historically contingent, Venice's very foundations are labyrinthine; Italo Calvino calls Venice the "first anti-Euclidean city."[26] Once the heart of the city was consolidated as a fish-shaped complex of islands around the beginning of the fourteenth century, all further development was conditioned by the need to reutilize the existing foundations, which had been laid out at great cost with wood, bricks, and stone imported by river, lagoon, and sea. Lagoon inhabitants were obliged into adaptive reuse, both of these foundations and of existing architraves, capitals, cornices, and columns fabricated in different places and periods—so that even when buildings were renovated during the Renaissance and beyond, they retained a certain Byzantine shape, or an odd eclecticism of languages and styles.[27] The urban fabric is thus inherently and uniquely anachronistic and polycultural. Nearly all of Venice's building took place between the ninth and the early seventeenth centuries,[28] and though a handful of edifices have been erected over the past two centuries (almost all in marginal zones) and bridges and landfill have made circulation possible by foot, rail, and automobile, no razing or construction campaigns have fundamentally altered its confounding mazelike form.

Marinetti's histrionic scheme to dredge the snaking Grand Canal, fill in small waterways, and expose Venice by electric light reflects this practical frustration with labyrinthine Venice (which is also responsible for its aesthetic allure): its resistance to synthesis—visual, spatial, and social. Jacopo de' Barbari fashioned a monumental panorama of the labyrinth as early as 1500, gathering the work of many surveyors to manufacture a composite bird's-eye view (figure I.6).[29] Yet this stunning panorama is the exception that proves the rule: on the ground, such clarity is impossible to find. Venice deflects synthesizing gazes, continuing to bend at odds against the modern French ideal of public space as ordered and legible, and resisting Haussmannian ideals of unfettered circulation, axial views, and the hermeneutics of strolling theatrically. A labyrinthine medieval

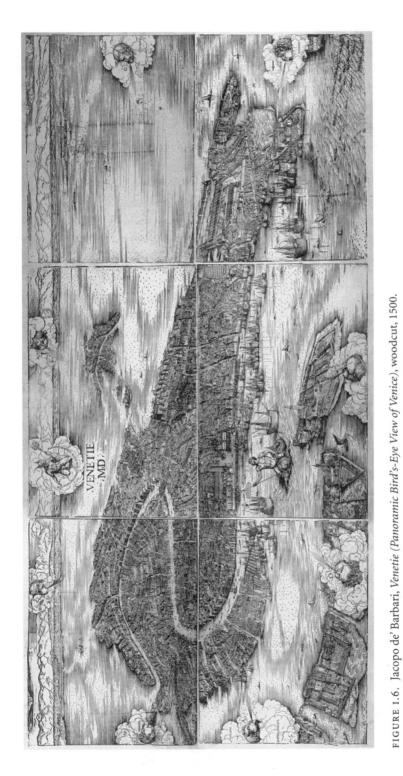

FIGURE 1.6. Jacopo de' Barbari, *Venetie (Panoramic Bird's-Eye View of Venice)*, woodcut, 1500. Photograph courtesy of The Newberry Library, Chicago; call number Novacco 8F7.

city would accommodate quakes of insurrection more easily, as Haussmann realized. It was in fact the populace of Venice that organized a crucial uprising against Austrian rule in 1848, beginning at the Arsenal, a node of power surrounded by the tortuous working-class passages of Castello; under Daniele Manin, these Venetians succeeded in establishing a Repubblica Veneta di San Marco. Though it lasted only five months, the Venetian resurgence laid a framework and inspiration for later key episodes of the Risorgimento, culminating in the Austrian surrender of Venetia in 1866, and its addition by plebiscite to Italy. Suppressing this insurrection required an invention in combat: the world's first aerial bombardment, with bombs dropped from balloons.[30]

In his influential 1907 essay "Venedig" (Venice), sociologist Georg Simmel charged the canalized city with forging a surface appearance of unity through architectonic "falsehood," accounting for the anxiety that will shadow the awe many artists have for Venice, particularly those authors of relationality such as Henry James and Ezra Pound. Venice's protean character refuses to conform to any stable, centralized model of union or belonging; even its bridges, which ought to render tangible some continuity between points in space, instead interrupt alleyways that "seem to *float* away without landings."[31] Deeper study of Venetian urbanism reveals that these morphological features are outgrowths of organic development: alleys, being less important historically than canals, conduct pedestrians at cross-purposes wherever land reclamation joined the distinct land masses, as if accidentally; and buildings were actually designed to "float" on the wet sand and mud to accommodate the constant motion of the tides.[32] Simmel disregards this historical development and reads Venice's circulatory features allegorically, as symptoms of a structural lawlessness; he concludes that the apparent harmony of the city is a radical lie—that of a "lifeless stage-set," in contrast to the life of a classical city like Florence, where appearance and essence register as conjoined. In the maze of Venice, the disappearances of inhabitants around innumerable corners make them "like actors who vanish to the left and to the right of the scene . . . being without causality in the reality of what occurred before, and without effect in the reality of what comes after"[33]—rendering time eternally out of joint.

But Venice's very noncompliance with the designs of "artist-demolitionist" planners such as Haussmann renders the city a continual lure to modernists, who grope through the cityscape to know the unknowable, to shatter mysteries suspended in romantic amber.[34] Venice's lasting obstructions to vision make for a literary tradition that does not catalogue knowledge, but scrambles the chronicle, or further encodes the unknown—provoking Ruskin's epic attempt to cobble together the city's history on a granular level, stone by stone. Modern literature gives rise to hosts of anxious tourists in Venice disoriented

on foot or surrendering themselves, like Aschenbach, to boatmen versed in the lagoon's illegible shallows. An attraction laced with anxiety continues to suffuse contemporary accounts of Venice—most obviously in the popular fiction that, like the Gothic novels of Ann Radcliffe and "Monk" Lewis, lodges an ill-defined conspiracy or evil in its maze. This tradition ranges from Daphne du Maurier's "Don't Look Now" (1971; adapted for film by Nicholas Roeg in 1973) and Ian McEwan's *The Comfort of Strangers* (1981; adapted for film by Harold Pinter and Paul Schrader in 1990) to the Venetian detective novels of Michael Dibdin (particularly *Dead Lagoon* [1994]) and Donna Leon (whose Commissario Brunetti series, begun in 1992, has been translated into over twenty languages, excluding Italian). Simmel's terms regarding the theatrical obscurity of Venice resurface in W.G. Sebald's 1990 *Vertigo*, in which the labyrinth (riddled with literary ghosts) emblematizes the novel's overall disorientation. Sebald parses a dual sensation of excessive exhibition and concealment in "the heart of that city": "you cannot tell what you will see next or indeed who will see you the very next moment. . . . These brief exhibitions are of an almost theatrical obscenity and at the same time have an air of conspiracy about them, into which one is drawn against one's will."[35] Venice still adheres to a medieval address scheme, lacking rationalized indices. Because it cannot be apprehended by way of standardized coordinates and is notoriously resistant to being charted accurately, modern visitors to Venice must call upon memories of visceral experience in order to "know" and read it. Venice obliges cognitive mapping to coincide with corporeal mapping—a fact reflected in Venetian writer Tiziano Scarpa's *Venezia è un pesce* (Venice Is a Fish [2000]), whose chapters "guide" the reader through the city's passages and eccentricities body part by body part.[36]

As we seek to know Venice, both viscerally and corporeally, we find a city that is gendered again and again. Venice is, by tradition, pointedly bereft of heroic monuments, and the city's only inherent approximation of a boulevard is the snaking Grand Canal.[37] This avenue, like the rest, leads the gaze astray, thwarting any strictly visual experience of the panorama. An eighteenth-century Grand Tourist notes the way the feminized topos engages the dizzied gaze: "Whilst you gaze upon those beauties which first present themselves . . . the neck and bosom, on the ever-varying surface of which the eye glides giddily without knowing where to stop, or whither it is carried,—it is all delight and admiration."[38] The canal then tows the eye figuratively downwards, disturbing the view with a broader assault of sensory data (still haunted by literary history through citation from *King Lear*): "But if the eye, with its neighbor nose, suffers itself to be carried down the Grand Canal, which—between those breasts turned by the hands of the Graces, and pointed by

Desire—leads to the chinks and crannies of the city,—fah! an ounce of civet, good apothecary, to sweeten my imagination—Venice is a stink-pot, charged with the very virus of hell!"[39] Suffusion of the canal city's topography with attributes of feminized corporeality is implicit in countless texts to this day (and may account for the relative scarcity of modernist women who chose it as a subject; "Venice by moonlight," as "static little pictures," would be the more overdetermining and "conclusive" for female protagonists such as H.D.'s Hermione). In the video for "Like a Virgin," Madonna gyrates at the tip of a gondola that permits the camera to bestride the city's canals, reincarnating a trope exploited for centuries while giving voice to the symptomatic fantasy of a virginal woman/site "touched for the very first time."[40] Venice remains an unreconstructedly sensual complex into the twenty-first century, undulating out of line with knowledge predicated on visibility and bereft of the architectonic indices and measures of hygiene imposed by modern political capitals.

Venice's singularity does not lie simply in its status as a canal city, reclaimed from marshes. Its commercial successor, Amsterdam, is a product of equally ingenious engineering; Michael Taussig characterizes both settlements as "continuously operating salvage operations squatting on swamps and mud."[41] Amsterdam too became the center of a far-flung mercantile and publishing empire, enabled by control over trade waters once the balance of power shifted from Mediterranean Venice toward Atlantic routes of exchange. Yet the wetland macroenvironment of Amsterdam was destroyed by modern and colonial development, like that of Tenochtitlàn, whereas Venice survives in its original (however modified) geographical context—standing alone as a paradigm of continued rapprochement with the natural environment.[42] Amsterdam was dramatically reconstructed during its Golden Age of the seventeenth century, in line with the design consciousness of the Italian Renaissance and the master plan for the reconstruction of papal Rome. While it lacks the grand monuments, avenues, and plazas characteristic of those developments, Amsterdam became an heir to their legacy: the modern "intellectual recognition of the city as an object of design," as Anthony Tung identifies it, with zoning and expansion programmed according to "an idealized mathematical configuration."[43] Venice, by contrast, continues to stand as a contradiction to the rational design of both Rome and the Renaissance.

Saint Petersburg, another canal city functioning as a cultural threshold, and one equally defined by a massive body of literature,[44] is often called "The Venice of the North." For Joseph Brodsky, who was born in Leningrad, disembarking at Venice's railway station of Santa Lucia feels familiar and strange, "like arriving in the provinces, in some unknown, insignificant spot—possibly one's own birthplace—after years of absence."[45] Yet the Russian gateway to the

West also differs from the Italian gateway to the East in being the decidedly modern product of a classical ideal. Its creation can be traced to the rule of a single figure upon the introduction of modern European cartography to Russia.[46] Peter's capital was designed by an Italian architect in the Baroque style, and as the city expanded, ongoing efforts to maintain stylistic consistency and to unify the space visually along the perspectives of avenues and embankments preserved a sense of harmonious design.[47] Petersburg thus persists in the Romantic imagination as an imperial monument, "comprehensively mapped" and only sporadically undercut.[48] Brodsky, doubtless influenced by the twisting, implicating channels of his adopted Venice, asserts that "insinuation as a principle of city planning (which notion locally emerges only with the benefit of hindsight) is better than any modern grid."[49]

The marvels of these other canal cities are fundamentally "modern," and thus could not have inspired the kinds of reverie that have been aroused by the archaic frame of Venice. Venice's gradual development—both more constrained and less rationalized—and its continued environmental exposure stand in uniquely delicate contrast to a modernizing world. And yet the fact that the legendary "museum-city" cannot exist wholly aloof from the current—both literal and figurative—obliges us to redefine Venice's bearing on the present day. The lasting stresses and intricate ecology of this city still challenge the monumental solutions of modern urbanism founded on the elimination or centralized control of wetlands, and have been studied with renewed attention by a contemporary generation of engineers challenged to find more resilient solutions for rising waters around New Orleans and New York from mounting severe weather events. The encroachment of modernity dramatized by catastrophic flooding renders the amphibious city a timely example of the need to collaborate with rising tides and uncertain waters, and modernist impositions of purity in design have proved incapable of either accommodating or expunging such needs. If Venice seems at first glance a museum, what it places on display is the continuous work of *tempo*—which can be translated as both "time" and "weather"—on the precarious reality of all human construction: Venice is a conglomerate of cultural treasures "under constant threat of catastrophe."[50]

Venice preoccupies artists and intellectuals unrelentingly, both as a bearer of the consequences of modern development and as the harbinger of a future in which many urban structures will be endangered by radical environmental change. If we respond to Zanzotto's appeal to offer Venice "something better than admiration" and examine the obscured ways in which this would-be museum reflects ongoing circumstances, we can begin to account for the powerful role that the city has played for artists and theorists committed to

understanding—and reinventing—the demands of the modern.[51] To appre-
hend the city's place within a modernist imaginary, we need to examine an
earlier moment in which Venetian collapse dramatized the onset of modernity.

VENICE AS CITATION: PERPETUAL TWILIGHT

Venetian modernity begins with the fall—the fall of the Venetian Republic
to Napoleon in May of 1797. The conquest by this self-proclaimed "Attila
to Venice"[52] aimed to signify the arrival of Enlightenment to the lagoons,
and it was enforced through a series of reconstruction campaigns. Venice's
Carnival—which had come to last as long as half the year, and was perhaps
the most celebrated feature of the city's perceived noncompliance with rea-
son—was suppressed first of all (though Napoleon's 1807 ban on gambling
was to make an exception for "cities of water").[53] A Tree of Liberty was erected
in Piazza San Marco, now desanctified as the Piazza Grande, consigning the
ritual space to the participatory practices of a bourgeois public sphere. The
Jewish ghetto was opened, and democratic theater was convoked in the La
Fenice opera house, associated with oligarchy.[54]

Whatever revolutionary democratic aspirations this show of reform might
have kindled in progressive Venetian intellectuals such as Ugo Foscolo were
soon disappointed, however; the Municipality was dissolved after the Treaty of
Campoformio formally granted Venice to the Holy Roman Emperor Francis
II in October of 1797, and Napoleon embarked upon an elaborate preemptive
looting campaign. This was only the first of several exchanges over the course
of two decades of conflict between France and Austria that rendered the for-
mer Republic a mere pawn and treasure-house ripe for despoilment: Napoleon
would take Venice back as Emperor in 1806 and then, after a series of clashes
in the Veneto, cede it once again to Habsburg occupation in accordance with
the Congress of Vienna in 1814.[55] During the brief periods of French occupa-
tion from May 1797 through January 1798 and 1806–14, 166 churches were
expunged from Venice; ecclesiastical properties were destroyed, converted into
magazines, gymnasiums, and prisons, or simply put up for sale. Symmetry was
exacted in the arcades of the Piazza through demolition of Jacopo Sansovino's
remodeled Church of San Geminiano to make way for a new Napoleonic wing
of the royal palace. Fractions of the city were razed and sporadically replanned
according to dictates of modern hygiene: The dead were removed to the sat-
ellite Island of San Cristoforo (now San Michele); the Rio di Castello was
filled in to create a broad 300-meter-long thoroughfare; and the Napoleonic

Gardens were imposed upon popular and ecclesiastical zones of the Castello quarter.[56] At the same time, Venetian artworks hailing from the pre-revolutionary epoch become desirable spoils: hundreds of manuscripts and scores of paintings and Republican sculptures such as the cherished classical bronze horses of St. Mark's (themselves plundered by Venetians from Constantinople in the thirteenth century) were dispatched to Paris, while the Doge's *Bucintoro* galley and other accoutrements of the *ancien régime* were dismantled and set ablaze for their gold. (Though Austria restored the bronze horses to great fanfare in 1815, the Habsburgs would confiscate their share of archives, artworks, and other treasures left behind by the French.) Napoleon's 1807 suppression of the Church and Scuola della Carità in order to found the *Accademia* picture gallery stands as one of the changes that definitively shaped the "modern" experience of Venice (however subtle). With so many paintings stripped from their ritual contexts and re-collected in accordance with the French determination of culture, this act may be seen as the definitive entrance of Venice into the modern—as large-scale rationalized planning was persistently foiled by the archipelago at large. This trend was to be reinforced at the century's end when the Venetian City Council inaugurated the first International Exposition of Art at the site of the Napoleonic Gardens.

The extinction of the Venetian city-state after more than a millennium of sovereignty (and over five hundred years as a republic), a feat unparalleled in its time, resonated through Western letters in conflicting ways: as the surrender of a corrupted *ancien régime* to the forces of Enlightenment, or as the surrender of an earlier model of liberty and sovereignty (a protodemocracy of the nobility, who resisted the papacy and hemmed in the powers of the Doge) to a modern version of democracy (bolstered by floating capital).[57] Though these interpretations of Venetian subjection tend to overlap and merge, the former was authored, broadly speaking, by the rivals of *La Dominante* ("The Dominant," an appellation emphasizing Venice's imperial power), most immediately the French, while the notion of Venice as a lost haven of republican liberty was produced by the admirers of *La Serenissima* ("The Most Serene," a name that stresses its freedom from armed conflict for centuries), among whom stood perhaps most vociferously the Romantic poets.[58] Their Venice, "the eldest Child of Liberty," inspired a rash of elegies: "She was a maiden City, bright and free; / No guile seduced, no force could violate," asserted Wordsworth's sonnet "On the Extinction of the Venetian Republic."[59]

The fact was that the economic foundations of Venice's maritime empire, which stretched from the Alps to Crete and Cyprus, had already been

compromised severely three centuries earlier: once Vasco da Gama navigated an alternate route to India and the concomitant discovery of the Americas opened up new markets for trade, power shifted inexorably from the hinge of Europe to the seafaring nations that bordered the Atlantic. With the Ottoman Turks having overtaken its trading colonies in the Near East one by one, and a legendary war fleet shrunken to twenty-odd vessels, Venice no longer held "the gorgeous East in fee," as Wordsworth put it—no longer stood, that is, as the sole gatekeeper to goods from the Orient.[60] Despite the maritime empire's drawn-out contraction—its long period of twilight—her "Extinction" by sudden violation drove many devotees to mourn, however belatedly. "Men are we, and must grieve when even the Shade / Of that which once was great is passed away," Wordsworth concludes somewhat defensively—with the syntax of his final couplet rendering more emphatic the gender difference between us as onlookers and the "maiden city" that was.[61]

The Venetian dialect poet Antonio Lamberti cast submission to Napoleon as the rape of a maiden by a godless man, suffered in the immediate, nautical lexicon of the native population:

> sta Dona, una zornada,
> xé stada bordizada,
> da un omo spiritoso,
> infedel, malizioso.

> this Dame, one day,
> was planked,
> by a wit of a man,
> malicious infidel.[62]

The loftier idiom of Ugo Foscolo's *Ultime lettere di Jacopo Ortis* (Last Letters of Jacopo Ortis [1802]), an epistolary novel of exile that opens with the aftermath of Campoformio, articulates a young Venetian's disillusionment with republican dogma: "Il sacrificio della nostra patria è consumato; tutto è perduto. . . . Devastatori de' popoli, si servono della libertà come i papi si servivano delle crociate" (The sacrifice of our fatherland has been consumed; all is lost. . . . Devastators of peoples, they avail themselves of freedom as the popes availed themselves of the Crusades).[63] There was a great deal to lament, though local testimony would be drowned out by choruses from without—not only in the immediate aftermath of the city-state's defeat, but also into the following generations. Those generations, who came to occupy the mythical shadow cast by the Romantics—and who were obliged to devise ways of

writing through it—are the focus of this study. They inherit Venice as a complex of competing myths: the city as a citation.

Venice had been a fetishized object of literary attention long before the Romantics. It had been rendered canonically dissolute by literature at least as far back as the mid-fourteenth century, when the introduction to Boccaccio's tale "Reprehending the Lewd Lives of Dissembling Hypocrites; and Checking the Arrogant Pride of Vaine-Headed Women" in the *Decameron* characterized the city in which it was set as a distinctly feminized "Vinegia d'ogni bruttura ricevitrice" (Venice, receptrix of all foulnesses), a site of vanity and counterfeit.[64] Boccaccio's disparagement was matched by praise from his contemporaries. Petrarch, a fellow Tuscan, took up residence along Venice's Riva degli Schiavoni soon afterward and extolled the city as the "unico albergo ai giorni nostri di libertà, di giustizia, di pace, unico rifugio dei buoni e solo porto a cui, sbattute per ogni dove dalla tirannia e dalla guerra, possono riparare a salvezza le navi degli uomini che cercano di condurre tranquilla la vita" (sole abode of liberty, of peace, of justice in our day, sole refuge of the good, sole port to which the everywhere war- and tyrant-tossed crafts of men who seek to conduct life in tranquility may repair).[65] Petrarch would change his mind, however, when informed by four noble Venetian *giovinastri* ("rotten youths") that his humanism was outdated—that the author to read these days was Avveroës, the Andalusian polymath. We know from the poet's letters to Boccaccio that this Venetian insult to his Western laurels, which resounds as shockingly cosmopolitan in our day, led Petrarch to desert Venice for good.

Positive and negative, these writings are all inflected by the Venetian Republic's own elaborate propaganda campaign, known to modern historians as the "myth of Venice."[66] A range of genres and media—popular histories, paintings, architectural environments, music and performances, and civic and ritual pageants—served to purvey Venice's reputation for beauty, religiosity, liberty, peacefulness, sobriety, republicanism, and stability. Literary works, state-sponsored and non, domestic and foreign, were central to its creation.[67] Lord Byron and his Victorian successor in Venice, John Ruskin, were not immune to the myth's influence in the decades after the Republic's fall. In fact, securing distance from myth in favor of documenting more substantive, animate forms of Venetian history becomes a core impulse in their writings, registering at the level of form as well as "plot." And yet such efforts at distance—a central preoccupation of the artists throughout this study—have always been outnumbered by works that continue to cite and elaborate on the fanciful literary inheritance of Venice (however unwittingly), like the shopkeepers who continue to traffic in the city's Carnival masks, as fine art and tourist schlock alike. The myth of Venice maintains its hold today, just as it did a century and a half ago.

As historians have noted, the myth of Venice spurred an equally vivid antithesis in the writings of Venice's enemies.[68] Venetian expansionism into terra firma, begun in Boccaccio's day, became more aggressive in the fifteenth and sixteenth centuries, provoking the so-called *leggenda nera* (literally "black myth"), or "countermyth," of excoriation by political and commercial rivals on the Italian peninsula as well as global competitors for maritime territories. In 1509, through grotesque narration of his encounter with a prostitute in the contested terrain of Verona, Machiavelli allegorized the degeneracy of a Venetian body politic whose mercenary troops fled "like whores and women" from the forces of the pan-European League of Cambrai.[69] European chroniclers reproduced this Florentine tendency to feminize and pathologize the porous city "dal mare . . . cinta" ("girded . . . by the sea") even as they marveled at it,[70] and the literary and popular imagination followed suit. Shakespeare produces a virtuous Venetian woman in Portia, but places Othello's phantasm of a "cunning whore of Venice" on the stage of possibilities as well; Shakespeare's London contained a brothel named, simply, "Venice."[71] The duality of Venice as representation was reconciled or reconfirmed in the figure of the prostitute, with its purified Venetian equivalent in the *cortigiana onesta* ("honest courtesan"), which emerged in the sixteenth century. The figure bolstered Venice's fastidious enterprise of self-fashioning, incarnating a myth of liberty, harmony, and dominion borne by a uniquely amalgamated feminine iconography—Venice as Justice/Dea Roma/ Venus/Virgin Mary—while serving as a ready scapegoat for the plague, corruption, and social instability. This embodiment of beauty and sexual unruliness was wielded by early modern chroniclers as proof of the Republic's progressive social policies and aperture to immigrant and marginal groups, yet also of its immersion in "luxury, spectacle, disguise, commercialization, voluptuousness, and sensuality."[72] Thomas Otway's 1682 she-tragedy *Venice Preserv'd* complicates the *leggenda nera* by placing defamation of the Republic in the mouth of a bloodthirsty mercenary soldier: the conspirator Pierre, who portrays the weakened city as "the *Adriatick* Whore, / Dress'd in her Flames . . . / Such as shall burn her to the watery Bottom."[73] Seed of revivals for 150 years, and of reinterpretations as recent as Simone Weil's *Venise sauvée* (begun in 1940 and published unfinished in 1955), Otway's drama and its ventriloquisms—figurations of the sole Italian state independent of Spanish hegemony, and therefore ripe components of political and cultural parallelism—had a lasting hold on the Northern European imagination, enduring through the justification of the Napoleonic conquest, its (partial) repudiation by the Romantics, and beyond.[74]

Centuries of writing on Venice from without disseminate these dual fantasies of republican integrity on the one hand and imperial dissoluteness on

the other. Ostensibly devoid of an intellectual tradition to match its painterly, architectural, and musical schools (Goldoni was regarded by Northern Europeans as author for a common local stage, and Casanova, as Tony Tanner points out, "did not so much 'write' Venice as 'embody' it"),[75] Venice presented a seemingly inarticulate theater—if *not* a blank slate, or Mont Blanc—for a throng of foreign authors. Edith Wharton encapsulates the prejudice in attempting to dismantle the countermyth of Venice: "There was no intellectual depravity in Venice because there was hardly any intellect; there was no thought of evil because there was no thought."[76] (Such projections disavow the long history of Venice as a publishing center that provided an aperture to classical Greek texts and Eastern thought, and thereby stewarded the evolution of humanism.) Chronicles from the early modern period forward represent the city-state as an exemplum of political autonomy, pragmatism, secularism, republicanism, class harmony, and libertarianism—*or*, and increasingly until its fall, as a hotbed of opportunism, oligarchy, oppression, and extravagant license.[77] These contradictory perspectives persist in the writing of Venetian history from the Napoleonic seizure into the twentieth century. Denouncement of Venetian decadence (however qualified by awe vis-à-vis its sovereignty) influenced Anglo-American literature of the nineteenth and twentieth centuries through the historiography of Jacob Burckhardt, Horatio Brown, Bernard Berenson, Mary McCarthy, and Jan (formerly James) Morris—an outlook that tended to privilege the values of the Florentine Renaissance. Yet vilification and praise often appear together, in the hands of single writers: think merely of Byron's "sea Cybele" and "sea-Sodom."[78] Perhaps more than any single quality of Venice, what surfaces most frequently in post-Romantic engagements with the city is the compulsion to tap into (and often abjectly to rehearse) this illustrious and ever-expanding network of writings about the life (and death, or degraded afterlife) of the Venetian Republic.

Although in actuality Venice's Great Council acquiesced quietly, passing a resolution to vote itself out of existence, the Republic's 1797 termination triggered a lavish tradition of aesthetic historiography continuing well after the Romantic elegies: Venice became the focal point of a transnational fantasy about a sumptuous and decadent age that had been terminated, or the glorious era prior to modern disenchantment. This fantasy seduced artists and intellectuals—both those in search of some inassimilable, labyrinthine, anachronistic material and cultural form, and those hoping to yank the city of twilight in the direction of modernity by "killing the moonlight" of Venice, in Marinetti's famous phrase. Literature prolonged both the Carnival and funeral of Venice, attempting to determine where one ended and the other began, and its tropes

made their way into the guidebooks of the loathed modern masses of middle-class tourists (postlapsarian successors of the Grand Tourists and sentimental journeyers of a prior age). Venice still represents a time-space dominated by enchantment, accessible to the rationalized capitals of modernity via coach-line, railway, hallucination, or ruse.[79] It still hovers in the Western imaginary as the last European holdover against reason in the strictest sense, and this renders the city the adversary of modernity and the darling of its critics, from Ruskin through Aldo Rossi and Federico Fellini. In Venice, authors imagine time and again, the age of Enlightenment was dominated by Carnival.

Nearly since Napoleon's victory, the scholarly record surrounding Venice has tended overwhelmingly to focus on the Republic, and to frame its termination via the reductive logic of splendor and decline. It was only in the 1990s, with the approach of the bicentenary of Napoleonic domination and the 150th anniversary of the landmark 1848 revolution against the Habsburgs, that a critical mass of scholars began to treat post-Republican Venice as vital material; today, more than two centuries after the Republic's fall, Venice is only beginning to be approached from the point of view of the present.[80] In the meantime, critical accounts of the literature inspired by Venice tend to treat the city as a temporally suspended representation, stopping short of accounting for the friction between representation and historical actuality, and declining to track the interchange between foreign authors and their Italian peers. Even in otherwise eloquent studies, Venice still emerges as an elaborate rhetorical construct produced by visitors, with the city itself "stagnating outside of history" (as Tony Tanner puts it in *Venice Desired*), an "Otherwhere, a circle or space of its own kind" (the guiding trope of Margaret Doody's *Tropic of Venice*), lacking a life independent of foreign projections beyond the eighteenth century.[81] These assertions posit the species of isolation and historical suspension at the heart of Mary McCarthy's more fanciful notion that "Venice lies, pearly and roseate, like the Sleeping Beauty, changeless throughout the centuries, arrested, while the concrete forest of the modern world grows up around her."[82] Such writing demonstrates how powerfully the work of a historically disencumbered imagination suffuses Western conceptions of Venice.

With this book, I will depart from this trajectory by introducing Venice into the geography of comparative global modernism and postmodernism, insisting on regarding it as a living city rather than as a metaphor for death (while accounting for the ways in which the reputed "death" of Venice fuels its life as a magnet of cultural production and tourism). The multiplicity of Venice, in both geographical and literary terms, necessitates a rigorously comparative study. In setting out to comprehend the logic behind an almost

viral recurrence of Venice as a locus of expiration, or perpetual twilight, in intellectual and artistic culture since Romanticism, I track the interchange between outsiders and inhabitants—because it is such traffic that generates both the city and the art that city inspires. The comparative nature of this project is not, however, restricted to the debates between Anglo-American and European artists. I have also sought to delineate the ways in which the decentralized, labyrinthine, amphibious urban organism conditions cognition through real space and time. I sustain a focus on materials in a site that has suffered (and at times indirectly benefited from) so many ideological projections. While Venice represents for many thinkers the prototypically "irrational" double, or underbelly, of a classical modernism, I aim ultimately to demonstrate that Venice as a site gave rise to specific and highly adaptable structures. Though the city's morphology does not fall into line with Cartesian forms of rationality, it possesses its own tactical integrity, having been shaped through continual negotiation with the tides. Venetian forms are neither "artificial" (to cite a frequent criticism) nor unconscious. And Venetian tempos continue to course against a mortifying corpus of citations.

The modernist works in which I linger foreground, and manifest formally, the disturbance of the entrenched tropes of twilight that every author brings to the place. Authors engaging with the material reality of Venice discover that the city abides by its own tempo: Venice subjects the "new" to tortuous redefinition while thwarting any direct satisfaction of nostalgia; Venice checks both the accelerated linear time of modernity and romantic fantasies of suspension. Arriving too late to publish a credibly Romantic elegy for the Republic, modern authors committed to engaging with the material actuality of the city felt the need for a different sort of ending: fifty years after the fall, they called for the termination of Romantic poetry and fictions surrounding the place.

We will begin with John Ruskin, first and most vehement among post-Romantics to revise perceptions of Venice, who admits in *The Stones of Venice* (1851–53) that it can be daunting to confront the spectacle of contemporary Venetian desolation, as "the last few eventful years, fraught with change to the face of the whole earth," have proved more fatal to the city than the last half-millennium.[83] The construction of a railway bridge in 1846 has made the fabled geographical transition from land to lagoon barely perceptible—though Ruskin takes a great deal of time to describe the old approach by watercraft in closing volume I of *Stones,* and exploits the break between books to amplify its contrast with the current day as he opens volume II: "the noble landscape of approach to her can now be . . . seen only by a glance, as the engine slackens its rushing on the iron line" (see chapter 1, figure 1.2). Ruskin

argues implicitly that we, too, must approach the city through new channels, like it or not. Many a "hurried traveler" will be inclined to gloss over the ruins, or to "disguise what is discordant" in the current scene—but Ruskin grants "no permission" to such obfuscations.

> The impotent feelings of romance, so singularly characteristic of this century, may indeed gild, but never save, the remains of those mightier ages to which they are attached like climbing flowers; and they must be torn away from the magnificent fragments, if we would see them. . . . Those feelings . . . are in Venice not only incapable of protecting, but even of discerning, the objects to which they ought to have been attached. The Venice of modern fiction and drama is a thing of yesterday, a mere efflorescence of decay, a stage dream which the first ray of daylight must dissipate into dust.[84]

If we are to discern anything at all in Venice, we must emancipate the city in "fragments" from the lugubriously literary, sentimental "stage dream" of Romantic fiction and drama. True engagement obliges us to view magnificent Venice as a complex of objects, however damaged, in the brutal light of the present. Only then can these objects become "touchstones" of a world that would counter our own.[85]

Half a century later, as Marinetti engineers the invention of the avant-garde, he echoes Ruskin's call for the merciless illumination of Venice, calling upon citizens to "kill the moonlight" that pervades popular representations of the city. But as if explicitly to rebuke Ruskin for *The Stones of Venice* (the first Italian edition of which had just been published in 1910), he appends an imperative to "fill the small stinking canals with the ruins of the . . . leprous old palaces," themselves "sodden with romanticism":

> Let us burn the gondolas, rocking easychairs for idiots, and erect the imposing geometry of metallic bridges and factories pluming with smoke to the sky, to abolish the falling curves of old architectures.
>
> Let the reign of divine Electric Light come to liberate Venice from its venal moonlight. . . .[86]

The careers of these demagogic figures, a nostalgic English Victorian and an Italian Futurist, could not appear more opposed to each other. In fact, Ruskin lamented the city's introduction of gaslight in 1845, "which Venice provides for your seeing her shop-wares by night, and provides against your seeing the moon, or stars, or sea," while Marinetti blamed Ruskin's "morbid dream

of rustic and primitive life" for having "singularly developed the obsessive cult of our past in Europe, and . . . entirely falsified the judgment of Europe regarding contemporary Italy."[87] And yet these authors pursue a common end, which appropriates the rhetoric of Enlightenment and becomes central to the scheme of modernism: they see the denouement of the pre-Enlightened Venetian state as coterminous with the exhaustion of "romantic" mystification. By striking Venice conceptually with the light of day and electricity, respectively (a task literally begun by Napoleon, who introduced municipal lighting to the city), they seek to collapse romantic distance from the place— to regard the city as material, however distressed, *in the present tense*. In the process, they aim to invent or recover a new species of objectivity. Such objectivity opposes what Ruskin named the "pathetic fallacy," or the literary attribution of human characteristics to inanimate objects—a critique that anticipates Marinetti's call to "[b]eware of attributing human feelings to matter" (and, more radically, to *replace* man, who is "ruled by a fearful logic and wisdom," with matter).[88] Their aspiration toward objectivity aims to restore to the "discordant" material at hand a radiant presence—even if their hopes and methods for arriving at presence are diametrically opposed.

Laden with centuries of subjective impressions, Venice is particularly resistant to unqualified assertions of objectivity and presence, however. Regardless of the hopes (and the diatribes) of Ruskin and Marinetti and their modernist cohort, many artists and intellectuals continue to regard the floating city through the dusk of Romantic poetry. An aspiration to usher Venice into the present moment by Anglo-American and Italian witnesses who identify opportunistically, due to political interests, with the struggle for Venetian and/or Italian sovereignty can be distinguished from a more allegorically oriented tradition trained on the city's decay, whose key works are composed in the languages of Venice's nineteenth-century political domination, French and German.[89] Simmel's "Venedig," which epitomizes this allegorical treatment of Venice, charges Venice with hypnotizing us into "the twilight state of the unreal" through its monotonously slow pace.[90] Venetian light itself registers in his account as an elaborate "falsehood" that "has only served as a face for a life that is dark, violent and unrelentingly functional."[91] These tropes are typical of the late-romantic modern literary tradition surrounding Venice, canonized by Maurice Barrès' *Amori et dolori sacrum: La mort de Venise* (Amori et Dolori Sacrum: The Death of Venice, 1903) and Thomas Mann's *Der Tod in Venedig* (Death in Venice, 1912), shared by Gabriele D'Annunzio in his early decadent phase, and finally appropriated by the Futurists for the purposes of repudiation, which dwells on the fallen Republic in morbidly

erotic terms—in a tendency Marinetti noisily pathologized as "the syphilis of romanticism."[92] Mann portrays the bygone, purchasable romance of Venice as that of a residual seductress/nurse: "half fairy tale and half tourist trap, in whose noisome air the fine arts once thrived luxuriantly and where musicians were inspired to create sounds that cradle the listener and seductively rock him to sleep."[93] Though narrated from the contemporary standpoint of beach resorts on the Lido, Mann's Venice is a locus of slumber and expiration, imagined through the remote frame of classical antiquity and the shadow of Wagner. The reflex to project twilight onto Venice persists into the twenty-first century in both high and popular culture. By concretizing the cliché of Venetian decline through functional sinks and forcing the trope of the mask to serve as a bodily entryway, Bruce Nauman's *Venice Fountains* ludically subverts this tendency to abstract and aestheticize the city's fall.

The aspiration to revive Venice by subjecting Romantic "falsehoods" to the light of the current day has yielded a century and a half of aesthetic experimentation whose struggle deserves its own chapter in the history of modernism. For insofar as modernity is defined by the myth of a radical break with the past, Venice persists as an exemplary aberration. Venice becomes the locus *par excellence* in which to contend with ghosts that impede the quest for presence—the quest that Habermas identifies at the heart of modernism. Responding to the city embroils the modernist enterprise in an eclectic, digressive historical reality, wherein the pressure to recuperate the past for present purposes gives rise to countless filtrations and detours. Venice, ultimately, provides routes through which to recover a vitally nonlinear form of history.

In Venice, every move forward entails a detour—from navigating its streets to navigating its history of mystification. As a result, this book is less a study of "Venetian modernism" than of modernism *in* Venice. While my subtitle echoes Mann's *Death in Venice*, but pointedly displaces "death" with "modernism," it also suggests that modernism did not really gain a foothold in Venice, despite manifold attempts. Instead, deflected modernist impulses—like so much else in Venice—became part of the assemblage. Mine is not, then, an attempt to make a claim for Venice's obscured role as a capital of modernity, nor to unearth a "local" or "minor" modernism. (Strictly defined as a local impulse with global resonance, Venetian modernism becomes most recognizable in the postwar period, through the singular oeuvres of Carlo Scarpa in architecture, Emilio Vedova in painting, and Luigi Nono in musical composition; but I have had to accept that a thorough account of this more recent phenomenon across the arts would necessitate a volume unto itself.) This book, instead, shows that Venice permits us to explore the aspirations, repressions, critiques, and failures of both modernity as ideology and

development and modernism as aesthetic response. While Venice appears to hover as an "elsewhere" just beyond the panorama of modernity, I will show that it has never been entirely removed from international political and aesthetic trends and economies, but rather reflects, shadows, and derails them.

In these Venetian incarnations of modernism, assemblage becomes a necessary tactic. The upstart nation-state of Italy and the historical avant-garde that intermittently, and ambivalently, buttresses it might desire to jettison the city's outmoded urban fabric and the vestigial sentiment that accrues to it, yet such casting off is impossible. Instead, historical traces must be written *through*, becoming incompletely assimilated parts of the new. Seeing Venice becomes a labor of editing and revising, or of a more tormented "dodging," to use Henry James's term; writing Venice becomes a work of transcription, translation, collage, pastiche, or adaptive reuse. Accounts of this eclectic urban complex become so tortuous as to constitute labyrinthine aesthetic objects themselves. The frustrated chronology of *The Stones of Venice* anticipates the ruptures of Ezra Pound's "poem including history" (*The Cantos*), the refracted Venetian recollections of *Invisible Cities*, and indeed, even Rem Koolhaas's pastiches for the galleries of the Guggenheim fleetingly lodged within The Venetian Las Vegas. Zanzotto assures us that any effort to establish an authentic rapport with Venice will be threatened by the need to read, select, and recopy from among so many stratified imprints of narcissistic individuals and crowds. Spectacularly expressive in itself, Venice in turn spawns a network of gazes of many great figures, gazes "that cross one another from all dimensions."[94] And more often than not, the weight of these gazes chastens the self-conscious (and all too "informed") author into the humbling labor of an editor who traffics ineluctably in the impressions of others past and present, rather than an adventurer who touches Venice "for the very first time." In contemporary engagements with the archipelago, we still witness an amalgamation (however resigned) of individual expression with the signatures of a fugitive collective of phantoms, an amalgamation of hyperlocal patois with global lingo. Such dynamics, which seem to exemplify postmodern practice, are only the most recent instantiations of a lasting Venetian predicament—and lure.

Venice as Cosmopolis: Cosmic Extraterritoriality

We have inherited generations of reductive ideas about Venice in part because scholars have excluded the city from both the historiography and the geography of modernity. Venice's capacity to appear as if it hovers at the threshold of history and dream, which seduces so many authors to its shores, is linked to its

geographical situation at the threshold between Europe and "the East." Always operative in the cultural imaginary (as Shakespeare's Othello and Shylock attest), this marginality with respect to Europe was intensified by the geopolitical subjection of the Republic to France and Austria and further aggravated by Venice's age-old detachment from the political capital of the new Italy.

Liminal Venice is, in turn, stamped with any number of characteristics vilified by heroic modernism at the turn of the twentieth century, in a metonymically linked chain of associations—as fluid, feminine, "Oriental," irrational, decadent (of the "moon")—and therefore cast rhetorically outside of the modern moment and terrain, outside of the dominant historical record. It is thus hardly surprising that notwithstanding its pervasive presence in modern literature, Venice has been virtually excluded as anything but a trope from accounts of modernism—which, until the advent of the new modernist studies in the late 1990s, depicted the expressive eruption of modernity as emanating from a restricted set of variously imperial metropolises (particularly those of Paris, London, and New York).[95] But even Marinetti's polemic against Venice shows that it has remained an integral part of global history. The city that resists both "progress" and the alleged ideals of high modernism continued nevertheless to fascinate both the bourgeois, or popular, imagination *and* the avant-garde, generating artifacts that intensify the contradictions at the heart of modernism—and that ask us to reimagine both the temporal and the spatial coordinates of artistic exchange. All the while, ongoing pressures to modernize interpose themselves into the city of lagoons, rendering would-be nostalgic visions of Venice uncannily redolent of "home."

This book does not seek to dislodge prevailing accounts of modernism but rather to enrich understandings of the geography of modernity by reading Venice as a cosmopolitan site of production by locals, visitors, and expatriates and of international cultural flows.[96] The latter-day conception of Venice as a "destination" elides a history of navigation and efflux registered in literature as far back as the thirteenth-century travelogue of Marco Polo, merchant-ambassador to China: Venice is one of the world's first and enduring cosmopolises. As an age-old rival and point of reference for other European powers—an eclipsed trade emporium, regional state, republic, and core of an empire extending uniquely Eastward—Venice has a distinctly equivocal relation to imperial concentrations of power in the modern moment. In the twentieth century, it continues to amalgamate waves of local, national, and international claims, giving rise to a mobile species of shadow modernism that no single regime or body politic manages to appropriate or oversee—and obliging us to redraft the confines of the modern in both temporal and geographical terms. *Killing the Moonlight* helps to chart the

uneven development of both modernization and the aesthetic reactions it pro-
voked by grounding them in this idiosyncratic geographical matrix. I mine the
variegated responses to Venice's shrinking from a world power to a "historical
center," reduced from imperial space to the status of a seemingly provincial and
endangered, yet consequently more beloved—and globally "haunted"—place.

As Simmel's critique makes clear, Venice has never conformed to any model
of a homogeneous social body as conceived in the nineteenth- and twentieth-
century heyday of national ideologies but has always existed within, and because
of, a broader system of exchange that is geological, cultural, and mercantile. In
his sixteenth-century laudation of Venice, Gasparo Contarini began a trend of
extolling the city as a "wonderful concourse of strange and forraine people"
and "so vnmeasurable a quantity of all sorts of marchandise to be brought out
of all realmes and countries . . . , and hence againe to be conueyed into so many
straunge and far distant nations"—"as though the City of *Venice* onely were a
common and generall market to the whole world," facilitating a tidal influx and
conveyance of populations and products.[97] One finds the depictions and com-
missions of these populations everywhere in Venice, but perhaps most centrally
in the cupola of the Pentecost in St. Mark's Basilica—mosaic work of a twelfth-
century Greek master that portrays the Gospel being distributed from the Holy
Spirit to the Apostles and, in turn, to thirty-two representatives of sixteen cul-
tures, many of which were in direct contact with Venetians (figure I.7).

In contrast to classical cities such as Florence, comprising bounded forms
in themselves, the archipelago of Venice is intrinsically open to alien influence;
commerce with the alien forms part of its self-definition.[98] In Henri Lefebvre's
classic 1974 account of *The Production of Space*, the city emerges as an exem-
plary instance of the dialectic between the singularity of an artwork and per-
vasive forces of production; it was not conceived in isolation as the design of a
finite sociohistorical order, but rather evolved in response to continuous trials
against nature and rivals and to the expanding needs of trade: "The space of the
settlement on the lagoon," observes Lefebvre, "cannot be separated from a vaster
space, that of a system of commercial exchange."[99] The Venetian empire was
based on this interchange with the greater Mediterranean and the East—and the
Republic's fall, while devastating, never walled the city off from the vaster space
of commerce, a space that can be tapped but not contained. As a republic and
since, Venice has remained uniquely vulnerable to transnational currents.

The Venice of modern literature is threateningly, tantalizingly open to for-
eign influx—and in particular to Asia. Thomas Mann's Venice, at once ata-
vistic and decadent, exemplifies this tendency in representation: it becomes
the vehicle that transmits the fatal disease of the Dionysian other to the

FIGURE I.7/PLATE B. Cupola of the Pentecost, Saint Mark's Basilica, Venice, first half of the twelfth century. Mosaic work depicting the Holy Spirit, Apostles, and representatives of sixteen peoples to whom the Apostles preached: labeled, as according to the Acts of the Apostles, *Parthi, Medi, Elamitae, Mesopotamia, Judea, Cappadocia, Pontum, Asiatici, Phrygiam, Pamphiliam, Aegiptum, Libiam, Romani, Judei, Cretes,* and *Arabes.*
Photograph by Dennis Jarvis, 2010.

classically imagined, Apollonian Europe of Gustav von Aschenbach. Venice leads the disciplined author "astray" to fall in love with a boy from Poland, and its fruit carries Asiatic cholera from the Ganges delta by way of Syrian merchant ships.[100] Situated, in Ruskin's words, "at the point where the influences of the East and West—of the old and new world—were to meet," Venice is also celebrated for being uniquely sited "to unite the energy of the one with the splendour of the other," for better or worse.[101] The stylistic idiolect of what William Hardy McNeill called "the hinge of Europe" thus verges on the exotic from a European standpoint.[102] Yet the estranging Venetian ambience "naturalizes" those it absorbs in a way that only a metropolis can. In

My Voyage to Italy: Pentecost 1912, the young Walter Benjamin observes, "It struck me very much that Venice . . . enveloped me in a wholly real and everyday atmosphere; as if a sojourn of just two or three days were able to turn the strangest, most beautiful thing into the most amenable or unusual, practical or hostile thing. Contributing to this perhaps is the metropolitan character of Venetian life, which is perfectly matched to the metropolitan citizen."[103] Metropolitan Venice so fully establishes its own dominion of effects that the marvel of its foundations is quickly normalized. The locality at once uniquely its own and cosmopolitan proves irresistible to modernist montages of future and past—to both archaeologies of the local by authors such as Ruskin and Zanzotto and to Ezra Pound's calls for a metropolitan "vortex" made new.

The otherness of Venice pervades discourse within Italy as well, reflecting a long-held tension between the mercantile Republic and the authoritarian capital of Rome that authors constantly seek to reignite or amend. Post-Republican Venice passes from the condition of a global commercial hub into what Henry James defines in 1902 as "the real, or certainly the finer, the more sifted Cosmopolis," eluding ardent participation in the newly formed nation-state.[104] (For while Venice's 1848 revolution against the Austrians remains a key episode in retrospective narration of the Risorgimento, cession of the Veneto region to the Kingdom of Italy in 1866 was not a direct result of Venetian fighting for freedom but an arrangement between Napoleon III, Wilhelm I, Franz Josef, and Victor Emmanuel.) As we have seen, it was Venice that, in 1895, founded the world's first explicitly international biennial exhibition of art; it was Venice that, in 1932, founded what is now the oldest ongoing international film festival at the Lido, where bathing establishments for Europe's leisure classes had burgeoned at the century's turn; and it was Venice that, in 1980, inaugurated the first world exhibition dedicated to architecture. Such civic decisions underscore the city's canny manipulation of the World Exposition format, substituting art for industry and progress; they need to be recognized as maneuvers to establish this place as a cultural, if no longer political and economic, capital.[105] Venice's unapologetic internationalism continued to mark its difference from other Italian cities through the Fascist era: in chronicling the Biennale, Enzo Di Martino shows that the city "remained an oasis of Europeanness in a country that had chosen the path of autarky."[106] Late in the twentieth century, Zanzotto still identifies in Venice "a sort of absolute, cosmic extraterritoriality," punning on its geographical position remote from terra firma. While Venice's imperial glory may have been based on rapacious acts of violence, the city remains relevant thanks to acts of culture: "Internationalism, which has cradled and practically put

it to sleep in a certain role, continues to gravitate around it anyhow . . . with the recognition that all populations owe something to this pure phantasm, of intersection, intercolloquy of peoples, times, and spaces."[107]

Unlike other elsewheres of modernity, Venice cannot be relegated to a time outside of history because the histories gathered in Venice are implicated in those of European and Anglo-American tourists. Venice emerges in modernist texts as an *internal* other to both Italy and Europe: it exists, however uneasily, within the time of nationhood and a common economy.[108] Urbane Venice, that "sifted Cosmopolis," is not easily imagined as a heart of darkness—as much as Marinetti might call on Venetians, in Nietzschean fashion, to strip away the city's burden of history, thereby exposing its "prehistoric lagoons."[109] Venice is decidedly *not* the "primitive wilderness" of "tropical swamp" populated by hairy palms, exotic birds, and tigers that the sight of a redheaded traveler at a Byzantine chapel in Munich provokes in Mann's Aschenbach.[110] Tempered by a Protestant work ethic that impedes him from traveling too far or long, the wanderlust of Aschenbach leads him, during "a year that for months glowered threateningly over our continent"—1911, whose diplomatic crises precipitated World War I—to "the surprising but obvious destination" instead. However swampy and exotic, Mann's Venice still forms a conspicuous part of "our continent."[111] The city is othered undecidably between cultures, like the stranger that triggers Aschenbach's desire to travel, who can be identified only through negation, as "clearly not of Bavarian stock"—and like the blonde gondolier who ferries the protagonist to the Lido, who is "clearly not of Italian stock," or the redheaded jester who sings "in an incomprehensible dialect" late in the city's cholera outbreak, and seems "not to be of Venetian stock."[112] In its ambiguous kinship with ascendant European powers, Venice may inspire more anxiety than the "darker" continents in which it traffics, Asia and Africa. The city that coined the term *ghetto* possesses the characteristics of the "stranger" theorized by Simmel: a member of a social group, classically a merchant or Jew, who brings qualities of the foreign inside—and in more sublime terms, a sociological phenomenon based on spatial relations that organize "the unity of nearness and remoteness" among humans, existing "beyond far and near."[113]

BETWEEN IMMEDIACY AND THE ARCHIVE: MODERNISM IN VENICE

Two axes of approach to Venice dominate the literary record: the quest for immediate access to the Venetian past and the recapitulation of Venice's

dissolution into sheer citationality. But spatial experience in the present and an experience of Venetian textures through reading are equally powerful; as such, the authors to which this study is devoted will find themselves plying continually between these poles. These diverging trajectories become clear when we compare their treatments of a commonly cited Venetian landmark with a complex history: While the material culture of Venice offers up myriad models of cultural assemblage, the city's ceremonial sea-gate of columns at the *molo* of Piazzetta San Marco, constructed with the help of spoils from mercantile and military campaigns over time, provides a paradigmatic case in point. These massive shafts of Egyptian granite, hauled from Constantinople and installed in the Piazzetta around 1172, and the apotropaic statues later erected upon them exemplify the hybrid nature of a city poised between the Romes of Italy and the East. The St. Theodore figure on the Western shaft representing Venice's first Byzantine patron saint is actually an assemblage: a Hellenistic head affixed to an Imperial Roman marble cuirass, yoked together with medieval armor wrought by a local sculptor during the fourteenth century, and planted atop a "dragon" (made up of a crocodile torso and canine head) dating to the second half of the fifteenth century (figure I.8). The so-called lion of St. Mark crowning the Eastern shaft, a symbol of Venice's adoption of a second patron and consequent departure from Byzantium, is thought to be an archaic Anatolian bronze chimera whose tail, wings, and Bible were tacked on at a later date.[114]

The writings of Marcel Proust, who found his own "touchstone" in Venice in the wake of Ruskin, epitomize the modernist quest for an immediacy of historical experience, in which the distances embedded in this discontinuous cityscape serve to conjure "dreamlike impressions" of the past inserted into the "present actual hour."[115] Marcel's involuntarily provoked memory of the undulating pavement of St. Mark's Baptistery in *À la recherche du temps perdu* (In Search of Lost Time), activated by a courtyard's uneven paving stone, somatizes recollection and fulfills the yearning for a "place" consisting of "pure matter."[116] In the introduction to his 1906 translation of Ruskin's *Sesame and Lilies*, Proust imagines the columnar figures at the Piazzetta as equally foreign custodians of another time interjected into ours: "beautiful strangers come from the Orient over the sea . . . who both, without understanding the conversations going on around them . . . keep on prolonging in our midst their days of the twelfth century, which they interpose in our today."[117] They repel our own days: "the columns push them aside, reserving with all their slender impenetrability the inviolate place of the Past [*la place inviolable du Passé*] . . . familiarly risen in the midst of the present . . . actually situated back many

FIGURE 1.8. Detail of "St. Theodore," sculptural assemblage made up of pieces from multiple periods, from its installation atop the western column at the *molo* of Piazzetta San Marco; original now exhibited in the courtyard of the Ducal Palace.
Photograph by Jennifer Scappettone, 2012.

centuries . . . yet there, in our midst, approached, pressed against, touched, motionless, in the sun."[118] These sculptures of the city's dual patrons from Amasea and Alexandria embody no one twelfth-century day or Eastern locus, as Proust imagines, but a dynamic interplay of historical and geographical influences—and an ongoing process of historical reconstruction. The authors we will explore in depth are enthralled by the mediation of tradition; they will not seek for the past any such "inviolate" or "motionless" locus.

And yet they also resist the impulse to read Venice in the opposite manner, as a floating signifier, or mere tissue of citation. Mary McCarthy, author of *The Stones of Florence*, typifies this second strain in literature by launching a polemic against the materialist approach to Venice that Ruskin inaugurated in her *Venice Observed* (1956). She embraces the city's status as a received trope, declaring, "A wholly materialist city is nothing but a dream incarnate. Venice is the world's unconscious: a miser's glittering hoard." In her imagination, the Piazzetta "saints" become fabulous guards of this "hoard": "a Beast whose eyes are made of white agate, and . . . a saint who is really a prince who has just slain a dragon."[119] "[T]he world's unconscious" always threatens to recur to the elaborate manipulation of ideologically determined inscriptions, however, in what Zanzotto calls the "opaque narcissism of groups and crowds."[120]

Venice's prodigious archive, both literary and material, constrains subjective projection to emerge as a countervailing agent in the works I foreground here, deflecting the textual attitudes that authors bring to the place.[121] The plural histories of Venice recovered by materialist modernists in Venice who are alert to such dynamics oscillate restlessly between experiential immediacy and historical palimpsest. Authors approach the Venetian past through texts only to be repelled physically, or they sidle up to the city's physical reality only to be confronted by the frictions of the historical record. Ezra Pound "places" himself in *The Cantos* relaxing under the St. Theodore "crocodile" in his youth; but the hybrid Piazzetta installation then provokes the punning citation of historical tensions from the Republic's archives:

. . . "Relaxetur"!

11th. December 1461: that Pasti be let out
 with a caveat
" caveat ire ad Turchum, that he stay out of
 Constantinople
" if he hold dear our government's pleasure.[122]

The marriage of West and East vaunted by the columns is vexed by the historical tension between Venetians and Turks manifest in Pound's quotation: the Council of Ten's paranoid imprisonment (and cautious release) of Matteo Pasti for spying when the artist was sent to Constantinople to work for Ottoman Sultan Mehmed II in the 1460s.

Throughout *The Cantos*, Pound records his compulsion to observe Venice from a multiplicity of viewpoints: "And I said: Tomorrow I will lie on the South side / And the day after, south west" (26/121). The aesthetic theorists of modernism insist on the integrity of such disorientation in formal and social terms: As Theodor Adorno proposes, "[T]he relation of parts to the whole, an essential aspect of form, is constituted by way of detours. Artworks lose themselves in order to find themselves."[123] An overall strategy of this book is thus to return, however obsessively, to the same materials from altered viewpoints to expose successive layers of meaning. I have preferred the strategy of intermittent return and "juxtaposition-conflict" (to steal Eisenstein's description of Piranesi) over a more linear mode of argumentation because it shadows the way that Venice re-arises, as if virally, through modern literature and art.

By juxtaposing responses to the city's touchstones from a kaleidoscopic sequence of perspectives, the following pages invite readers into a Venetian mode of revelatory disorientation. We will see how a century and a half of artists, from Ruskin to Zanzotto, have tried to illuminate the lagoon's obscured present and past, enacting the implosion of "Venice" as a received form, and rewriting history from the tormented outlook of the present. Ruskin and his successor in Venice, Henry James, refuse to turn a blind eye to the frustration of would-be romantic attempts to escape the current moment. They foreground being swept into the throes of a conflicted modernization as Venice is pressed to develop an industrial port for a new nation-state, even while accommodating trains full of sentimental tourists. These post-Romantics, seeking communion with Venetian masters, mostly see damage or a succession of restorations and reproductions, hemmed in by insensitive spectators; but the distressed quality of the present leads both writers to an "ambulatory" approach to history. Post-Romantic despair turns to idealism at the turn of the twentieth century, as Venice becomes the center of a new nationalist campaign of uplift in the writings and activism of D'Annunzio and the Futurists, focused on reviving Venetian dominance over the Adriatic—but their works end up being conditioned more by the city's own murky temporalities than by any instrumental historical narrative. In the same moment, an expatriated Ezra Pound models the aesthetic ideal of Venice as earthly paradise and modern vortex while rummaging unapologetically through its archives for

countervailing facts, granting an archipelagic discontinuity to the modernist (and would-be Fascist) epic.

In the postwar period, Venice becomes the focal point of a critique of modernism itself across theory and practice, which thrives in particular at the Architectural Institute of Venice. Postmodern narratives set in Venice by Italo Calvino, Jeanette Winterson, and Robert Coover reflect these reassessments of Venice's potential, treating the city as a locus of resistance to imperial fictions and a matrix of the "open work." Even as the "Venice" of the postdiluvian era is reproduced across the globe for profit as an eternally twilit casino paradise, its clichés are reanimated as critical pathos in the poetry of the New York School—while the fruits of Zanzotto's collaboration with Federico Fellini to invent a fabulous Venetian dialect sound the capacity of Venetian forms to mobilize a poetics of discordant cosmopolitanism.

As I make clear in the pages that follow, Venice did not mean the same thing to different artists. Successive generations of visitors—from James to Winterson, Le Corbusier to Fellini—arrived with distinct agendas, inflected by individual and collective exigencies. Nevertheless, certain attractions of Venice, which may be identified as obsessions, pervade these textual genealogies: its fluidity; its decadence and ephemerality; its obscurity and resistance to synoptic views; the residue of Romanticism; the discrepant copresence of epochs; its non-Euclidean geometry; its aperture to global networks that are intellectual, commercial, and aesthetic; its "internal otherness" (feminine, Eastern, Jewish, and/or cosmopolitan); and its distinct vernacular, both spatial and linguistic. These texts are by turns poignantly digressive; heavily filtered, foreshortened, and fragmented; amalgamative and anachronistic; miscegenated and amphibious; and continuously open to influence—reflecting modes of perception shaped by the archipelago itself. Here, the residual Venetian forms that appear to constitute hindrances to both modernization and high-modernist invention become the materials of experimental salvage; I trace their incorporation in literary and intellectual culture from Ruskin's histories through the nonlinear chronicles and conceptual archipelagos of the postwar environment.

Digressive modernist imaginaries, oscillating between invention and salvage, progress and regress, documentary and fantasy, presence and mediation, ultimately elude both nostalgic and positivist designs on the place of the past within modernity. The cityscape can exceed the status of a mere backdrop or prop in such texts: it can become the ground of a new poetic. In the work of those who travel to Venice seeking objective alternatives to exhausted logics of progress, the city emerges, against pervasive efforts of reification, as

"cross-grained, opaque, unassimilated material . . . which is not wholly obso-
lete since it has outwitted the historical dynamic"[124]—reframing the present
while exposing what Bill Brown has called "history's noninevitability."[125] The
texts provoked in the process resist the common impulse to shelve Venice's
past for aesthetic, political, or ideological gain.

Many an author has aspired to record the critical distortions produced
by and about Venice without merely reproducing the preconceptions that
have long cleaved to that city—and found that it requires a staggering effort;
Tafuri encapsulates the dilemma by reference to "the immense collection of
phenomena that have been crushed by the wor[d] Venice."[126] I have sought
to reinstall a century and a half of inscriptions into the discordant context
of modernity that gave rise to them, allowing the contradictions to remain
generative. My aim is to help redraft the geographical and temporal borders
of modernist studies, but also to discover and recover a materialist poetics
of collective space. I aspire to emulate the reciprocal interference between
form and content that makes my primary texts resonant; and my own mode
of analysis hews tactically to the accretive and paratactic syntax, the tortu-
ous, disjunctive, and immersive temporalities that characterize the city itself,
while making the case for their conceptual repercussions. Strategic acts of
immanent critique can help us overcome the unhelpful axioms that have
frozen Venice in critical discourse, leading to a more robust contemporary
vision of the beguiling city.

This book is an experiment in criticism that thinks implicitly with the
material in phenomenological and constructivist modes. If Venice is a place
of inherent transience and possibility, its continual mixing and regeneration
provide the ultimate vehicle for a history of cultural interaction that does
not homogenize. Criticism committed to fascination will always have a lab-
yrinthine relationship to explanation, multiplying alignments as it pursues
revised outlooks and revisited grounds. But this series of detours from the
capitals of modernity hopes to clarify why their *passé* urban other remains—
in spite of every cliché—a productively estranging place.

1. "THE ENTANGLEMENT OF MEMORY"
RECIPROCAL INTERFERENCE OF PRESENT AND PAST IN RUSKIN'S VENETIAN HISTORIES

> Repose, as it is expressed in material things, is either a simple appearance of permanence and quietness . . . or else it is repose proper, the rest of things in which there is vitality or capability of motion actual or imagined.
> —John Ruskin, *Modern Painters,* Volume III

Shifting Touchstones

"You know I promised them no Romance, I promised them stones. Not even bread. I do not *feel* any romance in Venice. It is simply a heap of ruins."[1] So writes John Ruskin to his father in 1852. In volume II of *The Stones of Venice* (1853), he redirects the force of this rebuke, condemning the ideal of Venice forged by his century's "impotent feelings of romance" as itself a ruin, but lacking substance: "The Venice of modern fiction and drama is a thing of yesterday, a mere efflorescence of decay, a stage dream which the first ray of daylight must dissipate into dust" (*Works* 10:8). Ruskin's brutal daylight takes aim at enchantments such as those underpinning Byron's *Childe Harold's Pilgrimage,* themselves derivative of tropes in Ann Radcliffe's *The Mysteries of Udolpho*—and reproduced to hollow effect in middlebrow novels and travelogues:

> I stood in Venice, on the Bridge of Sighs;
> A palace and a prison on each hand:
> I saw from out the wave her structures rise
> As from the stroke of the enchanter's wand:[2]

Rejecting any conception of Venetian "structures" erected through hocus pocus, and resisting the temptation "to submit ourselves to their undistinguished enchantment" (*Works* 9:59), Ruskin sets out instead to analyze their concrete "Foundations" (as announced by the title of *Stones'* opening volume). Ruskin's cautionary tale of Venetian rise and decline will be based on "frank inquiry," opposing "the indolence of imagination" (10:9), in what is perhaps a direct reference to Byron's description of Venice as "the greenest island of my imagination."[3] Stripped of Romantic embellishment, the "fragments" of Venice can be confronted in their immediacy—without recourse to parasitic indulgence in their decay or to fanciful restoration, whether literal or literary.[4] Ruskin's history will be based on the actual *stones* of Venice, however battered or unstable.

The seventeen years of research leading up to *The Stones of Venice* were only the beginning of Ruskin's audacious departure from the literary tradition surrounding the city. In *Praeterita* (1886–89), he justified a half-century of ensuing work on Venice by asserting that "her history had been falsely written . . . , and not even by any of her own people understood," and that before he began to study them, various Venetian masters were virtually unavailable to the senses: "Tintoret was virtually unseen, Veronese unfelt, Carpaccio not so much as named" (35:156). In restoring the sensuous immediacy of Venetian materials to the work of historiography, Ruskin underscores their failure to be still—and even goes so far as to invert the agency of the senses from time to time. *St. Mark's Rest: The History of Venice, Written for the Help of the Few Travellers Who Still Care for Her Monuments* (1877–84) grants the city itself the power of sight, invoking "this amphibious city—this Phocaea, or sea-dog of towns,—looking with soft human eyes at you from the sand, Proteus himself latent in the salt-smelling skin of her" (24:263). This prose embraces the sea-town's metamorphosis: It equates Venice with an ancient Ionian capital of navigators, then with the seal (*phoke*) immanent in its name, represented as a hybrid sea creature; next it personifies Venice, feminizing its "skin" only after infusing it with the scent of Proteus. The amphibious city exceeds the observer's grasp despite his efforts to conjure it with the deictic "this." The unfinished aggregation of essays he gathered under the heading *St. Mark's Rest* was intended to cap *Stones*, Ruskin's only prior history[5]; but its sentences stage their surrender to a flux made literal by the city of stone in water.

Henry James wrote of this series of pamphlets, "There is an inconceivable want of form in it, though the author has spent his life in laying down the principles of form and scolding people for departing from them; but it throbs

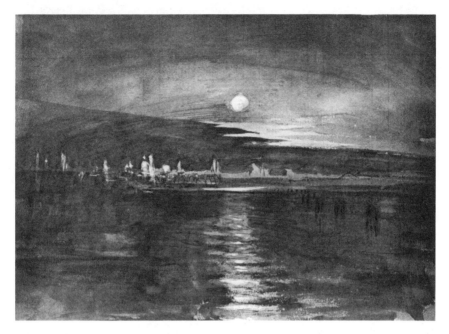

FIGURE 1.1. John Ruskin, "Moonlight on Venice, from the Lagoon," *The Stones of Venice,* volume II, plate J, 1853.

and flashes with the love of its subject—a love disconcerted and abjured, but which has still much of the force of inspiration."[6] Ruskin confesses to his passion for Venice in *Praeterita,* transcribing an 1841 diary exclamation: "This, and Chamouni, are my two bournes of Earth." (The diary may originally have read "homes," but Ruskin's 1887 transmutation of the quote for his memoir, characterizing Venice as both life's destination and boundary, is a generative one.)[7] Abjuring the decades of research that this passion inspired, consummated only in part, as "bye-work," the elder Ruskin then ruefully ascribes to the city the role of "a vain temptation," substantiating this claim with the diary's gushing observation that in Venice, "[t]here is moon enough to make half the sanities of the earth lunatic."[8] James revels in this tendency of Ruskin's writing to be led into temptation, straying from its author's "narrow theological spirit"[9]; the younger author is equally an admirer of Walter Pater, who noted that the value of attempts "to define beauty in the abstract . . . has most often been in the suggestive and penetrating things said by the way."[10] Both successors to Ruskin prize the empirical pursuit of an object as it dodges or exceeds abstract aesthetic principles "in the most concrete terms possible"[11]—the pursuit of an object that thwarts undeviating inscription.

In his first history, aspiring to chart a linear narrative of Venice's rise and fall, Ruskin had at least endeavored "to trace the lines of this image before it be for ever lost, and to record, as far as I may, the warning which seems to me to be uttered by every one of the fast-gaining waves, that beat like passing bells, against the STONES OF VENICE."[12] Such opening rhetoric exhibits the early venture's wish to capture the transient stones of Venice as a bounded image before the water's advance masters them once and for all. Aiming to distill what he later identified as "the laws of national strength and virtue" to which Venetian art could testify,[13] the nostalgic young aesthetic historiographer hopes to suspend the Gothic forms of the Venetian Republic in drawings and text. This struggle is twofold: he has to extract Venice from its tidal and sociopolitical tumult as a coherent "image" so as to isolate it in time as a historical case. *Stones* strives to assign exemplary monuments and dates to the phases of Venice's cultural zenith and fall into decadence,[14] and thus to contrast the comprehended site of the premodern past with contemporary states of affairs: "to succeed . . . in making the Stones of Venice touchstones, and detecting, by the mouldering of her marble, poison more subtle than ever was betrayed by the rending of her crystal" once several centuries of classical revivals eclipse a Gothic integrity.[15] Yet the stone environment Ruskin recruits to concretize the historical record proves impossible to bracket from interference by countervailing tempos—most dramatically that of the current forming its foundations.

It would be a mistake to read the turbulence of Ruskin's Venetian histories merely as the outcome of passion, "vain temptation," or lunacy. The errant discourse of these volumes stems from the critic's methodological aspiration to permit his unstable touchstone to speak for itself. "[Venice] shall also tell you . . . her own story, in her own handwriting," he avows in *St. Mark's Rest*; "Not a word shall *I* have to say in the matter, except to deepen the letters for you when they are indistinct, and sometimes to hold a blank space of her chart of life to the fire of your heart . . . , until words . . . are seen" (24:241). Constructing a history from the piecemeal testimony of Venetian objects in their labyrinthine environment, Ruskin overturns a burdensome legacy of inscription, dissipating the "egotism" of Enlightenment rhetoric and Romantic sentimentalism attaching to the place (10:221). As narrative, *St. Mark's Rest* subordinates the role of individual actors to artifacts, and grounds this focus on things in Venetian tradition, schooling readers in the fact that the Venetian Republic erected monuments such as the columns in St. Mark's Piazzetta "in memory of *things*,—not of the man who did the things" (24:208). Unlike the imperial column heroizing Napoleon (and invoking Trajan) at the Place

Vendôme, or Nelson's Column in London, the Venetian columns are there, supporting their saints, because they are beautiful in and of themselves, as pieces of stone (24:219–20). In the process of researching and submitting to things, the author drifts from his own rhetoric as a matter of course— provoking an ideological and epistemological conflict that will be tapped by the coming generation. All of the seer's morality is aesthetic, all his ontology material; and the Gothic forms he sets out to archive in the service of a cautionary tale about Venice's fall into early modern decadence finally prove inextricable from a temporality that is both rapacious and ongoing, as made legible in the motions of the sea to which the Republic was ritually wed.

What Kenneth Clark reads, in conjunction with many other critics, as "that lack of a sense of order and proportion which confused [Ruskin's] encyclopaedic philosophy" should therefore be recognized as the outcome of a strategy born less of "love," faith, or nervous exhaustion than of the meticulous observation of Venetian forms in their native context.[16] Turning from the prevalent tendency to read Ruskin's narrative errancy in psychological or deconstructive terms, I regard it as the outgrowth of an unruly empiricism whose insistence on reading history through a precarious material archive has repercussions for coming generations of artists. Repudiating the egocentric designs of Romantic imagination, and methodologically drawn to distraction from the contemplation of any single artifact in isolation, Ruskin as critic expands our historical perspective on premodern Venice. His historiography incorporates not only the traces of Venice's alterations through successive centuries, but also the distressed conditions of the place's observation in real time—amidst the stumbling blocks and cacophony of a city penetrated by tourism, industry, and the money economy. The organization of experience in the cityscape made present by his chronicles thus verges on (while never giving way to) a wholly ambulatory and even anarchic aesthetic. Ruskin's principal object of study, architecture, which is absorbed (as Benjamin noted) "by a collectivity in a state of distraction," in fact demands close attention to the incidental phenomena that surround and traverse it—even if such attention generates narrative interference.[17] The critic's concentration on the structural and experiential discontinuities within an imagined Gothic whole generates a polychronic "history" of proliferating paths, whose narrative detours represent the strain of experiencing the past within a postlapsarian present.

Ruskin's designs on Venice anticipate their own disruptions from the start. He admits as early as the opening chapter of *Stones* that despite his best efforts "to trace the lines of this image," his inquiries "will hardly render this outline

clearer." He is also ready to confess that his writing itself will alter its shape: "their results will, in some degree, alter its aspect" (9:18). In the preface to *St. Mark's Rest*, he makes more dramatic claims for the incomplete and wayward nature of his chronicle. In the later work, the history of Venice, taken chiefly to be written in the "manuscript" of its art (as opposed to those of its deeds or words), "once lay open on the waves, . . . a golden legend on countless leaves," but is now, "like Baruch's roll, . . . being cut with the penknife, leaf by leaf, and consumed in the fire of the most brutish of fiends" (24:203)—subject to despoilment and sale, neglect, and contamination by modern industry. Presenting himself as a metaphorical reader of a precious text, Ruskin foregrounds the inexorably fragmentary quality of his attempt to salvage Venetian history: "What fragments of it may yet be saved in blackened scroll . . . this book will help you, partly, to read. Partly,—for I know only myself in part" (203–04). The gaps that interpose themselves into these chronicles turn "Venice" into a matter more volatile than it was before. In prose composed under the stress of the political upheavals of 1848, the stones of Venice and the "sentence" they convey ("God has numbered thy kingdom, and finished it" [9:59]) appear as unstable as the transitive waves bound to wear them away. Though he wishes to safeguard Venice's lessons, if not its actual foundations, from *tempo*—a term connoting both time and climatic forces—Ruskin's prose ends up registering the damaging and ongoing effects of both. Ruskin forces us to conceive of building itself dynamically, in time.

Ruskin will find Venice eroding from a "national" perspective as well. For in the introductory "warning" of *Stones* quoted earlier, he has ascribed to the natural—to the "fast-gaining waves"—energies that are also, and more immediately, sociopolitical. The city sits at the distressed center of a Europe at the brink of war—war spurred by a republicanism altogether different from the antique, noble Venetian form he defends in writing. In 1849–50—when he returned to Venice planning only to obtain "some clearer assurance respecting certain parts of chronology," but was instead obliged to derive his own chronology "stone by stone" (9:3–4)—the Bourbon monarchy had collapsed, obliging Louis-Philippe and his queen to flee to England, where the Chartists had marched to Westminster demanding reform; republicans were agitating in Ireland; and Savoy was at war with Austria, along with Charles Albert's other territories of Piedmont and Sardinia. Most immediately for Ruskin and his new bride, Hungary and the entire Lombardo–Veneto region had revolted against Austrian rule. The Repubblica Veneta di San Marco was declared in 1848 by Venetians under the leadership of Daniele Manin; though it was suppressed by aerial bombing within five months, the revolt was crucial in symbolic terms,

awakening the revolutionary energies of an effort to unify Italy and of a broader European republican unrest. As Ruskin prepares the second and third volumes of *Stones* in 1851, the Republican–Royalist controversy is raging in Paris, and Venice is controlled severely by Austria in the wake of the uprising: "there is now no 'lonely isle' in all the lagoons of Venice" because "[w]herever you go . . . there is now a Sentinel and a powder magazine. . . . There is not a single shore—far or near, which has not in some part of it the look of fortification— or violent dismantling or renewing, for military purposes of some kind."[18] The effect on the cityscape is corrosive: even the merely decorative cannonades in honor of the Austrian Emperor in the Piazza San Marco are violent enough to shake "every pillar of the [Ducal] palace to its foundation."[19] *Stones* places the Venetian capitulation to rationalism at the onset of the Renaissance on a continuum with these corrosive current events. Ruskin represents the rationalist aesthetic of Sansovino and Palladio as an abrupt fall, "[i]nstant degradation" that triggers our progress to this historical moment: our being "hurried on to the fall of Italy, the revolution in France, and the condition of art . . . in the time of George II" (9:45). Tony Tanner glosses this account of modern Venetian history as "history with the history left out."[20] I propose that we read Ruskin's "hurried" chronicle instead as a performative attempt to represent historical knowledge as it is experienced, and even shaped, from the point of view of the present. This endeavor anticipates modernist montages of present and past— albeit in wistfully linear fashion.

Traveling to Venice in 1845 with the intention of writing about Titian, Ruskin found himself propelled more poignantly into the present moment, finding cloisters converted to barracks and the artworks he sought defaced, missing, or destructively "restored." His Venetian writings come to register this shock more forcefully than the historical repose implied wistfully by the title *St. Mark's Rest*. Over and over he will record the recognition that "the modern work has set its plague spot everywhere—the moment you begin to feel, some gaspipe business forces itself on the eye, and you are thrust into the 19th century, until you dream . . . that your very gondola has become a steamer."[21] Such dreams bring about a wakefulness to current conditions that intensifies over the course of Ruskin's half-century of research into Venice. The harsh awakening performed by Ruskin's Venetian texts parallels the work of his own epoch as Benjamin characterized it: "The nineteenth century . . . is the set of noises that invades our dream, and which we interpret on awakening."[22] When Ruskin permits the noise of modernity to interfere with the Romantic Venetian "stage dream"—and vice versa—the interpretative results emerge as productively convulsed.

Ruskin's histories have been criticized for their "chronological muddle,"[23] and his digressive prose style has often been characterized as confused. In a body of criticism dominated by biographical approaches (an ironic development, given Ruskin's own commitment to "*things*"), the wayward perceptual and discursive tendencies of his late writings have even been ascribed to outbreaks of madness. But Ruskin's style and syntax can be read more productively as extremely contemporary, in the literal sense. His early story-within-a-story about Venice, "Velasquez, the Novice," compels us to credit the author's deployment of lacunae and seemingly extraneous interpolations with more narrative craft than has typically been granted. The tale mimics a conceit of the Gothic novel: it represents the reconstruction from memory of a fictive manuscript whose "language was confused, and the writing broken . . . and blotted." In this palimpsestic text-within-a-text, "Blanks were left at intervals, some remaining, others filled up by another hand."[24] Robert Hewison's reading of this work of juvenilia demonstrates that the young author was citing a plurality of styles with canniness, and concludes that "[Ruskin's] writing developed out of pastiche."[25] Such eclecticism would have found an objective model in the "broken" historical aggregation of Venice.

Ruskin's view of architecture as a text—borne out in "The Nature of Gothic" through comparison of architectural ornament with that of Gothic illuminated manuscripts, later to be known as "pocket cathedrals"—compels us to investigate the way his own writing was shaped by the architecture of Venice, and in acerbic relation to the designs of his day.[26] The medieval urban complex stands as a composite antithesis to the modern obsessions with "the ball-room, the billiard-room, and the Boulevard" (12:428), whose destructiveness is rendered palpable through the author's bombastic alliteration. In his 1854 critique of the Crystal Palace and of Haussmannization, Ruskin laments the cultural homogenization spawned by the tendency of upper-class Europe to strive "to make every place in the world as much like the Champs Elysées of Paris as possible" (426). He foresees a day when "the formal street, in all its pride of perfumery and confectionery, has successfully consumed its way through wrecks of historical monuments, and consummated its symmetry in the ruin of all that once prompted a reflection" (427). The ideology of urban transparency inherent in both the boulevard and the glass Crystal Palace obscures their demolition of the "hated antiquities of the great cities of France and Italy" (426), ostensibly freeing those who inhabit these spaces from "the paralysis of precedent, and the entanglement of memory" (428). Ruskin's digressive style combats this tendency by obliging readers prone to amnesia to inhabit and endure "the entanglement of memory," while forcing

residual romantics to suffer the shock of being "thrust into the 19th century." His prose mimes the shape and order of perception in a fissured medieval cityscape whose central monument, St. Mark's, had been regarded by Ruskin's classically oriented, Palladio-loving compatriots as "a fortuitous jumble."[27]

The attempt to document a place that Ruskin perceives to be destroyed before his eyes hourly under colonization, through intermittent acts of war and acts of blotting *out* the scars of history through restoration—"the Austrian national distillation of coffins & jaundice"—becomes an obsession that encompasses his entire career, and that of many others to follow, for "the materials are so immense & the work to be done so various."[28] The third and final volume of *Stones* ends not in historical synthesis, but "trails off," as Hewison puts it, "into overmatter and appendices"; Ruskin recalls ruefully in his memoir the six hundred pages of notes for the project that are "now useless. Drawings as many—of a sort; useless too."[29] *Stones*' proliferation of footnotes, volumes, and subsequent qualifications articulates an excess of interpretable objects that fail to resolve themselves in coherent tableaus or trajectories.

For modernist authors trying to locate value in a material world subject to entropy, fracture, and other ambient encroachments, Ruskin's grappling would prove instructive. In translating Ruskin's *The Bible of Amiens*—an unfinished guidebook characterized by many critics as a tedious assortment of facts, "a hodgepodge of digressions and idiosyncratic pronouncements on many tenuously related subjects"—Marcel Proust signaled the constructive aspect of this epistemological fallout[30]:

> The object to which thought such as Ruskin's is applied, and from which it is inseparable, is not immaterial, it is scattered here and there over the surface of the earth. One must seek it where it is, in Pisa, Florence, Venice, the National Gallery. . . . Such thought, which has an object other than itself, which has realized itself in space, thought which is no longer infinite and free, but limited and subdued, incarnated in bodies of sculptured marble, in snowy mountains, . . . is perhaps less divine than pure thought. But it makes the universe more beautiful for us, or at least certain parts of it, . . . because it has touched them and introduced them to us by obliging us, if we want to understand them, to love them.[31]

Apprenticing himself to Ruskin from 1899 through 1906, Proust cherishes the fall from metaphysics that causes his master's thought to disperse itself amidst scattered objects of beauty. This thought merges with its object, as

Proust argues, becoming itself an object—it "realize[s] itself in space."
Ruskin's writing in turn becomes part of the material "reality" of Venice, oblig-
ing travelers who follow his trajectory to assume an attitude of "fixed atten-
tion" to Venetian structures, even when they are unwilling to acknowledge
the debt: *Stones of Venice* became the principal guide to the city (largely, if
ironically, through heavy quotation within the popular Murray guidebook).[32]
Henry James confirms the "very manifest . . . influence over the mind and
feelings of his own generation and of that succeeding it" that Ruskin had on
"forms of intellectual labour, or of intellectual play," but notes the tortuous
and obscured quality of this influence: "Sometimes the connecting path is
very sinuous, very tortuous, very much inclined to lose itself in its course, and
to disavow all acquaintance with its parent soil; sometimes it is a mere thread
of scanty vegetation."[33] Ruskin's thought is too various in its paths to have
coalesced into a "school" of criticism. The play of his intellect instead founds
an oppositional tradition of giving oneself over to the material instability and
digressiveness of this "bourne."

Ruskin's connections to Romanticism have naturally been the object of
extensive scholarly discussion.[34] Though he cast his attempt to derive a his-
tory from things that are "not immaterial" as a departure from the overween-
ing subjective designs of Romanticism, his writings nevertheless represent
an extension of the Romantic revolt against rationalism. The convulsions
of contemplation in his writings can be read productively as struggles
against the modern species of perception analyzed by Georg Simmel in "The
Metropolis and Mental Life" (1903), wherein an impulse toward calculation
reflects the individual's suppression as "a mere cog in an enormous organiza-
tion of things and powers which tear from his hands all progress, spiritual-
ity, and value in order to transform them from their subjective form into
the form of a purely objective life."[35] Simmel singles Ruskin and Nietzsche
out against this scenario for their insistence on thinking through things
from within, and thereby resisting the rationalizing tendencies triggered by
the complexity of metropolitan existence. The "general and precisely sche-
matized form of life" imposed on the metropolitan dweller from without
excludes "those irrational, instinctive, sovereign traits and impulses which
aim at determining the mode of life from within. . . . The passionate hatred of
men like Ruskin and Nietzsche for the metropolis is understandable in these
terms. Their natures discovered the value of life alone in the unschematized
existence which cannot be defined with precision for all alike. From the same
source . . . surged their hatred of money economy and of the intellectualism
of modern existence."[36] Simmel's conflation of these thinkers' resistance to

rationalism with the "irrational" and "instinctive" assumes a binary opposition that does not hold, however: it falls short of imagining a resistance to rationalism that is systematic.

Though pitted rhetorically against the "stage dream" of "modern fiction and romance," Ruskin's rigorous objectivity deviates from received universalizing schemas and into the spontaneity of sensed experience in ways that were modeled for him by the digressions of Byron's Venetian writings. He recalls in *Praeterita* that "Byron . . . reanimated for me, the real people whose feet had worn the marble I trod on."[37] Just as a fresh swarm of "black legends" about Venice flooded the cultural imaginary through works such as Pierre Daru's Napoleonic *Histoire de la République de Venise* (1819), the writings of Byron and Ruskin foregrounded the actual city's deflection of both the Republic's own freshly dissolved myths and the exoticizing fantasies imposed from without.[38] We can trace a segue toward modern encounters with Venice in Byron's dramatizations of the city's resistance to linear narratives. Tony Tanner's *Venice Desired* dwells productively on how Byron "turned fact into fabric" in his Venetian writings and on Venice's persistence through the twentieth century as a topos.[39] I will focus instead on an inverse movement: the toppling of that topos in the act of engaging the historical city as it is cast into the contemporary moment. By stepping back in time to trace the disorienting departure from literary fantasy to "reality" staged by Byron's Venetian poems, we can apprehend how a Venice freighted with literary history became the "touchstone" for Ruskin's materialist methodology.

A LABYRINTH OF EXTERNAL OBJECTS: BYRONIC DIGRESSIONS FROM FANTASY INTO FACTICITY

Rosalind: Farewell, Monsieur Traveller; look you lisp and wear strange suits, disable all the benefits of your own country, be out of love with your nativity, and almost chide God for making you that countenance you are, or I will scarce think you have swam in a gondola.

—*As You Like It*, 5.1.33–38

Annotation of the Commentators.
That is, been at *Venice*, which was much visited by the young English gentlemen of those times, and was then as *Paris* is *now*— the seat of all dissoluteness. *S.A.*

—Epigraph to Byron's *Beppo*

A decade after the collapse of the Venetian Republic, when it had already changed hands between France and Austria several times, Lord Byron adopted the bon voyage of Shakespeare's Rosalind to Jaques the Traveller for his epigraph to *Beppo: A Venetian Story* (1818), foregrounding Venice's lasting distinction in the English literary imaginary for provoking discomposure. Rosalind casts the gondola as a form of transportation that, in moving its passenger through Venetian space, estranges the Traveller from his speech, his vestments, his privileges, his affections, and even his "countenance." In Byron's poem of Carnival, these paradigmatic Venetian vehicles accommodate sexual diversions that belie their sober appearances, consequently diverting the author from his own story: "sometimes they contain a deal of fun, / Like mourning coaches when the funeral's done. // But to my story.—'Twas some years ago . . . "[40] The trope of gondola-as-coffin was pervasive in literature, recorded most recently by Germaine de Staël (*Corinne ou l'Italie*, 1807); it was to be rehearsed by Shelley (*Letters from Italy*, 1818), Mark Twain (*The Innocents Abroad*, 1869), and Thomas Mann (*Death in Venice*, 1912), among other authors. But Byron sees a pun in this metaphor through which he can digress out of a literary commonplace: that the gondola hosts two sorts of death suggests an irresistible aside for the author at play in a Venice "in the *estro* of her carnival," and he chooses to play up the distraction from his putative plot.[41] The polyvocal epigraph to his anonymously published poem in ottava rima has served from the first to divert readers from any consistent historical, narrative, or authorial trajectory. In the epigraph, the poet's contemporary and compatriot, an index-maker and librarian identified only by his initials, momentarily shifts the text's values with a provincial gloss: "That is, been at *Venice*, which . . . was then as *Paris* is *now*—the seat of all dissoluteness."[42] Ironizing the exegete's ideological stance in resituating this footnote (and revising it—for the original note read "licentiousness" rather than the more open-ended "dissoluteness"), Byron taps into, so as to dislodge, an age-old trough of tropes and fictions surrounding Venice.[43] Undercutting Shakespeare's evocation of the city of canals with this prudish nineteenth-century annotation to the play, Byron begins to construct a literary-historical labyrinth: a poem composed of historical detours and dead ends.

Venice itself represented a canonical deviation from the straight and narrow voyage to Enlightenment: the site of a sensuous digression along the Grand Tour, between the capitals of London and Rome—where, in Alexander Pope's punning *Dunciad*, "naked Venus keeps, / And Cupids ride the Lyon of the Deeps; / Where, eas'd of Fleets, the Adriatic main / Wafts the smooth Eunuch and enamour'd swain."[44] Whereas the Grand Tour's classical destination, Rome, was perceived as "the only common and universal city"

(to quote Montaigne), Venice represented the exception, its Byzantine and Muslim influences seemingly irreconcilable with European values.[45] A detour to this edge of Europe formed a constitutive chapter in the experience of many young English gentlemen of letters—the rising gentry being "wafted" to margins that were topographical, political, cultural, sexual, and textual. Such experience enabled Pope's fictive tutor to restore his pupil home to England intact[46]—but now supplemented by an encounter with a feminized and racialized other, invoked through another pun on the city of Othello: "to my country happy I restore / This glorious Youth, and add one Venus more" (echoing "Venice moor").[47] Bruce Redford characterizes the difference between Venice and Rome for the Grand Tourist in terms of stasis and destabilization: Rome was the end point of a trajectory of consumable heritage vital to patrician male rites of passage, yet existed in the mind of the traveler as "a static archaeological phenomenon, a quarry and a backdrop." By contrast, "[t]o move from Rome to Venice . . . was to enter an arena of multiple myths and fluid modernity—an arena that refused to arrange itself for the traveler in scenographic simplicity."[48]

Venice's resistance to stable visual arrangements and unconflicted narratives does not inflect the form of all literary accounts. *The Dunciad*'s detour to Venice does not generate textual digressions, only puns on tropes, as Pope's controlling eye on the human scene posits "A mighty maze! but not without a plan"[49]; Jonathan Swift likewise cautions in a satirical "Digression in Praise of Digressions" that "*Digressions* in a Book, are like *Forein* [sic] *Troops* in a State"—to be marshaled into service of the whole.[50] Laurence Sterne departed from both the Grand Tour's programmatic waywardness and literary tirades against poetical "error": his *Sentimental Journey Through France and Italy* caricatures the traveler who "with an immense fortune, made the whole tour; going on from Rome to Naples,—from Naples to Venice,—from Venice to Vienna,—to Dresden, to Berlin, without one generous connection or pleasurable anecdote to tell of," because "he had travell'd straight on, looking neither to his right hand nor his left, lest Love or Pity should seduce him out of his road."[51] Sterne's digressions model a new type of engagement with the city that embraces its tortuous pathways as a narrative strategy—one extending, as we'll see, from Byron and Ruskin through Italo Calvino and Robert Coover.

As the Grand Tour and sentimental journey were being eclipsed by bohemian and bourgeois tourists of the picturesque (like the young Ruskin and his parents), visitors were liable to discover in Venice a corpse politic that was *twice* dissolute: subject to a series of dominations and despoliations, nineteenth-century Venice comes to represent an advanced state of fragmentation,

reflected in Byron's poem. With its artistic masterpieces dislodged from their native contexts and its legacy divided among specters of renowned authors— "Otway, Radcliffe, Schiller, Shakespeare's art, / Had stamp'd her image in me"—Venice's history inspires recomposition as a play of conflicting agendas.[52] Occupying the wake of the expatriated Petrarch, Byron couches the tale of *Beppo*'s "Laura" in quotation marks ("we'll call her Laura" [21.167]), amid contradictory discursive trajectories. The friction between this Laura and that of the Italian humanist highlights the challenge of cleaving firsthand, literal experience away from the literary "echo's echo" (73.7) in this city. Meanwhile, Byron is diverted repeatedly from telling his tale of Carnival in the third person in favor of recounting the seductions of his own Venetian eves: "But to my tale of Laura,—for I find / Digression is a sin . . . " (50.395–96). The sin is a "literary" one. While the market demands the Orientalist "story" of an elsewhere, Byron instead points at the historicity and ongoing reality of Venice in contrast with that of contemporary England; *Beppo* has to chastise itself ludically back into fiction, out of its immediate circumstances. The poet ironizes his inability to dash off "easy reading": "How quickly would I print (the world delighting) / A Grecian, Syrian, or Assyrian tale; / And sell you, mix'd with western sentimentalism, / Some samples of the finest Orientalism!" (50.401– 08). The mingling of exoticism with sentimentalism was abundant in the Gothic literature on Venice; but Byron's poem manifests the swerving of his attentions from received fictions toward a crowding abundance of fact.

Just before he began to compose canto IV of *Childe Harold's Pilgrimage*— the melancholy counterpart to *Beppo*, produced in the same place and watershed year for his career—he declared in a letter to his publisher, "I hate things *all fiction*; and therefore the *Merchant* and *Othello* have no great associations to me: but [Otway's] *Pierre* has. There should always be some foundation of fact for the most airy fabric, and pure invention is but the talent of a liar."[53] The poet was more enthralled ultimately by that "reason plain and sense" resisting fancy for "the very fake" in Otway's recasting of the 1618 Spanish Conspiracy against the Venetian Republic (in *Venice Preserv'd, or, a Plot Discover'd*), or by the black veil painted over Doge Falier's portrait in the Great Council Hall of the Ducal Palace (eventual fodder for *Marino Faliero*), than by the specters of Schiller's *Ghost-Seer*. As *Childe Harold* puts it: "there are things whose strong reality / Outshines our fairy-land"—so that literary fantasies are left aside, "And other voices speak, and other sights surround."[54]

In the preface to the fourth and final canto of *Childe Harold's Pilgrimage*, composed from Venice (1818), Byron acknowledges that his earlier efforts to isolate the poem's fictive pilgrim and author from each other had failed,

and notes that his solution for this dilemma was to withdraw from the work as overweening personality. This desire to deviate from a typically Romantic mode of self-expression, to open his Spenserian stanzas to ambient facticity, or "Circumstance, that unspiritual god," does not come without its compromises and challenges. *Childe Harold* avers in the midst of ruin, "There woos no home, no hope, nor life, save what is here"—yet "here" is devilishly difficult to pin down, overreaching the poem's limits.[55] Byron's preface goes on to admit how unwieldy the convoluted foundation of fact became for the poem: "In the course of the following canto it was my intention, either in the text or in the notes, to have touched upon the present state of Italian literature, and perhaps of manners. But the text, within the limits I proposed, I soon found hardly sufficient for the labyrinth of external objects, and the consequent reflections."[56] To "recur from fiction to truth"[57] and account for Venice's "spell beyond / Her name in story" (4.4.28–29) also entails rupturing the bounds of subjective intention so far as to require an appendix of historical annotation: *Childe Harold's* annotations supplement its stanzas' engagement with the particulars of Italian history and geography—to the point that it was routinely quoted by nineteenth-century guidebooks to Italy.[58] The preface to *Childe Harold* confesses a stunted pleasure that this composition "in some degree connects me with the spot where it was produced, and the objects it would fain describe"—"however short it may fall of our distant conceptions and immediate impressions" (146). Such inundation of multivalent fact would be the immediate inspiration for the first close modern reading of Venetian structures: Ruskin's monumental *Stones of Venice*.

When compared with the playful digressions of *Beppo* or even the teeming Venetian "forms" of *Childe Harold's Pilgrimage*, Ruskin's discursive detours emerge as both more pointed and more susceptible to interference by uncontrollable forces. Byron still makes a claim for the transcendent character of literature to preserve the "fairy city" he loves, even after its "sway" has expired: "Ours is a trophy which will not decay / With the Rialto."[59] By contrast, Ruskin's narratives, which incorporate, or introject, the instability of Venetian structures, present themselves as equally vulnerable to "the dogeless city's vanish'd sway" (4.4.31) and "decay."

"Love of *Fact*": Feeling Through *Stones*

Ruskin's commitment to objectivity in the writing of history presages that of Poundian modernism in being based on a series of seemingly contradictory

rejections. His scorn for the superficial model of sympathy and attendant pathetic fallacies characteristic of "romance" is matched by his dismissal of the instrumental reason buttressing the work of eighteenth-century historiographers.[60] In contrast to "the modern English fact-hunter," who has an *a priori* truth in mind and pursues its proof to the denial of any dissonant material reality,[61] Ruskin allows his own telos to diverge in line with the animated contours of the object in time—over the course of contemplation. That Ruskin deemed "subjective" and "objective" "two of the most objectionable words that were ever coined by the troublesomeness of metaphysicians" suggests that his work will challenge the reigning conceptual divisions between them.[62] The consequent methodology favors feeling not *for* but *through* the object of analysis, so that the observer may discover the "truth" of the social bonds that object harbors. Ruskin locates evidence of such a principle in the empirically and sensuously charged "love of *fact*" found in the vegetational avenues and interlacings of decorative Gothic carving (10:232).

Unprejudiced by inherited wisdom and untrammeled by imperious scientistic paradigms, Ruskin's viewer becomes a witness to the truth of objective form: "Neither calculation nor hearsay," he writes in volume III of *Stones*, "may be allowed to come between the universe, and the witness which art bears to its visible nature." Operating in the realm between activity and receptivity, the work of the "*eye*-witness" entails both individual responsibility and response over time to the social and/or metaphysical truth embedded in aesthetic form (11:49). A novel celebration of "eyewitness" testimony was in fact reflected in the cultural output of the Venetian Republic in its heyday, appearing in the maps, Venetian guidebooks, and narrative painting of the fifteenth century; and the German historian Leopold von Ranke's pioneering work with the primary sources and eyewitness reports contained in the Venetian state archives triggered a revolution in historiography in the 1840s, influencing the generation of Ruskin's colleague and mediator in Venice, Rawdon Brown, as well as that of Ezra Pound.[63] Yet in transcribing the firsthand, real-time experience of symmetries that course through the universe as expressions of social truth, Ruskin's witness also leaves him or herself open to incidental trajectories shaped by the environment in which an object is placed. Alert to a "concentration of every fact" that "fills every . . . space of the picture with coincidences of witness" (3:367) such as those registered in the correspondences between Turner's hazy figures and cirrus clouds, seers may find themselves unable to unify the percepts at hand—and be obliged to wonder whether such vigilance in observation is "admirable or not?" (3:367). Venice, whose customs house is marked with a rotating sculpture of Fortune, or *Fors*,

dramatizing the city's aperture to the unknown seas, provides a particularly seductive arena for such engagement of coincidence.

In which aesthetic objects does sociohistorical truth inhere? Where must the witness direct attention in order to ensure that coincidences coalesce in a vital synthesis pertinent to the thesis at hand? Ruskin's answer becomes increasingly labyrinthine. After the publication of *Modern Painters*, volume I, and his continental tour of 1846, he begins to hone in on architecture as the "science" that fuses the contradictory drives of feeling and rule, offering a ground for the marriage of empirical and metaphysical inquiry. *The Poetry of Architecture* offers his earliest articulation of this conception (published serially from 1837 to 1838): "it is, or ought to be, a science of feeling more than of rule, a ministry to the mind, more than to the eye" (1:5). Architecture offers more than an immediate pleasure of impressions and surface effects. It presents models of meditation, of thinking infused with feeling: a syntax, or *poetic*. Ruskin's task as an aesthetic historiographer is also to isolate architecture's "nationality," however: "to trace . . . not only its adaptation to the situation and climate in which it has arisen, but its strong . . . connection with, the prevailing turn of mind by which the nation who first employed it is distinguished" (1:5). Architecture's formal structure bespeaks a social structure, or (in terms particularly animate in the nineteenth century) a "nationality." Far from petrified, architecture makes a population's adaptation to its environment legible, documenting social change over time. This adjustment to "situation and climate," particularly dynamic in the unstable lagoon context, also communicates the mental "turn" of those who come to occupy it.

The archaeology of Venetian forms that Ruskin compiles verbally and visually is far from seamless[64]: it has to account for accretions, adjustments, and "turns" in Venetian history. Moreover, his qualification regarding those who "first employed" a style of architecture draws attention to the fact that copies and imitations, or derivations and contact contaminations, may muddy national identity. To make matters more tortuous still, "turns" are accidental as well as programmed, so that isolating the role that chance has played in determining architectural style becomes a vexing necessity. As Ruskin remarks in a November 1849 entry of the preparatory notebook for *Stones*,

It is, I suppose, an architect's chief sorrow that his best designs must depend for their accomplishment upon accident

Chance. I never enter St Mark's Place without some thought of this kind . . . : For there the fancies of men have suffered the Sea Change of half a score centuries—there their minds have much from the east and

west—and the currents of a hundred nations have whirled & eddied in
the narrow vortex . . . and the Stern Pisan, and the Dreamy Greek—&
the restless Arab, and the languid . . . Ottomite—& the strong Teuton;
there the patience of early Christianity—and the enthusiasm of medieval
superstition, and [all] the fire of ancient—and [all] the rationalism of
recent infidelity, have all had their work—and all their time—There the
marbles of a thousand mountains have been laboured . . . [and] the offer-
ings of a thousand isles have met in one cloud of incense—and out of this
masque and mosaic of Kingdoms and times, there has arisen our wild Sea
Harmony, the sweetest that ever human soul conceived.[65]

The notebook entry emphasizes the way that circumstantial flow has been
built into and coursed through all architecture, but especially through this
Basilica of Venice. The passage on chance makes palpable the host of meth-
odological challenges—epistemological, historical, and moral—that arise
in chronicling its "wild Sea Harmony," demanding a new form of analysis.
While Ruskin scholars have dwelled productively on his oscillation between
synchronic and diachronic readings of history,[66] the anachronistic complex
of Venice that triggered Ruskin's only formal work of historiography invites
us to regard his texts as reflections of the city's own plurality of coextensive
chronologies. These writings anticipate Marvin Trachtenberg's recent re-
theorization of building as inherently durational and polychronic—based
on the obvious, yet widely disregarded fact that traces of competing epochs
or temporalities are embedded in premodern buildings, which were often
erected over the course of centuries in a volatile lifeworld. Trachtenberg
indeed nods to Ruskin for having identified "Ageing" as one of the "Seven
Lamps of Beauty": that "blind agency of time" with which "volitional plan-
ning" must perforce collaborate.[67]

In *Stones*, Ruskin details the ramshackle chronology of St. Mark's, whose
present form is a hodgepodge of more than eight centuries of labor, but
quickly amplifies the analytical challenge by emphasizing that most palaces in
Venice have sustained nearly as many "interpolations"; he confesses then to
having abandoned "all thoughts of obtaining a perfectly clear chronological
view of the early architecture" that he upholds as exemplary (9:6). Moreover,
the fragmentary and compromised condition of the material at hand ensures
a history riddled with aporias and scars. His writing strives to preserve the
"partial, though not dangerous, decay" of Gothic architecture that colors and
softens its lines, as at Rouen, "with unexpected change and delicate fracture,
like sweet breaks in a distant music" (12:425). The meticulous work of tracing

those "breaks" is disrupted increasingly by environing tempos and sound-scapes that are anything but "sweet"; but Ruskin finds it unconscionable to bracket these distressing phenomena from his representations of histori-cal masterpieces.[68] His prose thus takes on a rich texture of eclecticism and simultaneity mirroring that of the city, poised at the threshold between har-mony and noise.

Ruskin foregrounds that he is not the first to try his hand at the arduous enterprise of charting Venetian history; he argues that "in spite of the labour of countless chroniclers," it "remains in vague and disputable outline,—barred with brightness and shade, like the far away edge of her own ocean, where the surf and the sandbank are mingled with the sky" (9:18). Groping for a linear chronicle, Ruskin seeks to ground history spatially, in the horizon of Venice. Yet Venice's edges are contestable: loci where shore and sky coalesce as atmo-sphere, as in Turner's 1844 *Approach to Venice* (figure 1.2). The development of Venice's "throne" on the mudflats was contingent on a volatile conveyance of sediment from Alpine rivers into the lagoon: "*the only preparation possible, for the founding of a city which was to be set like a golden clasp on the girdle*

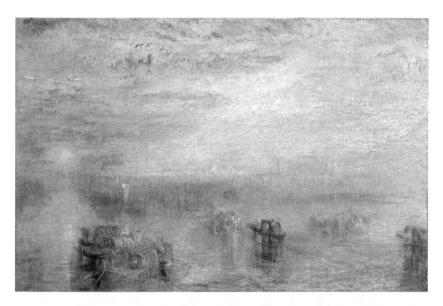

FIGURE 1.2/PLATE C. Joseph Mallord William Turner, *Approach to Venice,* oil on canvas, 1844. In the Royal Academy catalogue, it was accompanied by Turner's quota-tion from Byron's *Childe Harold*: "The moon is up, and yet it is not night, / The sun as yet disputes the day with her." National Gallery of Art, Washington, D.C. Courtesy of NGA Images.

of the earth, to write her history on the white scrolls of the sea-surges, and to word it in their thunder, and to gather and give forth, in world-wide pulsation, the glory of the West and of the East . . . !"[69] Its consequent character is equally volatile: Does that clasp lock or unlock a civilization's girdle on the luxuriant earth? And is Venice made of stone or sea? Ruskin will never quite decide. The city is "that beauty which seemed to have fixed for its throne the sands of the hour-glass as well as of the sea" (10:7)—and Ruskin's "Sea Stories" (the punning title of *Stones'* second volume) are based on the sandy first "story" that "on land we call a ground floor."[70] Limitless waters and eroding sand surface continually in his writings on the falling city, signs of its unpredictability; these concrete fluctuations dislodge the historian's framing abstractions. Metaphors of the bodily, as sensual unison or immeasurable lure, as well as of the body politic, water and sand elicit that Venice's carnality is itself a "vehicle." Rather than a contoured form whose motion can be tracked in linear terms, Ruskin's research yields an image *modeled*, as in the paintings of the Venetian school— distinguished by transient light. The sentence above suggests that it is the less confining values of brightness and shade, rather than any line, which "bar" Venice. His touchstone is a wavering lure.

Ruskin's vision of a Gothic Venice predating the divorce of form from fellowship, characteristic of the moment before the onslaught of rationalism, finally proves impossible to isolate. To build a diachronic narrative of Venetian glory and decline based on buildings that have lasted into the current moment, Ruskin would have to crop the propulsive alterations of time from "the fitful history of the Rivo Alto" (9:26)—a toponym that translates literally as "Deep Canal." But as early as December 1848, he responds to the quandary of distinguishing prelapsarian Venetian form by proposing "that Form . . . be considered as a function or exponent either of Growth or of Force." Plate 7 of *Stones'* first volume, "Abstract Lines" (figure 1.3), encapsulates this notion "that all forms are . . . either indicative of lines of energy, or pressure, or motion, variously impressed or resisted."[71] The plate subordinates "line" to "direction" to account for vectors of resistance, growth, and entropy. Its incompletely "abstract" curves, identified by Ruskin as those of a glacier at Chamouni (*a b*, in figure 1.3), of a paper Nautilus (*n o*), of an aquatic Alisma leaf (*q r*), and so on, are all "expressive of action." Placing disparate species, scales, and geographies into the same tableau, Ruskin forces them into relation; what unites all is their being "described by bodies variously in motion" (9:267–68).

The eyewitness would like to affirm that there is a determinable direction in all things; he still conceives of form as the end point of force. But

FIGURE 1.3. John Ruskin, "Abstract Lines," *The Stones of Venice*, volume I, plate 7, 1851.

the form of Venice cannot be extracted from the *fors* ("fortune") dramatized by the flux that its discontinuous contours accommodate. And this cityscape cannot ultimately be distinguished from its flickering (visual and temporal) shadow: "We might doubt, as we watched her faint reflection in the mirage of the lagoon, which was the City, and which the Shadow" (9:17). The lagoon's atmospheric shifts are more effectively registered by light than by line, as in the city's painting tradition—and light resists abstraction, for as Ruskin notes, "there are no such things as abstract shadows" (9:266).

Ruskin's ultimate refusal to narrate a unidirectional fall proposes a disruptive temporality that will be taken up by the next generation as a wellspring of futurity; John Dewey will affirm, "The past absorbed into the present carries on; it presses forward."[72] Modern energies and crowds surge through Venetian architecture as "precisely" in Ruskin's accounts as the historical phenomena it was supposed to hypostatize. Ruskin tracks forces from both past and present coming to cross in Venetian art—and in the archipelago that gave rise to it.

LONDON VERSUS/AS VENICE: RECIPROCAL INTERFERENCE

Stones' modeling of the Venetian advance toward Renaissance classicism endeavors to compose a negative exemplum that will prevent the English from following a parallel course to decadence, and presents the halted acme

of Venetian Gothic as a model for English social reconstruction. He opens
the work by charting the consummated or imminent decline of three mari-
time empires, identifying the Phoenician city of Tyre as the specter of imperial
power and Venice as its lingering ruin; England, "if it forget their example, may
be led through prouder eminence to less pitied destruction" (9:17). Because no
stones of Tyre remain to be read, Ruskin has to erect a lucid example out of
what stones remain in Venice, so as to establish a coherent opposition between
Venetian and British empires, past and present states. Such twinning and con-
trast of London and Venice has a long history in art and writing, propelled by
common maritime, commercial, and imperial impulses. The myth of Venetian
liberty that pervaded Elizabethan culture was confirmed by Venetian canon
lawyer Paolo Sarpi's resistance to the papacy; it persisted through the Crom-
well Commonwealth period, which took Venice as a model of republican sur-
vival, into the eighteenth century, when John Locke cast the Venetian Republic
as a model of justice.[73] Though Venice's political influence waned, its com-
parison to London was prolonged in the century after the Republic collapsed.
It was sustained in aesthetic terms by the expatriation and genteel tourism
of bourgeois Londoners and other English literati, from Byron through the
Brownings—and in economic terms by the Board of Trade, which advocated
for free trade policies by aspiring to make Britain "the Venice of the nineteenth
century."[74] (The heritage of diplomatic ties between these capitals would not
have been lost on Ezra Pound, Wyndham Lewis, and other key figures of
London modernism when, in the years before World War I, they met for T.E.
Hulme's salons at the former Venetian Embassy on Frith Street.[75]) But Ruskin's
writing consolidated a powerful post-Romantic trajectory of comparison in
which fallen Venice functions as the portent of a contracting British empire.
The Stones of Venice strives to uphold the organic society that built the Ducal
Palace against the capitalist society that manufactured the Crystal Palace for
the world's first international exposition in 1851, a society in which "it is not
only the labour that is divided; but the men:—Divided into mere segments
of men."[76] His reliance, in such argumentation, on the rhetoric of opposition
between Venice and England typified by Augustus Welby Pugin's 1836 work
Contrasts ("Shewing the Present Decay of Taste") has been well established.[77]

The juxtaposition of opposites, whether verbal or visual, forms an imper-
fect corollary to the nuanced definition of difference that Ruskin praises in
the Venetian colorists, however, which operates by way of the proximity and
commerce of hues—a phenomenon he names "reciprocal interference."[78] He
coins the term to describe a local effect, but his exegesis suggests broad aes-
thetic and social implications: reciprocal interference, mastered by Veronese,

Tintoretto, and Turner, involves "the taking of one nature into another" (11:23). This painterly emphasis on color over line permits a dynamic suspension of difference—with potentially implosive effects. The merit of the technique of Veronese, for example, resides in his ability to represent the relations *between* things while allowing each its distinction. Rather than representing "the exact *measure*" of light striking an object—conceiving of illumination as an isolated fact—this painter "holds it more important to show how a figure stands relieved from delicate air, or marble wall; how as a red, or purple, or white figure, it separates itself . . . from things not red, nor purple, nor white; how infinite daylight shines round it; how innumerable veils of faint shadow invest it; how its blackness and darkness are . . . just as limited and local as its intensity of light" (5:59). The figures in Veronese's paintings are distinguished via their relations to ambience, exposing that all is "capable of being joined in one great system of spacious truth" (5:59). In socio-aesthetic terms, Ruskin finds underlying this painterly method "the great principle of Brotherhood, not by equality, nor by likeness, but by giving and receiving; the souls that are unlike, and the nations that are unlike, and the natures that are unlike, being bound into one noble whole by each receiving something from, and of, the others' gifts and the others' glory" (11:19). Juxtapositions of color hold aberrant hues such as "the peculiar negro brown of Veronese" in check, while pearly grays model ethereal amalgamation (12:466). An imaginative "grasp" of social bonding prevents the confusion and hybridity of crowds in compositions such as Veronese's *Feast in the House of Levi* (1573) from spiraling into anarchy.[79]

While Ruskin's exegesis seems to subsume the bristling concept of "interference" under a more conventional Romantic theory of organicism,[80] I want to recuperate this term to render the more destabilizing effects of his histories legible. Reciprocal interference distinguishes a phenomenon I have traced throughout this chapter: the way in which the material complex of Venice—as a continual interchange of stone and water, distinguished not by contour, but by light—interferes with the production of an orderly linear chronicle. We can read as "reciprocal" the dynamic of interference through which, as Ruskin introduces "the entanglement of memory" into views of the nineteenth-century city, modern Venice repeatedly overruns the spatiotemporal bounds that would distinguish "past" from "current."

This interference is reflected at length in the ostensible opposition of England and Venice, for the "interval" between these sites, to which Ruskin insistently points, is under constant risk of collapse. The contrast between "The Nature of Gothic" and the nature of the world's largest, most modernized

and imperially marked metropole is conceptually unsettled by their shared "worldliness," while the Venetian archive of stones, now penetrated by gaslight, rail, and steam, begins to look more and more like London. In the fifth and final volume of *Modern Painters* (1860), Ruskin defines the Venice of Giorgione and the industrial-capitalist London of Turner by setting them against each other in "The Two Boyhoods," point by point, organism versus organization; but his classification oscillates between the two at such velocity that the poles of opposition begin to cross and blur. "The Two Boyhoods" moves from representing Venice as London's antidote to presenting Venice as uncanny London-in-utero.

In "The Nature of Gothic," published in volume II of *Stones* (1853), the Venetian Gothic exemplifies the bonding of labor to the craftsman's consciousness and person to person: a society of stonemasons and manuscript illuminators set against the splintering of the social body and human skill under the division of labor in industrial England. But Ruskin's critique of competition and alienation also contains the seed of his greatest anxieties surrounding revolutionary or democratic fusions of the masses. As he admonishes his expanding readership, "with wisdom we may also permit men or cities, to gather themselves into companies, or constellate themselves into clusters, but not to fuse themselves into mere masses of nebulous aggregation" (9:134). The line between a "pure" collectivity of difference (with its attendant hierarchies of authority and obedience) and the republican masses of "E Pluribus Unum" or an "impure" collectivity of chaotic miscegenation is thin, as revealed by the anxious timbre of Ruskin's term for socio-aesthetic commerce—"interference."

The world that William Wordsworth discovered in modernizing London was dominated by such interference. The Romantic poet finds that if exchange in the metropolis is poorly governed, "blank confusion" ensues; and the polis, with "the whole swarm of its inhabitants," becomes "[a]n undistinguishable world to men."[81] Then the enervated imagination beholds only "the same perpetual flow / Of trivial objects, melted and reduced / To one identity by differences / That have no law, no meaning, and no end"[82]—without limits or telos. The only force unifying the "trivial objects" of London is capitalist commerce: an anarchic exchange of atomized interests. In *Unto This Last* (1862), Ruskin disputes the "interest" that drives the liberal capitalist worldview, manifesting "in avarice and the desire of progress," through recourse to the countervailing terms of "social affection" (17:25). But contrasting the interests prevailing in London with those ineluctably at play in a commercial city like Venice proves challenging to sustain.

As precursor to the modern cosmopolis, the Venice of Gasparo Conta-rini had *always* made travelers aware that the harmonious character of its "wonderful concourse" was highly contingent: "there is no question to be made, but that euery ciuill societie is contained and linked together in a cer-taine vnitie, and by distraction and breach of that vnity is againe as easily dissolued."[83] Early English visitors such as Thomas Coryate exude anxiety regarding the cohabitation in the Venetian archipelago of "all the languages of Christendome" alongside those of "the barbarous Ethnickes."[84] For Ruskin as for Wordsworth, great artists are capable of reining in the potentially "delightsome inequality" at play in their environs (7:98). In contrast to Lon-don's abject subjects, Venetian artists coming before the fall into luxury were extraordinarily capable of harmonious composition, Ruskin maintains, because the artwork they produced reflected the principles of a thriving sociopolitical body, in which the apparent contradictions of feeling and rule, sensuous appreciation and staunch belief, industry and faith, and individual skill and collective enterprise were resolved. Such "resolution" did not raze difference, but generated singular artworks through harmonious interchange. Ruskin represents Venice as the city where seemingly incommensurate cul-tures mingle and eddy in an exemplary way.

In the initial sweeping movements of *Stones*, Ruskin literally maps this eddying through description of the cultural geography of Venice, employ-ing the confinable cardinal points of the compass or cross as guides to the diverse cultural influences it receives. Overriding his notebooks' overwhelm-ing admissions to accident and chance, Ruskin seeks to stabilize influence in *Stones* by way of spatiocultural poles. Sifting through the hyperbolic variega-tion recorded in his diary ("the currents of a hundred nations," "the marbles of a thousand mountains," "the offerings of a thousand isles"), he differentiates four influences that, having descended on the wreck of the Roman Empire, pool in the Venetian archipelago: the Latins to the north and west, and the Greeks to the south and east—and when the "sensuality and idolatry" of clas-sical culture led to its eclipse, "the fierce swords of the Lombard and Arab . . . shaken over its golden paralysis" (9:37). He takes time to chart the disparate stylistic impulses representative of these cultures. Yet what compels him above all is the crossing and mingling of their "errors" in the interstice of Venice—a city that consequently represents a coalescence of the world's architectures:

Opposite in their character and mission, alike in their magnificence of energy, they came from the North and from the South, the glacier tor-rent and the lava stream: they met and contended over the wreck of the

Roman empire; and the very centre of the struggle, the point of pause of both, the dead water of the opposite eddies, charged with embayed fragments of the Roman wreck, is Venice.

The Ducal palace of Venice contains the three elements in exactly equal proportions—the Roman, Lombard, and Arab. It is the central building of the world.

The reader will now begin to understand something of the importance of the study of the edifices of a city which concludes . . . the field of contest between the three pre-eminent architectures of the world:— each architecture expressing a condition of religion; each an erroneous condition, yet necessary to the correction of the others, and corrected by them. (9:38)

The "correction" of these influences occurs at a center that shores up fragments of a Roman fall—a "point of pause" or of "dead water." This ambivalent extract from "The Quarry" suggests that the struggle among cultures is bound to persist in Venice, a place of crossing contradictions, of passage.

EKPHRASTIC DISTRACTION: A DETOUR TO ST. MARK'S

Ruskin argues for the insufficiency of dyadic thinking through a seemingly paradoxical assertion in an 1858 address: "I have never met with a question yet, of any importance, which did not need . . . at least one positive and one negative answer. . . . I am never satisfied that I have handled a subject properly till I have contradicted myself at least three times" (16:187). Embracing contradiction, Ruskin reimagines research as transit around multifaceted problems in space. "Mostly, matters of any consequence are three-sided, or four-sided, or polygonal; and the trotting round a polygon is severe work for people any way stiff in their opinions" (16:187). Venice is the consummate setting for such permutations of contradiction. The archipelago as object— comprising labyrinthine forms inaccessible to Cartesian rationales—compels the critic literally to "trot round" it in space.

To view "The Four Venetian Flower Orders" (figure 1.4)—a transcription of the contours perceived as Ruskin circumambulated four Venetian column capitals, including the lily capitals of St. Mark's (3, in figure 1.4)—is to confront the challenge he set himself in transcribing this architectural environment into two dimensions, not to mention text. Viewing this plate, Ruskin proposes that we behold confinable "orders" of ornament. He ascribes our

FIGURE 1.4. John Ruskin, "The Four Venetian Flower Orders," *The Stones of Venice*, volume II, plate X, 1853.

delight in the "woven involution" of Arab and Byzantine decoration to "the joy that the human mind has in contemplating any kind of maze or entanglement, so long as it can discern, through its confusion, any guiding clue or connecting plan" (10:163). He suggests that we view in these decorative motifs the very weave of determined contingency: "the 'Weave the warp, and weave the woof,' of Fate and Time" (10:163). In the plate, we are confronted instead with dizzying sequences and juxtapositions of contours that presage the motion studies of Étienne-Jules Marey and a Cubist multiperspectivalism. The outlines represent perspectives on capitals generated as the spectator rotates around them without a resting place. Yet Ruskin is interested primarily in the *transitions between* perceived contours: "the passing of the one of these lines into the other is productive of the most exquisite and wonderful series of curvatures possible within such compass, no two views of the capital giving the same contour" (10:164). One can only comprehend this passage, the critic finally concedes, by witnessing the column's metamorphosis in space, as light moves across it over time, for "no amount of illustrations or eulogium would be enough to make the reader understand the perfect beauty of the thing itself, as the sun steals from interstice to interstice of its marble veil" (10:165). Linear representation falls short; one may only experience such beauty by passing through Venice in time.

In 1848, Ruskin's father portrayed his son's "Sealed Book" of architectural studies (the foundation of *Stones*, conceived of at the time as a mere section of the next volume of *Modern Painters*) as "neither . . . the shape of picture nor poetry. It is gathered in scraps hardly wrought for he is drawing perpetually but no drawing such as in former days you or I might compliment . . . by saying it deserved a frame—but fragments of everything from a Cupola to a Cartwheel but in such bits that it is to the common eye a mass of Hieroglyphics— . . . truth itself but Truth in mosaic" (35:64). This shift from critical fixation on the cupola to the mobile wheel, from framed composition to fragment, from contoured form to the discontinuous "truth" of mosaic, charts the evolution of Ruskin's work, both visual and textual. Ruskin's own conception of history further unsettles the metaphor of the mosaic deployed by his father, presenting its "bits" as, in fact, *mobile*: In 1864, he states, "There is no law of history any more than of a kaleidoscope. With certain bits of glass—shaken so, and so—you will get pretty figures, but what figures, Heaven only knows. . . . The wards of a Chubb's lock are infinite in their chances. Is the Key of Destiny made on a less complex principle?" (36:465). Destiny and chance are wedded here to trace a historical trajectory that is anything but linear; it coalesces instead as a shifting constellation of glass fragments.

While he might aspire to "rest" in social harmonies, Ruskin opts instead to represent the reciprocal interference at play between Venetian monuments and the urban commotion that forms their cosmopolitan foundation and destabilizing future. Inverting Wordsworth's operation, he begins with the already attained aesthetic harmonies of Venice and then shifts his focus to the hubbub surrounding and swarming through them. As R.H. Wilenski writes of Ruskin's books, "the confusing irrelevancies and discursions are as *real* and *organic* as the essentials."[85] As literary works, Ruskin's writings impress history on us as a literal field of inquiry, not an isolated zone of documentation, thereby rupturing the border between "work" and "context"; as Elizabeth Helsinger has demonstrated, the conjunction of historiography with travel through space is a fundamental component in the development of Ruskin's "excursive sight."[86]

In social terms, Ruskin's shifts of attention from artworks to ambient realities ensure that every meditation on Venice's past involves reckoning with its advancement toward a tortured present state of decrepitude, colonial abjection, and modernization. When he returns to Venice prepared to do research for *Stones* in 1849, clashes between the Repubblica Veneta di San Marco and the Austrian colonial powers are at a fever pitch: the paper money of Manin's oppositional republic has been set to fire; Venetian festivals have been suppressed by the Austrians, and an imperial band plays in front of St. Mark's every night in a gesture of cultural supremacy; Venetian intellectuals boycott public events; the aristocracy is fleeing to the mainland; the railway has been destroyed; the city has just recovered from a cholera epidemic; and thousands of citizens are unemployed and homeless. In mingling with the nobility, his wife finds herself forced to take sides between the colonizers and the colonized, as well as between Venetian sympathizers on both sides, the so-called *austriacanti* and *italianissimi*. Yet Ruskin claims in an 1849 letter to W.L. Brown that he has "no heart nor eyes for anything but stone" (36:104).

Was this really the case? Ruskin's chapter on the city's major Byzantine monument, St. Mark's—a set piece of *Stones*—suggests otherwise. It opens with a fairly traditional discussion of the landmark's history, but proceeds to sketch the contemporary disjunction of the building from its social context by way of a jolting movement between historical states. Before embarking upon the anticipated formal analysis of the basilica, Ruskin directs his readers to visualize an example of the Northern Gothic within a quiet contemporary English cathedral town: to contemplate "all its small formalisms," from privatizing wall to high gargoyles, in order to "[e]stimate its secluded, continuous, drowsy felicities, and its evidence of the sense and steady performance

of such kind of duties as can be regulated by the cathedral clock." He then abruptly shifts gears, having us "recollect" that we are (imaginatively) inhabiting an unregulated Venetian alley, before moving gradually toward the Byzantine landmark.[87]

Whereas patrician journeyers with their own gondoliers would have moored their vessels directly at the *molo* of the Piazzetta San Marco—the theatrical and long-eulogized gateway to the Piazza presided over by the columns of Saints Theodore and Mark—the Calle Lunga San Moisè through which Ruskin guides readers to the Piazza constituted the final stretch of the pedestrian route from the railway station to St. Mark's; it was (and still is) the route to the basilica taken by the fresh influx of middle-class tourists. Nostalgia would happily efface the low life of the present from a meditation on Byzantine visual glory, maintaining its purported focus on stone. And yet Ruskin averts neither eye nor ear from the vivid back-alley "full of people, and resonant with cries of itinerant salesmen,—a shriek in their beginning, and dying away into a kind of brazen ringing, all the worse for its confinement between the high houses of the passage along which we have to make our way. Overhead, an inextricable confusion of rugged shutters, and iron balconies and chimney flues" (10:80). We cannot even rest in this chaotic record of the *calle*, for a subsequent footnote marks that the alley has since been enlarged and renamed to commemorate the revolutionary Manin-led Republic of San Marco that briefly overthrew Habsburg rule. The Venetian landscape, virtually untouched for centuries, is now changing too quickly for publication to represent without later additions and qualifications. The resulting tempo of Venetian life possesses nothing of that steadiness that can be "regulated by the cathedral clock."

Ruskin's registration of this "inextricable confusion" does not exclude from its sights the contamination of faith by the material sphere. He points out that the relative success of a Venetian business is made legible in the amount of alcohol embellishing its shrine to the Madonna:

> Here, at the fruiterer's, where the dark-green water-melons are heaped . . . like cannon balls, the Madonna has a tabernacle of fresh laurel leaves. . . . Next comes a "Vendita Frittole e Liquori," where the Virgin, enthroned in a very humble manner . . . presides over certain ambrosial morsels of a nature too ambiguous to be defined or enumerated. But a few steps farther on . . . where we are offered "Vino Nostrani a Soldi 28.32," the Madonna is in great glory, enthroned above ten or a dozen large red casks of three-year-old vintage, and flanked by goodly ranks of

bottles of Maraschino, and two crimson lamps . . . and . . . when the gon-
doliers will come to drink out, under her auspices, the money they have
gained during the day, she will have a whole chandelier. (10:81)

A Protestant disgust with the material contamination of the divine, culmi-
nating in disgust with the distasteful commerce of the cult of the Madonna
with debauchery and money, pervades this itinerary (even as a footnote
controversially defends Mariolatry). Ruskin's compulsion to foreground
such circumstances leads to an irrepressible attention to the humble waste
products of Venetian spirit. He continues to usher readers to the entrance of
St. Mark's Square, choosing again to depict the countervailing modern phe-
nomena encountered en route to this most properly "Venetian" of sights as
we advance: "the Venetian character is nearly destroyed, first by the fright-
ful façade of San Moisè . . . and then by the modernizing of the shops as
they near the piazza, and the mingling with the lower Venetian populace of
lounging groups of English and Austrians." The crowning achievement of
Byzantine Venice can only be beheld by passing through signs of Renaissance
decadence, contemporary shops, and the seething animosity between the
Venetian proletariat and the Austrian leisure class.

For a brief moment, coincident with a violently achieved amnesia, Ruskin
summons a vision of cultural coherence: "We will push fast through them . . .
and then we forget them all; for . . . as we advance slowly, the vast tower of
St. Mark seems to lift itself visibly forth . . . ; and, on each side, the countless
arches prolong themselves into ranged symmetry, as if the rugged and irregu-
lar houses that pressed together above us in the dark alley had been struck
back into sudden obedience and lovely order, and all their rude casements
and broken walls had been transformed into arches charged with goodly
sculpture" (10:82). The celebrated climactic set piece exposes an acute eye for
the accumulation of sumptuous exotic, Orientalizing (and even erotic) details
that engenders the holiest site in Venice:

And round the walls of the porches there are set pillars of variegated
stones, jasper and porphyry, and deep-green serpentine spotted with
flakes of snow, and marbles, that half refuse and half yield to the sun-
shine, Cleopatra-like, "their bluest veins to kiss" . . . ; their capitals rich
with interwoven tracery, rooted knots of herbage, and drifting leaves of
acanthus and vine, and mystical signs, all beginning and ending in the
Cross; and above them, in the broad archivolts, a continuous chain of
language and of life—angels, and the signs of heaven, and the labours

of men . . . and above these, another range of glittering pinnacles . . .
—a confusion of delight . . . until at last, as if in ecstasy, the crests of the
arches break into a marble foam, and toss themselves far into the blue sky
in flashes and wreaths of sculptured spray, as if the breakers on the Lido
shore had been frost-bound before they fell, and the sea-nymphs had
inlaid them with coral and amethyst. (10:83)

That ample sentence, redacted here for economy's sake, barely contains its
shoring-up of details that would normally be incommensurable. Still, the
narrative insists that all is continuous in the archivolts: "a continuous chain
of language and of life" where celestial and earthly labor, sign and social
and spiritual meaning are still wedded. All sumptuousness points toward
and away from the cross (the shape of the church's interior), with its all-
encompassing, yet distinguishable cardinal directions. In this orgasmic but
neatly petrified culmination of the vulgar route to St. Mark's, the behold-
ing imagination envisions the elusive, vaguely threatening "breakers" on the
barrier beach visible from the Piazza being stultified by frost and studded
with solid jewels.

Very little of the confusion that ushered us to this climax seems to have
been cropped out. And yet a look at the revisions of *Stones* proposed by
Ruskin's father shows that even more distracting minutiae were present in the
initial manuscript:

These St Mark pieces are very lovely & as poetical as a [?] Broken Chain—
The finer objects marvellously described & the truth as marvelous tho
from my sympathies held only by the Beautiful or sublime in nature . . .
the very truth of your description deprives me of pleasure by making
me actually see what I so heartily feel to be decidedly unpleasant—from
the *jars of pickles all the way past Vinegar Cruets—stale apple Fritters—
sausage—crumbs* etc distresses me—yet I see that you put them as foils.[88]

The paragraphs characterized as "pieces" by John James register—against
Venice's "continuous chain of language and of life"—as those of a "Broken
Chain." In the published *Stones*, the vivid particulars of pickled, decomposed,
or stale foodstuffs deemed offensive to Ruskin's father have been reduced to
the phrase "certain ambrosial morsels of a nature too ambiguous to be defined
or enumerated" (10:81). Ruskin disciplines his youthful eye for the commo-
tion surrounding the object of beauty through abstraction as he effaces its
distressingly material environs under the sign of "ambiguity."

Descriptive, or ekphrastic, reflection on the beautiful always threatens to digress from or bypass the telos of overseeing truth. In contrast to the apparent immediacy of two-dimensional visual representation, the linearity and temporality of the verbal channel entail distraction on the one hand and overly local absorption in particulars not viewed in relation to the whole on the other. This condition is aggravated by the mazelike layout of Venice, which reveals itself (in contrast to the boulevard) only piecemeal, tortuously, and by compression along the narrow *calli*—until one arrives at the city's single open square of which St. Mark's is the crowning jewel. By narrating the byways of a lowly, post-Romantic route to the basilica, Ruskin transcribes a new way of perceiving and sensing.[89] Aiming to uphold the tenuous harmonies witnessed in Venetian artifacts, he ends up registering the transience and hazardous abundance of noise encountered in the cityscape along the way.

No hard-won vision of continuity goes without repeated challenges in *Stones of Venice*; and here, the glorious spectacle given to us by Ruskin's prose emerges as imperceptible to the inhabitants of the actual (current) Venice. Immediately following an exclamation regarding the contrast between the English cathedral and St. Mark's—"Between that grim cathedral of England and this, what an interval!"—Ruskin registers the contemporary world's indifference to the sublimity of the basilica: "you will not see an eye lifted to it, nor a countenance brightened by it. Priest and layman, soldier and civilian, rich and poor, pass by it alike regardlessly" (10:84). Cherished boundaries between professions and classes collapse in this atmosphere of homogenized indifference. Meanwhile, the tawdry economy of tourism is played out by the "meanest tradesmen" on sacred ground: "the foundations of its pillars are themselves the seats—not 'of them that sell doves' for sacrifice, but of the vendors of toys and caricatures" (10:84). Disturbances of colonialism, unemployment and poverty, class tension, and brewing revolution further riddle Ruskin's picture of harmony:

> [I]n front of the church ... the idle Venetians of the middle classes lounge, and read empty journals; in its centre the Austrian bands play during the time of vespers, their martial music jarring with the organ notes,—the march drowning the miserere, and the sullen crowd thickening round them,—a crowd, which, if it had its will, would stiletto every soldier that pipes to it. And in the recesses of the porches . . . knots of men of the lowest classes, unemployed and listless, lie basking in the sun like lizards; and unregarded children ... gamble, and fight, and snarl, and sleep, hour after hour, clashing their bruised centesimi upon the marble ledges of the church porch. (10:84–85)

Ruskin can only conjure a fleeting sense of Venice's prelapsarian harmony by literally shutting out the contemporary world of repression and aggression, withdrawing into the domed, jewel-like enclosure of the baptistery: "The heavy door closes behind us instantly, and the light and the turbulence of the Piazzetta are together shut out by it" (10:85). The sound of the secular Austrian authority still bleeds in through the window, mingling with an internalized voice of spiritual authority and confusing the "sentence of judgment . . . written on that Baptistery wall" (10:88). Ruskin's fastidious empiricism requires that the city's barrage of contradictory stimuli continue to seep in from the periphery of attention even here. It is no anachronism to see in his writing on the mercantile Republic a registration of the fact, observed by Jonathan Crary, that "[c]apital, as accelerated exchange and circulation, necessarily produced this kind of human perceptual ability and became a regime of reciprocal attentiveness and distraction."[90]

While removed in time, Thomas Struth's recent photographs of museums and churches in Venice represent a sort of apotheosis of Ruskin's attention to the tumult surrounding the city's masterworks. Struth's *Galleria dell'Accademia* (1992), measuring more than six by seven feet, frames tourists in tee shirts and shorts drifting in alternating states of distraction and contemplation before the linear perspective of Veronese's *Feast in the House of Levi* so that they seem to make up but the latest plane of activity in the painted scene, extending the painter's own transgression of the conventional bounds of depicting the Last Supper. Régis Debray notes in his 1995 polemic *Against Venice* that the integration of this painting into the Accademia gallery, and "beyond that, into the essentially decorative spirit of the city," is such that "this gigantic machine, its coloring way overdone, without an atom of sorrow, without an accent of truth, seems not only matched to but held up by the columns and full-vaulted arches bordering the canvas."[91] Struth's formal integration of a technicolor tableau of middle-class tourists into the scene presses beyond ironic commentary on the fate of feasts to represent a possible instance of reciprocal interference, eliciting the "Brotherhood" between painted nobles and their latter-day onlookers and thereby democratizing art that, as Ruskin later admitted, was based on "the pride of the so-called superior classes" (*Works* 16:341)—while still emitting a tinge of the social trepidation that such commerce instills in highbrow contexts. Struth's equally monumental *San Zaccaria* (1995) scans the rites of spiritual and aesthetic (or touristic) experience collapsed upon a shared surface. The ambiguity of visitors' postures before Giovanni Bellini's 1505 altarpiece of the Madonna, child, and saints hovers between states of praise and detachment just as the altarpiece and its protagonists hover

between dimensions godly and mundane—its sculpted frame and painted niche melting into an illusionistic succession of spatial planes that are represented in the surrounding two-dimensional oils spanning church walls, each with their own perspective. Taken as a diptych, the pair of chromogenic prints shot in Venice reminds us that Veronese's painting was destined for the Basilica dei Santi Giovanni e Paolo before the painter was set to trial by the Inquisition in 1573 for his insertions of vulgar actors into a sacred subject. Like Veronese's banqueters, poised precariously between religious and profane contexts, Struth's supplemental protagonists interject an undecidability of purpose into the sacred scenes to which they now formally pertain. Such ambiguity is redoubled by the monumental proportions of Struth's photos themselves, which usurp the place of the monumental oils of Veronese and Bellini mechanically reproduced therein. The works ultimately disclose the confusion of ritual with exposition spaces during an epoch in which sacrality has been seamlessly transposed into the aesthetic or anthropological dimension as curiosity or entertainment.

Against the formal balance of Struth's photographs, which sublates their irony, Ruskin's prose emerges as highly convulsed. The contrast between the reciprocal interference of the Venetian masters and contemporary dissonance continues to compel the Victorian witness to agitated narration of a transitional moment in the nineteenth century. He longs to hold Venice up as a foil to modernity even if the gulf between Giorgione's Venice and Turner's London is narrowing—even if he recorded the slow approach by boat to the *Stones of Venice* in volume I as telegraph and railway were yoking the lagoon to the velocities of a modernizing world. Modern commotion must rupture the Venetian scene rather than governing it.

RESTLESS HISTORY

I have argued that the jagged attention span of Ruskin's prose is an inherent outgrowth of his empirical method, an extension of his approach to history through material phenomena—suggesting that if his digressions in interrogating the object world emerge as rueful and melancholic, it is a social more than a personal melancholy that they express. In the ninety-six self-published open letters of *Fors Clavigera: Letters to the Workmen and Labourers of Great Britain* (1871–78; 1880–84), written in tandem with *St. Mark's Rest* from wherever Ruskin happened to be at the moment,[92] and in which modernity emerges as retrospection's undeniable telos, the social origin of

this melancholy becomes indisputably evident. Venice was flooded by new economic interests during this period: it had been linked by rail to Vicenza in 1846; by 1857 the line was complete to Milan; and after the opening of the Mont Cenis tunnel in 1871, thousands arrived annually from the mainland. The Austrians withdrew from power in 1866, and Venice was annexed to the Kingdom of Italy, reinstating its potential vitality as a cultural destination. These developments made the place a harbor of tourism and cosmopolitanism once again—for better or worse.[93] The epistolary genre's innate polyvocality allows a surge of contemporary noise to pierce Ruskin's pedantic missives to the working class.[94] In *Fors*'s sequence of broken meditations, the transcendental thrust of Ruskin's privileged didactic mode—which sets out to divine universal laws through nexes of appropriated classical and Biblical texts and the works of faithful Venetian masters—is toppled by the pressure of the contemporary. As industrial capitalism infiltrates his beloved city from a realm of modernity once rhetorically contained by England, Ruskin's metaphors collapse into metonymic figures of dispersion and dismemberment. The formal outcome proves to be an act of thwarted reconstruction instead of preservation: in his own words, *Fors* resembles "a mere moraine of separate and seemingly jointless stones, out of which I must now build such Cyclopean wall as I shall have time and strength for" (29:322–23).

Ruskin's narrative style witnesses a host of irruptions and aborted deixes that moor it in duration, in transit.[95] The epistolary conceit embraces chance as a strategy: Ruskin asserts that "*Fors* is a *letter*, written as a letter should be written, frankly, and as the mood or topic chances" (29:197). The occasional impulse turns out to be the core justification for the form; as he ultimately writes, "By the adoption of the title 'Fors,' I meant (among other meanings) to indicate the desultory and accidental character of the work" (29:315). Even this gloss is indeterminate, for the title's first word points to a constellation of terms: force, fortitude, and fortune. The second part of the title is meant to pin purposes down; *Clavigera* is the "club-bearer" of force, "key-bearer" of fortitude, and/or "nail-bearer" of fortune.[96] Ruskin, in other words, opts to incorporate the incidental into the work rather than merely surrendering to it. Hence the double edge of his commentary on Turner's remark, "I never lose an accident": "it is this not *losing* it, this taking things out of the hands of Fortune, and putting them into those of force and foresight, which attest the master" (7:228–29). A violent clash between *Fors*'s indeterminacy and *Clavigera*'s "driving the iron home with hammer-stroke, so that nothing shall be moved" is increasingly characteristic of Ruskin's praxis (28:231); however, we witness the first term playing an ever stronger role in this aggregation of open

"letters." Ruskin was aware of the potential problems with the work's digres-
sive nature—with his tendency "to yield, . . . without scruple, to the eddies of
thought which turned the main stream of my discourse into apparently irrel-
evant, and certainly unprogressive inlets" (29:445). Yet it is the eyewitness's
unruly empiricism, his vigilant attention to circumstance, that leads him into
these "eddies" at a breakneck pace. Presided over by an allegory of Fortune,
the urban structure of Venice is not merely the backdrop, but the *medium* of
Fors's most poignant resistance to linear narrative. The stylistic result proves a
precursor to the more enabling digressions of James's late works and strategic
fragmentation of Pound's *Cantos*.[97]

In tracking the evolution of Ruskin's methodology and style over the late
years of the nineteenth century—punctuated by scenes in which the rhetoric
of contrast gives way to pell-mell association—we witness his struggle against
the fact that modernity is, as T.J. Clark argues, "no longer characterized by
a system of classification and control but, rather, by mixture, transgression,
and ambiguity in the general conduct of life."[98] This ambiguity is concret-
ized in the figure of steam or seemingly poisonous smoke, modern manufac-
turing's correlative to the storied Venetian mist—steam that penetrates the
mythically remote lagoon environment to literalize an apocalyptic blurring
of boundaries between men (in a "miserable mob" [27:330]) and machines.
Fors's Letter 8 became Ruskin's celebrated "Storm-Cloud of the Nineteenth
Century" lecture—a text that reviles the mid-England sky shrouded by "a
dry black veil . . . partly diffused in . . . feeble mist, enough to make distant
objects unintelligible, yet without any substance, or wreathing, or colour of
its own" (27:132). The image ushers in his denunciation of usury; Ruskin was
at the time translating Canto XXI of Dante's *Inferno*, which compares the
lake of pitch punishing grafters to the boiling pitch used to caulk the seams
of unsound ships at the Venetian Arsenal. In Letter 19 of June 1872, Ruskin
returns to the image, interrupting a missive on hydraulic systems to report
on Venice's contamination by steam. In his tortured perception, the smoke
from trains and boats infiltrating the harbor has begun to infuse, and even
to compose, the bodies of Venetian citizens as well as their environment. It is
beginning to constitute both figure and ground:

> I can't write this morning, because of the accursed whistling of the dirty
> steam-engine of the omnibus for the Lido, waiting at the quay of the
> Ducal Palace for the dirty population of Venice, which is now neither fish
> nor flesh, neither noble nor fisherman—cannot afford to be rowed, nor
> has strength nor sense enough to row itself; but smokes and spits up and

down the piazzetta all day, and gets itself dragged by a screaming kettle
to Lido next morning, to sea-bathe itself into capacity for more tobacco.
(27:328)

The trigger of this missive was harmless enough: the inauguration of a new
public steamboat service, increasing access to circulation through the city,
which would be extended (amid controversy and protests by gondoliers) to
the exalted Grand Canal in 1881. Yet in Ruskin's hands, the scene takes a
phantasmagorical turn. His negative definition of the Venetian population as
"neither fish nor flesh, neither noble nor fisherman" expresses the impasse of
marshalling modern persons into dialectical syntheses of noble and fisher-
man: instead the city teems with middle-class idlers headed for the Lido's new
bathing establishments, the first of which opened in 1857.[99] The Venetian
aggregation has become a nebulous mass, inert in its drift and passive in the
thrall of machines. The leisure classes engage not in the "rest" that should fol-
low labor (nor in noble repose), but in laziness and ineffectuality; Venetians,
in turn, no longer work, but feed off of the decrepit phantom of their past. The
populace that once built the Ducal Palace now spits out smoke in unconscious
mimicry of the steamship. The steam celebrated by modern painters from
Turner (*Rain, Steam, and Speed*, 1844) through Manet (*The Railway*, 1872)
arises as a negative "metaphor for a general, maybe constitutive, instability—
for things in modernity incessantly changing their shape, hurrying forward,
dispersing, and growing impalpable,"[100] as Clark observes—reflected in the
fact that the approach to Venice described dramatically at the beginning of
Stones was itself documented in a period in which "the noble landscape of
approach to her," depicted by Turner (figure 1.2), "can now be seen no more,
or seen only by a glance, as the engine slackens its rushing on the iron line"
(10:7). In the Venetian mob of Ruskin's *Fors*, as in Wordsworth's London, per-
sons melt into smoky forms "That shift and vanish, change and interchange /
Like specters," amalgamating without being united.[101] Trade in the bodies
of saints gives way to the sale of "Living flesh . . . perhaps of prettier aspect"
(24:234); but worse, phantasmagorical forms of relation under modern com-
modity culture threaten to displace fleshly experience itself.

 In Letter 20, written from Venice on July 3, 1872, Ruskin dramatizes
the rush of the present into a missive on blessing and cursing in passages
that have attracted many elegiac readings. The word "Now" punctuates the
passage of a steamer through the lagoon whose clamorous "beating of her
screw" will force him to take note and to discontinue writing over and over
(27:335). Venice was renowned at the time for the silence of its waterways,

still navigated by human hands and arms, and for the consequent asylum it offered to visual contemplation; but *Fors*'s noise implodes this "picture" of silence. The steam whistle will issue repeatedly "at high pressure, going through my head like a knife" (27:342) as the letter's piercing refrain, a sign of the fall from fellowship and industriousness to an alienated landscape of industry and mindless tourism. Disrupting Ruskin's reference to the Gospel of Luke's promise that "the tongue of the dumb sing," the steamer sounds instead the harsh "intervals of time in modern music" (27:341). A fruitlessly tautological instruction of double negatives regarding the contrast between benedictions and curses gets lost between the screeches of these digressive parentheticals until Ruskin halts with the seventh whistle—a fell version of the Apocalypse's seventh trumpet—"from I don't know which of the boats outside—and I count no more" (27:342).[102] Ruskin's handling of this seemingly banal incident establishes terms of historical testimony uncannily similar to those of Benjamin's pronouncement that "[t]he nineteenth century . . . is the set of noises that invades our dream."[103] Indeed, Ruskin's missive is designed to perform an awakening from the Romantic "stage-dream" of Venice. Luchino Visconti will recuperate Ruskin's strategy in the opening sequence of his adaptation of *Morte a Venezia* (1971). The film's impressionist palette is introduced through a nearly monochromatic, indistinguishable dusk or dawn on an empty lagoon: as ambient light undims, black smoke stains the gray morning horizon, the camera veering left to introduce the tourist steamer (incongruously named *Esmeralda*) that conveys a dozing Aschenbach (literally, "Stream of Ashes") to his resort. The steamer's horn blast disrupts the euphonious *Adagietto* of Mahler's Fifth Symphony as the craft expels its smoke past the white Napoleonic lighthouses at San Giorgio, contrapuntally engaging the soundscape of Venice's militarization represented by the bugle call of a *bersaglieri* drill. Visconti thereby undercuts the late-Romantic tropes of twilight and sleep that pervade *Der Tod in Venedig*, while forging a parallel between the early moment of Venetian modernity in which the novella is set and the late-twentieth-century incursions of the petroleum industry responsible for the 1966 flood.

Ruskin's contrasts, however, aspire ultimately to model an ideal of bridging life and death by way of industry and grace. He accomplishes this at last through an epistle of July 4, 1872, which rhetorically shuts out the ambient hubbub of his prior letter, halting its hurtling discursivity to furnish us with an ekphrastic suspension on Carpaccio's *Dream of Saint Ursula* (1495). For Ruskin as for Pound, the Quattrocento exemplified by a painter like Carpaccio perfectly straddles the fifteenth and sixteenth centuries in art. This

period in painting relies on a supple yet definitive use of line that prevailed before the Cinquecento ingested "a mess of shadows for its meat," as Yeats would later put it[104]; Ruskin remarks that Carpaccio's picture represents a "faultless example of the unison of right delineation with right colour" (13:525). Carpaccio's Quattrocento is poised at the edge of an epochal disjunction that Ruskin posits between faith and reason, before "printing, and universal gabble of fools;—gunpowder, and the end of all the noble methods of war;—trade, and universal swindling,—wealth, and universal gambling,—idleness, and universal harlotry; and so at last—Modern Science and Political Economy; and the reign of St. Petroleum instead of St. Peter" (24:262). It is significant that Ruskin selected this canvas, unique in the painter's oeuvre for its interiority and lack of anecdotal distractions—for a containment and interiority antithetical to the welter of the Venetian archipelago, and to the convulsed historiography of his late prose. The other paintings in the Saint Ursula cycle depict outdoor scenes rife with exotics and grotesques; their variety often overwhelms their harmony, and their depiction of secular life threatens, like Veronese's, to obscure any sacred mandate. Ruskin purposely takes a great deal of time, amid the abridgements and accelerations of the contemporary world, to trace the lines of Ursula's perfectly legible bedroom, depicted "in the light of dawn, so that you can see everything in it" (27:343), and the saint in her bed/bier, "the sheet rising and falling over her in a narrow unbroken wave" (27:344). He values above all this scene's delightful continuity: "But the lovely characteristic of all is the evident delight of her continual life" (27:344–45). In the picture's faithful continuum between sleeping and waking, dreaming and seeing, life and death, even a wave never breaks.

In actuality, an obsessed Ruskin could not find "the slightest material trace" of the apocryphal Ursula; in 1876 he reported that "under scholarly investigation, she vanishes utterly into the stars and the aether" (28:732). Moreover, the painting itself was "terribly injured" at the time of his studies, falling away from the canvas.[105] All elements of Carpaccio's pictures come together "in one music of moving peace" (24:369), but a vast interval separates that precious hallucination of harmony from the dissonance of the contemporary. Ruskin will attempt, throughout *Fors*, to come to critical conclusions about the Ursula cycle so pivotal to his imagination of Venice, despite (or perhaps because of) "certain shortcomings and morbid faults throughout, unaccountable" (24:366). He will finally have to allow, in *St. Mark's Rest*, that "[w]hatever [Carpaccio] has to represent must be a reality; whether a symbol or not, afterwards, is no matter" (24:362); but his extended act of montage emerges

as a new method of confronting the gulf between symbolic and postlapsarian contexts of signification.

While John D. Rosenberg comes to the compelling conclusion that "*Fors* is the inspired metamorphosis of chance into design," subsuming all its incidents in fatal exempla, we need to recognize that Ruskin also stages—in fact, designs—the *failure* of design.[106] After intermittent, fragmentary glosses, he will be forced to confess, "I find it hopeless to reduce my notes to any available form at present:—the question of the influence of this legend on Venetian life being involved with inquiries belonging properly to what I am trying to do in *St. Mark's Rest*" (24:366). Working on a cycle is infinitely more difficult than focusing on a single canvas, and this particular cycle performs more like a series: its Ursulas are not frozen in character, nor in time. They thwart stable identification, let alone symbol-erection or the drawing of contrasts: "The girl talking to her father in 572 is not the girl who dreams in 578; and the gentle little dreamer is still less like the severe, stiffly dressed, and not in any supreme degree well favoured, bride, in 575; while the middle-aged woman, without any claim to beauty at all, who occupies the principal place in the final Gloria [576], cannot by any effort of imagination be connected with the figure of the young girl kneeling for the Pope's blessing in 577" (24:366–67). Having summoned Carpaccio's organic vision of wholeness in the midst of this late-modern rubble, Ruskin is immediately forced to contemplate its ephemerality, and the status of Ursula as a dispersive series of representations. But this will become an enabling condition in the work of his successors. Insofar as Ruskin viewed Ursula as a medium between himself and the dying young Rose La Touche (a subject that has dominated the critical record on these important texts), the passage above underscores a traumatic discontinuity between the referents of Ursula/Rose of the sort *embraced* by Gertrude Stein as an enabling condition of the "continuous present"—typified by her refrain "Rose is a rose is a rose."[107]

In Ruskin's *Fors*, the violent struggle to dissociate Ursula's traces from a landscape of sloppy amalgamation elicits that the work of segregating Venice past from Venice present, Venetian Republic from contemporary revolution, sacred from secular, visionary from sightseer cannot hold. Yet in the process of conjuring his irretrievable construct, the melancholy seer has cleared a channel for sea-changes to pass between the city of lagoons and its contemporary onlookers. In the turned figure of *St. Mark's Rest*, rather than insisting that we see in Venice any stable shape, Ruskin chooses to transpose the changeful "wine" of its sea.

In the history of great multitudes, these changes of their spirit . . . take place through so subtle gradations of declining and dawning thought, that the effort to distinguish them seems arbitrary, like separating the belts of a rainbow's color by firmly drawn lines. But, at Venice, the lines are drawn for us by her own hand; and the changes in her temper are indicated by parallel modifications of her policy and constitution, to which historians have always attributed . . . the national fortunes of which they are only the signs and limitation.

In this history, the reader will find little importance attached to these external phenomena of political constitution; except as labels, or . . . securing seals. . . . They are merely shapes of amphora. . . . But it is the grape-juice itself, and the changes in *it*, not in the forms of flask, that we have in reality to study. (24:240)

In his revised historiographical model, Venice writes its own history, recasting our interpretive categories as transmissions of a fluid corporeality. Ruskin doubles *Stones'* provisional division of Venetian history into two periods to arrive at four in *St. Mark's Rest*; but this is only a surface schema, not a heuristic. His emphasis on fluid over vessel anticipates Manfredo Tafuri's 1985 proposal that instead of characterizing historical categories as "containers," we should utilize them "to distinguish ephemeral boundary lines, or limits, in the immense collection of phenomena that have been crushed by the words Venice and the Renaissance."[108]

Having given up on guiding readers through Venice by way of a historical trajectory, Ruskin composes *St. Mark's Rest* according to a series of walks through contemporary Venice, invoking the reader's experience—corporeal, perspectival, temporal, intertextual, and social. Placing travelers under the Piazzetta columns, he presumes that the reader carries a Murray guide in hand addressed to English capitalists, and adjusts the comportment and assumptions of the "glib-tongued Cockney friend" accordingly (24:210). The tourist, who is assumed to be inundated by the noise of the plaza, is to be rowed across the Bacino di San Marco to San Giorgio Maggiore to read about the twelfth-century columns and crusades in peace—on the site, Ruskin reminds us, of an older monastery destroyed so that "this stately Palladian portico might . . . delight Mr. Eustace on his classical tour . . . and persons of excellent taste like yourself" (24:216). The tourist must then be rowed back across the canal to study the columns up close, and even to apprehend the shape of their capitals during a break for lunch by way of a fifteen-minute exercise in carving Gruyère cheese, before returning to the Piazzetta. While *St. Mark's Rest* was projected for completion with the help of professional historians such as Rawdon Brown who were working with the

Venetian state archives, the value of Ruskin's late history consists in its refusal to compose any chronicle divorced from a spatial context. It conceives a relationship to epistemology that William James would call "ambulatory":

> [W]e know an object by means of an idea, whenever we ambulate towards the object under the impulse which the idea communicates. If we believe in so-called "sensible" realities, the idea may not only send us towards its object, but may put the latter into our very hand, make it our immediate sensation. . . . [O]ur idea brings us into the object's neighborhood, practical or ideal, gets us into commerce with it, helps us towards its closer acquaintance.[109]

Insisting that history is a sited enterprise—sited in the interstices enabling correspondence between subject, object, and environment—Ruskin's empiricism points toward an aesthetic future.

In *Venice and the Renaissance*, Tafuri sums up his object of study thus: "Venice: she can be seen as the place in which antitheses have been removed, in which dialectics has no function, in which there is no contradiction between tradition and innovation, development and memory, continuity and renewal, sacred and mundane."[110] A functional dialectic would consist of productive antitheses, leading oppositional elements to subsume one another in synthesis. Ruskin's work longs to progress dialectically, but his writing registers instead what gets abjected or disavowed when binarisms are erected: what falls by the wayside. Ruskin's late labors finally propose that one no longer goes to Venice to behold a framed prelapsarian structure, but to watch "the rest of things in which there is vitality or capability of motion actual or imagined" (*Works* 4:114)—with the word "rest" providing a curiously animating double entendre. Ruskin reminds us why we ought to heed the *negation* of progress at "the very centre of the struggle, the point of pause of both, the dead water of the opposite eddies, charged with embayed fragments" (10:38): the point of pause or abeyance and not simply of stillness. Ruskin's material grapplings with a critical Venetian obsolescence and ongoing Venetian actuality deliver us no complacent image of permanence or repose, but a sense of how "the rest" of history moves—as it moves us.

 • • •

"I only asked you to look at the fresco just now, because therein is seen the end of *my* Venice,—the Venice I have to tell you of. Yours, of the Grand Hotels and the Peninsular steamers, you may write the history of, for yourself" (24:234). In the light of this chapter's arguments, Ruskin's late claim that

"his" Venice ends with Giorgione's fading fresco on the Fondaco dei Tede-
schi façade emerges as quite inaccurate—for it was he who solidified a tra-
dition of grappling with the Grand Hotels and the steamers, as well as the
vestiges of Republican glory lingering in this place. And yet, in spite of his
call to dissipate the stage-dream of romance in Venice, the "undistinguished
enchantment" of its streets (9:59) will constitute an ongoing lure. In the
decades following, Henry James—though haunting Venice equipped with
Ruskin's polemics—is still drawn abashedly to the writings of late "dispens-
ers of romance."[111] The increasing historical remove from Romanticism in
Venice will resound with faint irony through a fictive publisher's obsession
with an imaginary "American Byron" in James's 1888 novella: the ill-fated
Aspern Papers reanimate the loss of Byron's own memoirs, begun in Venice
as his labyrinthine poetic experiments were gaining ground and destroyed
controversially by fire after his death.[112] James's latecoming tales will exploit
the Venetian setting to stage the demise of Romanticism writ large: with *The
Aspern Papers*, James will write himself into literary history as the first irrepa-
rable post-Romantic. He can only depict the throbbing *lack* of a postulated
"American Byron" that resounds most poignantly within "the queer incidents
of a Venetian installation"[113]—to which Ruskin now returns us.

2. NEARER DISTANCES AND CLEARER MYSTERIES
BETWEEN PATCHES AND PRESENCE IN JAMES'S "VISITABLE PAST"

Not Italy itself is given here, but the proof that it exists.
—Max Horkheimer and Theodor Adorno,
Dialectic of Enlightenment

Masses and Stumbling Blocks: Sentimental Tourism

Seeing is tantamount to editing: this is the sobering thesis to which Henry James's travel writings from Venice lead us. From the moment of his first visit to the Ducal Palace in 1869, the Yankee tourist is estranged from Romantic history—even as he feels its weight upon him. Writing to his brother William from a Venetian hotel at age 25, he describes his struggle to take in the "tone of Italy," which "lies richly on my soul and gathers increasing weight, but . . . as a cold and foreign mass—never to be absorbed and appropriated." This letter immediately sets his sense of alienation against Ruskin's communion with Venice: "Ruskin recommends the traveler to frequent and linger in a certain glorious room . . . where P. Veronese revels on the ceilings and Tintoret rages on the walls, because he 'nowhere else will enter so deeply into the heart of Venice.' But I feel as if I might sit there forever . . . and only feel more and more my inexorable Yankeehood."[1] James is twice removed from Venice: removed both from the sense of a past that lies upon him (with paradoxical intimacy) as a "foreign mass" and from the literary ancestors who enjoyed authentic access to it. The city of Venice nevertheless became one of his life's haunts—a fact suggesting that James found some aesthetic advantage in the process

of reaching across those gulfs. James takes a post-Romantic approach to the obstructions he confronts in experiencing Venice, which accepts distance—and the cultural difference it represents—as an ineluctable, and even fertile, condition of modern encounters with the place. Incorporating his detachment from "the visitable past"[2] of Venice into works of narrative grappling over the course of his career, James will reconceive of the contemporary relation to both history and its representation.

In spite of his confessions of foreclosure from aesthetic communion with Venice, James communicates in the same letter to William a desire "in some neat formula to give you the *Italian feeling*—and tell you just how it is that one is conscious here of the aesthetic presence of the past."[3] Over the next four decades of visits to Venice, James lands upon no "neat formula" to express this "feeling," as it proves anything but universal. Although the past is made present through Italian art, luring visitors to approach it, James discovers over the course of many sojourns that Venetian art will convey him neither straightforwardly backwards in time nor to any present that seems "consanguineous" with the city's history. In his travel writings, the past encroaches upon the subject only through forms of interference to which travelers must constantly adjust: the mediation and mechanical reproduction of "Venice," on the one hand, and—for those who manage from time to time to dodge the tourism apparatus—the disorienting premodern layout and mutability of the cityscape on the other. Outlines of decline that Venice elicited in cautionary histories of the eighteenth and nineteenth centuries are eclipsed, in James's prose, by piecemeal chronicles: his aberrant tourist meanders through the historic complex in nonstandardized, anachronistically juxtaposed "Italian hours."[4] While the would-be seer of *Italian Hours* struggles with Venice's resistance to representation, James as novelist will exploit the cultural, structural, and atmospheric obstacles this city presents to vision as narrative devices in the composition of a defamiliarizing realism.

James composed an essay on Venice more or less every decade from 1872 to 1902 before gathering and revising these five pieces to form the opening section of *Italian Hours* in 1909—when, from his familiar perch at the Palazzo Barbaro on the Grand Canal, the well-traveled cosmopolitan singled the city of lagoons out in affectionate terms: "Never has the whole place seemed sweeter, dearer, *diviner*. It leaves everything else out in the cold."[5] The essays in *Italian Hours* foreground both the allure and the drawback of Venice for an American author seeking access not only to remote history but also to the nearer ghosts of "the past seekers of poetry and dispensers of romance."[6] James came to terms with the struggle to "visit" the past presented by his

travelogues by setting the climaxes of numerous fictions that grapple with passing time in Venice—from his first European tale, "Travelling Companions" (1870), through the novella *The Aspern Papers* (1888; revised for the 1908 New York Edition) and the late masterpiece *The Wings of the Dove* (1902; republished in the 1909 New York Edition).[7] Over nearly four decades of reading, revisiting, and writing not so much "about," but *through* the city famously laden with inscriptions past, he constructs a labyrinthine historical consciousness, made up of discontinuities and detours.[8]

Venice surfaces repeatedly in James's later travelogues as an "it"—so picked over, so "known," that it threatens to be emptied of any content beyond the indexical function: "We are in it so uninterruptedly, at home and abroad," he writes in 1892, "that there is scarcely a pressure upon us to seek it in one place more than in another. Choose your standpoint at random and trust the picture to come to you" (*IH* 45). Painfully attuned to the fact that he inhabits an age of accelerating reproduction, James intimates that the experience of travel is becoming obsolete. Its marvels threaten to be replaced by virtual encounters with the foreign at home and mass tourism's rote trajectories of transit between monuments already known; a crisis of epistemological horizons looms. Nowhere is this more glaringly the case than in the tourist capital of the nineteenth century, the most depicted of romantic European sites, which "of all the cities in the world is the easiest to visit without going there" (*IH* 1)—that is, through representation. The essay titled, simply, "Venice" (1882)—later chosen, at odds with chronology, to introduce the whole of *Italian Hours*—opens recursively, pointedly refraining from repeating the place's name: "It is a great pleasure to write the word; but I am not sure there is not a certain impudence in pretending to add anything to it. . . . Open the first book and you will find a rhapsody about it; step into the first picture-dealer's and you will find three or four high-colored 'views' of it" (1). Teetering between expletive and anaphoric deixis—referring forward to the delayed subject of "pleasure" in writing "the word" and back to the "Venice" of the essay's title—James's "it" stresses that direct access to Venice is foreclosed. Approaching Venice now obliges veering between potentially vacant signifiers, or dredging one's way through rampant representations without respite or "interruption." And yet the double negative here, a poignantly Jamesian effect, tempers the assertion that "its" revisitation is a useless enterprise.

Identifying himself (and by extension, the reader) abjectly as a "sentimental tourist" (4)—a postlapsarian heir to the Grand Tourist, Sentimental Journeyer, and Romantic—James suggests that sentiment must now make its way through a new commercial and representational apparatus.[9] Aspiring

toward an authentic encounter with Venice as (purportedly) enjoyed by Romantics and journeyers ever more remote, the tourist "likes to be alone; to be original; to have . . . the air of making discoveries" (*IH* 45). But in Venice, authenticity of encounter or expression is undercut by the place's institution-alized state, and by the concomitant presence of other consumers who violate the sentimental tourist's would-be exile at a turnstile's pace: "The Venice of to-day is a vast museum where the little wicket that admits you is perpetually turning and creaking, and you march through the institution with a herd of fellow-gazers. There is nothing left to discover or describe."[10] James defies any nostalgic projections of his readers by foregrounding the fallen republic's commodification: "You are reminded from the moment of your arrival that Venice scarcely exists any more as a city at all; that she exists only as a bat-tered peep-show and bazaar" (*IH* 7). Readers are not poised to *discover* these modern degradations but are *reminded* of them; even lamenting the city's fall into the status of a tourist trap is banal.

These conditions ensure a crisis not only of travel, but of experience itself (in the acquisition of which the Grand Tour was once a rite of passage). In the age of Thomas Cook's packaged tours, Wagon-Lits railways, the Austrian Lloyd shipping line from Trieste, and fact-spewing Baedekers, Venice was becoming less amenable than ever to original engagement.[11] As illustrated travelogues, souvenir etchings, and daguerreotypes codify the perception of the masses descending upon late-nineteenth-century Venice, James with-draws from "informing" his compatriots about Venice. He opts instead to plot detours from what is known, documenting an uncanonical Venice bit by bit— while still insisting on highlighting, in the process, the increasingly tormented filtration and foreshortening of any "impression" the city might inspire.

James navigates a minefield of available Venetian clichés in his third essay on the city, "The Grand Canal" (1892), which begins from a strategic vantage point across the channel from the Piazza San Marco: "I am glad not to find myself studying my subject under the international arcades, or yet . . . in the solemn presence of the church. For indeed in that case . . . I should become still more confoundingly conscious of the stumbling-block that inevitably . . . crops up in the path of the lover of Venice who rashly addresses himself to expres-sion. 'Venetian life' is a mere literary convention, though it be an indispensable figure" (31). The "Modern Venice" of the spectacular basilica and cosmopoli-tan arcades is nothing but a topos reproduced for purchase in the form of "the very vulgarest rubbish in the modern market" (31). Though unencum-bered rapture about monumental Venice is out of the belated author's reach, James responds with cunning, suggesting that "half the enjoyment of Venice

is a question of dodging" (23). He chooses off-hours, or sidles up to the city's innumerable margins to offer a less hackneyed sequence of glimpses.

Any artist committed to invention would have been self-conscious about the "stumbling-block" to original expression in late-nineteenth-century Venice; and yet the fact that the city is exhausted as a subject *necessitates* formal innovation. Two years before "The Grand Canal" was published, James's compatriot James McNeill Whistler modeled a way to revitalize perception through depiction of the Piazza San Marco and its famed gateway of columns: his etching *The Piazzetta* tackled the subject by placing a "stumbling-block" at the focal point of his composition, marginalizing the church in the background (figure 2.1). Whistler, like James, frequented the expatriate art scene in Venice that gathered around the Bostonian Curtis family at the Palazzo Barbaro and around patron Katherine De Kay Bronson at the Ca' Alvise.[12] He was in Venice from 1879 to 1880 on charitable commission from the Fine Art Society to produce twelve etchings, following the bankruptcy caused by his libel case against Ruskin—who had dismissed the young painter's *Nocturne in Black and Gold* (circa 1875) as "Cockney impudence."[13] Whistler approaches the square, the artistic tradition of *vedute*, or "views," dating back to the late seventeenth century (with its heyday in the mid-eighteenth-century Venice of Canaletto and Guardi), and the medium of etching itself with similar "impudence." The artist's unanticipated fourteen-month stay in Venice led him to radical revision of the popular conventions of "views," those panoramic compositions of the cityscape aimed to provide aristocratic (and eventually middle-class) tourists with souvenirs. Through the more than fifty prints and nearly one hundred pastels generated by this visit (in addition to other works on paper and a handful of paintings), Whistler modeled a freer and more partial method of framing, in which fragments remain fragments: "If by chance I did not see the whole . . . I would not put it in," he recalled.[14] In the *Piazzetta* composition, whose resolute verticality eschews the panorama form to resemble the compositions of Japanese woodblock prints and scrolls, Whistler iconoclastically crops Saint Theodore from the column in favor of the loiterers at its base, allowing this patchily rendered foreground mass to slice and block our view of the famed, now recessed façade of St. Mark's. Furthermore, in rendering the canonical scene immediately upon the etching plate, Whistler provides no correction for its reversal in the final print. These experimental etchings and pastels produced *en plein air* give the impression of a cityscape glimpsed, whose framing is both contingent and incomplete, flaunting its own distortions. In works such as *Upright Venice, Long Lagoon*, and *Little Venice* (all 1879–80), the "extreme distance" becomes a

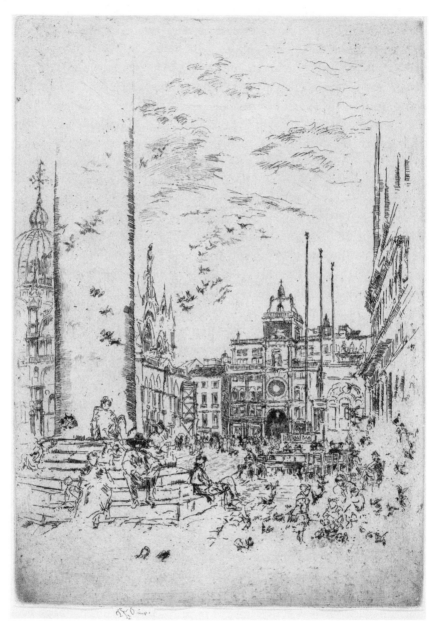

FIGURE 2.1. James McNeill Whistler, *The Piazzetta*, etching and drypoint, 1880. Gift of Mr. and Mrs. J. Watson Webb in memory of Mr. and Mrs. H. O. Havemeyer, National Gallery of Art, Washington, D.C.
Courtesy of NGA Images.

subject in itself; Whistler noted that he "would begin drawing that distance in elaborately"—a tactic that led to representation of the city by way of charged voids.[15] In other studies, the angles of minor *calli* and *campielli*, truncated and in half-light, become focal points. Whistler founds a novel and often radically abstracted Venetian iconography in the process.

The impact of Whistler's etchings on a generation of artists is made evident by an 1894 Alfred Stieglitz photograph that continues to treat Venice as an opportunity for abstraction and reorientation of a standard "view." *On the Piazza, 6 a.m.* directs the gaze away from St. Mark's Square altogether, past the truncated columns of the Piazzetta and toward the Dogana Point (figure 2.2). An anonymous personage dominates the foreground, as in Whistler's *Piazzetta*; sleeping on the base of the column of Saint Mark, the figure mars the familiar view of Santa Maria della Salute and the customs house across the canal. Addressing the obstacles to representing Venice in "The Grand Canal," and dodging the quotation marks around "Venetian life" (the title of a recent book by William Dean Howells),[16] James, too, shifts our

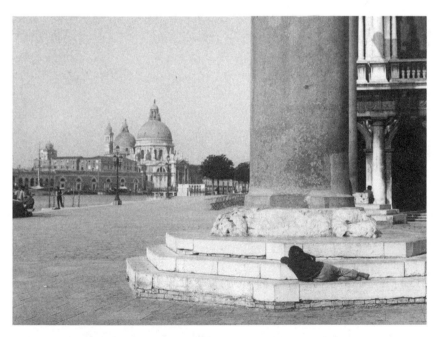

FIGURE 2.2. Alfred Stieglitz, *On the Piazza, 6 a.m.*, 1894, platinum print, 1895/1896 sheet (trimmed to image). National Gallery of Art, Washington, D.C., Alfred Stieglitz Collection.
Courtesy of the National Gallery of Art, Washington D.C.

attention to the margins of Venice. Turning his back on the city's only unob-
structed square, James faces the Dogana Point, with its rotating weathercock
of Fortune, and its aperture onto the Adriatic. (Pound will anchor the "I" of
his *Cantos* at the same perspectival rift.)

We must assume that James saw Whistler's Venetian etchings and pastels
exhibited in adjoining shows at the Fine Art Society while in London in the
winter of 1880–81, for they were well publicized, inspiring some to qualified
praise for their production of a "tangible Venice," and others to disparage-
ment.[17] A satire of the exhibition in *Punch* replete with caricatured reproduc-
tions of select works intuited Whistler's resistance to the commodification
of Venice, declaring that the artist as "Artful Doger" "may have conceived of
a violent animosity to Mr. Cook, and . . . hit upon this method of deterring
intending tourists from visiting the 'Pride of the Sea.'"[18] James had already
written about Whistler, expressing admiration for his etchings, and about the
notorious dispute with Ruskin in essays of 1878 and 1879[19]; his first extended
stay in Venice took place shortly thereafter, in June 1881. It is possible to
track James's warming to Whistler's "experiments" in the wake of this visit to
Venice through his art criticism.[20] In James's "Venice" essay and subsequent
prose, we witness parallel aesthetic tactics of cropping, foreshortening, and a
focus on minor subjects and voids—for the writer faces the same challenge of
artfully dodging the clichés of mimetic representation in this "vast museum."
It will be through fiction, however, that James ultimately overcomes the
impasse of representing Venice. In the tales and novels that he anchors in
Venice, an archipelagic structure of discontinuity emerges, wherein dramatic
manipulation of the view and knowledge of the past becomes both a theme
and a compositional strategy.

James ultimately embraces the discontinuities of experience that are ren-
dered spatially eloquent in the archipelago of Venice—in implicit rebuke to
the sense of "criminal continuity" with other places and times that modern
transport, by bridging lagoons with rail and introducing steamboats for tour-
ists to "rush about Venice as furiously as people rush about New York," can
forge.[21] From the Dogana promontory, James invites us "to look down the
great throat . . . of Venice" (32–33), or, in a modification of metaphors, to
traverse the "undulating serpent" of the Grand Canal, so much less accom-
modating to survey than any boulevard (37). The trajectory of "The Grand
Canal" suggests that one must broach the city of channels by veering con-
tinually, as if on water, marking along the way "a hundred component 'bits,'
with the baffled sketcher's sense" (37). Inverting the trend of contemporary
guidebooks, which had begun to present the city's spectacles within walking

itineraries designed for middle-class travelers,[22] James pieces together impressions, composing a "devious discourse" (45) by accretion.

The "sentimental tourist" ultimately arrives at a mordant awareness that he is destined to approach the place from a belated and estranged position—even while leaning against the marbles of St. Mark's. He can only hope to sidle up to the Venetian heritage and fleetingly to "taste" its difference through a distressed effort of aesthetic transport. This is, however, a characteristically Venetian experience, insofar as the Venetian archipelago, amalgam of islands and styles divided from one another by "that steady, liquid lapse" of lagoon waters,[23] dramatizes the condition of being united in difference. James's installments in *Italian Hours* are in fact too interested in the process of translation to claim an immediate rapport with the Italian past—particularly with that of Venice, which he singles out in "The Grand Canal" as the place in which the present is most "alien" and "discontinuous":

> Venetian life, in the large old sense, has long since come to an end, and the essential present character of the most melancholy of cities resides simply in its being the most beautiful of tombs. . . . Nowhere else is the present so alien, so discontinuous, so like a crowd in a cemetery without garlands for the graves. It has no flowers in its hands, but, as a compensation perhaps . . . it has money and little red books. . . . Everything else is only a reverberation of that. The vast mausoleum has a turnstile at the door, and a functionary in a shabby uniform lets you in, as per tariff, to see how dead it is. (31–32)

This passage charts an undeniable gulf between past and present—one bridged by money and Baedekers. Not only does it claim that Venice is long ruined; it distances itself from the urgent elegies of Wordsworth, Byron, and Ruskin by claiming that Venetian decadence has itself already been commodified. The distinction between authentic traveler and common tourist is thereby quashed by this topos—but not as tragically as we might think. As a participant-observer complicit in the spectacle,[24] James follows this passage with the not wholly ironical conclusion that "[f]rom this *constatation*, this cold curiosity, proceed all the industry, the prosperity, the vitality of the place" (76). Against the "industry" of the spectacle, the very discontinuity of the present with the Venetian past provides the grounds for the shocks of experiencing history, though those shocks will hardly be "immediate" (as the Romantically derived German term for experience, *Erlebnis*, which was in common use by the 1870s, suggests).[25] Constatation of the Venetian scene as it actually is enables

the renewal of perception: the vitality of James's travel essays consists, increasingly, in their pursuit of glimpses of "Venetian life" through the fissures in its elaborate mediation. His writings suggest that an embodied experience of Venice over time can vie with the reified city-as-spectacle.

James's sentimental tourist haunts the still-sumptuous vestiges of a Grand Tour rendered bland, working through the dialectic between historical belatedness and sensuous feeling for the past. Both sentiment and tourism come prepackaged in Venice, but the friction between overdetermining information and the recollected experience of urban textures yields a defamiliarizing sense of the past that is at once reanimating and threatening. Amid myriad assertions of foreclosure from being able to say anything about Venice, James's travelogues carve out discursive routes that admit to their derivation and even balk at the expectation of "discovery" in travel; for being barred from discovery also relieves the author of the burdens of mimetic representation and the dispersal of information about what he finds: "I write these lines with the full consciousness of having no information whatever to offer. I do not pretend to enlighten the reader; I pretend only to give a fillip to his memory" (1). Coming late as an author allows him to bypass the chronicling of Enlightenment historiography, the traveler's exposure of exotic novelty, or the art critic's corroboration of the Venetian artistic canon. It enables him to concentrate instead on representing the reverberating presence of history through an accretion of strategically filtered and framed perspectives, wherein seeing is akin to selection, or editing.[26] James mobilizes the past that he sensed in 1869 as "a cold and foreign mass" by staging the interference of received history by the more elusive matter of a still-unrecorded past—a Venetian history "mixed with its air," "unwritten," but "ineffaceable" (IH 76).

From the first, James's Venetian travel writings assume a digressive temporal as well as spatial structure, as if describing Venice entailed crossing between periods of "impressions" already historicized—both those of others and one's own. The earliest essay, "Venice: An Early Impression" (1872), already situates the author as a latecomer to his own perspectives, forced to account for the passage of time between his first two trips, though he finds in approaching the city that "the attendant sensations bore repetition remarkably well" (53). The friction between outlooks produced at different historical moments will be supplemented by additional returns in later pieces, which manifest a distracting attention to the intervening intervals. In fact, "impression" becomes too light a term for the historical consciousness that beleaguers and thickens these writings. James's Venetian essays suggest that impressions can no longer be immediate; seeing this most represented of sites imbues an author with a

stultifying awareness of the history of inscription. The "impression" in James's writing is always riddlingly historicized; John Carlos Rowe argues that it is "both material and immaterial . . . fleeting moment and enduring mark," or "divided present and rhetorical catachresis."[27] Venice exacerbates these schisms inherent in literary registration of the impression—but ultimately calls for a less binary, more mobile understanding of past and passing time. Shirking the antimony between the fleeting and the enduring, Venice as an urban composition models what James's brother called "*duration*." In Venice, "the practically cognized present" manifests a temporal breadth that William James argued for in 1890: here, our perception of time must be equipped with "a bow and a stern . . . —a rearward- and a forward-looking end."[28]

VENICE AS BACKGROUND, AMBIT, AMBIENCE: DESTABILIZING ENVIRONS IN WHARTON, PATER, AND JAMES

James's turn away from depiction of Venice's most eulogized sights in favor of scenes normally reduced to the status of "background" was not altogether unique; James participates in a larger documentary impulse to depict the popular margins of the Venetian cityscape. This impulse was bolstered by the rising taste for local color and had been adopted increasingly by foreign artists of the picturesque upon the build-up of the 1848 revolutions, when the English began to take the Venetian side in the conflict against the Austrian Empire. The trend persists through the focus on "minor" corners of Venice in the more starkly abstract depictions of Whistler, John Singer Sargent, and their followers. The tendency of James's writings to depict and aestheticize background phenomena finds its closest literary corollary in the prose of Edith Wharton, whose *Italian Backgrounds* (1905) reflects the interest in representing the margins of Italian society while paradoxically figuring the country itself as a painting or illuminated manuscript: "Italy, to her real lovers, is like a great illuminated book, with here and there a glorious full-page picture, and between these, page after page of delicately pencilled margins, wherein every detail of her daily life may be traced."[29] Responding to the banalization of canonical Italian artworks in the age of mass tourism, Wharton calls for a shift in focus from pictorial figure to ground: "The foreground is the property of the guide-book and of its product, the mechanical sight-seer; the background, that of the dawdler, the dreamer and the serious student of Italy," she argues outright, as the exhaustively represented foreground figures "have stiffened into symbols. . . .

Since they cannot be evaded they must be deconventionalized; and to effect
this they must be considered in relation to the life of which they are merely the
ornamental façade. . . . [I]n some cases the background is the continuation, the
amplification, of the central 'subject'; in others, its direct antithesis."[30] Venice
is a key site for Wharton because the painters of the Republic devoted them-
selves so zealously to the unceremonious incidents surrounding sacred and
classical contexts. She celebrates Carpaccio and Bellini for their appropriation
of exalted pictorial themes as opportunities to depict contemporary landscape
and life in the archipelago, rendered vibrant by contrast with religious motifs.
The disenchanted Grand Tourists of Wharton's 1902 historical novel *The Val-
ley of Decision* tend to reduce the Venetian background to an aesthetic surface
or instrument, however, venturing that "Venetian customs almost appeared
to have been devised for the convenience of strangers."[31] After praising this
novel, and as he was having Scribner's forward to Wharton the manuscript
of *The Wings of the Dove*, James offers an implicit critique of this reductive
tendency as he urges his correspondent to shift her attention to the less pic-
turesque, and less textually fatigued, "*American Subject* . . . round you . . . the
immediate, the real, the ours, the yours." Familiarity would lead Wharton to
a more dynamic relationship with her local subject: "Take hold of it and keep
hold, and let it pull you where it will."[32]

Whereas Wharton's documentary realism tends to domesticate minor
phenomena as backdrop through mimetic description, James's engagement
with the nonmonumental "ground" of Venice comes to exceed this impulse
of the picturesque aesthetic. In the late style consummated in *The Wings of the
Dove*, James develops an epistemology based on the reciprocal "pull" between
subjects and ambience. This leads his contemporaries to objections: in a 1903
discussion of *Wings*, William Dean Howells ventriloquizes a reader's com-
plaint that James's personages are one with the background—"merged in the
background so that you never can get behind them, and fairly feel and see
them all round."[33] We can see harbingers of this elision of figures and grounds
in Whistler's etchings, which obscure lines to generate atmospheric densities
as if in spite of their medium. The contours of Whistler's architecture dissolve
in pulled smears of ink; viewed only as glimpses, patches, and absences, his
palaces become ghostly participants in an all-over nocturne (figure 2.3).

The relationship between figures and grounds in James's work can be com-
pared more productively to a form of reciprocal interference. Against Whar-
ton's contrast, James observes a phenomenal *mutuality* between figures and
grounds in Venice, akin to what Pater identified in Venetian painting as "that
modulated unison of landscape and persons . . . characteristic of the Venetian

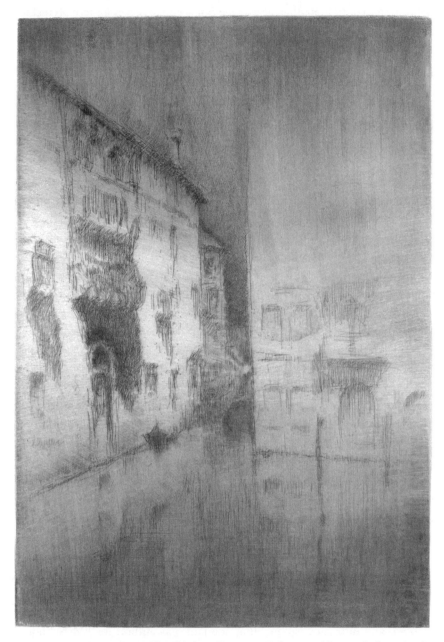

FIGURE 2.3. James McNeill Whistler, *Nocturne: Palaces*, etching and drypoint in brownish-black ink, 1879/1880. National Gallery of Art, Washington, D.C., Rosenwald Collection.
Courtesy of NGA Images.

school, so that, in it, neither personage nor scenery is ever a mere pretext for the other."[34] James notes in the 1882 "Venice" that pictures by the Venetian masters within their home city are "so much an extension and adjunct of the spreading actual, that it seems almost invidious to say one owes more to one of them than to the other": "Nowhere . . . do art and life seem so interfused and, as it were, so consanguineous. . . . That is the perpetual interest of the place—that you live in a certain sort of knowledge as in a rosy cloud"(*IH* 19). In a place that confounds the difference between art and life, seer and seen ("All Venice was both model and painter" [19]), knowledge itself becomes ambient. At the Dogana Point, the Jamesian tourist beholds palaces that "share fully in that universal privilege of Venetian objects which consists of being both the picture and the point of view"; but this reciprocity proves unsettling, for the "double character" of these object/subjects "adds a difficulty to any control of one's notes" (34). At the same time, James's compulsion to historicize anchors both his impressions and his aestheticism: "There is no happy mean . . . between the sense and the quest of the picture, and the surrender to it, and the sense and the quest of the constitution, the inner springs of the subject—springs and connections social, economic, historic."[35]

James's engagement with the "real" eventually draws away from the depiction of marginal figures as charming primitives, still operative in "Venice: An Early Impression," to focus on the more abstract ambient forces of a temperamental site that refuses to be still for any gaze, but instead alters "according to the weather or the hour" (6). He will explore the impact of a weathering, engulfing, and even corrosive environment on the subject—and its author. His writings on the Venetian scene expose vision's status as supremely contingent, dependent upon flukes of *tempo*, temperament, and social standing; vision in Venice and its close correlative, blind(ed)ness, are paratactically narrative in kind. James's novels will turn from "depiction" of Venice to address the city's motions through time: "As the picture is reality, so the novel is history."[36] This incorporation of *tempo* (time; weather; rhythm) into perception looks back to Pater and toward modernism.

The amplified attention to *tempo* in late-nineteenth-century writings on Venetian art distinguishes an additional reason why Venice was so compelling, and ultimately so enabling, for James as author. In "The School of Giorgione" (1877), Walter Pater defines Venice's early modern influence on aesthetics through its *unmooring* of aesthetic spirit from any stable, traceable artifact. Departing from dominant trends of antiquarianism concerned with establishing the authenticity of Giorgione paintings (as well as Ruskin's nostalgic efforts to salvage the contours of Giorgione's frescoes [figure 2.4]

FIGURE 2.4/PLATE D. Giorgione, *Nude*, fresco detached from the façade of the Fondaco dei Tedeschi (detail), 1508. Gallerie dell'Accademia, Venice.
Courtesy of Polo Museale di Venezia.

through engraving in the 1860 *Modern Painters*, volume V), Pater rereads Giorgione—and Venice itself—as inherently transitory phenomena. For the aesthetic philosopher, Giorgione's distinction consists in his invention of genre paintings: "those easily movable pictures which serve neither for uses of devotion, nor of allegorical or historic teaching" but which instead constitute climates of color, detached from the wall, "to enrich the air as with some choice aroma, and . . . live with us, for a day or a lifetime."[37] Pater locates the value of these Venetian artworks precisely in their depiction of "instantaneous motion" and in their inability to be transfixed. This leads him to a new, fluid conception of art-historical "influence":

> [O]ver and above the real Giorgione and his authentic extant works, there remains the *Giorgionesque* also—an influence, a spirit or type in art, active in men so different as those to whom many of his supposed works are really assignable. A veritable school . . . grew together out of all those fascinating works rightly or wrongly attributed to him; out of many copies from, or variations on him, by unknown or uncertain workmen, . . . out of many traditions of subject and treatment, which really descend from him to our own time, and by retracing which we fill out the original image. Giorgione thus becomes a sort of impersonation of Venice itself, its projected reflex or ideal. . . . (*The Renaissance* 116–17)

The "projected reflex or ideal" of Venice embodied by Giorgione's work recasts Venetian aesthetics as subject to drift: the product of recollection and transmission, from copy to copy or variation to variation. The flickering of "*il fuoco Giorgionesco*" ("the Giorgionesque fire" [118], a phrase Pater borrows from Vasari, and which will resurface in D'Annunzio's prose) suffuses the work of many artists and amalgamates them as a "school" with a vagrant character—or as the Italian term *ambito* suggests, an "ambit" or environment.[38] The artist and the city he personifies both assume an unseizable ambient condition.

James's title for *The Wings of the Dove* invites interpretation as oblique homage to Pater: it echoes the epigraph to *The Renaissance*, a fragment of Psalm 68 linking mortal passage and aesthetic transfixion: "Though ye have lain among the pots, *Yet shall ye be as the wings of a dove*, covered with silver, and her feathers with yellow gold."[39] While Pater continues to cherish Giorgione's compositions as "exquisite pauses in time," however, James's prose stresses that this pause is never total; the effects of history never cease to inflect the pictured present. Each moment occupies a depth of duration,

as in the "*durée*" of Henri Bergson and "stream" of William James; each narrated instant harbors a lingering sense of pastness and a foretaste of what is to come.[40] James's sense of the aesthetic mobility exemplified by Venice resists the reification of Venetian images, as well as the compulsion of the modern representational apparatus to rob this imagery of memory accruing over time. The slow weathering and decay of Venice makes of even its most humble waterway a "*promenade historique*" (37), expressing the continuity of consciousness in duration.

It is thus the redundancy of habit, not the adventurer's novelty or the historian's escalating "knowingness,"[41] which distinguishes the Jamesian experience of Venice from an abundance of more edifying accounts. Ruskin and Gautier have already described St. Mark's; having cited these predecessors, James is freed to dwell instead on the experience available "after you have been in Venice a couple of months . . . and you pass in under the pictured porticoes with a feeling of habit and friendliness and a desire for something cool and dark" (10). Felt recognitions take the place of discoveries, infusing the travelogue with a revised, physicalized "sense" of the past, redefining experience against any disembodied Cartesian paradigm. The irrepressible lagoon atmosphere interposes itself into the view of an eye abashed, embarrassed into its own corporeality. As early as "Venice: An Early Impression," James declares that the Venetian atmosphere responds to the beholder by "holding" in a strangely literal way: "Everything the attention touches holds it, keeps playing with it—thanks to some inscrutable flattery of the atmosphere. . . . You should see in places the material with which it deals—slimy brick, marble battered and befouled, rags, dirt, decay. Sea and sky seem to . . . blend their tones into . . . a lustrous compound of wave and cloud and a hundred nameless local reflections, and then to fling the clear tissue against every object of vision" (54). The Venetian atmosphere constitutes a luminous tissue assailing the eye with reflections so susceptible to change as to resist any contour or name. A consequent inability or refusal to catalogue Venice's contents drives James to aesthetic inquiries based on tactilities and habits rather than "views." His unlikely account of the art in this most viewed of cities starts out from the forbidding premise that while its masterpieces have been reproduced globally, it is practically impossible to see in person: snaking channels, grime, dark angles, and intemperate weather foil the outsider's "practiced, groping gaze" (*IH* 70). His writings affirm, in fact, that one rarely *sees* the works of Tintoretto: "in the great majority of cases your eyes fail to deal with him. . . . [S]o many of his works have turned to blackness" (21). Compromising conditions encroach upon would-be beholders, literalizing the limits of their vision: "You stand at

tip-toe on a three-legged stool, you climb a rickety ladder. . . . You do every-
thing but see the picture" (21). Those who wish to penetrate shifty Venetian
spaces visually are thwarted. Viewers' gazes rebound so that they are faced
instead with their own projections and predispositions, echoed and thereby
estranged—while the city, suffused with agency, vies with the hypostatized
"Venice" that would pose as object of the tourist's gaze.[42]

James's "Venice" oscillates between characterizations of Venetian space as
abject object of an invasive, if pathetic, foreign eye and as a sentient being
(though both poles remain unapologetically feminized). The "trooping bar-
barians" treat sites such as St. Mark's "as an orifice in the peep-show" (10);
but James's aesthetic comportment yields a gestural exchange between per-
ceiver and perceived over time. "Beauty of surface, of tone, of detail, of things
near enough to touch and kneel upon and lean against" (11) are on offer in
Venice, but visitors must make themselves vulnerable to Venice's touch as
well: "The only way to care for Venice . . . is to give her a chance to touch
you often" (4). This marriage or frisson between art and ambient life is less
comforting than it seems. James stylistically dramatizes the disorientation of
the eye by eddies of these living surroundings: Venice works on its gazers
rather than vice versa. Surrendering to Venetian conditions entails unfore-
seen changes in the tourist's habits, both commercial and corporeal: "you
wonder if you can accommodate yourself to the peculiar conditions. Your
old habits become impracticable and you find yourself obliged to form new
ones of an undesirable and unprofitable character. . . . You are obstructed and
encaged; your desire for space is unsatisfied . . . you have come to regard your
gondola as a sort of magnified baby's cradle. You have no desire to be rocked
to sleep" (5). Venetian transport infantilizes and discomposes the tourist by
way of envelopment. Transport by gondola grants the greatest sense of actual
participation in the Venetian scene while "the darkness and the plash, the
indistinguishable swerves and twists, all the things you don't see and all the
things you do feel" threaten the traveling I's equipoise and the author's ability
to compose.[43] At times enduring in this city of water is like being returned to
the womb—a regression, a suffocation. Such dislocations remind us that the
word *experience* harbors the Latin for *peril*.

James's novels dramatize capitulation to this atmosphere of flux. In *The
Princess Casamassima* (1886), Hyacinth Robinson, inspired by the beauty of
Venice to relinquish his revolutionary ideals, also reveals an anxiety about
being flooded by these environs. Hyacinth's letter to the princess from Ven-
ice describes the picturesquely impoverished local population, finding charm
in the ovals of their underfed faces and, in the "limp folds" of their cheap

clothing, "the same delightful line that everything else in Italy makes."[44] Yet ensconced within these "revelation[s] of the exquisite" is a threat to Cartesian perception or design, as the lapsed revolutionary fears being "spitted" by the heat, and overcome by the ambient flood: dampening the floor of his room to cool the torrid air, he observes, "if I keep on sprinkling, I shall be able to swim about; the green shutters are closed, and the place makes a very good tank."[45] He is ensconced in so dense an atmosphere that it resembles an immense fish tank in which all are trapped—a figure that will recur in representation of the (vaguely leprous) Palazzo Leporelli in *The Wings of the Dove*. In representing Venice, James turns increasingly to the effects of atmosphere upon onlookers unable to aestheticize or even to visualize their surroundings.

"Sentimental tourism" emerges as an implicitly dialectical mode of experiencing Venice, encompassing the struggle against the city's mediation by representation and tourism, and the effort to achieve an empathic, embodied relation to it as environment. The imbrication of knowledge and somatic experience can resist the mortifying effect of information: in the words of Adorno, "It is the somatic element's survival, in knowledge, as the unrest that makes knowledge move."[46] If romantic travel to Venice has been rendered obsolete, James's writing shows that the city nevertheless remains an animate force of estrangement; within the non-neutral lagoon ambience, his visitor is dislodged from the conventions of visual comprehension. Challenging the standard figure/ground hierarchy of depiction, James presages a shift in twentieth-century aesthetics toward the activation of apparently negative space. Like the eye that sought out the only apparently blind, luminous alley of Sargent's *Venice* (figure 2.5), James's ambulatory perception circulates with keen awareness of its infringement by spatiotemporal circumstance, reaching for—and illuminating—those things it is unable to see.[47]

IMPENETRABLE ROMANCE AND TRIVIAL MODERNISM IN THE ASPERN PAPERS

What becomes of historical experience when it is no longer topical, but instead insinuated into the syntax and figurative domain of James's fiction? Haunted, habitually touched, the past encroaches upon the subject as it is approached: Jamesian experience is this palpable negative dialectic between the subject and its historicity. James comes to theorize such encroachments of consciousness in a more rigorous fashion than the travelogues allow in his prefaces to the New York Edition. In several of these prefaces, the retrospective

FIGURE 2.5/PLATE E. John Singer Sargent, *Venice*, watercolor and graphite on woven paper, 1880–82. Metropolitan Museum of Art, New York.
Courtesy of Images for Academic Publishing.

recognition of Venice's impact on his writing process thickens the herme-neutic field, presenting palimpsestic scenes of composition and interpreta-tion. A celebrated passage from the preface to *The Aspern Papers*, James's first long work of fiction set in Venice, expresses the delight in reaching an ever-distanced past through the amalgamated senses: not sight, but touch, smell, hearing, and taste. "I delight in a palpable imaginable *visitable* past—in the nearer distances and the clearer mysteries, the marks and signs of a world we may reach over to as by making a long arm we grasp an object at the other end of our own table. . . . That, to my imagination, is the past fragrant of all, or of almost all, the poetry of the thing outlived and lost and gone, and yet in which the precious element of closeness, telling so of connexions but tasting so of differences, remains appreciable" (*Aspern Papers* 31).

The past is distant, but brought to a "nearer distance"; Venice is still mys-terious, but rendered one of the "clearer mysteries" by this act of grasping across a common horizontal plane. James's domestic metaphor of a table in this passage bespeaks an imagined intimacy, if not a seamless reunion, with the fragrant object of the past, even as tasting at this table makes its differences from our moment poignant.

James immediately contrasts such experiences with the impasse of visual perception—an impasse already signaled by Alvin Coburn's photograph commissioned for the frontispiece to the New York Edition, bearing the caption "Juliana's Court" (figure 2.6). Conjuring the image of a walled garden—apt, as the novella's protagonist uses Juliana Bordereau's garden as a lame pretext to get close to her dead lover's papers—James asserts that as one peers into adjacent gardens, "the view is mainly a view of barriers" (31).

FIGURE 2.6. Alvin Langdon Coburn, frontispiece to the New York Edition of *The Aspern Papers*, with the caption "Juliana's Court," photograph, 1908.

The frontispiece thrusts forward a paltry potted "garden" as barrier before the doorway and balcony to Juliana's chambers, further impeding our access through its oblique angle of approach. Rather than championing the achievement of a "coherent" view, James posits that "with more moves back the element of the appreciable shrinks" (31). With this claim he directly counters the synthetic mode of viewership described by Ruskin in *Stones of Venice*, which commends one to back up from an object in order to appreciate the "mystic whole" of which it is part. James's foreclosure from any accessible spiritual, or even merely visible, unity spurs his turn from optical synthesis to perceptual ramification, which also obliges the perceiver's motion across both space and time. James reports in his autobiography that he was subject to a type of vision laden with an intimate history—that he suffered from the "drawback" of "seeing the whole content of memory and affection in each enacted and recovered moment."[48] The visible draws him inexorably back to a nexus of memories that impinge upon the image in time. In the *Aspern* preface, James draws attention to, rather than drawing away, the veils of memory that separate him from the sight of his own written and imagined Venices: "[I]t is at any rate, fairly in too thick and rich a retrospect, that I see my old Venice of *The Aspern Papers*, that I see the still earlier one of Jeffrey Aspern himself, and that I see even the comparatively recent Florence that was to drop into my ear the solicitation of these things" (28). In reworking experience as a traversal of overlapping histories, James will acknowledge and then press beyond the mediation of Romantic literature. This preface distinguishes the multiple threads of the fictive narrator's quest for an authentic relation to the past—the same quest thrown into question by his travel essays.

Recollecting the germ of the story, James characterizes his position as author as that of a "navigator" whose "fine unrest" had led him to a marvelous Romantic situation. James fashions himself retrospectively as an inverse Columbus: translator of the Old World who discovers that Jane Clairmont—Mary Godwin's half-sister, Shelley's other wife, and Byron's lover—has recently died in Florence after many years of expatriation there, having thereby "overlapped" (27). James leaves the object of this graphic verb intriguingly unspecified—but insinuates that the overlapping is temporal and cultural. Like any explorer, the author delights in the "long uninterviewed and uninvaded state" of Jane, who is translated into his fiction as "a surviving unexploited unparagraphed Juliana" (31)—the dream of unmediated romance. James's first-person narrator relishes, in turn, the thought of an

unarchived (romantic) relation to Romanticism, in the form of the fictional Aspern's papers, to publish and consume. His quest additionally echoes the more remote romance of Shakespeare's "not far off" Verona (recalled, with a difference, by the fictional Jane Clairmont's name, "Juliana"—though the only incongruous correlative to Juliet in this tale would be the spinster Tina) (80). James's protagonist travels to this paradigmatic region of romance in search of a corpus, however, not corporeal passion; the story's Venetian setting is thoroughly mediated by Romantic text, so that all "romance" that emerges within it is double-valenced, referring to both emotional involvement and a literary-historical epoch. The American publisher's pursuit of the Aspern papers tragicomically dramatizes the tourist-artist's desire for an unmediated relation to the Venetian past—now conflated ironically with the desire for a direct link to its Romantic literary mediation.

In the contemporary scenario of *The Aspern Papers*, the "author," taking the form of James's anonymous narrator, has been definitively demoted to the position of a vampiric editor. The narrator attempts to exploit Venice as a mere instrument for the recovery of text. On the fraudulent surface of his quest for these Romantic "spoils," he seeks in the Bordereau home the sort of romantic garden James eulogizes in his travel essays as he digresses from the canonical Venice haunted by the genius of Ruskin, praising the city's modest yard gardens as "reminders, amid so much artifice, of the woodland nature of man" (*IH* 44). Indeed, such bits of greenery constitute those few spots in Venice where his latecoming critic might be able to dwell in subjective reflection unencumbered by the archive. James himself, far from seeking (as Ruskin had) to "strip the Romantic décor away" (*Works* 10:8), relished St. Mark's from a historical remove as "an immense piece of Romanticism," "entrancing you with its remoteness, its picturesqueness and its chiaroscuro" (*LPB* 70). As an author at the other end of the Romantic century, James is willing to underscore the recession of both Venice and Romanticism into remote history—and then to cast them into the current moment of calculation as such.[49] The *Aspern* preface recounts that he savored the unlikely appearance of the Romantic mistress in his epoch as "a final scene of the rich dim Shelley drama played out in the very theatre of our own 'modernity'" (30–31). In rendering the nonfictive "overlap" into a novella, James aims to sidle up to the Romantic poet's extension into contemporary life and "convert so the stretched relation into a value of nearness" (31). But he will not disavow the distance between a Venice past, an almost thoroughly archived Romanticism, and a present grappling with both.

"[T]he days of long voyages and sharp differences" to which Miss Bordereau seems to belong feed our anonymous narrator's fantasies of the premodern period: "When Americans went abroad in 1820 there was something romantic, almost heroic in it, as compared with the perpetual ferryings of the present hour, the hour at which photography and other conveniences have annihilated surprise" (77). Bordereau and her lover had been unbelated and singular, "had lived in the days before the general transfusion"; and therefore, as a poet, his fictive American Byron "had found means to live and write like one of the first; to be free and general and not at all afraid; to feel, understand, and express everything" (78). Aspern's mistress has managed to safeguard this shared authenticity, in spite of the culture industry's efforts to publicize such histories as hers, by absconding in a city of more blatant romantic spectacles: "it was a revelation to us that it was possible to keep so quiet as that in the latter half of the nineteenth century—the age of newspapers and telegrams and photographs and interviewers" (48). She and her niece live in the tourism capital "unvisited, unapproachable" (45).

The mere thought of the "sacred relics" of romantic correspondence that the narrator-editor imagines Miss Bordereau possesses mends the discontinuities of his own inauthentic existence by linking it to James's fictive Romantic: the literary fetishes "made my life continuous, in a fashion, with the illustrious life they had touched at the other end" (73–74). But although the abject protagonist of the revised story holds Juliana "too sacred for trivial modernisms" (91), his post-Romantic lust for this mistress's past is definitively modern; it will only be sated by unadulterated information. The enterprising researcher views Aspern's lover as a singular living font of information: "whereas among all these . . . other directions of research we had to deal with phantoms and dust, the mere echoes of echoes, the one living source of information that had lingered on into our time had been unheeded by us" (48). The tale renders Romantic "overlap" with the present less as conviviality in time than as a spatial joke: to reach the garden from his apartments, he must pass through a great empty hall connected to the Bordereau quarters. He counts on this corridor as his point of access to Juliana's information, though her death promises to offer a better opportunity for penetrating her bedchamber and "drawers" for the papers. Twinges of her demise generate an "emotion" (82) in him perfectly commercial in kind.

The publisher will prove incapable of encounter with an unmediated past, for he can only experience the Romantic personage within the terms of his own epoch: he regards Aspern strictly through visual and commercial channels. He visually assails the Bordereau household the day after arriving

in Venice for signs: "I besieged it with my eyes while I considered my plan of campaign. Jeffrey Aspern had never been in it that I knew of; but some note of his voice seemed to abide there by a roundabout implication, a faint reverberation" (46). Even if what he really desires is the poetry of the past expressed in Romantic terms, which privilege hearing over sight (the "implication" and "reverberation" of Aspern's voice), this literary historian only knows how to possess the past as visual seizure. A more corporeal yearning for Aspern is buried within the protagonist's craving "to look into a single pair of eyes into which his had looked," however—a longing to touch the poet through his lover's touch, "to feel a transmitted contact in any aged hand that his had touched" (48). We intuit that the transmission of Aspern's body through another bears more erotic charge than direct contact would; the narrator's desire for another man requires the divestiture of corporeality from the past, in ironic contrast to James's own insistence on the past's palpability. But touching Juliana (as opposed to the more contemporary Miss Tina) in any sense proves impossible within the scope of the tale, for the critic decides that shaking her hand would constitute a "trivial modernis[m]." Moreover, the ex-mistress adopts purely economic terms for their rapport as soon as she realizes that her shabby, out-of-the-way palace can be marketed to tourists in search of the Venetian picturesque.[50] The narrator despairs to realize that the "vision of pecuniary profit was most what drew out the divine Juliana" (92), but has to acknowledge that his propositions were bound to corrupt her: "I had descended on her one day and taught her to calculate," and "she had been intensely converted" (105). One cannot touch the past, he finds, without contaminating it. Furthermore, the past will return one's gestures with a vengeance, like Juliana does, "to show how she could overreach people who attempted to overreach her" (72). Once the liquid "border" of Aspern's lover is violated by imbrication with contemporary attitudes, interference ensues from both sides.

Venice provides the setting *par excellence* for such conclusions. In shifting Aspern's corpus away from Florence, the home of Byron's actual mistress, James moves from a locus whose signature style generated during the Renaissance is governed by rational linearity and abstract intellection—and which, as an inland city, is sealed off from outside interference by the Apennine hills—to a city and style of fluid borders, associated with the sensuous. Juliana's surname, "Border"-"*eau*," recalls the port of entry into Venice used before the railway bridge to Mestre was built in 1846: the unjoined columns at the Piazzetta, or *molo*, which mark the threshold from city to lagoon gatelessly like "lintels of a door no longer guarded" (79). Yet Juliana's apparently

permeable "border" proves as impenetrable as Venice itself, because water functions here as both link and obstruction.

James's Venice also confounds the seeming oppositions of inside and outside, actuality and semblance. His narrator's most sustained description of the Venetian cityscape within the tale expresses this duality. Upon returning from his exile in the lagoon spurred by Tina's undesired proposal of marriage, the distressed tenant declares that Venice seems as intimate as "an immense collective apartment" (140). Yet he pursues this characterization with the clashing assertion that "somehow the splendid common domicile, familiar, domestic and resonant, also resembles a theatre. . . . As you sit in your gondola the footways that in certain parts edge the canals assume to the eye the importance of a stage, meeting it at the same angle"—presenting a Venice thoroughly public, spectacular, removed, foreshortened.[51]

The blockage between the Romantic past and its would-be publisher gets played out in a gothic visual impasse that directly aligns Miss Bordereau with her adopted city. The expatriated inhabitant of the Carnival capital is perpetually masked: a "baffling green shade continued to cover her attitude."[52] The narrator constantly refers to her "attitude" instead of her face—to the untransfixable effect she produces in him rather than her irretrievable countenance. He also continually marks her piercing, though unseen, gaze: he *feels* her "look at me with great penetration" (61); she "remained impenetrable and her attitude worried me by suggesting that she had a fuller vision of me than I had of her" (62). He laments, "I look at you but don't see you," and Juliana returns, "I want to watch you—I want to watch you!" (112), her modification of his verb implying a desire for surveillance drawn out menacingly over time. Tina insinuates that the old mistress is blind by asking, "Do you think she can *see*?" (115), but Juliana's physical condition is beside the point; the very *suggestion* of her visual faculty imperils her seeker. The ultimate sight of her remarkable naked eyes is less a vision on our narrator's part than a penetration of him. At the novella's end, the seizure of the Romantic poet's countenance marks nothing but an impasse of knowledge. The image of Aspern painted by Juliana's father will hang above the narrator's writing table, but this synthetic appearance, however costly a commodity, resonates as a shallow souvenir of the Romantic; the narrator continues to crave the text of the past, which remains in ashes, destroyed by Tina out of vengeance or protection. In viewing the portrait, he encounters poetry's lack. The critic's chagrin stems from the loss of the sentimental and historical content produced by Jeffrey's own "hand," as inscribed in the papers. The narrator's disappointed iconoclasm shirks the satisfactions of modern tourism based on visual consumption.

The 1888 edition of the story closes with the words, "When I look at it [the portrait] my chagrin at the loss of the letters becomes almost intolerable." Twenty years later, in the thick retrospect of the New York Edition—having incorporated the temporality of belatedness into his narration—James constructs a recursive syntax for the final sentence. The revision mimics the fruitless backward glance, while underscoring the predominance of paper over embodied correspondence in his pursuit of the past: "When I look at it I can scarcely bear my loss—I mean of the precious papers" (142). The "loss" gapes in the sentence's present tense, its referent open to interpretation—until the narrator quickly returns to qualify that what he craves is text, mediation.

For the novelist, if only partially for his fictive literary historian and "publishing scoundrel," aesthetic permission lies within the multiple removes between ourselves and the past. In his preface, James describes Jane Clairmont's case as possessing "the air of the past" in just the right degree: "when the region over which it hangs is far enough away without being too far" (31). Its "region" must lie at some distance, because a past rendered falsely immediate by representation loses its appreciable content. However, although James's prose contests the reductiveness of visual synthesis, he knows that an excess of direct sensory input in Italy can lead to anarchic narration (like that of the late Ruskin). James reprimands authors who give themselves over excessively and immediately to their object of study. In 1876, he critiqued Fromentin's travel and art prose as "a too exhaustive enumeration of its constituent particles."[53] We reach the core of this critique at length: "He can say so much so neatly and so vividly . . . that he loses all respect for the unsayable."[54]

For James, then, the seductive challenge of incorporating a historic complex into fiction consists in accounting narratively for its fluid and inarticulable elements without lapsing into unmoored invention. The Aspern preface borrows tropes of channeling from the city of laboriously maintained canals to describe the structural governance of his tales. James calls for prose inventions rigorously conducted, against the fluid improvisation represented by such works as the Arabian Nights: "Nothing is so easy as improvisation, the running on and on of invention; it is sadly compromised, however, from the moment its stream breaks bounds and gets into flood. Then the waters may spread indeed . . . only violating by the same stroke our sense of the course and channel, which is our sense of the uses of a stream and the virtue of a story" (38). The storyteller's efforts of channeling are legible in his strategic digressions and dodges. Navigation around historical stumbling blocks checks narrative spontaneity in his fictions of Venice. Excessive sensory input encountered in that city resembles the excessive hospitality of the East this

port opens upon, an elaborate "offer" from which the guest must withdraw: "The offer has been too large . . . we peep at most into two or three of the chambers of their hospitality, with the rest of the case stretching beyond our ken and escaping our penetration. . . . So, right and left, in Italy—before the great historic complexity at least—penetration fails; we scratch at the extensive surface, we meet the perfunctory smile, we hang about in the golden air" (27–28). The narrator who fevers to pierce the surface of this historical complexity and fill its voids with solid substance fails to realize that in doing so, he would demolish the "differences" he seeks there. The novelist, who in reaching toward the past records the untraversable intervals estranging us from its contents, touches upon the unseen, expressing through prose that air of the unuttered; he remains suspended in the golden atmosphere. In James's developing architecture of fiction, as in the architecture of Venice, "the element of the unnamed and untouched became, between us, greater than any other. . . . It was as if, at moments, we were perpetually coming into sight of subjects before which we must stop short, turning suddenly out of alleys that we perceived to be blind . . ." (210).

COMPOSITION AS DISTRACTION

If Venice has exhausted and been exhausted by direct representation, the novelist under the spell of the fallen capital must allow it to infiltrate his fiction in subterranean fashion. Venice emerges in James's novels not as a placid "setting" or "subject," but as an influence diverting the novelist from his plot, shaping figures of reciprocal consciousness.[55] James describes this elusive Venetian influence upon his fiction most eloquently in what Ezra Pound called the "[c]harming Venetian preface"[56] to The Portrait of a Lady (1908), a novel whose plot carries its characters only as close as Rome. This piece recollects James's 1880 efforts to compose the novel while staying in rooms over the Riva degli Schiavoni. Despite his best efforts of portraiture in "the fruitless fidget of composition," he recounts, the human and maritime traffic of the lagoon infiltrated his windows, refusing to become the instrument of his authorial agenda, and underscoring "that romantic and historic sites . . . offer the artist a questionable aid to concentration. . . . They are too rich in their own life and too charged with their own meanings merely to help him out with a lame phrase; they draw him away from his small question to their own greater ones."[57] The author of The Portrait of a Lady finds himself unable to harness the Riva panorama for any plot but its own—like the narrator

of *The Aspern Papers*, who finds that searching for a solution to his romantic quandary in the bronze countenance of Verrocchio's Bartolomeo Colleoni at Santi Giovanni e Paolo is futile. James perceives in the animate vista of Venice a much vaster history—recollected again in the preface to "A London Life," composed at the Palazzo Barbaro, "where above all the strong Venetian voice, full of history and humanity and waking perpetual echoes, seemed to say more in ten warm words . . . than twenty pages of one's cold prose."[58]

Yet it is in being at odds with Venetian scenes, rather than documenting them as "subjects," that the place springs to this kind of life. Swelling against the author's ideological and aesthetic purposes, the environment ultimately invigorates the work at hand. As a journalist in Venice, James sighs at "the vision of so much more truth than he can use"[59]; as a novelist, he carries the problem one step further, to note that places that speak to the imagination "express . . . only too much—more than . . . one has use for; so that one finds one's self working less congruously . . . than in presence of the moderate and the neutral, to which we may lend something of the light of our vision. Such a place as Venice is too proud for such charities; Venice doesn't borrow, she but all too magnificently gives."[60] An excess of stimuli in Venice warps the superficial reciprocity of commercial relations; it renders the artist a debtor with little vision to lend. But these surroundings ultimately thicken the texture of the yearning imagination. James maintains that his novel was enriched by Venice's resistance: "Strangely fertilising, in the long run, does a wasted effort of attention often prove," he writes, because the novel as a genre possesses the capacity to present subject matter prismatically, from an abundance of constrained perspectives: "to range through all the differences of the individual relation to its general subject-matter, all the varieties of outlook on life, of disposition to reflect and project . . . but positively to appear more true to its character in proportion as it strains, or tends to burst, with a latent extravagance, its mould" (vi). Venice squanders the concentration, but the fact that it obliges the author to occupy a range of dispositions forces his plots to swell fruitfully against their immediate strictures. Decades later, the architect Aldo Rossi—an avid reader of James— will propose in speaking of his floating Venetian *Theater of the World* (1979–80) that "a place presents itself as a result of many observations: the panorama from the balcony, the flowing water, the drift of conversation. . . . Perhaps only through a kind of inattention, the most benevolent form of betrayal, is one faithful to a place."[61]

Even when Venice arises as a "subject" of attention in James's fictions, it works its way through the prose surreptitiously, like a habit, long-standing

passion, or disease. We can read a Venetian resistance to design in the fil-
trations, flows, and lapses of narrated experience in his evolving novels. In
The Wings of the Dove, the archipelago emerges as active ambience, diverting
description and plots, and infusing James's lexicon, syntax, and figures for
composition, consciousness, and social relations. While we cannot, naturally,
ascribe the development of James's style to his experiences of Venice in any
causal manner, James's writings about the cityscape invite us to view it as par-
adigmatic of the perspectival constraint that he incorporates into fiction—
and that resists the designing imagination. This cityscape offers, further, an
objective correlative for the riddled social and historical relations he seeks to
transcribe in prose.

James's preface to *Portrait*—written with the hindsight of having com-
posed *The Wings of the Dove*—notes that the text circuitously summons the
undocumented images and pitches of its site of composition: "There are
pages of the book which . . . have seemed to make me see again the bris-
tling curve of the wide Riva . . . and the repeated undulation of the little
hunchbacked bridges, marked by the rise and drop again, with the wave, of
foreshortened clicking pedestrians. The Venetian footfall and the Venetian
cry—all talk there, wherever uttered, having the pitch of a call across the
water—come in once more at the window, renewing one's old impression of
the delighted senses and the divided, frustrated mind" (vi). James presents
Venice as the medium of this narrative—a medium with a foreshortening,
interrupting, reverberating effect. Foreshortening, a painterly technique typ-
ical of the Venetian school and made canonical by James's beloved Tintoretto,
renders intervals conspicuous and perspectives oblique. The intervals that
bodies must cross and voices traverse in order to achieve communion in
Venice (and, we might argue, in the world of *Portrait*) become replicated in
the expatriated author's mind as gulfs between the composure of design and
sensuous immersion. He proposes a challenging new model for reading by
suggesting that these intervals are incorporated into his prose as interlin-
ear content: the outcome of a dialectic between the grounds for narrative
and what the prose figures, an unstated contrast between the open site of
composition (liminal Venice) and the framing—indeed imprisoning, for the
lady whose portrait is depicted—site of narration (capital Rome). A story
introjecting these conflicts produces echoes. Far from being aporias without
content, the intervals of James's prose constitute transitive meaning—and
this meaning is historical. Ezra Pound was to characterize his precursor's
donation to literary history thus: "He has written history of a personal sort,
social history well documented and incomplete."[62]

General Engulfment: The Venetian "Subject" in *The Wings of the Dove*

James opens his final travelogue pointed principally at the city of Venice, "Two Old Houses and Three Young Women" (1899), by confronting the site's resistance to representation once again: "There are times and places that come back yet again, but that, when the brooding tourist puts out his hand to them, meet it a little slowly, or even seem to recede a step, as if in slight fear of some liberty he may take." Part of the "charming solicitation" of such a time and place is the problem it presents to the tourist—"of *giving* the particular thing as much as possible without at the same time giving it . . . away." One is subject to "considerations, proprieties, a necessary indirectness" (*IH* 64). The tourist, now conflated with the artist, responds by embracing obliquity: as a solution, he "hangs his three pictures" (64). We come to find out what this statement means as the essay's structure unfolds: James adopts an almost cubist compositional procedure, juxtaposing three plotless episodes without discursive links. The "pictures" isolate scenes of muted aristocratic decrepitude: the engagement party for a noble Venetian and an Austrian hero, a tour of ducal relics stored in or exported from a domicile of sisters in "their resigned cosmopolite state" (70), and a private feast-day among ineffectual aristocrats within the emptied Corsini Palace. The distribution of collage elements inventoried in James's deceptively simple title turns out to be uneven, and the pieces' separation bespeaks the lack of social bonding that would render such scenes coherent within a larger public sphere. Division of the vignettes speaks, further, to the defunct state of these noble lineages, whose multiply "discounted" effects have reduced them to "representation and emulation" (75) of the past, to the point that a betrothed Venetian girl has been "habited, combed, curled in a manner exactly to reproduce the portrait" of her famous grandmother painted sixty-nine years prior (69). The essay's title therefore superimposes its private, domestic frame.

The first of James's "houses of fiction" to resist serialization, *The Wings of the Dove* builds on the fissured narrative scheme of "Two Old Houses" to further the "displacement of his general centre."[63] In the preface for the 1909 edition, James returns to a description of his compositional process, but transposes his figures from the pictorial realm to the sculptural: "There was the 'fun' . . . of establishing one's successive centres—of fixing them so exactly that the portions of the subject commanded by them as by happy points of view, and accordingly treated from them, would constitute . . .

sufficiently solid *blocks* of wrought material, squared to the sharp edge, as to have weight and mass and carrying power; to make for construction" (8). The sharp edges called for here depart from the Impressionist values of his early writing, moving toward construction of successive narrative viewpoints that are harshly cropped, and decidedly three-dimensional. Each block represents a "new mass of interest governed from a new center" (15). The preface makes the limitations of the pictorial analogy explicit, noting "the odd inveteracy with which picture, at almost any turn, is jealous of drama, and drama (though on the whole with a greater patience, I think) suspicious of picture" (10). "Turns" that press beyond the frames of two-dimensional presentation and the "patience" that drama permits, in its duration, lead the novelist toward this rupture of the pictorial, though he remains poised at its margin: "Beautiful exceedingly, . . . those . . . parts of an occasion when the boundary line between picture and scene bears a little the weight of the double pressure" (11–12). James's desire for narrative transit around the form—for multiple perspectives on the "reality," "thing," or "case" at hand—drives this move toward ambience: "Terms of amplitude, terms of atmosphere, those terms . . . in which images assert their fullness and roundness, their power to revolve, so that they have sides and backs, parts in the shade as true as parts in the sun" (9).

But while recalling these preliminary hopes, upon rereading his novel, the author judges that the end result fails to meet them. Though three dimensions remain in play metaphorically, he finds that temporal and spatial constraints resulted in "blocks" of material riddled with fissures, so that "to retrace the way at present is, alas, . . . but to mark the gaps and the lapses, to miss, one by one, the intentions that . . . were not to fructify. . . . I meet them all, as I renew acquaintance, I mourn for them all as I remount the stream, the absent values, the palpable voids, the missing links, the mocking shadows" (9). Here James drifts from the vocabulary of edges and blocks to the figure of an ungraspable stream—a seemingly incoherent shift. Yet this matrix of pieces and voids subtended by shadows and "liquid lapse"[64] resembles quite precisely the topography and architecture of the book's climax. Before emerging as part of the diegetic action, Venice suffuses the narration of *Wings* through figures of relationality—from those driving the scene of Maud Lowder's dinner party, where words and "appearances" reach the protagonist Milly Theale "from here and there like plashes of a slow thick tide" (105) while Lowder steers "a course in which she called at subjects as if they were islets in an archipelago" (106), to the "abysses" and "labyrinth" used to describe the silences and secrecies of the affair between Merton Densher and Kate Croy (120–21).

Venetians found a way to build upon the lagoon's islets and to bridge them, however, some 364 times, engendering an operative urban complex. James's awareness of Venice's architectonic voids suffuses his prefaces: he recalls composing "A London Life" within the Palazzo Barbaro, where Rococo ceilings rise above floors whose staircases "held together one scarce knew how."[65] Such architectural feats build on the unlikely example of the Ducal Palace, whose massive upper story is suspended over arcades and elaborately perforated loggias in defiance of building conventions—with the whole engineered over the seeming void of water. In Venice, interstices function as channels of communication and exchange: they are a vital part of its system. In reconsidering the strengths of *Wings*, in fact, James proposes that "the artist's energy fairly depends on his fallibility" in construction. Despite its missing pieces, the ambient text forms an architectural complex that somehow works. The author, now figured as an architect, notes that "the bridge spans the stream, after the fact, in apparently complete independence of these properties. . . . *They* were an illusion, . . . but the span itself . . . seems by the oddest chance in the world to be a reality; since, actually, the rueful builder, passing under it, sees figures and hears sounds above: he makes out . . . that it bears and is positively being 'used'" (9). James in fact declared in the *Portrait* preface that he would rather have "too little architecture than too much" if building should interfere with the truth of intense suggestion (viii); experience is prompted by implication, which provokes an active response.[66] The surveyor's elisions supply an additional value: they express the content of the artist's blindness. The inarticulable is conveyed through these negative spaces.

In a "virtual" Venetian scene of *The Golden Bowl* (1904), James will represent the poverty of unfissured architecture or character through Adam Verver's neoclassical figuration of his son-in-law Amerigo:

> "Say you had been formed all over in a lot of little pyramidal lozenges like that wonderful side of the Ducal Palace in Venice—so lovely in a building, but so damnable, for rubbing against, in a man, and especially in a near relation. . . . One would have been more or less reduced to a hash. As it is, for living with, you're a pure and perfect crystal." . . . [N]othing perhaps could more have confirmed Mr. Verver's account of [the Prince's] surface than the manner in which these golden drops evenly flowed over it. They caught in no interstice. . . . [67]

Lacking perforations and abrading interruptions of surface such as those of the Gothic Ducal Palace, Amerigo's seamlessness manifests the reification of

his existence as a *"morceau de museé"* (10), comprising utterly accountable relations to others.[68] Though both prince and palace are anachronistic figures within *The Golden Bowl*, Amerigo has been imported and incorporated into Gilded-Age American economies of exchange and display, while the Gothic structure remains recalcitrant to such economies—economies here rendered discomfitingly corporeal, tinged by predatory sexuality.[69] In a related passage, Adam compares his son-in-law to a Palladian church whose smooth, rationalist contours can be worked around without "visibility of transition" or "violence of accommodation," even when dropped suddenly into a piazza (136)—obliquely accounting for the Anglo-American embrace and emulation of Palladio (lampooned by James),[70] while the Venetians restricted execution of that architect's neoclassical designs to peripheral zones of the city. The mature conception of relational *imbroglio* motivating James's late novels ironizes Verver's faith in relations that leave both parties unabraded, composing instead "communities of doom" (*Wings* 7) made up of "deeply involved and immersed and more or less bleeding participants" (*GB* vi). The climax of *The Wings of the Dove* situates these participants in a cityscape riddled with "interstice[s]" that can make "a hash of mutual suspicion" (*Wings* 325). These topographical features become introjected into the novel as the immersive "channels" and voids of James's narrative structure.

In the landscape of *Wings*, as in James's Venetian travel writings, individual experience is doomed to be shared with others; discrete calculations fail to extricate individuals or couples from a communal eddying and sinking. The agency of all characters is meshed with that of the mortally ill Milly, the wealthy New York heiress and would-be instrument of Kate's scheme (to lure Milly into falling in love with her fiancé, Densher, and into willing her fortune to him before she dies). Instead of a pawn, Milly becomes a force field, or vortex, of fate and desire.[71] James first describes his characters' common subjection to Milly's "promptings" as the effect of a Rhine enchantress: "one would see the persons subject to them drawn in as by some pool of a Lorelei—see them terrified and tempted and charmed; bribed away . . . from more prescribed and natural orbits, inheriting from their connexion with her strange difficulties and still stranger opportunities" (5). In expanding upon Milly's composition, however, James revises this trope away from the allegorical and figural. The sick heiress's uncustomary pressure upon others now seems to emanate from a sinking ship or business; and this metamorphosis hauls the emphasis away from the figure of Lorelei to the force of the pool itself. In a work that represents relational influence as flow and overflow, Milly's expiring existence produces "all round her, very much that

whirlpool movement of the waters produced by the sinking of a big vessel or the failure of a great business; when we figure to ourselves the strong narrowing eddies, the immense force of suction, the general engulfment that, for any neighbouring object, makes immersion inevitable" (6). Located undecidably between the sinking "vessel" (itself either ship or container) and the liquid influence that wells up and engulfs neighboring object/subjects, Milly's presence bears morphological similarities to the sinking empire and mercantile port in which her fortune places her. She is herself not so much figure as ground: less an agent than a medium through which the agency of others is compromised. Those who would appropriate her for profit or social gain find that "[Kate's] dear Milly occupied . . . more of the foreground than one would have expected. . . . She took up room," and that despite their schemes, "It was a foreground in which [Densher] himself, in which his connexion with Kate, scarce enjoyed a space to turn round" (193). Exceeding the conventional role of the dying girl within the turn-of-the-century novel, a placid ground for narrative, Milly is expansive—an environment.[72] She inverts, then blurs the figure/ground distinction of the primary couple's plot (and allied neighboring schemes). Influence in the novel flows in both directions, however: James sees the dramatic complication "much more prepared *for* my vessel of sensibility than by her—the work of other hands (though with her own imbrued too)" (7).

The dynamic fragility of *Wings*'s central figure flouts fantasies of freestanding Romantic subjectivity envisioned by the American Adam Verver, as well as his early counterpart in James's 1877 novel *The American*, the "disembroiled, disencumbered" Christopher Newman.[73] Milly, an American ingénue and "capital case," at first appears to be a feminine version of these individuals; her economic autonomy and the fact that she has "no relations" (149) make her seem an example of "romantic isolation" (77), "not hideously relative to tiers and tiers of others" (170). But traveling to Venice as a person sentenced to die will prompt Milly's awareness of her foreclosure from a storied Venetian romance of simply "remaining aloft in the divine dustless air, where she would hear but the plash of the water against stone" (269): "Oh the impossible romance—!" (268), she articulates. Milly engenders an environment in which any individual scheme is engulfed—and she is herself in danger of sinking, already the "survivor of a general wreck" (149). James translates her condition as a mortally ill rich girl into the figure of a gilded Venetian abyss: "a great garnished void" over which the princess hovers, in slow syntax, like a "caged Byzantine" in the dusk, while above her, a "porcelain monument" to silence is patched together like "a mosaic at Ravenna" (157).

During the bulk of the novel's Venetian climax, this character herself becomes a void to which we suddenly lose access. James supplies Milly's reconstruction only by those surrounding her: "heaven forbid we should 'know' anything more of our ravaged sister than what Densher darkly pieces together, or than what Kate Croy pays . . . for her superior handling and dire profanation" (12). We must translate her condition for ourselves by piecing together a presence out of patches—though it has been determined that Milly is afflicted with something that is "past patching" (214). Like her physician, we are forced to watch the "little pieces" of Milly fall together by chance, "like the morsels of colored glass in a child's peep show" (150). The metaphor of the kaleidoscope destabilizes the construction of Milly as a Byzantine mosaic in advance, introducing the element of contingency on display in Venice that haunted Ruskin—but with a Gilded-Age urgency. This "caged Byzantine" threatens to be stripped of her gold, and her "pieces" dispersed, in a social sphere driven by interest rather than affection.

Our involvement in constructing an understanding of Milly animates the character at the threshold of mortality so that she is never still. With her days numbered as a "patient" before her time, in a way that she considers "romantic" (146), Milly represents to James's memory "a very old—if I shouldn't perhaps rather say a very young—motive" (3): the motive of the young woman "early stricken and doomed" who wants to "achieve, however briefly and brokenly, the sense of having lived," echoing the 1870 death of the author's cousin Minnie Temple. While Milly's youth and apparent freedom might bespeak a radiant presence, her fate stresses her being situated ineluctably in the stream of time. The ship imagery with which the novelist frequently represents her recalls William James's strangely motile figure for a "*duration-block*" that possesses "a bow and a stern . . . —a rearward- and a forward-looking end."[74]

Such instability of identity in duration is matched by the referential flux to which signs are subject in this prose, in the first full-length blossoming of James's late style.[75] The city built on unstable marshlands is an apt setting for narration whose steering trope is anacoluthon, or the syntactical shift that signals a break in grammatical, syntactical, or narrative continuity—and for a narrative in which readers must constantly adjust their assumptions regarding denotation as contexts shift and connotations morph.[76] Pronouns dodge or double their referents and become swapped for even more elusive "it"s. As the potential attribution of pronouns multiplies, the liquidation of referents for indexicals pools around Milly's unspeakable illness, a void that becomes an "it," a "that," a "matter," an "everything." Our "real thing" is herself a shifter, an indexical symbol. The fictive and compositional "blocks" of James's texts

loom in relation to such dissolution in ever more explicit figurative terms. It
was upon such prose scenarios, in which reference dissolves and drifts, that
Gertrude Stein could construct a prose aesthetic: "[James's] whole paragraph
was detached what it said from what it did, what it was from what it held,
and over it all something floated not floated away but just floated, floated up
there."[77] In pursuit of channels out of deterministic realism, Stein suggests
that James's prose has a dual effect.[78] While we have seen James aim to anchor
agents in social textures (an aspiration explicitly outlined in his preface to
The American), Stein shows that his prose wittingly or unwittingly founds
its own fluid medium apart, which allows meaning to float and drift: a literal
para-writing that begins to untether composition from narration. Through
the channel of the "emotional" paragraph, James unsettles the "settled lan-
guage"[79] of English—paving the way for a modernist realism that reconfigures
epistemology by translating ambient dynamics into climates of text. Stein—
who adopted various aspects of *Wings* in her early novel *Q.E.D.*—wrote that
"Henry James . . . was in some senses a forerunner. . . . You see he made it sort
of like an atmosphere, and it was not solely the realism of the characters but
the realism of the composition which was the important thing."[80] Though the
agent is not absent in this "atmosphere," Stein denotes no sealed-off subject in
such work: "I, he, it may not be set in place of stated. . . . He may not be seated
to settle in place of stating what there is to be stated. . . . This is the way it was
with Henry James."[81] In seeking to draw analogies between James's prose and
painting, scholarship on *The Wings of the Dove* often falls short of reckoning
with this extreme abstraction of the late style: its resistance, foreshadowing
Stein's, to the representation of distinct "subjects" and "settings." The Renais-
sance paintings that make appearances in this work, and which have been the
subject of substantial critical discussion, tend to distract from the way James
anticipates modernist visual abstraction in prose.

The novel's New York Edition frontispieces—photographed on com-
mission by Alvin Coburn, and pointedly refusing to offer a "view"—are
stripped of human figures, highlighting the text's subordination of subjects
to a larger urban matrix. Volume 1 opens on a frontal view of "The Doctor's
Door" that is stultifyingly shut, while the frontispiece to volume 2 approaches
the foreshortened façade of "The Venetian Palace" from an oblique angle
(figure 2.7), recalling the obliquity of Whistler's *Nocturne: Palaces*. Coburn,
a future Vorticist, crops architecture artfully here, as in his frontispiece to
The Aspern Papers. The photograph for volume 1 forces us to confront the
anonymous geometry of the threshold to the site of Milly's diagnosis in
London, an arch whose entry is foreclosed to us; the other broaches the

FIGURE 2.7. Alvin Langdon Coburn, frontispiece to volume 2 of the New York Edition of *The Wings of the Dove*, with the caption "The Venetian Palace," photograph, 1909.

façade of her "make-believe of a settlement" in Venice (135). Coburn's oblique perspective emphasizes the hovering of Palazzo Leporelli (a fictionalized Palazzo Barbaro) at the verge of the Grand Canal—described by James as a "great gilded shell" perched on the brink of the "slow Adriatic tide" (269, 267), to which Milly will cling as to the floating "ark of her deluge" (264). Architectural and transitional, domestic and public, the paired façade images foreground a situation over any agent, yet give us little sense of what lies in store for those who enter, or of what those who look out may see. Milly, "the potential heiress of all the ages" (109), is the singular motive that will traverse these blinded thresholds.

These images—the first characterized by taciturn frontality, the second by foreshortening—provide keys to James's own methods of depiction. James's disparagement of illustrated "picture-books" in the preface to *The Golden Bowl*, which aligns with his conception of "depiction" as the deadening of experience, parallels his withdrawal from ekphrasis in narrative art.[82] In his criticism, James challenges the "popular notion" that "to be real in writing is to describe" rather than to express; in an 1865 review of Harriet Elizabeth Prescott's *Azarian* and the descriptive school it represents, he articulates a frequent devout wish "that some legal penalty were attached to the use of description" and actually compares Prescott's word-painting to the painting of eyebrows upon a corpse.[83] Such resistance reemerges in the novel's celebrated set piece: Milly's encounter with the portrait at Matcham by Bronzino (a Venetian Mannerist James did not choose to address in his criticism).[84] Within the action of the novel, the socialites at the English estate claim that the New York heiress "matches" the portrait exactly. Milly's own encounter with the potential likeness opens on a more painterly semblance of fusion between history and a transitional present: "Once more things melted together—the beauty and the history and the facility and the splendid midsummer glow" (220). Yet this moment is immediately recast as beginning an end—a dawning of the girl's dusk: "a sort of magnificent maximum, the pink dawn of an apotheosis coming so curiously soon" (220). The rich young woman in the frame, whom critical consensus identifies as Lucrezia Panciatichi,[85] has been described infallibly by Bronzino's exquisite Mannerism: "all splendidly drawn, down to the hands, and splendidly dressed" (220; figure 2.8). The impeccably documented lady is not at all open to question, however: her doom is sealed. "The lady in question, at all events, with her slightly Michael-angelesque squareness, her eyes of other days, her full lips, her long neck, her recorded jewels, her brocaded and wasted reds, was a very great personage—only unaccompanied by a joy. And she was dead, dead,

FIGURE 2.8/PLATE F. Agnolo Bronzino (1503–72), *Portrait of Lucrezia Panciatichi*, oil on wood, ca. 1540. Galleria degli Uffizi, Florence.
Photograph courtesy of Scala/Ministero per i Beni e le Attività Culturali/Art Resource, New York.

dead" (221). James follows this stultifying sentence with a characteristic pronominal ambiguity that marries recognition with alienation: "Milly recognised her exactly in words that had nothing to do with her. 'I shall never be better than this'" (221). The second, doubling "her" here may refer either to painting or person, or both. In either case, the inanimate image painted for profit

by the Venetian Bronzino, fictively purchased and exported by Lord Mark (a fell double of the patron saint of Venice), falls short of "describing" our heroine. Mundanely circumscribed and superfluous in detail, the portrait of a patrician lady threatens to delimit Milly as "regenerate" *being*, "motive" both old and young, subject and environment, as in a coffin (3). While the fictional connoisseurs wish to identify Milly with the painting, James as artist insists— through free indirect narration of her perception—on her non-identification with the perfectly encapsulated dead woman. Her relation to the portrait establishes no common ground of comparison (she will be neither "better" nor "as good" as it), for their qualities are incommensurate. If anything within the portrait's confines suits the situation of "the awfully rich young American who was so queer to behold" (138), it is the vacant sculptural niche, hovering beyond Bronzino's subject, that echoes "The Doctor's Door," and whose seemingly detached columns recall those that mark the archaic port of entry into Venice—an entry that was also the site of the Republic's death-sentencing. In retrospect, this moment at Matcham will be said to mark "the climax of her fortune," and James places Milly figuratively at the Dogana Point's allegory of Fortune to describe the revelation: it is the moment of "her consciously rounding her protective promontory, quitting the blue gulf of comparative ignorance and reaching her view of the troubled sea" (268, 267). The mortifying specular relation between the salient Renaissance subject in the painting and the contemporary human presence before it occasions not self-awareness, but the impasse of any recognition that hangs still—the impasse of mimetic depiction and description in itself, which are strategically denied to us by both James and the frontispieces he commissioned.

James's representation of the limits of visual inventorying is not confined to this moment of *Wings*. He later has Milly's friend Susan Stringham liken the scenario in their Venetian apartments to the composure of a Veronese painting, disparaging her own status as sidekick by way of analogy with the painter's signature marginal grotesques[86]: "It's a Veronese picture, as near as can be—with me as the inevitable dwarf, the small blackamoor, put into a corner of the foreground for effect" (206). Susan's typology, imposing a one-to-one correspondence between Venetian pictures and contemporary persons, belies both their disparity and the slow encroachment of an engulfing Venetian environment upon its visitors, phenomenally expressed in the figurative immersions of the text.

Plotting for spoils within the Palazzo Leporelli, Kate proposes that her marriage scheme will supply her lover with "a clear field" (226). But under the influence of Milly's rooms, Densher is unable to maintain the steadfastness

of perspective needed to actualize either Kate's plot or Susan's pictorial analogy; he finds the New Yorker's "hired palace" (12) dislodging. His hostesses "sharpened his sense of immersion in an element rather more strangely than agreeably warm" (213). The overheated liquid medium that draws him into relation with the heiress and her guests estranges and engulfs.

> [H]e seemed to stand in it up to his neck. He . . . floated, he noiselessly swam in it, and they were all together, for that matter, like fishes in a crystal pool. . . . They were only people . . . who during the day had fingered their Baedekers, gaped at their frescoes and differed, over fractions of francs, with their gondoliers. But Milly, let loose among them . . . , brought them somehow into relation with something that made them more finely genial; so that if the Veronese picture . . . was not quite constituted, the comparative prose of the previous hours . . . w[as] at last almost nobly disowned. (213)

Milly's circulation through her rooms—or *stanze*, as we are asked to contrast them against "the comparative prose of the previous hours"—surrounds her guests with a liquid "element" repeatedly alluded to as "it": "something" James leaves abstract over the paragraph's course, invisible but palpable, which draws them out of their attitudes of touristic self-informing and ownership and into genial relation. The promise of Veronese's theatrical harmony hovers over the scene, but the "picture" is ultimately left unconstituted; for it would propose a correspondence between the framed painting and the contingencies stressed by the current situation—a tenuous residence on the Grand Canal "paid for" (269) but fleeting—and effectively fix the flows of collective experience into a hieratic visual order.

Milly's pervasiveness does not conform to the shape of subjectivity: "[Merton] wouldn't have known whether to see it in an extension or a contraction of 'personality,' taking it . . . for a confounding extension of surface." This "surface" thwarts the flattening of narrative figuration over and over. Densher, in his strategic period of waiting in Venice, "felt himself as he smoked shut up to a room on the wall of which something precious was too precariously hung. . . . [I]t must hang as long as possible" (322). While Densher imagines Milly as something "hung" on a wall, recalling the portrait at Matcham, her agency is registered in his feeling of being enclosed in a room filling with smoke; Milly is the suffocating environment rather than the contained portrait. A reified art object cannot form Milly's correlative: like the vitally sinking Venice, she is represented as pervasive and circulating. To

NEARER DISTANCES AND CLEARER MYSTERIES

grasp the dialectical function of *Wings*'s ekphrastic suspensions, we have to contrast these points of non-identification with James's oblique presentation of his protagonist, which he is able to detect upon "re-perusal":

> The whole actual centre of the work, resting on a misplaced pivot . . . pretends to a long reach, or . . . to the larger foreshortening—though bringing home to me . . . the author's instinct everywhere for the *indirect* presentation of his main image. [A]gain and again, I go but a little way with . . . the straight exhibition of Milly; it resorts for relief . . . to some . . . merciful indirection: all as if to approach her circuitously, deal with her at second hand. . . . All of which proceeds . . . from her painter's tenderness of imagination about her, which reduces him to watching her . . . through the successive windows of other people's interest in her. (16)

Rather than "exhibiting" Milly head-on, as if painting a frontal portrait, the author traces the byways that his subject might take to dodge her determination by corporeal fact and social interest. James's female subjects are on the move, even in their confinement—at play in the palpable drift of circumstance. Earlier in the New York Edition sequence, he describes his struggle to create a different *Portrait of a Lady*—to produce a "subject" out of a girl at all (Isabel Archer)—through recollection that although he seems to enjoy "complete possession" of it, he still "all urgently, all tormentingly . . . saw it in motion and, so to speak, in transit."[87] In this passage, the author's vision is inextricable from the distressed conditions of his seeing; rendered adverbially and in the context of an abstracted "all," tracking the shifting of this subject amid contingencies. In the later novel, all of our "information" about the central subject comes contaminated in some wise, filtered through Milly's ill-informed correspondents, whose vision is in turn mediated by their own self-interest, class, and geography.

At novel's end, Merton has to look at Kate through "the eyes he had brought back from Venice" (371), which cannot eradicate Milly from their sight. Milly's own point of view as "dove" installs us upon dizzying thresholds, such as the Alp precipice presenting a "'view' . . . of great extent and beauty, but thrown forward and vertiginous" (123). Her "views" hurl us into eddies and accidents, not into repose. Such narrative perspectives have more in common with the foreshortened visions of James's cherished Tintoretto than with the balanced compositions of Bronzino and Veronese that he replicates ekphrastically at the level of plot. James contrasts Tintoretto's *Last Supper* at San Giorgio and "the customary formal, almost mathematical

FIGURE 2.9/PLATE G. Jacopo Comin, called Tintoretto (ca. 1518–94), *Last Supper*, oil
on canvas, 1592–94. Basilica of San Giorgio Maggiore, Venice.
Courtesy of Cameraphoto Arte, Venice/Art Resource, New York.

rendering of the subject," whose symmetry is still adhered to in Veronese's
transgressive, renamed *Feast in the House of Levi*: James prefers Tintoretto's
"long, diagonally placed table, its dusky spaciousness, its scattered lamp-
light and halo-light, its startled, gesticulating figures, its richly realistic fore-
ground" (*IH* 59; figure 2.9). In *Wings*, "the larger foreshortening" becomes
an implicit motif.

Within Milly's consciousness as it is transmitted to us, the distances
enhanced by foreshortening abound. In *Wings'* Chelsea, British class hier-
archies leave the American ingénue to ponder the need to "bridge" the
"intervals" between social positions: "It was as if at home, by contrast, there
were . . . neither the difference itself, from position to position, nor . . . the
awfully good manner, the conscious sinking of a consciousness, that made up
for it. . . . [T]he difference, the bridge, the interval, the skipped leaves of the
social atlas—these . . . had a little, for our young lady, . . . to work themselves
into the light literary legend" (191–92). An experience of the city familiar
only through books educates the rich New Yorker in social disparity and in
the "conscious sinking of a consciousness" that tries to reconcile it. When
Milly moves from London to Venice, James's figures for social difference and
communion are concretized; the archipelago literalizes the need for social

linkage, as well as the lingering "abysses" between intimates that cause Susan to exclaim, "My dear child, we move in a labyrinth" (121). Milly becomes the ingenuous—and victimized—mediator between separate worlds.

Relation across difference is "confounding," however: it requires communication. When the pervasive "medium" of the novel, having been informed of Kate and Merton's marriage scheme, "turn[s] her face to the wall" (270), refusing further contact with Merton, the geniality that her presence once enabled breaks down. A telegraphic exchange of cross-purposes between Merton and Milly's servant Eugenio—each speaking in a broken tongue alien to himself—reveals that she has closed the palace doors to her suitor; this arrest resounds atmospherically as a storm of social breakdown, underscoring the archipelago's potential to stop up circulation:

> It was a Venice all of evil that had broken out for them alike, so that they were together in their anxiety, if they really could have met on it; a Venice . . . of wicked wind raging through narrow passes, of general arrest and interruption, with the people engaged in all the water-life huddled, stranded and wageless, bored and cynical, under archways and bridges. Our young man's mute exchange with his friend contained meanwhile such a depth of reference that . . . they might have reached a point at which they were equally weak. Each had verily something in mind that would have made a hash of mutual suspicion and in presence of which . . . they were more united than disjoined. . . . [T]he air had made itself felt as a non-conductor of messages. (325–26)

In this passage, long-standing tropes of Venetian darkness resurface as the storm exposes the misery and social discontinuity of contemporary Venice, demonstrating how tenuous the New Yorker's palatial "make-believe of a settlement" is.

James's peripheral social consciousness becomes evident in the fact that it is the intercession of Eugenio—one of the few live Venetians, and members of the working class, actually given narrative room—which helps bring this impasse about. The disruptions of traffic caused by the storm concretize the disrupted communication between Milly's associates—but also expose the unarticulated hardships of the Venetian "natives" often abstracted in James's works. The gondolier Pasquale's refusal to "say either was anything" (by "either," James refers obliquely to Susan and Milly, who refuse to allow Merton inside) so as to explain why Milly is "not 'receiving'" (256) bespeaks not a lack of content but an obscurity Densher assigns to "members of a race in

whom vacancy was but a nest of darknesses—not a vain surface, but a place of withdrawal in which something obscure, something always ominous, indistinguishably lived"—in James's capitulation to the *leggenda nera* of Venice (324). Eugenio, the scene's second working-class Venetian, speaks to Densher within the loggia of the Leporelli, but only to vex, estrange, and withhold: "by a profundity, a true deviltry of resource, he always met [Densher's] Italian with English and his English with Italian" (259). Now servant and writer can only commune via their mutual estrangement and suspicion. Merton leaves to wander through this Venice of unbridgeable inequalities, observing a "shuffling crowd" that superficially amalgamates shabbily dressed "brown men" with entitled Northern European cosmopolites (327). The contingent nature of Venetian unity, punctuated by the dispossession of its current inhabitants and the dissolution of commerce, overwhelms the scene. (Such riddling moments enable us to understand George Oppen's conviction "that James and not Hemingway was the useful model for 'proletarian' writers."[88]) This is a Venice of Gothic weather, an impenetrable underclass, and ultimately of ruptured figures and grounds: "he took his course, through crooked ways, to the Piazza. . . . Here, in the high arcade, half Venice was crowded close, while, on the Molo, at the limit of the expanse, the old columns of the Saint Theodore and of the Lion were the frame of a door wide open to the storm. . . . [I]t was to Densher precisely as if he had seen the obliteration, at a stroke, of the margin on a faith in which they were all living" (326). Densher's route leads him to the architectonic correlative of this obliteration of bounded faith: the columns onto the sea (echoed in the backdrop to Bronzino's dead woman). The dying girl withdraws into that expanse as the consolidating frame of a post-Napoleonic St. Mark's Square, "the drawing-room of Europe, profaned and bewildered by some reverse of fortune" (327), appears to embrace fortune's purely financial future.

In James's hands, the halting expiration of this "heiress to all the ages" and her rented city withdraw from depiction, resounding instead as narrative interruption and entropy. The spatial intervals that intercede between James's agents and temporal intervals between narrated moments of expression trace the margins of the sinking determination of both city and woman. Riddled with these gaps, information is given at second hand or on second thought; an accretion of phrases makes us less rather than more certain of situations. Diegetic narration is abandoned in favor of truncated perspectives that nevertheless multiply and pool in paragraphs, and the interstices between moments of reportage ("skipped pages" made literal) enforce the experience of loss without warning. James's prose holds us in abeyance regarding

conditions medical and social while thrusting us into the plotted future of mortality: fortune.

Wings begins with the phrase "She waited, Kate Croy" (21), whose syntax describes the amplitude and duration of waiting before filling them in with a subject. At the novel's close, this waiting finds its echo, with a difference, in Kate's lover. Though Densher feels the "sharper need to arrange himself with his interval"—to pretend that Milly is already gone, thereby deadening the pain of anticipating her death—he finds that "the taste of life itself was the taste of suspense. That he *was* waiting was in short at the bottom of every-thing" (368). James follows this protracted and psychically vivid anticipation of Milly's passing away with the refusal to narrate its mere incidence; the gap registers in reading as suspense halted abruptly by loss.

These aporias in James's fiction, while expressing a greater discontinuity in the social fabric of the Gilded Age, also express the regenerate deter-mination of that which sinks. In a critical passage of *Dialectic of Enlight-enment*, Horkheimer and Adorno sound the historical truth pronounced by gaps in the descriptive composure of literature: "when speech pauses, the caesura allows the events narrated to be transformed into something long past, and causes to flash up a semblance of freedom that civilization has been unable wholly to extinguish ever since."[89] As an example of elo-quent narrative detachment coming to a halt in reticence, they cite Homer's unmoved description of the hanged servant women in Book 22 of the *Odys-sey*, in which a final qualification (the sudden detail that the feet of the executed women "kicked out for a short while, but not for long") belies the poet's objective composure; Homer's reticence prevents us "from forgetting the victims of the execution and lays bare the unspeakably endless torment of the single second in which the maids fought against death" (62). James's own diagnosis of description and the provision of information as exercises in mortification leads him to truncate from narration altogether not only the horror of Milly's death, but also the pain of the revelation of Kate and Densher's inheritance plot that precedes it. In resisting their depiction, he keeps the obsolete motives of Milly—both her suffering and her generos-ity—in circulation. By having Kate burn Milly's final letter to Densher, the author obliterates from view not a Romantic commodity fetish, such as his publishing scoundrel saw in the Aspern papers, but the romantic motive that would have spiritualized the inheritance of fortune. New York lawyers and "published" information in the papers will make the commercial terms of Milly's will plain; yet "the undisclosed work of her hand" (394) persists as a pulsing absence in Densher's imagination: "the part of it missed for

ever was the turn she would have given her act. This turn had possibilities that . . . his imagination had extraordinarily filled out and refined. It had made of them a revelation the loss of which was like the sight of a priceless pearl cast before his eyes . . . into the fathomless sea, or rather even it was like the sacrifice of something sentient and throbbing, something that . . . might have been audible as a faint far wail. This was the sound he cherished when alone in the stillness of his rooms" (398). The "unsayable" byways of Milly's bequest and the legacy of her love are constructed imaginatively, in the enriched romance of retrospection. Within these detours, the melancholic force of a more primal commerce, now overcome by gilded values payable in cash, continues to course.

The passional relations that contradict the calculating plots of modernity in this novel are made palpable in Venice, where history can be submerged or put up pathetically for rent, but not extinguished. In addressing the "burden" of the "residuary" (16) through acts of recollection within Venices both actual and invented, James offers us an aesthetic historiography that conveys the inassimilable past into the future, as both desire and responsibility. This motive presages that of the next century's historical materialism, which will reanimate outmoded and undocumented life to salvage history from the deadening linear narratives dictated by ascendant powers. Adorno's words encapsulate why Venice attracted so many artists and theorists seeking a way out of the dialectic of Enlightenment: "knowledge must indeed present the fatally rectilinear succession of victory and defeat, but should also address itself to those things which were not embraced by this dynamic, which fell by the wayside—what might be called the waste products and blind spots that have escaped the dialectic. . . . Theory must needs deal with cross-g[r]ained, opaque, unassimilated material, which as such admittedly has from the start an anachronistic quality, but which is not wholly obsolete since it has outwitted the historical dynamic."[90] James's late Venetian narrative undermines prevailing determinations of obsolescence. At the novel's close, Densher's "aftersense, day by day, was his greatest reality" (366); he is in love with a memory. It is this melancholy that breaks his decadent relation to the spoils of plotting desire.

James describes the "false and deformed" latter half of the novel in apparently disparaging terms: "This whole corner of the picture bristles with 'dodges'—such as he should feel himself all committed to recognise and denounce—for disguising the reduced scale of the exhibition, for foreshortening at any cost, for imparting to patches the value of presences" (13). Yet the fictive medium invented by means of such dodges has thickened the texture of the past, intensifying our experience of the great historic complexity by

thwarting our access to any reified picture of it. The stumbling blocks and lapses of James's prose stultify our views of the visitable past—thereby multiplying our senses of it.

• • •

In 1912, when James's companion, the artist Hendrik Christian Andersen, asked him to write a statement of support for the prospectus of a "World Centre of Communication" that Andersen had designed with French architect Ernest Hébrard in Rome (figure 2.10), James passed down to the record a lucid articulation of his sense of the development of cities, and of composition in general—a development that must, he insisted, be durational and piecemeal. The "World City" was Andersen's utopian collaboration with Paul Otlet and Henri La Fontaine, founders of an "International Federation of Information and Documentation" whose cataloguing system would provide mankind with access to all information, universalizing all knowledge; the city's boulevards, towers, and monumental symmetries, fashioned in grandiose plans for distribution to prominent persons, mimicked perfectly the blueprint of the Haussmannian city. Andersen was soliciting support for the project from Rome to Rye to the Jersey Shore and seeking a site for its implementation. James's response was to "simply . . . turn my face to the wall"; but he did not hesitate to elaborate on his doubts: "As *if* . . . any use on all the mad earth can be found for a ready-made city, made-while-one-waits, as they

FIGURE 2.10. Hendrik Christian Andersen (urban planner) and Ernest M. Hébrard (architect), *Creation of a World Centre of Communication, Bird's-Eye View*, published in Paris, 1913. Museo H.C. Andersen, Rome.
Courtesy of Ministero per i Beni e le Attività Culturali/GNAM, Rome.
Photograph © Giuseppe Schiavinotto.

say, & which is the more preposterous & the more delirious, the more elaborate & the more 'complete' . . . you have made it. Cities are *living* organisms, that grow from within & by experience & piece by piece; they are not bought all hanging together, in *any* inspired studio."[91] James diagnoses such "colossal" tabula rasa planning as megalomaniacal, dangerously cut off from any "close relation to some immediate form of life," "cut off from all root-taking in this terribly crowded and smothered and overbuilt ground that stretches under the feet of the for the most part raging and would-be throat-cutting and mutually dynamiting nations." Such designs contradict experience—"the very law of our difficult human sphere being that things struggle into life . . . by slow steps and stages and rages and convulsions of experience, and utterly refuse to be taken over ready-made or *en bloc*."[92] The novelist's suspicions and accusations of megalomania proved to be on the mark: La Fontaine went on to win the Nobel Peace Prize in 1913, at the brink of World War I, while Mussolini granted Andersen ten minutes of conversation in 1926, expressing interest in seeing the "World City" established at Ostia; and Andersen hailed Mussolini's achievements as expressions of shared ideals in a 1935 American broadcast from Rome.[93]

No geographical context would be less accommodating to the World Centre of Communication, with its symmetrical designs splaying themselves to the aerial view of Hébrard's rendering—a kind of rationalized American City—than James's beloved Venice. But as we shall see, Venice's incompatibility did not stop other burgeoning futurists from descending upon the archipelago to imagine such an overhaul in the name of the raging present.

3. ADRIATIC FANTASIES
VENETIAN MODERNISM BETWEEN DECADENCE, FUTURISM, AND THE WORLD WARS

—Cosa xelo sti futuristi
—I xe gente che vede il mondo a l'incontrario

—What are these Futurists anyway
—They're people who see the world backwards
—F.T. Marinetti, *Venezianella e Studentaccio*

"Against Passéist Venice"

We repudiate antique Venice, exhausted and undone by centuries-old voluptuousnesses, which even we once loved and possessed in a grand nostalgic dream.

We repudiate the Venice of outsiders, market of fakers and antiquarians, magnet of snobbery and of universal imbecility, bed unbottomed by caravans of lovers, hip bath bejeweled for cosmopolite courtesans, Cloaca Maxima of passéism.

We want to heal and cicatrize this putrescent city, magnificent sore of the past. We want to reanimate and nobilize the Venetian populace, fallen into decay from its antique greatness, morphinized by a nauseating cowardice and vilified by the habit of its fishy little trades.

We want to prepare for the birth of an industrial and military Venice that would dominate the Adriatic Sea, great Italian lake.

Let us rush to fill the small stinking canals with the rubble of the crumbling and leprous old palaces.

Let's burn the gondolas, rocking easychairs for idiots, and erect the imposing geometry of metallic bridges and factories pluming with smoke to the sky, to abolish the falling curves of old architectures.

Let the reign of divine Electric Light come to liberate Venice from its venal moonlight of bedrooms for rent. (dated April 27, 1910)[1]

When on July 8, 1910, the poets and painters F.T. Marinetti, Umberto Boccioni, Carlo Carrà, and Luigi Russolo hurled a reputed 800,000 copies of this manifesto, "Contro Venezia passatista" ("Against Passéist Venice"), from the early modern Clock Tower of St. Mark's Square—air bombing the crowds returning from fashionable new beach resorts on the Lido—they symbolically hijacked the timekeeping function of the venerable medieval Campanile that had collapsed across the square and ushered the leisure class into a new, accelerated tempo. A follow-up attack was staged through a Futurist *serata* at the Teatro La Fenice on August 1; the manifesto's postscript claims that this variation on the polemic against Venice, delivered to two hundred spectators and later published as "Futurist Speech to the Venetians," incited a riot. Thanks to Marinetti's publicity skills, news of these performances spread at least as far as New York, where the *New York Times* reprinted the "curious manifesto" in translation (replete with its English errors) under the headline, " 'Futurists' Desire to Destroy Venice: Would Pull Down Its Palaces and Replace Them with Modern Factories. They Issue a Manifesto: Want a Commercial and Military City on the Adriatic, Able to Brave the 'Eternal Enemy, Austria.' " The *New York Times* concluded with the judgment that despite their pretensions, the Futurist poets and painters were "decadent."[2] The utmost in a newfangled rhetoric of the modern was indeed being thrust at calculated intervals through an agglomeration of exhausted tropes of decadence—tropes in which Venice was exceptionally fecund.

In launching a critique of the cultural, economic, and hygienic decadence of Venice, the savvy 33-year-old Marinetti was joining better-known personalities of the early twentieth century, including Sarah Bernhardt and the French critic Camille Mauclair.[3] However, the founder of Futurism had specific motives for fulminating against the city of "venal moonlight." At the beginning of 1909, he had circulated the first, founding "Manifesto of Futurism" to a wide range of Italian periodicals before disseminating it internationally. By February 20, when the progressive editor Gaston Calmette published it, with Marinetti's audacious narrative prologue, on the front page of the Parisian daily *Le Figaro*, it had already achieved a certain renown: newspapers and journals from Milan to Naples had printed the text with editorial captions

expressing tacit support for the upstart aesthetic movement. The *Gazzetta di Venezia* was alone in assembling a front-page retort to the manifesto, which appeared the week before its Parisian publication, pairing excerpts with sarcastic point-by-point commentary. The Venetian daily begged to differ with the precepts of Futurism: "there will be opponents to this noble and great ideal of art: the languid lovers of our old local poetry, most ancient poetry that hadn't yet been capable or knowing enough to adopt the frenetic pace, the slap and the punch of Futurism, and contented herself . . . with celebrating heroes, women, love, divinity, the sky, life, death."[4] The newspaper staff was astute in intuiting that their city, with its *vecchia poesia nostrana* ("old local/home poetry"), likened to a *povera vecchia donnetta* ("poor little old woman"), would constitute an ideal target for the nascent movement—as Venice was associated in the cultural imagination with the feminine, love, spirituality, and the patina of expired time instead of "heroes" and "life."

Marinetti's retort to the Venetians became a document seminal to this nascent avant-garde movement: the third manifesto of Futurism, and the first to moor its imperatives in an explicit place. "Against Passéist Venice" echoes Marinetti's second 1909 manifesto-fantasy "Uccidiamo il chiaro di luna!" ("Let's Kill the Moonlight!"; see figure 3.1) while grounding its polemic in real space: "When we screamed 'Let's kill the moonlight!' we were thinking of you, old Venice soaked and rotten with romanticism!" he specifies in his "Futurist Speech to the Venetians."[5] "Time and Space" had not passed away upon publication of the founding Futurist manifesto, despite that document's willful assertions that they "died yesterday" ("Il Tempo e lo Spazio morirono ieri")[6]; the lingering historical centers of decadence, lures for poetic meditations on twilight, would have to be expelled from the new Italy first, and cities to rival contemporary European epicenters of futurity erected. Marinetti calls upon the Venetian citizens to join him in razing their decrepit palaces and dredging canals in order to prepare for "the birth of an industrial and military Venice that could dominate the Adriatic Sea, great Italian lake" (*TIF* 34)— that last phrase phantasmatically sealing off foreign traffic through the permeable city to forge an unfissured reservoir of national sea-surge. Yet the Futurist aims simultaneously at increasing commercial traffic: "Widened and dredged, your Grand Canal is fated to become a great mercantile port. Trains and trams launched along the great streets constructed on canals finally filled in will bring you heaps of merchandise, among a sagacious crowd, rich and bustling with industrials and merchants!" (35).

Revitalizing the city by filling in canals and sections of lagoon, boarding over the Grand Canal, erecting carriageways, developing industry, and

FIGURE 3.1/PLATE H. Giacomo Balla, *Street Light*, oil on canvas, 1910–11, but dated 1909 so as to coincide with the date of Marinetti's "Let's Kill the Moonlight!" Hillman Periodicals Fund, The Museum of Modern Art, New York.

opening the Adriatic to Italian concerns had all already been debated by the Venetians themselves for two decades.[7] Moreover, the Futurists' symbolic brutalization of Venice by "divine Electric Light"—"we want the electric lamps of a thousand points of light brutally to cut and tear your mysterious, bewitching, and persuasive shadows!"[8]—disregards the ongoing initiatives of the Società Adriatica di Elettricità (S.A.D.E.), which had been formed in 1905 to bring hydroelectricity to the Veneto. Yet the performative force of these early modernist tractates does more to drive Venice ruthlessly into the rhetoric of the modern than any piecemeal step toward modernization. From 1917 forward, a group of capitalist impresarios headed by the so-called twentieth-century doge, Giuseppe Volpi di Misurata, founder of S.A.D.E., were to develop the Port of Marghera as the "lung" of Venetian modernity.[9] Yet the Futurist polemic struck such a resounding chord that today's Venetians view the port and petrochemical plants (now rife with controversy) as *Marinetti's* dream realized.

Marinetti's choice to target Venice as the locus antithetical to the values of his nascent movement highlights the specific geopolitical urgencies bolstering the avant-garde's logic of rupture with the past. Pontus Hultén suggests that Italy's marginality, like Russia's, augmented the craving of an avant-garde minority to resist the dominant bourgeois culture centered in Paris. Paolo Valesio clarifies the Futurists' prospects further by proposing that Italy was the ideal state in which to stage a break with the past because, as they intuited, "an effective break . . . can take place only at a weak (but not the weakest) link in the European chain, at the margins (but not at the remote periphery) of Europe."[10] Extending this logic of the periphery to the national context, we can postulate that within Italy, Venice—internal other to Rome, and a signifier of weakened grandeur at the edge of Europe—would be the ideal city in which to stage a rebuke to the reigning European fetishization of the past.

As an Italian national raised in the cosmopolitan seaport of Alexandria, educated in French, and descending upon Venice via Paris and Milan, Marinetti was particularly attuned to the play of cultural dynamics across continental lines. He was thus particularly equipped to recognize in Venice—beyond its obvious need for rejuvenation—a tactical fit for his aesthetic and political agenda. Eclipsed politically and commercially, but still a lure for global elites and the mobile bourgeoisie, Venice constituted a potent harbor of both anxiety and promise for the upstart nation-state of Italy. The city was still seen as an oasis of amalgamated Europeanness bordering on the Orient: historic home to one of the first cosmopolitans, the merchant and explorer Marco Polo—and to "cosmopolite courtesans" such as Veronica Franco, who

attracted an international clientele. Home of diverse foreign populations, the eponymous "ghetto," and the iconic strangers Shylock and Othello, Venice represented, in literature and in life, the advantage and risk of cultural marginality and mixture. At the turn of the twentieth century, foreign influx was on the rise as politicians and planners recognized that the city could revitalize itself by attracting tourists in search of civilized beaches and, above all, of art. The city thus constituted a seductive if anxiety-producing matrix for modernists with political imaginations, both within the burgeoning nation-state and abroad.

"Against Passéist Venice" imparts a visceral sense of what an avant-garde borne by a belief in progress and national fortification felt was necessary to pathologize and suppress. The phantasmatic economy of this document links Venice metonymically with the decadent, the romantic, the faked, the foreign, the domestic, the "Oriental," the carnal, the filthy, the fluid, the feeble, the crepuscular—or, that is to say, the feminine, a category that tends to engorge all of the above, and whose idealization was central to the Republic's self-mythologizing as Venice/Venus/Virgin.[11] At the dawn of the century, Marinetti and his colleagues insist that the moonlit ambience that made the site of the fallen Republic darling to foreign Romantics and their languorous progeny, the Decadents and aesthetes, must be dissolved in favor of a military-industrial complex to serve the lagging nation-state. When "Against Passéist Venice" was launched, preparations were under way for commemorating the fiftieth anniversary of Italian unification, yet the nation had yet to enter modernity in many senses—and its founding would be celebrated through homage to the legacy of classical antiquity at the 1911 World's Fair in Rome. Venice's reputation as the site of amorous interludes had to be expunged if the newly Italian Venetians were to participate in the modernizing mission and take charge of their public sphere: "We are sick of erotic adventures, of luxury, of sentimentalism and of nostalgia!" Marinetti shouted to the crowd at the Fenice Theater.[12] The manifesto's metaphorical treatment of Venice as a consumed, diseased "cosmopolite courtesan" draws on a literary tradition stretching back at least as far as Machiavelli, which was buttressed by the pornography of Pietro Aretino and reputation of Casanova[13]; five hundred years later, the prostitute—an emblem of uncontrolled intercourse and social category play celebrated by the dandy, realist fiction, and the shock of late-nineteenth-century painting—seemed an all-too-literal figure for the degrading tendency of both tourists and Venetians to traffic in the city's romantic past. Marinetti preys analogously upon Orientalist tropes in attacking the city that had for centuries trafficked with the East[14]: the city is cast as a sort of

harem, with feminized *Venezia* rebuked as a Byzantine "procuress" who insists on offering us "veiled women at every crepuscular turn of [her] canals" (35).

Launched on the heels of Daniel Burnham's 1909 *Plan of Chicago*, the Futurist scheme to "cicatrize" Venice, and its resurgence in *Ricostruire l'Italia con architettura futurista Sant'Elia* (Reconstructing Italy with Sant'Elian Futurist Architecture; written between the late 1920s and early 1930s), ushers the nineteenth-century urban ideal of Haussmann's Paris—which was being implemented internationally—into a cityscape particularly unaccommodating to such blueprints.[15] The impetuous Futurist conflation of urban with political contours prefigures broader infrastructural and social campaigns to be espoused by the Fascist regime in the decades to come—signs as much of a "politicization of aesthetics," in a nation appropriating its ancient imperial artistic heritage, as they were of an "aestheticization of politics."[16] These include the military-industrial reactivation of Venice, which under the direction of Count Volpi, Mussolini's eventual Minister of Finance, saw the transformation of Fort Marghera into Port Marghera over the course of the 1920s; *bonifica integrale*, or land reclamation for agricultural and residential purposes, focused on Italian marshlands in the 1930s[17]; the concomitant creation of "New Towns" of rationalist architecture, such as Littoria, which attracted many residents from the Veneto[18]; and the advancing campaign of *sventramento*.

This last, the mission of urban "disembowelment," was the most improbable in a Venetian context, as it entailed the clearing away of architectonic eclecticism, inessential decoration, and "picturesque filth" (as Mussolini characterized it). The Duce's planning crusade would set out to integrate the corporatist project through an urban environment suffused with *romanità* by isolating and freeing the august monuments of imperial (and early Christian) Rome from traces of subsequent epochs that "encumbered" them. In his "New Rome" address in the capital published on New Year's Day of 1926, Mussolini championed the legacy of Augustus as he declared, "You will continue to liberate the trunk of the great oak from everything that still encumbers it. . . . [E]verything that grew up around it during the centuries of decadence must disappear. . . . The millennial monuments of our history must tower over all in the requisite solitude [*debbono giganteggiare nella necessaria solitudine*]."[19] This scheme, realizable only in sporadic parts of Rome's city center and in several peripheral zones, entailed abolishing the remains of nonclassical epochs (or one-third of the historic buildings within Rome's imperial walls, as well as the left-leaning working classes that inhabited them) to make way for stark monumentalism, axial views, and zones of automobile traffic and assembly in the capital and beyond.[20] While Marinetti considered *romanità*

another passéist myth to be combated, it authorized a destructive modernizing campaign that cleared the way for the sterilized routes and circulation of goods called for in "Against Passéist Venice"—in one of many volatile points of convergence between Futurist and Fascist ideals.[21]

Venice's artistic and architectonic heritage renders it singularly oppositional to Fascist urbanization and to Marinetti's anticipatory, if antihistoricist, call for an industrial city. Lacking a direct Roman heritage, Venice is also devoid of any purist classicism, a feature of the cityscape that enhanced its appeal to many artists during the nineteenth century.[22] Venice was built almost exclusively during what Mussolini called the "centuries of decadence," upon an ensemble of small islands unaccommodating to the modern taste for oceanic assemblies and unimpeded display of merchandise. To facilitate movement through the city, two large bridges were to be built across the Grand Canal—which only the Rialto had straddled previously—at the Accademia (in 1933) and the railway station at Santa Maria degli Scalzi (in 1934, as the station was being planned); and canals were filled in around the city to forge several uninterrupted stretches of pedestrian flow.[23] But Venice's resistance to the traffic of the new century would hardly be mitigated by these, or even by the 1932 construction of an automotive causeway connecting Mestre on terra firma with the historical center at Piazzale Roma. The speed and noise beloved to Futurists would be held singularly and symbolically at bay by the confines of the Venetian lagoon. Such noncompliance, rather than keeping the modernists away, only amplified Venice's allure.

From Decadence to Dominance

For years, the phrase "Italian modernism" was considered something of an oxymoron. While the relation of Italian aesthetics to Fascist modernity has become a subject of increasingly nuanced and lively debate since the 1980s, only recently have comparative scholarly efforts worked to conceptualize an Italian modernism conversant with other national modernisms and operating in excess of the terms of Fascist cultural autarky.[24] The term still hovers within the Italian context as a contradiction and lacuna, oscillating in definition between the discordant aesthetic categories of decadentism, hermeticism, crepuscularism, and the avant-garde, and the agendas of Fascism. By conceptualizing such lacunae through the artistic production specific to the "extraterritorial" geography of Venice, we can restore a history of cultural traffic and of clashes between institutional and counterinstitutional discourse

that took place within the still culturally fragmented nation-state of Italy. In turn, we can amend the reductive characterization of this modernist public sphere as exclusively virile, brought into being by the will and manifesto of heroic personalities such as Mussolini and his aesthetic precursors in Gabriele D'Annunzio and Marinetti. The archipelago's structural resistance to the monumental designs defining modernity then ascendant in European capitals renders it an exemplary ground for rethinking this chapter of cultural history. In conjunction with Venice's strategic position along the Adriatic, such resistance intensified the fascination of the place for modernists with political aspirations—though their fascination fluctuated between seduction and repugnance, ultimately encapsulating the ambivalent (and ill-fated) condition of the marriage of aesthetics and politics in this moment.

As a sort of corpse politic, turn-of-the-century Venice spurred political fantasies from a range of national perspectives: those of recent colonizers, their rivals, and Italy itself. Yet the city's legacy as the counter to Rome, or site of a digression *between* political capitals along the Grand Tour, made it prone to absorb, rather than fall in line with, any number of nationalist agendas. Its labyrinthine topography deflected the accelerating geometries of blueprints emanating from Paris or Rome, while its dramatic landscape drew the concentration of artists to "a lyrical obsession with matter" over "the psychology of man," to echo Marinetti's prescription for a new aesthetics.[25] If the territories of the ex-maritime empire are "dissolute," in the obsolete sense of the word—"disunited," and "traversed by flows of power that originate elsewhere"[26]—the archipelago must also lend itself toward imaginative recomposition. However, the Venetian complex, as matter and as literature, tends to weigh upon the imagination as a "splendid accumulation of material," cramping any single designer's power to mold it.[27] In the work of modernists who place increased value on achieving a novel degree of "objectivity," this environment turns from a manipulable metaphor into a medium with the capacity to condition, or even implode, ideological projections.

The impact of Venice, with its "extraterritorial" inclinations and age-old ambivalence vis-à-vis Rome, on Italian modernists D'Annunzio and Marinetti can help us to revisit these authors' variegated careers with an eye toward the way that their writings exceed both the Fascist values with which they have been too readily conflated and their own formal dictates. Their Venetian works bring such excess to the fore: both figures were driven to Venice to redraft the borders of their nation, and eventually to usher the specters of Venetian empire into a corporatist agenda—but these texts are increasingly inflected by the forms and materials of the city itself.

The viral reemergence of Venice in aesthetic experiments of the early twentieth century laces the history of modernism with contradictions: its rejection by the Futurists coincides with its appropriation by artists keen to channel the city's anachronistic forms to new aesthetic (and would-be sociopolitical) ends. The clashes between Italian and foreign allegiances in the literature produced around this aesthetic haunt (and their disjunction from the practical negotiations of Venetians with the pressures of the day) help us to understand modernism as a phenomenon that oscillates, in its obsessions, between the poles of a dichotomy forged by modernity: between nostalgia and an anarchic cult of the new. Notwithstanding their differences, both Futurist and "passéist" modernisms viewed the premodern, anticlassical urban complex as a material example out of which to imagine alternatives to Enlightenment and more broadly rationalist conceptions of history. Unaccommodating to both the axes of modern urbanism and linear histories, Venice represents an opposition to monumental abstraction, always verging on the hazardously sensuous.[28]

To understand the vitriol fueling the Futurist manifesto against Venice, we must first view the city in the reified twilight of Marinetti's immediate predecessors, the Decadents—and above all, of his compatriot D'Annunzio.[29] Decadent fictions surrounding Venice grew out of the intersection of potent, but conflicting, political agendas during the *fin de siècle*. The apparently moribund city was a locus of ambivalence for those contemplating Italy's geopolitical options at the turn of the twentieth century. The provocation of the place continued to derive from its representation as an internal other by both its detractors and proponents: it was, heritage-wise, a city poised between Rome and Constantinople. It represented, on the one hand, a site of Gothic materialism, with its social associations of Protestantism, socialism, and communism—and on the other, a perceived "Oriental" decadence, linked in immediate political terms with the Ottoman Empire.[30] Appropriating Nietzschean concepts inspired by Richard Wagner, who had famously composed the second act of *Tristan und Isolde* (and later passed away) in Venice, *fin-de-siècle* demagogues of the *Übermensch* such as Maurice Barrès invoked the city more and more aggressively as an art-sodden backdrop of physical and moral decline (as well as industrial decline, singled out by Barrès at the Murano glassworks). Barrès cultivates an ideologically determined landscape of "*paludisme*"—literally, "swampism"—of deathly miasmas against which the heroic figure distinguishes himself.[31] D'Annunzio's early novel *Il fuoco* (Fire; or, The Flame), published in 1900 after an extensive period of gestation, participates

in this myth of Venetian decadence as a means of becoming cosmopolitan, or "European" in the literate sense; the Italian author was to pay homage to the decadent tradition in 1911 by dedicating his *Le martyre de Saint Sébastien* to Barrès. However, D'Annunzio's self-consciously patriotic *fin-de-siècle* narrative deviates from those of Northern authors as it dramatizes a thwarted attempt to recapture Venice's majesty, disparaging the majority that considers the city "merely a great, inert reliquary," to whose "pallid eyes Venice appears as a mild city of death embraced by a soporific pond," and who thereby ineffectually "increase that singular scent of sickly things."[32]

In D'Annunzio's handling—both in *Il fuoco* and in his next two decades of fiction and poetry—Venice would instead be resurrected as a crux of Italian access to the Adriatic: the city was an apt focal point for the mounting interest in turning back to the *mare nostrum* claimed by classical Rome in order to redeem Italy, an interest that would swell following the signing of the Treaty of Versailles.[33] In the interwar period, Italian *irredentisti*—those agitating to recolonize former Venetian territories in the East, such as Trieste and Dalmatia, denied to Italy by the Versailles accord--exploited Venice's geographical position to stage the convalescence of the nation-state. Through writings and performances that oscillated feverishly between the aesthetic and the civic, D'Annunzio helped for a brief moment to realign the attentions of Italian political life from Mediterranean to Adriatic currents of power and exchange, thereby rendering Venice central rather than marginal to the future of the nation. Reading the succession of D'Annunzio's Venetian writings in this context, from *Il fuoco* through *Notturno* (published two decades later), clarifies both the polemic of Marinetti's manifesto against Venice and its nationalist aspirations, revealing that it is more continuous with the pasts it rejects than at first appears—for the works of Marinetti's principal Italian predecessor and rival contour a shift in representations of Venice from a magnificent, decaying stage set to a launching ground for expansionist war.

The Flame dramatizes the rejuvenation of Venice and Italy through a reawakening of Venetian artistic traditions. D'Annunzio's protagonist, Stelio Èffrena, is a poet who channels the city's historical legacy in music, painting, architecture, and—in the novel's focal metaphor—glassmaking. The renowned glassworks at Murano, active since at least the eighth century, and linked in its development to the Venetians' 1204 conquest of Constantinople, had languished under colonization in the nineteenth century, as Austria imposed restrictions and taxes designed to favor Bohemian glass production; but following Italian unification, they were being revitalized. *The Flame* opens on an extravagantly depicted late-September dusk at the Bacino di San

Marco; from this opening scene forward, glassmaking becomes the vehicle of transition between Venice's death and rebirth. D'Annunzio's poet conjures an "Epiphany of Fire" (the title of the novel's first half) for his lover and muse, Perdita Foscarina, whose given name alludes to loss and whose surname, hailing from the Venetian family of doges, calls up the term *fosco*, or "dim, overcast, dark"; the aging mistress (a thinly and contentiously fictionalized Eleonora Duse) is identified throughout the narrative with the city. This landscape/woman forms a compliant backdrop for prophecies of the poet, a hero in the form of a self-conscious Nietzschean superman—and for the climactic death of Wagner. In Èffrena's opening vision, time is held in crystalline suspension as lagoon matter, forged through the mastery of Venetian craft into spectacular glass, encases the moribund summer. The mirage of death enclosed serves as a precursor to phoenix-like resurrection: "[D]oesn't it seem that we are part of Summer's funeral procession? . . . [T]he cortège sails her toward the island of Murano where a master of fire will enclose her in a shell of opal glass until, submerged in the lagoon, she can at least watch the soft play of seaweed through her diaphanous eyelids . . . awaiting the time of her resurgence [*l'ora di risorgere*]" (7). The agent of crystallization is the fluid force of "volatile and multicoloured [*versicolore*] Fire," driver of the forge, which transforms the cityscape: flashing and writhing from sky to reflections on the water, fiery dusk transfigures Venetian architecture so that it becomes weightless and measureless, so that doves in flight now tinted gold seem "to attain the heights of immaterial edifices" (76).

D'Annunzio's flame self-consciously concretizes Pater's proposal in the conclusion to *The Renaissance* to burn with a "hard, gemlike flame," "[w]hile all melts under our feet."[34] But the funeral procession imagined here specifically allegorizes the melting away of the *ancien régime*—associated not only with the decadent oligarchy of the late Republic, but also with its conquerors. *The Flame* surveys the decay of patrician life from within the rotting playgrounds of Venice's colonizers in the Veneto: from the Venetian apartment where the Countess of Glanegg, a legendary member of the Viennese aristocracy and a sort of politicized Miss Bordereau, has retired permanently, to the eighteenth-century Villa Pisani, home of exiles from the Napoleonic era, and from 1814 forward, of the Habsburg family and other European aristocrats. Napoleon's bedroom is so reduced from its former grandeur that it sits in "the deafness of the silence in which the great name did not echo at all."[35] The general desolation of the Veneto is reflected in a decaying feminized landscape: "patrician villas—where a life of pale veins, delicately poisoned by cosmetics and perfumes, had faded into languid games . . . were

falling into decay in desolation and silence. . . . [S]ome of them seemed about to disintegrate and crumble into dust like the hair of dead women when tombs are unearthed" (216). The novelist weds Thanatos to Eros repeatedly in figurative terms, as the heroic Stelio imagines "the entire City burning with desire before me, palpitating expectantly in its thousand green girdles, like a lover waiting for her moment of joy"—a fulfillment that consists in death, in feminized Venice's "reaching out her marble arms to wild Autumn" (42–43). D'Annunzio's gorgeously prolonged autumn, the twilight of both landscape and cityscape, parallels the seemingly interminable expiration of the body of the hero's mistress, who is linked to the Venetian "honest courtesan," but evokes as well the figure of the prostitute in the works of Flaubert, Zolà, and Pater. In "loving," this "creature of fleeting flesh" becomes "ardent, ductile matter, subject to all the animations of the poet," who is the metaphorical glassmaker, identified with the Master of Fire.[36]

The abjection of both the beloved and the landscape as matter to be shaped becomes an object of critique in a 1902 review of *The Flame* by Henry James. James parodies the Lord of Fire by casting himself, the critic, as an individual who, sensing some stench amidst hedonistic environs, goes with a flame in search of a gas leak: "The bad smell has . . . to be accounted for; and yet where, amid the roses and lilies and pomegranates . . . can such a thing possibly be? . . . [O]ur test gives us the news, not unaccompanied with the shock with which we see our escape of gas spring into flame."[37] James finds the problem with *The Flame* to be the lack of any reciprocity in the novel's relationships other than carnal exchange: the actors in the work's "most serious relation" are "deprived of any enlarging . . . personal relation, that is of any beneficent reciprocity."[38] James himself, as we have seen, ascribed more agency to both his female protagonist and her animate Venetian environs in writing *The Wings of the Dove*, published the same year.

The prose of *The Flame* does not in fact transmit the lightness or quickness of fire. Rather, in this novel, which casts Venice as "bent over beneath the weight of its own ornament like an aged courtesan" (4), the writing itself comes to function as a weighty ornamental tapestry—one that Marinetti seems to be mimicking in "Against Passéist Venice." D'Annunzio draws heavily, even obsessively, upon the repetition of images as epithets metaphorizing the cityscape, as if the city itself were an amalgamation of encrusted figures. Venice's "thousand green girdles" echo throughout the narrative[39]; the author imagines the lagoon waters repeatedly as "flowing through a terrifying water-clock," or "hourglass" (*clessidra spaventosa*).[40] Perhaps the most frequent epithet casts Perdita as "the woman who was no longer

young": indeed, James mocks the hammering quality of Stelio's representations of "her poor *corpo non più giovane*, as he so frequently repeats."[41]
James describes the resultant picture as "steeped to the eyes in the gorgeous
medium of Venice"; he admits that "the value of the Italian background has
to this end been inestimable, and . . . every spark of poetry it had to contribute has been struck from it."[42] The resultant prose is a "splendid accumulation of material," as he puts it, in ambivalent admiration. Yet in spite
of the pleasure derived in poring through D'Annunzio's gorgeous clusters of
imagery, James as realist is left longing for "the interference of some element
that starts a complication or precipitates an action"—something that would
render Venice more than a "background."[43] The lack of what James calls,
rather prudishly, "moral sense proportionate to the truth" alerts us to a disproportion in the whole, so that the action appears to have been registered
merely "because it was material that the author had become possessed of. . . .
We get the impression of a direct transfer, a 'lift,' bodily, of . . . something not
really produced by the chemical process of art, the crucible or retort from
which things emerge for a new function."[44] D'Annunzio's taking possession
of Venetian material grants little agency to the city itself, differing substantially from the reciprocal interference registered in James's fiction between
figure and Venetian ground. Despite the "local" glassblowing metaphor, *The
Flame* forges a hyperbolically aestheticized, passive, and redundant Venice
of poetry, theater, song, dance, painting, architecture, and craft. The whole
falls in line with a Tintoretto-like "Allegory of Autumn," and this approximates the vision propounded by the text at the level of plot, for as Stelio narrates, "In Venice, just as one cannot feel except through musical modes, one
cannot think except through images. They come to us from all directions,
innumerable and diverse, more real and more alive than the people who
elbow us in a narrow *calle*."[45] The images shored up by this prose register
overpoweringly as *received*, so that the mediated representation of Venice
is more real than its actuality, part of a "decadent nature."[46] James protests
against this, above all, because "in 'Il Fuoco' nothing whatever interferes."[47]

The set piece of *The Flame* is a speech by Èffrena that aims to revivify
the degenerate contemporary inhabitants of Venice through reawakening of
their artistic heritage. It is based on the "Allegory of Autumn" address that
D'Annunzio actually delivered at the Teatro La Fenice (literally, the "Phoenix
Theater") for the closing ceremony of the first International Exposition of
Art in 1895. The expo, an embryo of the contemporary Biennale di Venezia, was inaugurated as an effort to revive the city culturally, but its significance extends well beyond lagunar confines. It was the first such exhibit of

its kind, and the most important worldwide for some hundred years. Its lasting innovation was to merge the model of nineteenth-century international expositions of industrial progress and notions of "national" expression with a characteristically Venetian aesthetic focus: nations would build pavilions at the Public Gardens through which to feature their most promising artistic representatives. The biennial exhibit helped redefine the metropolis as a center of cultural tourism—a role that endures today, both in Venice and globally. It also extended Venice's legacy as a cosmopolitan, international center of exchange—a legacy that would stand in increasing contrast over the coming decades to that of Rome, the site of elaborate nationalist political exhibitions, beginning with the 1932 *Mostra della Rivoluzione Fascista* (Exhibition of the Fascist Revolution).[48]

In its fictional transcription, D'Annunzio's speech is delivered as an extemporaneous performance in the Ducal Palace's Great Council Hall, where it evokes more vividly than in a theater the cultural and political past the superman/orator hopes to reawaken in the stock of his listeners. Èffrena feels disgust in facing the contemporary Venetian crowd, represented many times over as a "*smisurata chimera occhiuta*" ("immense eyed chimera") at odds with the strength and beauty of this historical space.[49] He dreams of recovering the dignity of the Venetian populace immanent in the art of Veronese, Carpaccio, Bellini, and especially (in Paterian key) Giorgione, whose revelations "fire" Venetian art, and, by association, the dignity of "Latin" races (who are set repeatedly against "barbarian" races).[50] Èffrena imagines that upon listening to him, the feminized "soul of the multitude" seems to find "the indestructible signs of primitive generations within herself . . . and recognize her right to an ancient heritage [*retaggio*] of which she had been despoiled: that heritage which the messenger was announcing to be still intact and recoverable" (62). Once again James's lampooning of the D'Annunzian hero as "quivering intensely with the treasure of his 'will,' inherited in a straight line from the cinque-cento," is instructive, and clarifies what the American author was pressing against in his own prose.[51] James charges that in D'Annunzio's work, "the will is a sort of romantic ornament, the application of which, for life in the present and the future, remains awkwardly vague, though we are always to remember that it has been splendidly forged in the past."[52] The "ancestral" assertion of a direct connection with the past registers as forgery because it prevents D'Annunzio from contending with the tortuous process of cultural inheritance—a digressive and disjunctive process, which James's portrayals of historical mediation, as well as those of Ezra Pound's more disruptively anachronistic modernist works, sought to reinstate. Faced

with D'Annunzio's unproblematized relation to fossilized historical exempla, one begins to comprehend the vehemence of Marinetti's impulse to destroy Venice's antique environs altogether.

Èffrena's speech to the Venetians ends on a typically carnal image of fertility promising ancestral awakening. Contemplating the prow sculpture of an imaginatively reconstructed *Bucintoro* (the doge's ceremonial barge, the last of which had been set to fire by Napoleon to plunder its gold) that reenacts Venice's ritual *Sposalizio*, or marriage to the sea, Èffrena cries, "There is the distant ship! It seems to be conveying a message [*annunzio*]. Look at the thighs of the symbolic Woman! They are capable of bearing the seed of a world" (63). D'Annunzio's next Venetian work, *La nave* (The Ship; 1908), collapses this romantic distance from Venice's maritime glory through a willed classicism, casting itself into the perspective of the vessel itself in a more imperialist, propagandistic key. This sequel of sorts actualizes Èffrena's political longings to dominate the sea, which find their inspiration in Venice past: "In another age," Èffrena dreams, "I might also have been able to conquer an Archipelago."[53]

While the tedious subjection of Foscarina/Duse to the will of her superman/lover persists throughout *The Flame* (even as she ultimately leaves Èffrena to his poetry and pursues her acting career abroad), D'Annunzio had been inspired by, and collaborated with, Duse herself to create a great Italian tragic drama, a total theater.[54] *The Ship*, a play in verse celebrating the maritime dominion of Venice, troubles the aesthetic categories normally assigned to works of this period: despite its Symbolist and aestheticist impulses, the poetry vaunts a nationalist orientation, choral structure, and syntax that participate in the *école romane*, a self-conscious "Latin Renaissance" aspiring to return to the classical harmonies and collective functions rejected by Romanticism. In line with this shift in genre—and as Ildebrando Pizzetti's compositions for the work, based on medieval choral music, accentuate—*The Ship* subsumes the isolated hero of earlier works, and instead renders a collective voice the catalyst for shoring up the state. Breaking down the imperious subjectivity represented by Èffrena, which was set against the confusion of monstrous masses, *The Ship* disperses its voicings among nameless clusters of the Venetian populace; its choral harmonies constantly threaten to give way to the anarchy of the frenzied crowd.

In political terms, *The Ship*, dedicated "to the Adriatic Sea," lays out the parameters of a veritable D'Annunzian phenomenon later defined as "Adriatic nationalism."[55] The work invokes Venice as an instrument of the interventionist campaigns leading up to World War I, resonating with the production of pro-war publications in the city.[56] Performed provocatively before King

Umberto and Queen Margherita in Rome's Teatro Argentina in January 1908 before moving to La Fenice for St. Mark's Day, *The Ship* enjoyed a rousing success as both propaganda and art, adapted as a silent film in 1912 and as an opera in 1918 (with productions traveling as far as Chicago). It invokes the infrastructural and military rise of a sixth-century Venice-in-embryo, defined from the start in mythic and archaizing terms as "la città novella che il popolo libero dei Pròfughi—sfuggito al ferro e al fuoco dei Barbari, francato dalle leggi della patria illustre—costruisce su le velme, su le tumbe e su le barene col legname delle foreste e col pietrame delle ruine" (the novel city that the free populace of Refugees—fled from the iron and the fire of the Barbarians, freed from the laws of the illustrious fatherland [Rome]—constructs on the velme, on the tombs and on the mudflats with the wood of the forests and with the rock of the ruins).[57] D'Annunzio emphasizes the act of will it took on the part of refugees under duress to build this cityscape, as his fictional Magistrate of the Waters declares, "Dov'era mare, sarà terra; dove / terra, mare a giudicio del Dio nostro / che di sua mano vi governi il legno" (Where there was sea, there will be land; where / land, sea by judgment of our God / which shall govern your wood with his hand [14]). Though the hendasyllabic meter and exalted lexicon through which D'Annunzio's message is channeled could not be more antithetical to Futurist dictates, the foundational ambition of this tragedy is essentially akin to that of Marinetti's contemporary manifesto: the play literally stages the national turn to the *mare nostrum* to recolonize coastal territories along the Adriatic Sea (which "Against Passéist Venice" will wishfully represent as a "great Italian lake"). The work's opening hymn ends with explicit reference to this discourse:

> . . . O Iddio che vagli e rinnovelli
> nel Mar le stirpi, o Iddio che le cancelli,
> i viventi i viventi saran quelli
> che sopra il Mare
> ti magnificheranno, sopra il Mare
> ti glorificheranno, sopra il Mare
> t'offriran mirra e sangue dall'altare
> che porta rostro.
> Fa di tutti gli Ocèani il Mare Nostro!
> Amen.

> . . . O God who weighs and replenishes
> tribes in the Sea, o God who erases them,

> the living the living will be those
> who upon the Sea
> will magnify you, upon the Sea
> will glorify you, upon the Sea
> will offer you myrrh and blood from the altar
> that bears the rostrum.
> Make Our Sea of every Ocean!
> Amen.
>
> (opening, n.p.)

The restraint of such passages, whose language aspires toward hardness, is met by a self-consciously Orientalizing, "barbaric" clamor in other sections. The juxtaposition of the two styles invites comparison with the Apollonian and Dionysian impulses that will be scattered through Pound's *Cantos*, but it has contemporary political implications as well. As a stylistically elaborate Symbolist drama composed in a classicizing idiom, *The Ship* dramatizes through both plot and form the threat of Venice's submission to the seductive East, coded as effeminate, on which it verges—a possibility that would rupture the dream of an autochthonous, virile Italian *stirpe*, or "stock" (or, in Pound's eventual translation, "tribe").

The conflict between possible futures for the nascent Venice of this play—a pull between the two Romes of Venice's cultural heritage, or the current Italian political capital and the Ottoman Empire—comes to a head in the plotted conflict between destruction, in the form of the mythical whore Basiliola Faledra (representing a dissolute Greece/Byzantium), and a savagely virile superman, the political "despot" Marco Gràtico, a Venetian of Roman ancestry (as according to the city's legend), who assumes a divine (Catholic) mandate to conquer and plunder the seas.[58] Venice thereby becomes a site for programmatically conflicting energies: land versus sea, man versus woman, Christian versus pagan, autochthonous state versus a state of amalgamated peoples. In the process, D'Annunzio distinguishes Parisian modernism (coded as Byzantine) from a new, virile Italian modernism capable of rising out of decadence to dominance—though the poet's own weakness for luxury, seduction, and décor (shared by his hero) poses obstructions to such an opposition.

D'Annunzio's nationalist imperatives are couched in literary trappings that would be regarded as anathema by the rising Futurists. Repetition creates an arras-like decorative texture in *The Ship*, as it had in *The Flame*; in verse, D'Annunzio indulges more fully a taste for the vestments of ritual and archaic idioms, and forges linguistic patterns akin to those of Gustav Klimt's

contemporary canvases, which themselves emulated Byzantine mosaics. While *The Ship* enjoyed popular success in its day as theater, its devotion to tradition keeps it from being remembered as poetry, because its ponderous phrasings are out of step with the direct approach to language soon to be propounded by modernists (including D'Annunzio himself).

> Ma non a furia sùbita di nembo
> tagliaste mai la gòmona in travaglio
> abbandonando l'ancora nel fondo
> per cappeggiare contro la tempesta?
> Tale nel fondo il peso dell'antica
> cittadinanza, tronco il suo ritegno.

> Did you never in the overwhelming fury of the cloud
> slash the hawser in struggle
> abandoning the anchor to the depths
> so as to heave against the tempest?
> Thus into the depths the weight of ancient
> citizenship, severed its restraint.
> (Prologue, vol. 2, 64)

In this stanza, "the weight of ancient / citizenship" threatens to sink the verse as well.[59] D'Annunzio's research on the Venetian dialect for *The Ship* presages the linguistic experimentation of Andrea Zanzotto, though with very different political and aesthetic outcomes. Here, he makes an objective reality of the mythical autochthonous "tribe" (the one Stelio inherited fabulously, as if in a straight line) through the performative metaphoric use of a Venetian image: the anchor. Charged with the same desire to channel the latent forces of history into an objective present tense, and admiring D'Annunzio's ability to "move the crowd in a theatre," Ezra Pound—who quoted from *The Ship* in both his essays and in *Rock-Drill de los Cantares*—came to theorize this method of activating tradition for a generation of writers.[60] As we will see, Pound offers us a crucial perspective on these Italian modernists, as he amalgamates their backward- and forward-looking approaches to Venice. He does so by shunning recurrence to figurative language altogether, concretizing sociopolitical visions through direct citation and juxtaposition of historical fragments, and thereby imparting to the "tale of the tribe" an archival clarity and integrity. But first, Marinetti will attempt to revamp D'Annunzio's campaign of resurrected citizenship by doing away with the archive altogether.

CRASHING THE SALON

Having reconstructed the political and artistic context of D'Annunzio's Venetian writings, we are better equipped to appreciate the extremist rhetoric of "Against Passéist Venice": drafted on a sheet of hotel stationary, the Futurist manifesto aimed to take the cosmopolitan sea-city back for a rising Italy. Venice could vie with other world cities again only if it recuperated its heroic energies and ceased debasing itself by accommodating the moonlit fantasies of foreigners. Decades of literary nostalgia were still drawing highbrow and lowbrow tourists to the defunct city-state. Equating history with illness as Nietzsche did, Marinetti wanted these spectators and their poetry expelled: he exhorted the Venetian crowd, "Free Torcello, Burano, and the Isle of the Dead from all the diseased literature and endless romantic fantastication draped over them by poets poisoned with the Venetian fever, and laughing with me, you will be able to think of these islands as heaps of manure dropped here and there by mammoths as they forded your prehistoric lagoons!"[61] But his atavistic vignettes of Venice could only embellish—even as they snubbed—the clichés produced by these parasitic poets; presenting a Venice stripped of historical contamination was far more difficult. (In 1915, Wyndham Lewis administered an ultimate insult as he branded Marinetti's propaganda "tyranically literary," "romantic and rhetorical."[62])

Marinetti's attacks on tourism were not restricted to the manifesto genre. In his *serata* "Speech to the Venetians," which effectively revises that of Èffrena, Marinetti transforms the administered, if dilapidated, scene of tourism into an abject allegorical terrain of boundless filth navigated by imperial sightseers: "Say your guest is an Emperor: for hours he has to navigate the filth of this immense sewer full of cracked historical crockery; his gondoliers must dig their way with oars through several kilometers of liquefied excrement, passing close, in a sacred stink of latrines, by barges heaped with lovely garbage, escorted by dubious floating paper bags . . . !"[63] This parodic panorama of servility had some grounding in Venetian civic policy. Despite the arguments of the Medical Chief of Hygiene, plans for workers' housing on the Lido were being deflected to make way for tourist establishments like The Excelsior and the umbrella Compagnia Italiana dei Grandi Alberghi (Italian Company of Grand Hotels), which Marinetti singles out for scorn.[64] In this scenario, recapitulated and elaborated by the manifesto, local labor was being left to its own filth even as it enabled the illustrious tourist destination.

Death in Venice—begun the following year and published in 1912, as if Mann had set out to rebuff Marinetti's aspirations outright—echoes such critique, but from the tourist's perspective, with a healthy dose of the *paludisme* that Barrès developed in his 1903 *La mort de Venise*. Gustav von Aschenbach discovers that his asylum in Venice has been infiltrated by Asiatic cholera from the Ganges delta—and that the local authorities are invested in covering it up: "concern for the newly opened exhibit of paintings in the public gardens, for the losses that the hotels, businesses, and the whole tourist industry would suffer in case of a panic or a boycott—these matters proved weightier in the city."[65] Aschenbach's hallucinations of an atavistic Venice throughout the novella echo Marinetti's erasure of history in the lagoon; but while Mann taps into Venice's primeval aspect to nurture an aesthetic program of "Mythos plus Psychologie,"[66] the Futurist expunges history in the service of social reconstruction.

As activists, the Futurists viewed that "newly opened exhibit of paintings" as a fundamental part of civic health; like D'Annunzio, these artists were pioneers in promoting the vanguardist precept that civic change arises through the renovation of consciousness. The charge of Venetian deference to tourists, so impassioned in "Against Passéist Venice," was staged strategically during the well-publicized preparations for the ninth edition of the International Exposition of Art that D'Annunzio had helped inaugurate in 1895. The Futurist bombardment of St. Mark's Place with manifestos seems to have drawn the attention of the *New York Times* because of the exhibit's reputation: the newspaper's publication of the manifesto begins, "Not long ago there was a curious scene in Venice, where, in the last few years, the International Art Exhibition has gradually become one of the most important artistic events in the world."[67] As the first aperture of modern Italian art to a broader European context, the exposition was instrumental in rendering Venice once again a prominent crossroads of prestigious cultural flows. However, after a pioneering start, which included the display of English Pre-Raphaelite paintings, French and German Symbolism, and Whistler's *Woman in White*, the exhibit had become more conservative in its tastes, and in its initial years hosted few artists at the cutting edge of aesthetic trends.[68] To young artists like Marinetti, the mortification of the fallen Republic would only be prolonged by a culture that upheld French salon standards and lauded works by recent colonizers such as those of the Vienna Secession. Gushing reports by the *Gazzetta di Venezia* on the number of foreign aristocrats and authorities— "august Princes" and "excellencies"—attending the exposition's opening ceremonies likely repelled the Futurists, who effectively hailed from bourgeois

backgrounds.[69] From the standpoint of those wishing to overcome Venice's association with the decaying *ancien régime*, such an assembly of figureheads would constitute an embarrassing token of servility.

The young artists launched their antidote: not only the manifesto, with its follow-up "happening" *avant la lettre* at St. Mark's, and that summer's Futurist *serata* at the Fenice Theater, but an infiltration of the expo galleries themselves. According to a 1926 history of *The Venetian Biennials of the Avant-Guerre (from I to XI)* by the critic Arturo Lancellotti, published by an Alexandria press, the ninth expo's international galleries were notable for "two . . . Futurist paintings by Romolo Romani" (ellipsis in original). The expo launched a new initiative that year in devoting a hall to young artists, but it was in the international galleries instead that the youthful avant-garde of Italy would make its first Biennale appearance. Romani (1884–1916), a young Milanese painter of abstract *Sound Reflections* and *Prisms*, had contributed to Marinetti's journal *Poesia* and met Boccioni and the architect Antonio Sant'Elia around 1909, and was embraced immediately as "an authentic Futurist."[70] He was one of the signatories of the first "Technical Manifesto of Futurist Painting" leaflet printed for *Poesia* in 1910, but quickly withdrew from the group upon the violent reaction of the public; in the official manifesto of February 11, the signatures of Gino Severini and Giacomo Balla appear in his place alongside those of Boccioni, Russolo, and Carrà. Romani's withdrawal did not, however, prevent the Futurists from seizing this opportunity for another publicity stunt in the halls of the international establishment. Lancellotti reports that the "gregarious" Futurists disseminated copies of a manifesto lacking Romani's signature (identifiable as the "Technical Manifesto") through the expo halls themselves, citing its polemic against the "pure lies" of pictorial convention, illusionism, and opacity, and its valorization of the destruction of space through atmospheric rendering and electric luminosity.[71] With this infiltration of the salon, the newly launched group of painters thumbed a collective nose at the establishment while making the most of Venice's "passéist" international forum to expound their agenda.

A decade later, Giacomo Balla executed a "Futurist Portrait" of Carlo Carrà on the frontispiece of the illustrative supplement to Lancellotti's book (figure 3.2), commemorating these early penetrations of the establishment (and, indirectly, the war they anticipated). The portrait in watercolor and colored pencil marks the men's aesthetic and affective bond with "a brotherly hug" by crossing, as if to cross out, the contours of a female allegory of victory perched on a gondola prow with explosive centripetal lines of force, reinforced by the composition's corner arrows. The halo of an

FIGURE 3.2/PLATE I. Giacomo Balla, *Ritratto Futurista [Carlo Carrà]*, 1918–20, colored pencil and watercolor, on frontispiece of illustration supplement to Arturo Lancellotti's *Le Biennali veneziane dell'ante guerra. Dalla I alla XI* (1926). Reads "Futurist Portrait / Italy // to my friend Carrà / a brotherly hug / from your Balla the Futurist. . . ." Collection of the American Academy in Rome.

audacious chromatic spectrum and inverted elliptical curves that culminate in a "B" for "Balla" upset the delicate balance of the frontispiece's classical silhouette—simultaneously serving to frame, even to exalt, the characteristically low Venetian skyline they surround. The mixed-media work, with its strategic choice of found material and "compenetration" of figure and ground, synthesizes immaculately the Futurist use of Venice as, simultaneously, a matrix of negation caught in the crosshairs and a vortex for brewing aesthetic ideologies.

The impact of "Against Passéist Venice" and related Futurist performances at the expo was more retrospective than immediate. In its coverage of the opening ceremonies, the *Gazzetta di Venezia* recognizes voices of protest only by way of negation: "not the slightest incident disturbed the solemnity of the celebration, and the noted screeching of one orator was lost, suffocated by the unanimous hymn to the new affirmation of beauty."[72] This aesthetic affirmation perceived as "new" resulted from an exhibit featuring works by an aged Renoir and the dead Courbet—though it must be acknowledged that in context, these curatorial choices were regarded as relatively progressive and cosmopolitan. Gino Damerini, the director of the *Gazzetta* and an influential critic, argued somewhat belatedly that in its first fifteen years, the expo had moved from a focus on Impressionism to "a vivacious movement of aspirations toward the ideal, toward the symbol, toward dream, toward decorative fantasy" and praised its "new conceptual and aesthetic tendencies."[73] The ninth expo awarded Grand Prize to the Austrian Gustav Klimt, whose retrospective of paintings was eulogized for the very qualities Marinetti detested: refined aestheticism, feminine grace, brilliant ornamentation, and the composition of harmonious symphonies in precious hues—all demonstrating affinities with the millennial Venetian decorative tradition, and culminating in the 1905 *Three Ages of Woman* included in the exhibit. Damerini praises Klimt as "the most acute and profound conductor of femininity and modern voluptuousness; philosopher and ironist; sentimental and satirical poet."[74]

To Futurist eyes, such verdicts would have perpetuated passé *fin-de-siècle* ideals and the fetishism of the past represented by the city's conservatism at the urban scale—exemplified by its choice to rebuild the San Marco Campanile, which had collapsed in 1902, exactly *com'era, dov'era* ("as it was, where it was"), rather than pursuing a bold new design. This six-year reconstruction project, which attracted international attention, began in 1906 and was under way at the time of the manifesto. Marinetti traces the Venetian penchant for self-replication to "the deplorable Ruskin," declaring that the English critic would have applauded the passéists who "wished to reconstruct that absurd

Campanile of San Marco, as if to give a little girl who had lost her grandmother a stuffed cardboard doll destined to stand in for the defunct."[75] But the "Futurist Speech to the Venetians" chastises the Venetian populace above all for perpetuating the Ruskinian wake: "you were once invincible warriors and genial artists, audacious navigators, industrialists and tireless merchants. . . . And you have become hotel waiters, tour guides, pimps, antiquarians, swindlers, makers of old pictures, plagiarous painters and copyists. Have you thus forgotten to be Italians above all, and that this word, in the language of history, means: *constructors of the future?*"[76] History would prove correct Marinetti's linking of cultural to industrial development, though he failed to prevent tourism from becoming the central industry of the city's future, or indeed to recognize the potential reciprocity between these enterprises. Count Volpi, the principal protagonist in the development of Port Marghera from 1917 forward, governor of Tripoli from 1921 to 1925, Mussolini's Minister of Finance from 1925 to 1928, and eventual president of the Biennale—who in 1932 instituted the world's first international Biennale of Film as well—acquired the Lido's Excelsior and Grand Hotels after World War I, helping bring about Fascism's rapprochement with capitalism. (Pound would memorialize this figure in *The Cantos*, citing "Volpe's kilowatt energy" in a move that would have pleased Marinetti, as Volpi was responsible for the rural electrification of the Adriatic coast.[77]) The "constructors of the future" in Venice would not, in the end, be those who destroyed history, but those who managed strategically to reconstellate its artifacts and redirect its energies.

Despite its broad attack on Venetians, the Futurist manifesto was actually in line with local efforts of aesthetic dissent against the backwardness of the expo. The exhibit's conservatism had roused the oppositional energies of a youthful avant-garde that gathered around Nino Barbantini, curator of a new museum of modern art on the Grand Canal at Palazzo Pesaro, patronized by the Duchess Bevilacqua La Masa, enjoined to support young artists "who are often compelled to cede their works to vampiric hawkers and speculators."[78] The composition of "Against Passéist Venice" coincided with the inauguration of Ca' Pesaro's collection in April 1910, while the aerial bombardment of manifestos upon St. Mark's Square in July was clearly timed to advertise the young Umberto Boccioni's first solo exhibition at the core of this so-called counter-Biennale. Boccioni had studied and worked in Venice in 1907, amplifying his approach to landscape and his experimentation with color and space.[79] The forty-two paintings and drawings displayed at Ca' Pesaro consisted mainly of works in a Divisionist vein, but Boccioni was already forging his stylistic passage to the Futurist *Riot in the Galleria, States of Mind,*

and *The City Rises* that year within the city that sinks. He began working on the canvas for *The City Rises* shortly after the opening, requesting an advance from Barbantini on sales for more materials with the words, "You can see that there's meat on the fire; let's hope it goes well and death to passéism!"[80] Marinetti seized the chance to reiterate Futurist principles in his catalogue essay. In a review of the show, Damerini judged the Futurist cause "completely outside of the innovative current of aesthetic theories; arbitrary and dogmatic; rendered possible only by a deficiency of modern artistic culture, lacking even the value of novelty."[81]

The Futurists were not recognized officially by the Biennale di Venezia for another sixteen years, after most of the original members of the group had dispersed and Boccioni had been slain during military drills for the Great War. Notwithstanding the Futurists' nationalist agenda, their revolutionary energies and irrepressible negativity made for a volatile relationship with the increasingly reactionary Fascist party as it rose to power from 1919 forward. Even the second wave of Futurism, which made amends with the regime after 1923 by proclaiming its own restriction to the domain of "pure fantasy," plied a highly contradictory course.[82] In 1926, it was the Soviet Pavilion, not the Italian one, that conceded space for the Futurist Biennale exhibit Marinetti curated. In 1929, however, Marinetti—who had once called for the dissolution of arts academies—became an official part of the establishment, appointed by Mussolini as Accademico d'Italia; the opportunism was mutual. Marinetti curated a Futurist exhibit for nearly every expo thereafter until 1942, using it as a base for launching "aeropainting," with its celebration of flight's synthesis and cosmic transfigurations.

Marinetti's fantastic bombardment of Venice by manifesto was only the first and most rhetorical episode in a lifelong vacillation between strategic assaults and reconciliations with the city of lagoons. A Futurist *serata* he engineered in May 1911 that took a more conciliatory approach to its audience and ensuing performances evoked enthusiasm on the part of Venetians; by the mid-1930s, a group of Futurists had gathered in the Veneto under the name "Savaré."[83] Marinetti was to return to Venice for a final rapprochement in the bitter denouement of World War II, engaging the topography he had rhetorically razed in an "aeronovel" and a work of words-in-freedom called "Convegno sul Canal Grande" (Encounter on the Grand Canal), whose sparse lines sound and materialize the revivifying thrashing of a ferry boat against the frozen city's contours.[84]

Executed on the title page of a history of *avant-guerre* Biennials, Giacomo Balla's fraternal portrait of Carrà already accomplishes something more

substantial: it reframes both the expo and its host city in terms of world war. The face of Carrà, rendered in cartoon-like strokes that mime ambient lines of force, also assumes the hues of the national *tricolore* from the violently buoyant color spectrum floating above it. As such, the piece both transgresses and resuscitates the cosmopolitan Venice of the salon—in the name not only of Futurism, but also of an "*ITALIA*" hovering in capital letters, whose relation to the portrait as a whole remains unclear. Through this portrait, produced after the devastation of the Great War, we gain a sobering historical perspective on the "artificial optimism" of the Futurist *avant-guerre*,[85] its prewar aspirations rendered legible as either nostalgic or delusional.

D'Annunzio's Venice as Political Front

The historical record is prone to gloss over the fact that as the first Italian city to be attacked in World War I, Venice constituted a front: the Austrians forced Italy's admission into the Great War on May 24, 1915, with nineteen bombs landing in the Arsenal zone (see frontispiece). Venice's extenuating spatial situation in a shallow lagoon, a source of its longstanding sovereignty, rendered it necessary indeed for Austrians to attack the city from the air—in 1915 as in the nineteenth century. Within a few weeks, the face of the city, then hosting the 14th International Exposition of Art, changed completely. Over the course of the following forty-two months, the city was subjected to more than forty air raids, with more than a thousand bombs dropped, most upon nonmilitary targets (though those dropped on St. Mark's and the Ducal Palace fortunately did not explode). In the years prior, Venice had, as we have seen, become a haven for residual personalities of the *ancien régime* and upstart protagonists of the wealthy bourgeoisie—from Princess Marie von Thurn und Taxis, patroness of Rilke, to the American expatriates Daniel and Ariana Curtis, hosts of artists such as James and Sargent; it had become an ideal receptacle of the Belle Époque. Now the commercial port was closed, hotels were converted to hospitals, unemployment skyrocketed, and economic crisis set in. The civic population plummeted from 158,698 in July 1914 to a historical low of 40,263 in April of 1918 as aristocrats and the moneyed fled, until the armistice ushered in a chaotic period of repatriation.[86] During the buildup to and fallout of war, the ghost of the maritime empire and border hub loomed over a sharpening national imagination, while its lasting grandeur within art history—only enhanced through the contrast with its current devastation—led artists to seize it as a stage for dramas of sociopolitical renewal.

Stage-set became a battleground in July 1915, when as a 52-year-old volunteer for combat, D'Annunzio decided to make Venice his headquarters. D'Annunzio had become the foremost poet-aviator of Italy when he flew with Wilbur Wright in 1908 and was honored by a flight at the first international air meet at Brescia in September 1909, launching a veritable air craze in Italy that crossed political and cultural realms. The poet's eight-minute flight was featured in the cultural section of the *Corriere della Sera* as he proclaimed the birth of no less than "a new sensation . . . a new necessity, a new passion."[87] During the war, the poet became commander of the 87th flying squadron, which he provocatively named *La Serenissima,* appropriating Tintoretto's image of St. Mark freeing a slave as emblem, and the Lion of St. Mark as embellishment for his fighter plane, in what has been called a "rhetorical and ideological bombardment without equal" of *venezianità* (a word that had for centuries demarcated and celebrated the alterity of Venetian values with respect to Roman ones). D'Annunzio's campaign is credited with having successfully shifted "the ideological, geographical, and semantic axis of the war" from the Mediterranean horizon of Italy to the Adriatic.[88]

In January 1916, while operating as observer in a propaganda mission over Trieste, D'Annunzio was thrown against a machine gun in a seaplane's emergency landing, and the retina in his right eye was detached. During three months of convalescence at the Casetta Rossa—a palace on the Grand Canal where Antonio Canova had kept a studio and the Austrian Prince Frederick von Hohenlohe had lived—he composed *Notturno* (Nocturne), an experimental work of prose poetry D'Annunzio called his "commentary on the shadows."[89] The work was constructed laboriously out of more than ten thousand strips of paper wide enough for one or two lines of writing, all scribbled blindly when the recovering author was obliged to remain supine, immobile: teeming observations from the literal darkness composed almost exclusively in a distressed present tense. D'Annunzio claimed that during the production of this work, "[t]he optic nerve drew on all the strata of my culture and my previous life, projecting innumerable figures into my vision."[90] The process of revising and retroactively ordering these fitful glimpses on sibylline "scrolls" took five years, and it changed D'Annunzio's style intrinsically; for as he noted, extending the metaphor of the forge established in *The Flame*, "I had a forge of dreams inside my wounded eye which my will could neither conduct nor interrupt."[91] The romantic will satirized by James no longer commands this imaginary forge; the eye itself is abjected, and the author's every word and syllable, asserted in the constative mode to be written "on water" instead of sand, "vanishes as if in abduction by a dark current."

The narrative cognition that results takes on the fluid yet discontinuous trajectory of the archipelago in which D'Annunzio lies and writes: "Thought rushes as though across a bridge that collapses behind it."[92] *The Ship*'s wistful metaphor of heritage as anchor becomes more tenuous as D'Annunzio's lofty idiom is conducted through a newly direct and restless prose: "Scrivo come chi caluma l'àncora, e la gomena scorre sempre più rapida, e il mare sembra senza fondo, e la marra non giunge mai a mordere né la gomena a tesarsi" (I write like one who lets the anchor slip, and the hawser runs faster, and the sea seems bottomless, and the fluke never arrives at its bite, nor the hawser its frap).[93] In a harrowing shift from *The Flame*'s willful focus on the decomposition of the "aged" female body, D'Annunzio's involuntary dreams now include the bodies of dead young soldiers from what would soon be hailed by Fascists as a *vittoria mutilata* ("mutilated victory"). These visions cause fantasies to well up of "a city washed by Lethe or Avernus" before "Ghosts pass by, graze, vanish."[94] Ezra Pound, the recent author of "Three Cantos" ("Ghosts move about me patched with histories") translates from *Notturno* in a 1922 essay as he praises its ambitions: "I am stretched by the window. The moon is full. There is no wind-froth about her.[. . .] / There is no voice heard, no fall of oars, no rumour at all. Life seems to have breathed itself out ages before. . . . / And the insensible moon contemplates a beauty as exanimate as that of Angkor or Anuradhapura."[95] Pound, who had in 1913 echoed Ford Madox Hueffer in calling for an objective, precise "prose tradition" in poetry, found a touchstone in D'Annunzio's fractured prose topography; in *Notturno* as in Pound's evolving *Cantos*, a dream of sociopolitical totality endures in suspension while the truncation of rhetorical linkages between passages generates an intrinsically fragmented whole.[96]

The experience of convalescence also fueled D'Annunzio's extraliterary activities: his interwar political escapades. At the end of the Great War, Venice itself was vindicated in the face of its former colonizer and reconciled with France, but crisis set in on a national level. The war had served harshly and at last to unite long-disparate strains of Italian regional consciousness as part of a traumatized and enraged collective (though the broad gap in living conditions between a modernized North and agricultural South persisted). After four years of impossible conflict, there were 700,000 mutilated veterans in Italy between 17 and 55 years of age forced to survive on a minimal pension provided by the state, while an economic crisis without precedent was taking hold throughout Europe. The Treaty of Versailles nullified the secret 1915 Treaty of London that had promised Fiume and part of Dalmatia to Italy in return for its entry into the war on the side of the Allies. This snub became

fodder for vengeful plans for Italian expansion across a gamut of political tra-
jectories; these political schemes, though often self-contradictory, were based
on a common fact: "the ideology of war, violence and power had become
one of the bases of Italian society."[97] Between 1918 and 1920, a "confusedly
subversive and revolutionary psychology" was taking root in a number of
"more or less political" developments in Italy against a government that was
widely considered to be inept and to have left most of the population dis-
enfranchised: the growth of revolutionary syndicalist and interventionist
movements, the belligerent leftist movement of *Arditi del Popolo*, the birth
of the Futurist Party, and the first *Fasci di combattimento*. On the ground,
as ideological ambiguity was marshaled into differently "revolutionary" fac-
tions, Venice became a literal site of battle between blackshirts wielding hand
grenades and socialists armed with boiling water and roof tiles in the work-
ing-class zones of Castello, Dorsoduro, and Cannaregio.

Prominent among these developments was the notorious seizure, between
1919 and 1921, of the historically Venetian port of Fiume in Dalmatia led
by D'Annunzio himself (and supported by various Futurists, including
Marinetti—until he was ousted for aggravating command).[98] D'Annunzio jus-
tified his occupation of Fiume through a rhetorical campaign of *irredentismo
adriatico*, alleging that Italians were among the "oppressed races" unjustly
treated by the Treaty of Versailles and must reclaim former Venetian posses-
sions along the Adriatic that were rightly theirs. While stylistically repellant
to the Futurist agenda, D'Annunzio's literary seizure of Adriatic topoi shared
(and undoubtedly helped shape) Marinetti's perception of Venice's strategic
importance in redefining the nation—and actualized this political dream in
a moment when the Futurist Party and its alliance with the rising *Fasci di
combattimento* were in crisis.

Because the Venetian Republic had been governed according to local cus-
tom, aloof from an evolution that led other Italian cities to autocracy, Venice
vaunted a history of pluralistic and particularistic political rhetoric, and was
thus seen as an exception within the Italian context—one that D'Annunzio
could tap selectively to model his own version of a new Italy. In a canonical
work of twentieth-century historiography characteristically in line with the
"myth of Venice," William Bouwsma argues that Rome, representing both the
ancient origin of imperialism and a universalism renascent in the tyranni-
cal papacy, was "the anvil against which [Venice's] political consciousness was
hammered out at last."[99] It was in fact the *fall* of Rome that, according to Ven-
ice's self-glorifying myth, led to the inhabitation of the Venetian lagoon and
its establishment as a polis in AD 421. Through the eighteenth century, Ven-
ice crystallized the political values of Renaissance republicanism, defiant to

Rome's universal sanctions, for many Europeans. Those Europeans regarded Venetians as eloquent defenders of civic life for their refusal to subsume human capability under any single principle or to organize it into hierarchies. The popularity of political writings by Venetians such as Paolo Sarpi, and their apparent substantiation within the adaptable city-state, made Venice a supreme vehicle for the transmission of the Renaissance's political tradition to Enlightenment thinkers—until the city came to epitomize a degenerate state "extinguished at last, the oldest . . . in Europe, by the convulsions of the French Revolution."[100] Yet the Republic's mythical values continued to be favored by modern Anglo-American and Italian political thinkers resistant to the Holy Alliance that held sway over the lagoon throughout the nineteenth century.

In contrast to Roman rhetoric, Republican Venice's imperialist rhetoric embraced ethnic diversity; this difference was crucial for D'Annunzio's expansionist cause because the government based in Rome supported Yugoslavia's claim to Fiume rather than D'Annunzio's. Leading 2,500 "legionaries" (deserters from the Italian army) into conquest without the support of the Italian state, D'Annunzio took Fiume "like a Renaissance *condottiere* with a modernist twist," as Stanislao Pugliese puts it—a figure invoking the illegitimate, charismatic, and culturally invested icons of Bartolomeo Colleoni and Sigismundo Malatesta (or Napoleon, or the Duce to come).[101] The poet-imperialist appeared to Futurists as a dazzling example of bringing art and imagination to power, though perhaps too much an aesthete; indeed, the Fiume constitution contained a "*fatica senza fatica*" clause, which established a "corporation" of superior beings—heroes, poets, and prophets in the deliberate shadow of Nietzsche's *Übermensch*, who would "labor without exhaustion." Much activity surrounding the seizure of Fiume was cloaked in Venetian references, "in the shadow of some proud Doge," in order to invoke the Republic's historical possession of Dalmatia. D'Annunzio demanded support for his military campaign through a 1918 "Letter to the Dalmations" published in the *Gazzetta di Venezia*, and as a self-proclaimed "Venetian among Venetians" at the first public demonstration of the *Fascio veneziano di combattimento* (replete with fifteen thousand leaflets thrown from the Campanile) in the Piazza San Marco on St. Mark's Day of 1919. He publicized the Fiuman constitution at Fiume's own Teatro Fenice on August 30, 1920, when he read it to an audience of authorities, legionaries, and citizens.[102] The activity electrified Venetian veterans, and Venetian leaders supported the occupation because Fiume was in the path of their commerce with markets to the East.

D'Annunzio's Fiume soon acquired a revolutionary meaning that galvanized a range of political stances.[103] Although this episode is widely recognized as a precursor and conduit for Mussolini's performative 1922 March on Rome,[104]

its appeal spread through the political and cultural spectrum, and led to an early form of Venetian Fascism more anarchic than that of Mussolini. Even if, as Robert Dombroski argues, the colossal failure of Fiume "determined the containment of utopian dreams" held by artists like the youngish Ezra Pound, "Fiume, seen as a mythical event, is a supreme example of the new model of energy or libidinal apparatus . . . that cuts across all political boundary lines to forge a transnational spirituality of heroic citizen-warrior, devoid of every pragmatic or utilitarian impulse and perpetually nourished by a religious and magical communion, by heroic action. . . . Fiume illustrates how D'Annunzio's mythical vision was capable of exploding into history."[105] As a foreign reader cobbling together a dream of sociopolitical renewal led by cultural luminaries, Pound set D'Annunzio against Woodrow Wilson in November 1919 as an initial (although imperfect) exemplar of the "Revolt of Intelligence." His response to D'Annunzio's heroic escapades in Fiume was mixed: "If Sig. d'Annunzio . . . were not part histrion . . . he would have behind him so stiff an intellectual backing from the whole of Europe that there would be small question of dislodging him."[106] Pound's commentary concludes, however, that D'Annunzio "represents art and literature (with rhetorical detriments, *mais passons*). He represents the individual human being, the personality as against the official card-index . . . system."[107]

Fiume's impact reverberated further in the belated 1921 publication of *Notturno.* Pound's 1922 "Paris Letter" turns away from a discussion of artistic activity in the French capital to focus on the transformation of histrionic political activity into literary experiment in D'Annunzio's Venice: "One turns from the indisputable enervation of Paris to D'Annunzio's *Notturno,* I think with relief. . . . In the fury of Fiume, in the general bewilderment of manifestoes, aeroplanes [sic], bombs, *fascisti,* et cetera, together with memories of vast verbal emprise, one had forgotten . . . a critical estimate of the 'poet hero' as a writer. . . . Gabriele is a male, civilized, he writes of Dolmetsch, Wm. Lawes, Scriabine, Venice, of the things that make life bearable."[108] In insisting that we turn away from Paris, Pound reveals the growing importance of the tenuous reality being crafted along the Adriatic rim in Venice. Pound admits in his analysis that neither D'Annunzio nor any writer to date (besides James) has taken up his own challenge to compose prose from "an instinct of negation," which would identify and analyze in detail the mediocrity of present existence that "one wants to eliminate."[109] D'Annunzio instead "lies with a bandaged eye in a bombarded Venice, foaming with his own sensations, memories, speculations as to what Dante might or might not have done had he been acquainted with Aeschylus."[110] Yet Pound's own poetry will

draw inspiration from such juxtaposition of memories, ghosts patched with histories. In the end, Pound locates a heroic consciousness in D'Annunzio as yet undefeated, reinvigorated by the specters of beauty: "some sort of vigour, some sort of assertion, some sort of courage, or at least of ebullience" in D'Annunzio's work "throws a certain amount of remembered beauty into an unconquered consciousness."[111] If the recollected beauty of a vanquished Venice can cast itself into unconquered states of mind, Pound proposes, there is hope of cultural reinvigoration there. D'Annunzio would have concurred, and Marinetti may have as well, though with an important difference: the Futurist's negativity aspires, indeed, to "eliminate" the mediocrity of the Venetian present, albeit in a performative mode so exaggerated as to be ludic. Marinetti will take up arms against such mediocrity even if it means taking flight from the regime and from linear time writ large.

FECUND SIMULTANEITY, FROM THE AIR: TAKING FLIGHT ABOVE A GLASS VENICE

Amidst the drama of World War I and of D'Annunzio's military-aesthetic occupation of Fiume, Venice's historical dominion over the water was supplanted by a new obsession: with the air. Despite the trauma of having been the target of the first aerial bombardment in history in 1849, Venice's strategic importance during the Great War and corresponding development of *idroscali*, or airports for seaplanes, made it a seductive locus for the eventual application of *aeropoesia*, or "aeropoetry." This phase of Futurist production was stimulated by the experience of air combat and founded in 1931 by yet another manifesto; after the inauguration of "aerial theater" in the immediate wake of World War I (1919), manifestos followed for "aerial architecture" (1934), and of "aeropainting" (1929), the latter also launched with a 1931 exhibit upon Marinetti's expedient nomination to the Accademia d'Italia.

Marinetti had been briefly aboard a plane at the 1909 air meet in Brescia that honored D'Annunzio and launched the air frenzy; enchanted, he opened the "Technical Manifesto of Futurist Literature" with an account of how a propeller dictated to him a means of liberating language from the shackles of syntax as *parole in libertà* ("words in freedom").[112] Marinetti continued to be a proponent of the air rage, publishing a *First Aerial Dictionary* in 1929 that ventured to provide the national aeronautics industry with properly Italianate neologisms for its mechanisms and effects. The Futurist was particularly concerned to distance this cultural lexicon from the archaizing strain

of D'Annunzio's aerial rhetoric, which had adopted Venetian insignias of old and yoked aerial to ancient sea exploration (recommending, for example, that an airplane be called *velivolo*, after *mar velivolus*, Ovid's term for the sea seemingly covered by veils).[113] Futurism wanted to distance itself from the oceanic in general. But Marinetti returned to *La Serenissima*, the site of his precursor's flying squadron and convalescence, in the late stages of the next world war. From Venice, he undertook an elaborate revision of D'Annunzio's passéist Venetian narratives of water and fire—in the form of a final "aero-text" that renders the undersea itself and its decorative elaboration, glass, a medium of would-be social healing.

Marinetti's *Ricostruire l'Italia con architettura futurista Sant'Elia*, an unpublished theatrical work of the late 1920s to early 1930s, had already revisited his 1910 vision for Venice by casting the city's aerial bombing as a precursor to urban renewal—several times over. In this hilarious "*divertimento rappresentabile in molte sintesi*" or light theatrical work in interchangeable parts (literally, a "diversion representable in many syntheses"), which begins in an aerodrome, the allied forces of *Velocisti* ("Velocitists") and *Spazialisti* ("Spatialists") provide fictive stand-ins for rival Futurists and cool architectural Rationalists such as Giuseppe Terragni, who advanced the principles of Antonio Sant'Elia that were curtailed by an untimely death. (Sant'Elia, who was the first to apply Futurist principles to urbanism with his 1914 "Manifesto of Futurist Architecture" and "The New City," was killed in combat in 1916, in the disputed Adriatic terrain of Gorizia.) Together these forces will construct one hundred "aeromarine" cities based on Sant'Elian parameters that will enable a "high simultaneous fast and synthetic life without monotony, without memory," before destroying the historic cities they have replaced.[114] But in the work's third section or "synthesis," we find ourselves in a postapocalyptic Venice whose Futurist utopia and historic city alike have been demolished by the enemy *Mollenti* ("Softies" or "Give-Ins," presided over by the fetishist of all pasts, *Mollazon*, and the English "Lord Antiquity"); these *Mollenti* have barbarically stripped the precious columns from the Ducal Palace as weapons with which to destroy the Sant'Elian city. The avant-garde leaders are captured and coerced to assist the deleterious passéists by refabricating a moribund version of Venice with absurd contrivance: the *Velocisti*'s *Passatificio*, or "Passéifier" machine, re-erects the city for antiquarians in ten days, "come era, tale e quale" ("exactly as it was," in a parodic echo of the Campanile reconstruction campaign), replete with ersatz patina and electric mold; and as both sea and moon have vanished, the abducted Futurists are forced to reanimate the great fetish of moonlight via electric projection of lunar effects.[115] In the end, Furr,

Velocista and President of Trust Automobiles and Aeroplanes, chained to the ruin of a wall of St. Mark's, is released from fetters by his lover, the Futurist dancer Vif-Glin—and a climactic rumbling of airplanes heralds the bombardment and replacement of the basilica's "walls of memory, history, repetition, imitation, fear" with the multicolored plate glass planes of "the empire of unequalism, originality, and speed."[116] While this satirical scenario effectively restages the plan of "Against Passéist Venice," its prophetic commentary on the destructive, hypocritical fetishism of the antique city claimed, by Lord Antiquity, as an "affare internazionale" (international business matter) troubles any dyadic contrast between the historic city's preservation and devastation.[117]

Marinetti was to reimagine the new Venice yet again, from the midst of a world and civil war, in what is arguably his last major work—and a rare example of experimental narrative in twentieth-century Italian literature: *Venezianella e Studentaccio* (roughly, "Venicella and Rebelstudent"), dictated to his wife Benedetta and their daughters and Futurist comrades in 1943–44, and unpublished until 2013. This work, a self-proclaimed transgeneric "aeronovel or aeropoem," goes a step further in developing the aerial aesthetic: it adopts the lightness, velocity, perspectival diffuseness, and radical shifts of scale characteristic of flight to recompose the city of lagoons as a teeming amalgam of "simultaneity" in time and space. In nineteen sections of poetic prose virtually free of punctuation and running to 125 pages, this aerotext permeates a vertiginous series of vantage points, staging the rebuilding of Venice in modes by turns visionary and carnivalesque. Futurists fictive and actual, animals, insects, and inanimate components of the city—from stone steps and statues to the frescoes of St. Mark's—are granted a conscious part in the scene of immense reconstruction, while the prose takes audacious liberties with time. Written from the ground zero of World War II, months before his death (and the concomitant death of Futurism), Marinetti's vagrant plot departs lavishly from his *avant-guerre* dictates for the polis, and from the failed species of syncretism issued by Fascism's displaced center in Salò.[118] It envisions the reconstruction of Venice in the form of an anachronistic and polycultural pastiche: a baroquely embellished female colossus of glass.

The founder of Futurism returned to Venice at age 68, remaining in the city from October 1943 through July 1944, damaged by pneumonia and a heart attack from the stress of volunteering on the Russian front. Though the city was culturally paralyzed at the time due to funding shortages and bombing threats to industrial outposts on the mainland, it provided a relatively safe haven for Marinetti and his family, who ended up there due to a bombing's disruption of railroad service. In contrast with its fate during World War I,

secret agreements between the Allies and the Vatican made Venice the only major Italian city almost wholly saved from bombardment during World War II.[119] The city thus managed to follow through with the 22nd Biennale despite the breakout of conflict in September 1939, featuring exhibits of Futurist aeropaintings and "simultaneous aeroportraits." The 23rd Biennale was held, even more remarkably, in 1942, serving to preserve the illusion of sociopolitical stability through what the dogmatic catalogue text calls the "austere rite of contemporary art" in the face of the Allied enemy, an enemy deemed incapable of recognizing the value of "the universal wealth of civilization."[120] In September 1943, the Repubblica Sociale Italiana was founded at nearby Salò in a desperate attempt to preserve Fascist power against the Kingdom of Italy's armistice with the Allied forces. Regarded by this point as relatively insular and "neutral," and thus unaccommodating to the orchestration of partisan guerrilla activity as well, Venice became a cultural capital of the puppet regime: the Public Gardens became the site of Salò's short-lived film studios, and many of its publications (pocketbooks, pamphlets, and the like) were produced in the historic printing capital.[121] Notwithstanding a scarcity of oil and food that reached severe levels in 1942, Venice became populous as a site of general asylum, accommodating refugees, diplomats, new bureaucrats, foreigners, artists, and war profiteers. The privileged reality of these new residents was very different from that of the local working classes, and most brutally from that of the Jewish community: 160 Venetian Jewish citizens, of all ages and professions, were arrested and deported to Germany between 1943 and 1944 in one of the first enactments of the new racial laws imposed in occupied Italy (laws, it must be noted, that Marinetti openly opposed, just as he opposed the German alliance itself). Marinetti's family was eventually assigned to a home facing the Rialto fish markets that had been requisitioned from Jewish owners.[122] From this compromised position, in the midst of a raging war, inhabiting the "illustrious ruin" he had rhetorically leveled with alacrity in the decades before, the aged Futurist continued to meet and collaborate with Futurist colleagues.[123] Here he also produced a major narrative experiment that redefines both city and chronicle, consummating Venice's status as a rhetorical and material framework that —however polemicized and problematic—shaped the trajectory of his career, and thus of modern Italian literary innovation writ large.[124] *Venezianella e Studentaccio* diverges from Marinetti's early adventures in the modernist planning of Venice, envisioning a "nuovissima Venezia" (utterly new Venice) that yields to, and "immensifies," the feminized, epochally and culturally eclectic depths of the city—rendering the once monodirectional impulses of the Futurist enterprise kaleidoscopic.

This work participates concretely in that *riflusso*—"reflux" or "resorption"—of the rejected sentiment, nostalgia, natural landscape, and Christian love that Cinzia Blum has identified in post-World War I Futurism—with a vengeance.[125] Yet the text only confirms the conflict at the heart of Marinetti's originary delectation in the city—unearthing an ambivalence that Christine Poggi locates in the "'artificial optimism' . . . that never fully repressed its negative counterpart."[126] If Futurist texts of the *avant-guerre* thematized the superman's mastery of all "natural or societal obstacles to his limitless expansion,"[127] the author begins this one at a structural disadvantage, as the scene of eradication is revisited intact, in all its sensuous detail. Though *Venezianella e Studentaccio* restages a series of battles against the cultural stasis of Venice (and of Italy), it follows no steady route of recapitulation. The 1910 attack on passéism proposed to replace the caving curves of Venetian palaces, alleys, and canals with a new skyline of "imposing geometry" and smoke; *Venezianella e Studentaccio* swerves from these aims in temporal, spatial, and material terms. While the text's rhetoric is aerial, the central errand of its narrative—construction of the new Venice as an eclectic colossus by Futurist *vetrai*, or glass artisans—involves "rummaging" into the city's detrital depths. Venice's undersea and traditional glassworks, furnishing ornamental mosaics, "beads of glass and other cultural weights" (*VS* 11), become the medium of a metropolis of "sweet simultaneity" (18).

Simultaneity was a value espoused by the regime, of course. Mussolini's appropriation of Giuseppe Mazzini's "Third Rome" concept was articulated in 1925 with the assertion that "[a]fter the Rome of the Caesars and the Rome of the popes, there will be Fascist Rome, which, with its simultaneity of the ancient and the modern, imposes itself to the admiration of the world. . . . It is not a city, but a political institution, a moral category."[128] Fascism's targeted "simultaneity" with Imperial Rome would be reinforced upon declaration of the Fascist Empire after the 1935 invasion of Ethiopia and 1936 seizure of Addis Ababa: the *Mostra Augustea della Romanità* in 1937 celebrated the bimillennium of Augustus's birth and explicitly celebrated "The Immortality of the Idea of Rome" by juxtaposing icons of domination, such as obelisks and steles from Egypt and Ethiopia expropriated by Augustus and Mussolini as "Dux," to suggest "that *romanità* was a stable, timeless essence, immune to local variations of any significance or substance, the product of historical necessity rather than contingency"—while the Ara Pacis, which marked the consolidation of Augustus's authority, was excavated alongside his Mausoleum and reconstructed from dispersed fragments in 1937–38.[129] The explosive coagulation of histories formulated

by Marinetti's palingenetic fantasy of urban planning strays far from the dictates of this Fascist imperial style, which necessitated the subtraction of all encumbrances to a Roman ideal that must "tower over all [*giganteggiare*] in the requisite solitude." Marinetti's reconstructed *Venezia* also waxes in excess of moral and institutional categories, celebrating the singular and even aberrant qualities of Venice as a city whose harmony vaunts its status as the product of assemblage rather than autarky.

"Delinquent" or "Rebelstudent," the lapsed university student become a wounded volunteer in the war, and now a director of Venice's reconstruction, actually forms a parodic third term between two iconic, yet deviant students in the popular literature of post-Risorgimento Italy: the mediocre pupil Enrico Bottini, fictive protagonist of Edmondo De Amicis's nation-building *Cuore* (1886), which was aimed at establishing civic virtues in Italian youth, and the deviant Pinocchio (1883). Marinetti coagulates the two figures in a digressively patriotic tale of regeneration, more Venetian in its aesthetic than syncretically Italian. Studentaccio's companion, the stalwart Red Cross nurse wounded in a failed colonial defense in North Africa, seems to be based on Colonna Teresa, a Venetian ballerina known as *La Venezianella* ("The Graceful Venetian") who performed throughout eighteenth-century Europe. This sensuous new Venus/Virgin Mary/Beatrice literally gives shape to the reconstruction of her "mother," Venice, by acting as an elusive model.[130] The lovers are cast suggestively as "two crooked straight lines that no plane can contain" (*VS* 12).

The landscape of simultaneity amassed by *Venezianella e Studentaccio*, a "mobile mosaic of detritus" (24) that is both representational and syntactical/lexical, is as stylistically sumptuous and inclined toward all-over coverage as a Klimt canvas—despite the fact that "Against Passéist Venice" had been launched to challenge just this kind of décor. But the perspective of "[t]his aeronovel or aeropoem" produces the all-over surface with a difference. The "aeromusic of an alphabet in freedom"[131] is assembled from an outlook hovering as if from an airplane—in a giddily modernized, dynamic corollary to the ship's periplus, a navigational point of view abundant in historical Venetian cartography and taken up by Pound's Venetian cantos. "Aeropoetry" as prescribed by the 1931 manifesto, authored by Marinetti and signed by Futurist painters, begins by rehearsing more familiar Futurist principles called for in the 1913 "Destruction of Syntax/Wireless Imagination/Words in Freedom": "The simultaneous accord I have invented is a sequence of short essential verbalizations synthesizing different states of mind words in freedom which without punctuation and with strongly contrasting tenses achieve the maximum polyphonic dynamism. . . ." Yet the new genre aims to reproduce the sensation and perspectival delirium of flight: here, the near-total abolition

of punctuation will enable the adjective "to melt its colour-sound-smell-tactile quality-temperature onto nouns and verbs near and far becoming adjective-atmosphere."[132] Objects, even actions dissolve into one another in the multiply sensuous presence of their qualifications, becoming themselves atmospheric, but not seamless, so that it becomes difficult to track where one begins and the next ends—as in *Venezianella e Studentaccio*'s opening scene, where a blood clot hovering between phrases may act as both object and subject: "Partorita agevolmente da una candida nuvola zenitale l'aeroambulanza argentea le cui ali infantili offrono al sole un innocente grumo di sangue sceglie spiralando la sua culla di giardini conterie e lustrini" (Birthed with ease by a candid zenithal cloud the silvery aeroambulance whose infantile wings offer the sun an innocent blood clot spiraling chooses its cradle of gardens beads and spangles; 6). Marinetti's celebration of atmospheric and material lightness, like Ezra Pound's, opposes the staid monumentality of stone: closed meters, with their "immovable bolted down marmoreal and lapidary natures," are "absurd and grotesque in Aeropoetry."[133] What better place to defy lapidary natures than in the city where "they built out over the arches / and the palace hangs there in the dawn, the mist"?[134] The aeropoetry manifesto underscores another seduction of Venetian environs as it continues: "Without the succession of tenses and without division of space the omnipresent simultaneous accord contains all times all space. . . ."[135] In *Venezianella*, lexically rich prose blocks pile neologisms and the technical jargon of the glass industry upon exotic colonial and Venetian dialect terms; Marinetti's linguistic invention and archaeology allow the neologism "rutilio" (rutilation) to exist side by side with the literary "meriggio" (noontide), or the phantasmagorical verb "cammelleggiare" (to camel, deployed to describe the action of Venetian bridges). The effort to contain "all times all space" rather than negating or imposing a hypotactic order upon history aggressively revises Futurism's founding declaration that "Time and Space died yesterday." It makes Venice—a vortex of influences from the four cardinal directions that never expunged traces of the "centuries of decadence"—an even more seductive locus for the aeropoet to render.

The aerotext opens, surprisingly, not with any airborne protagonist, but on a freighted landscape: "La laguna tutta contenta di pesare e ripesare sulle sue bilance di cristallo glicine e rose straripate dai giardini" (The lagoon wholly content to weigh and reweigh wisteria and roses overflowing from the gardens upon its crystal scales; *VS* 3). The lagoon transforms the solids it reflects into liquids, doubling them and conversely creating the visual effect of weight. Aerial perspective both releases the author from this weight and, in turning a body of water into a mirage of precious solids, returns attention to the depths. Proceeding from the ground level up, Marinetti's late aerotext reflects the

Venetian cityscape's swallowing of Cartesian perspective; a dazzling, discomposing mosaic effect is the result.[136] Adjectives that might be assigned to one object or another hover between them, coagulating elements so that they form a decorative ground at large, rendering a "[c]ompressibility of the quasisolid atmosphere."[137] *Venezianella e Studentaccio* literally assumes the perspective of the Austrians who attacked Venice from the air—in 1849 and again in 1915—but Marinetti's aviation identifies unexpectedly with the landscape, politically and passionally, creating the text as an *ambiente emotivo* ("emotional environment"), as the 1912 preface to the "Technical Manifesto of Futurist Painting" had prescribed.[138] Instead of mapping and plotting strategically, perspective in this work oscillates between panning for immense stretches and zooming erratically, scattering as much as it synthesizes the subject. From time to time, the narrator materializes so as to address readers before shifting again to a panoramic outlook, rising and plummeting from twilit sky to its reflection:

> O my sympathetic readers I wish to remind you that the fainting of the Sun envious of the Moon in one of these cities candied in the spices of the past arouses a sibylline hour of vaporous decoctions on a wooded little fire with alembic filters and conspiring penumbras . . .
>
> Venice reengraves herself wholly by herself in the saffron with reflections desirous to resound up to the tympanums of the clouds
>
> Philharmonic gondolier I row them indolently and care only to cast off the opulent green brocades of the wake that encumbers the long shadows of sumptuous solar reception (*VS* 122–23)

Casting off only the "brocades of the wake," or of the "aftereffects" that encumber the shadows, Marinetti's text now wallows in the "saffron" filtration of this swooping point of view: we are immersed in the same lagoon atmosphere once rejected in the call to kill the moonlight. This passage crystallizes both lagunar vapor and water by imagining a Venice that engraves "her" own reflections.

The unedited bird's-eye view that photography made possible at the turn of the century, and that neutralizes the frenetic rhythms and sensory assault of the metropolis, is of no interest to the Futurists; more important than the possibility of a fixed surveying view is a sense of the subjective experience of flight by machine.[139] When the frenzied, multiply encumbered, erratic drives of flight are applied to urban planning and reconstruction, an implosively amalgamative city complex results—one whose protagonist is rendered diffuse. In its sweeping vision of the city, Marinetti's experimental prose invites

comparison with aeropainting, which sought to represent the transfiguration of perspectives, possibility of visual synthesis, and rush of flight in a variety of idioms from 1929 to 1940. Giovanni Lista argues persuasively that *aeropittura* departs from the perspective wrested of landscapes viewed from above by artists of the Italian Renaissance, replacing historical emphasis on the individual's place within a larger *civis* with a depiction of a modern individual's domination of the world.[140] While this is true of the aggressively individual pitch of outlook in the vistas of Dalmatian-Italian painter Tullio Crali, or those of Gherardo Dottori, subjective perception in the aeropainting of Benedetta Cappa Marinetti and Enrico Prampolini leaves a trace only in the form of helixes and bows, which indicate lines of flight and propose axes of rotating perspectives on the landscapes below.[141] The hybrid aeroprose/poetry of *Venezianella e Studentaccio*, with its "Destruction of the I" and of a strictly human viewpoint, is far closer to the latter (*TIF* 50); like Benedetta's *Incontro con l'isola* (Encounter with the Island; figure 3.3), its perspective dives and rises balletically, pivoting toward islands and sea in implicit spiral motion,

FIGURE 3.3/PLATE J. Benedetta Cappa Marinetti, *Incontro con l'isola* (Encounter with the Island), oil on canvas, 1939. Galleria Nazionale d'Arte Moderna e Contemporanea, Rome, acquired at the Third Quadriennale of Rome.
Courtesy of Ministero per i Beni e le Attività Culturali, Rome; reproduced by permission of the Estate of Benedetta Marinetti.

rather than commanding the view in freefall. In the presence of a landscape so heavily freighted with sociocultural meaning, Marinetti ultimately relinquishes a strictly aerial perspective. The author does not subject ground to any salient figure, but merges them preposterously.[142] The *Nuova Venezia* will be a colossal female form blown in glass, made up of outrageously amalgamated architectures, to be inhabited by the collective. *Coagolare* ("to coagulate") and *amalgamare* ("to amalgamate")—efforts of unification that do not quash differences—are the text's key terms of assemblage.

In a radical shift from the violent tabula rasa and plan imposed by the 1910 Futurist vision for Venice, the sporadic plot of *Venezianella e Studentaccio* embraces the city's gradual, processual founding, seizing upon the city's potential for spontaneous rebirth. In a chapter titled "In Search of Sweet Simultaneity," the "analytic and meticulous liquidating night" is given a voice to lay out the basis of Venetian urban planning: "Poiché Venezia ha per origine una fuga da terraferma a isole in collaborazione col caso è indiscutibile che il capolavoro non è necessariamente il risultato di un piano preciso predisposto ma può anche nascere casualmente labirinticamente a vanvera" (Since Venice's origin is a flight from terra firma to islands in collaboration with fortune it's indisputable that this masterpiece isn't necessarily the outcome of a precise predetermined plan but can also be born haphazardly labyrinthinely by chance; 18). The structure of this aeroprose-poetry mirrors that of the cityscape: an episodic series of responses to contingency rather than destiny or a preconceived plan, irreducible to a linear plot. Studentaccio responds to the night's account of Venetian origins by proposing that a plan be created by Futurist *passi* ("steps"; "passages"; "paces"), with designs for the city ricocheting from them as they walk:

—Procediamo a crearne uno coi nostri passi che staccatisi da noi oscillano come alcuni liquidi specchietti d'acqua d'accordo coi ritocchi di tono che pittori stranieri di passaggio sognavano interrotti dal pasto dal sonno dalla pioggia o da una pulce artistica

Stimolate da sempre nuovi guazzabugli di penombre le immagini si accoppiano ad altre immagini

—Let us proceed to create one with our paces which detached from us oscillate like little liquid mirrors of water in accord with retouchings that foreign landscape painters passing through dreamt interrupted by meals by sleep by rain or by an artistic bug

Stimulated by ever new hodgepodges of penumbras the images couple with other images (18–19)

Coming to structural terms with the city's aggregative, collaborative foundation means subverting the figure/ground rapport of Marinetti's *avant-guerre* designs on the city. The text activates this plan by privileging lagunar matrix over heroic figure in its descriptive and narrative prose blocks. Passages accrete sumptuous detail paratactically, in syntactically tenuous, almost hallucinatory clusters set off against bouts of casual dialogue. Futurist words have been freed by a plane's "whirling propeller," but they are also freed in this text of any pilot or surveyor. The new Venetian urbanism will emerge on the heels of design's detachment from its authors' feet and its subsequent "oscillat[ing]," as if reflected quiveringly on the lagoon surface. Moreover, the new plan of Venice will accord with, rather than expunge, the "retouchings" (*ritocchi*) applied dreamily to that water by "foreign landscape painters"; though these painters remain unnamed, Marinetti's description recalls the Impressionists who depicted the vibration of Venetian tones—from Turner through Monet. The "hodgepodges of penumbras" and coupling images here indicate a voracious incorporation, rather than annihilation, of the innumerable styles and histories inscribed in Venice.

The expected Futurist domination of landscape and, by association, of woman is also missing at the level of plot: instead of the superman/Icarus dominating aeropainting perspectives, our male lead through Marinetti's Venice is the puerile Studentaccio, prone to youthful error and disobedience—and above all, to pining in unbridled sentimentality for Venezianella, who is missing for the bulk of the narrative. The relative abjection of this protagonist and the agency of the female hero in building the new city constitute a critical swerve from Marinetti's early dreams of male parthenogenesis. In 1909, Marinetti had declared that "we strongminded Futurists," in the intoxication of witnessing flight, "immediately felt detached from Woman, become suddenly too earthbound, or, better, become the symbol of the earth which had to be abandoned."[143] Venezianella counters this version of femininity: she is an aviator-warrior asked to resolve the poles of "indispensable delicacy and indispensable virility" (*VS 42*). The text begins with a gravely wounded Venezianella's return from Tobruk, a Lybian port city that had formed an important strategic colony for military operations in the Mediterranean during World War II, changing hands through combat between Axis and Allied armies. She has had to swim among sharks to reach her "aeroambulance" conveyance back to the lagoon city, once "magnificent sore of the past" (*TIF 33*), yet now "most aquatic hospital" (*VS 3*). In a fantastic scene of aesthetic cicatrization, Futurist glassblowers are hailed to heal the wounded daughter of Venice by investing her with a spectacular "mantle of mosaics" (*TIF 35*),

forming a synthetic bubble or "Coibente Sublime" (Insulating Sublime) of glass, marble, mother of pearl, and precious stone. This sculptural bonding, which revises both the glass coffin for summer that opened D'Annunzio's *Il fuoco* and the tetric nocturnal ambience of the aviator's convalescence in *Notturno*, is the precursor to the polis's rehabilitation and renewal: Futurist artisans will proceed to "amalgamate the mosaics of the New Venice" (*VS* 8).

Identification with a feminized cityscape possessed of its own play of social forces and meanings complicates the rhetoric binding the nationalist, Orientalist, imperial fantasies of D'Annunzio and Marinetti—those widely acknowledged as buttressing a mounting Fascist imaginary and diagnosed in a persuasive series of critical works as a rhetoric of virility.[144] The syntax of the amalgamative fantasy of virility links the decadent to matter, which is in turn linked to woman. Kaplan notes of the tropes of Fascist modernism, "The earth is played by woman—so is war, the machine, the sea, and, in fact, nearly every possible thing except woman herself, who . . . is completely void of intrinsic meaning."[145] As both natural and hyperrefined landscape, Venice was rich in cultural associations with the feminine, including feminized males. In "Against Feminine Luxury," Marinetti warns against the road to "pederasty" (his slur for homosexuality) through reference to Venice: "Males capable of taking and enjoying a beautiful woman without worrying about the trimmings and contact with fabrics, glitters, and colors are ever more rare. . . . [S]oon we will have recourse to that hygienic measure taken by a Venetian doge who required the beautiful Venetian women to expose their naked breasts at the window . . . in order to lead males back to the straight and narrow."[146] Venice's "solution" to this waning of virility was—whether intentionally or not—much suppler than the Futurist's, allowing sexual contradictions to circulate and coexist in a context that is anything but "straight and narrow." The city's lavish unruliness renders Venice a lure for this phase of "reflux," abundant in obsolescing repressions. From the time of his first calls to kill the moonlight, Marinetti could not help but trace the sinuous trajectories of his rejections, delectating in what was allegedly being purged: "I too loved, O Venice, the sumptuous penumbra of your Grand Canal, impregnated by rare luxuries, and the feverish pallor of your beauties. . . . But enough!" (*TIF* 35). *Venezianella e Studentaccio* does not resolve these conflicting impulses in envisioning a *Nuova Venezia*, but instead coagulates them in a colossus pushing the limits of kitsch as it mingles the antique and the modern, the natural and the technological, the crepuscular and the sunstruck, sea and sky. This unleashing of contraries in forging an amalgamative topography is founded on the matter of the lagoon itself (a liquid medium that produces glass solids);

the effigy of Venezianella is then embellished by the forms of Venetian historical detritus, natural resources from other Italian regions, exotic products from the foundering Fascist empire, and aging technofantasies of various orders. As a port city opening onto the sea that Marinetti once envisioned as a "great Italian lake," Venice now becomes a catch-all for the refuse of the Fascist national and colonial dream.

Effluvial Venice, a wellspring of revulsion but also of fertility for the avant-garde, emerges as the double of that feminized basin of industrial sludge from which Marinetti was born a Futurist in the prologue to the founding manifesto. In rebuking its "centuries-old voluptuousnesses," Marinetti's "Against Passéist Venice" had set Venice as the decadent inverse, both decaying and overly urbane, of the tropological "past" represented by a hybrid, industrialized *Mater*: the factory drain presided over by the memory of his Sudanese nurse's breast.

> Oh! Maternal ditch, brimming with muddy water! Fair factory drain! I gulped down your nourishing sludge; and I remembered the blessed black breast of my Sudanese nurse.... When I came up ... from under the capsized car, I felt the white-hot iron of joy pass deliciously through my heart! ... And so, faces smeared with good factory muck—plastered with metallic waste, with senseless sweat, with celestial soot—we, bruised ... but unafraid, declared our high intentions to all the *living* of the earth.[147]

As critics have noted, the scene of Marinetti's rebirth as man-machine relies heavily on gendered and colonial tropes in which the feminized and racialized primordial sphere is simultaneously rejected and retained, refreshed by technology.[148] Works such as Boccioni's *Materia* (now part of the Guggenheim Collection in Venice) highlight the Futurist compulsion to return to feminized origins so that the future can advance by way of opposition, bringing out the movement's indebtedness to the dynamic between motion and a more basic "matter" that Venice embodies (a dialectic upon which Pound's poetry also builds).[149] Boccioni's studies of iconic brooding mothers depicted as a form of reciprocal interference with the city's rush throw into even greater relief the Futurist dependence on a feminized matrix to stage virile unleashing.[150] Less prominent in the critical discussion, however, is Marinetti's choice to wallow in the drainage, sludge, and soot that form the *detritus*, rather than the antithesis, of modernization—rendering the past and the present two relative moments on a continuum. The womblike basin of industrial by products is reworked thirty-five years later in *Venezianella's*

lagunar basin of human cultural detritus: no longer a site to be destroyed, but the fertile (if rat-infested) basin out of which a *Nuova Venezia* will emerge. This vision inverts the early hallucinations of a primeval Venice by both Marinetti and Mann.

Marinetti opposed Symbolist and Decadent poetry for its fixation on the female body as a source of unstructured truth, and insisted above all that D'Annunzio, "nostalgic and hovering . . . over the naked female body," must be fought "at all costs" (*TIF* 304). Yet battling D'Annunzio once and for all entails returning to his education in the older author's topoi. Marinetti is himself a *studentaccio,* or rebel student—for his creation of a female colossus of glass revises, and invests with power, the *fin-de-siècle* "forgery" of a woman identified with Venice in modern Italian literature: Perdita Foscarina, a love object as fragile as a precious glass vessel. Enflamed by her desire for Èffrena, Foscarina is "[a]ttracted as though into a forge," where "she felt herself subject to all the transfigurations that the animator might wish to work upon her" (*Il fuoco* 11). Marinetti redirects D'Annunzio's imperious flame in forging a stalwart New Venice of blown glass and crystal, invested with the energy of "ingenuous invention" envisioned by Venezianella herself (*VS* 121). In so doing, he revises the unidirectional, hieratic relation between woman and man, creator and created, with Studentaccio becoming an abject devotee. The aged Futurist's text draws on Venetian materials and historical forms while resisting the magnificent stasis, temporal suspension, and fragility of D'Annunzio's "ghostly creations."[151]

That glass should constitute the medium of Venice's reconstruction in *Venezianella e Studentaccio* is rich with contradiction. The Futurist calls on the one hand, as D'Annunzio did, on a long and illustrious history of glassmaking at Murano—a crystallization of the oceanic that still harbors potential for renewal (even though colonization had severely compromised the industry during the nineteenth century, and it was now associated chiefly with trinket-making). The Biennale's dedicated decorative arts exhibition inaugurated in 1930 featured the Venetian glassmaking tradition above all; by 1938, a Venetian pavilion promoted the glass industry as a means of liberating the population from slavish economic dependence on foreign nations, even if the results of its revival thus far had been described largely as "intimate anarchy, colliding extremes, convulsed shadows."[152] Sheets of glass, on the other hand, exemplified the modern in architecture—from the Crystal Palace of London's 1851 Great Exhibition (excoriated by Ruskin in comparison with St. Mark's)[153] to the plate-glass windows of skyscrapers built by the Chicago

School of Architecture and the glass atria of modern department stores, banks, and government buildings. They signified a daring use of materials in the industrial age as well as a contemporary form of theatricality and display. The Futurists had exalted this technology from the founding years: in his 1912 "Technical Manifesto of Futurist Sculpture," Boccioni hailed glass among the materials that could compose interpenetrating "atmospheric planes that bind and intersect things," in a new plastic conception to be wielded against the regressive mimicries of figural statuary characterizing traditional academic sculpture.[154] The "Futurist Manifesto of Aeroarchitecture" began by applauding the lyrical use of new construction materials in the urbanism of Sant'Elia. In *Reconstructing Venice with Sant'Elian Futurist Architecture*, vast, brightly colored, rotating glass plates are presented as the building blocks of "a fluid, infinite, incessant architecture."[155] With *Venezianella e Studentaccio*, Marinetti definitively corrects D'Annunzio's casting of "the all-powerful construction of buildings of iron and glass" as typical only of "colonies of bastard races that ferment and are corrupted on a virgin soil" (*Il fuoco* 89).

The most immediate precursor for Marinetti's vision may be the German novelist Paul Scheerbart, who had himself been influenced by the Futurists, and whose utopian tract *Glasarchitektur* (Glass Architecture; 1914) was inspired by Bruno Taut's mosaic-lined, polychromatic, kaleidoscopically lit Glass Pavilion displayed at the German Werkbund's 1914 exhibition in Cologne: a prismatic glass cupola over a concrete and glass drum dedicated to Scheerbart. Both works are now viewed as transitions from nineteenth-century engineering to an aesthetic conception of glass architecture for the twentieth century. Dedicated to Taut, *Glass Architecture* dreams of glass's ability to create floating, mobile, transparent yet colorful constructions that would transform European habits of thought and feeling.[156] In Scheerbart's fantasy, colorfully lit zeppelins illuminate experimental glass buildings; his imagined cityscapes comprise glass airports and models of historic airships, highlighting the fact that this material invited associations with air and sky. As Reyner Banham points out, Scheerbart's aesthetic fits uncomfortably within the canon of high modernism, as it is more indebted to nineteenth-century anticlassicism than to twentieth-century classicism: it is closer kin to the culture of Gothic Europe (which Scheerbart and Taut saw as anticipating great nineteenth-century structures of iron and glass), the decorative tradition of the East, and the craftsmanship of Tiffany than to Futurism. Banham argues that this trend forms a crucial but undersung strain in the history of the modern—one that delights in ornament and continues the revival of craft that extends from nineteenth-century neo-Gothicism through the Arts

and Crafts movement, the Bauhaus, and beyond.[157] Given these Gothic associations, it is not surprising that *Glass Architecture* imagines "a new Venice," enabled by "indestructible" foundations of reinforced concrete in water, "to eclipse the old one."[158] Scheerbart's text proposes that a mobile Venice could be formed of a cluster of glazed, terraced pyramids built on these reputedly more stable foundations. He envisions a floating archipelagic architecture, no longer based on the façade, in which buildings are recombinable, to be "juxtaposed or moved apart in ever changing patterns."[159] Scheerbart builds a challenge into his vision for the likes of an Italian Futurist, noting that "Venice is no longer the pinnacle of glass culture, although it has contributed much that often obliges one to return to it," and that "present-day Italy, without glass, really has very little attraction."[160] Marinetti answers to this challenge imaginatively.

Scheerbart ultimately envisions a glass-world citizen for whom the transparent edifices of the modern city had dispensed with the gloomy spaces of old buildings and with a culture of secrecy and deceit. Glass's transparency is indeed the key to its modern political connotations. Marinetti's fictive use of glass resounds within a particular political as well as cultural context, as it follows perhaps the most renowned example of modernism in Italian architecture, which also served as an exemplary instrument for integration and politicization of the masses: Giuseppe Terragni's 1936 Casa del Fascio, built as the provincial headquarters of the Fascist Party in Como (figure 3.4). As Emilio Gentile and Richard Etlin have underscored, a "quasi-mystical" use of glass in buildings such as Terragni's embodied Mussolini's 1929 declaration that Fascism be "a house of glass" visually open to all, giving the public "an immediate sense of the full integration of the Party into the lives of the people and of the direct communication between the masses and their leaders."[161] Terragni underscored the metaphorical implications of Mussolini's statement as they pertained to his work, declaring that the building would present "no hindrance, no barrier, no obstacle between the Fascist leaders and the people." He allowed for the directorate's meeting room to overlook the central atrium by a glass wall, and consequently the facing piazza as well, which was separated from the atrium only by eighteen glass doors "that open simultaneously to usher in [the crowd] directly from the piazza to the hall for musterings."[162] Terragni concurrently wields Mussolini's dictum to justify the values of Rationalist architecture accentuated by his use of materials: "organicity, clearness, and honesty of construction."[163] His building deployed an unprecedented percentage of glass surfaces, developed in conjunction with the Italian glass industry. It thus stood as a point of national pride in craftsmanship as well;

Un'adunata del popolo comasco di fronte alla Casa del Fascio (5 maggio XIV).

FIGURE 3.4. Giuseppe Terragni, photomontage from *Quadrante*, nos. 35/36 (October 1936). Depicts assembly at Como in front of Terragni's Casa del Fascio, during which the crowd listens to the radio broadcast announcing the seizure of Addis Ababa, May 5, 1936.

Terragni received laudatory responses to a double issue of *Quadrante* featuring the Casa del Fascio in 1936 from the Italian Glass Union.[164]

Marinetti visited the Casa del Fascio in late 1938 to commemorate Sant'Elia—and simultaneously to deliver a "most violent polemic" against racism, aiming specifically at Telesio Interlandi, the director of the extremist Fascist publications *Il Tevere* (The Tiber) and *La difesa della razza* (The Defense of the Race; launched in August 1938), who had announced publicly that "'modern' art" was "a tumor that must be cut."[165] This instance of Marinetti's bold deviation from the regime follows other points of conflict, emergent throughout his career, that become legible in the excess of his aeronovel's convulsive, polychromatic, feminized and pluricultural glass city, so unruly by comparison with Terragni's Rationalist design. Marinetti's metropolis of glass constitutes a totality that is both fragile and implosive— as volatile as the prospect and process of melding Futurist with regime values. In *Venezianella e Studentaccio*, glass of beguiling, changeful hues filters views, providing no transparent threshold of social integration. Here, glass composes not an abstract body politic, but a female body—"virile," yet invested in décor. It might even be argued that this monumental *Nuova Venezia* expresses the longing for the "intimate anarchy, colliding extremes, convulsed shadows" that characterize not only the disparaged Venetian glass production of his day, but also a collective memory and emotion left unmastered—aspects of public architecture that Ruskin regarded as annihilated by the blank materiality of the Crystal Palace, but which he hoped to reintroduce by exhorting the Architectural Association in 1857 to contemplate erecting a roof of "variegated crystal" over the English capital, placing "all London under one blazing dome of many colours that shall light the clouds round it with its flashing as far as the sea."[166] *Venezianella e Studentaccio* invests glass with the capacity to produce passionately, apocalyptically eclectic visions of social synthesis.

Marinetti's tale of a rebel student makes fun of "[t]he university professors diseased with positivism," who "proclaim that every great patriotic dream is a felony and that one mustn't push Italy to take steps longer than a leg" (75). In his own anarchic "patriotic dream," a bolder, more errant species of time can inhere. The Futurist no longer sets out to clear away past forms but to amalgamate them in the project of "fecund simultaneity" (28). Studentaccio intuits that Venezianella would like to be freed of past memories, but wants "your sculpture immeasurably magnified too" (*la tua scultura smisuratamente ingigantita,* with an echo of D'Annunzio's *smisurata chimera* and a reworking of

Mussolini's *giganteggiare*), and this necessitates enhancing rather than cutting back Venetian eclecticism: "you should resemble yourself truly as you resemble St. Mark's the Ducal Palace and the Ca' d'Oro" (41). With the help of cauldrons filled with Sicilian lava, Futurist glassworkers manufacture a mantle for the New Venice at the Bacino di San Marco six hundred meters in height: it is wrought of a waistcoat in the form of a massive Ducal Palace imagined as a splendid heart, and a gown composed of an aggregation of "immensif[ied]" St. Mark's Basilicas (9) in "Oriental" green crystal (41) laced with Neapolitan coral and Walls of China—an ensemble made more outrageous by the addition of a bonnet made up of a gigantic glass Ca' d'Oro. The Futurists Franco Ciliberti and Mario Menin introjected into the fiction propose to transfigure "the much-discussed suture" between the Byzantine and Gothic styles implicit in the colossus: they will correct "the strident conjunctions of the two architectures" by planting tropical forests of banana, date, bamboo, and palm along the basilicas' edges, producing a "caressable African most sensual" belt of hanging gardens upon which citizens can promenade "erotically and mystically" (21). That pensile African forests should be elected to rein in the stylistic cacophony of this gown suggests more than mere incorporation of the colonial elsewhere of the author's birth: here, as when "[l]o scirocco consiglia alle onde che Bernini arrotonda" ([t]he sirocco wind advises the waves that Bernini curves [18]), we see several species of "irrationalism" agglomerated, their differences intensified rather than neutralized in synthesis. The audacious process of coagulating the clashing forms of the city, nation, and world in Venice occupies the bulk of the narrative, swelling out of sync with the more restorative fantasies of autarky and simultaneity implicit in the Fascist empire's self-stylings.

The aeronovel's "sweet simultaneity" is not content merely to restore the forms of the past acritically, as Marinetti makes clear in a parodic nuptial scene "of shameless modernity" (26). This slapstick diversion from the text's central action recounts the honeymoon of Bizzone, a skilled Futurist glassworker whose name forms an off-rhyme with "garbage bin," and Rosabionda ("Pinkblonde"), descendent of an ancient Venetian family "whose heroic glories are preserved only in an arrogance . . . and a love of abroadness insufficiently reined in by patriotism" (25). Prankster Futurist comrades have fashioned their nuptial mattress out of a dozen *nature morte* ("still lifes" or literally, "dead lifes"), which are the weakness of Bizzone, an otherwise laudable Futurist. The still lifes crack to pieces when the spouses lie down, scratching and splintering their half-naked bodies. Their passéism is finally "corrected" by the phenomenal apparition of an electric lamp lighting up Boccioni's

painting *The City Rises* "like an insurrectional blaze . . . in crazed white keys" (27). Here, electric light is likened to music, which the narrative credits with delivering the honeymooners from the "barbarian genius" of Wagner (and, by way of association, his literary devotees in Venice, D'Annunzio and Mann) to the "synthesis of the sea" achieved by Futurist composer Aldo Giuntini (27). This episode suggests that Venice can become the scene not only of negation, but of erotic consummation for classic Futurist ideals.

In fact, *Venezianella e Studentaccio* pays homage to Futurism's foundations in Venice by citing Marinetti's call to kill the moonlight and manifesto against Venice, multiplying the number of pamphlets dropped from the Clock Tower to a sublime thirty-eight million—but now imagines the Venetian reaction as citizens and even palaces talk back in Venetian dialect: "—Cosa xelo sti futuristi / —I xe gente che vede il mondo a l'incontrario" ("—What are these Futurists anyway / —They're people who see the world backwards") (49–50). *Venezianella e Studentaccio* delights in contretemps and epochal pastiche that amp up its clamorousness; the Futurists' youthful dictates are now piled upon one another far more self-consciously and hyperbolically. Over the course of construction of the *Nuova Venezia,* the library crumbles; the oared warship of Doge Morosini is fished out of the lagoon and outfitted with escalators; a Futurist Crystal Palace is erected; and all is overhung by a balcony 1,000 meters high and a translucent 2,000-meter ceiling. Along the way, the text itself, citing a range of Futurist publications as well as passéists such as Barrès, becomes an anarchic work of historiography, chronicling both Futurism and the history of aesthetic engagement with Venice while glimpses of the damaged present tense spasmodically seep through the cracks. In *Reconstructing Italy with Sant'Elian Futurist Architecture*, a postal worker with no more mail to carry in a disinhabited Venice learns that what he thought he saw in the *rosone* of St. Mark's—a crowd of workers restoring its glass—is instead a mass of rats that had followed the troops in the Great War but found no more corpses to eat, and now huddle gnawing at the crumbling basilica walls; in *Venezianella e Studentaccio*, a *campiello* becomes a synthesis of misery, hosting nothing but a march of rats and "the drawn-out shadows of remote pulverized cadavers of beggars who didn't dare even hope for a pallet and in this pain . . . vanished before being born" (21).[167] The sumptuous eccentricities of Venezianella's mantle emerge as the imperfectly melded reflux of all those cultural and colonial particulars that failed to cohere in one state, dazzling this brutal reality of war and desolation that trickles through the narrative sporadically.

The New Venice threatens constantly to implode, in a carnivalesque echo not only of the world war, but of the conflicts embedded in the city's histories,

both distant and actual—for the civil war in Italy would have distressed any facile synthesis on the patriotic artist's part. Marinetti's Island of San Giorgio becomes the site of an aerial theater quite different from that of the Fascist film industry that had taken over Venice proper[168]: on its three-hundred-meter high screen, Futurists project reenactments of the battles and loves of historical styles represented in Venetian architecture. One film features the love triangle between "the Church of the Salute with St. Mark's and the Ducal Palace"; this story precipitates "the conflict of the Gothic Eighteenth-Century Venetian Baroque and Byzantine Veneto Styles" (VS 111, 116). Illuminated by a "muddle of light-forces on the Dolomites," the first style "deigns to sensualize round circumvent enring spheres breasts bellies thighs arches fruit enfram- ing . . . the paintings of Giorgione Titian Carpaccio with grace and opulence" while the second style's ruckus of obelisks and pilasters collapses in a groaning "craze of trembling compasses" (116). Studentaccio finally emerges "from the wrinkles of a lapidary past" to attend the conference at an imaginary modern- ist building called the Severe Palace of Venice, where Aeropoetry and Aero- painting are hailed as the "ascensional pulsing geometry of colors musics hues tactilisms" that modulate severity and lead to the divine (117–18).

In one particularly tender Futurist projection into the stylings of the past, the text confesses to Venezianella, "now I remember that I am a little boy full of memory and it is very beautiful but too serious"—a confession delivered vis-à-vis the inscription that appears on a book purveyed by a stone cherub on a seventeenth-century ceiling (66). Such exaggerated mediations of the story's diegetic dialogue form Marinetti's own ludic, even self-conscious support for the critical claim that "[t]he avant-garde, while it defines itself ideologically by its polemical . . . attitude toward every form of historiographical mediation, cannot even begin to conceive of itself as a form of organization if it does not see itself as a radically historical creature, almost obsessively attentive to all the nuances of the 'before' and 'after.'"[169] Venezianella e Studentaccio deviates into traditional narrative modes—of fable, epic, blazon—that dilate, multiply, and hone in on time, amplifying the text's self-reflexive generic instability: in a metanarrative moment, we are told that "this aeronovel or aeropoem cares lit- tle for time and space" (107). Sparing its readers, who are "sure to sympathize" with Futurism and hence assumed to be impatient by nature, the aerotext abbreviates its telling, assigning approximate numbers of years to its climactic episodes rather than recounting them exhaustively (106). In the epic war over a New Venice, battles against the pantegane (Venetian dialect for "rats," possi- bly echoing the term used by Germans for the Allies at Tobruk) last half a cen- tury each, and nine generations of irrepressible Futurists must fight off troops

of cesspools (106). Along the way, the work permits itself multiple asides by storytellers and soliloquizing palaces, sparrows, and mice. In each instance, confrontation with the past could not be farther from D'Annunzio's umbilical access to cultural heritage, "inherited in a straight line from the cinquecento," as James had satirized.[170] Mediated on stylistic, generic, and material fronts, *Venezianella* engages history as an amassment of filters, blockages, and encrustations through which the living must bore in order to renew society. Writing from within the tenuous asylum of a Venice hemmed in by war, Marinetti is assailed with the tortuous routes of cultural inheritance. His late text expresses that a new day for the city (and the nation) can only be erected by navigation *through* preceding forms and teeming residua. Out of persistent combat comes volatile coagulation with the past.

"To weigh"—the text's opening verb, expressive of historical freight and contrasting the levity of flight—becomes an important action late in the text. When Venezianella finally reappears, she bids, "free me of my task / To weigh the ideals of our time and above all communist antiwoman antifamily antimodesty antiart Atheism and because of this with open hand I wait / From the Aerogarden a vulture flies off to reach the aeroaquarium dives in head first and comes out flying to offer Venezianella a huge black eel coupling with a rat" (113). To be freed of history's weight, one must sound the lagoon's depths for an emblem of coupling between two metonyms for Venice, the *pantegana* and the eel, vaguely repellant representatives of its mammal and aquatic life fetched by a bird that specializes in hunting carrion. Studentaccio responds that the oars of Venice, nerves of the city, should act to "weigh patriotic heroism" (114) and "tender voluptuous carnal delight, generatrix of virile males and little girls" (106) against what the Futurist glassworkers hail in chorus as "tons and tons and tons, incalculable, of holy water from God's purest ocean" (114).[171] The young protagonist calls for the transference of a historical burden to the weight of both secular ideals and sacred substance.

Earlier Futurisms depended on a "polarized . . . configuration of masculine totality and feminine lack," which provided "a blueprint for the Futurist destruction and reconstruction of the universe"[172]; by contrast, the reciprocal interference of aquatic and terrestrial, terrestrial and aerial, historical and ideal, feminine and masculine surfeit in this blueprintless city of glass spurs the implosion of both the composition and a dispersed "I." A final battle between matter and ethereality, past and present takes place when the despotic Futurist Negrone extracts syringes from the *fondamente* that line Venetian canals, threatening to inject "all the holes of Venice," as he denigrates the "waters plushy with mold fastidious aristocracy worn-out effeminate elite

and rashes of the skin" (124)—when suddenly a procession of marble lions emerges in the Campo of San Giovanni e Paolo, "palpitating with majestic conquest" in Venice's defense (124). The quaking of a basilica wall casts out equestrian monuments and funerary urns as the tomb of Jacopo dei Cavalli cries out, "we declare you vile because you let your strength become petrified by vanity and took little heed of us who in order to appear as lions dozed off in lapidary forms"; he calls on the lions to "tear to pieces the sludgey Past that reawakens" (124). Here the Futurists are cast as complicit both in the petrifaction of force and in overlooking the potential power embedded in stone Venetian forms to reawaken Italy. The text next takes on the voice of the once vilified Campanile as tolling Venetian bells threaten, "harm will come to you o Lions if you disobey us Bells who are the daily bread of starving Space" (124–25). Venezianella finally appears to resolve the battle between awakened stone and the tolling of time: she declares, "Thought which survives the end of the body and petrifaction is pleasing to God and you dear Studentaccio will feel me again fused with the cusp of the New Venice constructed by you and in the sinuous lips of the effulgent cigarette case of gold that was your gift to me" (125). Upon this declaration of a heroic female Venice now cast as a lover transfigured—and by the light of a diminutive and somewhat parodic *flame*—the Futurist's final narrative ends, closing once and for all this founding chapter in the history of modernism.

VENETIAN COUNTER-ENLIGHTENMENT

The bizarre mingling of Futurist and passéist impulses in *Venezianella e Studentaccio* might well be viewed as consonant with a Fascist tendency to bind contradiction as oxymoron. Fascism's "refusal (or incapacity) to define itself philosophically" has been held responsible for this tendency to yoke together the poles of past and present and "to attempt a realignment of signifiers and signifieds," such that "in oxymoronic fashion, war comes to be aligned with life and peace with death; socialism comes to be national; the revolution is conservative; and neologisms (in particular, invective) abound."[173] But the species of irrationalism present in Marinetti's final vision of Venice is less successful in its acts of binding. Here the *Nuova Venezia* is misaligned with the old, insofar as Venice offers up an improper, miscegenated species of antique form.[174] *Venezianella e Studentaccio* leaves us with unsettling questions: was counter-Euclidean, nonclassical Venice, home to the capricious eighteenth-century architectures of Piranesi and Canaletto, the perfect objective correlative

for the anti-Enlightenment strain of modernity espoused by Fascist thinking in the form of "activism, instinct, and irrationalism"?[175] Or does the Venetian heritage that the late Marinetti clamorously resurrects persist in excess of that ideology?

It would be impossible to reduce Venice's irrationalism to a mere proxy for the regime if we heeded Mark Antliff's call to treat Fascism "as a form of cultural politics in dialectic (or dialogic) relation to other anti-Enlightenment movements, both left and right."[176] The New Venice established by the text would be closer to the anarchistic utopia envisioned by the Futurist Party from 1918 until 1920—one in which young elected Futurists helped govern through excitation rather than moderation, even if individual liberty and cultural cosmopolitanism would ultimately be reined in by a religion of the nation and imperialistic violence. And yet this Venice has abandoned any coherent governing scheme under which to convene except through "Poetry at all costs and Creative Pride at all costs" (121)—energies bound together in a mystified synthesis of love. The Venice imagined by an aged Marinetti provides an elaborate forum for Futurism's aesthetic unsettling of any consistent politics that once seemed to subsume its motions.

Venice does not expire despite the centuries of its surface abjection, nor during the decades separating Futurism's founding and termination. It persists as a site of influx and efflux that remains steadfastly "Venetian," forcing incursions into it to change their ways or channels—literally. As such it resists the dyads of future and past implicit in what Adorno called "the fatally rectilinear succession of victory and defeat," forcing authors to contend, in a vengeful obsolescence, with "the waste products and blind spots that have escaped the dialectic."[177] Marinetti's late deployment of unassimilated and anachronistic material should help us to extricate his writing from a unidirectional, monolithic narrative of futurity, and to bridge the history of a never-quite-rejected Symbolism and the aging stylistic disfigurations of the avant-garde.

The forms of the *aero*aesthetic return to fundamental elements of Italian art history: the study of perspective and "transfiguration," or a "new plastic extraterrestrial spirit." But as Lista argues convincingly, the flattening and dilation of representation in aeropainting ultimately expresses finitude, pushing us to the "irreversible exhaustion of the traditional perspectival model" by exposing the mythology of the conquest of space as just that, a myth: "The new perception of the earth as finitude turns inside out in a titanic sentiment . . . in which man revindicates and reactivates his ancestral cosmic vocation."[178] Marinetti's return to Venetian forms might be seen to

participate in a corresponding shift of focus by aeropoetry, and the culture of the 1930s and 1940s in general, to regional ancestral landscapes within the autarchic state.[179] The "Manifesto of Aerial Architecture" was already in tension with this regionalist nationalism, declaring that new Futurist "aeroways" would "abolish every regionalism belltowerism [*campinilismo*] ruralism and grant Italy a single city of continuous lines of velocity health pleasure in living, truly worthy of Fascist aviation and its Head Benito Mussolini."[180] Marinetti's 1944 Venice of civil and world war conforms neither to the limits of a *strapaese* aesthetic nor to the principles of this syncretic Italian monolith from the air. The fissuring of the adamant, singular, arrogant purpose of the Clock Tower leaflets—and of any Fascist consensus—by *Venezianella's* war-tinged multiplicity of perspectives admits that Venice was always a transnational complex. Its ushering into the programmatic national and imperial history and future of Fascist *trasmigratori* was bound to be internally contradictory, and incomplete.

The case of Venice as a site of discursive traffic proposes that perhaps the modernism with the most lasting potential "immensif[ies]" (*VS* 9) rather than disembowels incompatible cultural surplus. Amplification and kaleidoscopic recombination of the lagoon's Byzantine décor, Gothic embellishments, "remembered" machines, crepuscular and electric illumination all give rise to *Venezianella's* "fecund simultaneity," in fantastic rebellion against the transparent rationalism of modernisms prior. Residue of the pasts that the Futurists of 1910 sought to expunge become reactivated, a few decades later, in Marinetti's sumptuous assemblage, which rewrites the failing social totality as an implosive conglomeration rather than synthesis.

 ● ● ●

The lingering life of Futurism's repressions became palpable (yet again) when visitors to the 2007 Biennale found themselves colliding with displays of "anachroheroism." Luca Buvoli's *A Very Beautiful Day After Tomorrow (Un Bellissimo Dopodomani*; figure 3.5), a four-phase multimedia installation situated in the opening galleries of the Venetian Arsenal, both dated and localized the Futurists' earlier Biennale antics. In this and other elements of a "Meta-Futurist" project pursued since 2003, Buvoli aims at Marinetti and cohort from a perspective he characterizes as "post-utopian." In *Entanglement of Modernist Myths,* a circular gallery installation, a sculptural assemblage titled *Vector Tricolor* surrounded the viewer with a crash of large suspended planes in fiberglass and Plexiglas such as are used in aviation technology, filtering the light and casting splinters of shadow on the walls and floor; the

FIGURE 3.5/PLATE K. Luca Buvoli, *A Very Beautiful Day After Tomorrow (Un Bellissimo Dopodomani)*, multimedia installation at the Arsenal exhibition of the 52nd Venice Biennale, 2007. View including the suspended sculpture *Vector Tricolor [Entanglement of Modernist Myths]* in foreground, and in background, the wall sculpture *A Very Beautiful Day After Tomorrow Marquee*. Installation encompasses digital video, reinforced polyester and polyurethane resin, metal, Plexiglas, plaster, and other materials.
© Luca Buvoli. Reproduced by permission of the artist.

form of a human figure fused with a stealth bomber mounted and hung from the ceiling in their midst embodied the idealist delusion of Futurist flight. In the context of this circular room, conditioned by *A Very Beautiful Day After Tomorrow*, a video documentary/animation in which Fascist propaganda films' expired frenzy was amplified through the addition of visual noise, the dozen or so transparent planes of *Vector Tricolor* recalling the "plastic complexes" of Balla and Depero registered as an exhibit at a history museum— hanging in fractured suspension, not in motion. As pinkish and turquoise prostheses from the painted wall destined to decay, the "tricolor" resin forms tinted, cheekily, with the "energy enhancer" of Gatorade recalled the soft hues and transparency of local materials rather than the *tricolore* of the Italian flag and bold colors of doctrinal Futurism.[181] These sculptures worked in concert with "Propaganda Posters" and videos to gloss an interview conducted with Vittoria Marinetti. The eldest daughter of F.T. recounted in video footage that when her father was dying in the mid-1940s, she worried about his illness

and about the political situation in Italy and asked, "What happens now?" He replied, "Remember: 'now' isn't important. There will be a very beautiful day after tomorrow [*Ci sarà un bellissimo dopodomani*]." The citation ricocheted, sculpted, across the gallery walls as on a marquee, its M (a recognizable metonym for "Mussolini" and in this case, by extension, "Marinetti") suggestively sunken to the floor as stone effigy, moribund by contrast in permanence and opacity. Footage from Buvoli's film *Velocity Zero (Aphasia)* in annexed rooms featured patients at speech pathology clinics stammering their way through pronunciation of the tenets of the first manifesto of Futurism, in a violent embodiment of conceptualism. Aphasia slows down and corrupts the Futurist agenda considerably: "No work without an aggressive character can be a masterpiece" comes out "No world without an election can be a Mose's—pace."[182] After lingering in an installation coming so decidedly after the "tomorrow" of modernism, at the 52nd edition of a hoary old art exhibition in Venice, it becomes difficult indeed to accept the founding manifesto's utopian assertion that "Time and Space died yesterday."

4. FROM PASSÉISM TO ANACHRONISM
MATERIAL HISTORIES IN POUND'S VENICE

... pur trovandosi uniti strettamente da un unico ed altissimo ideale,
civico al mille per mille, ... appartenevano a parti decisamente contrarie,
irriducibilmente avverse ...

... even in finding themselves strictly united by a single and most high ideal,
civic by a thousand percent, ... they belonged to decisively contradictory parts,
irreducibly averse ...
—Aldo Palazzeschi, *Il Doge*

FESTINA LENTE: THE INVENTION OF A MODERNIST IN THE CITY OF ALDUS

as of less and more than a day
by the soap-smooth stone posts where San Vio
meets with il Canal Grande
between Salviati and the house that was of Don Carlos
shd/I chuck the lot into the tide-water?
le bozze " A Lume Spento "/
(*Cantos* 76/480)

In July 1908, two years before the Futurists bombarded St. Mark's Square with leaflets of their manifesto against Venice, a 22-year-old Ezra Pound took decisive steps to bring himself into being as an author in the passéist city. Resisting the urge to throw the proofs (*le bozze*) into the Grand Canal from the worn stone bridge of San Vio, he printed 150 copies of his first collection of poems, at his own expense, in the place he credited with having awakened his interest in "civilization" as an adolescent.[1] Performative self-publication of this first book, initially assembled in Indiana and rejected by American

editors, was only the initial chapter in a 74-year relationship with the city so encrusted with literary capital out of which Pound emerged as author—as early lyricist and burgeoning polemicist, scattered first person of *The Cantos*, and reticent exile of the years after Fascism's fall and his detainment at St. Elizabeth's Hospital, until his monumental interment on the cemetery Island of San Michele.[2]

In the context of Marinetti's imminent career-launching call to "Kill the Moonlight," the title of Pound's first collection, *A Lume Spento* (*With Tapers Quenched*, in Pound's own translation), registers as the product of a temperament saturated in the crepuscular ambience of the *fin de siècle*. When apprehended as a citation, however, the phrase reveals itself as far antedating decadent fashion, leading us back to a thirteenth-century heretic and patron of vernacular poetry remembered by Dante. The title is lifted from *Purgatorio*—citing the moment when the shade of Manfred, epicurean King of Sicily and son of Emperor Frederick II, whose illustrious court had given rise to the sonnet and the first school of Italian vernacular poetry, describes his disinterred bones, ordered by the papacy to be desecrated and transported unlit due to his excommunicated status: "Now the rain bathes and the wind moves them / Beyond the kingdom, nearly along the Verde, / Where he transported them [*le trasmutò*] with tapers quenched."[3] As Marinetti was formulating the founding rejections of Futurism, an upstart born on the Idaho frontier was basking in the shades of the Dorsoduro quarter, developing equally iconoclastic poetic methods of dealing with the past.[4] Rather than raising the dead in metaphysical speculation, as Byron had in his closet-drama *Manfred*, or proposing to expunge their traces as the Futurists would, Pound disinters heroes remote and romantic, then transports their cited remains intact into alien contexts. Adopting exhumed voices, named and anonymous, from a motley corpus of prior epochs, Pound's first collection initiates an archaeological process that will pervade his oeuvre: it sounds "the mingled chords" drawn "from out the shadows of the past" in verse that refuses to temper either their differences from one another or the noise that results from their transmission. In transporting these shadows into his poetry, he undertakes a transformative process of translation or, to use Dante's term, "transmutation."[5]

The antique cosmopolitan city of Venice, notoriously drenched in competing shadows, provides one archive for these "mingled chords" that remains generative for the duration of Pound's career, though he never settles on a single meaning or instrumental use of the place. From the colophon of his first collection, which cites a tradition of printing and editing pioneered in Venice, through multiple phases of *The Cantos*, which transcribe Venetian

editions and state documents alongside passages of lyrical absorption in the city's ongoing dialectic between stone and water, Venice emerges as a repository of material histories that motivate Pound's antihermeneutic, open historiography. While Venice cannot be isolated as the overriding source of Pound's capacious, polycentric poetic (like any single site or trope), it stands out in his oeuvre as a place that literalizes the translation of history as disunited fragments, presenting kaleidoscopic possibilities for reading both city-state and epic anew. We will see how Venice as archive inspires Pound to poetic reanimation that challenges both backward- and forward-looking teleological approaches to time—approaches manifested in D'Annunzio's restorative nostalgia, *avant-guerre* Futurism's projected obliteration of the past, and the instrumental historicism and related *romanità* of the Fascist *ventennio* (what the regime would call "simultaneity," in its imperial hearkening to Futurist rhetoric). Pound's engagement with Venice also demands that we revisit the truisms that have shaped his critical reception, distressing the notion that the dictates of Imagism, Vorticism, and heroic monumentality—including Pound's own "Don'ts" for poetry and his eventual Fascist ideology—overcome the strains of the nineteenth-century avant-garde at work in his earliest publications.[6] The strategic untimeliness of Pound's poetic approaches to Venice endures, though it takes a range of forms, transmuted from passéism to anachronism, crepuscularity to archival clarity, digression to disjointed assemblage, ideological historicism to eccentric recollection.

The colophon of *A Lume Spento* announces that the book was printed "IN THE CITY OF ALDUS / MCMVIII." With that allusive Venetian inscription, the young poetaster invokes the city's status as a capital of innovative early modern publishing, placing himself willfully in the lineage of the high Renaissance as it was galvanized by Venetian works of printing and curation—in addition to the more evident lineage of authorship represented by the Florentine Dante. We can easily apprehend the influence of this Venetian editorial legacy on Pound's poetics, both early and mature, as it vaunted both pedagogical and aesthetic values in line with the ones he was developing. At the turn of the sixteenth century, Aldus Manutius, the celebrated Venetian humanist, grammarian, translator, editor, and typographer—who had adopted as his printer's mark the dolphin and anchor icon, signifying the classical oxymoronic adage *Festina Lente*, or "Make Haste Slowly"—printed classical texts such as *The Odyssey* and Aristotle's complete works in the original Greek after centuries of unavailability. (An influx of Byzantine refugees to Italy after the Ottoman conquest of Constantinople in 1453 had led to the demand for editions in Greek, bolstering Venice's emergence

as one of the first great global printing centers.) He also printed portable touchstone editions of Dante's *Commedia*—under the title *Le terze rime di Dante Alighieri*—and Petrarch's *Canzoniere* prepared by the Venetian poet and humanist Pietro Bembo.[7] Though Bembo was an outsider to the Tuscan dialect of the poets he was editing, his labor was regarded as a promotion of the illustrious Italian vernacular for which Dante had argued; transcribing the texts of early manuscripts directly, he accomplished a virtuosic act of philological salvage that made creative, and at times controversial, new readings possible. Aldus's production of the Dante octavo was considered equally revolutionary in its attention to the poetry itself: it encouraged a more direct relationship between reader and work through its portable dimensions and by printing the poem without the mass of theological exegesis that had accrued in the two centuries after its composition.

Pound thus marks his first collection, with its non-exegetical transmission of alien historical idioms, as carrying on not only the Dantean legacy of narrative colloquy with a company of the dead, but also a Venetian tradition of poetic salvage, reinterpretation, and distribution—a tradition tantamount to a revolutionary poetics. Significantly, in launching himself into the literary marketplace, Pound identifies as much with Dante's Renaissance editor and publisher as with the author himself and the shade of Manfred the fourteenth-century epic poem invokes—presaging a later interest in Confucius as anthologist. In so doing, Pound brings a poetic into being whose relationship to time is altogether different from that of the Futurists: one characterized by the contradiction embedded in *Festina Lente*—a motto glossed by Giorgio Agamben in *Categorie italiane* (*The End of the Poem*) as a "slowed agitation and breathless tarrying [*ritardata concitazione e . . . affannato indugio*]." This poetry revitalizes a process that Agamben exhumes in Aldus's imprints: the "reciprocal deformation [*reciproca deformazione*]" of a dead language and a more fluid vernacular.[8]

Pound's approach to poetic authorship as a vocation yoked to lingering in archives, to tasks of editing, translation, and transmission—shirking conventional parameters of originality as well as of undistressed access to "tradition" for a strategically belated stance—renders Venice critical to his self-invention: it is a city remembered less for its individual poets than for its historical role in intellectual transport and "transmutation" between antiquity and the present, East and West, and for its enduring seduction of post-Romantics who, amidst so many illustrious signatures, find over and over that there is nothing new to say. Digging out from under the stance of the solitary speaker, Pound's early lyrics become choral even as they transmit the assertions of a

first person; they refashion the would-be poetic I as a site of passage, or vortex. In an October 1908 letter to William Carlos Williams, Pound recounts his excision of "gloomy" sonnets from *A Lume Spento* conducted in Venice, yet defends his still "rather gloomy and disagreeable book" as a refusal to set the eight exhausted "facts on which I and 9,000,000 other poets have spieled endlessly" into pretty verse, asserting, "Why write what I can translate out of Renaissance Latin or crib from the sainted dead?"[9] The subject of the early lyric "Plotinus" is already a crossroads lacking a distinct voice, who "knew all nothing my unconquered own"; this figure's "New thoughts" must be funneled not only through an iambic pentameter to be broken in later work, but through the burdensome awareness of "one that would draw thru the node of things, / Back sweeping to the vortex of the cone, / Cloistered about with memories" (*PT* 46). If, as Agamben writes in his post-Nietzschean Venetian meditation "On the Uses and Disadvantages of Living Among Specters," "living in Venice is like . . . trying to pronounce every word, syllable by syllable, in a dead language; learning how to lose and rediscover our way in the bottlenecks of declensions and sudden openings of supines and future infinitives," Pound's poetic taking shape in the spectral city reminds us that "one should never declare a language dead, because it still speaks somehow and is read; it is only impossible—or nearly impossible—to assume the position of a subject in such a language, of the one who says 'I.'"[10]

Pound's 1908 residence in Venice is indisputably formative. In identification with the city of Aldus, he launches a system for making lyric presence new through poetic production of what Nietzsche called the *unzeitgemässe*: by occupying lingos and topoi that are outside of one's own time.[11] His early volumes have attracted minimal critical interest, being routinely dismissed as quaint post-Swinburnean, Pre-Raphaelite, decadent, youthful exercises, eventually overcome by the parameters of Imagism, Vorticism, and ideogrammatic montage theorized by Pound.[12] The author himself dismissed these volumes as "a collection of stale creampuffs" in a 1965 reprint before adding affectionately, "'Chocolate creams, who hath forgotten you?'"[13] Pound criticism has tended to take the poet's rhetoric rather than his poetry at its word, crediting Imagism and the modernist tenets to which it gave rise (direct treatment of the thing, elimination of ornament and extraneous verbiage, and freedom from time limits and space limits, for example) with a more naïve relationship to historicity than the one delineated by the work itself. Marjorie Perloff voices a critical distance from these scholarly narratives by pointing out that after 1917, the year the first "Three Cantos" (or so-called "Ur-Cantos") were published, Pound's lyric production "oddly becomes less rather than more

imagistic, Vorticist, or ideogrammatic."[14] This claim is well taken, and I draw on it to mark the fact that Pound's lyric production after 1917 consists largely of translation (or in Pound's literalizing translation from French, "traduction") and passages integrated into the epic work of editing and assemblage that is *The Cantos*. Like Ruskin, James, and Marinetti, Pound will reject, yet continue to haunt the outmoded literary inheritance of his youthful education and its elaborated object of a city for the entirety of his career.

Analyzing this work from the standpoint of twenty-first-century poetics, we can assert that rather than being dismissed for its reputedly regressive qualities, as if it constituted uncritical mimicry of nineteenth-century mannerisms alone, the archaizing and editorial, translational lyric strain nursed in Venetian environs deserves to be recognized as a fundamental impulse of the epic genre reinvigorated by Pound.[15] It recruits into poetry that function of criticism that, in "Date Line," Pound calls "excernment": "The general ordering and weeding out of what has actually been performed. . . . The work analogous to that which a good . . . curator would perform in a National Gallery. . . . The ordering of knowledge so that the next man (or generation) can most readily find the live part of it, and waste the least possible time among obsolete issues."[16] *A Lume Spento* emphasizes the friction inherent in the poetic strategy of *personae*, asking in "Masks," "These tales of old disguisings, are they not / Strange myths of souls that found themselves among / Unwonted folk that spake an hostile tongue . . . ?" (*PT* 45). The early collections' unharmonious idioms amplify the hostility of the present to these "old disguisings." *A Lume Spento*, moreover, already anticipates *The Cantos* in the form of "that great forty-year epic / . . . yet unwrit" in the toying fingers of an eighteenth-century scholar/poet almost lost to history, who is to witness "the sculptors of new ages carve me thus."[17] Pound's initial act of homage to the city of Aldus exists on a continuum with his culminating project of "poetry as sculpture" inaugurated nine years later: Canto 1 famously interrupts its narration of a visit to Hades to pay homage to the translator and printer of Homer from which he is working ("Lie quiet Divus. I mean, that is Andreas Divus, / In officina Wecheli, 1538 . . .")—citing the colophon of a reproduction from Divus of Capodistria's literal translation of the *Odyssey*, first printed in Venice and, Pound noted, in dialogue with Aldus's prior edition.[18] From 1923 forward, *The Cantos* will open with a translation of an ancient trip to the underworld that places unprecedented poetic emphasis on the editorial work that made it possible to convey this material vividly to our day, unearthing the labor that preceded the interpretations of Chapman, Keats, and beyond.

The Cantos' emphasis on editing, translation, and tactics of circulation in the generation of meaning—on what we might call the status of the book as vortex—becomes fully embodied through the high production values of the first three, so-called "deluxe" editions of the work—those preceding the modern commercial editions by Farrar and Rhinehart, Faber and Faber, and New Directions that were issued from 1933 forward: the folio-sized *A Draft of XVI. Cantos of Ezra Pound, for the beginning of a poem of some length, now first made into a book with initials by Henry Strater* (Paris: Three Mountains Press, 1925) and *A Draft of the Cantos 17–27 of Ezra Pound: Initials by Gladys Hynes* (London: John Rodker, 1928), and the smaller-format *A Draft of XXX Cantos* (Paris: Hours Press, 1930), whose decorative Vorticist initials were produced by Pound's wife, Dorothy. These limited-edition, hand-processed books, printed on precious materials such as Imperial Japan, Whatman, and Roma paper, and even vellum, with special watermarks, and inscribed with decorative initials, have routinely been passed over as artifacts—as if the material properties of Pound's texts were somehow extraneous to his conceptual aims. Jerome McGann demonstrates convincingly that Pound's epic "will not allow an editor to proceed on the assumption that final distinctions can be drawn . . . between the work of the poet, on one hand, and the work of the compositor, the printer, even the bibliographer on the other"; he locates the editions' "elaborate bibliographical coding" within a "radial network" that includes the recent Pre-Raphaelite revival of illuminated medieval manuscript production, and through it, the Renaissance revolution in printing.

McGann stresses in particular the 1925 and 1928 editions' allusions to the work of William Morris's Kelmscott Press, which printed works of contemporary literature through the unalienated methods and forms of medieval aesthetics inspired, most immediately, by Ruskin's "The Nature of Gothic" (a work that received its own Kelmscott edition).[19] But Pound distinguished his modern "dee looks edtn" from the "Kelmscott mess": "It is to be one of the real bits of printing; modern book to be jacked up to somewhere near level of mediaeval mss. No Kelmscott mess of illegibility."[20] The spare illuminations of these *Cantos* may be read fruitfully through Ruskin's earlier call for a reopening of the field of illumination, and his more theoretical conception of "the continual play of the fancy of the writer in every species of grotesque imagination": "A fine grotesque is the expression, in a moment, by a series of symbols thrown together in bold and fearless connection, of truths which it would have taken a long time to express in any verbal way, and of which the connection is left for the beholder to work out for himself; the gaps, left or overleaped by the haste of the imagination, forming the grotesque character."[21] Such tactics pave the

way toward Pound's more radically discontinuous "earthly paradise": reading the "open field" of this epic as an extension of a Victorian project that revived the generative convolutions of Gothic pattern and the tradition of fine Renaissance printing further illuminates a shadow modernism that taps the book as a sensuous artifact of encounter rather than a functionalist container for meaning. Pound's radically nonlinear poetics, which flaunts its participation in the discontinuous architectures of history, ultimately confutes the precepts of such impetuous avant-gardes as Futurism, and makes poetry new by delectating in the device of Aldus: *Make Haste Slowly*. The poetic tense that results unfolds in no single time signature. The first three *"Drafts"* of *The Cantos* enact a full-scale clash between Pound's contemporary languages, references, and fragmented, spatialized verse forms and the anachronistic materials and cultural allusions that frame and interrupt them—and vice versa. The open-ended process of producing and interpreting these "drafts" exists in paradoxical relation to the heavily labored architecture of their transmission. As such, these editions and the epic they set into circulation represent a full-scale extension and transmutation, rather than rejection, of the poetic mode inaugurated by *A Lume Spento.*

Pound's innovations rely on the collision between diction, tropes, and forms of the past and the site of their translation. "Villonaud for this Yule," from *A Lume Spento,* incorporates lines from Villon's *Le Lais* ("Sur le Noël, morte saison, / Que les loups se vivent du vent") into a polyphonic opening stanza of words from hybrid cultural origins and metaphors incommensurably mixed, in which wind becomes liquid: "Towards the Noël that morte saison / . . . / Then when the grey wolves everychone / Drink of the winds their chill small-beer. . . ." (*PT* 28). The contemporary voice of the poem, while explicitly citing Villon, wonders who authored the simile (or rather *paragon*, from the Greek) it deploys—a simile in which wine becomes the agitated "lake" (or, significantly, "border") of an Old English term (*mere*), as the speaker excavates a verb out of Old Norse (*skoal*) to toast the ghosts of dead love in a harrowed iambic tetrameter: "I skoal to the eyes as grey-blown mere / (Who knows whose was that paragon?) / Wineing the ghosts of yester-year" (*PT* 29). The young poet of *A Lume Spento* invokes, and toasts, precursors from Homer to Villon and beyond in a key so self-conscious as to antagonize—to the point of second-guessing—the "paragons" he deploys as inexorably echoed, cited.

Pound's mature work will build on these beginnings, in the first phase of what I call his strategic passéism—a dissonant species of invention whose wayward strains of backwardness, in the context of an anachronistic whole,

operate in excess of both philological propriety and naïve nostalgia. As one poetic speaker puts it in "Anima Sola," the resultant music is "Barbarous, wild, extreme": it reflects a clash of cultures that are distinct in temporal and geographical terms. Such music ". . . is your disharmony / . . . / For the clang of a thousand cymbals / Where the sphinx smiles o'er the sand" (*PT* 33–34). By excavating the "notes" that have come down to him to recompose the music of "some poor song-bird / Battering its wings, against this cage we call Today," the poet resolves to make "A new thing / As hath not heretofore been writ."[22] The "new" will arise from struggles *against* the present.

Pound's acts of salvage in these first poems, while making a case for the poet as editor, also transgress the limits of merely archival and curatorial work toward a "new Renaissance." They introduce neologisms into current English through strategic use of archaism and incomplete translation, so that an elegiac echo of the past becomes synonymous with experimentation. A decade later, in 1919, "Homage to Sextus Propertius" articulates in the modernized voice of the ancient elegist,

> My cellar does not date from Numa Pompilius,
> .
> Nor is it equipped with a frigidaire patent;
> Yet the companions of the Muses
> will keep their collective nose in my books,
> And weary with historical data, they will turn to my dance tune.[23]

The poet will launch a series of attempts to render historical content as music by which to dance, while remaining aware of how much such data can weigh on the Muses' wearied "companions"—presumably artists, who are significantly cast as *readers* rather than self-sufficient creators. Taking up a belated stance in Venice, Pound faces the challenge of resisting the tendency to purvey the past as cliché or dead information. As such, he follows in the footsteps of his New World precursor in Venice and avowed paragon for clarity in prose, Henry James. Venice is one site where a central problematic of Pound's poetic—the continuity or tension between past and presence—becomes concretized, located in space and in the present moment.

Invoked early on as the paragon of a cosmopolitan vernacular poetics achieved through radical textual editing, Venice will remain a touchstone in continual metamorphosis as Pound's poetic begins to cleave more self-consciously to "things." In succeeding decades, the archipelago famed for amalgamating disparate islands and cultures will provide the poet with both

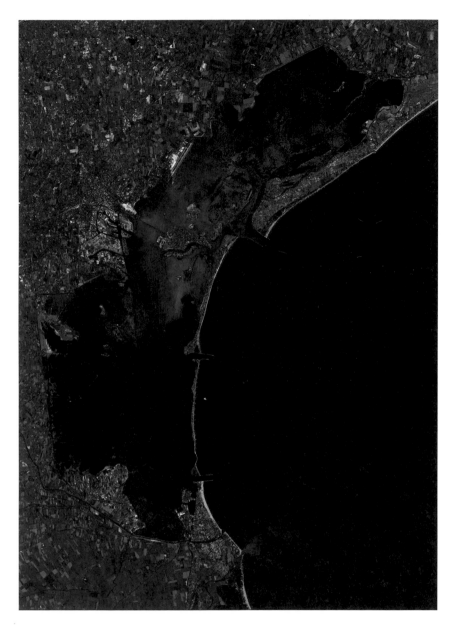

PLATE A/FIGURE I.3. Image of Venice from the Advanced Spaceborne Thermal Emission and Reflection Radiometer on the Terra satellite, acquired in December 2001, and showing the saltwater lagoon that lies between the river mouths of the Po, Adige, and Brenta (to the south) and Piave (to the north), with the fish-shaped historical complex just west of the Lido barrier island. False-color enhancements bring out the details of water and vegetation.
Courtesy of NASA.

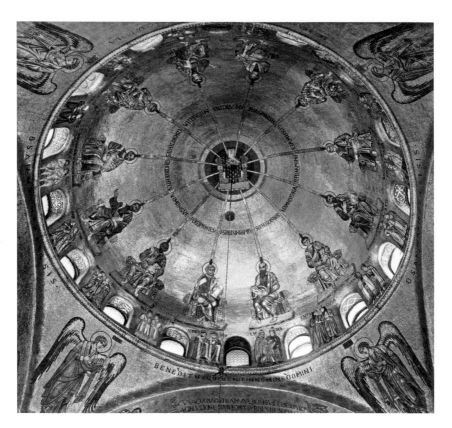

PLATE B/FIGURE I.7. Cupola of the Pentecost, Saint Mark's Basilica, Venice, first half of the twelfth century, mosaic work depicting the Holy Spirit, Apostles, and representatives of sixteen peoples to whom the apostles preached: labeled, as according to the Acts of the Apostles, *Parthi, Medi, Elamitae, Mesopotamia, Judea, Cappadocia, Pontum, Asiatici, Phrygiam, Pamphiliam, Aegiptum, Libiam, Romani, Judei, Cretes,* and *Arabes*. Photograph by Dennis Jarvis, 2010.

PLATE C/FIGURE 1.2. Joseph Mallord William Turner, *Approach to Venice*, oil on canvas, 1844. In the Royal Academy catalogue, it was accompanied by Turner's quotation from Byron's *Childe Harold*: "The moon is up, and yet it is not night, / The sun as yet disputes the day with her." Andrew W. Mellon Collection, National Gallery of Art, Washington, D.C.
Courtesy of NGA Images.

PLATE D/FIGURE 2.4. Giorgione, *Nude*, fresco detached from the façade of the Fondaco dei Tedeschi (detail), 1508. Gallerie dell'Accademia, Venice.
Courtesy of Polo Museale di Venezia.

PLATE E/FIGURE 2.5. John Singer Sargent, *Venice*, watercolor and graphite on woven paper, 1880–82. Gift of Mrs. Francis Ormond, Metropolitan Museum of Art, New York.
Courtesy of Images for Academic Publishing.

PLATE F/FIGURE 2.8. Agnolo Bronzino (1503–72), *Portrait of Lucrezia Panciatichi*, oil on wood, ca. 1540. Galleria degli Uffizi, Florence.
Photograph courtesy of Scala/Ministero per i Beni e le Attività Culturali/Art Resource, New York.

PLATE G/FIGURE 2.9. Jacopo Comin, called Tintoretto (ca. 1518–94), *Last Supper*, oil on canvas, 1592–94. Basilica of San Giorgio Maggiore, Venice.
Photograph courtesy of Cameraphoto Arte, Venice/Art Resource, New York.

PLATE H/FIGURE 3.1. Giacomo Balla, *Street Light*, oil on canvas, 1910–11, but dated 1909 so as to coincide with the date of Marinetti's "Let's Kill the Moonlight!" Hillman Periodicals Fund, The Museum of Modern Art, New York.

PLATE I/FIGURE 3.2. Giacomo Balla, *Ritratto Futurista* [*Carlo Carrà*], 1918–20, colored pencil and water-color, on frontispiece of illustration supplement to Arturo Lancellotti's *Le Biennali veneziane dell'ante guerra. Dalla I alla XI* (1926). Reads "Futurist Portrait / Italy // to my friend Carrà / a brotherly hug / from your Balla the Futurist. . . ." Collection of the American Academy in Rome.

PLATE J/FIGURE 3.3. Benedetta Cappa Marinetti, *Incontro con l'isola* (Encounter with the Island), oil on canvas, 1939. Galleria Nazionale d'Arte Moderna e Contemporanea, Rome, acquired at the Third Quadriennale of Rome.
Courtesy of Ministero per i Beni e le Attività Culturali, Rome; reproduced by permission of the Estate of Benedetta Cappa Marinetti.

PLATE K/FIGURE 3.5. Luca Buvoli, *A Very Beautiful Day After Tomorrow (Un Bellissimo Dopodomani)*, multimedia installation at the Arsenal exhibition of the 52nd Venice Biennale, 2007. View including the suspended sculpture *Vector Tricolor [Entanglement of Modernist Myths]* in foreground, and in background, the wall sculpture *A Very Beautiful Day After Tomorrow Marquee*. Installation encompasses digital video, reinforced polyester and polyurethane resin, metal, Plexiglas, plaster, and other materials.
© Luca Buvoli. Reproduced by permission of the artist.

PLATE L/FIGURE 5.3. Dionisio González, *Venice Hospital, Le Corbusier, 1965* (top), and *Venice Without Le Corbusier, 2011* (bottom), from *The Light Hours*, C-Print/Diasec photographs, 2011. Exhibited in the *Real Venice* exhibit at the 2011 Venice Biennale, sponsored by the London-based Venice in Peril Fund. © Dionisio González. Reproduced by permission of the artist.

PLATE M/FIGURE 5.4. Peter Eisenman, *Presentation model including Cannaregio West and Le Corbusier's Venice Hospital*, gold and pink paint over wood and cardboard, commissioned ca. 1978. Showing the railway station of Santa Lucia, Le Corbusier's unbuilt hospital project, and a projected conceptual plaza designed by Eisenman. Canadian Center for Architecture, Montreal.

Credit and copyright: Peter Eisenman Fonds, Collection Centre Canadien d'Architecture/Canadian Center for Architecture, Montreal.

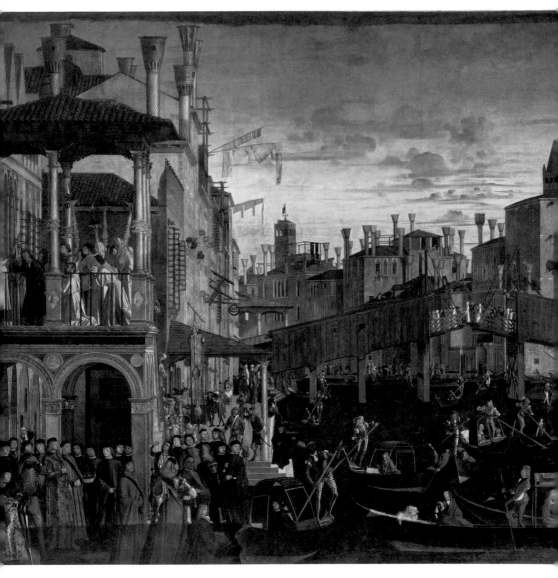

PLATE N/FIGURE 5.9. Vittore Carpaccio, *Il miracolo della reliquia della Santa Croce al Rialto* (The Miracle of the Relic of the True Cross at the Rialto), oil on canvas, 1494. The sacred subject is overwhelmed by Carpaccio's depiction of the life along the Grand Canal, including the wooden Rialto, with drawbridge, before its replacement in stone. Gallerie dell'Accademia, Venice.
Courtesy of Polo Museale di Venezia.

PLATE O/FIGURE C.1. View of The Venetian Resort Hotel Casino in Las Vegas, along the Strip, with duplicates of (from left to right) the Ducal Palace, Rialto Bridge, St. Mark's Campanile, columns of San Marco and San Teodoro, and electric gondola. The Mirage across the way highlights the lagoon's dislocation to the Nevada desert.
Photograph by Jennifer Scappettone, October 2012.

PLATE P/FIGURE C.2. The Venetian Resort Hotel Casino in Las Vegas, interior view, at high noon, of eternally twilit "Grand Canal Shoppes," as a tourist photographs a singing gondolier. At right, a duplicate of the Fondaco dei Turchi.
Photograph by Jennifer Scappettone, October 2012.

PLATE Q/FIGURE C.4. Giovanni Domenico Tiepolo, *Il Mondo Nuovo* (The New World), 1791–93, fresco detached from the artist's country Villa di Zianigo near Mestre and now installed at the Ca' Rezzonico Museo del Settecento Veneziano, Venice. Spectators peer into a *mondo nuovo*, or cosmorama. Courtesy of Bridgeman Art Library.

PLATE R/FIGURE C.5. Federico Fellini (director), *Il Casanova di Federico Fellini*, 1976. Still from closing dream sequence: Venetian *Rückenfiguren* approach a faux Rialto wrapped in plastic, in a "frozen" Venice.

a textual archive and poetic structure: a vortex from which to draw in his attempt to forge an epic that incorporates distances and disharmonies. "A man does not know his own ADDRESS (in time) until he knows where his time and milieu stand in relation to other times and conditions," Pound would come to theorize in 1938.[24] The Venetian archipelago, a disjunctive "address" bridging distinct times and milieus through trade, publishing, and artistic production, forms an optimal staging ground for transcribing their relations in a nonlinear fashion—one far less determining than the orders of knowledge and governance to which the author himself eventually ascribes.

The self-conscious acts of backwardness in Pound's first publications are to characterize his approach to verse for the years to come, the ghostly materiality of which Daniel Tiffany has characterized as "cryptaesthetic."[25] Flagrantly transmitted by a cast of shades, these early lyrics clarify a range of motives for which Venice haunts the Anglo-American modernist's poetic output—motives that are not merely metaphorical, but philological, material, and structural. Against Futurism's rhetoric of propulsion and immediacy, Pound offers his own restructuring of Western tradition within a cityscape highly filtered by literature: the result is a poetic of thick mediation. By reckoning with their ineluctable citation of prior discursive traditions surrounding Venice, his early lyrics emphasize the historical echo-chamber through which the "new" must pass.

This dynamic becomes explicit in a number of poems from his 156-page "Venetian sketch-book—'San Trovaso'—" (commonly referred to as the "San Trovaso Notebook"), the resource from which Pound drew in preparing his second published collection, A Quinzaine for This Yule (1908). The notebook is named after the neighborhood Pound inhabited during the final segment of his 1908 sojourn—when he had direct contact with the last gasps of the Romantic tradition by occupying the apartment of Zildo, model for the androgynous gondolier/servant at the center of Frederick Rolfe/Baron Corvo's 1910 The Desire and Pursuit of the Whole: A Romance of Modern Venice. Pound begins his fifteen-poem cycle, or quinzaine, with "Prelude: Over the Ognisanti," a lyric whose protagonist dwells "alone with beauty" over the Ognissanti Canal's echoes of song.[26] (The title significantly uses the local Venetian spelling for the canal rather than the standard Italian.) This lone subject is no Romantic seer, but a belated scribe reduced to recording the re-echoing of song: "Which shades of song re-echoed / Within that somewhile barren hall, my heart, / Are found as I transcribe them following" (PT 69). The songs' shades are passively "found" over the Ognissanti within the heart

of a listener figured as an empty hall where voices from the outside congregate, the poetic speaker himself remaining voiceless and abject. The subject in Venice is reduced to "following"—a stance emphasized by the speaker's exiting this iambic pentameter with a dactylic falling. His heart is barren "somewhile"—undecidably situated in time, as we cannot know whether to read this awkward adverb for its obsolete meaning, "formerly," or the current "sometimes." In this echo chamber, we witness Pound's transformation of lyric expression as the work of accumulation and transcription, anticipating his conception to come of the poet as wearer of masks, as vortex, as editor of a montage.

The only poem of the San Trovaso cycle that Pound included in his third volume, the sifted 1909 collection *Personae*, was "Night Litany." It calls in faintly obscuring French upon some elemental god (of waters, of the night, of silence) to "purify our hearts" and continue inscribing lines into the speaker ("Yea the lines hast thou laid unto me": already a strikingly passive authorial stance).[27] But this imperative has to be voiced across a series of removes, because Venice filters the divine:

> For we have seen
> The glory of the shadow of the
> likeness of thine handmaid,
> Yea, the glory of the shadow
> of thy beauty hath walked
> Upon the shadow of the waters
> In this thy Venice.
>
> (*PT* 70)

This vision recasts the conception of immanence as itself a form of mediation—calling upon a god witnessed via the shadow of a likeness of its handmaid, the shadow of its beauty treading the shadow of the water.

In 1908 and beyond, Venice serves the function of distressing "the longing for an undefiled, immaculate and stable present"[28] that Habermas locates at the heart of modernism. In this chapter we will track the filtration of that immaculate condition of presence that becomes integral to Pound's injunction to "make it new." Futurism wishes to conjure a sun divorced from any prior darkness: its founding manifesto goads us to "Look there, on . . . the very first dawn!"[29] Pound's dawn, by contrast, is laden with the epithets of ancient epics and with a palpable sense of imminent expiration. *A Lume Spento*'s "In Tempore Senectutis" (a title from Psalm 70:9, "In the Time of Old

Age") announces that "There is strange Night-wonder in our eyes / Because the Moth-Hour leadeth the dawn," so that the verb "to lead" is haunted by the substance "lead."[30] But the poet cognizant of the history and future of the dawn has the capacity to refresh present wonder with strange ancient words, such as those of Homer invoked in "The rosy, slender fingers of the dawn": "The wind fills our mouths with strange words / For our wonder that grows not old" (35). Even the dawn in the dedication of A Quinzaine for This Yule is "reflected in the west," like the dawn of Pound's "Venetian June"; it is viewed through the site of dusk.[31] Writing in the wake of an Impressionist stress on the transit of perception conveyed by light, Pound reconfigures the Futurists' willful naïveté surrounding light by suggesting that Venice's shrouding haze actually prolongs the illumination of the city. An uncollected lyric from the San Trovaso sketchbook prefiguring Imagist modes of association registers crepuscular shifts through mist over the Guidecca as passages that perpetuate luminescence:

> Thoughts moving
> in her eyes
> as sunset color
> shadows
> on Giudecca.
> The haze
> that
> doth the sun prolong.
> (PT 65)

These lines trace the protracted, yet staccato temporality of aesthetic under-standing reflected in the passage of the sun over the lagoon and made explicit in the epigraph to A Quinzaine for This Yule: "Beauty should never be pre-sented explained. It is Marvel and Wonder, and in art we should find first these doors . . . and, coming through them, a slow understanding (slow even though it be a succession of lightning understandings and perceptions) as of a figure in mist" (PT 68). "Partenza di Venezia" (Departure from Venice—whose "di" [of] in the place of "da" [from] produces an archaizing timbre in Italian) presses to conclude that it is precisely out of the "half-light" that "feign'st reality" in Venice that a "clear tone" emerges (PT 75). These pieces reveal the influence of the tradition of painted nocturnes established by Whistler in particular—to whom Pound dedicated his first poem for Poetry magazine in 1912, in praise of the American artist's "searches" and "uncertainties," as well as reviews, and

passages of *Gaudier-Brzeska* (1916).[32] Yet Pound's approach to nocturnal and atmospheric obscurity is scholarly rather than immediate or intuitive, built on the act of deciphering through research.[33] As the uncollected early "Notebook" lyric "[In That Country]" expresses, the sight of Venice makes us aware that research can illuminate the obscure, as "deep hollows / Behind the veil of shade grow luminous / If eye but knew the secret there indwelling" (*CEP* 248). "Partenza di Venezia" turns away from the spectral Romantic "Venice of dreams" in the spirit of Ruskin, aspiring ultimately to apprehend the clarities expressed by the city itself, here rendered the faculty of speech: "If first we fear the dim dread of the unknown / Then reassured for the calm clear tone / 'I am no spirit. Fear not me!'" (*PT* 75). The poem's final movement transforms the quasi-religious mystique projected onto the city into an effect of the city's own agency by rhyming "mystery" with its revision, "mastery": "So we bewildered, yet have trust in thee, / And thus thou, Venice, / show'st thy mastery" (*PT* 75).

Pound will play on decadent tropes of shadows and their signature city for the remainder of his career, even as his poetic rhetoric begins to invoke an Enlightenment rhetoric of clarity (present, as we have seen, in Ruskin and Marinetti) by favoring the recovery of a "radiant world where one thought cuts through another with clean edge"—a description more Cubist than Impressionist.[34] Shadows remain salient in the 1920 *Umbra* (Shadow; Shade) and the contemporary "Hugh Selwyn Mauberley," whose epigraph, by Nemesianus, reads, "*Vocat aestus in umbram*" ("The heat calls us into the shade"). Citing Cavalcanti, Pound will aim through research to restore the energies radiating through that which is half-obscure, "'*mezzo oscuro rade*,' '*risplende in sé perpetuale effecto*,' magnetisms that take form, that are seen, or that border the visible, the matter of Dante's *paradiso*, the glass under water, the form that seems a form seen in a mirror, these realities perceptible to the sense, interacting."[35] In Cavalcanti's "Donna mi prega," which occupied him for four decades, radiance arrives through the "half-dark": Pound translated the first phrase, *mezzo oscuro rade*, as "In midst of darkness light light giveth forth" (*LE* 157), then again as "Disjunct in mid darkness / Grazeth the light, one moving by other" (*Cantos* 36/179). The monumental experiment of *The Cantos* is galvanized by engaging "the sunless dead," though blood has to flow through the "fosse" of the archived Homerian underworld to make them speak to us (*Cantos* 1/4). The mediation of poetic address founding this project—which makes it possible to conflate the "I" of Odysseus in Hades with the "I" who says, "I mean, that is Andreas Divus" (1/5)—is already present in *A Lume Spento* and the San Trovaso sketchbook.

Pound adopts a constative mode in Venice—focused on articulating what is established or manifest, as Henry James did before him (both with cutting negativity); but he does so with a ponderous recurrence to the archive. The constative mode could not be further from the wistful performative invocation of a future driving the modernist manifesto—yet it is no less modern.[36] Pound's lyric utterances carve out a visible and even archival remove from their immediate circumstances, poignantly expressing the discontinuity of presence within the archipelago. James characterized this remove as a historical one in the passage discussed in chapter 2: "Nowhere else is the present so alien, so discontinuous, so like a crowd in a cemetery. . . . It has no flowers in its hands, but . . . it has money and little red books."[37] Placing Venetian life between quotation marks, James outlines a vast rift between past and present in the city, but follows with the ironic conclusion that this cultural economy (signaled by little red Baedekers) sustains Venetian vitality: "From this *constatation*, this cold curiosity, proceed all the industry, the prosperity, the vitality of the place" (32). Writing consciously in the wake of this prose stylist, in 1913—at the dawn of Imagism—Pound echoes this word, *constatation* (from the Latin *constat*-, "established"), to articulate an aesthetic ideal. He advocates for "the 'prose tradition' of poetry" as the "constatation of fact": "It presents. It does not comment. . . . It is open to all facts and all impressions."[38]

Pound's 1913 imperative has been read as a bid for categorically modern diction and syntax; but this interpretation overlooks both the historical precedents for such poetic "presentation" (in the anti-exegetical tradition of Venetian humanism and in late-nineteenth-century historiography, for example) and the strategic passéism of his verse: the Benjaminian tiger's leap into past moments of possibility that these poems urge readers to take. Pound's often quoted but rarely contextualized prescription arises within a review of Laurent Tailhade's poetry, which he identifies as an example of " 'rendering one's own time in the terms of one's own time' "—before immediately complicating this statement: "[Tailhade] is . . . full of tricks out of Rabelais and out of Villon, and of mannerisms brought from the Pléiade. . . . When M. Tailhade parodies the antique [he] is considerably more than a parodist. He writes to his subject and the 'snatches of ancient psalmody' are but a part of the music."[39] For Pound, constatation of fact never takes place in a historical abyss, but instead arranges the present and past into novel constellations.[40] He admits that "the method of constatation drifts off imperceptibly into description and . . . pages of poetic description can have no interest save for those particularly interested in the things described, or for those interested in language as language."[41] To be authentic and interesting, then, description has to be open

to "all facts and all impressions"; transmitted across multiple strata of prior inscriptions, it triggers cognitive and linguistic alterations of the already-perceived. Vital description, interested in language as language, takes the act of its own constatation as part of its referent: its iteration, though often a repetition, alters the facts that it cites, and in the process participates in history.[42] The discontinuity of the Venetian present with its past makes generative jolts of historical experience available to literary expression.[43] Pound's lifelong engagement with Venice thus calls for us to reconstruct our understanding of the nature of his innovation from Imagism forward, as this place prompts not "[d]irect treatment of the 'thing,'" but citation, adaptation, transmutation.[44]

Pound's initial phase of writing around Venice consists in its self-conscious confrontation with a topos—in its citation of historically disjunctive textual voices, images, genres, and tempos. When writing about a city that exists most compellingly as "an indispensable figure," as James put it,[45] all descriptions are freighted with transmission of the many texts that have represented and produced the place in tandem with the facts pertaining to the site itself, displacing and invoking the place at the same time. Site, in other words, is always also citation. A lyric from the San Trovaso sketchbook called "*Piazza San Marco. June*" exemplifies this strategy, defying expectations roused by its title through a refusal to depict the famed plaza. The poem turns out to be about Shakespeare—not even as the author of *The Merchant of Venice* or *Othello*, but as love lyricist. Thematically, the poem concentrates on the ineluctability of robbing from the cultural past (befitting its rhetorical posture before St. Mark's Basilica, storehouse of the most grandiose acts of Venetian piracy from Alexandria and Constantinople): "Some comfort 'tis to catch Will Shaxpeer stealing. / All bards are thieves save Villon, master thief" (*PT* 63). Pound's own thievery, depicting the thievery of previous masters, leaves tracks so salient that it forces readers to recast their distinctions between original poems, translations, and affected echoes.

The recursive drive of this tripartite poem sets time out of joint. The title announces that it was composed in or on June, but the refrain of its final section, "*After Shakespeare's Sonnet 98*," recalls "[w]hen proud pied-April leadeth in his train"—echoing the Shakespearean line, "When proud-pied April, dressed in all his trim."[46] Pound's poem therefore transports us beyond its declared season and space, back to the Elizabethan work, where we encounter the absence of a beloved who renders the floral blushes and purities of spring derivative: "Drawn after you, you pattern of all those." Shakespeare's concluding couplet posits a poet reaching back to the memory of winter, when the beloved was still present: "Yet seemed it winter still, and, you away, / As with

your shadow I with these did play."[47] Pound's own verse recalls a woman whose beauty delivers his heart to a fabulous wood where laughter reigns "'gainst all laughter slain / Ere proud-pied April led in feat his train" (*PT* 63). These lines invite us to recall the laughs annihilated before April led what it drags to this here and now—a here and now implicitly framed in quotation marks, within the cycle of references. They render laughter—that spontaneous utterance dear to the Futurist—as instead a stylized, melancholic citation that reminds us of its own end.

Tapping the contradictions between radiant current states of fact and their deep histories in letters, Pound's poetic interpretation of constatation elides characterizations of "decadent" and "modern" tendencies in verse. Critical dismissal of his early diction has overlooked his anachronistic strategy in attempting to trace a coherent progression from Victorian to modern style within the Anglo-American avant-garde. Richard Sieburth, in a useful divergence, asks of the archaism of Pound's Cavalcanti translations, "Is it simply a vestige of the pseudo-historicist Wardour Street diction of the Victorians, an elitist desire . . . to steep the commodity in nostalgia . . . ? Or are we to understand archaism as a more modernist strategy, . . . as an attempt to violently estrange language from its current linguistic norms by displacing it into an anachronistic—or indeed an a-chronistic—dialect . . . untimely, out of date, and which thereby calls into question what exactly it might mean to speak as a 'contemporary'?"[48] But Sieburth's introduction to the 2003 Library of America *Poems and Translations* resorts to a more familiar critical narrative: "In . . . *A Lume Spento*, the Pound of 1908 is still very much . . . steeped in the archaisms of the Pre-Raphaelites. A mere four years later . . . he has reinvented himself as a modernist proponent of 'Imagism,' before moving on, in rapid succession, to the avant-garde aesthetics of Vorticism and translations from the Chinese (*Cathay*), the Japanese ('*Noh*,' or *Accomplishment*), the Provençal (*Arnaut Daniel*), and the Latin ('Homage to Sextus Propertius')" (*PT*, n.p.). While attempting to map the poet's effort "To break the pentameter" (*Cantos* 81/538), the notion of stylistic "advancement" becomes a crutch in Pound criticism that is particularly curious, considering how thoroughly his mature poetry in *The Cantos* depends on the construction of all thought as a "contemporaneity" of clashing signatures in time. To appreciate the torsions effected by Pound's untimely verse, we have to recognize the traffic between archaism and invention, lyric and epic that drives a constant dynamic, from the early work to the late.

In early poems such as "*Piazza San Marco*. June," the outmoded features of love lyric function strategically: as a screen for making manifest the

historiographical work that can be accomplished by poetry. This poem recasts the erotic as a historical channel. What better stage for such an experiment than the European capital of desire, chided by Marinetti as an "old procuress, who . . . still insist[s] on preparing exhausting nights of love" (*TIF* 31)—the site of romance *par excellence*? Since the epoch of Shakespeare, love is considered possible only "if Cupid have not spent all his quiver in Venice"; centuries later, Aschenbach's pre-death delirium in Venice spurs the climactic reflection, "'you know that we poets . . . may be heroic after our fashion, disciplined warriors of our craft, yet are we all like women, for we exult in passion, and love is still our desire—our craving and our shame.'"[49] Pound's Imagist and Vorticist peers and Futurist rivals alike called for a "hard and clear," dry, classical modernism, impervious to "sentiment."[50] But Venice continues to summon the romantic long after romance falls out of fashion; amidst its sensuous canals, the most ardent polemicists still submit to feeling. In parentheses within stretches of salient commentary, Pound is willing to insist, "(One goes on 'falling for' Venice, no doctrinaire attacks on romanticism will, in our time, eliminate this trait from our characters)."[51] Rhetorically and stylistically, his verse in the thrall of the sentimental past couldn't be farther from Futurist "words in freedom." Yet we have seen that though they would like to hover in the luminous future without props, even Marinetti's manifestos are laden with the voluptuous tropes of centuries previous, however self-contemptuous.

The protomodernist Pound does share some of the Futurists' desires: he does aspire to cut through the crepuscular, sentimental stance of the prior generation. The 1909 edition of *Personae* includes his "Revolt: Against the Crepuscular Spirit in Modern Poetry," which appeals to a *deus ex machina* for a virile new race: "Great god, if men are grown but pale sick phantoms / That must live only in these mists and tempered lights / . . . / I bid thee grapple chaos and beget / Some new titanic spawn . . ." (99). The poem that follows dreams of death, but entirely in quotation marks: the outmoded pronouncement, "Aye! I am a poet," opens a call for the speaker's tomb to be strewn with flora, as Pound hoists a satiric ambivalence toward the morbidity of the Decadents (*PT* 100). In the same moment, the Decadent D'Annunzio of *Il fuoco* is becoming the "titanic" author-agitator of *La nave*, from which Pound would quote in his seminal 1911–12 "I Gather the Limbs of Osiris" essay outlining "the method of Luminous Detail" and in a later canto ("*Non è mai tardi per tentar l'ignoto*" / "It is never too late to attempt the unknown").[52] In 1919, soon before he leaves England for the Continent, and while working on the two critiques of empire that would eventually become *Diptych Rome-London* ("Homage to Sextus Propertius" and "Hugh Selwyn Mauberley"), Pound will present D'Annunzio's

occupation of Fiume as one of "many small and scattered things [that] serve to show the movement and direction of a current."[53] His 1922 "Paris Letter" presents D'Annunzio's Italy as the site of a new vortex more decisively than ever, setting "a reawakening Italy, . . . an inchoate America" against "a decadent wallow like London" and "an enervated centre like Paris"; reviewing and selectively translating from *Notturno*, he presents the clarities of D'Annunzio's prose amidst the bombardment of Venice against the bourgeois impressionism of Proust—as a critical estimate of "the 'poet-hero' as a writer."[54]

The impasse of an ironic relation to the past is indeed overcome by Pound's writing after the 1920 poem of breakage from England (and, by extension, its signature prosody), "Hugh Selwyn Mauberley: Life and Contacts." Hereafter, as *The Cantos* develop, Pound will recruit more literal remnants of the past into a poetry aimed at a futurity both aesthetic and social. The jaundiced memory of Mauberley's ". . . consciousness disjunct, / Being but this overblotted / Series / Of intermittences," inscribed on an oar adrift—"'I was / And I no more exist; / Here drifted / An hedonist'"—is released in favor of the oar of Elpenor appearing in Canto 1, translated literally from Divus's Latin and Homer's Greek. Elpenor's oar, "swung mid fellows," is inscribed with the future-oriented epitaph, *"A man of no fortune, and with a name to come."*[55] Pound will now tap into historical "intermittences" by setting the remains of conflicting epochs adrift among each other, without the rhetorical syncretism of D'Annunzio as the first *Duce* in Fiume, without syntactical bridges, as verse fragments semi-dispersed across the field of the page—offering up, in Robert Creeley's words, "the literal instance side by side with that which gave it context."[56] As in Ruskin's grotesque, "the connection is left for the beholder to work out for himself"; Pound honors "the gaps, left or overleaped by the haste of the imagination."[57] The result is more joltingly anachronistic than passéist. Unlike that of the early Marinetti, this poetry delectates in the untimely; unlike the late Marinetti of amalgamative excess, it thrives on negative space. Pound found material examples of such a structure in Venice.

To understand the impulses of Pound's literalist, materialist modernism, and to distinguish it from the ironic reuse of what has already been said and done, we may compare it to T.S. Eliot's contemporary 1919 poem "Burbank with a Baedeker: Bleistein with a Cigar." "Set" in Venice, Eliot's work offers a politically barbed example of the city's representation as a decadent trope— precisely the tendency that Pound's "poem including history" will deflect.[58] Eliot's aim was "[t]o get Venice not too directly," but rather to invoke a succession of literary echoes, so that "every reference to Venice should call up something as well and vice versa."[59] Composed just following the fall of the

Habsburg Empire, with obvious bonds to *The Merchant of Venice*, "Burbank with a Baedeker" highlights the centrality of the Venetian crucible in a political theater of disintegration and "Balkanization"[60]—fallout of the Great War that, for Eliot, signified the latest in a long sequence of events evincing the modern "dissociation of sensibility" (akin to Mauberley's "consciousness disjunct").[61] Such dissociation of feeling and mind is reflected in the poem's deadening citationality, a cold rehearsal of established truisms such as James found borne by the Baedeker, but with little interest in reanimating the site to which they refer. Reifications of Venice are filed into Eliot's mordantly mechanical quatrains of iambic tetrameter. These lines mock as they march four character types through a Venice that is as unreal, as virtual, as the "perspective of Canaletto" glimpsed from the "protozoic slime" at the poem's core: Burbank, a Northern tourist whose name hints at a history of usurious Venetian banking practices; the "phthisic," post-Habsburg Princess Volupine, descending into whoredom with Jewish clients; Bleistein, a minstrel-like descendent of Shylock, whose racial caricature through "A saggy bending of the knees / And elbows, with the palms turned out, / Chicago Semite Viennese" generated considerable controversy; and one "Sir" Ferdinand Klein.[62] Through their admixture, Venice becomes the symbolic site of miscegenation between contemporary vulgarity and a fallen or specious nobility.

Eliot's Venice gives rise to the "[d]efunctive music under sea" of a banalized allegory of "decline": sinking and "passing" infect nearly every action in the poem, beginning with the opening: Burbank's "descending" at a hotel to meet Volupine, which culminates in the anticlimax "he fell." A decade after Marinetti's call to "kill the moonlight" of Venice, "Burbank" depicts a Venetian sun forever held at bay: the horses of St. Mark's, now mechanically subjected to the "axletree," "Beat up the dawn from Istria / with even feet" that are reflected (as if punningly) in Eliot's own hammering prosody. Evening inverts sunrise as the poem rehearses a decadent tradition of engagement with Venice: "The smoky candle end of time / Declines" alongside the flames of dawn's burning barge. The vignette's only "Lights, lights" are those of Volupine's performance for her client Klein. The poem closes with a meditation on decadence: "Who clipped the lion's wings / And flea'd his rump and pared his claws?" Burbank wonders, as he meditates on "Time's ruins, and the seven laws" (those of the Noahide code, which prohibit sexual immorality, among other vices).[63] The allegory of Venice represented by the Lion of St. Mark has been groomed and rendered pathetically effeminate.

Eliot's condemning masque reproduces an apocalyptically deracinated (read: Jewish), postimperial and postcolonial Venice, where painting and

poetry do not ground, but unmoor tradition. The poem's abstracted Jewish types and unnamed "jew [sic] . . . underneath the lot" feed on a stereotype of Venice that colors its age-old representation as a "stranger" to Europe—the city's living by intermediate trade (and interest), as Simmel theorizes, not by the "grounded" professions—while the princess-cum-prostitute locates in Venice the corruption of reproduction. (Pound will take up both of Eliot's critiques in Fascist and anti-Semitic writings decades later.[64]) Eliot's bitter irony and lurching enjambment evince a modernist attitude forced through figures and forms that resonate as stiffly received.

The epigraph to Eliot's poem, in its discontinuous texture of quotations, models a less paralyzing engagement with Venice as citation—one that forgoes decadent narratives to present the act of rearranging the archive itself as a creative intervention:

> *Tra-la-la-la-la-la-laire—nil nisi divinum stabile est; caetera fumus—*
> *the gondola stopped, the old palace was there, how charming its grey and*
> *pink—goats and monkeys, with such hair too!—so the countess passed on*
> *until she came through the little park, where Niobe presented her with a*
> *cabinet, and so departed.*[65]

The epigraph teems with violently fragmented and spliced traces of the European literature surrounding Venice: Gautier's *Enamels and Cameos*; the inscription over Mantegna's Saint Sebastian at the Ca' d'Oro ("nothing if not the divine is certain; all else is like smoke"); James's *The Aspern Papers*; Othello's cry of adultery; the "[d]ear dead women" of Browning's "A Toccata of Galuppi's"; and Marston's *Entertainment at Ashby*. The cleft between the poem's epigraph and body—nowhere more pronounced in Eliot's pre–*Waste Land* verse than in his Venetian poem—traces the contours of a polemical impasse in the face of *fin-de-siècle* tropes, an impasse also seen in "Mauberley," produced the same year. The performative failure of the narrative quatrains that follow Eliot's protocollage—whose mechanical inertia contrasts the historical context on red alert that generated the poem—will give way to a new poetics: the collaborative experiment in fragmentation that generated *The Waste Land* and *The Cantos*. As an embarrassing residuum of Romanticism and of a feminized aestheticist and decadent tradition, the topos of Venice incites monumental efforts to reanimate the husks of history through a process of radical objectification. Resisting abstractions of decline enables the apprehension of Venice not as a set of passéist tropes, but as an anachronistic montage of pasts to reanimate.

"The Old Kick to the Senses": Venice as Archive

The methodology of *The Cantos* pushes Pound's "constatation of fact" a step further, granting to historical manifestations an unruly autonomy that is typical of the history of Venetian republicanism. Pound engages with the particulars of Venetian history throughout the half-decade of "drafting" this unfinished epic of more than 117 poems, beginning (as we have seen) in the first cantos, but with enhanced focus in Cantos 17 through 30 (composed beginning in 1924 and published in book form in 1928 and 1930)[66] and the Pisan Cantos 74 through 84 (composed after the poet's notorious Fascist radio broadcasts, during his 1945 internment for treason, and published in 1948, after his commitment to St. Elizabeth's Hospital for the Criminally Insane). Venice can be tapped, in its sporadic emergence throughout Pound's career, as the site of the poet's primordial literary and cultural formation, as a publishing center, as earthly paradise, and as a state where the money economy begins to corrupt production and exchange; but the details sampled ultimately exceed the orchestration of any single governing abstraction, even in the cantos authored fully under the spell of Fascism (from the mid-1930s forward). Historian William Bouwsma identifies in Venetian political thinkers of the Renaissance a sense of "obligation to confront the data exposed by historical research directly, without dogmatic preconceptions"; this attitude was epitomized by the influential Republican scholar, canon lawyer, and historian Paolo Sarpi's insistence that "historical truth was a matter not of authority but of fact."[67] This attitude reverberated in more immediate terms through the historiography of the mid-nineteenth century. Pound's philological education was shaped by transformations in the study of history that originated in Venetian archives, initially reflected in secondary sources he was reading by historians such as Charles Yriarte. Venice had become the center of a revolution in the way history was written in the 1840s, when Leopold Ranke, a historian from Berlin, "discovered" the Venetian Republic's extensive state archives at the convent adjacent to the church of Santa Maria dei Frari. The archives filled three and a half miles of shelves with dispatches and memos authored by ambassadors acting as seemingly detached observers. Ranke transformed his discipline by turning from a historiography based on books and chronicles, pamphlets and propaganda to the objective remnants of the past contained in these official letters and reports; he regarded them as opportunities to see beyond the distortions of "particular views of parties or of private individuals," to an objective

history of global relations.[68] Ranke's approach shaped the work of Victorian historians such as Horatio Brown, who spoke of the "material nearness to the past" provided by an archive, and James Anthony Froude, who saw in Ranke's work nothing less than "the thing itself."[69]

Generations of scholars were drawn to Venice to study and translate the "State Papers Venetian." However, the sheer number of documents now seen as relevant sent some exasperated younger historians on deviant paths, from the synthetic to the historical materialist approach, which asserts (as Benjamin writes) that "to articulate the past historically does not mean to recognize it 'the way it really was' (Ranke)," but instead to seize hold of memories that surface fleetingly and are in danger of being appropriated by an overpowering narrative conformism.[70] Pound's citation of state archives in *The Cantos* was much more ludic than that of Ranke; Lawrence Rainey argues convincingly that the poet's overly literalist translations of archival documents parody, even as they invoke, the ideal of a philological accuracy that lacks any commentary or intervention on the part of the transcriber.[71] However playful, selection, transcription, and translation of these archives provided Pound with a material history of the transmission of power and knowledge that became central to his attempt at "including history" in the modern epic (as he rather abjectly worded it).

Discussions of the cantos surrounding Sigismundo Malatesta as hero (8–11) have dominated studies of the research and extensive cross-checking that Pound conducted from the archives of Florence, Milan, Mantova, Siena, Ravenna, Rimini, the Vatican, and Venice in composing his epic. But it may be that Pound's work with fragments from the decrees of the Venetian Great Council and the *Deliberazioni* and *Secreti* of the Council of Ten (in the so-called Venetian Cantos 24–26) best illuminates the challenge of marshaling an amassment of historical data. This process has equivocal results: it tends to swamp both the archivist and the historical agents he discovers in research with the ambient data of mundane hubbub, while exposing lacunae in the record. Pound's archival research led to the recuperation of *both* "luminous details" and fault lines from the past; both salient figures and negative space shape his new methodology.

A core characteristic of Pound's mature verse lies in its fissures: in its lack of hermeneutic links between cited materials. Although the scattered content of Venetian history plays a crucial role in Pound's poetry—as it does in the eventual, tragic canon of political ideals that he developed in parallel— any attempt to pinpoint or rationalize what the city *stands for* in his poetic is bound to fail. Pound's Venice instead arises as the material archive "of less and more than a day"—a space of conflict between stances that fall short of and

exceed the categories of linear histories (*Cantos* 76/474). The city where stone and water flaunt a reciprocal relationship is incommensurate with conceptual petrifaction; Venice instead becomes a site for working through relationships to the past on the part of poet *and* reader. Wherever in *The Cantos* the city starts to represent a lofty selfsame abstraction, mythical or sociopolitical (*paradiso terrestre*; jewelbox; radically tolerant and/or despotic state; site of the West's penetration by luxury and usury), the verse is soon unsettled by constatations of topographical fact and conflicting historical voices: this hybrid topography makes literal the unsettling of any epic or monumental drive. From the beginning of *The Cantos*, the translators of myth are quieted only in part ("Lie quiet Divus" [1/5]). Invocations of preexistent tropes are recontextualized by accumulating lines and thereby transformed into more textual flotsam and jetsam to be vivified.

Pound found a further model for engagement with history in the poetry of an elder expatriate in Venice, Robert Browning, whose anachronistic epic *Sordello* comprises errors of historical *fact* that nevertheless register an accurate historical *effect*:

> And half your dates are out, you mix your eras;
> For that great font Sordello sat beside—
> 'Tis an immortal passage, but the font
> Is some two centuries outside the picture—
> And no matter.
> Ghosts move about me patched with histories.
> ("Three Cantos," *PT* 318)

Browning made these "patches" palpable for the young Pound. The 1908 lyric with the bracketed deictic title, "[In That Country]," also citing Browning, recalls the older poet's touch of hands upon his hands: "Looking upon my Venice and the stars / There stood one by me and his long cool hands / On mine were layed as in the times before. // Wherefor [sic] this question rose which I set forth" (*CEP* 248). The "question" posed asks whether it is better to fashion "One lone man's mirroring on the sand" or to hover between persons in a collective venture of poesis: "Weighing man's song by other signs of worth / To hover astral o'er some other soul." Choosing the latter, the poet roves through a landscape inhabited by prior authors, from Dante through Heine and Gautier, activating their shades by setting their writings into relation as distinct masses. Having traversed a Venetian landscape everywhere inflected by writing, Pound accumulates and registers literary influence in *The Cantos*

spatially, in the form of a "periplum," as it would be charted from the perspective of a ship; history and literary influence take on spatial as opposed to chronological form—permitting the strain of "contemporaneity."[72]

James, for example, first appears in the group of cantos that Pound composed as he was writing "Mauberley" (4–7; first collected in *A Draft of XVI. Cantos* in 1925), but in the trappings of the ghost of Sordello: "And the great domed head, *con gli occhi onesti e tardi* / Moves before me, phantom with weighted motion, / *Grave incessu*, drinking the tone of things, / And the old voice lifts itself / Weaving an endless sentence" (*Cantos* 7/24). With his interest in Sordello ignited by Browning's epic, Pound will reroute Dante's description of this Troubador moving amid the shades of Purgatory so that the constatation conjures a James "*con gli occhi onesti e tardi*"—a snatch of phrase from *Purgatorio*, meaning "with honest and late eyes"—who "[m]oves before me" with "*grave incessu*" ("solemn walk")—an echo of the "*vera incessu*" or "true walk" of Venus described by Dante's guide, Virgil (and which was cited by James in "The Figure in the Carpet").[73] These few lines of description thus place James in the company of Sordello, Dante, Virgil, Browning, and Pound—recapitulating nineteen centuries of influence in a single space.

As a result of these juxtapositions, the realist phantom moves "before" his literary heir spatially as well as temporally; the effect is one of a contemporaneity lacking the immediacy of the "contemporary" strictly defined. Enriching description through these mediations, Canto 7 as a whole implicitly critiques the constative realism of his narrative predecessors James and Flaubert for its purgatorial outlook, mired in the ersatz stuff of its own time ("The modish and darkish walls," "Le vieux commode en acajou: / beer-bottles of various strata" [7/5, 6]); Pound ultimately depicts such realism as smothering the epic past of Homer's "ear for the sea-surge" (2/6, 7/24) in its "damn'd fuss about furniture" and other "heaping up of factual data."[74] In order to forge his own "prose tradition" in poetry, Pound has to find a way to modernize the accents and associations invoked by these authors while registering their incompatibilities; as with his use of historical "intermittences," here too he found a testing ground in Venice.

Pound's early attempt at tracing his own "mirroring on the sand" in the form of a circuitous memoir, *Indiscretions: or, Une Revue de Deux Mondes*, was serialized in 1920, just as the thirty-five-year-old author and his English wife were to leave London, where he had resided since 1908, permanently for the Continent (first for Paris, then Rapallo). This autobiographical sketch begins, significantly, in Venice—an iconically feminine, exoticized, decorative Venice, though the work was composed during D'Annunzio's fifteen-month

siege of Dalmatian Fiume. D'Annunzio's interwar exploits in Dalmatia and quasi-religious insistence upon the historical memory of the "tribe" ("*stirpe*"), when stripped of Decadent trappings in *Notturno*, roused an idealist Pound who, disgusted with England, began looking toward Italy as the site of a new Renaissance. The late Republic presents an irresistible "kulchural" conglomerate to the young cosmopolitan poet and polemicist: here, he could write himself into an aesthetic network that was transnational and cross-epochal, of an authorship local and remote, with an unparalleled legacy of editing and translation; here, he could make a more comprehensive contemporary impact than he could in Paris.[75] If, as Donald Davie argues, Rapallo constituted a point "on the Mediterranean littoral which [Pound] could conceive of as a midway between the Provence of the troubadours and the Florence of the *dolce stil novo*," site of a "cultural transaction in the European past" routing Ovid's language into a new moral focus,[76] we can conceive of Venice as the literary consolidation of Pound's interests in the opposite cardinal direction: for the Adriatic capital of Aldus gave onto the East of Homer, Confucius, Byzantine and Gothic craftsmen, and Marco Polo—as well as the Dalmatia then at the forefront of Italian political consciousness. (Even the Malatesta Cantos ask to be reconsidered in this light, given Malatesta's origins and building campaign along the Adriatic coast, in Rimini, as well as his leadership of the Venetians' 1465 campaign against the Ottomans.)

Through *Indiscretions*, Pound defines himself most immediately in the wake of his fellow expatriate in Venice, James, master of the transatlantic theme who cherished Italy, and Venice in particular, with unique affection— even referring to his home near the Dover crossing as a quick way of getting to Italy "without the interposition of the lumbering London, or even . . . of the bristling Paris."[77] Pound's 1918 essay on James placed this novelist foremost in the canon for his painstaking analysis of contradictory national temperaments, "the . . . fundamental hostilities and incompatibles."[78] Pound's autobiographical essay begins "weaving an endless sentence" (*Cantos* 7/24) through a thick, even beleaguered Jamesian syntax, and encrustation of picturesque details. Like "Hugh Selwyn Mauberley," composed in the same year, *Indiscretions* is both a farewell to London and an "attempt to condense the James novel" while employing an altogether different method.[79] It thus foregrounds the difficulty of wresting a modern poetry out of Venice as it posits "the speculation as to whether . . . Venice could give one again and once more either the old kick to the senses or any new perception": whether living material can be extricated from Venice as symbol. "It is particularly fitting that this manuscript should begin in Venice, from a patent Italian inkwell designed to

prevent satisfactory immersion of the pen. If the latter symbolism be obscure, the former is so obvious, at least to the writer. . . ."[80] Pound declares that it is appropriate to begin writing of himself in Venice both despite and because of the blatancy of the city's literary associations. The autobiography of the mask-wearer is most fittingly composed, in wavering ink, through the clichés and qualifications of past forms. Through a parodically digressive, protracted Jamesian sentence, Pound dramatizes the difficulty of achieving an authentic individual existence amidst so much cultural bulk (or thin picturesqueness):

> Whereafter two days of anaesthesia, and the speculation as to whether, in the development and attrition of one's faculties, Venice could give one again and once more either the old kick to the senses or any new perception; whether coming to the belief that human beings are more interesting than anything possible else—certainly than any possible mood of colours and footlights-like glare-up of reflection turning house-facades into stage card-board; whether in one's anthropo- and gunaikological passion one were wise to leave London itself . . . ; . . . and whether . . . the figures in the opposite windows of the Cavaletto . . .—à la Matisse . . . adequate recognition, presumably, of their claim to individual existence; or the Kirchner cuts emerging from the archway from the Piazza S. Marco, and skirting the Bacino Orseolo . . . ; or the possible 'picturesque' of roof-tiles, sky-tones, mud-green tidal influx, cats perched like miniature stone lions on balconies, etc., is going to afford a possible interest—after all that has been 'done' about Venice; and whether the Kirchners—let us say the female who advances . . . , her attendant being and remaining both on the way to, and on the return from the Piazza, about half a pace to the rear; or the exaggerated turban, or the transparent very wide hat brim, united, all three, by a certain thinness of tone, not, let us say, an exaggerated preoccupation with their basic unmaleness, but by a consciousness of this fact outweighing any possible modifications of that consciousness by the personal element, as if, indeed, the whole of their mental content might be emptied out of the current number of 'Femina' . . .[81]

Pound's contempt for the unmaleness—and implied "non-individuation"—of the scene, replete with Kirchner ladies and Matisse-like décor of the leisured class, ultimately registers as a contempt for the homogenization of contemporary consciousness, more than a denigration of *der alte Venezia* herself. Pound's eventual engagement with the city will depend on carving away those "Mouers Contemporaines" that fill the center of present Venice—thin stage

sets, pleasant picturesques, and modish modernist portraiture surrounding the Piazza San Marco. We witness such cutting in *The Cantos*, whose complexities are numerous, but are utterly devoid of the rambling, digressive description we see here. The problematic potency of these details as indices of the contemporary culture that haunts sites of historical grandeur, in scenes always verging on reification, accounts for how often the author returned to this tourist town to record their "fundamental hostilities and incompatibles."

The conditional mood of these reflections betrays, moreover, Pound's phenomenal attraction to what they reject: the nonpersonal, the picturesque, the Oriental, "the female," so well-matched to her surroundings, "who advances" ahead of her attendant rather than behind—in other words, the feminine environment engulfing heroic individuality that Pound confronts in Venice. "However: Venice, Der alte Venezia, with lurking suspicions that the cursed noun is feminine and demands a different approach, but that the sometimes sentimental tone of the Harzreise must be recalled to oneself if not to the reader, and that some sort of salvo must be allowed the habitat where one's first recueil was printed. . . ."[82] The poet then records that after the initial, formative trip to Venice with his great aunt at age twelve, he has returned to the "cursed noun" beloved by Heine and scores of others he leaves uncited in 1898, 1902, 1908, 1910, 1911, 1913, and 1920.[83] And he was to return "again and once more": once in 1922, and then countless times between his 1924 move to Rapallo in Liguria and his 1945 imprisonment by the Allies for treason (visiting his mistress Olga Rudge in her "hidden nest" on the Zattere from 1928 forward). Upon his release from St. Elizabeth's in 1958, he returned to Italy, resettling with Rudge from 1962 until his death and burial on the lagoon's Island of San Michele ten years later.[84] His poetic attempt to compose what he sees in James's prose—"history of a personal sort, social history well documented and incomplete"—turns from Jamesian scenes of current expatriates in Venice and "certain digressions" toward the Venetian archive; and it will present the annals lodged in the interstices of contemporary Venice as so much scattered material rather than narrating or qualifying them.[85] If "the sentence [is] the mirror of man's mind," the historical consciousness that will arise out of Pound's "Venetian" cantos will be a reflection of the archipelago: an intractably disjointed, horizontal assemblage orchestrated to "kick . . . the senses." The poem's aesthetic and political directions will multiply and refract in response to this environment.

The autobiographical speaker of the first Ur-Canto composed in 1917, who is more prominent than that of the final published poem, vaunts his early exposure to Venice as proof of his cultural preparation to write an epic:

"True it was Venice / . . . / So for what it's worth, I have the background" ("Three Cantos" 117). Venice was of course a notorious background for romance: upon reading of Venice in Gautier's *Enamels and Cameos* (a work essential to Pound), Wilde's Dorian Gray muses that "Venice . . . had kept the background for romance, and, to the true romantic, background was everything."[86] But Pound literalizes the structure of this "background" in verse: in *The Cantos*, background becomes active ambience, with the capacity to scatter and anchor the subject by turns.

Around 1917, Pound drafts the canonical moment of *The Cantos*—the first lines of Canto 3, in which he "places" himself for the first time into the poem, as a budding author in the Venice of 1908. He does so by transforming D'Annunzio's wistful narration of antique Venice in *Notturno* ("he lies . . . in a bombarded Venice, foaming with his own sensations, memories, speculations as to what Dante might or might not have done had he been acquainted with Aeschylus")[87] into an assemblage of scenes rendered contemporaneous through the facility of the inexplicit conjunctive "And."

> I sat on the Dogana's steps
> For the gondolas cost too much, that year,
> And there were not 'those girls,' there was one face,
> And the Buccentoro twenty yards off, howling "Stretti,"
> And peacocks in Koré's house, or there may have been.
> > Gods float in the azure air,
> Bright gods and Tuscan, back before dew was shed.
> Light: and the first light, before ever dew was fallen.
> > (*Cantos* 3/11)

Rather than creating speculative fictions that merely hypothesize the proximity of disparate epochs, Pound composes from "an instinct of negation"[88] and compels readers to experience the juxtapositions first hand, as they would in the eclectic cityscape. Unlike the autobiographical verbosity in *Indiscretions*, rife with Jamesian qualification, this signature vignette of Pound at Venice's customs house constitutes an exercise in cuts, stylistic and conceptual. He sculpts a willfully, violently visionary scene into early-twentieth-century Venice while subordinating the heroic subjectivity to which D'Annunzio still clings, even in convalescence, to an environment of disjunctive historical facts. The first appearance of *The Cantos*'s unmasked I spatializes his exile, placing him at the borders of Miss Bordereau's city, at the customs house, where the canal and the economy of crossing it divide his desire from his aesthetic designs.

The gap separating the belated youth from St. Mark's Place allows the mature poet to echo, rather than to repeat, D'Annunzio and Browning "on a ruined palace-step."[89] From this vantage point he also occupies James's detour from the canonical city center in "The Grand Canal"—and stylistically forgoes continuity for what he identifies as James's registration of "an idea and a crowd of its effects, atmospheres, contradictions."[90] The poet's recollected youth crowds the specters of ancient pageants and gods with the noise of quotidian Venetian life: howls of popular Neapolitan song from the rowing club are conflated with celebrants of the ancient festival revived fictionally by D'Annunzio in *Il fuoco* (both were called *Bucintoro*). Pound's second translation of D'Annunzio's *Notturno* ("In Kore's house there are now only white peacocks")—a wistful vision of Persephone in the Palazzo Venier dei Leoni, which had become a rookery—next enters the poem, making possible the entry of gods.[91] Lacking a narrative transition, otherworldly "first light" is thrust into, as it "bust[s] thru," the confined historical time and space of "that year" (1908), already rendered apposite to the year of "those girls" seen in Browning's 1840 *Sordello*. Pound's "first light" insists on the radiant presence of the gods, yet these "Bright gods and Tuscan" have already been historicized, invoked vis-à-vis the mediation of the Florentine Renaissance.

The archipelago's objective discontinuities propel a perspectival play that reactivates phenomenologically what is happening historiographically: plural perspective prompts the plural time of myth and the contemporary Venices of epochally distinct lyricists. Approaching a lyrical suspension of time, the Pound of the initial cantos moored in Venice instead crowds the mythical present with incompatible debris of history. The site of Venice will continue to pull the poem "inextricably [in] the direction of historic and contemporary particulars,"[92] so that gods and other tropes become historical "sea-wrack" swept into the current of an archive that is ongoing. The poems eventually collected in *A Draft of XXX Cantos* anchor the specters that abound in the literature surrounding Venice in an environment of clashing historical contexts and particulars.[93] This is the shifting ground of Pound's Venetian utopia, which always borders on the dystopian.

Utopia Interrupted: Archipelago as Structure in *A Draft of XXX Cantos*

In the years after World War II, Charles Olson articulated a prevalent attitude toward Pound's epic poetry: the montages of "history present"[94] in *The*

Cantos, he argued, are an "ego-system," composed of materials by "intelligent men whom he can outtalk." He argues that this method of making an epic is beautiful "because it destroys historical time, and / thus creates the methodology of the *Cantos*, viz., a space-field where, by inversion, though the material is all time material, he has driven through it so sharply by the beak of his ego, that, he has turned time into what we now must have, space & its live air."[95] Olson's generation of American poets regarded Pound's ability to render historical time as a "space-field" an effect of his overpowering *virtù*, or individual initiative. As Robert Creeley put it, "This side of the water we need heroes, models of active human context, call it—I mean, people who make clear a life can be lived specifically, not just drifted along with."[96] Yet the potency of Venice as an environment forces us to revise this heroic view of Pound's poetic.

As the first coherent segments of his epic, Pound's provisionally framed early drafts of *The Cantos* clarify the lasting resonance of Venice as a structure within his poetry that recasts both history and monumentality—two tasks fundamental to the reimagining of epic poetry. While one aspect of Pound's modernist rhetoric parallels that of his peers, promoting the figure of the virile hero, his epic verse composed under the sway of Venice assembles a dialectical other to that figure: a vortex of collective energies inciting "free groups" (or, in his more disturbing formation, arising in discussion of D'Annunzio, "groups formed about men who had reached a condition of more than freedom"[97]) to act. The subject of the Venetian cantos is not a hero, but an environment of conflict in which the urban frame is elaborated over time. This environment mirrors the structure of a republic whose constitution comprised an impersonal set of checks and balances: a Great Council of aristocrats and *cittadini originari* (including members of lower classes and foreigners) and the elected Council of Ten, established to offset the doge's authority and police the patrician order.[98] Venice's recurrence as an implicit structure within *The Cantos* stands as a counter to the ideal Fascist city of Imperial Roman hearkening and pedantic circulation patterns, in which nature and masses all become organized by the *Dux*, as well as to the Ecbatan/ Dioce (Ecbatana, or Deïoces) of concentric walls, whose social reality is rendered ethereal through the Pisan cantos's lyric interludes on its mapping of the planets and stars.[99]

The Cantos, which increasingly become the effort of a titanic individual in search of synthesis, do trail charismatic personalities through the Venetian archipelago: mercenaries Sigismundo Malatesta and his beheaded would-be father-in-law, Carmagnola, his comrade Borso d'Este, and the prince/patron/

banker Cosimo de' Medici.[100] Pound also tracks a Venetian cult of "luxuria" through characters who emerge as salient here and there—from Doge Selvo, who enlisted the Greek artisans that enriched St. Mark's with mosaics, and whose wife is credited with introducing luxury to Venice through the use of gold dining forks, through the voluptuary Lorenzo Tiepolo, and Baron Franchetti, the contemporary owner and restorer of the sumptuous Gothic Ca' d'Oro. But the Venetian "space-field" that incorporates these heroic figures in the first thirty cantos insists upon the volatility of commerce *between* historical individuals.

The entryway to Venice at the Dogana Point, with its rotating sculpture of Fortune, also acts as a spectacular theater for the *fortuna*, or chance, that ultimately contests any individual's *virtù* (in terms Machiavelli famously developed in *The Prince*). Venetian history and topography sustain an assertion that Pound must have read in Horatio Brown's tract on "Carmagnola, a Soldier of Fortune"—that the history of Italy "is the history of highly organized but conflicting particles."[101] As an urban structure, Venice localizes and concretizes these dialectical relations. Bernard Berenson voiced a common impression of the city's unique totality when he wrote to Isabella Stewart Gardner that the Piazza San Marco and *molo*, with their distinct views, seem "to form an indissoluble unity, made by time and tide, and the spirit of a people in a way that . . . no merely individual genius could ever invent."[102] Historically, the Venetian Republic had never identified itself with an individual: it in fact forbade the erection of freestanding monuments to Venetian families and declined to place a monument to any individual outside of a church. The Signoria made an exception for the Bergamese soldier of fortune Bartolomeo Colleoni, who willed all of his possessions to the Republic—but deliberately misread his will, which specified that his monument be erected at San Marco, and instead placed the *condottiere's* likeness in front of the Scuola di San Marco at the city's far northern edge.

True to this tradition, it can be said that the "subject" of the cantos in which Venice appears is their monumental urban framework rather than any individual who would force poem or polis to cohere.[103] In this, they likewise reflect modernist attitudes toward monumentality. "The notion of a modern monument is a contradiction in terms," wrote Lewis Mumford in his 1938 *The Culture of Cities*.[104] Yet the wish to register collective experience over time made evident by both the doctrines of impersonality and epic projects produced by Anglo-American modernists demands that we regard that contradiction in terms as the driving force of a productive dialectic. In authoring *The Cantos*, Pound aspired, like D'Annunzio in *La nave*, to fashion

a monumental record not of individuals, but of a "tribe"—however wistful and offensive the term may be—and did so through an assemblage of hybrid "masses in relation."[105] This commitment to incorporating past exempla into structures that would reach and, further, *produce* a public sphere links his poetry to the monumental tradition. Yet in order to appreciate Pound's role as a "sculptor" of rhyme and his attempt to commemorate sites "where memory liveth,"[106] we have to revise received parameters of monumentality; for as a contemporary of the Futurists, Pound recognized that "a 'memorial' should speak not to the present but to the future."[107]

A survey of modern responses to static figural statuary makes it clear that this genre was no longer deemed fit to embody public values. The equestrian statue of Colleoni in Venice by Andrea del Verrocchio was one such monument that haunted modernist authors seeking models of a newly public, collectively oriented art. The narrator of *The Aspern Papers* stares in vain at this "finest of all mounted figures"[108] for a solution to his amorous quandary before determining that the historical effigy has no relation to contemporary life. Wallace Stevens argues in "The Noble Rider and the Sound of Words" that such codified sculptures as Clark Mills's equestrian statue of Andrew Jackson only make us "conscious of ourselves as we were," not as we are; as memorials, they have no contemporary ramifications.[109] In Pound's formulation, such mimicries of historical statuary are "Noble forms, lacking life . . . / . . . / and the cry: Civis Romanus"—a cry that imperial Britain had parroted, in Pound's view, with disastrous results (*Cantos* 25/118). Exhausted standards of salience, density, and permanence forge epilogues for Mauberley at once heavy and vacuous as the morbid amassment of cultural weight that he finds in contemporary England: the "two gross of broken statues" for which "[t]here died a myriad" (*PT* 552). The radical modernist monument will avoid reference to a transfixed or centralized mass of memories, seeking alternate routes—and the sculptural impulse enters what Rosalind Krauss famously identified as the monument's "negative condition."[110] Boccioni will go so far as to call for the "*absolute and complete abolition of finite lines and the self-contained statue*": "*Let's open up the figure and let it enclose the environment.*"[111]

In Pound's *Draft of XXX Cantos*, it is no longer the salient mass alone (the Colleoni bronze) but the ground of crossing-spaces between many such masses (the topography of the city in which the statue stands) that is set into relief. The poetic monument that results is "sculpted" out of collectively generated material by the poet/editor, who presents isolated characters within a field of interlinear relationships left open to interpretation and reformulation. As Charles

Altieri elucidates, in modernist aesthetic practices, "The powers are relational, not conceptual. It is 'concentration,' therefore, not 'mass' or its literary analog, heroic rhetoric, that can be 'monumental.'"[112] The peace of remembrance "benedetta" (literally "well-said") will until the end take the form of

> Brancusi's bird
> > in the hollow of pine trunks
> or when the snow was like sea foam
> > Twilit sky leaded with elm boughs.
> Under the Rupe Tarpeia
> > weep out your jealousies—
> To make a church
> > or an altar to Zagreus Ζαγρεύς
> Son of Semele Σεμέλη\
> Without jealousy
> > like the double arch of a window
> Or some great colonnade.
> > > > ("Notes for CXVII et seq."/821)

In *The Cantos*, the carved always communicates with surrounding hollows: solid "sculpture" corresponds through voids such as those of the unfinished Palazzo Venier dei Leoni to which this passage returns, and which, upon the Guggenheim Collection's establishment in 1951, host Brancusi's *Bird in Space*.[113] The poet sets sculptural masses in paradoxical apposition to more elusive material—here, to snow resembling sea-froth. According to Pound's imperative, selfishness must be "wept out" under the Rupe Tarpeia, the rock from which Roman criminals were hurled to their deaths. Memorialization thus takes the form of the colonnade, which functions as both presence and absence—not the form of the self-reflexive figure, column, or wall. The poetic being developed requires that we heed the structural influence of spaces normally relegated to aesthetic ground.

Pound's celebrated reliance on the sculptural analogy for composing verse has led commentators into a trap: they recruit mimetic paradigms of sculptural monumentality to readings of his epic poem. The scholars who have explored *The Cantos*'s relation to public space most provocatively consolidate their discussions around the Malatesta and Pisan cantos, seeking out the monumental urge in the salient representation of a central "I" (whether the subject is Malatesta or the poet himself).[114] Rainey concludes that the heroic effort of *The Cantos* consists in "the reconstitution of that lost identity" of the

poem's first two lines, which lack a subject ("And then went down to the ship, / Set keel to breakers . . .")—to close "the gap between narrator and hero, author and reader."[115] Yet Pound's explicit prescriptions for major poetry undercut his heroic rhetoric in affirming that poets with a "gift from Chronos" have been given the task "to heap together and harmonize the results of many men's labour": "This very faculty for amalgamation is a part of their genius and it is . . . a sort of unselfishness" (LE 49). One predominant characteristic—and lasting innovation—of A Draft of XXX Cantos is its dislocation of the identical "I" able to declare from any stable vantage point, "I have seen what I have seen" (2/9). The crepuscular Venice that emerges sporadically within this sequence tends to engulf individual seers. The urban structure's intermittent presence compels us to conceive of his monumental experiment as the response to a demanding environment rather than a triumphalist design, and to read against the heroic subjectivity that forms both a critical crutch and an impasse in Pound criticism.

Even the apparently reliable autobiographical subject that emerges at sparse intervals in A Draft of XXX Cantos, from time to scattered time, continually repositions himself in the discontinuous Venetian landscape, assuming a horizontal pose beneath its monumental pillars to compose a piecemeal view of the place:

> I came here in my young youth
> and lay there under the crocodile
> By the column, looking East on the Friday,
> And I said: Tomorrow I will lie on the South side
> And the day after, south west.
>
> (Cantos 26/121)

Impulses to traverse the landscape freely are thwarted, so that the itinerant I gazes across articulated gaps in the directions of the city's influence. Pound incorporates the discontinuity of Venice that disconcerted Georg Simmel into a new poetic: because the "separation and connection" between any two points in Venice are never "one and the same," the place is open to nonlinear reconstructions of cultural influence.[116] The poet taps this displacement throughout the first thirty cantos, even as the subject takes the form of the first person plural: "And we sit here . . . / there in the arena . . ." (4/16); "Where are we?" (21/96). The space these cantos encompass tends toward the heterogeneous. We need to resist isolating A Draft of XXX Cantos's local wholes from this larger environment of interruption. For even the Tempio Malatestiano—the monument

in Rimini that has granted critics such as Rainey a chance to synthesize *The Cantos* conceptually—is an "*interrupted* work," as architect Aldo Rossi writes in 1978, a building reflecting the "echoes of the East and the North that one finds in Venice," which make up a "diverse totality."[117]

To understand Pound's developing poetic, we must refrain from reducing his ideal of poetry as sculpture to a more general Vorticist call for solid repose (launched as a polemic to distinguish the English movement against Futurism, and later qualified by Pound).[118] The phenomenological concentration on the situation of the archipelago and its art in the first thirty cantos leads to a site-oriented and riddled utopian formalism, one that taps the city's founding dialectic between stone and water. Even in his earliest poems composed in Venice, Pound is drawn to the way that water simultaneously wears down and builds up the city's stone foundations: one fragment from the San Trovaso sketchbook reads simply, "Marble smooth by flowing waters grown."[119] Instead of jettisoning flux and its tropic loci in femininity, supposed oriental formlessness, foreignness, and passing time (all associated with Venice), Pound will suffuse his striving to sculpt a new monumental poetic with this principle of fluidity, to produce a dynamic paralleling the one between the masses of Venice and its ambience, between state and sea. (Instead of suppressing associations with Eros, as the model polis must, *The Cantos* commences with the veneration of Venus [1/5].[120]) In this monumental work, sculpted stone contradicts the contradiction of kinesis and stasis by taking on a new volatility: that material tethered traditionally to inflexible, indelible imprints on history is everywhere placed into commerce with water, which is itself conceived as "cutting" (2/7). Pound himself described the affinity between these matters by way of a vision through Venetian portals composed in Italian: "Per portoni di Palazzi: Venezia eterna, acqua e pietra che sembra galleggiare ed essere semplicemente una parte dell'acqua stessa" (Through the portals of Palaces: eternal Venice, water and stone that seems to float and simply to be a part of the water itself).[121] Donald Davie points out that "*The Cantos* force us to dismiss from our minds most of the familiar connotations of 'marmoreal' or 'stony.' Where 'marble' appears, or 'stone,' it is a sign of resurgence and renewed hope."[122]

While seemingly paradoxical in the light of contemporary associations with stone, this attitude—like many other features of Pound's work—constitutes an extension of a long tradition. Indeed, a central miracle of Venetian history involves the legendary emergence of Saint Mark's arm from a column of the third Basilica while it was under construction in 1094 to reveal his obscured

remains, thus linking the marble of the church to the animated saint himself. But conceptions of stone as fluid and alive can be traced back through Augustine to Pliny, who viewed crystal as frozen water, to the Book of Revelation, where the throne of God appears before "a sea of glass like unto crystal" (King James Version, 4:6), a vision from which Pound's "Glass-glint of wave in the tide-rips" (2/10) seems to borrow. Marbles in the Middle Ages were actually viewed as "congelations of clammy vapors"[123]; and even from the rationalist vantage point of the Renaissance, Palladio refers to them as *"pietre vive"* ("live stones").[124] Stone in this tradition, and in *The Cantos*, where "[t]he stone is alive in my hand" (7/21), composes architecture that stresses its own being in duration, obliging us to view building as a process of becoming—and pushing us further, toward a durational understanding of architecture's material components.[125] Stone in this conception signifies not petrifaction but potential.

Critic Adrian Stokes offers an elucidating commentary on Pound's conception of stone in *Stones of Rimini* (1934), a work inspired by *A Draft of XXX Cantos* and written with Pound's encouragement.[126] In these essays, Stokes goes to great discursive lengths to outline a geological continuum between water and limestone (and marble, limestone's metamorphosed, recrystallized tributary), which he regards as the material and conceptual basis of Mediterranean art. His perspective demands that we abandon conventional taxonomies, that we efface the boundary between living and nonliving matter, for as he claims, "Limestone, for the most part formed of organic deposits, is the link between the organic and inorganic worlds."[127] Water and limestone, Stokes explains, exist in a decreative and creative symbiosis: water continually sculpts the stone by a slow dissolution of its basic mineral, calcium carbonate, while limestone absorbs water, collecting calcite deposits that eventually form stalagmites and stalactites—the fluted columns of caves. This dynamic, he suggests, composes a material history of the city, traceable to those attentive to the wayside of historical succession. "No marble, no conventional phrase" composes histories of such inconstant regions "of short distances and definite places" as will resurface in Yeats's 1939 "Under Ben Bulben" and Auden's 1948 "In Praise of Limestone."

Stokes intended for his essays to illuminate the fifteenth-century bas reliefs of the Tempio Malatestiana, where, as he argues, "Mediterranean life has complete expression: there, water is stone."[128] As a poetic analogy, however, this guiding affinity between matters corresponds more directly to *A Draft's* passages through Venice—in which the affinity between water and stone is set into relief—than to the Malatesta cantos.[129] Stokes himself locates in the maritime topos of Venice—a whole city built of Istrian marble, thus "distilled

agleam from the whirls and liquid tresses of the Adriatic"—not a fallen civili-
zation's battle against time and the sea, but a "sculptural communion between
the masonry and the water piercing and renewing its stones."[130] The water
and architecture check and complement each other: "Water and builded
stone vivify the one the other; they are at peace."[131] Venetian glass, as artifact,
literalizes this harmony, generating a new, hybrid material from water and
sand, which also permitted heightened light effects in mosaic works: the
famed Murano glassworks drew on sodium carbonate produced by charring
the lagoon's seaweed. In Stokes's Venice, as in Pound's, history's persistence
exists in a symbiotic relation to entropy, while constructive art and decre-
ative nature flourish in an idyllic harmony of purposes. The city's foundation
thus emerges as "no gesture, no extravagance"—as it was characterized by
Romantic authors who pathologized its artifice—"but a miraculous condition
of Nature that *demands* art from man."[132]

In a review of *Stones of Rimini*, Pound praises Stokes's "basic unity or antith-
esis: Water and Stone."[133] This portrayal's refusal to resolve the two matters
into continuum or contradiction parallels Pound's poetic manipulations. Like
the stones of Rimini and Venice, the building blocks of Pound's monumental
fixities are inherently fluid. His imperative to "Damn the partition!" (7/25)
suggests that conventional taxonomies and stolid stone boundaries will
obstruct the distribution of historical forces. The poet-sculptor's situation at
the lintel or "threshold" between conflicting personalities, periods, tongues,
matters, and topoi produces a fissured topography of gateways and travers-
able channels. In *The Cantos*'s recasting of realism, matter matters not for its
fixity but for the way it interacts with other matter: "Relations are more real
and more important than the things which they relate."[134] Pound's frequently
metamorphic poetic draws on "the medieval conception of Relation *whose
appropriate images were always connected with water.*"[135] So rock becomes
elastic as Pound's sea surges through the grooves it forms, as he follows the
plotted alleys of stone Ecbatan with a crowd's rush, then marries the polis to
the Nile and the measureless sea (5/17), or conjures a stone Venice literally
wedded to the sea (25/124). The fissured monument that results encompasses
both the carving and modeling acts Stokes ties to male and female principles,
clarity and confusion, stasis and kinesis—or, in aesthetic terms, salience and
ambience, figure and ground.

The reading of history in this epic takes place as we read the sea-surge
through the archive's gaps, following Pound's insistence that what we know
of the past "we know by the ripples and spirals eddying out from us and from
our time."[136] Isolated citations from history are "bust thru" and linked by

assemblages of lyric time that, for all their calling on gods, produce a reading experience that is anachronistic, not transcendental. Pound creates a phrase-oriented rather than sentence-oriented syntax, analogous to the movement between narratives and images, and based on disparate phases of perception, which allows for poems to be aggregated through surges of assonance, and sense to succumb to consequent tributaries. Pound's epic relies on lyric suspensions that bridge distinct moments of constatation: crossing-points between historical discontinuities—both syntactically jagged and textually mediated—that do not elide their underpinning lacunae. Even Confucius "'. . . can remember / A day when the historians left blanks in their writings, / I mean for things they didn't know, / But that time seems to be passing'" (*Cantos* 13/60). The result is a collectively lyric (or sociolyric) alternative to the piercing standardized time of the ticking clock (5/17, 5/18).

The intellectual, artistic, and mercantile vortex of Venice surfaces in the first thirty cantos as a regenerative ideal or topos as well as historical "sea-hoard."[137] Beyond figuration, the city's structure lends this monumental experiment praxis. The complex of stone in water literalizes a sculptural volatility that one experiences elsewhere only as abstraction; topography obliging commerce between distinct "masses in relation" provides the epic poet with a paratactic syntax.[138] That figure of masses is a Vorticist one—but in the Venetian vortex the tension between masses is historical, expressed architectonically. Venetian urbanism provides spatial experience of the fact that a collective expression, city or republic, can arise in the act of transit between component parts.

As ideologue, Pound shares Ruskin's contentious conviction that Venice fell, with the onset of the Renaissance, into social relations contaminated by rhetoric and usury. Beginning in the 1930s, his prose will attempt to incorporate the Venice of Marco Polo and Shylock into a "left-fascist" and anti-Semitic meta-narrative of the West's fall under "usura."[139] But in the initial Venetian cantos, the literalized antagonism between stone and water exceeds any reified antinomies the author may invoke at the level of argument: in spite of all fragments situated in the topography of *The Cantos* to suggest such a fall, the poem ultimately embraces the city's continual mutation, mediated by Aeschylus, Heraclitus, and myriad others into the present. Pound generates a poetic monument continually regenerated by the force of the water that, in Wallace Stevens's words, "never formed to mind or voice"; his epic activates rather than stalls the scrolls of sea-surge that so tormented Ruskin.[140]

Pound introduces these sea-surges in the first lines of *The Cantos* as "breakers," at once broken by shore and agents of breakage themselves. His

"objective" translation of *The Odyssey*'s Book 11 (including the passage that Ruskin cited, in Pope's translation, to dismiss the poetic fallacy, the literary equivalent of subjective hermeneutics and instrumental reason) underscores the emphasis on material rather than man from the beginning.[141] Set against by navigational keel, the waves flexibly frame Odysseus's periplus, then fuel the second canto, a tour de force of protean verse. Water rushes through Canto 2's opening lines as an impersonal agent of transformation:

> But Sordello, and my Sordello?
> Lo Sordels si fo di Mantovana.
> So-shu churned in the sea.
> Seal sports in the spray-whited circles of cliff-wash,
> Sleek head, daughter of Lir,
> eyes of Picasso
> Under black fur-hood, lithe daughter of Ocean;
> And the wave runs in the beach-groove:
> "Eleanor, ἐλέναυs and ἐλέπτολιs!"
>
> (*Cantos* 2/6)

The oceanic "so" carries us from the first canto's consequential "So that:" through discontinuous cultural strata encompassing Sordello, So-shu, and Picasso, connecting these remote luminaries with the facility of the "also" that emerges at the canto's end, yet without the need for this grammatical connective. Sea-dog and sea-god inhabit and animate this flood of relation created by Pound's Homeric "ear for the sea-surge" (2/6), or "poluphlois-boios" (74/427). The Chinese character for *wave*, composed of the radicals for *animal* and *hide*, may be the cognitive construct ushering in the seal-skin ("black fur-hood") that disguised Menelaus's men as they leaped on Proteus to bind him. Water takes solid form, still elastic; soon "void air" itself will be "taking pelt" (2/6, 2/8).

Countering this urge to bind the protean, Helens of various generations threaten male attempts to navigate, through flux undercutting the keel: conjured up by Aeschylus's pun, Helen is destroyer of ships that strive to stay "stock fast in sea-swirl" (2/7) as well as destroyer of rock cities, capable of reducing them to "smouldering boundary stones" (4/13). Such negative feminine principles in *The Cantos* repeatedly strike a "bust thru from quotidian into 'divine or permanent world'"[142]; in Canto 2 they mobilize the beach-groove and summon the metamorphic works of Dionysus. In the interim, the aquatic passage of the poetry forms kenning-like Anglo-Norman compounds

("rock-pool," "sea-bords"), and marries algae to "Naviform rock" (2/7). The canto's representative (and often violent) marriages of the feminine and the masculine, liquidity and solidity—the moon rousing influxion with her phallic "churn-stick" (2/9), the "spray-whited circles of cliff-wash" (2/6), and the wave running in the "beach-groove" (2/6), stirring up rock—are meant to dramatize the productive force in poetry as well as building itself.[143] Fluid energy's resurgence mobilizes *A Draft* throughout, churning shingles, panels, or islands (17/77; 20/92, 20/93), enacting "Sea-change[s]" (5/18); it propels the poem through hell.

The second canto finally segues into a 1908 Venice by way of the accordant "And . . ." (2/10); the third opens by presenting us with the poet who gazes at St. Mark's Square from across the Grand Canal (unlike Browning, who occupied something closer to an insider's position on a Ducal Palace step). Yet as we saw earlier, this distance from the center enables Pound to echo rather than merely to repeat the authors who have preceded him. He fills in the topographical gap between palace and customs house with inhuman presences; "Gods float" amidst the "lit cross-beams" (3/11) as they would on water. Such lyrical passages between historically anchored perspectives function as sculpture's negative space, as fundamental to the whole as the "rock-hollows" and "wave-runs" that channel the sea's coursing (2/10), for example, or the double arch through which Cabestan's lover flies (4/13). Whereas Ruskin tries to produce Venice as a stable touchstone, and thus fixes his study on its stones themselves, Pound devotes poetic attention equally to the spaces between the stones, especially the threshold onto the sea from St. Mark's Piazzetta—the *molo* and execution-space marked by stone columns—and the negative presence of the sea itself. The interstice is active in both aesthetic and social senses as a space of crossing, or traduction.

Exploring the fissured structure of the archipelago that fascinated Pound alongside its recent emergence in political theory can help us read *A Draft of XXX Cantos* as representative of twentieth-century reimaginings of the body politic—as a volatile sociopolitical terrain of union in transit.[144] Fifteenth- and sixteenth-century Venetian atlases, called *isolari* because they represent the earth as a series of islands, emblematize the maritime republic's world view. Modeling the globe in its own image (that of some 120 islands defined by more than 200 canals), the city famed for its navigators and cartographic inventions generated a vision of the world as archipelago that persists in current geophilosophy. The Venetian philosopher, political scientist, and politician Massimo Cacciari, founding editor, with Antonio Negri and Alberto

Asor Rosa, of the journal *Contropiano* and a core protagonist in the 1980s and 1990s at the Architectural Institute of Venice (IUAV), offers this vision of the archipelago as a corrective to the modernist utopia. His book *L'Arcipelago* (The Archipelago [1997]) was written during his first term as mayor of Venice, from within an increasingly federalist political landscape and the concurrent theorization of the European Union.[145] Cacciari presents this topographic figure as an irreducible plurality whose singular elements are bound through their separation. His volume opens by citing Eugenio Montale's notion of the sea as a "risk-driven law"—a law "vast and diverse / and bound."[146] The Greek term *pélagos* represents a sea at once embracing and threatening, which in its fluidity and ceaseless extension contradicts the "halted rhythm" of our "stammering speech."[147] In Cacciari's account, the arch-*pélagos* emerges as the site of interchange, of ineluctable relation and confrontation among the islands inhabiting it, "all distinguished and intertwined by the Sea; all nourished and risked by the Sea."[148] Lacking a rigid axis, Cacciari's idealized archipelago resists the hierarchy and subordination implied by received notions of organic unity. The sea grants its islands boundaries that fluctuate, harmonizing without reducing them violently into one.[149] It unites them in a common "research." Cacciari locates the archipelago's center, in fact, in the urge to navigate: in "that impetus which obliges each to 'transcend itself' navigating toward the others, and all toward the absent Fatherland [*Patria*]."[150] Their voyage is bound "in a common love [*philia*] for that Name or Fatherland which all are lacking"[151]—bound *toward* (rather than *by*) that land or name. Conceived of as a totality held in abeyance, the archipelago capsizes Romantic models of organic unity still pervasive in the late nineteenth century. It also offers an alternative to European science's desire to reduce all things to bodies, critiqued by Edmund Husserl; applying that objection to political science, Cacciari's geophilosophy eludes the imperious paradigm of a "body politic" bound by a sovereign. The archipelago literalizes the conception of an objective monument that espouses fissures, compelling infinite internal crossings.

In his reading of Cantos 17 through 30, a sequence dominated by Venice, Hugh Kenner declares, "Venice arose from the water a stone Aphrodite, splendidly dead," "a splendid mortuary place entoiled for centuries with the history of financial practices."[152] Yet being sculpted and built up by that water, the stone of the republic these cantos present registers as no petrifaction. Even the purgatorial "aqua [sic] morta" (dead water) of Canto 16 that ushers in the sequence contains "limbs fluid, and mingled" whose dismemberment is a prerequisite to regeneration. Fragments of bodies and marble are immersed in a pool of embryos that contradict the mire: "and here an arm upward,

clutching a fragment of marble, / And the embryos, in flux, / new inflow, submerging" (16/69). Although, as we have seen, the cosmopolitan Venice of the Belle Epoque had been devastated during the Great War, Venice was being infused with public attention surrounding D'Annunzio's campaigns in the Adriatic while Pound was writing these poems. Pound viewed the energy as part of "the movement and direction of a current"—a possible vortex within a "reawakening Italy" contrasting the decadent centers of London and Paris.[153] The Venice Pound saw in this moment would have defied the sociohistorical calcification implied by Kenner's articulation; it arises instead in the volumes consolidated as *A Draft of XXX Cantos* as an interrupted utopia.

The cityscape with which *A Draft of the Cantos 17–27* opens, Venice portrayed as "a sort of paradiso terrestre,"[154] emerges as an antidote to the corrupt landscape of the Hell Cantos, 14 and 15, which as the poet claimed in a 1932 letter, represented "specifically LONDON, the state of English mind in 1919 and 1920"[155]: an inferno of profiteers, financiers, vice-crusaders, usurers, and "the perverters of language, / [. . .] who have set money-lust / Before the pleasures of the senses" (14/61). *A Draft of XVI. Cantos* closes with these Hell Cantos, 14 and 15, their perverters engulfed in dung, mud, and "bog-suck" (15/66), and the final "purgatorio" of 16: a liquid terrain constituting the underbelly, and perhaps the underpinning, of the earthly paradise that follows as the poet prays to Medusa for "the petrifaction of putrefaction" (16/64).[156] For the dystopian landscape of Cantos 14 and 15 is, like London itself, not *entirely* antithetical to that of Venice; in fact, Pound's bog recalls Dante's celebrated description of the lake of boiling pitch as was used to repair ships in the Venetian Arsenal, one of the *Inferno*'s most celebrated similes.[157] Ruskin reads Dante's lake of pitch for the peculators as a figure for usury in an 1872 letter of *Fors Clavigera*: it signifies the "love of money" which "clogs and plasters its margin all over," and "bubbles up and down"—or the erosion and inflation of value that results when commerce is no longer tethered to concrete substance.[158] As an early modern architect of abstract banking, Venice had a hand in this erosion. Ruskin presages Pound's rhetoric concerning usury, contrasting the ooze of peculation and finance with the precision of Dante's metaphor and with the honest work of stonemasons; Ruskin also invites the association of Venice with usury as he identifies the "swiftly progressive ratio" with which "modern philosophy considers the rate of progress in Venice, from her days of religion, and golden ducats, to her days of infidelity, and paper notes."[159]

The episode of regeneration ushered in by Canto 16 stages the purification and supple petrifaction of the bog—an analogue to the petrifaction of wood piles in the mud that form Venice's foundations. The landscape of transition

between the first two published volumes of *Cantos* is a swamp reclaimed, resonating metaphorically with the economic tropes of damming, draining, and recirculation that were to be found in the pages of Social Credit journals advocating for redistributing flows of money, and which began to pique Pound's interest from the moment that he met C.H. Douglas in 1918—as well as with the Italian government's reclamation project in the Pontine Marshes, begun in 1924.[160] Canto 16's "new inflow" (16/69), a concretely liquid momentum, propels us toward the succeeding poem, a pinnacle of the Venetian sequence. Canto 17 (composed around 1924) constitutes a utopian vision of Venetian stone and water whose inhabitation by gods turns "at one time" into a regenerative cycle of "time after time" (17/78) unakin to Niccolo d'Este's sundered "a day, and a day" (30/147–48). Gladys Hynes's illuminated capital "S" for the 1928 volume's opening phrase—an echo of Canto 1's permissive "So that"—pictures the transition from nymphs and satyrs awakening from branches and Diana running from the "oak-wood" to the "trees growing in water, / Marble trunks out of stillness, / On past the palazzi": a vision of the Ducal Palace and Basilica suspended over the lagoon, the buildings' voids becoming a fantastic triumphal arch over the waves (figure 4.1).[161] This elastic space, harboring the potential for cultural renewal through aesthetic redistribution, becomes the environment that frames appearances of Venetian decadence in the cantos to follow.

The Charon-like rower of Canto 17 gestures toward the marble forest of Venice to describe—in a series of interruptions, of fragmentary phrases suspended in space—the crossings of elements in a landscape at once organic and inorganic, architectural and flame-like:

> " There, in the forest of marble,
> " the stone trees—out of water—
> " the arbours of stone—
> " marble leaf, over leaf,
> " silver, steel over steel,
> " silver beaks rising and crossing,
> " prow set against prow,
> " stone, ply over ply,
> " the gilt beams flare of an evening"
> (17/78)

Here, syntax allows the gilded beams' climactic flare to enact an evening that does not deny the differences of these matters, which intersect without wholly inundating one another.

THE XVII CANTO

O THAT THE
vines burst from my
fingers
And the bees weighted
with pollen
Move heavily in the
vine-shoots:
chirr—chirr—chir-rikk—
a purring sound,
And the birds sleepily in the branches.
ZAGREUS! IO ZAGREUS!
With the first pale-clear of the heaven
And the cities set in their hills,
And the goddess of the fair knees
Moving there, with the oak-wood behind her,
The green slope, the white hounds
leaping about her;
And thence down to the creek's mouth, until evening,
Flat water before me,
and the trees growing in water,
Marble trunks out of stillness,
On past the palazzi,
in the stillness,
The light now, not of the sun.
Chrysophrase,
And the water green clear, and blue clear;
On, to the great cliffs of amber.
Between them,
Cave of Nerea,
she like a great shell curved,
And the boat drawn without sound,
Without odour of ship-work,
Nor bird-cry, nor any noise of wave moving,
Nor splash of porpoise, nor any noise of wave moving,

FIGURE 4.1. "The XVII Canto," with decorative initial by Gladys Hynes, from *A Draft of the Cantos 17–27 of Ezra Pound: Initials by Gladys Hynes,* John Rodker, 1928. Reproduced by permission of Ernest Rodker and the Estate of John Rodker. Image courtesy of the Special Collections Research Center, University of Chicago Library.

The guide over the liquid threshold points, with additional and darker implications, toward the marked absence (conjured repeatedly by "time after time") of Borso d'Este, hailed patron of the arts, and Carmagnola, the Captain General of Venice—who have been "shipped," without directional verbs, "Thither" (both were killed in Venice). Pound refers to these fifteenth-century crafters of peace, war, and art as "*i vitrei*" or "the glassmakers" (78), calling to mind Stokes's argument that Venetian glass, a compost of sand, water, and limestone, "expresses the taut curvature of the cold under-sea."[162] The label identifies these "men of craft" as combative forces of transmutation: Borso tried to make peace between Malatesta and Federigo d'Urbino; Carmagnola worked for Venice as a *condottiere*, but was tried for treason. The poem never arrives "thither," at the absence toward which these figures are bound. Pound's invocation of such figures lost in Venice's fractures—one slain by an arrow while traveling by gondola, one executed between the columns of St. Mark and Theodore—highlights the brutal suppressions that are also implicit in the Venetian Republic's synthesis. It recasts Venice's gaps as potential tombs, forcing us to presume that many such renegades have been callously "chucked in the water" by state order.[163] That in this gloom "'the gold / Gathers the light about it'" (17/78) is a matter of some ambivalence: Neoplatonic light hovers over a substance at once divine (a medium of craft that girds the love goddess in Canto 1) and hazardous (as a plutonian concentration of wealth).

This celebrated passage of lyricism ultimately suggests that the watery forest of marble is a site of decreation rather than a mortuary; and indeed, Pound's rower eventually gestures toward another transitory zone that resembles a paradise on Earth. In the Eleusian rite that follows, Aletha, perhaps an oblique relative of the river of forgetfulness antecedent to reincarnation, recuperates drifting, ragged "sea-wrack" that has become salt-bright memorial through the water's churning. In the complete sequence of *A Draft of XXX Cantos*, as in the violent process of direct carving, or Burckhardt's Nietzschean account of the Italian Renaissance—Burckhardt and Nietzsche are key sources for Pound's poetry—salient construction and the "cleane slayne" are wedded over and over, in architectonic, social, and textual realms; Aldus's printers, to whom Pound returns in the sequence's last poem, are described as "cutters of letters," and given equal credit for the constructed "grace and charm" of Petrarch's *Rime* (30/147, 148). The "instinct of negation" that drives revolutionary "cutters" such as Aldus forms the antidote to Hell's "usurers squeezing crab-lice, pandars to authority, / pets-de-loup, sitting on piles of stone books, / obscuring the texts with philology" (14/63).

The sundown in the last line of Canto 23—"like the grasshopper flying"—forecasts one of the most syntactically discontinuous phases of the first thirty cantos: Pound's shattered translation of poetic fragments by Stesichorus on the set sun's nocturnal passage through the ocean, in Greek, Latin, and English (replete with lacunae and residue of the poet-scholar's research: "Derivation uncertain"). "[A]lixantos, aliotrephès, eiskatebaine ['Worn by the sea, sea-reared, he went down into'], down into, / descended, to the end that, beyond ocean, / pass through, traverse" (23/107) are the phrases that come down to us (mediated by Johann Schweighäuser and Athenaeus). This sun's vivifying sea crossing is juxtaposed with Byzantine humanist Gemistus Plethon's un-Venetian obstruction of distribution between East and West—to "build wall across Peloponesus" against Turkish and "Eyetalian barbarians" (23/107)—and the loss of Greek books at sea. The implied ellipses the reader must traverse to follow Stesichorus's sun, this myth interrupted,[164] emphasize the dynamism stimulated by Pound's discontinuous archipelago, a city sparsely populated by "the discontinuous gods" (21/99). Such ubiquitous structural clefts grant his poetic monument elasticity.[165]

Cantos 25 and 26 hint at the beginning of a decay of organic relations between Venice and the artists it patronizes. Yet in citing the performative bureaucratese of "THE BOOK OF THE COUNCIL MAJOR" (or Great Council, translated literally from the Italian *Maggior Consiglio*) preserved in Venice's Archivio di Stato, Pound shows how language in the maritime republic continues to make room for the "miraculous" (a "nativity" of lion cubs within the doge's quarters) and the biblical ("a note from Pontius Pilate" [25/116]), while providing for a cloistered daughter's continued care for her ailing father and the livelihoods of Titian, Carpaccio, and Bellini; patronage for artists parallels the example of the father's care in Pound's poem, being essential to the health of the state. These painters still work with the Venetian city-state as they embellish the German merchants' quarters at the "Fondamenta dei Thodeschi" or the far courts of Mantua and Constantinople, whereas Mozart can only plead repeatedly with the "supreme pig, the archbishop of Salzburg" for permission to leave a city that barely sustains him (26/128). The first, ornate edition of these poems published by John Rodker makes the two books one: the good of the state is made present again by way of its citation in the exalted material form of Pound's textual archipelago: "be it enacted / In libro pactorum ['In the book of the agreements'] / To the things everlasting / memory both for live men and for the future et / quod publice innotescat ['and which may be publicly made known']" (figure 4.2).[166] Hynes's decorative initial, here as throughout the volume, provides a key for reading as it

HE

BOOK OF THE COUNCIL MAJOR
1255 be it enacted:
That they mustn't shoot crap in the hall
of the council, nor in the small court under
pain of 20 danari, be it enacted:
1266 no squire of Venice to throw dice
*any*where in the palace or
in the loggia of the Rialto under pain of ten soldi
or half that for kids, and if they wont pay
they are to be chucked in the water. be it enacted
In libro pactorum
To the thing's everlasting
memory both for live men and for the future et
quod publice innotescat
in the said date, dicto millessimo
of the illustrious lord, Lord John Soranzo
by god's grace doge of Venice in the Curia
of the Palace of the Doges,
neath the portico next the house of the dwelling of
the Gastaldio and of the heralds of the Lord Doge.
being beneath same a penthouse or cages
or room timbered (trabesilis) like a cellar
one Lion male and one female *simul commorantes*
which beasts to the Lord Doge were transmitted small

FIGURE 4.2. "The XXV Canto," with decorative initial by Gladys Hynes, from *A Draft of the Cantos 17–27 of Ezra Pound: Initials by Gladys Hynes,* John Rodker, 1928. Reproduced by permission of Ernest Rodker and the Estate of John Rodker. Image courtesy of the Special Collections Research Center, University of Chicago Library.

portrays the stylized, seemingly modernist lion and lioness (clearly based on the *molo* column's archaic lion/chimera assemblage) springing as if from both the landscape and the illuminated Gothic tracery, textual and architectonic, along the verse's left edge. One lion's leap, in its arch, parallels the action of the Rialto Bridge—suspended in oblique dynamism over the emphatic black cleft of the Grand Canal. The "dee looks" field of this page, with its tapping of the gaps between epochs made contemporaneous in tense assemblage, stages the reciprocal deformation of a seemingly dead language and a more fluid vernacular, a performative constatation of fact that reconstellates past and future "To the thing's everlasting / memory."

Out of the Council's isolated decisions, through Pound's own "grotesque" invocation of meaning between the lines or "*inter lineas*" (128), arises a visionary passage echoing Cantos 4 and 17: "Which is to say: they built out over the arches / and the palace hangs there in the dawn, the mist, in that dimness, / Or as one rows in from past the murazzi" (25/117). The architects of Pound's decidedly earthly paradise constructed the seemingly impossible: myriad bridges and a Ducal Palace that appears to be suspended in air, with its thickest arcades set above the more rarefied, defying weight. Constructing a palace of incomparable lightness, protected by the lagoon instead of by massive walls, they saw

> " as the sculptor sees the form in the air
> before he sets hand to mallet,
> " and as he sees the in, and the through,
> the four sides
> " not the one face to the painter
> (25/117)

In the sculptor's execution, as in the process of direct carving Pound advocated in *Gaudier-Brzeska*, as in the carving of letters, what appears as a void is rendered a vigorous and breathing presence by the infusion of energy and intelligence. Pound contrasts this "nothing" with Ferrara's " 'Nothing we made, we set nothing in order, / 'Neither house nor the carving,' " mouthed by heavy voices out of tomblike stone pits (25/118). The center of Ferrara, whose duomo is buttressed by other structures, ordered nothing around gaps, vistas, clarities of the kind arising from the negative spaces and unevenness of Venice, where a vital cleft breeds new shoots: "Form, forms and renewal" (119) represented by Phaethusa's "Springing in cleft of the rock" (118), while wave takes form "as crystal" in a world of forms volatile "as glass seen under water" (119).

Expanding in *Stones of Rimini* on "the medieval conception of Relation *whose appropriate images were always connected with water*," Stokes writes, "Fluidity, influence, confluence, effluence, are words that belong to medieval parlance in matters of Relation. In accordance with astrological thought, relations of all kinds were conceived as influences flowing between two or more objects. No wonder that a *Philosophy* of Love is . . . the basis of spirituality as well as the scaffold of erotic poetry!"[167] Yet the difference between this acquiescent communion of Stone and Water and Pound's irresolute description of that dyad as "basic unity or antithesis" reveals the shortcoming of Stokes's analysis in sounding the more radical possibility generated by the poetry. For all of Pound's apparent stress on the conventional union of masculine and feminine in these cantos (especially in Canto 29), these sections of the epic explore "Relation" without rendering love a totalitarian force of unification. Pound does not designate in "love," nor in the city notorious for accommodating it, what Jean-Luc Nancy identifies as "one sole essence—an ordering (or disordering) principle of the totality of being and of beings, of nature, of the city, of knowledge, and of God."[168]

Critics eager to make Pound's monument cohere have fallen back on a Neoplatonic conception of harmony to see in *The Cantos* a comfortable dialectic between history and a transcendent Spirit resolved in "the reconciling synthesis of love."[169] Cacciari too locates the archipelago's center in a voyage bound "in the common love (*philia*) for that Name or Fatherland [*Patria*] that all are lacking."[170] But the archipelago of Pound's text—at once a historical republic and a virtual terrestrial paradise "spezzato" ("fractured") (74/438)—has to be imperfectly bound by the plurality of crossings it compels, reflecting the plurality of touches, of migrations implied in Nancy's "shattered love": its love is an *eros* rather than a brotherly *philia*.[171] The love memorialized by, and driving, this early phase of Pound's epic manifests itself as Nancy's "love break," in which the immanent subject is opened up, in which " 'I can no longer . . . pro-pose myself to myself (nor im-pose myself on another) without remains, without something of me *remaining*, outside of me' " (97). The poetic monument consequently contains the residue Pound describes in "Cavalcanti":

There is the residue of perception, perception of something which requires a human being to produce it. Which may even require a certain individual to produce it. . . . You deal with an interactive force: the *virtù*. . . . The senses at first seem to project for a few yards beyond the body. Effect of a decent climate where a man leaves his nerve-set open,

or allows it to tune in to its ambience, rather than struggling, as a north-
ern race has to for self-preservation, to guard the body from assaults of
weather. (*LE* 151–52)

Though this passage opens on the residue of individual human perception in
the environment, it ultimately stresses that such perception entails the figure's
aperture and tuning to ambience. This intercourse between salience and ambi-
ence, an "osmosis of persons" (29/145) as well as things, complicates traditional
notions of figure and ground—notions we read in an early figure's relegation
of Venice to passive backdrop by the Ur-Cantos's much more imperious I: "So
for what it's worth, I have the background" (117). It helps us to apprehend both
the utility and the shortcoming of Olson's notion that this poetry reconstitutes
history by spatializing time through the force of the poet's ego.

Pound describes instead a scene of reciprocal interference between per-
ceiving figure and ground, operative where the scattered subject of his poetry
opens his "nerve-set" to ambient forces—on a continuum with his early lyric
speaker over the Ognissanti Canal configured as an empty hall. The poet's
emphasis on the space of interaction outside of human perception, which
is tantamount to the negative space in any monumental work attempting a
truthful representation of collectivity, is the site of what Altieri calls "an active
negative, a non-objectivity that is not simply an aporia but an immediacy
and silence pointing beyond our practical sense of ourselves as agents."[172]
Rather than contouring a state ideal, Pound's poetic monument literalizes the
negative spaces that give rise to commerce between islands in the Venetian
archipelago, which like no other European capital "impart[s] to patches the
value of presences."[173] The "tribe" to be configured there is riddled with fault
lines, even in the utopian formalism of its poetic representation.

SWAMP RECLAIMED: POUND'S VENICE UNDER
(AND AFTER) FASCISM

The earthly paradise of Venice that emerges throughout *A Draft of XXX
Cantos* is a swamp reclaimed *per eccellenza*, antiquely, and tenuously. It rep-
resents a gem of cut stone poised at the threshold of a "muck"—both literal
and figurative—that constantly threatens to re-enclose it. Building toward the
notorious hymn against usury that would confirm his "left-Fascist" econom-
ics, Pound opens Canto 41 with Mussolini's reaction to the deluxe edition of
A Draft of XXX Cantos in 1933: " 'Ma questo,' / said the Boss, 'è divertente.' "[174]

The poet amplifies (and surely exaggerates) the meaning of the *Duce*'s apprisal of his work—his supposed "catching the point before the aesthetes had got there"—by devising a subject rhyme with Mussolini's highly propagandized campaign of *bonifica integrale*, or reclamation of the swamps: "Having drained off the muck by Vada / From the marshes, by Circeo, where no one else wd. have drained it. / Waited 2000 years, ate grain from the marshes; / Water supply for ten million" (41/202). By draining the swamplands, an act to which the intelligentsia on the Italian peninsula had aspired since the age of Tiberius, Mussolini supports "Nature's increase" (51/250): he develops agriculture, increases the water supply, and "find[s] site for his dwelling" (45/229). Pound yokes this massive and successful public works campaign, ongoing between 1924 and the fall of Fascism, metonymically to the battle against usury's erosion of labor, value, and language. As Casillo notes, "confronting the 'tangle' of the swamp, Mussolini creates the determinate out of chaos. Where usury destroys walls and barriers, he builds them" (201). The muckraking poet wishes to enlist this energy in an art practice that stands "halfway between writing and action," invented by Lenin, and in the vein of D'Annunzio and Marinetti.[175] Pound's *Jefferson and/or Mussolini* (1935, published in Venice in 1944) celebrates Fascism's "material and immediate effect: *grano, bonifica, restauri*, grain, swamp-drainage, restorations, new buildings"—then wistfully appends to these practical accomplishments, "and, I am ready to add off my own bat, AN AWAKENED INTELLIGENCE in the nation and a new LANGUAGE in the debates in the Chamber."[176] Not surprisingly, it was inhabitants of another zone of wetlands—the Veneto—who were drawn to settle the Fascist "New Towns" around the Pontine Marshes as farmers. They named the new library at Littoria (founded in 1932, and now known as Latina) after a hero of their homeland: the humanist Aldus Manutius.

As the passages above make clear, Pound's conceptions of fluidity were themselves subject to ideological calcification following the Great War and the Great Depression—in tandem with the contradictory development of Fascist doctrine in Italy, where he settled beginning in 1925. From the 1920s forward, the poet tapped sporadically into centuries-old tropes that associate swamps, and fluidity in general—so readily applied to the Venetian wetlands—with a stagnant or monstrously engulfing female sexuality.[177] Pound's postscript to his 1921 translation of Remy de Gourmont's *The Natural Philosophy of Love* places the dyadic understanding of gender underpinning the first thirty cantos into a context that stiffens the elastic conceptions promised by his poetry. Woman emerges in this text as "the conservator, the inheritor of past gestures, clever, practical, as de Gourmont says, not

inventive," while crediting man with "the 'inventions,' . . . the impractical, merely because in him occurs . . . the new bathing of the cerebral tissues in the residuum."[178] Pound's commentary pathologizes the female relation to fluidity—diagnosing the feminine ovular "bath" as regressive in its abandon and predisposing women toward stagnancy: "A flood is as bad as a famine . . . ; where one woman appears to benefit by an alluvial clarifying, ten dozen appear to be swamped."[179] Though written after de Gourmont, and aping the French author's voice, this pseudoscientific conception of the feminine flood does not sound an aberrant note in Pound's critical production. A 1919 letter to Marianne Moore confides, "Thank God, I think you can be trusted not to pour out flood," and follows with a poem that celebrates the blending of exaggerated gender types: "The female is a chaos, / the male / is a fixed point of stupidity. . . . "[180] The Cantos sporadically produces abstractions of woman as "submarine": in Canto 29, "she is an octopus, she is / A biological process," set against an Eliot confronting "the wave pattern cut in the stone" when they visited Excideuil together in 1919 (Cantos 29/145).[181] These abstractions are undercut by concrete images of fluidity—until they find their way, between the mid-1920s and the mid-1930s, into increasingly available dogmas, and Pound's Fascist rhetoric overruns his objects. Canto 45, first published in the journal Prosperity in 1936, represents this fever pitch as it declares that "WITH USURA" there "Came no church of cut stone signed: Adamo me fecit" (45/229)—directly citing Ruskin's material example of the pride of Gothic craftsmanship in the Veneto Church of San Zeno Maggiore, as well as Ruskin's critique of interest prevalent in Fors Clavigera.[182] We can trace a continuum in Pound's thinking about Venice through this political transition; though the city still fails to signify in any single adamant political direction, his juxtapositions of its cultural and geopolitical histories become more tendentious in the "Middle Cantos," 30–45. They fall into line with a disavowal of flow that Andrew Hewitt identifies in Fascist discourse, arguing that Fascism's nondialectical conceptions reduce masculinity and the entire phallic order "to stasis and statuary," despite the fact that "the phallic order, like that of capital, is an order of flows and exchanges."[183]

Modernist notions of chaotic feminine materiality found a buttress in the work of Johann Bachofen, the Swiss legal philosopher and amateur philologist who had in 1861 traced a progression from the promiscuous fecundity of early "Oriental" matriarchies through the Hellenic cult of Demeter, which bridled these dark, "chthonic," irrational energies through marriage, agriculture, and settlement.[184] Bachofen's ideas had been taken up by Marx, Engels, and Bebel; in the early twentieth century, they were employed increasingly

by theorists of the right, such as the Fascist Alfred Baeumler, who found in
them a justification for reining in an organic feminine realm with paternal
authority. Pound translates de Gourmont's prescription for staving off the
"swamping" of the male realm along similar lines: "The liquid solution must
be kept at right consistency; one would say the due proportion of liquid to
viscous particles, a good circulation; . . . the balance of ejector and retentive
media."[185] Such philosophies are always within the purview of the poet seek-
ing real-world correlations for the reclamation of land and culture. While
the poems making up Pound's *Draft of XXX Cantos* hold right romance in a
volatile balance, reciprocity gives way to a series of banalizing, stagnant bina-
risms as these concepts migrate into political policies; through both essays
for forums such as *The New English Weekly* and *The Cantos*, from the early
1930s forward, he advocates for the policy proposals of Social Credit, Gesell's
monetary reforms, and Fascist political economy.

As plaintive compositor, "cutte[r] of letters" (30/148), the younger Pound
aims to grant steady form to that excrescence expressed in contemporary
letters as a "prose kinema" through "the 'sculpture' of rhyme."[186] The poet
as sculptor must carve away the formless "mouthing" of fanatical obstruc-
tors of cultural and intellectual circulation, depicted in a hell whose sur-
face is described as a runny "ooze full of morsels, / lost contours, erosions"
(14/62). Pound begins dating his letters according to the Fascist calendar in
1931 (which took as its Year 1 the 1922 of Mussolini's March on Rome—
coinciding auspiciously for the poet with the publication of *The Waste Land*
and *Ulysses*), marking the integration, however eccentric, of his early concept
of monumentality into a right-wing political line.[187] The commentary on de
Gourmont presages the capacity for gender binarisms to stiffen into instru-
mental ideologies as Italy moves, from the March on Rome forward, from a
revolutionary and antagonistic species of modernism (manifest in the Futur-
ist Party and initial *Fasci di combattimento*) to a traditionalist modernism of
the regime's interwar *ritorno all'ordine* ("return to order").[188] Pound increas-
ingly extends the balancing of flood and famine, passivity and action, to the
spheres of cognition and "economy" by way of passive apposition:

> The female principle being not only utility, but extreme economy, woman,
> falling by this division into a male branch, is the least female of females,
> and at this point one escapes from a journalistic sex-squabble into the
> opposition of two principles, utility and a sort of venturesomeness.
>
> In its subservience to the money fetish our age returns to the darkness
> of mediævalism.[189]

Satisfactory art reins in the flood of sensation without recourse to the abstraction of the "money fetish," or untethering of substantive value from exchange. It thus enacts poetically what Tratner calls Pound's "economics of regulated excess."[190] But poetry's sculpting was also supposed to be a scattering of historical substance, and of a terrestrial paradise "spezzato" against "unnecessary idea-clots."[191] When Fascism rather than art begins to stand in as Pound's principal corrective, constatation becomes prescriptive, and that illumination sought "'mezzo oscuro rade,' 'risplende in sè perpetuale effecto,' magnetisms that take form, . . . interacting" ("Disjunct in mid darkness / Grazeth the light, one moving by other" [Cantos 36/179]), becomes contrasted with the mis-imagined "two maladies, the Hebrew disease, the Hindoo disease, fanaticisms and excess."[192] The resultant thought becomes manically amalgamative rather than fuguelike, corporatist in its course; it agglomerates flood and femininity, femininity and muck, muck and usury, usury and abstraction, abstraction and deracination, deracination and Jewishness, Jewishness and nonproduction, nonproduction and castration, until these categories collapse. They begin to show in a disturbing fusion of regressive femininity and Jewishness, or "the almost intravaginal warmth of / hebrew affections, in the family" (35/172–73, from Eleven New Cantos XXXI–XLI, published in 1934), and pool in the ideological abstraction of post–World War I Mitteleuropa in The Fifth Decade of Cantos (42–51; published in 1937): "hell's bog, in the slough of Vienna, in / the midden of Europe in the black hole of all / mental vileness, . . . / in Metternich's merdery in the absolute rottenness, among embastardized cross- / breeds" (50/247). Echoing Eliot's anti-Semitic 1919 "Burbank with a Baedeker," these passages disparage the consolidation of European markets that enabled usury to dominate commerce as well as the perceived miscegenation under the Habsburg empire that subjugated Venice.[193] In this frame, the "middle" becomes not a site of revitalizing exchange, but a "midden"—a contaminated dunghill or refuse heap.

One of Pound's economic tracts published in a German art journal in 1924, a decade before his most virulent anti-Semitic turn, links this developing racial diatribe explicitly with Venice. The essay "Law and the Merchant of Venice" (re)produces an unimpeded chain of associations between slavery, castrated sexuality, interest, and Jewishness in the Venetian Republic. Pound draws upon the eccentric historiography of Heinrich Leo, a rival of Ranke in Berlin whose own work with statute books rather than traditional historical testimony led him to conclude that post-Byzantine, eighth-century Venice, facing the "[d]earth of all manufactured articles in Europe, and of practically

all other products whatsoever," then "plunged actively into the slave trade 'and was then as is Siout in our day, the most important eunuch factory in the world.'"[194] The sudden cessation of production (here linked to a perversion of reproduction) "made the slave trade the easiest and most profitable" enterprise.[195] A Venetian economy that thrives on slavery clears the way for Shylock to demand his pound of flesh, which is why "The Bard of Avon mentioned the subject" (usury, that is; *Cantos* 93/627) in relation to the slave trade eight centuries later:

> *Shylock*:
> You have among you many a purchased slave,
> Which, like your asses and your dogs and mules,
> You use in abject and in slavish parts,
> Because you bought them. . . .
>
> If you deny me, fie upon your law!
> There is no force in the decrees of Venice.[196]

Pound's reactionary interpretation of the famous scene invokes the variety of races and classes depicted in Veronese's *Feast in the House of Levi*. He reads the slave as a precursor to the economy signified by the merchant of Venice; both are expressions of a reigning barbarity. "The black page in Veronese's banquet scene is not a freeman, and by the light reflected from his trappings we may consider Shylock—. . . not a villain of exceptional imagination or ferocity, but . . . an expression of an earlier order, an order whose barbarities we have exchanged for another series of evils."[197] Against this barbaric order stands Portia, whose "legal learning is solid" because she takes the "bond" between Shylock and Antonio literally: Shylock is to have exactly a pound of flesh, no less and no more.[198] Portia's insistence on exactitude in language countervails the usurer, who wrests value where value does not lie; she thereby restores force to the decrees of Venice.

Pound's effort at sculpting toward a renewed civilization aspired to reproduce this linguistic exactitude. Such precision in language can hold in check the "alchemy" of turning mulberry bast into silver, as the Venetian Marco Polo witnessed in the Cathay of the Grand Khan (18/80); linguistic precision can lend figures on paper the stable value to anchor an economy, without recurring to the paranoid governing mechanisms of tyranny. In an essay produced in 1920, Pound glosses Polo's characterization of paper money as alchemy in *Il Milione*: "Polo regarded the issue of paper money as a sort of clever hoax,

backed up by tyrannic power. The real tyranny resided, of course, in the Khan's control of credit. The parallels are fairly obvious."[199] The subject rhymes of later cantos spawn further "obvious" parallels. Canto 45 declares that there came "Zuan Bellin' not by usura" (45/230); yet Giovanni Bellini (whose name Pound transcribes in Venetian dialect) inhabited a port of mercenaries open to finance, the slave trade, and sexual trafficking, while incorporating the Jewish quarter that gave us the term *ghetto* within its core. Nearly one hundred years before Bellini produced his late masterpieces—at the apparent height of Venice's powers—da Gama charted an alternate route to Asia, causing Venice to lose its monopoly over shipping and trade, so that to maintain its status as *Dominante*, it needed to invent interest schemes to support itself:

> That
> Venice be *luogo di contratto* may we
> say the place where the deal is made
> and the profits
> most assuredly from the pocket
> of the last man who buys . . .
> ..
> 9 per cent in, and 9 out, for the upkeep of "The Dominant"
> (35/175)

In the poet's strategically riddled history, *usura* and *luxuria* creep in through financial exploitation of interest to cripple Venice. The first thirty cantos contain the initial breaches through which "Venice at first democratical" (47/394) will be contaminated by "Oriental" luxury and the depredations of the Medici Bank's control of credit, to turn toward plutocracy during the Renaissance, a "Midas lacking a Pan" (21/99). The developing epic circuitously tracks the decadence of a mercantile culture that begins dealing rather than producing, alienating value from objects and labor from local culture: "Tell the Wazir that that stuff is ours only in name / it is made by damned jews in exile, made by damned jews in / Ragusa and sold with Venetian labels" (35/176). This passage, from "Mitteleuropa," in *Eleven New Cantos* (appearing individually between 1931 and 1934), voices the stirring of a mass propaganda campaign that preceded the implementation of racial laws throughout Italy, even in the relatively integrated Venetian Jewish community, between 1938 and 1945.[200]

In this middle period, *The Cantos* threaten to become less a stage of conflict than a mere platform where truisms and objective histories coagulate.

Anachronism can always become the instrument of an institutional nostalgia—
no longer giving rise to the estranging perspectives introduced by histori-
cal mediation. Pound's 1938 remark that the archaeology of Leo Frobenius,
anthropologist and theorist of the "paideuma," "is not retrospective," but
"immediate"[201] is more dangerous than it at first seems. When appropriated
for a total body politic and incorporated into a preemptive present, citation of
history can be traduced into a poetic field lacking in sociolyrical—political
and aesthetic—difference. Ernesto Laclau has argued persuasively that the
ideological specificity of Fascism lies not in the elements it gathers together,
but in the discursive mechanism of binding itself[202]: Fascist discourse func-
tions by yoking together incompatible elements and polarities, subsuming
both Futurist and antimodernist stances in a "totalitarian pluralism."[203] This
was the type of pluralism that Pound saw on display at the 1932 *Mostra della
Rivoluzione Fascista* and the 1937 *Mostra Augustea della Romanità*—one
increasingly touting the violent seizure of "simultaneity" between an Imperial
Roman present and past.[204]

In Pound's conception, which threatens to shift from diverse totality to
totalitarian pluralism, proper economic channels must flow into productive
exchange between beings and states, staving off a rapacious flood of usurious
values. By 1944, he will have recast the relations between Venice and romance
in a comparative discussion of the economy of New England (composed in
Italian): the American cult of business was still "romantic" until 1860, con-
tinuing the tradition of the Republics of Genoa and Venice—but "Usury . . .
is a cancer, Finance a disease."[205] Good sexuality and good economics (exem-
plified by the practices of Siena's Monte dei Paschi bank) need to be safe-
guarded against the depredations and perversions of interest that seeped in
through decadent Venice's fissures (orchestrated from 1619 on by its Giro
bank, which was the first public debt system of its kind, based on theoretical
money). Once rank financial practices take hold, the love of money rather
than people and sensual pleasures begins to fuel labor, until one finds the
mysteries in honor of Demeter and Persephone themselves populated by
"whores for Eleusis" (*Cantos* 45/230).

Canto 51, which echoes Canto 45's attack on usury somewhat monoto-
nously, opens on the opposition of divine light and mud staged by Guido
Guinicelli's Neoplatonic thirteenth-century *canzone*, "Al cor gentil rempaira
sempre amore": "Fere lo sol lo fango tutto 'l giorno: / vile reman, né 'l sol
perde calore" (The sun shines on the mud all day long: / [the mud] remains
vile yet the Sun loses no heat). In his syntactically and semantically literal
translation of the *canzone*, Pound accentuates the light that cuts through this

muck, then enforces another contrast with the entropy of a social landscape
subtended by usury:

> Shines
> in the mind of heaven God
> who made it
> more than the sun
> in our eye.
> Fifth element; mud; said Napoleon
> With usury has no man a good house
> made of stone, no paradise on his church wall
> With usury the stone cutter is kept from his stone
> > (51/250, echoing 34/166 and 45)

A lyric written decades back at San Trovaso had called upon the Venetian sun
to summon the speaker's soul "From out the far crevices."[206] The later Pound
cites the lament of Napoleon—Venice's first conqueror in more than a thou-
sand years—that mud was a hindrance potent enough to be included among
the canonical elements. The specter of usury ushers in further "bog-suck"
until the plutocratic empire sinks into its own "muck":

> Mistress of many tongues; merchant of chalcedony
> I am Geryon twin with usura,
> You who have lived in a stage set.
> A thousand were dead in his folds;
> in the eel-fishers basket
> time was of the League of Cambrai:

> (51/251–52)

Pound's introduction of the Confucian *cheng ming* "ideogram," which trans-
lates as "precise verbal definition" or "the rectification of names," means to
interject a visual-verbal corrective into the time of dead eels and Dante's
monster of Fraud, here made usury's twin. Hosting usurious exchange
between tongues and tribes, unmooring value, abandoning local production,
the Venetian Republic of these lines collapses into the decadence of theater

and Carnival, leading the best of its populace to regard the world as a "stage where every man must play a part."[207] Here Pound invokes the countermyth of Venice built up by its opponents in the 1508–10 League of Cambrai, and recurs to the trope of the city as stage.[208] Having surrendered to parasitical economies of finance and imperialism, the archipelago finds its natural abundance swamped: the fisherman's basket stores eels presumably absent or dead, calling up the epoch of the alliance that combated the inland expansion of a Venice desperate for new sources of wealth and fueled by mercenary forces. Linguistic exactitude must cut through these forces of putrescence.

But if totalitarian pluralism founders outside of verse, its composition likewise founders on the page. In 1945, Pound will be held in a U.S. military detention center near Pisa on charges of treason for some 120 pro-Fascist and anti-Semitic radio broadcasts he made between 1940 and 1943,[209] and find himself forced to memorialize the fall of Mussolini ("Ben and la Clara" [74/445]), strung up by the heels in Milan. Hence *The Cantos*'s ultimate confession, "I cannot make it cohere" or, in a later revision, "I cannot make it flow thru" (116/796–97). While the political experiment at large fails, its poetic collapse continues to oblige readers to participate, *inter lineas*, in a revision of Pound's monumental quest for synthesis. This quest's surreptitious logics course into and out of Pound's Venice, "to affirm the gold thread in the pattern" established by its Byzantine mosaics (116/817).

Venice always threatened to problematize any spiritualized, purified notion of the "tribe," for it is not difficult for authors to read into the place's very topography, as Simmel does, "a life without roots"; this place troubles the notion of a *patria*, or "fatherland," offering "our soul no home but only an adventure [or 'love affair']."[210] This rootlessness obliges us to reread the polemic of Simmel against Venice in a positive light: the sociologist criticizes the city's structure because it is not autochthonous and "does not obey the law of an overarching spiritual reality": "the parts may harmonize with one another and may be complete as the *whole* grows from a root which does not belong to it. And the more complete it is in itself, the more radical is the lie when inserted into the context of . . . a worldview . . . which it denies in its innermost being."[211] Cacciari locates potential in Simmel's analysis in a book-length treatise reflecting the philosophical movement of "weak thought," *Architecture and Nihilism* (1993). He presents the archipelago as an apotheosis of the metropolis's challenge to "give an order to the absence of synthesis": "Synthesis is no longer given among the dissonances. . . . Here every moment of familiarity, every appearance of *Gemeinschaft* [community] is a lie—as nothing has roots, nothing direction."[212] For Simmel and others in

the philosophical and sociological tradition Cacciari tracks, Venice stands as "an *unheimlich* braiding of streets and canals lacking direction, in the perennial flowing and reflowing of stagnant waters"[213]; in this perpetual flow it becomes "a symbol of the loss of the fatherland [*patria*]."[214]

Casillo reads the lack of borders in amphibious Venice as a negative feature of Pound's poetics, "where demarcations disappear and usury therefore inhabits."[215] But this topographical and social amphibiousness also embodies a potential for change. Though the poet of Fascist doxa may attempt to incorporate usurious Venice into a historiographical trajectory of decline, the place in fissured verse spurs more anarchic ramifications. Exceeding the rhetoric of instrumental reasoning, the Pisan Cantos ultimately address a shifting, interstitial state, one that alters as it heaves the subject along with it through time:

> as of less and more than a day
> by the soap-smooth stone posts where San Vio
> meets with il Canal Grande
> between Salviati and the house that was of Don Carlos
> shd/I chuck the lot into the tide-water?
> > le bozze " A Lume Spento "/
> > > and by the column of Todero
> shd/I shift to the other side
> > > or wait 24 hours,
>
> > free then, therein the difference
> > in the great ghetto, left standing
> with the new bridge of the Era where was the old eyesore
> > Vendramin, Contrarini, Fonda, Fondecho
> > > (*Cantos* 76/480)

From the aftermath of Pisa, the Accademia bridge built of wood in 1933 according to head Fascist modernist engineer Eugenio Miozzi's design—the "new bridge of the [Fascist] Era"—is recollected and cast back into a plural, more cosmopolitan form of marking time. Within the larger context of heterogeneity in "the great ghetto" of Venice that is "left standing," the Adriatic flux below the monumental modernist structure cannot be seized for the nation-state; it is no "*mare nostrum.*" After the fall of the Fascist "Era," Pound must patch together in memory the pieces of an archipelago that is itself a "great ghetto"—a word that in the original Venetian literally signifies

foundry. Through the invocation of proper names (embodying, as Rabaté notes, "an absolute difference, a designation that loses all 'sense'"),[216] we are reminded that this place comprises Roman, Jewish, Bourbon ("Don Carlos," Duke of Madrid), and Turkish ("Todero," San Teodoro) components alongside those of aristocratic Venetians and the modern visitors of the palazzi they left behind ("Vendramin"-Calergi, where Wagner died in 1883; "Contrarini," for the Palazzo Contarini Pound inhabited in 1939). Pound's own English, here as throughout, is archaizing and contemporary by turns, inflected and interrupted by his own vagrant Venetian/Italian blend ("Fonda," possibly from the Venetian word "Fondamenta" [indicating a quay along a canal]; "Fondecho," an errant transcription of "fontego," or the Venetian term for the warehouses and living quarters of the foreign merchant populations of Venice). The postlapsarian portrait flashing through Canto 76 places Pound's former "free" self squarely within the heart of the "foundry," the internal elsewhere, the "ghetto" at the core of both his "earthly paradise" and his monumental body of work.

In Pound's glimpses of Venice after the fall of Fascism, we witness a unique aggravation of the dissonance between his mature poetics and the politics of the "tribe." Venetian urbanism offers a model of social life made up of parts that are allocthonous: it is formed primarily from materials and persons originating from elsewhere. Itself the edited amalgamation of materials culled from remote sources—material facts that retain their own conflicted autonomy, framed by negative space—his epic perpetually in process reflects this state, undercutting its own subscription to a totalitarian "reclamation" of the condition of middleness, of difference.

THE RESIDUAL PRESENCE OF MODERNISM

Lines 9–35 of Ezra Pound's Canto 72, the first of the two cantos he composed in Italian, first appeared on January 15, 1945, under the heading "*Presenza: F.T. Marinetti*" in the *Marina Repubblicana*—a military journal printed in Venice and addressed to the navy of Mussolini's puppet Republic of Salò. The title echoes the Fascist call to order—"Presente!" ("present" or "here")—the word inscribed a thousand times around the Sacrarium of the Fascist Martyrs at the core of the 1932 *Mostra della Rivoluzione Fascista* in Rome. The task of recruiting citizens and Fascist martyrs into the present tense of the "Era" through poetry had been left to the Futurists' successors: the fragment and eventual completed canto

function as an elegy for Marinetti, who had passed away in Bellagio on December 4, 1944—four days before Mussolini's last public speech and call for a counterattack upon Allied forces.

In her commentary on these unabashedly Fascist poems, Mary de Rachewiltz avers that they were born of Pound's indignation at Marinetti's death and the bombing of the Tempio Malatestiano in Rimini. Though we would domesticate the poems too much in confining the author's motives purely to elegiac ones, the verse makes clear that these events compelled Pound to reexamine his orientation toward time. What becomes Canto 72 begins by pointing bitterly and heretically back out of historical time—"In the beginning" ("*Nel principio*")—and by shifting away from remembrance of "certain facts" that "will well up again" ("*Certi fatti risorgeranno*"; *Cantos* 72/425, 72/432). The poem next conjures the Futurist ghost, who asks to occupy Pound's body so that he can continue fighting in the ongoing war. Pound promises him a place in the *Cantos* instead, then bids,

> Lascia a me ch'io mi spieghi,
> > ch'io faccia il canto della guerra eterna
> Fra luce e fango.
> > Addio, Marinetti!

> & leave the talking to me.
> And let me explain,
> > sing of the eternal war
> > > between light and mud.
> Goodbye, Marinetti[217]

He imagines Marinetti's response as an amalgam of rebuttal and regret:

> Io cantai la guerra, tu hai voluta [sic] la pace,
> Orbi ambidue!
> > all'interno io mancai, tu all'odierno.

> I sang war, and you wanted peace.
> Both of us blind, me to the inner things
> > > you the things of today

Following colloquy in the mode of Ulysses and Dante with a series of phantasms, at Canto 72's close Pound is paralyzed as some force arrests him like a

nail in a wall. Hallucinating, he sees a fist grasp his wrist and hears the dead Futurist's foreboding "paternal" bid,

> "La voglia è antica, ma la mano è nuova.
> Bada! bada a me, prima ch'io torni
> Nella notte."

> "Dove il teschio canta
> Torneranno i fanti, torneranno le bandiere."

> "The will is old but the hand is new,
> Listen to me before I turn back into the night
> Where the skull sings:
> > The regiments and the banners will return."
> > > (*Cantos* 72/431, 437)

Composed in fits and starts of hendecasyllable lines and attempts at *terza rima*, the poet's rueful return to the underworld, and the brutal historical prophecy that it engenders, set into motion the bidirectional relation to time characteristic of Fascism. Fascist ideology draws both from the Futurists and from the antimodernist return to order of the 1920s—undoing, via oscillation, the "presence" that it seeks so ardently.[218]

In *Fascist Modernism*, Andrew Hewitt outlines the kinship between the historical logic of fascism and that of modernist experimentation, arguing that both promise and derealize a metaphysics of presence: "As the moment of full unfolding, the avant-garde, no less than fascism, could think itself as both the completion and the liquidation of historical sequentiality." The logic of historical plenitude promised by both movements is undone because a transcendental history liquidates the historical present: "The present becomes no more than one among many historical and stylistic possibilities, and thereby loses its determinant power."[219] Structurally, topographically, against the poet's "*voglia*" (or "will"), Pound's output will both presage and extend Hewitt's conclusions. Upon the fall of a Fascist utopia, against the rhetoric of total contemporaneity, the semi-remorseful prisoner at Pisa, recalling longingly the landscape where his first volume was published, admits that "things have ends and beginnings" (76/462). Recollected particulars of Venice cobble together a textual archipelago that renders the discontinuity of history palpable, thereby countering both the mock-Biblical "beginning" and the "eternal war" of a fallen Fascist song.

Pound's use of a poignantly non-Tuscan dialect in the Italian Cantos to index the time of Fascism's fall in the "giorni del Settembre Ventunesimo, / Nei ziorni

del crollo" ("days of the 21st of September, / in the days of the collapse"—
though these lines were later translated by the poet only as an abstracted "time
of the collapse" [72/425; 72/432])—lends a local specificity and vulnerability,
and thus a more complex species of historicity, to both this ambitious "Era"
and to the local cultures that were not wholly absorbed by it. The Italian
text's zetacism—from *giorni* and *giovanotto* to *ziorni* and *giovinotto*—bears an
uncanny, unhome-ly, resemblance to contemporary features of Venetian and
Ligurian dialects.[220] As Kenner notes of Cantos 72 and 73, Pound had "started
translating his 'poem including history' into the language of the people among
whom he lived," shirking a current literary Italian he regarded as incapable
of "handling grisly actualities."[221] Pound's self-reflexive declaration on the
matter in Canto 72 rubs against the Tuscan vernacular of Dante that became
standard for all under the Fascist Era, while accentuating the oddities of its
pronounced "H" sound in local spoken discourse: "mi viene ora a cantar' /
In gergo rozzo (non a (h)antar 'oscano)" (72/425) (roughly, "now it comes to
me to sing / In coarse dialect (not in Tus-(h)an)").[222] In Canto 73, he pushes
this hybrid language insistently through a *terza rima* inherited from Dante via
Cavalcanti (and published, stripped of obscuring philology, by Aldus). The
result of such mongrelization is disorienting.[223]

Constatation of this singular language, space, and time bring Pound closer
to an experience of a Venetian present, even if the city's own relation to its
past is a touch pathetic:

> and the Canal Grande has lasted at least until our time
> even if Florian's has been refurbished
> and shops in the Piazza kept up by
> artificial respiration
> and for La Figlia di Jorio they got out a
> special edition
> (entitled the Oedipus of the Lagunes)
> of caricatures of D'Annunzio
> (76/476)

If Venice cannot be a vital state in the present moment, *The Cantos* finally
proposes, it can at least be a vital state of mind produced by art; this formal
response, however abject, vexes both the selective obliteration of the past and
the restorative nostalgia of Fascism. Pound sculpts an epic that calls on us to
animate Venice's historical ruptures, or those competing versions of time that
are given material form in the city of lagoons. In the process, he reinfuses the
chronicles of the "tribe" with the confrontational residue of presence.

5. FABULOUS PLANNING
UNBUILT VENICES

E infatti: come tornare da una Venezia inesistente?

And in fact: how does one return from a Venice that does not exist?
—Manfredo Tafuri, *The Sphere and the Labyrinth*

Venice Versus Utopia

The novelist Italo Calvino opens his reflections on "Venice, Archetype and Utopia of the Aquatic City" (1968–74) by identifying Venice as "the first anti-Euclidean city"—where the shortest distance between two points is never a straight line. "The shortest line [*La linea più breve*] that unites two points is never a straight one, except in the abstract constructions of Euclid," Calvino claims, and this makes Venice "the model for the city that has the most future [*avvenire*] ahead of it."[1] Venice's resistance to abstract geometry makes the misalignment of intellectual projection in space with embodied experience in time tangible, enriching—and protracting—experience through its denial of disembodied will. The shortest, or "briefest," path between any two points in Venice varies, Calvino reasons, according to the mode of travel; the relativity of Venetian space makes for an urban context where superimposed pedestrian and vessel paths never converge, but generate innumerable permutations of transit. The amphibious city, which can be occupied aquatically, aerially, and terrestrially, offers up a multidimensional imaginary, where "space opens and closes before us in ever-changing configurations."[2] Calvino's planned Norton lectures of the mid-1980s clarify how such spatial diversity might lead to

more "future," logically speaking. His talk in praise of "Rapidità" (Quickness) complicates our sense of this literary value as it cites a 1958 reading of *The Life and Opinions of Tristram Shandy, Gentleman* by the Jewish writer and activist Carlo Levi, who had been sent into exile and imprisoned under Fascism, and who saw in the "labyrinth of duration" created by Sterne's digressions a "spell cast over clock time": "If a straight line is the shortest [*la più breve*] distance between two fated and inevitable points," writes Levi, "digressions will lengthen it; and if these digressions become so complex, so tangled and tortuous, so rapid as to hide their own tracks, who knows—perhaps death may not find us, perhaps time will lose its way."[3] The digressions that the anti-Euclidean city obliges us to follow dilate time, Calvino suggests; by dodging, they stave off the ending inherent in linear temporality.

The aquatic city presented in Calvino's essay embodies promise in infrastructural terms as well. From the midst of an oil crisis signaling the apparent end of an era of transport, Calvino points out that Venice—one of few cosmopolitan cities that resisted the brief eighty-year monopoly on transportation by automobile traffic—poses new possibilities for hovercraft transit and the cultivation of food from the waters instead of land.[4] He marks the increasing emergence of "Venetian" structures in plans for future metropolises as cities become "unlivable" (*invivibili*), while admitting that recruiting these structures to a dry environment would "amputate" from his model city its most profound "anthropological" satisfactions—presumably the result of our primordial attachment to the water.[5] On this basis, Calvino imagines a future "populated by innumerable Venices," or of what he calls "Supervenices, where complex networks of differing heights will be juxtaposed and linked." His utopianism erupts into a blend of pragmatism, soft Futurism à la Sant'Elia, and a touch of Orientalist primitivism, as he envisions horizontal planes of transport encompassing navigable canals with underground, elevated, and underwater railways; paths for bicycles, horses, camels, cable cars, and pedestrian drawbridges; and a vertical axis encouraging density: hanging gardens, elevators, cranes, helicopters, and floating ladders.[6]

The fact that Venice is an open system becomes a central tenet of Calvino's vision. For the sea links Venice and its inhabitants "not to a particular aquatic route but to all water routes, to the spreading waters that envelop the entire planet." Calvino proposes that this is why the principal door of a building for Venetians is the one that opens onto the canal, not the alley or square: like a radio or television antenna, the water entry of Venetian edifices forms a threshold onto an "invisible and unlimited" global dimension, rather than a conventional door frame through which one receives merely local data.[7]

This archetypal Venetian *palazzo* makes manifest Henri Lefebvre's 1974 conceptualization of the house as part of a network extending beyond its physical confines—emphasizing the permeation of domestic space "from every direction by streams of energy which run in and out of it by every imaginable route," and replacing the domicile's "image of immobility" with "a complex of mobilities, a nexus of in and out conduits."[8] In Venice, such a nexus is fully visible and audible at the *porta d'acqua*, or canal door.

As a literary and conceptual structure, Calvino's Venetian *oikos*, with its incalculable reach, resembles Henry James's "house of fiction," insofar as it is open at many points to chance or fortune: "there is fortunately no saying on what . . . the window may NOT open; 'fortunately' by reason, precisely, of this incalculability of range." However, the realist James argues that the "pierced aperture" of " 'literary form' " is "as nothing without the posted presence of the watcher."[9] His "watcher" grounds reflection inextricably in a sociohistorical situation—a fact that prevents him from turning a blind eye to the contaminations of modernizing infrastructure, economies, and values in Venice, and against which Calvino's willful utopianism (standing in contrast to the mordant postdiluvian visions of Lotti's contemporary *Venezia muore* and Visconti's *Morte a Venezia*) seems the more fanciful. Indeed it was, in a bitter historical irony, precisely during the period in which Calvino composed these utopian reflections, from 1961 to 1969, that a two-hundred-meter-wide, eighteen-meter-deep canal for oil tankers was plowed into the Venetian lagoon from the Lido inlet of Malamocco to the petro-chemical refineries at Marghera—thereby facilitating the global addiction to oil spurred by the automobile while opening the floodgates to ecological stresses brought to a focal point by the 1966 deluge. (It must be acknowledged that this development, while literally destabilizing the city's foundations, nevertheless stabilized the Venetian economy for a couple of decades.)

Calvino's analysis of Venice resonates compellingly with that of Lewis Mumford's 1938 *The Culture of Cities* and its 1961 amplification, *The City in History*—works invested with authority in Italy and France even among nonspecialists, and which Calvino was reading. Mumford presents Venice as structurally *resistant* to any form of utopia, if by "utopia" we mean any rationalist successor to the totalizing vision of sociopolitical perfection coined by Thomas More.[10] In "Venice Versus Utopia," Mumford proposes that Venice represents a vital alternative to the medieval fortress city and paves the way toward a possible, if neglected, future for metropolitan order. As a nuclear, open constellation, Venice constitutes "a new type of urban container, marked by the etherialization of the wall."[11] While Calvino presents Venice as "a living archetype looking toward utopia,"[12] Mumford, as urbanist, recruits the

long history of the city's development to his analysis, underscoring that the plan of Venice was never projected as an ideal, but instead grew out of the needs of forced immigration, war and conflict, piracy and trade, diversified industry, and decentralized yet paranoid governance over time. Mumford sets the human scale and structural flexibility of the archipelago against the civically decent, yet programmatic, regimented, four-square city of Amaurote at the heart of More's *Utopia* (published in 1516, just as the material fortunes of the Venetian Republic were turning). Venice's nonconformity with modern conceptions of synthesis such as are exemplified by Amaurote renders it a touchstone for critiques of monumental planning in the decades after World War II. In Lefebvre's classic 1974 account of *The Production of Space*, the city that "was not planned in advance," but "born of the sea, . . . gradually, and not . . . in an instant" emerges as an exemplary instance of the dialectic between the singularity of a "work" and pervasive forces of production; it is not the design of a finite sociohistorical order, because it evolved in response to continuous trials against nature and rivals and to the expanding needs of trade, in "a vaster space . . . of commercial exchange."[13]

Mumford nonetheless identifies Venice's cumulative internal innovations as models for modern urban planning: the organic development of cellular neighborhood units that prevented concentrations of wealth in any single quarter, and zoning for industry and circulation, with canals as "greenbelts" forming precinct borders. Planners did not recognize these essential features of Venetian topography as vital precepts to apply to other cities, Mumford argues, until five centuries later, with the 1928 Radburn Plan for American garden cities[14]; Venice's example was not adequately absorbed elsewhere because the city was regarded as an exception rather than the result of "a series of bold adaptations which, though based on singular natural features, had a universal application."[15] Ironically, as we will see, global appropriations of Venetian urbanism over the course of the twentieth century have tended to seize upon "Venice" as an escapist image of otherness rather than the outcome of organic adaptation over time.

The imaginary and material circulatory functions given form in Venice have proved an inspiration and a quandary to both modernist planners and their late-capitalist patrons and collaborators, to idealists and pragmatists. Their investment in Venice's penetrable, unruly morphology contradicts naïve futurist strategies to stop up the lagoon city's curves and fluidity with fortifying geometry, instead seeking a future in the multiple possibilities of transit enabled by a flooded matrix. In *Quand les cathédrales étaient blanches: Voyage au pays des timides* (When the Cathedrals Were White: Journey to the Country of Timid People; 1937), Le Corbusier argued that due to its

liquid foundations, Venice "represents the most formal machinery, the most exact functioning, the most incontrovertible truth—a city which in its unity, unique in the world, still is . . . a complete and integral image of the harmonised and hierarchic actions of a society."[16] He had famously championed in *Urbanisme* (Urbanism; 1924) and *La Ville radieuse* (Radiant City; 1935) what he perceived as Venice's harmonious division of natural and artificial circulation and "economy of urban installations," all organically "'shaped' by a lagoon," and respecting the dignity of human scale.[17] In a rare historicist strategy, Le Corbusier "call[ed] upon Venice as a witness" as he proposed a plan for Antwerp that separated pedestrian traffic from that of automobiles, and disentangled railroad and shipping routes from one another in disparate zones. In the conception of the modernist working in the mid-1930s according to manifesto-like aphorisms, plans enable the architect to master chance through reason: "Plans are the rational and poetic monument set up in the midst of contingencies."[18] But the harmonies of Venice arose out of no single "monument" of planning. As a planner grappling with history, Mumford recognizes that Venice's form and content are "the products of cumulative urban purposes, modified by circumstance, function, and time: organic products that no single human genius could produce in a few months over a drafting board."[19] They persist precisely because they do not reflect the monolithic vision of a single moment: "the plan of Venice was no static design, embodying the needs of a single generation, arbitrarily ruling out the possibilities of growth, re-adaptation, change: rather, here was continuity in change, and unity emerging from a complex order."[20]

Venice's structural resistance to any centralized, rationalist utopian vision renders the city a crucible for reimagining urbanism in the period following the world wars—at a historical remove from the fantasies of consolidation on the part of modernity's imperial capitals and the compromises of modernist artists and architects that buttressed them. As a polycentric complex, open to cultural flows and forced directly to confront drastic, largely uncontrollable changes in environmental conditions, Venice models the formal possibilities that come to herald a critical postmodern practice. Architects and authors alike return to antique Venice as an "archetype," "analogue," or "metaform" of the network, open to difference, as they stage a turn away from the designs of heroic modernist totality that never secured footing in the city of lagoons.

Calvino's "Venice: Archetype and Utopia" produces a counterintuitive analogy between the medieval cityscape and contemporary relational networks as they are described in Mumford's 1961 meditation on the "Invisible City" (appended to *The City in History* and eventually echoed in Calvino's title

for *Le città invisibili* [1972]). Calvino's characterization of Venice's thresholds onto invisible planetary networks gives oddly concrete form to a contemporary phenomenon that Mumford identifies as the "de-materialization, or etherialization, of existing institutions" and accompanying abstraction of relations. Mumford reflects that in the face of recent developments in physics, contemporary life "is not merely open on the surface, far beyond the visible horizon, but also open internally, penetrated by invisible rays and emanations, responding to stimuli and forces below the threshold of ordinary observation."[21] Because the original functions of the city have been transposed into or superceded by "forms capable of swift transportation, mechanical manifolding, electronic transmission, worldwide distribution," Mumford reasons that the metropolis no longer has a monopoly on circulation and exchange, but instead becomes a forum where juxtapositions in shared space and time serve to humanize the "vast impersonal network that now spreads around it."[22] Calvino's Venice allegorizes these global and localizing phenomena. His characterization of Venetian urbanism suggests somewhat paradoxically that in a city of etherealized walls, such etherealized relations manifest themselves in sensuous material form. The archipelago's manifestation of otherwise invisible networks will make Venice a seductive locus for meditations by postmodern novelists and theorists on the newly labyrinthine circuitry of social relations, as we shall see.

Calvino's vision of the Venetian cityscape is compelling for the way that it translates postwar reassessments of modern urbanism back into the graspable matter of a medieval archetype. But Venetian topography harbors additional implications for a writer: Calvino goes on to argue that Venice's heterogeneous morphology literalizes the recombinatory potentialities and voids of language. He remarks that while the Venetian dialect's lexicon for streets is of an unparalleled richness, the local vocabulary does not "rationalize" the variety of forms in which "the lagoon labyrinth is introduced"[23] by coining terms for waterways. He deduces from this lexical lacuna that water unifies the city, whereas Venice's rising and descending walkways and bridges "introduce the discontinuous element which is exactly that of language."[24] The waters come to signify the invisible, the ineffable, the unknowable matter that unites the cosmos, while the human constructions for traversing these gulfs emblematize the discontinuity of human attempts to rationalize experience through language: the varieties and divagations of signification.

While Calvino's treatment of Venice as an allegory for contemporary energy and information networks may seem more compensatory than convincing, his linguistic analogy resonates with a long tradition of engagement:

we have seen the city's transnational reach and interruptive syntax prompt countless and multichanneled explorations of the horizons of language and of narrative for post-Romantic and modernist authors. Venice remained a seemingly anomalous point of reference in the postwar period, despite the collapse of Fascist visions of a revivified Italian Adriatic axis. In fact, Venice's apparent and lasting symbolic remoteness from the Fascist center of Rome would have made it possible to flush uncomfortable political associations more easily, and to seize upon the historical center that had largely confined the architecture of Fascist modernism (led by Eugenio Miozzi) to its industrial Western edge as an "open" conceptual system. In the eyes of intellectuals of this period, modular, liquid Venice represented an irresistibly material model for recombinatory processes of poeisis, both urban and textual.

At the time of these writings by Calvino and Mumford, the notion of the open work was circulating, with certain footholds in Venice. In 1957, Venice became the site of what Guy Debord identified as "the first psychogeographical work applied to urbanism"; the English Situationist artist Ralph Rumney chose Venice for this pioneering but never-published project, because of the potential for instructive contrast in opening up the city's reified sentimental ambiance.[25] (Debord later filmed the Dogana Point in his last cinematic work, *In girum imus nocte et consumimur igni* [1978], representing the journey beyond this promontory and its customs house, designed for geopolitical conditions now overcome, as a metaphor for an age being left behind apocalyptically in favor of unknown waters and perspectives: "one traverses an era as one passes the Dogana promontory. . . . [Y]ou discover it as you come abreast of it, and you cannot fail to recognize that it was designed to be seen in this particular way and no other. But already we are passing the cape, and leaving it behind us, and heading into unknown waters.")[26] Meanwhile, Umberto Eco was developing his concept of *L'opera aperta* (The Open Work), inspired both by the theorization of space in architecture by the U.S.-educated, Venice-based historian Bruno Zevi, and by the new music coursing through Italy through the work of Venetian composers Luigi Nono and Bruno Maderna (as well as others with literary ties, such as Luciano Berio). Eco delivered his lecture "The Open Work" at the 12th International Philosophy Conference in Venice in 1958, shortly before John Cage performed "Sounds of Venice" on a *Radiotelevisione Italiana* quiz show.[27] In Calvino's dexterous handling, which builds on this burgeoning discourse, the first anti-Euclidean city becomes the structuring device for a new type of narrative, come to fruition in *Le città invisibili* (Invisible Cities; 1972): "a many-faceted structure in which each brief text is close to the others in a series that does not

imply logical sequences or a hierarchy, but a network in which one can follow multiple routes and draw multiple, ramified conclusions."[28]

Calvino's manifesto surrounding Venetian futurity, leading to his "invisibly" Venetian meditations, moves our steering questions surrounding place and space, passéism and futurism, obsolescence and presencing into the postwar moment. It captures discursively the contentious endurance of a city whose historical center deflected the visual and circulatory rationalization that Haussmann's Paris had defined as modern. Beyond its quotidian life as a conflicted "museum-city" attempting to make amends with industry, Venice endures through an "afterlife" that unfolds, in large part, in the representational realm, where the city serves as the host of conceptual architecture. In tracking modernism in Venice and Venetian modernity as two sides of a split project, we have seen how several phases of post-Romantic materialism routed through Venice trounced fantasies that the past could be appropriated for current purposes without "violence of accommodation."[29] In the postwar period, fantasies of Venice's potential appropriation as a revived nexus of political power have dissolved, and the city begins to be severely depopulated, with particular ferocity after the devastating 1966 flood; it is to be occupied increasingly by quickening flows of outsiders. As Northern Italy begins to emerge as an increasingly industrialized, consumerist, late-capitalist society, Venice becomes notoriously hostile to inhabitation by working Venetians— and at the same time, vulnerable to both environmental damage and global traffic that the fragile lagoon environment cannot accommodate. Calvino's quixotic vision of innumerable future Venices signals, however, its lasting intellectual lure: its tenacious resistance to rationalist modern design renders it an oppositional paradigm for authors, historiographers, theorists, and urbanists. The city becomes a crucible for retrospection on the failed project of modernity and for visionary critiques of modernism.

For both practitioners and theorists, Venice's apparently autonomous historical center represented an alternative to the formal designs of modernist planning. Because lagunar Venice remained hostile both to the "internal colonialism" of Fascism under Mussolini as *Dux* and to the unchecked private development licensed by the "economic miracle" of postwar Italy—criticized by Calvino as "the jungle of the building trade" that "makes Italy a monstrous country"[30]—the city could become a forum for international reassessments of urbanism. Such discussions were cultivated at the Architectural Institute of Venice (IUAV) and through the architecture biennials—beginning with shows curated by Vittorio Gregotti for the Biennale d'Arte in 1975, 1976, and 1978 devoted to the fate of the abandoned Stucky Mill, the 1907 Werkbund,

and *Utopia and the Crisis of Anti-Nature*, which featured visionary projects from the likes of John Hejduk, Superstudio, and Archizoom. As we have seen, Portoghesi's inaugural independent architecture exhibition of 1980 introduced postmodernism to a mass audience as it transformed the Arsenal's ropemaking works into a *Strada Novissima* of façade-fantasies designed by leading architects from around the world, including Rem Koolhaas, Michael Graves, and Arata Isozaki (see figure I.5). The twenty faux facades were fabricated in plywood and plaster by Cinecittà studios, though constructed to actual scale. Their pastiches of disparately styled and mock-spoliated columns, masonry types, and entrance thresholds proposed a wistful reawakening of the "street" as a rebuke to the heroic modernist enterprise, generating heated debate across Europe and the Atlantic.[31]

The clash of conceptual Venices with the immediate need for systemic "salvage" of the imperiled historical center generated intellectual debates in which late-capitalist and postmodern logics characterized by space-time compression and vagrant signifying practices could be shaped and challenged— though capitalist developers abroad would nevertheless continue to devise acritical "Venices" from New York to Los Angeles, then from Las Vegas to Macao. These debates ensure the city a lasting relevance in the postmodern moment as a forum for rethinking urban design against modernist models of synthesis and postmodernist pastiche, as writers rechart the byways of historiography and narrative itself.

"Anguishes of Heroic Modernism" in Venice

Local governance and economic interests in Venice continue to oscillate in the period after World War II between civic imperatives to modernize and to preserve the city's cultural heritage. Clashing mandates for the city's future seem to dictate that Venice either arrest its past for tourists or secure space and prospects for long-term residents, though more inventive solutions recognize the necessity to rethink such binarisms. This struggle, fundamental for any historical city, is reflected in civic decisions wrought within what James called the "vast museum"[32] of Venice as perhaps nowhere else in Europe, due to the extenuating and expensive circumstances of its "extraterritoriality." The 1966 flood is regarded as a key episode in a continuing trend of drastic depopulation—the material determination of Venice's legendary morbidity. Between 1966 and 2006, a population of 120,000 was halved, leaving the ratio of tourists to residents at two hundred to one, with 25 percent of the remaining inhabitants over 64 years of age. In 1995, about

14 percent of the dwellings in the city center were unoccupied; authorities currently estimate that 70 percent of the city's private rental housing is occupied by nonresidents. Housing and transportation crises have escalated in tandem with the rising numbers of tourists that disembark annually, provoking swells of one-day sightseers, or *pendolari* ("commuter" tourists), raising prices, provoking the establishment of trinket shops and hotels in the place of basic services for citizens such as bakeries and daycare facilities, and leading the vast majority of the city's laborers to emigrate from the historical center to the mainland zone of Mestre, while offices and plans for fancy commercial towers like Pierre Cardin's "Palais Lumière" attempt to take up residence in the postindustrial zones of Marghera.[33] The recent decision to convert the Giudecca's gigantic Stucky Mill, left to dereliction from 1955 forward and featured in Gregotti's crucial 1976 exhibit, into a Hilton Hotel instead of affordable housing as had been debated epitomizes this trend; the hotel's 2007 opening marks the permanent alteration of the economic balance of a former working-class zone.[34]

Lagunar Venice in the postwar era emerges as increasingly disinhabited and embalmed on the one hand, and endangered on the other, by civic catering to the tourism and petrochemical industries. Over the past decade, it has accommodated increasing numbers of cruise lines whose ships are dragged through the Giudecca Canal to park at the western edge of the historical center, thereby jeopardizing the city's delicate foundations of wood piles. The number of tourists visiting Venice on cruises rose from less than 100,000 in 1999 to 1.6 million in 2010; actions by Venetians to occupy the canal and to encircle cruise ships with small boats in 2012 and 2013 resulted in swift police suppression. The colossal floating cities dwarf their urban environs, while oil tankers cruise slightly farther off through channels dug to a depth more than ten times the lagoon's natural average. These dual features of Venetian modernity, whose consequences are laid bare by increasingly catastrophic *acque alte*, make the city an exemplum of the need for delicate negotiation with natural and cultural influx. As such, Venice *demands* the application of the latest megastructural thinking surrounding urbanism and ecology; and it has figured in recent reconceptualizations of the boundary between nature and culture as an example of a site where "the continuity between human imaginings and material processes of world formation is made manifest."[35]

After the 1966 flood, the Consorzio Venezia Nuova ("New Venice Consortium") was formed, linking twenty-four Italian and European engineering and construction firms in an effort to "save" Venice from flooding. In one of the most controversial schemes in the city's complex engineering history, the consortium proposed to erect mobile dikes in the form of pontoons that would

block the highest tides where the Adriatic Sea enters the lagoon: at openings between the barrier islands at the Lido, Malamocco, and Chioggia. Silvio Berlusconi laid the symbolic cornerstone in 2003 for this tenure-defining project sponsored by the Forza Italia party and known by an acronym at once Biblical and banal: Mo.S.E. (Modulo Sperimentale Elettromeccanico, or Experimental Electromechanical Module). Underway in fits and starts for two decades, the largest public-works project occurring in Europe is slated for completion in 2016. Sponsored by the powerful Venetian Ministry of the Waterways, the consortium supervises an extensive global publicity campaign that produces documentary films and reports and, since 1989, a series of limited-edition books on Venice commissioned annually. The book series, inaugurated with Joseph Brodsky's magisterial *Fondamenta degli Incurabili* (later published in English as *Watermark*), has since included a bilingual edition of Derek Walcott's *Tiepolo's Hound*, Venetian writings by Sergio Bettini, and a volume about the myriad "Venices" that have cropped up globally.[36] Regardless of these efforts, "NO MOSE" campaigns persisted at length; the project continues to inspire opposition for its expense (roughly five billion euros) and its myopia, as well as a major corruption scandal that led to the arrest and resignation of Mayor Giorgio Orsoni in 2014. Critics charge that salt water will quickly corrode the hinged gates of steel, while others cite the project's failure to comply with European Union standards regarding the protection of nature by disturbing a rare wetland zone—one that hosts crucial migrations of fish between salt water and fresh water and the largest population of water birds in Italy.[37] Environmentalists claim that the damming of the lagoon will prevent natural flushing, creating a stagnant body of water. Margaret Doody represents the sentiment of local opposition eloquently, pointing out that "[t]he truly Venetian engineering is a way of living *with* the water, which flows through this cloven city." She echoes an age-old distinction between Venice and classical Rome in her judgment that the project constitutes "a truly and hideously 'Roman' idea. It is Palladianism rushing into the sea."[38] Mo.S.E. assumes that systemic imbalance and global climate change can be corrected by design. Against such top-down "modernist" design solutions, other thinkers propose returning to an organic solution via "soft architecture," or a more attenuated infrastructure. A 2010 project for New York City's Palisade Bay by Guy Nordenson, Catherine Seavitt, and Adam Yarinsky took Venice as a corrective model of urbanism that treats the sea not as negative space, but as a vital part of the city. The project addresses the urgent threat of rising waters to New York City by reintroducing wetlands off the shores of Staten Island, citing the Venetian mudflats that once functioned to attenuate and disperse incoming tides.[39]

Reflections on the *acque alte* produced in the immediate aftermath of the 1966 flood reveal a dystopian view at odds with this millennialist optimism, however. Architect Yona Friedman's 1969 design for a "City on Stilts" proposed to rebuild Venice as a series of viewing platforms suspended over the lagoon from which the living could watch the surpassed historical center sink, dramatizing the general lure of watching the obsolescent city decay over time with equal doses of marvel and dread. (Friedman nonetheless focused on saving the Venetians themselves, in a swerve from the dominant frenzy surrounding Venice's endangered artifacts.) Superstudio's more bitterly ludic response to the flooding of Florence and Venice was to propose the development of a resort town based on aquatic amusement at the site of the inland city, while paving the whole of Venice with concrete and glass tiles to stave off the damage of its signature waves and enable transit by automobiles (figure 5.1). Superstudio's satirically dry Venice would free up space for an "extremely modern underground city . . . protected from atmospheric variability," reattracting residents by subtracting Venice ironically from its unique context— from "the distinctive problems which water poses regarding communications and rapidity in moving from one spot to another, fundamental factors in

FIGURE 5.1. Superstudio, *Salvataggio di Centri Storici Italiani* (Rescuing of Italian Historic Centers), collage, 1970. Fondazione MAXXI–Museo Nazionale delle Arti del XXI Secolo, Rome.
Courtesy of Fondazione MAXXI/Ministero per i Beni e le Attività Culturali, Rome.

modern living."[40] Meanwhile, their "salvaged" Venice would satisfy nostalgic longings for the vanquished city of lagoons by resurrecting the specter of traditional transport: motor vehicles in the shape of gondolas would be driven by gondoliers via remote-control functions embedded in their oars.

It is a commonplace that in the face of its "distinctive problems," Venice's operative city fabric has been subject to ossification on fronts both social and cultural. The clairvoyant blind woman in Nicholas Roeg's 1974 filmic adaptation of the Daphne du Maurier story "Don't Look Now"—whose protagonist Roeg transforms into a conservator on assignment for the Venice in Peril foundation—relates her sister's distaste for the city: "[I]t's like a city in aspic left over from a dinner party and all the guests are dead and gone."[41] That is not entirely true, as guests continue to arrive in the millions, becoming the new hosts in the process. These visitors are attracted not only by the treasures of epochs surpassed, but increasingly by exhibits of modern and contemporary art. Since 1947, when Peggy Guggenheim settled definitively in the Palazzo Venier dei Leoni, bringing her collection with her, Venice has drawn crowds of cosmopolitan spectators, collectors, speculators, and artists invested in modernism and its wake.[42] The Biennale became less provincial and increasingly hospitable to experimental practices beginning the following year, when the Guggenheim collection was displayed alongside the works of avant-garde European schools suppressed under Nazism and Fascism. Under the ownership of Fiat, Palazzo Grassi became another important site at midcentury for exhibits featuring the Fronte Nuovo delle Arti, the Spatialists, and the Group of 8, with innovative exhibition designs by Carlo Scarpa. Recent years have seen a resurgence, not a dampening, of such initiatives. In 2006, the French billionaire Francois Pinault purchased Palazzo Grassi as a home for his collection of contemporary art, commissioning Tadao Ando to remodel the interior. In 2009, the Pinault collection was expanded through a satellite museum housed in an even more celebrated historic site reconstructed by Ando: the Punta della Dogana. Another intimate gallery devoted to the work of the late Venetian painter/sculptor Emilio Vedova, and featuring an innovative "floating" mobile display of paintings designed by Renzo Piano, opened in 2009 at the site of Vedova's studio in the Magazzini del Sale. Meanwhile, editions of the Biennale in music (since 1930), theater (1934), and dance (1999) have joined those dedicated to the visual arts, film, and architecture to place Venice on the agenda of those with a stake in the contemporary culture industry, reanimating historic palaces and churches while ensuring a steady stream of tourism revenue.

A common polemic "Against Venice" running from Marinetti through Régis Debray (in 1995) through Garry Marvin and Robert Davis (in 2005)

insists that the city is dead, reduced to a museum.[43] As much as one may sympathize with this charge, it dismisses the potential for renewed vitality through increased support for and access to culture, threatening at times to fall in line with the nineteenth-century critique of the railway bridge that opened Venice to middle-class tourists. Mumford offers an eloquent counterargument for the reciprocity between the museum and the metropolis, noting that one of the historical city's principal functions is to serve as a "collection of cultural specimens": "Every variety of human function, every experiment in human association, every technological process, every mode of architecture and planning, can be found somewhere within its crowded area. That immensity, that retentiveness, is one of the greatest values of the big city . . . its capacity for making available layer upon layer of human history and biography."[44] Beyond its archival function, the museum as form can spur dialogue between real and imaginative spaces, accommodating innovation in design more easily than functionalist sites. The Venetian architect Carlo Scarpa subverts critiques of Venice as a "dead," institutionalized "museum city" through his experimental restructuring of just these sites—museums, university spaces, and cemeteries—by making revolutionary use of Venetian material fragments and dynamics such as natural flooding.

The architectural domain has seen a more conflicted history than that of portable artworks in postwar Venice. Over the course of the 1950s and 1960s, the city council neglected, out of conservatism or timidity, to approve the building of architectural projects by the world's leading architects—even projects by local hero and "*magister venetiantatis*" Scarpa. These frustrations go hand in hand, however, with Venice's conceptual generativity in contemporary architectural theory. As we shall see in this chapter and the next, a significant part of Venetian "development" over the second half of the twentieth century consists in the city's translations abroad and in its unbuilt projects—in "*Le Venezie possibili*" ("potential Venices"), as an exhibit for the 1985 Architecture Biennial put it.[45]

In 1953, Frank Lloyd Wright submitted his design for a *palazzina* on the Grand Canal that would originally have been a home for his collaborator, the young architect Angelo Masieri. Masieri was killed in an automobile accident during a journey to the United States to discuss the project with Wright, and his wife recommissioned the project as a memorial that would provide housing and studios for the students of IUAV. Wright envisioned a building with balconies cantilevered over the canal, and incorporated slender marble shafts affixed to concrete piles in the silt that, as the architect explained, "rise from the water as do reeds." Perhaps anticipating the conservatism of city officials, Wright called the project "Venetian as Venetian can be," specifying that it

represented "[n]ot imitation but interpretation of Venice."[46] However, he
exhibited the plans in New York City before receiving approval. The ensuing
two-year controversy received attention in the international press. The proj-
ect was praised by local architects and intellectuals such as Giuseppe Samonà
and Sergio Bettini, who called it the best design to have reached Venice for
a hundred years, and emphasized its embodiment of Wright's understanding
that in nonclassical Venice, "[s]pace is not felt as a closed form, but as a *con-
tinuum* which proceeds through time."[47] Other prominent voices were less
sympathetic: Duilio Torres, a Venetian architect who had worked on the Lido
and for the Società Adriatica di Elettricità (S.A.D.E.), attacked the design as
derivative of Wright's Emil Bach house, while respected American expatriates
Bernard Berenson and Ernest Hemingway excoriated the plan for being out
of step with its projected environs. After substantial delay, and amidst heated
public debate, the city council rejected the project, recurring safely to build-
ing and civil codes rather than to aesthetic judgment in its argumentation.[48]

The influential Venetian scholar, critic, and director of the Querini Stam-
palia Foundation, Giuseppe Mazzariol, advocated for two additional projects
destined to become paradigmatic examples of Venice's rejection of mod-
ern architecture. He was behind the mayoral commission of Le Corbusier's
iconic master plan for a new hospital at the slaughterhouses of San Giobbe
(a neglected industrial edge of Cannaregio) in 1964. Le Corbusier's project
imposed a stark grid reminiscent of Mondrian upon the archipelago's curves,
embodying the architect's early definition of the plan as "the rational and
poetic monument set up in the midst of contingencies." The "mat" building
plan, encapsulating six decades of his fascination with Venice, adopted the
morphology of Venetian *calli* and *campielli* to extend the social experience
of the city to the site of healing (figure 5.2); from canal level, the complex
revealed a porosity distinguishing it from tabula rasa schemes by this modern-
ist and others. Though Le Corbusier aspired to incorporate the "cardiac sys-
tem" of Venetian pedestrian and water networks into his modular design, his
Euclidean geometry nevertheless stood in stark contrast to the archipelago's
irregular topography. His design also included elements alien to Venice, such
as vehicular access from the Santa Lucia Station (incongruously, as he had pre-
viously upheld the city's traditional isolation by water and rejected the intro-
duction of industry to the lagoon).[49] The hospital plan was deemed irrelevant
to its context and fell definitively to the wayside by 1971, but it still remains
a fulcrum of architectural discourse. Its attempt to operate on the wounded
city was later eulogized by Peter Eisenman as "one of the last anguishes of
heroic modernism," symbolizing "modernism's remedial ideology"—as if a

FIGURE 5.2. Le Corbusier, *Model for Venice Hospital*, 1964. Fondation Le Corbusier. Courtesy of Fondation Le Corbusier. © 2012 Artists Rights Society (ARS), New York/ ADAGP, Paris/F.L.C.

modernist hospital could heal the city whose liquid vulnerability led to so many meditations on illness and death in the earlier half of the century.[50]

Louis Kahn's conference hall for the gardens of Castello and Biennale grounds in 1968 met a similar fate.[51] Kahn's suspension structure in reinforced concrete, surmounted by three domes of lead echoing those of the Basilica of San Marco, was relocated to the Arsenal when the site was deemed too sensitive; it would have straddled a canal like a bridge and offered panoramic views of the city from the roof. The funding for this project never materialized. One of Mazzariol's few successful ventures in advocating for new architecture was his overseeing of a project commissioned by his predecessor: Scarpa's pathbreaking renovation of the interior, entrance, and garden for the Querini Stampalia Foundation in Venice, where penetrable architecture and sculpted channels permit the continual expression of *tempo*, both atmospheric and chronological, through the weathering action of water.[52]

Yet the unbuilt plans for Venice continue to inspire creative interpretation (with a critical edge) to this day. An exhibit sponsored by Venice in Peril for the 2011 Biennale included a series of photographs by Dionisio González, *The Light Hours* (figure 5.3), which reconstructed the projects of Le Corbusier, Kahn, and Wright and imagined further interventions: a revision of Ignazio

FIGURE 5.3/PLATE L. Dionisio González, *Venice Hospital, Le Corbusier, 1965* (top), and *Venice Without Le Corbusier, 2011* (bottom), from *The Light Hours*, C-Print/Diasec photographs, 2011. Exhibited in the *Real Venice* exhibit at the 2011 Venice Biennale, sponsored by the London-based Venice in Peril Fund.
© Dionisio González. Reproduced by permission of the artist.

Gardella's weak, conformist architecture built along the Zattere, and a viewing platform based on Palladio's *Four Books on Architecture* (published in Venice in 1570). González's foreword outlines the sequence's aspiration to express "the spirit of redress, of restitution," forming "a cautionary tale about a city that looks in multiple directions but on which a global responsibility falls, not just for its singularity and cultural wealth, but for having become a symbol."[53]

Many would argue that Venice has shirked this symbolic responsibility, as perhaps the most notorious decisions of the Venetian Council involve those legislating Venice's architectural self-replication. After the Teatro La Fenice was destroyed by fire in 1996, the design competition for its rebuilding was dominated by intentions to restore the edifice virtually "as it was, where it was," perpetuating the tendency established ninety years earlier to rebuild the Campanile *com'era, dov'era*—even as underimagined and intrusive hotel extensions were allowed to break ground throughout the city. (Ironically, reconstruction relied on gaslit scenes from Visconti's 1954 film *Senso*—the only accurate record of how the opera house interior actually looked.) The resurrected Fenice theater is cited routinely as a symptom of a morbid Venetian tendency to live the need for rebuilding as tragedy—as "a devastating loss of collective memory, an unfillable void in the city"—rather than an opportunity to create new spatial contexts within the historic frame.[54] Aldo Rossi contributed the only new element to be added: a hall designed in 1997, using a fragment of a Palladian basilica as a ludic source; given the chance to build a permanent new structure here, the architect created a historical

pastiche and cited Henry James on Venice with irony, giving voice to the exhaustion of expression: "There is notoriously nothing more to be said on the subject."[55]

Given these resistances, it registers as apt that an account of architecture understood in the canon of contemporary theory to pronounce the impasse of planning—and hence an entire strain of thinking about architecture after modernism—would emerge from a writer stationed in Venice. The monograph that defined an epochal disillusionment with the salutary aspirations of modernism was Manfredo Tafuri's *Progetto e utopia: Architettura e sviluppo capitalistico* (1973), based on an essay first published in 1969, and translated somewhat imperfectly as *Architecture and Utopia: Design and Capitalist Development* (since "*progetto*" properly means project, plan, design).[56] In his seminal analysis of *Postmodernism, or the Cultural Logic of Late Capitalism*, Frederic Jameson singles Tafuri out as "the most implacably negative" of theorists who repudiate modernism—who rebukes both modernist formalism, with its substitution of cultural for political revolution, *and* modernist work that seeks to demystify and refute modernity. In Tafuri's account, both forms of modernist subversion, aesthetic and critical/political, eventually lead to the instrumentalization of modernist utopianism by capitalist development, manifesting itself ultimately as "form without utopia."[57] For Tafuri, that is, architecture as a discipline in this period becomes no more than "an ideological climate for fully integrating design . . . into a comprehensive Project [or "Plan"] aimed at the reorganization of production, distribution and consumption within the capitalist city."[58] That Venice resists the administration of any utopian scheme insensitive to its delicate historical and environmental context renders it a fitting perch for lucid disenchantment with modern urbanism. The suspicion of any totality aloof from physical and social context that shapes the postmodern attitude subtends Venice's very foundations, without accommodating the ludic ripostes of postmodern practice in any stable form. Venetian *tempos* ebb and flow at odds with both nostalgia and positivism—but also with the annulment of space and time that results from the random, unthinkingly cannibalistic historicism of pastiche.

In 1978, as part of an international design seminar for new housing in historic centers sponsored by the city of Venice and the IUAV, Peter Eisenman designed a conceptual project for Cannaregio West (figure 5.4) that forms an objective correlative to Tafuri's devastating critique of planning—and shows how unbuilt Venice could become the matrix for rejecting the nostalgia that the architect saw in both modernism and the postmodernism of contemporaries

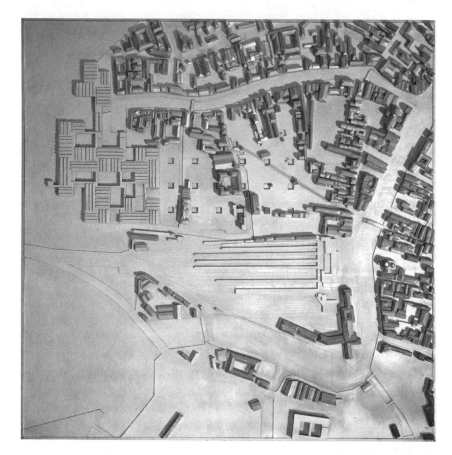

FIGURE 5.4/PLATE M. Peter Eisenman, *Presentation model including Cannaregio West and Le Corbusier's Venice Hospital*, gold and pink paint over wood and cardboard, commissioned ca. 1978. Showing the railway station of Santa Lucia, Le Corbusier's unbuilt hospital project, and a projected conceptual plaza designed by Eisenman. Canadian Center for Architecture, Montreal.
© Peter Eisenman Fonds, Collection Centre Canadien d'Architecture/Canadian Center for Architecture, Montreal.

such as Venturi and Scott-Brown. The design recreates Le Corbusier's hospital as if it had actually been built, while subverting the modernist's Euclidean geometry through "topological" deformation: Eisenman transmutes the hospital's wistfully salutary grid into a series of eighteen square holes in the urban fabric meant, as his accompanying "Three Texts for Venice" specify, to "embody the emptiness of rationality" and of modernism's nostalgia for the future.[59] At the same time, Eisenman interrogates the nostalgia for the present nourished

by superficially derived "contextual" architecture through an echoic series of aberrant, ambiguously scaled pink structures—L-shaped houses, museums, or mausoleums—installed sporadically over the open postindustrial expanse of the slaughterhouse site. Eisenman's project, finally, deflects postmodernism's facile appropriation of history, imprinting what he claims to be an incommensurable archaeology into the site. A diagonal cut in the ground at odds with the hospital grid—its "skin" peeled conceptually back—recalls that wounds such as those inflicted by modern urbanization "cannot forever be suppressed by or submerged under the rationality of an axis" (48)—nor glossed over by a surface historicism. Eisenman's terminology suggests a transverse scarring of public space that denies, while eulogizing, the would-be utopia of healing embodied by the unbuilt modernist hospital. Eisenman's project simultaneously scrambles "the longing for an undefiled, immaculate and stable present" that Jürgen Habermas identified in modernism's relationship to temporality (and which he saw violated by the sort of historicism taking root in the celebratory exhibitions of postmodernism at the 1980 Architecture Biennial).[60] Needless to say, Eisenman's implacably negative project housed no one. One apprehends in the model a kind of assassination of architecture—such as that of Aldo Rossi's famous drawing, dedicated to Tafuri, which now appears on the cover of *Architecture and Utopia*.

In abstracting the apparent nihilism of *Progetto e utopia* from Tafuri's rich histories of architecture's contestations and negotiations with development, presenting the book as a death sentence for the vocation, Jameson and others who focus on this work in isolation shed its polemic of crucial context— especially in light of Tafuri's assertion that "[t]here is no such thing as criticism, there is only history."[61] As Tafuri himself points out in the preface, *Progetto e utopia* cannot be taken as a renunciation of architecture if read in light of his *Theories and History of Architecture* (1968), a materialist account that would define his future 28 years of work at the IUAV.[62] *Theories and History* traces the critical analysis of rational space achieved through architectures that infiltrate the revival of classicism in Rome, Florence, and (especially) Venice from the fifteenth century forward. He presents these periodic "perversions" of the classicism that becomes associated with the modern as the eruption of ghostly things, of *bricolage*—in short, of history—against the unities of rational measure and *concordia discors*. Tafuri sees this trend reemerging in the nineteenth-century eclecticism advocated by Ruskin and in the antihistoricism of Art Nouveau, Futurism, and the avant-garde movements that followed. Mapping these implosions, Tafuri as architect-turned-historian highlights architectural ruptures of the stultifying totality that he

would diagnose in *Progetto e utopia* in the more flexible form of late-capitalist administration—and simultaneously locates a space for political intervention in the work of criticism.

Such intervention took root in the ensuing decades of collaboration and debate at the IUAV and neighboring universities, undertaken by a group of luminaries working across architectural history, theory, and practice: a heterogeneous community of intellectuals that came to constitute the fore-most laboratory for critical architectural thinking in Italy, now known as the "School of Venice" (though in reality it lacked the unifying program of a "school"). Economic crisis and the consequent paralysis of building set-ting in amidst the cultural and political upheaval of the late 1960s and 1970s prompted an explosion of conceptual activity in the emerging discipline of urbanism. Against this backdrop, a Venice inhabited by pathbreaking writers and practitioners became, in its apparent fragility and paralysis, a crucible of discourse. The School of Venice set out to revisit the history of modernity and the ideology of the historical avant-garde from the point of view of the pres-ent, while concomitantly rethinking the current impasse of building through historical research—inspired, as I will show, by their immediate environs (and corresponding literary record).

The IUAV was founded after an extended period of gestation in the cul-turally effervescent 1920s, with the help of a major bank, the S.A.D.E. elec-trical association, and a group of local industrials that included Giuseppe Volpi; it was the second Italian institution devoted to architecture after that of Rome. Its financial autonomy and lack of a tie to any polytechnical school eventually became the IUAV's strength rather than a shortcoming, freeing its curriculum from the disciplinary limits and fiscal domination of engineering and science faculties. Under the direction of Giuseppe Samonà from 1945 to 1970, it emerged as a nucleus of radical (and mark-edly leftist) thought surrounding the burgeoning fields of urbanism and industrial design within a relatively conservative region. Samonà recruited theorist/practitioners from Venice, Rome, and Milan who would not have found a position in a traditional Italian academic setting: leading figures in architectural discourse born in the 1930s—Aldo Rossi, Vittorio Gregotti, and historians and champions of "aggregative" vernacular architecture Bruno Zevi and Egle Tincanato; Tafuri, who eventually became chair of the IUAV's Historical Institute; and Scarpa, the maverick architect and designer.[63] These and subsequent faculty members, including Francesco Dal Co, Marco De Michelis, and Massimo Cacciari, recast international

discussions surrounding the critical and historical analysis of architecture, starting out from the premise that "the air-tight division between the history of architecture and criticism of contemporary phenomena has disappeared."[64] The institute forged a partnership with the city even as it was viewed with suspicion; it played a strong supportive role in the ill-fated projections for Venice by Wright in 1952 (having awarded the architect an honorary PhD and *Stella della Solidarietà* in 1951) and Le Corbusier in 1965. Institute colleagues concurrently developed an expansive and contentious context for modern architectural thinking through their teaching, writing, practice, and editorial work for the journals *Angelus Novus* (1964–1972) and *Contropiano* (from 1967 forward).[65] Their efforts were amplified through the architectural editions of the Biennale.

These discussions were shaped by the history and actuality of their host city, even when directed at other geographies—while insisting on a principle, inherited from the historicism of Benedetto Croce and Antonio Gramsci, that history must dispel rather than inspire nostalgia. The IUAV has attracted considerable critical attention in Europe and North America, particularly through the teaching of Tafuri and Rossi and the publication of writings by these figures abroad by advocates such as Eisenman. However, an account of the school's relationship to Venice as a city—and its collective overturning of the myth of Venice across disciplines on an international scale—remains to be written. The Venetian School extends Venice's conceptual bearing on the countervailing spatiotemporal context of modernity by defining the challenge that the city has posed to modern design. This project continues to resonate in the oeuvre of Pier Vittorio Aureli (born in 1973 and trained at the IUAV), who seeks to resuscitate architecture's critical vocation by stressing its "absolute," or confrontational, power. In *The Possibility of an Absolute Architecture* (2011), Aureli tacitly revisits Cacciari's earlier thinking surrounding the archipelago by presenting this figure as a "metaform" for the city, "where parts are separated yet united by the common ground of their juxtaposition," yet emphasizes its resistance to the integrative capitalist governance of urbanization.[66] Reinflecting the discourse surrounding the stasis and potential futures of architecture and urbanism, and conversing directly with the literary-historical record surrounding the city of lagoons that we have traced thus far, these thinkers grant critical impact to the clichéd intellectual and cultural "death of Venice." Indeed, it is this very "death" in the face of the imperatives of heroic modernism that ensures the city a life in the late twentieth century as an oppositional intellectual center.

CAPRICCIO AS HISTORICAL SURFEIT:
REVISITING THE VENETIAN ENLIGHTENMENT

In reviewing exhibitions of Aldo Rossi's drawings in New York in 1979, the poet John Ashbery saw fit to set them into the context of Rossi's pioneering treatise on *The Architecture of the City*—a critical reassessment of the modern project in architecture that placed renewed stress on the city as an imaginative repository of collective experience. Ashbery noted that the singularity of Rossi's conception of urbanism consists in its being metamorphically responsive to contingencies that cannot be visualized entirely or planned for in advance—even to contingencies that make architecture's actualization in the city fabric impossible. Rossi's is "[n]ot the utopian concept of an urban planner but the city as it is continuously coming into being—a concept perpetually modified by the exigencies of everyday reality, where what is unbuilt or incomplete has a function no less important that what is actually there, as part of a never completely visible or measurable totality."[67] Publication of *The Architecture of the City* in 1966 (with an English edition edited and introduced by Peter Eisenman in 1982) coincided not only with that of Robert Venturi's *Complexity and Contradiction in Architecture*, but also with the catastrophic flooding of Venice and Florence—poignantly so, given Rossi's ambivalent polemic against the modern movement's naïve functionalism and plot to sanitize the city. A member of the neorationalist group La Tendenza, which was composed of architects who came of age in the early 1960s (thus in the wake of the bombings of World War II), Rossi labors in this tractate to resituate architecture conceptually within the preexisting city fabric rather than treating it as a disciplinary island apart. He emphasizes architecture's status as installation rather than object, restoring material qualities of the city to systematic studies, and identifying architecture itself as "the construction of the city over time [*tempo*],"[68] in the dual sense of the word *tempo* as "both atmosphere and chronology, . . . a principle that presides over every construction."[69] This supple understanding of architectural temporality and ambience pits "pathological" permanences in the city—monuments that have become museum pieces—against what Rossi calls the *locus*. The locus is at once an urban artifact and an event that links past to present, hosting historical and ongoing events while granting apprehensible form to the singularity of place. It harbors the collective memory of the past while propelling the potential memory of the future.

Rereadings of his own work and experiences in the United States and elsewhere inspired Rossi to append prefaces to each new edition of *The Architecture*

of the City—compositions that underscore the influence of changing spatio-temporal contexts on his thinking. The second, 1969 edition of this work puts forward a new concept—that of the "analogous city"—which takes Venice as a fabulous point of departure for meditations on resistance to the confinement of design. Rossi drew his inspiration for this constructive hypothesis from a Venetian *Capriccio* ("Caprice") by *vedutista* Giovanni Antonio Canaletto (1697–1768) that posits an imaginary Palladian Venice within the otherwise recognizable zone of the Rialto (figure 5.5), thereby proposing a neoclassical version of the city center that would never be built. This painting produces what Rossi calls an *"analogous"* Venice springing forth between architectural references both real (in the form of two Palladian monuments built in Vicenza, the Palazzo della Ragione, or Basilica, and Palazzo Chiericati, transposed to

FIGURE 5.5. Giovanni Antonio Canal, called Canaletto, *Capriccio with Palladian Buildings*, depicting Palladio's unbuilt project for the Rialto Bridge as if it had been installed in Venice alongside the architect's Palazzo Chiericati (in partial view) and Palazzo della Ragione (right), both actually erected in Vicenza. In his preface to the second Italian edition of *The Architecture of the City*, Aldo Rossi quotes from Francesco Algarotti's *Raccolta di lettere sopra la pittura e l'architettura* on this work: "It is easily seen that the painting does not lack boats or gondolas, nor anything else to transport the viewer to Venice; and I know that many Venetians have asked what site in the city it was which they had not yet seen." Oil on canvas, ca. 1756–59. National Gallery, Parma, Italy. Photograph courtesy of Scala/Art Resource, New York.

the Grand Canal) and imagined (Palladio's unsuccessful design for a new Rialto bridge, fantastically installed into its projected context).[70] Through this montage of existing and invented elements of the cityscape, Rossi suggests, the fabricator of the analogous city generates new possibilities for urban design, in spite of practical constraints.

Beyond the aesthetic liberties of Canaletto's Palladian *Capriccio*, Rossi emphasizes its progressive sociohistorical orientation, wherein "Venice is posited as the analogous city of the Venetian Republic [*repubblica veneta*] and of the vaster modern nation." While the weakened oligarchy of the Venetian Republic will ultimately be subjugated by French and Austrian imperial powers in the name of rationalism, Canaletto's analogous city points toward an implicit or alternative future that will spring forth in the spirit of the modern revolutionary republic. As Rossi points out, "the destiny of Palladian architecture will be elsewhere"; it goes on to take root not only in the villas of inland territories on which the waning maritime republic set its sights, but also in Anglo-American soil.[71] The architect alludes here to the downfall of the maritime capital that rejected Palladio's design in favor of less classicizing styles, and the proliferation of Palladian neoclassicism throughout the modern democratic world. (Rossi's focus on Canaletto was itself unusual for an Italian, as that painter's *vedute* were consumed largely by English aristocrats on the Grand Tour, and consequently much more prevalent in British collections.) Rossi's concept of the "analogous city" suggests that in inspiring imaginary recombinations of historical possibility, Venice harbors a potential to send historical destiny off course.

Rossi's obsession with the global footprint of Andrea Palladio echoes Henry James's more immediate and condescending curiosity surrounding the phenomenal proliferation of Palladian edifices in America. In *The American Scene*, James describes "the great Palladian pile just erected by Messrs. Tiffany on one of the upper corners of Fifth Avenue" as "but a more or less pious *pastiche* or reproduction, the copy of a model that sits where Venetian water-steps keep—or used to keep!—vulgar invasion at bay" (presumably that of San Giorgio Maggiore, near the customs house).[72] Yet the Tiffany building forms more than a travesty of the Palladian monuments in Venice; for James ultimately arrives at the assertion that the stones of Palladio address themselves best to the light of New York: "press the spring hard, and you will see that, to whatever air Palladian piles may have been native, they can nowhere tell their great cold calculated story, in measure chapter and verse, better than to the strong sea-light of New York."[73] The "analogy" between Venice and the rising mercantile republican city, noted throughout *The American Scene*, makes adoption of the

Palladian template natural in New York.[74] Rossi's essay "Un'educazione pal-
ladiana" ("A Palladian Education") takes such reflections to an extreme, trying
to understand why Palladio is, as James Ackerman observes, the world's most
imitated architect. Rossi describes his own fascination with the Home Depot
aisles of New Orleans stocked with democratic pediments and columns: a do-
it-yourself Palladianism available to all. Palladio's architecture establishes a
typology opposed to the mythological anthropomorphism of the irrational-
ist Michelangelo or religious Raphael; Palladianism is instead characterized
by pragmatism, Rossi claims, which he labors to identify as a Venetian qual-
ity—and one that appeals to the Anglo-Saxon world. Thus, while a drawing by
Raphael can only represent loss in a contemporary context, the neorationalist
Rossi locates in Palladio's slightly troubling "professionalism" and "engineer-
ishness" not redundancy, but a fresh "possibility of construction, of repetition
. . . that will develop in ages to come."[75] This potential for reproduction does
not imply that Palladio's buildings are estranged from the site of their found-
ing: Rossi detects Palladio's response to a particularly Venetian architectural
blend in the Church of the Redeemer, whose cupola and tower/minarets hail
from a tradition more Byzantine, Turkish, or Ottoman than Roman, express-
ing a cosmopolitan "Venice turbid with history and with juxtapositions."[76] The
novelist Robert Coover will later credit Palladio with incorporating "echoes
of Venice's corrupt and mongrel history into his designs even as he gently
chastised the city with his intimations of a rational geometric ideal."[77] Para-
doxically, it is the pragmatic Palladio that becomes keyed as fantasy within the
reality of Venice in the hands of the Enlightenment-era painter of "views." Yet
it took a Venetian artist to imagine the implosion of classicism within the "first
anti-Euclidean city."

For the 1976 Biennale, Rossi and colleagues Eraldo Consolascio, Bruno
Reichlin, and Fabio Reinhart exhibited their own strategic proposal of an
alternative within the real: La città analoga, their own Analogous City, which
recalls the psychogeographical works of the Situationist International, but
with historicist inclinations. The work was an "arbitrary" montage of city
plans with objects invented or actual, and with the abstract forms of the
sphere, cone, and cube—aiming to impose the internal dimension of mem-
ory upon a collective "invention that takes place within the time of the city."[78]
Through such juxtapositions, design seeks to make space for unforeseen con-
sequences within the cityscape, so as to evolve what Rossi calls, in A Scientific
Autobiography, "a fabric of artifacts and feelings that is stronger than either
architecture or form, and goes beyond any utopian or formalistic vision of the
city."[79] Rossi's writings revive a longstanding Italian tradition of the architect/

author, stretching from Vitruvius through Alberti and Palladio himself, whose importance lies as much (or more) in projections on paper and a subsequent modeling of types as in any built opus. His understanding of architecture as "construction," with its parallels in writing and cinema, allows Eisenman to claim that "Rossi's drawings are not merely drawings 'of' architecture . . . , they are architecture. They do not demand to be built."[80] Eisenman's affirmation leads Ashbery, in turn, to note that "the city, at any rate the 'analogous' city of Rossi's sketches, is both physical and metaphysical, a set of imperfectly realized concepts and a physical plant which evolves through misuse or misunderstanding"—expressing at once a launching point of Ashbery's own poetic and of the ambivalent destiny of contemporary Venice.[81]

In his *History of Italian Architecture, 1944–1985* (1986), Tafuri, Rossi's colleague at the IUAV, takes the analogous city concept, alongside such architectural fantasies as Rossi's drawings and his cemetery at Modena—which are strangely redolent of the frozen realms of De Chirico's metaphysical paintings or of Giorgio Morandi's still lifes—to task for their "indecent and provocative" immersion into imaginary spheres.[82] Tafuri opposes Rossi's production of a realm that we may recognize as prototypically postmodern, in which one "is forced to annul space and time," being delivered into the void of what he calls disparagingly, invoking Blanchot, merely "literary space."[83] Tafuri tracks a series of projects exhibited at the 1985 Architecture Biennale directed by Rossi which imaginatively redesigned the Accademia and Rialto bridges and the Guggenheim Palazzo Venier de' Leoni (by architects such as Izumi Oki and Ludwig Thürmer, Francesco Cellini, and Venturi, Rauch, and Scott-Brown) as *capricci* in the weak sense: arbitrary recompositions of a Venice devoid of identity. While Paolo Portoghesi had called in his catalogue preface for Venice to become "a capital of hope for design," Tafuri chastises these conceptual projects for failing to deal with pressing contemporary problems in marginal zones of the city such as the Tronchetto port, the bus terminal on Piazzale Roma, and other neglected areas such as those on which Gregotti had focused in favor of recursion to "the reign of the mask and of frivolous discourse, with the goal of libertine 'voyages.' "[84] In this sense, Tafuri views Rossi's Biennale as an echo of Portoghesi's 1980 *Strada Novissima* exhibit, in which wood and papier-mâché recruited architecture to serve the sphere of "fiction": "development of a new realm opened to the architectural imagination by more modern circuits of information and consumption."[85] Tafuri, moreover, notes the projects' paralysis in the face of "the deep anxiety that Venice itself generates in 'modern' sensibilities," given that the entire history of this urban complex problematizes "the 'civilization of the project' "

(or "plan"). He concludes with an admonishing reaffirmation of Venice's lasting opposition to modern and contemporary design: "Venice offers a subtle challenge that affects the very presuppositions of modernity."[86]

Tafuri brings this challenge to light with fresh urgency by extrapolating from, and revising, Rossi's *Capriccio* research in his own experimental historical/theoretical writings. Tafuri's essays on architectural caprice parse the spatial and philosophical fantasies proposed by Canaletto's compatriot and successor Giovanni Battista Piranesi (1720–78), who assumed the title of *architectus venetianus* despite his few built projects and extended residence in Rome. Piranesi's inventions work in an inverse relationship to Canaletto's (and by extension Palladio's): not through the infiltration of classicism into anti-classical Venetian spaces, but through the implosion of a Venetian eclecticism and labyrinthine perspective within the rationalized spaces of classical Rome and of the law. Even the monumental Via Appia becomes a site of excess under Piranesi's stylus, piled high with memorials as if from all cantons of empire at clashing scales (figure 5.6). Tafuri's writings on this peculiarly Venetian strain of Enlightenment stress the eruption of historical bricolage within the Venetian interpretation of the design of classical Rome and of the reigning neorationalism of the eighteenth century. The first chapter of Tafuri's

FIGURE 5.6. Giovanni Battista Piranesi, frontispiece to volume II of *Le antichità romane*, etching, published 1756. Showing the Via Appia (identified at center), piled high with monuments. Gift of Mr. and Mrs. Earl H. Look, National Gallery of Art, Washington, D.C. Courtesy of NGA Images.

monumental work *La sfera e il labirinto: Avanguardia e architettura da Pira-nesi agli anni '70* (*The Sphere and the Labyrinth: Avant-Gardes and Architec-ture from Piranesi to the 1970s*; 1980) situates Piranesi's anticlassical revival of sixteenth-century inventions in spatial representation as the direct precursor to the historical avant-gardes through the 1970s.[87] He reads Piranesi's imagi-native reconstructions of the Roman *Campus Martius* (which he presents as experimental design in the guise of archaeology), sadistically labyrinthine *Carceri d'invenzione* (Prisons of Invention; figure 5.7), and etched *Capricci* as critiques of conditions that had stripped art of its universality (before it became bourgeois). *The Sphere and the Labyrinth* credits Piranesi with tear-ing urban space apart, extracting architectural elements from a hieratic clas-sical syntax and subjecting them to the law of mere contiguity. Even Piranesi's references to Republican and Imperial Roman monuments with a basis in the real *Campus Martius* "are arbitrarily inserted into a continuum of fragments that deprives them of any autonomy as well as of the very status of 'monu-ment'"; this plan stands, against Augustus's imperial blueprint, as "a virtual catalogue . . . of models based on an *exception* that very effectively gives the lie to the *rule*."[88] Tafuri appends a full translation of Sergei Eisenstein's essay "Piranesi, or the Fluidity of Forms" (1946–47) in his chapter on this "wicked architect" to further delineate the link between Piranesi's etchings and mod-ernist montage: the Soviet filmmaker sees in the *Prisons of Invention* a total-ity based on a "juxtaposition-conflict."[89] Eisenstein foregrounds his sense of the anti-imperialist implications of Piranesi's aesthetic by opening his essay pointedly on the memory of partisans fighting off Napoleon's invasion of Moscow; he goes on to analyze the prisons' "spatial movements into the depths cut off from each other," which are constructed "like a succession of broken links of independent spaces strung out not in terms of a single, unin-terrupted perspective, but as a sequence of collisions of spaces."[90] Eisenstein credits Piranesi with triggering the explosion of the geometrical basis of form realized by Cezanne and Picasso; we can easily follow the repercussions of this spatial fragmentation through the nonlinear, multiperspectival works we have encountered in this study.

Tafuri contends that the erudite, yet anarchically juxtaposed citations of the *Carceri* and *Capricci* etchings construct a "negative utopia" that implodes the determinative value of space in an act that is nothing short of revolutionary, implicitly rebuking empire as a coercive geopolitical domain.[91] Piranesi's dis-quieting fracture, distortion, and disarrangement of collective space expresses much more than psychological anguish—the proto-Romantic "delirium of a fever" that Thomas De Quincey saw in the prisons[92]: it effects a "systematic

FIGURE 5.7. Giovanni Battista Piranesi, *Carceri d'invenzione* (Prisons of Invention), plate VII ("*The Drawbridge*"), etching, engraving, scratching, 1761 edition (reworked from 1745), published 1780s. Rosenwald Collection, National Gallery of Art, Washington, D.C.
Courtesy of NGA Images.

critique of the concept of a 'center'" ["sistematica *critica del concetto di 'cen-tro'*"].[93] Piranesi's youth in Venice is regarded as a basis for these explorations of space: he had been apprenticed to the Venetian Savi alle Acque and Proti de Mar (the ministries in charge of hydraulic issues, river and sea engineering, and the policing of canals) and worked in the restricted basements and float-ing fortress spaces of the Arsenal.[94]

Tafuri argues that Piranesi turned to invention through etching in the face of building's impossibility, as the Roman aristocracy of his day remained aloof to the construction of public works. Through occupation of this impasse, he introduces "*imagination*" into modern architecture and prefigures the utopian aims of the historical avant-gardes: "The *invention*, fixed and circulated by means of the etching, renders concrete the role of utopia, which is to present an alternative that departs from actual historical conditions, one that *pretends* to be in a metahistorical dimension—but only in order to project into the future the bursting forth of present contradictions."[95] Piranesi's inventions thus, paradoxically, exceed the domain of fantasy: they profile, by contradict-ing, the political and architectonic stasis of their own day as they propose a utopian alternative to it. By amputating historical fragments from any govern-ing totality and setting them into mercurial new urban constellations, these prints thus foreground the capacity of unbuilt invention and even whimsy to alter the destiny of the city.

It is not only Piranesi's "negative utopia" or dark hypothesis of the prisons that refracts historical circumstances. Tafuri's argument turns at length to the "etching-commodities" and *vedute* produced by Piranesi and Canaletto for the Grand Tourist market—the sources of what Manilo Brusatin calls "that 'reproduction effect' laden with desires and views that filter the Venetian vista" for foreign travelers.[96] These souvenir compositions are commonly regarded as transfixing the city in a scenography familiar to us through the clichés of the Romantic era: they are the visual basis upon which "the literary text will nourish itself in non-verisimilar fashion, producing those ulterior crusts and proliferations of metaphor and commentary . . . through the 'second' nine-teenth-century commonplaces: the gondola, color, the 'death' of Venice."[97] The *vedute* ought to fuel the literary reification of the city. However, in Tafuri's analysis, the publicity-driven *capricci* of Canaletto and heretical implosion of *vedutismo* in Piranesi testify paradoxically to Venice's "reality" in the age of Enlightenment, insofar as they manage to manipulate both the city and the trade in which they are complicit: "The change wrought by Canaletto upon the urban context of Venice attests to the profound reality of this city for the eighteenth century; to the fact . . . that the most devastating manipulations

are legitimate on an urban organism that has become merely an object at the disposal of the fantasy of a tourist elite."[98] Venice's subjection to the gaze of the Grand Tourist on the one hand, and to an indifferent governing aristocracy on the other, renders it a field of play for architectural experiments of a synthetic/utopian or analytical/dystopian type. Venice provides no tabula rasa for these experiments, but instead a crowded matrix that forces viewers to contend with a multiplication of historical projections, whether implicit or explicit. The architect/designer must build on the precarious bases of preexistent architectures that may be, in Piranesi's words, "infected at the roots."[99]

Rather than subtracting history from the landscape in hedonistic, quiescent panoramas for the Grand Tourist, Tafuri suggests, the "publicity material" of Canaletto and Piranesi generates "counter-sites," or "heterotopias," in Foucault's sense of the word.[100] Heteropias destroy syntax, Tafuri notes via Foucault (with distinct echoes of Marinetti), rather than offering accommodating avenues of viewing/reading; these heterogeneous spaces, jammed with fragments that have no rationalized relation to one another, devastate the conditions through which the economy of travel might be completed through complacent return to a non-Venetian home, or *oikos*.[101] For Tafuri, the *avventura* ("adventure," or love affair, as condemned by Simmel) of the Grand Tourist who consumes these views of Venice is doomed to limitlessness because their montages leave irreconcilable histories in place. The collector returns to his London laden "with the fragments of an antiquity rendered hermetic, . . . obliged to continue his painful journey into the labyrinth of history."[102] In the face of the Grand Tourist's commodity-souvenir, the voyage is "prolonged indefinitely," so that "*one cannot return from it*," but remains trapped in the spatiotemporal labyrinth. Tafuri ultimately poses the question: "And in fact, how does one return from a Venice that does not exist? How indeed, from a form exaggerated in its dimensions, distorted in its reality, and confronting us with the wanderings in the maze of the *Carceri*?"[103]

Piranesi's typically Venetian eruptions of Enlightenment measure propel a waxing of historicity that will leave one American author/collector in a "Prelusive" purgatory. The prisons constitute a visual correlative for the closed prosodic form of hammering tetrameter split by unpredictable caesurae that structures Herman Melville's *Clarel*:

> In Piranezi's rarer prints,
> Interiors measurelessly strange,
> Where the distrustful thought may range
> Misgiving still—what mean the hints?

Stairs upon stairs which dim ascend
In series from plunged Bastiles drear—
Pit under pit; long tier on tier
Of shadowed galleries which impend
Over cloisters, cloisters without end;
The hight, the depth—the far, the near;
Ring-bolts to pillars in vaulted lanes,
And dragging Rhadamanthine chains;
These less of wizard influence lend
Than some allusive chambers closed.[104]

Tafuri's astonishing arsenal of references does not include Melville—but he aspires toward an infinite historiography whose effects are patterned in these lines. Echoing the postrationalist, post-Cartesian "weak thought" of Gianni Vattimo and Aldo Pier Rovatti, Tafuri contends in *Ricerca del rinascimento* (Interpretation of the Renaissance) that "[t]he 'weak power' of analysis" becomes "a step in a process that lets the unresolved problems of the past live, unsettling our present."[105]

LIMINAL BUILDING: *THEATER OF THE WORLD*

In his *Scientific Autobiography* (or "Scholarly Autobiography"), Rossi writes of the way that Melville's sea stories infused his architectural consciousness, and retrospectively finds echoes of them in his *Teatro del Mondo* (Theater of the World; figure 5.8)—a floating theater installed at the Dogana Point for the 1979–80 Biennale that recalled both a ship and a lighthouse, which became particularly dear to the architect as a project: "Perhaps this was and is my America—the white houses of New England, the boats, the Maine that I had already envisaged in my adolescent reading, where the house was the Pequod and the meaning of the search could only be a white object. . . . "[106] Rossi's thinking through analogous cities constructed in the face of an impasse in building could only have led to an architecture that was fragmentary, mobile, and ephemeral—apparently out of a dream, yet moored ineluctably in time. Venice's migratory and homeless qualities were literalized for a fleeting period in Rossi's floating theater of iron and wood produced in conjunction with the theater and dawning architecture biennials, as well as the first resuscitated Carnival. Rossi's structure was anchored by the Napoleonic lighthouses of San Giorgio at the Dogana Point, its stiff tower pennant aligned with the rotary

FIGURE 5.8. Aldo Rossi, *Teatro del Mondo* (Theater of the World), floating theater of wood and iron created for *Venezia e lo spazio scenico*, 1979–80. Documentary photograph of theater being transported to the Dogana Point, center right, with the Basilica of Santa Maria della Salute at left. Fondazione MAXXI–Museo Nazionale delle Arti del XXI Secolo, Rome.
Photograph courtesy of Fondazione MAXXI/Courtesy of Ministero per i Beni e le Attività Culturali, Rome. © Fondazione Aldo Rossi.

allegory of Fortune. The theater was crafted in the shadow of the sixteenth-century *theatrum mundi* concept that haunted Venice and on the model of specifically Venetian floating festival architectures called *teatrini*, though Rossi's title for the work evokes the magic-lantern panoramas of the eighteenth century that Goldoni called *mondi nuovi*, and aspires to call up Shakespeare's Globe Theater as well.[107] Rossi designed the work as a theater of limited capacity for occasional works, thereby permitting "direct performances," with a stage in the round produced by a simple path between the theater door and window.[108] The structure was dismantled (against Rossi's will) in 1981.

In characterizing the form of his floating theater, Rossi supplies an excess of analogies from geographically remote sources, from New England to the Muslim world—a move that confuses the signature typologies that define his practice while insisting on the importance of the project's Venetian context, with Venice represented as the "analogous city" *par excellence*[109]: "The tower of my Venetian theater might be a lighthouse or a clock; the campanile might be

a minaret or one of the towers of the Kremlin: the analogies are limitless, seen, as they are, against the background of this preeminently analogous city."[110] Elsewhere he relates the *Teatro del Mondo* structure to the beach cabins at the Lido, the anatomical theater of Padova, port and mercantile architecture in the Venetian colonies, towers that were once mills or storehouses, and the wooden hovels of the Po Delta.[111] Through the lighthouse analogy, he invokes Melville, just as the American author had invoked Piranesi. In this seemingly limitless plurality, Rossi's structure coheres around its liminal status as building or object, vacillating between ship and tower, land and sea; it thereby consciously expresses a Venice that endures between marshes and sea through an "ancient and ever precarious rapport where the construction of mankind and the transformation of nature constitute the preeminent aspect of architecture"—but also, we might add, emerges as symptomatic of the impossibility of installing new permanent structures in this place.[112] A slight seasickness produced in watching the waterline shift through the windows from inside confirmed the theater's precarious and mobile character; Rossi relates that he had not foreseen the mobilizing effect of passing boats entering the theatrical spectacle.[113] The marginal identity of the city on the water is further embodied by its synthesis of "the possible passages, not only physical or topographical, between the two worlds" of Gothic fogscapes and the East.[114] The *Theater of the World*'s voyage to Dubrovnik consummated these relationships while fulfilling its peripatetic potential: in the summer of 1980, the 250-seat theater was ferried across the Adriatic along the coastline of the former Republic, thereby taking on fresh associations with a once colonized landscape.

Tafuri argues that Rossi programmed a confrontational function into the building's resonances of elsewhere, turning clichés of Venice and the language of the theater against themselves: in being set against the "over-concluded dreams" of Palladian façades along the rim of the Bacino di San Marco, the itinerant theater "impiously tears away masks that time has glued to faces."[115] It is as if in stripping away the marble façades of Palladian architecture at San Giorgio and the Giudecca (constantly compared, in their mere illusion of depth, to scenography), Rossi had stripped away the mask of Carnival being revived for tourism revenue, liberating Venice from the inertia of the reified sign. Echoing the reaction of his colleague Giuseppe Mazzariol to the work, Rossi himself affirms that his theater longs to express a premodern, or "premonumental Venice, a Venice not yet white with the stone of Sansovino and Palladio." Instead, he aims to invoke the Venice of Carpaccio's Quattrocento. Rossi even claims to see the memory of a wooden, mercantile harbor architecture *through* the Venice "stilled by Palladian monuments."[116]

Rossi viewed the Venetian *teatrini* as ephemeral hosts of a suspended, repetitive theatrical temporality, as "fragments and opportunities," whose dramas "made no *progress*."[117] This amphibious architecture was anchored in a space "where architecture ended and the world of the imagination or even the irrational began."[118] In this it is supremely "Venetian," for the inverse is also true: Rossi recollects that he wanted to link the design to "a Venetian type of construction," in the very sense that it represents "a mode of designing that seeks fantasy only in the real."[119] It seeks within the real a fantasy outside of progress, outside of linear time.

MAPPING THE LABYRINTH

The visionary 1968 reading of the Venetian cityscape as networked text by Italo Calvino with which we began compels us to consider the consequences of postwar developments in urbanism and architectural theory for the literary production of the period (and vice versa). The trope of the city as text was pervasive in this intellectual climate, spurred both by semiotic analysis and by the search for a new vocabulary of urban space. The dual failure of modernism and of planning articulated by Tafuri in *Progetto e utopia* resonates explicitly with literary debates encapsulated canonically in Calvino's oeuvre—where critical interrogations of the inconceivable "labyrinth" of objective reality under late capitalism explore the limits of *progettazione*, both architectonic and literary. Calvino's 1967 tribute to the late Elio Vittorini, "Vittorini: Progettazione e letteratura," uses the key term *progetto* to eulogize his collaborator's utopian affirmation of literature's value in the service of a total design that sought to impose itself on an unprecedentedly "open" reality. Lucia Re argues that Calvino's elegy for Vittorini represents his swan song to a literary practice with immediate political designs in favor of the more contemplative mode exemplified by his 1972 magnum opus, *Le città invisibili* (*Invisible Cities*; begun in 1970). Dominated by semiotic and other formal analyses, many critical readings of this work cast it as detached from urban realities, but Calvino insisted that the book develops a discussion about "the city of today."[120] Calvino's fiction of cities grapples with the problem of *progettazione* conceptually: it articulates a desire not only to comprehend, but to contest the totality in which we live through the act of mapping.

In his influential essay "La sfida al labirinto" ("The Challenge to the Labyrinth," 1962), which doubtless nourished Tafuri's fascination with that figure, Calvino had famously deployed the labyrinth archetype to describe

the confounding epistemological multiplicity of the world under late capi-
talism—or what he prefers to call the "'second industrial revolution'" of
"hypermechanization, hyperproduction, hyperorganization" that throws the
oppositional rhetoric of the avant-garde into crisis, obliging its own repre-
sentation as a "cold kaleidoscope of linguistic-ideological-moral fragmen-
tation."[121] Calvino stakes out a controversial claim regarding the utility of
rationality in confronting this refracted posthumanist reality of data: he pro-
poses that a literature with aspirations toward the "cosmic" must map the
kaleidoscopic multiplicity of languages and interpretative possibilities of a
"gigantesque apparatus of production-distribution-credit" in detail in order
to master it. In its mapping function, literature represents a *challenge to
the labyrinth*" [italics Calvino's] within a chaotic welter of objectivity: litera-
ture must supply the key that "allows one to find the exit, even if this exit is
nothing more than a passage from one labyrinth to another."[122] (Later, in
his Norton lecture on quickness, Calvino will note his own propensity "to
calculate the series of linear segments that will lead me out of the labyrinth as
quickly as possible," then cite as his own the motto of Aldus, *Festina Lente*.[123])
Calvino's contemporaries in the *Neoavanguardia*, who were committed to a
view of literature as a realm of negativity and demystification, attacked his
defense of a rational stance; Calvino has continued to be challenged by con-
temporary critics of Enlightenment thinking for his approach to this day. Yet
we need to understand Calvino's mapping aspiration, his search for a kind
of totality, as one pole of a dialectic ultimately staged by *Invisible Cities*, a
work which he later cited as the one that satisfied him most precisely because
the city as subject allows for expression of the *tension* between "rationality"
(imposed through planning) "and the tangled mass of human existences."[124]
Such tension—embodied in *Invisible Cities* by the wistfully dialectical fram-
ing dialogue/agon between the Mongol Emperor Kublai Khan and the Vene-
tian merchant Marco Polo—also characterizes the confrontation between
modernist and rhizomatic postmodernist approaches to knowledge. In this
work, Venice provides the matrix for a new species of totality: the notoriously
labyrinthine *forma urbis* that underpins all the *Invisible Cities* Polo remem-
bers and projects is the city where digressive reverie in complex and entropic
tempos necessarily infiltrates every charting scheme. Calvino's Venices ren-
der the conflict between totalizing rationalist and decentralizing materialist
approaches to experience visible.

The vocation of mapping has a particularly rich history in Venice; Vene-
tians filled in the lacunae of the global atlas for centuries as navigators and
cartographers—and as narrators, for the travelogue of Marco Polo was itself

an act of detailed narrative mapping. The first cosmopolitan's tale of his epis-
temological quest through Asia was allegedly dictated to Rustichello da Pisa
from the confines of a Genoese prison in 1298; dubbed *Il Milione* for the mil-
lion fictions it contained, it nonetheless served as a font of knowledge, even
disabusing the West of such fantasies as the existence of the unicorn.[125] In the
work's preface, Rustichello, a writer of chivalric romances, testifies to the text's
veritable accuracy, asserting that the chronicle constitutes a (more or less)
eyewitness account by a "sage and noble citizen of Venice who with his eyes
saw every thing"; he adds, "And even if he did not exactly see everything with
his eyes, he was always helped by the testimony of men worthy of trust."[126]
Calvino drew on Polo's hybrid unfurling of rationality and fantasy over more
than a decade of writing. He composed a script in 1960 for a filmic adaptation
of *Il Milione* that explored both fable and Venetian dialect forms, and returned
to Polo's serial tale-telling to shape *Le città invisibili*.[127] At a 1983 lecture on
Invisible Cities to students at Columbia University, Calvino stressed that Polo's
text was *itself* an elsewhere: one of those books that become "an imaginary
continent in which other literary works find space for their own particular
worlds: continents of 'elsewhere,' now that there is no longer any 'elsewhere' in
the world, and the whole world is becoming more and more uniform."[128] His
work finds and multiplies space inside Polo's encyclopedic premodern literary
continent, leading, in turn, to the narration of further continents. One such
continent emerges through the Venetian dramatist/*cantastorie* ("storyteller")
Marco Paolini's *Il Milione: Quaderno veneziano* (The Million: Venetian Note-
book [1996–2007]), which creates an *isolario* of Venice using a "tapestry of
texts" that were recombined freely over more than a decade of performances;
this work's Polo-like narrator/protagonist—trudging through lagoon muck
after having forced an emergency landing of his flight from Marco Polo Air-
port to elsewhere—concludes of Venice, "l'Altrove è già qui" ("Elsewhere is
already here").[129]

Taking the anti-Euclidean city of Venice as an implicit structure, *Invisible
Cities* represents the culmination and potentially infinite expanse of Calvi-
no's attempts to map the labyrinth. Reconstellating components of the pre-
Cartesian Venetian cityscape, and charting the ramification of "invisible"
networks outward from the urban complex as theorized in "Venice: Arche-
type and Utopia," Calvino gives rise to a polycentric and post-Cartesian
literary design that refracts and multiplies time and space. The influential
reading of *Tristram Shandy* by Carlo Levi that Calvino cites in his Norton
Lectures locates potential for contemporary narrative in Sterne's digres-
sions, which replace clock time with "the labyrinth of duration" to produce

a sense of "the infinite mutability of reality, of its being made of inexhaust-
ible relations, of the contemporaneity of times." Sterne's duration "undoes
and destroys the structure and time of the novel . . . almost two centuries in
advance."[130] The structure of Venice as a "labyrinth of duration" subtends *Le
città invisibili*, a work that fractures the linear structure of the novel further
to generate a network of tales or plans. The design of Esmeralda, where "a
network of canals and of streets span and intersect each other," just as in
Venice, functions self-referentially as an exemplar of the book's multiplica-
tion of narrative pathways; Calvino recycles language from his essay on the
archetypal aquatic city to describe this "Trading City," where "the shortest
distance between two points . . . is not a straight line but a zigzag that rami-
fies in tortuous optional routes," so that "the ways that open to each pass-
erby are never two, but many."[131] This statement characterizes the design of
Invisible Cities as a whole: Calvino later described its structure as a serial one
"that does not imply consequentiality or a hierarchy but a network, within
which multiple pathways can be traced."[132]

Adopting Polo's description of the cities of Kublai Khan's dominion as a
frame, but staging narrative expedition as an activity conducted under condi-
tions of submission, *enforced*, Calvino from the first emphasizes the violent
and impulsive aspects of the mapping compulsion and of *ratio* writ large. The
narrative opens in the voice of an emperor desperate to secure hold of his ter-
ritories through knowledge, who implicates readers through a first-person-
plural address. Sensing the corruption and disintegration of his domain, the
Khan is almost ready to give up any thought of comprehending it; he is seized
evenings with the awareness that "this empire, which had seemed to us the
sum of all wonders, is an endless, formless ruin" (*IC* 5). Polo's stories emerge
as the sole force that gives shape to this domain, a pattern to shore against
the Khan's ruin: the merchant's accounts reveal to the ravenous listener "the
tracery of a pattern so subtle it could escape the termites' gnawing" (6). How-
ever, the mercurial errands of storytelling threaten everywhere to go astray,
to exceed the imperial extraction of design. While Kublai Khan seeks refuge
in the chessboard as a model of the invisible order that governs the destiny of
cities, Polo's telling stresses the "infinite deformities and discords" that ulti-
mately elude the imposition of a "coherent, harmonious system" from with-
out (122). In opening up fissures in the topography of narrative, Polo ensures
more future for himself as well as for the cities—or city—he describes. Cal-
vino's frame manipulates and expands narrative through ruptures that recall
a canonical Eastern structure: in his essay on quickness, Calvino calls on
One Thousand and One Nights to stress the way its governing conceit dodges
linear temporality: "The art that enables Scheherazade to save her life every

night consists of knowing how to join one story to another, breaking off at just the right moment—two ways of manipulating the continuity and discontinuity of time."[133]

As readers learn halfway through the text, Polo's city-stories all derive from a common source: a city that goes unnamed until the emperor charges the Venetian traveler with never having spoken of his home. All of the metropolitan possibilities Polo has charted for the "Tartar" turn out to be refractions of his native city—reflections of an empire at the opposite pole of the known world: "Every time I describe a city I am saying something about Venice" (*IC* 86). When Kublai rebukes the traveler for failing to speak of each city in its proper place, Polo replies, "To distinguish the other cities' qualities, I must set out from [*partire da*] a first city that remains implicit. For me it is Venice" (86).[134] Calvino's protagonist here articulates a classic economy of nostalgic travel in which the home, or *oikos*, provides the global template for the traveler's perceptions of the outside. However, this city does not provide for the closed circuit of return typical of travel narratives; its recollection invites instead a vertiginous proliferation of possibilities that are configured as "exceptions." The Venice of *Invisible Cities* forms the paradigmatic opposition to Calvino's ideal city of New York, whose Manhattan grid, with its analog in the Khan's chessboard, represents the promise of a fully synthetic complex. The novelist later wrote that if New York represents a "geometric, crystalline city, devoid of a past, of depth," then it is "the city that I can delude myself into thinking that I master mentally, conceiving of it all as a whole in the same instant."[135] Calvino identified Venice, by contrast, as a paradigm of "extreme diversification, non-uniformity in a homogeneous experience"—a still-unified harbinger of the labyrinth to map.[136] In a review of a Parisian exhibition of maps, Calvino sets the cartography of Venice, where maps "are always in need of remaking" due to the shifting margins of land and sea, against Roman imperial maps, which consisted of linear images in scrolls that represented the world as a continuous totality.[137] Marco Polo specifies that modes of representation must be multiplied to map Esmeralda, to include "all these routes, solid and liquid, evident and hidden," as well as the aerial parabolas of its swallows: a diversification of languages is required to account for the material diversity of its pathways. From the perspective of the Venetian merchant, even the geometry of the chessboard reveals itself as a product of hybrid material origins embedded, like a historical script without end, in the wood: he points out that the board was cut from the ring of a trunk that grew in a year of drought, full of pores that reveal the traces of a larva's nest, and scored by the wood carver with his gouge.[138] The structuralist schemas demanded by the emperor thus congeal material histories at odds with those

abstract totalities—read by the materialist merchant, they emerge as tenuous containments of damage and decay.

Alessia Ricciardi identifies the mapping task of *Invisible Cities* as the search for a recovery of a "mythic origin of modernity" (the birth of mercantilism) accomplished by "domesticating a terrain halfway between an apocalyptic wasteland and a wonderland of simulacra."[139] She argues that Calvino attempts "to 'urbanize' postmodernity by abiding in zones of imaginary order that resist all entropic impulses."[140] But Calvino's act of "urbanization" constitutes only one impulse in a dialectic that inheres at the level of diegetic narration. Writing as if in fear of entropy, Calvino's signature "lightness" cannot be said to avoid the gravity of imminent decline, particularly as the cities begin to resemble more and more the urban sprawl and blight of the time of writing, until it is said that the final pages of the Khan's atlas of the world contain "an outpouring of networks without beginning or end, cities in the shape of Los Angeles, in the shape of Kyoto-Osaka, without shape" (*IC* 139). This pairing of Kyoto and Osaka, ancient and contemporary city, is an apt analogy for the contemporary bipolar amalgamation of Venice and its twin city of Mestre/Marghera, the historical center linked by both bridge and water to the sprawl of the industrial Veneto and the global trade networks that it feeds.[141] The Khan's own efforts to master his empire are seen as the paltry work of fancy in the face of his admission to its "rotting like a corpse in a swamp" (59). Strictly speaking, the text's attempts at "domestication" resonate as profoundly dysfunctional, in the sense that public and private space, dystopia and utopia, death and life, reality and fantasy are continually confounded. Section 7 opens with a reflection on the division of palace from wasteland in which Polo concludes, "Perhaps all that is left of the world is a wasteland covered with rubbish heaps, and the hanging garden of the Great Khan's palace. It is our eyelids that separate them, but we cannot know which is inside and which outside" (104). One is the realm of dream, the other of actuality: realms confounded in Venice.

What follows is a series of allegories of contemporary Venice as wasteland/wonderland. Clarice is a city subject to centuries of decadence, resurrected by survivors through reappropriated bits of its splendor rearranged cyclically in different orders. The city's most recent reemergence is characterized, like that of the museal or "Disneyfied" Venice, by an overflow of new materials, buildings, objects, and people that have no connection with the former city,[142] while the salvaged shards of its original splendor are "preserved under glass bells, locked in display cases, set on velvet cushions, and not because they might still be used for anything, but because people wanted to reconstruct

through them a city of which no one knew anything now" (107). Beersheba is composed in the minds of its inhabitants of a golden celestial and a fecal city, in a division uncannily like the remarkable contrast between the historical center of Venice and its infernal industrial margin; in defiance of appearances, though, Polo notes that the infernal city of greed and calculation is the golden one designed "by the most authoritative architects, built with the most expensive materials on the market" (112). Other cities, such as the dual Eusapia of the living and the dead, breed situations in which the living are reduced to copying a copy of themselves that is generated by the dead, the only extant beings capable of innovation—so that in the end, no one can say which population is dead and which alive. All of these seemingly fantastic urban situations reflect the contrasts of late Venetian modernity pushed to extreme proportions.

One of the ironies of empire exposed by *Invisible Cities* lies in the fact that the emperor as sovereign depends on foreign mediators to seize as knowledge the territories he has conquered (11); otherwise, we come to understand, these domains become fully integrated and domesticated, no longer signifying triumph over an other. The emperor thus forms part of the first person plural of contemporary subjects destined to hunger for an experience of the unknown that would remain unmediated and unrationalized. To reinscribe fantasy into an "elsewhere"—the premodern world read via Venice, the Orient, and the wondrous text of *Il Milione*—that is thoroughly "known," Calvino's text imagines a storyteller outside of language. Freshly arrived in the East and ignorant of the Levantine tongues, Polo is at first capable of describing the cities of Kublai Khan's domain only through gestures, inarticulate cries, and the arrangements of objects: "[W]hat enhanced for Kublai every event or piece of news reported by his inarticulate informer was the space that remained around it, a void not filled with words" (38). Being indeterminate, the merchant's recombined poses, gutturals, and props permit Polo to communicate across differences, and permit the Grand Khan to forge an infinitude of imperial fictions out of this interpretive terrain—until the traveler's gestures themselves become codified, the gulfs between sign and referent sealed.

Invisible Cities literalizes the impasse and generative challenge of speaking of a place overdetermined by both fiction and the documentary apparatus— about which James asserted, a century ago, that there is no information left to be given, only a "fillip to [one's] memory." The work participates in—while explicitly theorizing—a trend we have tracked in experimental literature surrounding Venice, through which the city, exhausted by mimetic representation, emerges instead as an implicit structuring influence, an archipelagic

arrangement of disparate parts immersed in an overall context of flux. Polo justifies his evasion of representing his home city to the Khan by asserting that in representing it explicitly, he would annihilate it as memory: "Perhaps I am afraid of losing Venice all at once, if I speak of it" (*IC* 87). Here Calvino will be echoed by Rossi, who after various allusions and passing references to the city in his *Scientific Autobiography* finally states: "I try never to speak of Venice, even though it is one of the places where I have taught and hence lived for nearly twelve years."[143] One risks losing Venice even by inventory-ing it obliquely, because language does violence to the unsayable, and further burdens an archive that is subject either to petrifaction through reification or to potential decay. Polo finally confesses, "perhaps, speaking of other cities, I have already lost it, little by little" (87).

When faced with the Khan's atlas of the world, Polo warns that the search for the city toward which his journey tends is infinite, given that it is "discon-tinuous in space and time": "Perhaps while we speak, it is rising, scattered, within the confines of your empire" (164). The ultimate city that rises will be cobbled together piece by piece and dispersed throughout an invisible global expanse, "made of fragments mixed with the rest, of instants separated by intervals, of signals one sends out, not knowing who receives them" (164). In this schema of transmission, the interrupted city resembles the encyclo-pedic novels of the twentieth century—encyclopedias that, like atlases, must remain *open*, as "today we can no longer think of a totality that is not poten-tial, conjectural, and manifold."[144] Venice as structure ultimately becomes a paradigm of the networked topography of global traffic and transmission in the contemporary moment.

In positing Europe's "internal other" as the home within an account of the "Orient," Calvino produces elsewhere as a confounding dialectic between the potentiality of global extension and a suffocating play of mirrors. Calvino's metacity, though defying the modernist totality of the emperor, does threaten to undermine a materialist premise, Ruskinian at base, that appears early on in the framing narration: "The city does not tell its past, but contains it like the lines of a hand, written in the corners of the streets, the gratings of the windows, the banisters of the steps, the antennae of the lightning rods, the poles of the flags, every segment marked in turn with scratches, serrations, etchings, slices/skids [*rigato a sua volta di graffi, seghettature, intagli, svir-gole*]."[145] Suspended in a Xanadu of letters, Calvino's navigator does not trail these "slices" or "skids" through space and time. The postmodern novelist risks simply inverting the emperor's structuralist city of norms "from which all possible cities can be deduced" in imagining his own model city "made

only of exceptions, exclusions, incongruities, contradictions" (69)—in pos-
iting, vis-à-vis an imagined dialogue with the Khan, that "[e]lsewhere is a
negative mirror" (29). The doubling structure of the cities suggests over and
over a confounding of actual difference that is paradoxical, incapable of gen-
erative contradiction. Rather than reconstellating the past, this chessboard
of urban permutations, in its self-reflexive infinitude, threatens to reproduce
Eutropia, the topos that continually shifts, yet remains programmed, so that
inhabitants "repeat the same scenes, with the actors changed" in a grueling
seriality: as citizens take up "a new job, a different wife" (64), they "repeat the
same speeches with variously combined accents; they open alternate mouths
in identical yawns" (65).[146] This programmatic exhaustion of recollective
and recombinatory possibility constitutes the underbelly of Calvino's uto-
pianism: a negativity neutralized by its integration within a limitless, yet all-
encompassing economy of urbanization as diagnosed in Tafuri's *Progetto e
utopia*—the underbelly of all potential Venetian utopias.

IMPERIAL SHAPE-SHIFTING: *THE PASSION*

Calvino's *Invisible Cities*, while offering up a paradigmatic postmodern
perspective on the textuality of historical knowledge, ultimately proposes
a model of utopia realized through its pulverization and etherealization:
"less solid than gaseous: . . . a utopia pulverized, corpuscular, and in sus-
pension."[147] In spite of the materialist inclinations of this proposition, Cal-
vino's rationalization of the labyrinth, its transmission as knowledge, relies
on regression to the depiction of feminized transhistorical Venices, each with
a woman's name, that are set against the disembodied, yet integral cogitat-
ing subjects of the narrative frame; the fifth of the "Cities & Desire" series,
which maps the city of Zobeide, allegorizes this design by describing a city
built by men of various nations to pursue and imprison a naked woman who
remains forever out of reach. The boundless potential of his invisible cities
is predicated on recurrence to an archetypal matrix that conforms to Judith
Butler's analysis of the feminine in possessing "no morphe, since it is that
which contributes to the contouring of things, but is itself undifferentiated,
without boundary."[148] By contrast, Jeanette Winterson's *The Passion* (1987)
limns so as to destroy boundaries time and again in a metamorphic Venice
of wall and canal, persona and mask, cross-dressers and "Siamese" souls (57),
Babel and Pentecost. This novel stages the continual transgression of national
and sexual categories that are yet definitively embodied—taking hold in a

Venice molded by amphibious and androgynous values, which shirks linear contours.[149] Winterson's quivering city "is not built on any lines I can fathom but rather seems to have . . . swelled like yeast in a shape of its own" (110). Inspired most immediately by *Invisible Cities*, which Winterson characterized as "a tribute to Venice in all her disguises," *The Passion* also reveals the influence of Ruskin's unruly historicism, while reanimating queer perspectives on the city of lagoons such as those of Frederick Rolfe and Jan Morris. Such perspectives trounce centuries of ideological binarisms inherent to the discourse surrounding Venice by dwelling in the liminal zones between genders, languages, and cultures; they embrace the miscegenation characteristic of Venetian cosmopolitanism rather than casting it as contamination. The episodes unfolding among the islands of the lagoon depart, in turn, from a conventional focus on the consolidated historical center of Venice—stressing the polycentric nature of the archipelago, which is predicated on transit among loci with distinct identities, such as San Lazzaro degli Armeni, site of an Armenian monastery, or San Servolo, the site of the former psychiatric hospital where Winterson's novel ends. The polycentrism celebrated by *The Passion* reanimates a vital characteristic of Venice that has been suppressed by reliance on the rail and automobile bridges to the mainland since 1846, leading to the abandonment of two-thirds of the minor lagoon islands.[150]

The Passion is at base a historical novel that lets fantasy in through fissures in the knowable. It begins at the historical confines of Enlightenment and Romanticism: the institution of the Napoleonic Empire in 1804. The book's second and third sections weave into and out of an occupied Venice in a key deviation from customary literary engagements, which tend either to take narrative refuge in the Carnival of the eighteenth century, before its suppression by the militarized forces of reason, or to seize upon Venice as a dehistoricized backdrop for tales of present-day inertia, decadence, and even evil, as Ian McEwan's 1981 *The Comfort of Strangers* recently had.[151] The contours of Napoleonic expansion brutally determine the trajectories of this novel's protagonists: the ambiguously sexed Henri, Napoleon's devoted assistant and chef, sent off for his effeminate blushing to be disciplined as a male soldier, and the wayward, amphibious Villanelle, the web-footed daughter of a gondolier and a cross-dressing casino dealer. Both are hauled into the infernal "Zero Winter" of the Russian campaign: Henri through his passion for the sovereign, and Villanelle through coercion, when after deserting her detested husband she is sold into prostitution at the service of the French troops.

Venice's resistance to Napoleonic designs is made manifest in the living cityscape, which is perhaps the true protagonist of these sections of the

novel. The city absorbs every nationality and design, folding back on itself, so that advancement can never take place. "Although wherever you are going is always in front of you, there is no such thing as straight ahead," writes Winterson, so that the streets lead you "to do something not planned" (49; 113). Henri arrives in Venice in 1813, just before the return of the Austrian government, and gets lost everywhere but in the new Gardens, where Napoleon had razed churches to make way for sporadic impositions of Euclidean geometry: "Where Bonaparte goes, straight roads follow, buildings are rationalized, street signs may change to celebrate a battle but they are always clearly marked. Here, if they bother with street signs at all, they are happy to use the same ones over again. Not even Bonaparte could rationalise Venice. . . . The only rational place in the whole city is the public garden and even there, on a foggy night, four sepulchral churches rise up and swamp the regimental pines" (112). The irrational parameters of Villanelle's being—her webbed feet, permitting her to walk on water, and her unfixed heart, which must be recovered by Henri—render her equally impossible to seize. They are matched and inverted by Henri's irrational insistence on his own imprisonment on "The Rock" of San Servolo, the madhouse in the lagoon, once she refuses to marry him—an act through which he redoubles the emperor's fate as island exile.

The spliced narrative of Winterson's third novel takes hold, as Calvino's does, in the tension between the surveying of empire and a subject who dodges subjection through inventive storytelling. Henri commits to the private documentation of a geopolitical "romance" under duress, against the presentism of conquest: the wedding of France to an emperor he eventually understands to have been a fiction, "invented." He later attempts to chart his semirequited love for the mer-creature Villanelle—whom he asserts in the end, from the San Servolo mental hospital, to be by contrast "not a fantasy or a myth or a creature of my own making" (157–58), reversing received formulas of myth and reality that have been consolidated by the literary record. The sustained livelihood of Calvino's Marco Polo depends upon his recollection and constant reinvention of his home city. Villanelle's name casts her very existence as a poetic form that dictates lyrical variation within constraint, in concert with the shape-shifting city of her birth; we meet her as a *vivandiére* who, like Scheherazade, surpasses humiliation by recounting the story of her adventures and eventual subjection. She moves between sexes as nimbly as between languages and landscapes, reminiscent of the Zildo/Zilda of Frederick Rolfe's wildly macaronic *The Desire and Pursuit of the Whole*—a gondolier who is "a good-enough girl but for her awkwardness in the habit femminile,"[152] and who trounces Crabbe's fortress-like psychic barriers in a

"breaching of innermost bulwarks" through sexual attraction.[153] Villanelle
is the decisive counter to the husband of her lover "Madame Clicquot," who
collects rare maps of treasure: she has become "skilful with the compass and
map" (101) by sleeping with generals (she explains), yet remains elusive,
like the "uncertain" geography of Venice (68)—and reminds readers at sev-
eral junctures that "[t]he cities of the interior . . . do not lie on any map."[154]
Linguistically, Villanelle occupies thresholds; "She wants it to be Pentecost
every day" (122). This postlapsarian courtesan's pragmatically metamorphic
shape and passions elude the profiles of so many reified versions of Venice
as a disorienting feminine matrix, though they partake indulgently of the
fabulous. A metafictive refrain courses through the meshed accounts of the
protagonists' convergence and ultimate division from one another: "I'm tell-
ing you stories. Trust me."[155] The novel was in fact written before Winterson
had been to Venice.

Villanelle accounts for the deviancy embedded in Venetian traditions in
historical terms, but reverses the reigning narrative of Enlightenment to posit
that Napoleonic reason spawned Venice's irrationality: "Since Bonaparte cap-
tured our city of mazes in 1797, we've more or less abandoned ourselves to
pleasure. . . . We became an enchanted island for the mad, the rich, the bored,
the perverted" (52). The novel veers from deployment of dehistoricized Car-
nival tropes abundant in popular culture; instead, the shells of aristocracy
roam through this Venice in the tradition of Voltaire's *Candide, ou l'optimisme*
(*Candide, or Optimism*; 1759), which posited that the feast reunited the earth's
monarchs and disappeared persons thought dead in masquerade.

The "passion" of Winterson's title is lodged not in a dialectic, but in an
interstice, where "life is a foreign language. Somewhere between the swamp
and the mountains" (68): "In between freezing and melting. In between love
and despair. In between fear and sex" (76). Love, Henri decides, is a state
in which persons formerly fluent in a language find themselves at home in
being unmoored, where "[i]t is as though I wrote in a foreign language that
I am suddenly able to read" (122)—so that differences are reconciled with-
out being neutralized, as in a Pentecostal feat. But the loves of this work are
all interrupted. Their objective correlatives are the cityscape's many bridges:
"A bridge is a meeting place. A neutral place. A casual place. Enemies will
choose to meet on a bridge and end their quarrel in that void. One will cross
to the other side. The other will not return. For lovers, a bridge is a possi-
bility, a metaphor of their chances. And for the traffic in whispered goods,
where else but a bridge in the night?" (57). Here a bridge provides no stable
zone of consummation, but a suspension over a liquid lapse, a communion of

isolated parts that is always subject to contingency. To dramatize the subjec-
tion of bridging disparities and stopping up voids in the Venetian cityscape to
forces beyond any individual's control, Winterson imagines an anachronism
into this nineteenth century: the wooden Rialto as it was depicted by Car-
paccio, before its late-sixteenth-century reconstruction in stone (figure 5.9).
The itinerant Villanelle, hijacker of funeral and police gondolas and vegetable
boats, pushes on under this drawbridge, "that strange half-bridge that can be
drawn up to stop one half of this city warring with the other." Bridging does
not bring harmony, but paradox, contradiction: "They'll seal it eventually and
we'll be brothers and mothers. But that will be the doom of paradox. Bridges

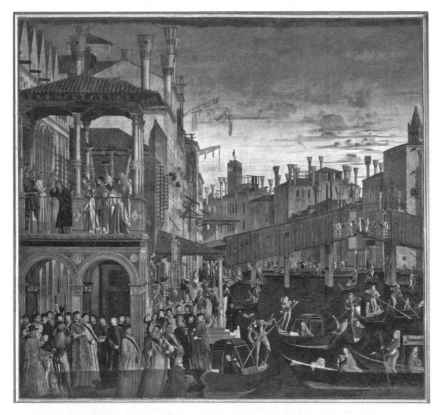

FIGURE 5.9/PLATE N. Vittore Carpaccio, *Il miracolo della reliquia della Santa Croce
al Rialto* (The Miracle of the Relic of the True Cross at the Rialto), oil on canvas, 1494.
The sacred subject is overwhelmed by Carpaccio's depiction of the life along the Grand
Canal, including the wooden Rialto, with drawbridge, before its replacement in stone.
Gallerie dell'Accademia, Venice.
Courtesy of Polo Museale di Venezia.

join but they also separate" (61). Henri will out of passion insist on isola-
tion from Villanelle, keeping himself detained at the Island of San Servelo
[sic], at the novel's close. *The Passion* dwells in a confrontation between parts
that is fundamental to the archipelago's resistance to neutralizing projects of
integration—a feature stressed in Pier Vittorio Aureli's treatment of the ago-
nistic struggle between islands, "opposing to urbanization's ubiquitous power
their explicitness as forms, as punctual, circumscribed facts, as stoppages."[156]
Napoleonic planning ultimately did little to eliminate the fissures that define
Venetian space; and Winterson's narrative stresses their correlatives in dis-
continuities that are social, sexual, and linguistic, which persist in spite of the
consolidating drives of empire.

We have seen that for Simmel, the bridge is charged with rendering the
continuity between points in space tangible, "their separation and connec-
tion as one and the same," whereas in Venice, to the sociologist's distress,
"[t]he alleyways seem to *float* away without landings."[157] In *History of Italian
Architecture, 1944–1985,* Tafuri tracks the apocalyptic vagrancy of the bridge
figure in Rossi's work, which, having presented itself as inconceivably capable
of connecting extremes—memory with history, sign with meaning, the indi-
vidual with external reality—eventually "broke off and flew into space" as
pure signifier (139); Rossi's trajectory becomes a labyrinthine one character-
ized by misleading dead ends, where the reality of architecture is always and
negligently linked to the unreal. Such fanciful interpretations of Venetian
urbanism will license developers to bridge incommensurable landscapes in
the most implausible ways, while provoking artists committed to difference
to the task of reanchoring them in space—and simultaneously reanchoring
the late twentieth-century sense of place.

PINOCCHIO, UNBUILT: THE HYPERTEXTUAL
VENICE OF ROBERT COOVER

In his 1991 deconstruction of a beloved late-nineteenth-century children's
tale, *Pinocchio in Venice,* Robert Coover violates the romantic fantasy of
Venice as a self-contained utopia by way of a painfully corporeal, playfully
queer metaphor, in which the Fascist modernist railway station of Santa Lucia
begun by Angiolo Mazzoni becomes "a gleaming syringe, connected to the
industrial mainland . . . and inserted into the rear end of Venice's Grand Canal,
into which it pumps steady infusions of fresh provender and daily draws off
the waste." The station, with its bridge to Mestre, epitomizes the injection of

ubiquity into a city only fabled to be "insular" in the figurative sense: it is "that tender spot where the ubiquitous technotronic circuit of the World Metropolis physically impinges upon the last outpost of the self-enclosed Renaissance *Urbs*, . . . a kind of itchy boundary between everywhere and somewhere, between simultaneity and history, process and stasis, geometry and optics, extension and unity, velocity and object, between product and art."[158] The result of an epic literary deviation from Coover's planned sequel to his first novel, triggered by his year-long residence in Venice in 1987, *Pinocchio in Venice* continues the work of remapping the labyrinth in which Calvino, Jeanette Winterson, and generations of predecessors have been engaged.[159] But Coover collapses any remaining sliver of romantic historical distance from Venice assumed by his predecessors, choosing instead to jam the Pinocchio fable into the phantasmagorical realism of a bipolar globalization. Coover's Venice is *open* as a system, but explicitly *for business*—everywhere permeated by the corporate interests of "l'Omino e figli, S.R.L." (The Little Man & Sons, Inc., a latterday Count Volpi enterprise) and the foreign oil barons, munitions manufacturers, banking magnates, and other aristocrats of dubious origin who fill palaces converted into retirement hotels. In this barely masked contemporary context, Mo.S.E.-like tidegates are being erected, presumably to stave off the damage of "a channel deep enough for sixty-thousand-ton tankers" being planned between Marghera and Malamocco to make the Veneto region "the rival of Osaka, Manchester, and New Jersey" (203), while the "terrible responsibility" of caring for Venice's historical landmarks is sold off to private enterprises such as Pinocchio's alma mater, Disney (202). Coover's ribald, Bakhtinian reworking of Carlo Collodi's marionette antics via the forms of the *commedia dell'arte* is never untainted by a caustic humor surrounding the resuscitation of Carnival since 1980 by civic authorities as a tourism ploy. While it partakes hardily of literary topoi of decadence, his Venice bears the site-specific scars and jaundice of contemplating an apocalyptically endangered city. "If you stand still and watch, you can actually see pieces of the city split off and fall into the canals" (108), relates Alidoro, Pinocchio's old friend from Playland; these disintegrating "pieces" of the city gouged and eroded by industry are paralleled by the patches of flesh and organs that fall grotesquely from the centenarian puppet throughout the novel.

In choosing to rewrite Collodi's tale of metamorphosis as an epic journey through an infernal late-capitalist Venice, Coover multiplies exponentially the challenge of rewriting what has been rewritten many times before. Rebecca West provides just one recent survey of Collodi's invocations of the Bible, the *Odyssey* and *Aeneid*, Ovid, and Dante, and of the puppet's many

twentieth-century reappearances in the hands of authors like Calvino, who praised *Pinocchio* as "a model of narration, wherein each theme is presented and returns with exemplary rhythm and precision."[160] In transferring the story of Collodi's puppet from a Tuscan village to Venice (as Henry James did with the story of Byron's mistress in *The Aspern Papers*), on the premise that the original tale contains three transformational "island stories,"[161] Coover thickens the plotting, shoving an aged Pinocchio's relived tribulations into a literary-historical labyrinth, amidst the notorious network of "gazes that intersect from all dimensions" imprinted on that city.[162] Coover's retelling takes on this "impossible baggage" of text (13): filled with a manuscript-in-progress, baggage is literally dragged through alleys by his bedraggled protagonist (puppet-cum-author) on holiday—concretizing the ponderous figurative baggage imposed by reflecting on a city whose Piazza appears as "a book he'd read a thousand times before, or perhaps a thousand books he'd read before compressed to one, . . . readable at a glance, yet somehow illegible" (195). With its multiple reticula of citationality, *Pinocchio in Venice* compresses the "thousand books" that haunt this city and fable into one. It generates a virtual—that is, strictly intellectual—Venetian hypertext, crammed with difficulty into the sequential form of the novel.

Throughout this novel, Coover's puppet is turning back to wood: the narrative's overall arc literally reverses the destiny of Pinocchio that progressed from log, to trickster marionette and rotten student, to *ragazzo per bene* ("good boy"), and from Hollywood celebrity to (as Coover imagines) double Nobel laureate and professor emeritus at an illustrious East Coast "I.V." ("so named, he pointed out, because of their innovative method of education by intravenous feeding" [60]). But this Christmastime counter-resurrection is no mere volte-face. Coover lampoons the narrative domestication of Collodi's puppet, which evolved from two serial publications between 1881 and 1883 (the second reviving the puppet from death by hanging due to popular demand), to a would-be didactic *Bildungsroman* for the new Italy (1883), to ideological wartime American Disney schmaltz (1940). When transferred from the pedantically linear layout of a Tuscan village, imagined "with its one main street running from home to school and crossed by another leading to . . . to . . . ?" (60), to Venice's "befuddling network of alleyways and squares" (42), Pinocchio's salutary education—and the nation-building mission to which it is yoked—become scrambled.[163] Readers must be familiar enough with the episodes of the original text to recognize their transposition into the Venice of a hundred years later, related with Coover's signature hyperbolic stylistic and sexual excess, but "in fragments only and in no particular

order" (163). The resultant "unbuilding," as it were, makes many demands on the reader, who is forced, as in confronting Pound's *Cantos*, or Marinetti's recapitulatory de-education through *Studentaccio*, into the position of the student—in anything but an I.V. administration of learning.

Given that postmodern fictions are defined by being both richly citational and nonlinear, it is fair to wonder why *Pinocchio in Venice* should be granted particular credit for the hypertextual impulse—even if it is rife with a constant, even cumbersome, indexing of other texts, from the *Metamorphoses* through *Ulysses*, from Goldoni through *Der Tod in Venedig*, often side by side within a single sentence ("to return to this sinking Queen, this treacherous sea Cybele 'as changeable as a nervous woman,' this 'most unreal of cities, half legend, half snare for strangers,' this home of the counterfeit and the fickle heart, this infamous Acchiappacitrulli," to cite just one example, moves from Byron to James to Mann to Collodi in half a sentence [135])—and even if it conjures texts by way of others, so that those saturated in the literary tradition glimpse Rolfe's Nicholas Crabbe through the crablike scuttling of Pinocchio-as-Prufrock ("advancing down the windblown platform toward the station proper like a crab" [15]).[164] I propose that Coover's chosen "texts," *Pinocchio* and Venice, provide immaculate (or maculate, as it were) forums for metafictional play due to their modular flexibility and openness, on the one hand, and their burden of interwoven revisions and revisitations on the other. These texts function as networks, enabling a narrative experiment akin to those that Coover witnessed as a pioneer in the development of electronic media at Brown University, where hypertext was developed in 1967; Coover taught a first course on hypertext there in 1989.

The fragmentation and vulnerability of the printed book as medium interpose themselves from the first at the level of Coover's plot. The return of "Professor Pinenut" to Venice is a return to his "roots" in the land of the Blue Fairy, who made him a boy; by returning, he hopes to complete his final, autobiographical "monograph," *Mamma* (in a ludic return to the repressed mother of the original tale, but one in which the author-son is presented as "pregnant" [67]). The voyage is meant to tie together the strands of Pinocchio's hardly regal "I-ness" (32) under the Aschenbach-like theme of "virtuous love and the lonely enobling labor that gives it exemplary substance": "only by returning here—to his, as it were, roots—would he find . . . that synthesizing metaphor that might adequately encapsulate the unified whole his life has been, and so provide him his closing chapter" (14). But the manuscript, hauled to Venice on his portable computer, in printed form, and on two sets of backup diskettes, is stolen by the Fox and Cat within a few short

chapters, leading him to abject pleas for his *Mamma* (textual and actual) that resound "as though the language has lost its referents and is only good for the noise it makes" (51). While drawn to the Venetian masters because they were "magicians of the transitional" (115–16), the scholar's career has been devoted to a misplaced search for Platonic forms in this tradition of painting; his thought parodies the meditations of the dying Aschenbach through misguided application. "[T]he mysterious shimmering *light* of Venice," he thinks, "seemed permanently to fix before the eye the very flux that excluded all fixity, . . . so spellbinding the gazer in a process that more or less mirrored that of the moviegoer" (114)—while the mutable Venetian environment that turns wood piles to stone also threatens to turn the increasingly wooden puppet to pulp. He is dying, in the book's insistent present tense, though in the footsteps of Aschenbach, Milly, and a score of others who have come here to expire; even as Eugenio (imported by Coover from *The Wings of the Dove*) describes the kitschy coffin of Murano glass in which Pinenut shall be preserved in burial (straight out of D'Annunzio's *The Flame*), we are reminded at every juncture of the fragility of literary data (as in *The Aspern Papers*) and, in turn, of the humanoids it aspires to synthesize. Coover's swan song for the romantic figures of Pinocchio and Venice is also a swan song for his chosen medium—and at the same time, a reassertion of their ability to reemerge from the dead in uncanny citational form.

Pinocchio in Venice was published the year before Coover published his seminal essay "The End of Books," which pronounces the imminent death of his own print medium, a once vital form "destined soon to be consigned forever to those dusty unattended museums we now call libraries."[165] Coover's 1992 eulogy for print describes and to some extent forecasts the transformations of narrative precipitated by hypertext and, later, by the World Wide Web. "Much of the novel's alleged power is embedded in the line, that compulsory author-directed movement from the beginning of a sentence to its period, . . . from the first page to the last," he notes, and while countless strategies have been devised to counter the line by novelists such as Sterne, Calvino, and even the form's father, Cervantes, "true freedom from the tyranny of the line is perceived as only really possible now at last with the advent of hypertext."[166] In its webs of linked lexias, hypertext constitutes an "interactive and polyvocal" technology, "favoring a plurality of discourses over a definitive utterance."[167] Plurality of discourse is inherent to Collodi's tale, which begins famously with a disrupted line: "Centuries ago there lived—'A king!' my little readers will say immediately. No, children. . . . Once upon a time there was a piece of wood"; and the story's many interpretations, adaptations, and popular bowdlerizations

act as further interpolations. Coover extends this tradition of generative inter-
ruption in fraying the story of the puppet *senza fili*: both puppet and story are
"without strings," or "wireless," in the Futurist sense—but also in the sense
that the novel's hapless hero lacks Ariadne's thread for escaping the labyrinth.

Venice's hypercitational status permits Coover to revel, in turn, in the
structures of kinship between texts hailing from distinct cultures and times
that are bridged over and over: to plot disruptive anachronistic linkages to the
fullest degree possible within a medium that obliges use of the sentence and a
more or less chronological turning of pages. Coover's description of hypertext
in "The End of Books" clarifies the attraction of Venice as a medium for side-
tracking the pathways of linear storytelling. In hypertext, "[t]he traditional
narrative time line vanishes into a geographical landscape or exitless maze,"
to such a degree that "the creative imagination often becomes more preoc-
cupied with linkage, routing, and mapping" than with statement, style, char-
acter, or plot—so that, indeed, much of the experience of both reading and
writing "occurs in the interstices and trajectories between text fragments."[168]
The premodern labyrinth of Venice is thus doubly appropriate as a matrix
for this work: its obsolescence mirrors the obsolescence of the book, while
its urban and literary infrastructures host the potential for a future means
of ordering experience in a world of "invisible and unlimited" global con-
nections.[169] Coover's third-person narrator imagines an infinite emanation
of worlds in this place: "in all the hidden alleyways throughout that disinte-
grating but multilaminous island . . . , there were whole discreet worlds to be
found like DNA clusters or nested microchips, belying their material limits"
(*Pinocchio in Venice* 295). This is the reason given for the fact that Marco
Polo, who had seen all of the East, would never claim to have seen all of Ven-
ice, but would assert (in the imagination of Coover's Lion) that "[n]o one has
or can. The distances are unimaginable" (295).

Throughout Coover's novel, we are reminded of the fallibility of paper,
but also of its "endlessly recyclable" character (31). The crumbling bundle of
sticks to which Pinocchio is reduced by the end of the work (thus becoming
an unwitting signifier of modern Italy's defunct Fasces), dead and pulped to
"help ease the world paper shortage," will finally be made into a book, as the
Blue Fairy promises—or a "*talking book*," per Pinenut's plea (329); presum-
ably it is the book we are reading. In *RC_AI* (2010), a post-hypertextual web
work, electronic writer Judd Morrissey (who studied hypertext with Coover
at Brown in the late 1990s) consummates this promise in the digital field,
tapping into the fact that Coover's turn to the Pinocchio fable at the dawn of
electronic writing resonated with the story's role as a magnet for deliberations

on artificial intelligence and the posthuman.[170] Morrissey recycles both *Pinocchio in Venice*, the work of his literary mentor, and his own father's literary-critical treatment of "RC's" novel as metadata for a panoramic restructuring of intelligence and of reading, wherein phrases recombined according to generative algorithms and loose grammars rush past us in one direction, then another, far too quickly to be legible, while the text itself is granted the ability to "talk," cyborg-like (in a female Quicktime croon queering Steven Spielberg's robotic Pinocchio of *A.I.*). *RC_AI* renders the "original" Pinocchio tale, its annotations, and its remixings lateral in a potentially infinite re-traversal of "these strings that bind us."[171] *Pinocchio in Venice* anticipates this outcome: Coover's book celebrates the intellectual, and carnal, pleasure in continuing to revisit and rework what is materially doomed—and in haunting a place where even etherealized, hypertextual relations are hypersexed. Such pleasure is reflected in the polymorphous and interspecies perversity studding the phallus-nosed puppet's final hours in a feminized landscape, and his masturbated "EXIT" (the title of chapter 29) from the labyrinth. Such perversity, heedlessly, implies regeneration.

Palladio's neoclassical architecture may have tried to rationalize the labyrinth, to bring it into line with an early species of modernity; in Coover's Venice, Palladian structures sit "gravely at anchor like an ordered thought within a confused sensuous dream, this damp dream called Venice, 'the original wet dream'" (175). But Coover's pulped utopia, a rematerialized version of Calvino's pulverized utopia, continues to expose rationalist designs as thin schemes, so that the famously illusionistic stone façade of Palladio's Church of San Giorgio Maggiore emerges as itself a mask, a chintzy carnivalesque effort to impose order, "framed . . . between the two absurd columns of the Piazzetta like a carnival mask hung in a window" (175); as the musicians of Carnival sing in Venetian dialect (in one of few Cooverian passages quotable in decorous discourse), "*Più in alto che se va, . . . più el cul se mostra!* The higher one climbs, the more he exposes his behind" (134). The dogged appeal of "'the original wet dream'" keeps those most exhaustively aware of its condition as a trashed cliché returning to speak its distinct vernacular: a *lengua venexiana* marked by infinite "x"s and *incroci*, or crossings. It keeps them returning to the place where refusing to fall into line with Cartesian rationality is the most reasonable approach to building.

CODA
LAGUNA/LACUNA

Venezia è allora veramente . . . l'emblema della modernità. Il nostro tempo non è
nuovo, ma novissimo, cioè ultimo e larvale. Esso si è concepito come poststorico
e postmoderno, senza sospettare di consegnarsi così necessariamente a una vita
postuma e spettrale, senza immaginare che la vita dello spettro è la condizione
più liturgica e impervia, che impone l'osservanza di galatei intransigenti e di
litanie feroci, coi suoi vespri e i suoi diluculi, la sua compieta e i suoi uffici.

Venice is therefore the true emblem of modernity Our time is not new, but
latest, that is to say, final and larval. It has been conceived of as posthistorical or
postmodern, without suspecting that this necessarily means being consigned to
a posthumous and spectral life, without imagining that the life of the specter is
the most liturgical and impervious condition, that it imposes the observance of
intransigent rules of conduct and ferocious litanies, with all their special prayers
for dawn, dusk, night, and the rest of the canonical hours.
—Giorgio Agamben, "On the Uses and Disadvantages of Living Among Specters"

"Very Modernized Venice[s]"

Approximately one hundred years after the fall of the Venetian Republic to
Napoleon, the City Council of Venice declared its intention to revive the city
culturally by importing new aesthetics and spectators; in 1895, this coun-
cil inaugurated the International Exposition of Art. A century afterward, the
same city, faced with escalating depopulation, saw the virtual exportation
of its urban morphology to the Las Vegas Sands Hotel site for a new casino
(figure C.1). This development was not altogether out of line with Venetian
history, as Venice was the site of the world's first government-sanctioned
house of gambling, or *casinò*, established in 1638; Winterson's *The Passion*
builds on the fact that Napoleon, the symbolic terminator of all things carni-
valesque, made a special allowance for the continuation of games of chance
in the city of water where they had thrived. Indeed, though it rises out of
sand, The Venetian Resort Hotel Casino vaunts an adjectival moniker that
avoids identification as a Disneyland facsimile. Unlike Las Vegas's simulacra
of modern metropolises, New York–New York and Paris Las Vegas, which
purport to reproduce the cities named by replicating their monuments, "The
Venetian" suggests, perhaps more outrageously (and as an ironic extension

FIGURE C.1/PLATE O. View of The Venetian Resort Hotel Casino in Las Vegas, along the Strip, with duplicates of (from left to right) the Ducal Palace, Rialto Bridge, St. Mark's Campanile, columns of San Marco and San Teodoro, and electric gondola. The Mirage across the way highlights the lagoon's dislocation to the Nevada desert. Photograph by Jennifer Scappettone, October 2012.

of Pater's thesis on Venetian mobility in "The School of Giorgione"), that we ponder the capacity of "Venetianness" itself to be transmitted anywhere, even to the American desert. Sheldon Adelson, CEO of the Sands Hotel (which was destroyed to make way for construction of The Venetian), dismissed New York–New York as a fake by contrast: "We are not going to build a faux Venice. We are going to build what is essentially the real Venice."[1] He did so at nearly full scale (contrasting the other casinos' preposterous juxtapositions of scales) with the help of extensive on-site reconnaissance that generated a catalog of 3,000 photograph-blueprints to rival Ruskin's sketchbooks, 250 sculptors and artists, and resident historians, including Dorit Raines of the University of Venice—despite the protests of then-Mayor Massimo Cacciari, union leaders representing 11,000 Venetian workers, and a group of professors at the IUAV: "Besides being a mega-galactic example of kitsch," Cacciari wrote, justifying his repudiation of an invitation to visit, "the project was developed without involving the city of Venice in the least bit."[2] Foam clones of Venetian forms hover in site-unspecific pastiches within the resort megaspaces,

FIGURE C.2/PLATE P. The Venetian Resort Hotel Casino in Las Vegas, interior view, at high noon, of eternally twilit "Grand Canal Shoppes," as a tourist photographs a singing gondolier. At right, a duplicate of the Fondaco dei Turchi.
Photograph by Jennifer Scappettone, October 2012.

their interiors climate-controlled and illuminated by carefully fabricated perpetual twilight, in an arresting consummation of Marinetti's call for a duskless Venice of "divine Electric Light" (figure C.2). As "city-building," the Las Vegas Venetian Resort Hotel Casino offers a strikingly syncretic panorama of Venetian stylings forged out of 100 million dollars' worth of cast concrete, Styrofoam, glass-fiber-reinforced gypsum, drywall, and a touch of marble allegedly quarried from the same site as the Doge's Palace, navigable by way of people movers and motorized fiberglass gondolas.[3] Having succeeded in outstripping, in ambition, faithfulness, and scale, all previous enterprises of Las Vegas mimicry, magnate Sheldon Adelson then translated The Venetian's ersatz sumptuousness to the Special Administrative Region of Macao within the People's Republic of China, where a second incarnation of "Venice" now forms the scaffolding for the largest casino in the world; at over 10 million square feet total, The Venetian Macao Resort Hotel that houses the new gambling facility is the largest building in Asia and one of the largest globally. In the latest Venetian, the Western gateway to the East meets the easternmost colony of the West by way of Portugal in a chiastic merger of difference.

We have investigated a range of ways in which artists and intellectuals have, since Ruskin in 1851, treated Venice as a lens through which to critique the space-time compressions of modernity. What happens when Venice is transported abroad as ambiance devoid of context, through opportunistic schemes of development more cynical than those Tafuri decried in *Progetto e utopia*? Both the general public and intellectual discourse have been equipped to tolerate, or at least painlessly to dismiss, the elimination of horizons in Las Vegas that leaves us with only "the pregnancy of enlarged, exaggerated and highlighted forms"[4]; Vegas has democratized and banalized myriad singularities through their reproduction as spectacle. But the fact that a city eulogized throughout the twentieth century as an exemplar of difference—the urban organism built to human scale of Le Corbusier's 1935 *La Ville radieuse*; the "highly imageable" Venice of Kevin Lynch's 1960 *The Image of the City*; the "shrine to livability" contrasted rhetorically with the spatial homogeneity, amnesia, and formlessness of "edge cities" in Joel Garreau's 1991 study—now stands as paragon of a posturban phenomenon of duplication is particularly troubling to many critics.[5] In an analysis of "industrial tourism" titled *Venice, The Tourist Maze* (2005), however, sociologists Robert Davis and Garry Marvin identify the Vegas clone as a just apotheosis; with its hotel, mall, restaurants, spas, casino, and resident staff of thousands, "The Venetian is indeed arguably a genuine town in its own right, going about the postmodern world's most real business, that of selling image for profit."[6] Meanwhile, they claim, Adelson's figures for describing his reproduction (as a jewelbox or magic treasure) divulge unwittingly that "without its vital human element, Venice is indeed what he claims—a toy town, a heap of baubles, magic or otherwise"— and further, that The Venetian can reasonably be claimed as "more real than what the original has become." The project team for *Migropolis: Venice / Atlas of a Global Situation*, the two-volume outcome of Wolfgang Scheppe's 2006 course on the "Politics of Representation" at the Architectural Institute of Venice, asserts with greater nuance that "if Venice regards itself merely as a profitable touristic infrastructure, then it is made obsolete by the unsoiled and more accessible version."[7]

In 1974, Henri Lefebvre asserted that "Venice, more than any other place, bears witness to the existence . . . of a unitary code or common language of the city" that "goes deeper, and in some sense higher, than the spectacle Venice offers the tourist."[8] Such articulations of Venice's unique integrity resound with irony in the face of these colossal trouncings of context, through which, as Andreas Ruby describes it, "[t]he city as an iconographic cliché becomes an interiorized condition that can be produced at any required position

within postsuburban territory."[9] Dislodged from its lagoon, subtracted from organic tempos and from the light that dramatizes the foundations of Venetian aesthetics in contingent conditions, the crown of idealistic contrasts against failed modern projects on the part of twentieth-century urbanists has entered the "transurban condition." Naturally, Venetian morphology must be violated to a considerable degree to accommodate these developments. While architects from The Stubbins Associates and Wimberley Allison Tong & Goo cleverly incorporated the twists and pedestrian bridges of Venice into the design of the "Grand Canal Shoppes" in Vegas, the casino developers also adapted some Haussmann-like principles for the late twentieth century: consultants Dan Blatteis and Robert Schnur report that at first, along The Venetian's "Grand Canal," "the traffic flow was wrong. . . . the walk was originally all on one side of the canal. Single loaded. And there were *cul de sacs*. We had to get rid of all the dead ends. We had to develop desirable sight lines. All the great streets have two sides lined with interesting shops and activities to entice the consumer. . . . You must entice the consumer to see the whole project."[10] The resultant success of the 1.5-billion-dollar megaresort's "Shoppes" has inspired the Mall of America and Prime Outlets in San Marcos, Texas, to appropriate "Venetian" stylings as well.

The phenomenal appeal of The Venetian to postmodern sensibilities—its amped-up compliance with understandings of the simulacrum so well disseminated as to be themselves clichéd—has also attracted homages in the highbrow realm: rumors spread in 2005 about the casino serving as a set for a film adaptation of *The Merchant of Venice* starring Sir Ian McKellen and Patrick Stewart.[11] Rem Koolhaas's Office of Metropolitan Architecture (OMA) collaborated directly with The Venetian, designing a conceptually site-specific Guggenheim Hermitage Museum and Guggenheim Las Vegas exhibition space for the complex, in the year 2000 (enterprises that lasted only a couple of years before closing). Koolhaas entrenched features of Vegas high pastiche within both spaces: artworks on display within the Hermitage "Jewel Box" stuck to stark walls of Cor-Ten steel, as the architect described "[l]earning from refrigerator magnets"—metonyms for the changing "schedule" of Vegas signs analyzed by Venturi, Scott-Brown, and Izenour; in the hangar-like Guggenheim gallery, instead, Koolhaas took his learning from the Las Vegas Strip's time-space solecisms by installing a canvas reproduction of Rome's Sistine Chapel frescoes into a ceiling of glass and steel struts.[12] In the process, the decrier of Junkspace gave expression to the displacement and confused representational apparatus of twenty-first-century Venice with immaculate complicity.

In 2013, Koolhaas's OMA design team received approval to usher such worldly citations into the city of lagoons itself: OMA is now building a "prestige department store" and public exhibition space for Benetton within the sixteenth-century Fondaco dei Tedeschi—the site of Giorgione's erstwhile frescoes, whose twentieth-century civic function as a post office waned in the face of a dwindling population (once again exposing Marinetti's projections as prophesy). Public outcry led Koolhaas to revise his plan to incorporate Venice's first escalator into the central courtyard, moving the conveyances to a more marginal position beneath the portico; the Venetian resistance surely intuited the elevator's function as a totem of consumption that, with its halo of dollar signs, brands the cover of Koolhaas's *Harvard Design School Guide to Shopping*—a tome that admits that "shopping has infiltrated, colonized, and even replaced, almost every aspect of urban life."[13] In the meantime, Koolhaas's theoretical exhibition project *CRONOCAOS* explores the crisis of unchecked preservation as a new form of historical amnesia and a stumbling block to the living, to change. *CRONOCAOS* received the ultimate form of validation in being awarded the Golden Lion at the 2010 Architecture Biennial; in addition, Koolhaas was appointed to direct the esteemed exhibition's 2014 edition.

The Venetian is only the latest (and most fastidious) in a series of exportations of premodern Venice fueled by the enthusiasm and wiles of modern collectors and entrepreneurs. The inhabitation of Venetian palaces by expatriated Anglo-Americans and Northern Europeans in the nineteenth century led to an inverse movement in the early twentieth century: the exportation of the palaces themselves abroad. It was at the Palazzo Barbaro that Isabella Stewart Gardner acquired a taste for the accumulation of Venetian things, under the tutelage of Charles Eliot and Richard Norton, Joseph Lindon Smith, and Bernard Berenson. To house these and other European treasures, she built a "Venetian" palace on the Boston Fenway in 1902, transporting stones across the Atlantic in its service, and inspiring Henry James to write of Fenway Court, with its "most delicious Venetian and Barbaresque associations," as "a thing of so much interest and importance."[14] But plans of a much larger scale were soon afoot in New York, a mercantile capital that was beginning to be called "the Venice of the Atlantic."[15] An expatriated New Yorker, James remarks upon the resemblance between Venetians and the inhabitants of the Upper East Side in *The American Scene*. While the bourgeois "bidders" at the auction of life that is New York City fail to compose the grandeur of "a Paul Veronese company"—James's condescending aside suggests that "the nearest approach might have been in the great hounds and

the little blackamoors"—the author does see "a kind of analogy" between the two populations. As he detects in the New York attitude of wanting only "to outbid and prevail" a harbinger of "the last revelation of modernity," he muses paradoxically that there is a kinship underlying his vision of incongruity between the cities, asking rhetorically, "for what were the Venetians, after all, but the children of a Republic and of trade?"[16] The comparison suggests that Venice has an even richer and more ongoing relation to the modern than New York does—that Venice was modern in the sixteenth century.

James's intuition of an analogy anticipates the comparative fantasies of urban planners seeking to increase the efficiency of traffic and trade in the growing metropolis. A key instance of citing Venetian morphology through planning arises in Harvey Wiley Corbett's 1923 proposal to relieve the congestion of Manhattan island by rendering it "*a very modernized Venice,* a city of arcades, plazas and bridges, with canals for streets . . . filled . . . with freely flowing motor traffic," thereby increasing the capacity for automobile traffic sevenfold. (What twentieth-century urbanists regarded as Venice's natural "zoning" function, or the integration of traffic into the city fabric while separating pedestrians from vehicles, continued to figure in even more outrageous visions of "dry" Venices: in his 1966 *Freeways* and 1970 *RSVP Cycles*, Lawrence Halprin presents the layout of Venice as a "street score," with the Grand Canal acting as a "major freeway," and side canals providing access and service.[17]) Venice's exportation is thus hardly limited to décor; the city at large has become abstracted as a transportable form, called upon to order and dignify the havoc of distant upstart sites. This phenomenon has given rise to more than one hundred cities, townships, and villages or urban zones that boast the name of Venice or Rialto. The moniker "Venice" graces many more city quarters and parks, such as London's Little Venice, and makes at least thirty-five "Venice[s] of [insert geographical zone here]" intelligible from Saint Petersburg (the "Venice of the North") to Sitangkai (the "Venice of the Philippines"), taking forms more beguiling than those Calvino envisions in *Le città invisibili*.[18]

A sense of the kinship between the capitals of the modern and early modern worlds persists in theoretical reassessments of modern urbanism under late capitalism, wherein Venice reemerges as New York's antique doppelgänger. In his "retroactive manifesto" for Manhattan, *Delirious New York* (1978), Koolhaas presented Corbett's scheme of picturesque "Venetian" congestion as part of a metaphoric "*matrix of frivolity*" that "substitute[s] for literal organization—impossible in any case—a form of poetic control."[19] Koolhaas stressed the plan's cunning, calling it "[p]ragmatism so distorted" as to

become "pure poetry"—with Venice functioning as "a metaphor that orders and interprets an otherwise incomprehensible Metropolis."[20] *Delirious New York* outlines the continuum between Corbett's proposal and Sen. William H. Reynolds' plan for the Canals of Venice in Coney Island's Dreamland, opened in 1904: at this early amusement park, visitors would float through a Grand Canal on gondolas inside a miniature Ducal Palace containing reproductions of all of Venice's major buildings. Like the Columbian Exposition design that provided patterning for Burnham's 1909 Plan of Chicago, such spaces of leisure must be regarded as blueprints anticipating those of the city itself; Koolhaas notes, "Dreamland is a laboratory and Reynolds an urbanist: this interior Venice, wrapped in its cocoon of many layers of canvas, is an urban model that will reappear."[21]

Indeed, in the heart of Wall Street, in 1910, Trowbridge & Livingston fantastically merged the form of the St. Mark's Campanile with a crowning Mausoleum of Halicarnassus to produce their 539-foot-high office tower and monument to Bankers Trust. That Venice figures in the plans of both Coney Island recreation and in traffic and trade patterning in the city center becomes a metonym for the marriage of Luna Park with the city proper, fantasy with actuality. And New York is far from alone: Abbot Kinney's "Venice of America," inspired by the seaside resorts at the Lido and founded on reclaimed Pacific marshlands in 1905, combined entertainment with residential living in a single space. Again and again, Venice supplies the promise of a habitable mirage.

Less ludic analyses of the correspondences between New York and Venice by Massimo Cacciari and Manfredo Tafuri preceded that of Koolhaas. Both Italian theorists gloss one of Nietzsche's aphoristic fragments concerning Venice in seeking to comprehend the urban and economic developments of their time: "One hundred profound solitudes form the whole of the city of Venice: this is its spell. An image for the man of the future."[22] Tafuri's "The Ashes of Jefferson" (1976–78, published in *The Sphere and the Labyrinth*) presents the New York of the 1890s onward as "an allegory of the Venice of modern times."[23] Tafuri's sustained philosophical reading stresses Nietzsche's departure from the romantic reading of Venice to focus instead on its embodied prophesy of the city of the future as a *"system of solitudes."*[24] In Tafuri's interpretation of Nietzsche, Venetian city structure and the mercantile impulses it enables fuel the social fragmentation that will be consummated by Manhattan's more advanced concretion of capitalism, modeling the self-interested associations of *Gesellschaft* (impersonal "society"; "company") as opposed to the communal values of *Gemeinschaft* ("community," in German sociology)—so that it becomes "a place wherein the loss of identity is made an institution," giving rise to a metropolis driven by "the anguished consumption of multiplied signs."[25]

Tafuri's analysis marks its debt, in turn, to the writing of Cacciari, his colleague at the IUAV, who in *Metropolis* (1973) builds on German sociology to read relations in the city through the development of a monetary economy. Cacciari locates in the rootlessness of Nietzsche's Venice an "*immanent*" detachment that makes "of *each* building, of each mo(ve)ment, *a solitary thing*" or volitional individuality.[26] For these theorists, the archipelago's intrinsic fragmentation renders the seemingly unique city of lagoons paradigmatic of, not antithetical to, an advancing late-capitalist society. In the same period, Koolhaas built on Nietzsche's aphorism to propel his argument in *Delirious New York*, suggesting that the structure of Venice prefigures the destiny of Manhattan as a conglomerate of estranged skyscrapers on sites as distinct as warring city-states—"a metropolitan *archipelago* of 2,028 islands of its own making."[27] Koolhaas's vision is realized to the point of absurdity in the dry archipelago of Las Vegas's fantasies-for-risk.

We might view Venice's vagrancy in the twentieth century as a logical extension of its dissolution and drift under colonization, and of its aperture to importations and exportations of laborers, spectators, and art once becoming part of the Italian state. Celeste Langan's analysis of the exchange of the former republic between Napoleon and Metternich suggests that as early as the beginning of the nineteenth century, "Venice came to represent an entirely different model of 'floating capital,' demonstrating how even the most apparently fixed forms of property—even the built environment of a city—can be traded for profit."[28] In *The Golden Bowl*, James's Adam Verver contrives a Gilded-Age highbrow harbinger of Las Vegas: his "American City," whose great museum will feature painted Venetian "lustres" left quizzically unqualified as objects, now awaiting their "final far migration."[29] Such distribution of Venice through art would have appealed to the Futurists. Though Marinetti reprimanded the English for their fetishization of Italy's oppressive past, emblematized by their obsession with "the chance preciously to bring home a miserable stone trampled by our forefathers,"[30] he applauded the exportation of Italian art abroad, taking it on as one of his first initiatives upon being nominated as an Accademico d'Italia. *Futurist Democracy* declares in the wake of the disastrous Great War that "[t]he sale of our artistic patrimony . . . will demonstrate to the world that a young populace . . . knows how to . . . transfor[m] its dead riches into live forces, as an intelligent aristocrat renounces all vain splendor and throws his gold into industry. . . . [O]ur ancient works of art, sold in America, in England, in Russia or in France, will become the most efficacious of *réclames* to the creative genius of our race."[31] But Marinetti also supported more sublime shrinkings of distance: his "Wireless Imagination" applauded a "[n]ew tourist sensibility bred by ocean liners

and great hotels (annual synthesis of different races)" and "[t]he earth shrunk by speed" so that a deprovincialized "man will gain the sense of his home, of the quarter where he lives, of his region, and finally of the continent," satisfying an "urgent need to establish relations with all mankind."[32] Paradoxically, it is Venice more than the industrial city of Milan that best represents this destruction of provincial syntax; Marinetti did not recognize that passéism would drive, rather than diminish, Venice's eventual global reach and lure.

The unfastenable, flexible archipelago endures due to its unhampered traffic during the years of its mercantile monopoly and thereafter due to its aperture to foreign influx and efflux. Wolfgang Scheppe's *Migropolis* takes boundaryless Venice as a paradigmatic junction of the global flows of industrial production, tourism, and labor-induced migration: a concrete space of flows, whose sea connects the city "to all aggregate states of flight." Poised at the juncture of "the two largest continents of migration," Venice is the place where we can witness most visibly and precipitously the transformation of the particularity of historical metropolises "into the generic model of a territorial entertainment industry."[33] Conducting case studies of the eighty thousand commuters who flow daily into the historic center to work, and of the illegal immigrants who represent ten percent of the legal population in the central districts, the project launches a more profound critique of both tourism as an industry and of the abstract concept of globalization by examining the convergence of "*leisure-based mobility*" and "*subsistence-based mobility*" in Venice. Scheppe's culminating publication takes Antonio's lines from *The Merchant of Venice* as an epigraph:

> For the commodity that strangers have
> With us in Venice, if it be denied,
> Will much impeach the justice of his state;
> Since that the trade and profit of the city
> Consisteth of all nations.
> (*The Merchant of Venice* 3.3.32–36)

Venice's porosity, its thoroughfares open to strangers from Shylock on, epitomizes the modern nation whose boundaries are no longer defined by "bonds" of kinship, but by those of commerce.[34] The proposal that Venice "[c]onsisteth of all nations" has been key to the city's power and allure for centuries. That sense of the city's cultural hybridity has been bastardized by projects that equate Venice's worldliness with the notion that it can be duplicated as a heap of unanguished signs anywhere on Earth. Yet these projects simultaneously epitomize the fate of a place cherished for its uniqueness under transnational capitalism.

In an ironic shift from Ruskin's demonstration of the unique contingencies leading to the founding of Venice's "throne" (*Works* 10:15), it seems there are *infinite preparations possible*, under late capitalism, for the founding of "Venices." But are there limits to the city's conceptual portability? As Venice is increasingly packaged for tourists at home and exported abroad, it becomes a seductive arena for metastructural thinking surrounding the fate or futurity of place in the throes of globalization. In *One Place After Another*, Miwon Kwon characterizes site-specific art as a compensatory act: one that attempts, against its commodification, to resist the "spatial undifferentiation and departicularization" theorized by postmodern geographers, resulting from the drives of technology and telecommunications "to accommodate an ever-expanding capitalist order."[35] Kwon's thesis spurs questions that resonate with the translation, importation, and relocation of Venice in globalizing contexts; for increasingly, it is the morphological totality of place *itself*, rather than its artifacts or souvenirs, which becomes a desirable export.

Unmoored from the geographical conditions that molded Venetian forms, and stripped of *tempo*, of weathering and time such as the authors encountered in this study have labored to reconstruct, "Venice" constitutes little more than a jumble of topoi cloned to ensure an uninterrupted flow of abstracted consumption—albeit one anticipated by the *capricci* of Canaletto, which bespoke Venice's manipulability as an image to be consumed by foreign gentry two centuries before. The clever reshuffling of monuments at The Venetian to compose a continuous "view" from the Las Vegas Strip would quickly lose its interest were the elevator not ready to escort busied spectators, through pseudo-convolutions, directly to slot machines or Grand Canal Shoppes: there is no reason to remain otherwise for any longer than the instant it takes to capture, as pixels, an apparition that splays itself so readily to the gaze. And if one were to linger outside rather than entering to gamble on apparently immaterial value undeterred by the rhythms of night or day, she might become wary of the stultifying monotony of a perpetual present inside—a present become the doom of a twilight that never expires.

REFUSAL OF SITE AND MEMORY WITHOUT DEPTH: VENICES OF THE NEW YORK SCHOOL

According to Frederic Jameson's canonical account of the logic of late capitalism, postmodern historical narrative either recurs to fabulation or shows that contemporary citizens are in a new historical situation, "condemned to

seek History by way of our own pop images and simulacra of that history, which itself remains forever out of reach."[36] The seemingly obsolescent genre of lyric poetry can pose a powerful, if marginalized, resistance to this narrative crisis of the actual; the flexible time-space of lyric, when conceived outside of the transhistorical frameworks that dominated its reception in the post-Enlightenment period, can be seen to dodge and expand the mortifying sameness of a present stripped of any local difference, memory, or portent.[37] Poets continue to be drawn to Venice in a postwar context of collapsing temporal and geographical horizons—and must inevitably negotiate the trouble in representing the place either from or as any stable vantage point.[38] The Venice of the late twentieth century is still perceived to be both ubiquitous and unique; The Venetian is merely the most recent instantiation of its irrepressible reproduction. "We are in it so uninterruptedly, at home and abroad, that there is scarcely a pressure upon us to seek it in one place more than in another," James wrote of the relentlessly depicted city in 1892.[39] Or are we? Is there? Venice's age-old status as *both* citation and sumptuous site, lacuna and lagoon, renders it an irresistible topos in poetry alert to the fate of place under transnational capitalism, crystallizing both what Lucy Lippard has named the "lure of the local" and the spreading phenomenon of deterritorialization (whether chosen or imposed). That contemporary Venice dramatizes, more than ever, the difficulty of establishing a stable contemplative standpoint and an authentic, original channel of expression necessitates a more mobile, more flexible and capacious species of lyricism; when an endangered genre addresses a clichéd and endangered place, both are transformed.

Given Venice's portability in the late twentieth century, one can easily imagine John Ashbery's disembodied I quipping, "My wife thinks I'm in Venice—Venice, California, that is," to convey, and playfully purvey, the floating of signifiers for place. Yet joking gestures toward the precession of Venetian simulacra would themselves be platitudes in the postmodern moment. Ashbery ends his 1972 poem "Worsening Situation" with the punchline "Oslo—Oslo, France, that is," instead, and invokes Venice more obliquely in the book's next line, within "[t]he shadow of the Venetian blind on the painted wall."[40] The displacement seems symptomatic, but it could be strategic. As one of several members of the New York School of poets who stage a literary return to Venetian scenes in the wake of modernism, Ashbery provides a valuable perspective on contemporary questions of place, space, and banalization. Ashbery, as we have seen, followed and commented on Aldo Rossi's conceptual work on the city, while Frank O'Hara selected U.S. representatives for the 29th Venice Biennale in 1958.[41] But Venice embodied

a more substantive appeal; for these poets made up a new generation that was ready to float and reanimate preexistent, lowbrow tropes—in a word, clichés—within a postmodern aesthetic that was erudite, campy, and urbane by turns.[42] Venice offers postwar poets the opportunity to reengage the dregs of romanticism still operative after the rejections of modernism. Like James Merrill and his circle, Ashbery and O'Hara were willing to invoke the gay *fin de siècle* of Arthur Symonds, Frederick Rolfe/Baron Corvo, Pater, James, Sargent, the Decadents, and other aesthetes as part of a lasting queer tradition, without contempt. They did not need to hurl off heroically (and anxiously), as high modernists had, the sentimental history and "unmanning" legacy still suffusing the Venetian scene. Jean-Paul Sartre had in 1953 written of Venice as a castrating and painfully literal "no-man's land," a place of the Other "that is wherever I am not"; and intimations of Venice's archetypal alterity and effeminacy continue to saturate postwar writing on the place.[43] Robert Duncan's "The Venice Poem"—written in 1948–49, before Duncan had been to Venice, imagined instead through Shakespeare, Proust, and Pound and the replicated "Campanile" on the University of California at Berkeley campus— cleared the way for these New York School efforts through a symphonic composition surrounding love and *Othello*-laced jealousy punctuated by moments of unmitigated queer passion: "Men fuck men by audacity. / Yet here the heart bounds / as if only here, / here it might rest."[44] The paternalistic literary influence defining Venice, often cast as an Oedipal burden to be wrestled with, thus assumes a sentimental, even homoerotic possibility; and the phallic but "Fatherly towers in the air!" ringing out the hours at the poem's close recast what it could mean to compose *melopoeia* in the wake of modernism.[45]

The most compelling sustained meditations on Venice produced over the past fifty years address the tension between the fiction, and condition, of Venice as a commonplace and the city's role in an ongoing history—its history being imbricated in that of Los Angeles, Macao, the San Francisco Bay Area, and New York, whether through commerce or reduplication. Poets of the postmodern era can manipulate signifiers of Venice become omnipresent to the point of absurdity and/or kitsch, while subtly refusing to disavow the distinction between here and there, then and now—distressing the jaundiced, chlorinated, simulacral Venices that have arisen through the schemes of twentieth-century planning by plumbing the city's history as the vehicle of a *mise en abyme* of signatures.

Reverberations of an inexplicit "Venice" resound throughout John Ashbery's body of work, begging for localization. "Two Scenes," the opening

poem of his first full-length volume *Some Trees* (1956) evokes, while refusing
to identify, a potentially "Venetian" vignette:

> A fine rain anoints the canal machinery.
> This is perhaps a day of general honesty
> Without example in the world's history
> Though the fumes are not of a singular authority
> And indeed are dry as poverty.[46]

"Two Scenes," in two numbered sections: though vaguely redolent of a Vene-
tian *capriccio*, they nonetheless decline to materialize. Figures and grounds
alike are abstracted as "canal machinery" in this unfixed "scene" taking place
everywhere or nowhere, during a day whose honesty is posited, and "general,"
rather than fixable within a particular historical exemplum. The "distinctive
offering" that comes "[f]rom every corner" within the poem's first section
is distinctively abstract, as spectral as the pronominal "us" that replaces the
"ourselves" expected in the poem's first line ("We see us . . ."). On the sonic
register, "so much news" collapses into "such noise" as historical specificity
is set aside in favor of bland mouthing about pleasant weather. In the sec-
ond stanza quoted above, time and place have been equally rarefied. The
"dry" effluvia issuing from unidentified authorities that pervade the moist
scenario register as figuratively so: as ironical, given that they are grounded
in no matter of decay. "Destiny guides the water-pilot, and it is destiny": the
only navigational force that makes this dissolute topography cohere is tautol-
ogy; direction and destination are supremely discursive. The spatial chart the
scenes lack is akin to the last line's now-notorious "schedule" that everything
has, " 'if you can find out what it is.' " As Marjorie Perloff argues of the media-
saturated 1950s in which the poem was written, " 'everything' no longer
pointed at anything in particular."[47] Harry Mathews's wistful, if riddled and
thwarted, attempt to place Ashbery's early lines into the mouth of a mandolin
player in the bowels of a palace near Naples—Naples, Florida, that is—in his
experimental novel *The Sinking of the Odradek Stadium* (1971) stresses their
flirtation with emplacement, while evoking the pathos the lyric's overriding
placelessness produces.[48] Mathews himself, living in Venice in this period,
was all too aware of the appeal of that city's "local aura," staged and produced
both ludically and pathetically vis-à-vis cardboard pageantry.[49]

The pathos of placelessness persists in spite of Ashbery's signature detours
from sentiment: in 1991, the postmodern poet is still in the same boat of
unoriginality as post-Romantic James, still adrift on the infinite voyage

among signs diagnosed by Tafuri in *The Sphere and the Labyrinth*, "Still in the published city but not yet / overtaken by a new form of despair."[50] This is the opening of *Flow Chart*, a revisionary epic of abstracting space and time riddled with flux that has become blatantly figurative, representational, diagrammatic, as "history constantly dwindles" (157) and "[t]here is / only the fading, guaranteed by the label, which lasts forever" (6). The poem's decentered lyric subject is situated in an inhospitable, yet managed—we might say "landscaped"—archipelagic vista, obliged to ply the purgatory between "[s]till" and "not yet." *Flow Chart*'s entropic discourse deploys tropes of water, stone, and mud that mark a hearkening back to a city that dare not speak its name; these materials supply irresistible figures for moorings in a landscape that yet remains surreptitious, unchartable, and threatens to sink, drift, or dissolve. The poem's canals *could* be located in Delaware or Bolinas, but they reek of Venice by dint of being placed in verse at all, due to Venice's monopoly on the "poetry" of canal landscapes.[51] Moreover, "whatever void we may be living in" here is likened suggestively to "a romantic, nocturnal place that must sooner or later go away" (*Flow Chart* 76).

In documenting ramifying, elusive "channels" that could be watercourses or frequencies ("Pick a channel, explore, document it" [43]), Ashbery's digressions recall lagunar structures of transmission still capable of generating intimacy: "We called across / shallow lagoons to each other; it seemed to help" (50). The text wonders counternostalgically, "Does the lagoon still stink? Or did somebody drain it after all those years of miasma . . . ?"(129). Its "chart" traces the infrastructure of disjunctive relational pathways, syntactical deviations from the administered "flow" of surpassed engineering, computing, and communications models. With "plates empty / and brimming with moonlight," Ashbery's elusive "we" attempts to "make sense of this arbitrary and tangled forest of misplaced / motives and other shades of imperfect sympathies," sentiments that become auratic, that engulf: "I feel their aura, Mother, like a water table ascending" (72). As the text floods the reader with unanchoring queries such as, "do you know . . . that dams are collapsing in Italy, . . . ?" it redrains deixis: "This is the way to go—here. This the place / to be" (102). The poem is riddled with metastatements regarding the erstwhile dependence of lyric personhood upon place become text: "Yet I see you are uncertain where to locate me; / here I am" (27); "There has to be a space, even a negative one, a slot / for me, or does there?" (29); "I had / many ties to the region" (103). The book-length poem closes on an "opening" to a new landscape that is either freeing or terrifying, being linked in altogether equivocal relation to a bridge: "It's open: the bridge, that way" (216).

The contemporary vertigo of Ashbery's poetic finds precursors in the vertiginous landscapes of Venetian art. In a 1978 essay composed upon the bicentennial of Piranesi's death, Ashbery cites Horace Walpole on the Venetian printmaker's fantastic aporetic architectures: "He piles palaces on bridges, and temples on palaces, and scales heaven with mountains of edifices." Conversely, he cites Sir Kenneth Clark's remarks on the resemblance between the engraver's prison interiors and the rational architecture of modern bureaucracy: "You must go up the stairs to obtain a permit, then take it over to one of those little round towers to be stamped; unfortunately this office is closed, and you are instructed to go up to the top gallery, but in doing so you have taken a wrong turning and have infringed the regulations, so you must come down and visit the office of the security officer."[52] In this interpretation, Piranesi's spatial marvels present the illusion of boundlessness within a dizzyingly panoptical scheme of rational management that pervades the modern world. Ashbery glosses the deformations of space enacted by earlier Venetian art in a liberating key when reviewing an exhibit on *Space and Dream*, identifying Carpaccio as the precursor for Metaphysical and Cubist efforts to "pulverize" matter so as to "discover a medium no longer ruled by the compass, where potentialities could become facts merely through being evoked." In paintings such as those of the Saint Ursula cycle, Ashbery claims, "a detail in the foreground will often seem inextricably welded to something in the background."[53] He argues that the modern spatial fantasy to which Carpaccio gives rise—which he describes faux-naïvely as "freedom of the skies"—is the "hereditary province" of poetry, a genre distinguished because in verse, "the mere mention of a place-name ('Aleppo once') is sufficient to transport us there, and a girdle may be put around the earth in something less than forty minutes."[54] Yet "transport" within Ashbery's writing is less immediate than this seemingly unremarkable claim allows; the concluding phrase cites *A Midsummer Night's Dream*, while the "Aleppo" within Ashbery's parentheses is not so much the city in Syria as a citation from Othello's pre-suicide soliloquy. From Shakespeare's Cyprus, the Moor of Venice commands,

> Set you down this,
> And say besides that in Aleppo once,
> Where a malignant and a turbaned Turk
> Beat a Venetian and traduced the state,
> I took by the throat the circumcisèd dog,
> And smote him, thus—[55]

and redoubles this smiting act by stabbing himself, thereby melding enemy Turk with geographically indistinct "Moor," Syria with Cyprus: other with internal other, elsewhere with internal elsewhere, "once" with twice.

Ashbery's " 'Aleppo once' " more immediately recalls Nabokov's citation from *Othello* in the 1943 title "That in Aleppo Once. . . . " This story's narrator, a Russian poet-émigré, recounts his apocryphal wartime honeymoon of "waiting for unscheduled trains that were bound for unknown destinations, walking through the stale stage setting of abstract towns"; now betrayed and deserted by his spouse, the jealous narrator writes so that his friend or double, an equally displaced compatriot, might clarify the circumstances of her disappearance through his writing.[56] Haunted by visions of his wife's pacing where reflected light plays upon a punningly "moored" fishing boat, the narrator closes his tale with self-reflexive talk of titling, revealing that he is addressing himself: "It may all end in *Aleppo* if I am not careful. Spare me . . . : you would load your dice with an unbearable implication if you took that for a title."[57] The *mise en abyme* of references invoked by Venice's long registration in art and literature provokes digressions that render poetic transport far more vertiginous than sheer "freedom of the skies." Ashbery's "province" as poet is omnivorously, burdensomely cosmopolitan, and ponderous with the "unbearable implication[s]" of past signatures, for those availed of keys to these allusions. Yet the precession of references undercuts the weightlessness of the relentlessly depicted Venetian environment; even as it digresses into more abstract channel machinery, this poetry's space is haunted.

Ashbery's place-name lacks altogether the modernist will to immanence embedded in the incantatory recollections of Pound's postwar Pisan Cantos ("Trovaso, Gregorio, Vio"[58]) or the more attenuated promise of a "complete museum" ensconced within Proust's place-name:

> I need only, to make them reappear, pronounce the names: Balbec, Venice, Florence, within whose syllables had gradually accumulated all the longing inspired in me by the places for which they stood. . . . [T]he guide-books ministered even more to it than books on aesthetics, and, more again than the guide-books, the railway time-tables. What moved me was the thought that this Florence which I could see, so near and yet inaccessible, in my imagination, if the tract which separated it from me . . . could yet be reached by a circuit, by a digression, were I to take the plain, terrestrial path. When I repeated to myself . . . that Venice was the "School of Giorgione, the home of Titian, the most complete museum of the domestic architecture of the Middle Ages," I felt happy indeed.[59]

Unlike Proust, Ashbery does not dream of the digressive path to an intact aesthetic elsewhere, nor, perhaps, of arriving elsewhere at all; in a context so thoroughly managerial and overseen, his poetry only invokes the absent "schedule" for getting there. Ashbery's refusal of site points to the persistence of Venetian topoi in thinking through cultural mappings and flows as "the region" becomes more rarefied, in the face of globalization and the city's translation abroad, while clarifying what remains critical—or symptomatic—about more insistently localized modernism and the site-specific work in its wake.

The play of Venetian surfaces across Frank O'Hara's "In Memory of My Feelings," composed the year *Some Trees* was published, provides a provocative contrast with the precession of his comrade's "Venetian" "scenes." In O'Hara's long autobiographical poem, begun on his thirtieth birthday, Venice provides a shifting *mise en scène* for the effort of memorialization. The poem opens with a figure whose campy Venetian meandering borders on the absurd: "My quietness has a man in it, he is transparent / And he carries me quietly, like a gondola, through the streets."[60] The misplacement of the vehicle of this urban pastoral renders it more stylized still: the Venetian vessel would have to float the speaker through streets rather than canals (presumably those of his New York). The quietude of putative affectlessness beginning a piece written "in memory of" feelings belies the anxious tenor of this opening statement: a man conveys the I in a vehicle associated with infantilization, sex, and/or death, undermining any meditative self-possession on the part of the poet. Occupying the speaker's quietness, this transparent man is the thin inverse of the love like a "cancerous / statue which my body could no longer contain" (257) at the poem's end. This figure's likeness to a series of things other than gondolas elicits the poem's digressive slipperiness, but it also shows why the gondola was an apt figure for the verses' motions in the first place; Breslin notes that "[w]riting about a poem like this is like trying to write on water."[61] The stanzas lack even the nervous countenance of O'Hara's walking narratives, being pervaded by the "seasickness" of the hunted; the poet is "hit" (putatively by the Marines that fill this sea), "*ergo* swim[s]," in a hilarious if terrifying capsizing of Cartesian meditation (254). In section 2, another rococo simile compares the coolness of a mind syntactically estranged from the poet—who is "blue" rather than truly "cool" (253)—to a hotel suite along the Grand Canal:

> And now the coolness of a mind
> like a shuttered suite in the Grand Hotel

> where mail arrives for my incognito,
> > whose façade
> has been slipping into the Grand Canal for centuries;
> > (254)

Shutter itself off as the mind may, the post ineluctably arrives to its persona in the tourist town; an exile retreats to Venice to stage the loss of feeling, but this in itself inspires a feeling akin to the nostalgia "for mere ideas" in section 3. The figurative hotel façade's lasting slippage into the Grand Canal is mirrored in the fading of fireworks dramatizing Venice's marriage to the sea—pairing "cool" with "hot" images of transience:

> rockets splay over a *sposalizio*,
> > fleeing into night
> from their Chinese memories, and it is a celebration,
> the trying desperately to count them as they die.
> But who will stay to these numbers
> when all the lights are dead?
> > (254)

The poem that would project the poet's memories onto the dying rockets, linking them to the rockets of his martyred great-aunt's blood vessels, here marks their origins in the East instead, and underscores their surrender one by one to the unmarked depths of equally foreign Venice. Where, as O'Hara writes, "Memory / is a soundless ruin" (28), it counters its potential depthlessness with depth that exceeds our capacity to sound it.

Such dramas of recuperation and loss within the sinking city underscore that O'Hara is "still very much a post-Romantic poet, yearning for presence, for a particular palpable self that is anchored in a particular body."[62] But what remains, and is affirmed, is only, as Altieri points out, "presence as landscape without depth."[63] The poem's closing lament—"I have lost what is always and everywhere / present, the scene of my selves, the occasion of these ruses, / which I myself and singly must now kill"—implicates the Venetian scene in a series of others, celluloid-thin, grounded in Hollywood flicks and apocryphal historical events.[64] But Venetian surfaces have a special role to play in a poem about the casting off of personae. For Venice's marriage to perpetual change, unlike New York's, is drenched in centuries of pathos. Its perennial liquidation registers in paradoxically permanent and material form the lyric drifter's guiding dilemma that "[s]ensations"—and

the affective responses they invoke—"disappear almost as soon as they are presented."[65]

Postmodern poets willing to reckon with the mediations of history as they are registered within a re-occupied—if increasingly disinhabited and rarefied—Venice contest a prevailing sense of what Jameson, in *Postmodernism, or, the Cultural Logic of Late Capitalism*, famously called the "waning of our historicity" and attendant "waning of affect."[66] Venice's feminized, Orientalized, irrational, fluid character, however much a product of literary fantasy, still necessarily invokes the sentimental. That this sentimentality is clichéd complicates but does not disqualify the matter of Venice for the New York School, as nevertheless "it shall be seen and printed that all our care / is quaint anachronisms or prompt-scripts for retro-chic" (*Flow Chart* 157). Representations of Venice by authors who engage the place as a "traffic jam" of histories—of tropes clashing with the affects of ongoing life—rather than as a mere elsewhere apart answer eloquently to the city's spectral replication across the so-called global village.[67] While Venice still looms in the late-twentieth-century literary imagination as a topos, whether utopian or dystopian, a trajectory of poetry that is urbanely "regionalist" continues to resist the city's abstraction—permitting it only by way of negation and transmutation. Granting that presence is always in quotation, yet resituating aesthetic vessels so that they "ferment place"[68] instead of floating touristically through seamless space, this new regionalism salvages the critical potential of a seemingly residual zone within late modernity. Contemporary poetry that is inflected by film and attuned to the abstractions of space emphasizes, rather than squelches, the resistance shored up by a veritable Venice to modern design's administered "matrix of frivolity."

Two Archipelagos

When apprehended as a collaboration, two seemingly discrepant approaches to the representation of Venice made manifest in the 1976 film *Il Casanova di Federico Fellini* constitute an exquisite expression of the city's paradoxical status as a "place" at once uniquely sited and citational. Reinterpreting the life of a stock eighteenth-century philanderer—Casanova—for an epoch of Italian culture that saw the rise of feminist activism, as well as of economic crisis and violent social turmoil that gave rise to the epithet "the Years of Lead," Fellini's work sets out both to milk and to topple topoi of Venetian irrationality—its primordial fecundity and eroticism, and its dream of perpetual

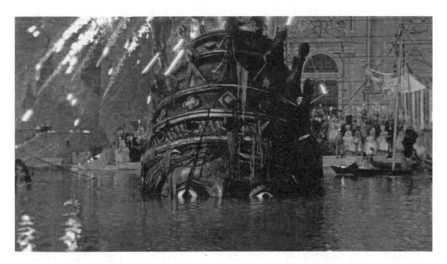

FIGURE C.3. Federico Fellini (director), Andrea Zanzotto (lyricist), Nino Rota (soundtrack), *Il Casanova di Federico Fellini*, 1976. Still from opening sequence: the simulacrum of Venùsia breaks loose and begins to sink into the lagoon in the midst of Carnival rites.

Carnival—through both extravagantly mediated channels of representation and research into local vernaculars. The film opens with a fictive Venetian rite during a Carnival borne by masks, puppets, dolls, and other simulacra. The scene is choreographed around veneration of what Fellini envisioned as "the Great Mediterranean Mother, the mysterious female who lives in each of us," a "dark female simulacrum" heaved by the populace out of the lagoon (figure C.3).[69] The citational quality of this maternal fetish is far from naïve. In the film, Casanova's native city is a literal "stage-set," a spectral embodiment of that trope imported to Venice by outsiders from Shakespeare through Simmel, Pound, Sebald, and beyond: the director chose not to film on location, but to produce the place in the studios of Rome's Cinecittà. This Campanile is two-dimensional, and the stormy Adriatic upon which our hero first appears unmasked is composed patently of black plastic, recalling the trashy Venice of Marinetti's vision of "barges heaped with lovely garbage, escorted by dubious floating paper bags."[70] Fellini explains to his collaborator Andrea Zanzotto— the major poet and one of the most incisive contemporary commentators on Venice—that the fictive fertility ceremony constitutes "to some extent the ideological metaphor for the entire film," in that the "obscure and grandiose fetish" of the opening rite breaks from its rigging and is submerged in the lagoon before the populace manages to heave it out of the water: "the great

head must return to the depths . . . of the Canal, to remain down there on the bottom forever, unknown and unreachable."[71] This course of diegetic events is at once catastrophic and cathartic, in the sense that it preserves Venice's potential as a (faulty) placeholder for primal longings—as what Zanzotto will call, punningly, a *lacuna*. At the same time, the scene portends a historical crisis: the inexplicable failure of the mechanism contrived to haul the fetish out of the lagoon suggests that the profligate Venetians, once illustrious engineers of the seas, are falling haplessly out of step with the advance of the modern.

Fellini cast Donald Sutherland in the role of a post-Romantic Casanova imagined as "a big spermful waxwork with the eyes of a masturbator," whose athletic cosmopolitan intercourse across Venice, France, and England will have polluted his virility before the halfway point of the film.[72] This would-be incarnation of Venetian romance makes love like canal machinery, a seeming droid rising and falling according to the invisible dictates of a perversely engineered choreography.[73] From the first, Fellini's Casanova is literally and metaphorically overseen by the coming regime of Enlightenment: a French ambassador peers in on his first sexual encounter—presumably for kicks, but subsequently assessing the Venetian's performance through the peephole with banalizing scientistic precision. Throughout the film, Casanova's every erotic encounter assumes the pace of a mechanical cuckoo clock's wings, beating out abstract time in tandem with the brittle jingle of Nino Rota's award-winning soundtrack. The apotheosis of Casanova's desiring mechanism takes the form of his seduction of an automaton late in the film; the obsolescing womanizer recites Petrarch lyrics to the mechanical doll before asking, "Will you abandon your delicate mechanism to my desire?" Yet their mechanisms are, in fact, perfectly matched. The hero makes his final appearance dancing with the automaton in stiff revolution on a Grand Canal whose flux has become frost-bound—within an ersatz icy Venice wrapped in plastic.

The film's postlapsarian philandering sardonically undermines the distinction between the measures of modernity and that romantic dream of Venetian Carnival to which so many artists have recurred since the fall of the Republic. The fable that Napoleon was responsible for Venice's disenchantment permits the myth of an inherent Venetian irrationalism to thrive throughout post-Romantic literature: Edith Wharton expresses this well-entrenched notion when portraying the costumed revelers replaced by mannequins in the Museo Correr as Napoleon's victims: "poor dolls of destiny . . . in attitudes of puzzled wonder, as if arrested in their revels by the stroke of the dread Corsican magician."[74] In a 1983 essay sketching the terms of a second collaboration with Federico Fellini for a televised film on Venetian Carnival, Andrea Zanzotto

recasts this period of "perennial festival," taking place as if outside of history, as the result of an intuition by the Venetian ruling class that "no purely historical renewal would have saved the city"—and that politics could thereby be substituted by "utopia" (posed provocatively in quotation marks).[75] That the death of the penultimate Doge Renier was itself "masked" until the end of Carnival exposes a phenomenon Zanzotto names the "autocarnivalization of power" in Venice—or the awareness that it was Carnival, and not the doge, that really ruled the city. In the spirit of his contemporaries at the IUAV, who view artists as posing conceptual solutions for the enervated Republic's political stasis, Zanzotto suggests that eighteenth-century Venice opens up a space for utopian disenchantment: for the resolution through fantasy of encroaching crises that resist political resolution. Aldo Palazzeschi's 1967 novella *Il Doge* had recently suggested as much, narrating the public fracas around the seemingly interminable postponement of the doge's appearance to contemporary Venetians, suggesting in the process that it is a lacuna, and projections surrounding it, that truly governs an otherwise disunited populace.[76]

Zanzotto's ambiguity of outlook, which lodges the utopian impulse of Carnival within an overarching political infirmity, is characteristic of Fellini's film as well. In his intercourse across the Continent, the cosmopolitan Casanova enacts a most tedious collapsing of boundaries between the irrational and rational worlds, and literally embodies the framing of Venetian sensuality by Enlightenment over and over. This collapse is consummated in Casanova's pre-death dream of 1797, the year of the Republic's fall: the embodiment of *Carnevale* embracing the automaton, a new *sposalizio* rotating as music-box effigy in the eternal stasis of clockwork, on an infertile frozen Grand Canal. Estranged from his Venetian home and mother by ambitions in business and intellectual enterprise, Casanova is destined to encounter them again only in glimpses—just as he glimpses the sunken head of the female simulacrum, barely visible through a sheet of "ice" in the final dream sequence.

The Venetian women who advance, their backs to us, toward the simulacral, Saran-wrapped Rialto in Casanova's closing dream recall those of a 1791–93 fresco by Giandomenico Tiepolo, now detached from the wall of the artist's private villa and known since 1906 as *Il Mondo Nuovo*—in which unmasked Venetians and a single lingering Pulcinella figure become *Rückenfiguren* (literally, "back figures") who look away from the viewer and from an implied Venetian landscape (figures C.4 and C.5). Tiepolo's figures look instead toward the abstracted space of an apparatus conflated through language with the modern world: the "*Mondo Nuovo*" (New World), Goldoni's apt term for a cosmorama and peep show.[77] Directed by the showman's stick,

FIGURE C.4/PLATE Q. Giovanni Domenico Tiepolo, *Il Mondo Nuovo* (The New World), 1791–93, fresco detached from the artist's country Villa di Zianigo near Mestre and now installed at the Ca' Rezzonico Museo del Settecento Veneziano, Venice. Spectators peer into a *mondo nuovo*, or cosmorama.
Courtesy of Bridgeman Art Library.

certain spectators peer in; others crowd around the device, or look into a vague beyond. While the panorama we imagine inside the cosmorama would have celebrated the visual comprehension of landscape as domination, the wide panorama of Tiepolo's own fresco—dating to the moment just before the Napoleonic conquest—literally rebukes such domination, turning its back to us. As onlookers interpolated into a Venetian perspective on this new world, we are shut out definitively from the spectacle—twice belated.

After the fall of the Republic, Venetian aesthetics continue to thrive most recognizably in the byways leading away from national style—in regional vernacular and oral cultures. In commissioning Zanzotto to invent a fantastic eighteenth-century Venetian dialect for select scenes of *Casanova*—a choral hymn for the opening ritual, conversations in dialect among Venetian seamstresses, and a nursery rhyme to be sung by a giantess from the Veneto whom the philanderer encounters after she is sold into a London circus—Fellini spurred the formation of a poetry that revitalized a literary heritage of the Veneto threatened with extinction by languages both national and global.[78] Galvanized by the collaboration, Zanzotto's body of neodialect verse transforms both national and local tongues, forcing anachronism and neologism, vulgar and literary idioms, regional expression and the language of global technologies to cohabit. Fellini lays out his hopes for the film's idiom in a letter to Zanzotto: "I would like to try to break the convention of the Veneto dialect which, like all dialects, is frozen in an emotionless and tiresome cipher, and to try to restore freshness to it, render it more alive, penetrating, mercurial, keen, . . . perhaps . . . attempting

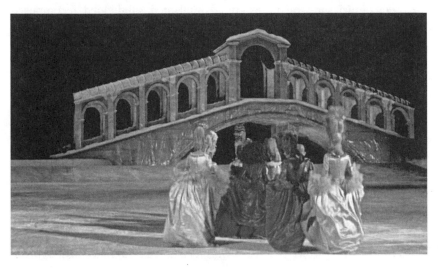

FIGURE C.5/PLATE R. *Il Casanova di Federico Fellini*, 1976. Still from closing dream sequence: Venetian *Rückenfiguren* approach a faux Rialto wrapped in plastic, in a "frozen" Venice.

a capricious promiscuity between that of Ruzante and the Veneto dialect of Goldoni. Better yet, rediscovering archaic forms or indeed inventing phonetic and linguistic combinations."[79] The result of this research, both literary and oral, archaeological and imaginative, is a body of experimental verse that Zanzotto continued for decades to develop, taking a step beyond Pier Paolo Pasolini's more classical social-realist incorporation of dialect. Zanzotto forges an "Apocolocíntosi" ("Apocolocyntosis," playing on Seneca's satirical "Pumpkinification," but with a hint of "Apocalosynthesis") that cleaves to the linguistic "rubble" "del gnentintut che l'è stat al jeri" (of the lil-or-null that was yesterday).[80] Fellini asked Zanzotto to continue working with the "liquid sonority, the confused gurgling, the syllables that melt in the mouth, that sweet broken baby's singsong in a mixture of milk and dissolved solids, a sleep-inducing lapping sound" of a Veneto *petèl* ("baby-babble"), which the poet had explored on an intimate scale in *La Beltà* (The Beauty, 1968). Fellini saw in this work a linguistic corollary for "the kind of subaqueous iconography that characterizes the film, the placental, amniotic image of a decomposed and shifting Venice of algae, messiness, and musty dank darkness."[81]

Infant-ile imagery ("infant" meaning literally *without language*) permeates Zanzotto's writings on the dialect, but far from naïvely, being shot through with a rich historical texture: it is "laden with the vertigo . . . of

the megacenturies in which it extended, infiltrated, subdivided, recomposed itself, in which 'the' language died and was reborn . . . within a very violent drift that causes us to tremble with unease because there we *touch*, with the tongue . . . our lack of knowledge from whence speech comes, and, in the moment in which it comes, rises like milk."[82] Zanzotto's lyrics do not capitulate to the regressive archetypal femininity so readily available to seekers of "Venice," but incorporate his research into the pre-Roman paleo-Venetic goddess Reitia—and nonetheless admit to the necessarily figurative origins of any such auratic image. His Venetian recitative for the film's opening scene calls out to this figure of Venice as "Vera figura, vera natura / slansada in ragi come 'n'aurora" ("Real figure, real nature, / flung out in rays like an aurora").[83] Zanzotto's *vox populi* calls on *Venezia* through many names, each expressing another migration across tongues in time: she is *Venessia* (Venezia, in dialect), *Regina* (Queen), but also *Venùsia* (with its echo of Venus), *Venissa*, *Vanègia*, *Venaga*, *Venùlula*, *Venàssia*, *Frutagna*, *Venàia*, *Venòca*, and finally *Strùssia* (Trouble, in local parlance). Each suffix to the root being venerated suggests a fresh dawning of her qualities, familiar through their music while remaining indeterminate—not fully rationalized as inscription.

In terms of artfulness, the Venetian vernacular has an illustrious and complex history, a literary heritage as robust as Dante's Florentine (the so-called national language), while the oral tradition of the Veneto dialect—or as Zanzotto prefers to call it, the "vecio parlar" (old-time tongue, a phrase that shirks the condescension of a cultivated perspective)—stands as its own powerful linguistic phenomenon. However, lest the local "idiom" withdraw into "idiocy," or a pathological interiority, Zanzotto preserves the power of dialects to *move* rather than suspending these traditions in amber. He composes in order to capture and span the dialects' "infinitesimal capillary movements" without compromising the resources or the reach of global languages "tending toward panterrestrial diffusion."[84] (Fellini's film itself was shot "recklessly" in English and later dubbed [5].)

Zanzotto credits Fellini's visual discourse within *Casanova* with awakening in him "a variety of resonances." In responding to Fellini's visual language (presumably its amped-up mediation), Zanzotto began to tap into both his kinship and his distance from this tongue, produced "within a certain linguistic aura to be called of the Veneto (Venetian only in part) both by excess and by lack": "I came upon a way of speaking lost in the diachrony and in the synchrony of the Veneto, up to the paradox and the unreality of a paleo-Venetic quotation, a way of speaking partly invented, partly imitated from excessively high models, in which apprehension for the rights of glottology and philology could not hold at bay the desire to tear up the margins, to go far away" (*Peasants Wake*

87). The poetry in the wake of this collaboration infuses the spoken *lengua* of the Veneto with the lingo of globalism, as well as centuries of Venetian literary invention—in consummate expression of the archipelago's aperture to global influence, or what he elsewhere calls its "cosmic extraterritoriality."[85] Because dialect emerges from a place of no writing and no grammar, it remains "far from every throne," and designates a place where boundaries dissolve, as "every territoriality vanishes into those that are contiguous."[86]

In *Filò*, a lyrical account of this project that takes its name from the pastime of telling "yarns" in the peasant culture of the Veneto—and whose title in English, *Peasants Wake*, was proposed by Zanzotto so as to echo Joyce's *Finnegans Wake*—an inventive Venetian idiolect imagines verse as that fire which makes all foundations creak

inte la gran laguna, inte la gran lacuna—
la é 'l pien e 'l vódo dela testa-tera
che tas, o zhigna e usma un pas pi in là
de quel che mai se podaràe dirse, far nostro.

in the great lagoon, in the great lacuna—
there's the plenitude and void of the earth-head
who keeps silent, or winks and sniffs out a track beyond,
one we could never name or make our own.

<div align="center">(Peasants Wake 83)</div>

And yet, while affirming this topos's elusiveness, the poet makes no claim for its authenticity outside of transmitted media, but announces that the "earth-head" has "come back" to him precisely "da l'aldelà de ciaro mort e morta celuloide" ("from the hereafter of dead diffuse light and celluloid") (62). He recollects the "landsliding" of this new language into his pen, but maintains that the result "no l'é qua né là, venizhian sì e no, / lontan vizhin sì e no. . . . " ("is neither here nor there, Venetian yes & no, / out of reach, near, yes & no. . . . ") (60–61). In an essay, Zanzotto explains that this work required a nearly "metalinguistic" use of the dialect of his home region—a zone that is "obscurely constrictive," yet whose ultimate flexibility leads him to conclude, "Dialect . . . is an absolute freedom, capable of tracing consistent/mutable limits" (88). Resuscitating an endangered local vernacular while resisting any nostalgic effort to seal archaic folk forms off from the influence of a living *lingua franca* becomes a species of freedom. In linguistic and geographical terms, Zanzotto's archipelago, always open and vulnerable to remote influence, can be read as the uncanny but tenuously liberated prefiguration of a global network.

Riddled with tinctures of local and imported luminescence, the apparently museal city remains splayed to the imagination; and the dialect of one archipelago inevitably feeds another. While Zanzotto ascribes the source of his poetry's inventive lagunar dialect as much to film's plastic "hereafter of dead diffuse light and celluloid" as to the fading vernacular of Venice's islands, Derek Walcott explores routes for representing the "local terror" of his homeland of St. Lucia (named after the martyr associated with light and vision) through a stroke of Venetian light hung in the Metropolitan Museum of Art. This is the basis of *Tiepolo's Hound* (2000): Walcott's decades-long search for the painted pink stroke on the thigh of a white hound glimpsed begging for scraps in a Venetian feast—in a painting, he thinks, by Tiepolo or Veronese, a painting he probably saw during his first trip to New York in 1958, the year he became interested in the work of the New York School, particularly that of O'Hara.[87] Though the sought-out stroke is "so exact in its lucency" (18), memory blurs the identity of its painter and medium, and even casts doubt upon the site in which it was seen: "The hound's thigh blurred the smoky dyes around it, / it mixed the schools of distinct centuries, // fixed in its stance it stays where I had found it, / painted by both, Tiepolo, Veronese" (264). This painted twilight becomes the core of a vertiginous exploration of the movements of three painter-exiles whose common search for illumination collapses their identities across space and time: Walcott's father (a Bohemian civil servant and painter), Camille Pissarro (the Impressionist and Post-Impressionist painter born in St. Thomas to Sephardic Jewish and Creole parents), and Walcott himself, who meet the painted traces of Veronese, Giambattista Tiepolo, and his son Giandomenico. In blurring identities and landscapes, the pink Venetian light becomes in this work "the exact perspective of loss" (20).

The trope of light, though potentially a springboard for transcendental meditation, takes on complex historical resonance in this work. In *What the Twilight Says*, an earlier collection of essays that adopts twilight as an elaborate figure for the distance between the poet and the public, Walcott writes with cutting awareness of the capacity of dusk's luminescence to aestheticize damage, turning impoverished colonial zones into cheap theater. In the tropics, the elevated language of the poet trained through the literary classics of European colonizers appears as a sun doomed to set, with the fall of empire, over the dialect of the street: "The dusk was a raucous chaos of curses, gossip, and laughter; . . . but the voice of the inner language was reflective and mannered, as far above its subjects as that sun which would never set until its twilight became a metaphor for the withdrawal of empire and the beginning of our doubt."[88] The poet and playwright must thus make creative use of his

double consciousness, expressed through the dual metaphor of sun and twilight: his "schizophrenia, an electric fusion of the old and the new."[89]

While Walcott has been alternately criticized and lauded for appearing to remove his verse from the tumult of Caribbean history through the equanimity and grace of fixed, traditional Western forms, the formalism of *Tiepolo's Hound* contours a loss that is both personal and historical, based on a founding displacement that characterizes his native land. The ocean that bridges Europe with the New World also becomes the site of oppressive division.

> That middle passage, that bridge the bank provides,
> is one the submerged memory must negotiate
>
> between the worlds it finds on both its sides,
> the Caribbean, the Atlantic with its reeking freight,
>
> the archipelago's bridge. On one side is the healing
> of Time measured in ruins, the empires of Europe,
>
> its smoke, its spires, and a gold Tiepolo ceiling
> towards which we are hoisted by an invisible rope
>
> that hauls us with Ezekiel into a whirlwind
> of roiling clouds and trumpeting seraphim
>
> over this pond, but on the other side of the wind
> is what exile altered and banishment made dim. . . . [90]

Meditations on the power of water to trump history—"empires vanish / while water has one tense and cannot run backwards" (230)—appear in couplets propelled forward through iambic pentameter and alternating rhyme, at times registering as forced; these measures swirl around the missing visual and temporal "stroke" in kaleidoscopic sequences of meditations that undermine their equilibrium. While the adoption of this meter and rhyme would seem to suggest a seamless coupling of Anglo-European and Caribbean aesthetics, metaphors of divisiveness everywhere hyphenate reflections on a postcolonial condition.[91] Though his friend Joseph Brodsky had haunted Venice to great renown, even being buried ceremoniously on the Island of San Michele, Walcott affirms that as a West Indian, he hoped never even to write the word "Venice" or follow the trajectory of a Grand Tour[92]; imposed European names had estranged his island from itself, while its "Reality was

riven / by these reproductions" (184) of paintings of the Western tradition: "Paintings so far from life fermenting around us! / The skeletal, scabrous mongrels foraging garbage, // the moss-choked canals" (32).

The actual words of "a dialect forged / from burning asphalt" (24) in the Caribbean appear in *Tiepolo's Hound* only once: in the mute "mouths stitched shut" of fishermen anticipating Pissarro's departure for France, nevertheless transcribed from silence by the poet: "We know you going. / We is your roots. Without us you weak" (54). This patois, which the poet elsewhere chooses not to use, represents the stubborn perseverance of what took root upon the brutal dispersion of Africa: "Our tribes were shaken like seeds from a sieve. / Our dialects, rooted, forced their own utterance" (312). The result can only be "a divided life, drawn by the horizon's hyphen" (194). However, the poem suggests that this division is bridged by the search for a light that radiates in excess of any empire. Migrant artists searching for such light in the cathedrals and palaces of Europe find that the search "will lead us // where we began: to islands" (312). Seen in the conceptually colonial shadow of the elusive white hound, the mutt that the poet finds uncannily "here" renders lucid the condition of "bastardy, abandonment, and hope" that "shook with local terror" (274).

Over the narrator's years of searching for the stroke in books of reproductions, the museums of Europe, and the canals of Venice itself, the marginal figures in Venetian paintings—Sephardic Jews, Moors, and hounds depicted with exactitude in Veronese's *Feast in the House of Levi* and other works—become the signs of a historical surfeit that ruptures the violent propriety of social exclusion and erasure, to the point that such paintings led Veronese to trial before the Inquisition. The speaker of *Tiepolo's Hound* identifies with both the African figures ("I was that grey Moor clutching a wolfhound" [264]) and with the stray dog itself, "the hunched phantom at the feast's surfeit" (236). The wealth of ravenous and dispersive empire is itself depicted as "wandering like a hound, / made homeless as those distances increased // that left me emptiness as an inheritance" (296). Venice's very twilight is what allows Walcott as a New-World exile to negotiate the passage from the "crumbling Carthage of sunsets" (220) in the empires of Europe to the "local terror" in the dialects of his Caribbean.

What unites these poets—and so many other modernist and would-be Romantic artists—is the capacious temporality that Venice makes possible. The fugitive, but enduring water and light that animate the seemingly exhausted topos and that cannot, by nature, be fixed by a line also provokes authors to return, over and over, to what is and will remain unfrozen in time—while the annotated archipelago as structure enables them to envision and conduct translations between places, times, and the idiolects to which they have given rise.

History that cannot be seized as appearance, or schematized in a programmatic flow chart, requires continual negotiation. "[T]o arrive without memory at twilight" may be inevitable in the late twentieth century, as Ashbery suggests, but

> ... Blips from the maritime
> provinces made it all disturbingly real: that anyone should have to die
> so that we may stay on here, sodden but alive, fortunate
> to be able to contemplate our mortality from a distance amid kindness
> and late imperial emblems, golden dregs of another civilization
> than the one we gulped down just a short time ago.
> (*Flow Chart* 157)

Itself "sodden but alive," the province of Venice offers both a localized promontory and remote conceptual matrix for reckoning with the historical dregs we continually "gulp down": it makes our habits of consumption and their aftermath "disturbingly real."

In his philosophical work *L'Intention poétique* (*Poetic Intention* [1969]), the Martiniquan poet-theorist Édouard Glissant links the "exhaustion" of landscape with its continual realization and rediscovery: "We must exhaust our landscapes, in other words, realize them. But we must not fear discovering them endlessly."[93] He goes on to issue a rejoinder to positivist history and thought, asserting that "there are no outdated thoughts which perish beside new energies that are uncontrolled, naïve, rudimentary." Because thought cannot be overcome by time, and the new is never wholly naïve, history must be lived as experience, so that we may move on: "History must be assumed *completely* (lived together) in order perhaps to move beyond it (like the sea) once more."[94] The poets we have followed here do not merely assert that the exhausted landscape of Venice cannot be arrested or absorbed into description. They go one step further: contesting the seamless conceptual portability of "Venice" realized in the fever dreams of urban planners and casino owners, their texts body forth the confused, entropic phenomenal and historical situation—or "traffic jam"— that gives rise to the archipelago, an assemblage that fails both to be resolved into a fixed image and to conform to a plan, or permit acts of unambivalent syncretism. Such waxing of historicity suggests that Venice continues to exceed the satisfactions of its acquisition and distribution across space—unmanageably. Across this half century of poetry, Venice, in its "cosmic extraterritoriality," emerges as a vortex of what James Clifford calls "discrepant cosmopolitanisms," engendered by "worldly, productive sites of crossing; complex, unfinished paths between local and global attachments."[95] Such productive crossing of the worldly and particular seems an all but inevitable element of aesthetic

engagement with Venice. In the New York School, we witness the salvaging of affect in an abstracted global space through the engulfment of lyric by an omnipresent cliché for place; in Walcott, we see archipelagos and aesthetics on two sides of the world confront one another through the vivid translation of Venetian light. Zanzotto's conception of place, in turn, insists on its intrinsic status as plural, as a site of both lasting rooted substance and transformative encounter: "Places exist, consist, coexist; they call for new ways of thinking."[96]

Zanzotto's last Venetian poem, "Muffe" (Molds, a term also used figuratively to refer to an antiquated idea), addresses itself to the industrial margins of Marghera. It calls on the undead archipelago of Venice—always re-arising as a species of déjà vu in a "vertigine di risvegli" (vertigo of reawakenings) characterized by "tanta nebulosa verde / fiammellante" (so much nebulous flickering / green)—with multiple exclamations of *basta!* ("enough!"—with an echo of Marinetti). Through puns that confound age-old and twenty-first-century topoi (which are untranslatable, and consequently rendered here as bracketed possibilities), the archipelago emerges as a site of global access and contamination:

> —Ti concediamo brevetti e licenze
> d'alta seduzione—ma basta
>
> —Destini zecchini, pinocchi, sbocchi,
> torsioni di déjà-vu, ma basta
>
> —Muffetta del pianeta o grattugiato
> pan di legno munito
> di un logos comunque sconfitto
>
> —E dàgli con l'eterno tremolio delle foglie
>
> —"Grigia scende la sera e si confonde
> col rumore del forno a microonde"
>
> —We grant you patents and licenses
> of high seduction—but that's enough
>
> —Destinies of [ducats/sequins], [pinocchios/pinenuts],
> [mouths/outlets/markets],
> torsions of déjà-vu, but that's enough
>
> —Little mold of the planet or grated
> chestnut bread meted
> with a logos nonetheless defeated

—And enough already with the eternal quavering of leaves

—"Gray the evening descends, confused in a haze
with the rumbling of the microwave"[97]

Its light now neither of the moon nor of dusk, but gray, and yet still undying, its seductiveness authorized by patent, its "leaves" both those of native tree species and printed text, a storied port that hypnotizes with its eternal resistance to the modern insists nevertheless on delivering the present moment back to itself. Like Agamben's "specter," which replaces the mournable "cadaver" of twentieth-century Venice with a vengeful, larval agency still dictating our speech and our rhythms, this *laguna/lacuna*, or *locus/logos*, ground of the reasoned word, remains inexhaustible, critical in its uncanniness, incongruous.

Today just as a century ago, and a century before that, Venice declines to oppose either future or past, though it does hold puerile impulses of the new in check. In its impasses, instead, we witness modernity coming to a standstill. Modernism in Venice finds itself implicated, entangled, in an omnivorous and nonlinear historical continuum—in an effort of presencing that is never complete. As a cross section of forces originating elsewhere, canalized Venice constitutes a subtly adversarial and complicit party to the present day, as well as to the tradition of aesthetic rupture that is its latest historical inheritance. Writing in 1976, from the "years of lead," Zanzotto describes a schism generated by the floating city's capacity to check the "leaden" interposition of present reality:

And the whole city, in its growing and changing along with the times, in its remaining . . . "outside of maximal time" and yet always racing, has conserved the times coiled round her, or rather implicated in inlay, . . . like a point of the absurd within the current day. A tenuous, non-violent absurdity, opposed in ambiguous fashion to "life that irrupts," and yet capable of splitting at the wedge the other, monotonous and leaden [*plumbea*] absurdity . . . which seems to connote current [*attuale*] reality.[98]

An unrelenting absorption of cultures and times has made Venice a uniquely "extraterritorial" host of modernity: one that makes no claims on the present, but folds innumerable quarrels into its constrictive domain before redispersing and disseminating them. Venice continues to channel the new into traffic with the vestigial cultural forms that the most virulent strains of the modern would have negated. Navigation of these straits has been—and remains—fundamental to the regeneration of the anachronism we call the present day.

NOTES

Introduction: Venetian Modernity

For additional notes, references, and original texts, marked by asterisks in the notes, please visit http://www.cup.columbia.edu/scappettone-notes.

1. For a classic period document advocating for the "dry, hard, classical" aesthetic in verse against the "damp" "vagueness" of Romanticism, see the 1911 essay "Romanticism and Classicism," in T.D. Hulme, *Speculations: Essays on Humanism and the Philosophy of Art* (London: Routledge and Kegan Paul, 1924), 113–40. Nauman may additionally be citing the Baroness Elsa Von Freytag-Loringhoven's assemblage *God*—also from 1917—which set a plumbing trap as twisted phallus upon a miter box. On the way the Baroness's work cuts against the grain of heroic male modernism such as Duchamp's, see Amelia Jones, *Irrational Modernism: A Neurasthenic History of New York Dada* (Cambridge, MA: MIT Press, 2004).*

2. Preface to Gasparo Contarini, "De Magistratibus & Republica Venetorum" (Paris: Michael Vascosani, 1543), translated by Lewis Lewkenor in 1599; qtd. in Peter G. Platt, "'The Meraiulouse Site': Shakespeare, Venice, and Paradoxical Stages," *Renaissance Quarterly* 54:1 (Spring 2001), 126.

3. From the 39-volume Library Edition of *The Works of John Ruskin,* ed. E.T. Cook and Alexander Wedderburn (London: George Allen, 1903–12), 9:38. Hereafter cited as *Works* with volume and page numbers.

4. For a history of *acque alte* in Venice from the medieval period through the nineteenth century, see Gianpietro Zucchetta, *Storia dell'acqua alta a Venezia dal Medioevo all'Ottocento* (Venice: Marsilio, 2000).

5. The Italian reads "una constatazione dolorosa." Giuseppe Longo, "Solidarietà," *Il Gazzettino*, November 6, 1966. All translations in this book are my own unless otherwise noted. Due to pressing spatial constraints, I have been obliged to limit the inclusion of original texts to works and passages that presented particular challenges in translation.

6. Ferruccio Zapponi, "24 ore apocalittiche per le genti della laguna," *Il Gazzettino*, November 6, 1966.

7. UNESCO, *Rapporto su Venezia* (Milan: Edizioni Scientifiche e Techniche/Mondadori, 1969), 122.*

8. The charities Save Venice, Venice in Peril, and Venetian Heritage evolved between England and the United States, for example, joining a score of international organizations that have hastened to preserve the city's artworks and edifices. A sensationalized account of the controversies of conflicted interests surrounding these foundations appears in John Berendt, *The City of Falling Angels* (New York: Penguin, 2005). References to Venice in the *Gazzettino* of November 1966 and beyond emphasize the term *attuale*.

9. On the consolidation of the archipelago, see, for example, John Julius Norwich, *A History of Venice* (New York: Vintage, 1989), 12.

10. Contarini, "De Magistratibus & Republica Venetorum" as translated by Lewis Lewkenor in 1599; qtd. in Platt, "'The Meraiulouse Site,'" 131.*

11. For more on the hydraulic engineering that allowed early modern Venice to thrive, see Salvatore Ciriacono, *Building on Water: Venice, Holland, and the Construction of the European Landscape in Early Modern Times*, trans. Jeremy Scott (New York and Oxford: Berghahn Books, 2006).

12. UNESCO, *Rapporto su Venezia*, xiii.

13. A complete account of the challenges to the lagoon ecosystem appears in Pierre Lasserre and Angelo Marzollo, eds., *The Venice Lagoon Ecosystem: Inputs and Interactions Between Land and Sea* (Paris and New York: UNESCO and Parthenon Publishing Group, 2000). The waters had also been polluted by waste disposal and the direct dumping practices of petrochemical, iron, and steel plants. Port Marghera, developed through the 1920s, then expanded at mid-century, has since become a symbolic center of protests around working conditions. Veneto dramatist Marco Paolini's performance piece *Parlamento chimico: Storie di plastica* (Chemical Parliament: Histories of Plastic, premiered in 2002, and recorded and issued by Jolefilm in 2005) narrates an ill-fated 2004 trial against twenty-eight industrials charged with negligence.*

14. Flooding is considered normal when less than three percent of the city is under water. *Acque alte* of 110 centimeters or higher, on the other hand, now occur roughly five times more frequently than they did in the 1920s. The Venice in Peril Fund, a British committee for the preservation of Venice, published an accessible diagnosis of

these trends as of 2003: see Caroline Fletcher and Jane da Mosto, *The Science of Saving Venice* (London and Turin: Umberto Allemandi, 2004).

15. From the documentary by Barrie Gavin, "Vive a Venezia" (BBC, 1978).

16. Andrea Zanzotto, *Le poesie e prose scelte*, ed. Stefano Del Bianco and Gian Mario Villalta, I Meridiani (Milan: Mondadori, 1999), 1052. Hereafter *Poesie e prose.**

17. Ibid., 1060.

18. From "Contro Venezia passatista," in Filippo Tommaso Marinetti, *Teoria e invenzione futurista*, ed. Luciano De Maria (Milan: Mondadori, 1983), 30. This volume will hereafter be cited as *TIF* with page numbers. See also the 1909 text "Uccidiamo il chiaro di luna!" (Let's Kill the Moonlight!), in *TIF* 14–26.

19. "The Founding and Manifesto of Futurism," *TIF* 9.

20. The popular ditty "La biondina in gondoleta" was sung across Europe, thereby exacerbating the association of the city with moonlight; it was copied, for example, into Jane Austen's songbook.

21. Jürgen Habermas, "Modernity—An Incomplete Project," trans. Seyla Ben-Habib, in *Postmodern Culture*, ed. Hal Foster (Trowbridge, England: Pluto Press, 1983), 3.

22. Ibid., 5.

23. Manfredo Tafuri, *History of Italian Architecture, 1944–1985*, trans. Jessica Levine (Cambridge, MA: MIT Press, 1989), 186.

24. Francesco Sansovino, *Venetia città nobilissima et singolare* (Venice: S. Curti, 1663), 389.*

25. Eugène Haussmann, *Mémoires*, 3rd ed., 2 vols. (Paris: Victor-Havard, 1890), 2:203.

26. Italo Calvino, *Saggi*, 2 vols. (Milan: Mondadori, 1995), 2:2688. Hereafter *Saggi*, with volume and page numbers.

27. See Franco Mancuso, *Venezia è una città: Come è stata costruita e come vive* (Venice: Corte del Fontego, 2009), 5–42. For a pioneering account of Venice's reconditioning of Renaissance architecture, see Manfredo Tafuri, *Venice and the Renaissance*, trans. Jessica Levine (Cambridge, MA: MIT Press, 1989).*

28. The church of Santa Maria della Salute is an important exception to this temporal frame, being a prominent Baroque edifice dating to the late seventeenth century.

29. For a concise account of this landmark in cartography, see Bronwen Wilson, *The World in Venice: Print, the City and Early Modern Identity*, Studies in Book and Print Culture (Toronto: University of Toronto Press, 2005), 25–30.

30. For more on the revolution of 1848–49, see Paul Ginsborg, *Daniele Manin and the Venetian Revolution of 1848–49* (London: Cambridge University Press, 1979); Vincenzo Marchesi, *Storia documentata della rivoluzione e della difesa di Venezia negli anni 1848–49, tratta da fonti italiane ed austriche* (Venice: Istituto Veneto di Arti Grafiche, 1913); Guglielmo Pepe, *Narrative of Scenes and Events in Italy from 1847 to 1849, Including the Siege of Venice*, 2 vols. (London: Henry Colburn, 1850). For Effie Ruskin's testimony, see Mary Lutyens and Euphemia Chalmers Ruskin, eds., *Effie in Venice: Effie Ruskin's Letters Home, 1849 and 1852* (London: Pallas Athene, 2003), 131–2.*

31. Georg Simmel, "Venice," trans. Ulrich Teucher and Thomas M. Kemple, *Theory, Culture & Society* 24, nos. 7–8 (December 2007): 44.

32. For more on this development, see Deborah Howard, *The Architectural History of Venice* (New Haven, CT: Yale University Press, 2002), 51, 57. For the way that pre-modern architects enhanced the civic mythology of Venice as a floating city, creating a dramatic urban scenography to be viewed from the waterways, see Daniel Savoy, *Venice from the Water: Architecture and Myth in an Early Modern City* (New Haven, CT: Yale University Press, 2012).

33. Simmel, "Venice," 44.

34. To cite Georges-Eugène Haussmann's self-stylization, qtd. in Walter Benjamin, *The Arcades Project*, trans. Howard Eiland and Kevin McLaughlin (Cambridge, MA: Harvard University Press, 1999), 128.

35. W.G. Sebald, *Vertigo*, trans. Michael Hulse (New York: New Directions, 1999), 52.

36. Tiziano Scarpa, *Venezia è un pesce* (Milan: Feltrinelli, 2003). Having surveyed Venice from the point of view of the body, Scarpa's work nevertheless ends, tellingly, with a section titled "Books."

37. Exceptional instances of monumental sculpture are Verrochio's Colleoni and the Garibaldi monument occupying edges of the historical center.

38. Letter from the Reverend John Warner to George Selwyn, from John Heneage Jesse, *George Selwyn and His Contemporaries; With Memoirs and Notes* (London: R. Bentley, 1843), available at www.archive.org/stream/georgeselwynhisc03jess/george-selwynhisc03jess_djvu.txt. Text file. III:317–18.

39. Ibid., III:317–18. The Shakespeare citation is from *King Lear*, 4.4.113–14.

40. H.D., *HERmione* (New York: New Directions, 1981), 7. Some authors, including Goethe, have a more favorable reaction to the feminization of Venice: "Venice, if all your canals were girls, and if only their cunts were / Like your alleyways—what city could vie with you then!" Johann Wolfgang von Goethe, *Erotic Poems*, trans. David Luke (Oxford and New York: Oxford University Press, 1997), 71.

41. Michael T. Taussig, *Walter Benjamin's Grave* (Chicago: University of Chicago Press, 2006), 115.

42. See Anthony M. Tung, *Preserving the World's Great Cities: The Destruction and Renewal of the Historic Metropolis* (New York: Clarkson Potter/Publishers, 2001), 319–20.

43. Ibid., 217.*

44. See, for example, Julie A. Buckler, *Mapping St. Petersburg: Imperial Text and Cityshape* (Princeton, NJ, and Oxford: Princeton University Press, 2005).

45. Joseph Brodsky, *Watermark* (New York: Farrar, Straus & Giroux, 1992), 8. First published as *Fondamenta degli Incurabili*, trans. Gilberto Forti (Venice: Consorzio Venezia Nuova, 1989).

46. See Buckler, *Mapping St. Petersburg*, 9.*

47. The plan drafted in the nineteenth century was not entirely successful. Buckler points out that this monumental effect gives off "a false, wishful memory of a unity that never was." Ibid., 62–63.

48. Ibid., 1; and 2–3.

49. Brodsky, *Watermark*, 47. For a fascinating comparison of Venice with the labyrinth of James Joyce's Dublin, see Judith Seaboyer's dissertation, *Second Death in Venice: Cognitive Mapping in the Venetian Fictions of Jeanette Winterson, Ian Mcewan, and Robert Coover* (Toronto: University of Toronto, 1997), 15–17.

50. Theodor W. Adorno, "Valéry Proust Museum," in *Prisms*, trans. Samuel Weber and Shierry Weber Nicholsen (London: Neville Spearman, Ltd., 1967), 185.*

51. Zanzotto, *Poesie e prose*, 1063.

52. Napoleon famously declared himself "Attila to Venice."*

53. Maria Vittoria Martini, "Breve historia de *I Giardini*" ("A Brief History of *I Giardini*"), in *Muntadas: On Translation: I Giardini, Spanish Pavilion, 51 Venice Biennal* (Barcelona: Actar, 2005), 211. The suppression of Carnival has, interestingly, been read as one of the more oppressive actions of French sovereignty.*

54. For an account of the constricted urban transformation of Venice during the nineteenth century, see Giandomenico Romanelli, *Venezia Ottocento: L'Architettura, l'urbanistica*, Venetiae (Venice: Albrizzi, 1988). For an illuminating analysis of post-Republican Venetian self-fashioning through manipulation of the Teatro La Fenice, see Martha Feldman, "Opera, Festivity, and Spectacle in 'Revolutionary' Venice: Phantasms of Time and History," in *Venice Reconsidered: The History and Civilization of an Italian City-State, 1297–1797*, ed. John Jeffries Martin and Dennis Romano (Baltimore: Johns Hopkins University Press, 2002), 217–62.*

55. For the first thorough account of Venice's despoliation at the hands of Napoleon and the Treaty of Campoformio, see Alvise Zorzi, *Venezia scomparsa* (Milan: Electa, 1972). For an account of the adulteration, restoration, and conservation of the city and its artifacts since the fall of the Republic, see Gianfranco Pertot and Sarah Quill (photographer), *Venice: Extraordinary Maintenance* (London: Paul Holberton, 2004). John Julius Norwich provides colorful narration of the Napoleonic occupation in *Paradise of Cities: Venice in the 19th Century* (New York and London: Doubleday, 2003); see 1–50.

56. For a compressed account of the history of the Napoleonic Gardens, see Martini, "Breve Historia de *I Giardini*."

57. Venice was an independent, sovereign state for a millennium; for half of that period, it was a republic, a species of oligarchic democracy. For a history of the Venetian port function's transition from gateway to the East to a "new capitalistic asset" for France, see Cesco Chinello, "La produzione, il lavoro, i movimenti," in Cesco Chinello et al., *Porto Marghera: Le immagini, la storia, 1900–1985* (Turin: Musolini, 1985). Under the Austrian Empire, it was Trieste, and not Venice, that promised to serve the port function—hence Venice's relative economic obsolescence. For a history in English of the period that followed the fall, see David Laven, *Venice and Venetia Under the Habsburgs, 1815–1835* (Oxford and New York: Oxford University Press, 2002).

58. A popular and influential history aimed at justifying the seizure of the Venetian Republic was produced by a high-ranking aristocrat under Napoleon: Pierre-Antoine-Noël-Bruno Daru, *Histoire de la République de Venise*, 7 vols. (Paris: Firmin Didot, 1819).

59. William Wordsworth, "On the Extinction of the Venetian Republic," in *The Poetical Works of William Wordsworth*, ed. E. De Selincourt and Helen Darbishire (Oxford: Clarendon, 1954), 4:95, lines 4–6.*

60. Ibid., line 1.

61. Ibid., lines 13–14.

62. "Lamento della sorte di Venezia," qtd. in Laven, *Venice and Venetia Under the Habsburgs, 1815–1835*, 29. Translation mine; "planked" could also be translated as "tacked."

63. Ugo Foscolo, *Ultime lettere di Jacopo Ortis*, 3rd ed. (London: H. Berthoud, 1818), 3, 4.

64. Giovanni Boccaccio, *Decameron*, ed. Vittore Branca, vol. 4 of 12, in *Tutte le opere di Giovanni Boccaccio* (Milan: Mondadori, 1976), 367. I have used the tale heading of the first English translation, sometimes attributed to John Florio.*

65. Petrarch in the 1360s to Pietro Bolognese: for a complete English translation, see Francesco Petrarca, *Seniles, or rerum senilium (Epistles of an Old Man)*, trans. Saul Levin, Aldo S. Bernardo, and Reta A. Bernardo, 2 vols. (Baltimore: Johns Hopkins University Press, 1992), book IV, letter 3; 1:132. For the Avveroës incident, see *Seniles*, book V, letter 2, 1:164–65. Italian texts are in *Lettere senili di Francesco Petrarca*, ed. and trans. Giuseppe Fracassetti, 2 vols. (Florence: Le Monnier, 1892), 1:227 and 1:281.

66. For a selection of key primary texts in English translation reflecting this phenomenon of mythmaking, see David Chambers, Brian Pullan, with Jennifer Fletcher, eds., *Venice: A Documentary History, 1450–1630* (Oxford and Cambridge, MA: Blackwell, 1992). The canonical components of the myth—"Venezia-stato-misto," "Venezia-stato-di-libertà," "Venezia-città-galante"—were first laid out by Franco Gaeta, "Alcune considerazioni sul mito di Venezia," *Bibliothèque d'humanisme et Renaissance*, no. 23 (1961): 58–75. These form the basis of an extensive scholarly discourse. See Elisabeth Crouzet-Pavan, *Venice Triumphant: The Horizons of a Myth*, trans. Lydia G. Cochrane (Baltimore: Johns Hopkins University Press, 2005); David C. McPherson, *Shakespeare, Jonson, and the Myth of Venice* (Newark: University of Delaware Press/ Associated University Presses, 1990). For a syncretic and highly readable contemporary history, written in light of the efforts of historians from Frederick C. Lane to Gaetano Cozzi and Alberto Tenenti, see Alvise Zorzi, *Venice 697–1797: A City, A Republic, An Empire*, trans. Judyth Schaubhut Smith (Woodstock, NY: The Overlook Press, 2001). An important collective attempt to rethink the history of Venice in less dualistic terms, admitting that the place emerges as "an enigma, an indecipherable maze of interweaving stories, false and true," was curated by John Jeffries Martin and Dennis Romano in *Venice Reconsidered*; quote appears on p. 3.

67. Francesco Sansovino, son of Jacopo (the sculptor and architect), authored a key component of the myth in 1581: *Venetia: Città nobilissima et singolare*. Marin Sanudo's diaries, precious fonts of information about early modern Venice, are available in Patricia H. Labalme and Laura Sanguineti White, eds. *Venice, Città excelentissima: Selections from the Renaissance Diaries of Marin Sanudo* (Baltimore: Johns Hopkins University Press, 2008).

68. See, for one summary among many, Gina Fasoli, "Nascita di un mito," in *Studi storici in onore di Gioacchino Volpe* (Florence: Sansoni, 1958), 449. Frederic Lane offers a thumbnail sketch of the myth and "countermyth" in *Venice: A Maritime Republic* (Baltimore: Johns Hopkins University Press, 1973), 87–91. For a discussion of the changing European attitudes toward the aristocratic republic, progressing from an admiration of its pragmatism and permissiveness to a growing disapproval, see William James Bouwsma, "Venice and the Political Education of Europe," in *A Usable Past: Essays in European Cultural History* (Berkeley: University of California Press, 1990), 266–91.

69. This quote on the cowardice of Venetian troops facing the League of Cambrai hails from Girolamo Priuli, *I diarii*, ed. R. Cessi (Bologna: Zanichelli, 1938), 54. For a reading of the hag-whore in Machiavelli's letter number 157 (December 8, 1509) as degraded Venetian body politic, see Linda Carroll, "Machiavelli's Veronese Prostitute: *Venetia Figurata?*" in *Gender Rhetorics: Postures of Dominance and Submission in History*, ed. Richard Trexler (Binghamton, NY: Center for Medieval & Renaissance Texts & Studies, 1994), 93–106.

70. The English text is in Petrarch, *Seniles*, book IV, letter 3; 1:132; see 1:227 in Italian edition.

71. William Shakespeare, *The Tragedy of Othello, the Moor of Venice*, in *The Riverside Shakespeare*, ed. G. Blakemore Evans (Boston: Houghton Mifflin, 1974), 4.2.94. This poignant historical detail concerning the brothel is supplied in Tanner, *Venice Desired* (Cambridge, MA: Harvard University Press, 1992), 5.

72. Margaret F. Rosenthal, *The Honest Courtesan: Veronica Franco, Citizen and Writer in Sixteenth-Century Venice* (Chicago: University of Chicago Press, 1992), 2–3.

73. Thomas Otway, *Venice Preserv'd: Or, a Plot Discover'd*, in *The Works of Thomas Otway* (London: J. Tonson et al., 1728), II.iii.292–94.*

74. This history ranges from Abbé de Saint Réal's *Conjuration des Espagnoles contre Venise en 1618* (1664), the immediate precursor to Weil's unfinished drama, to Hugo von Hofmannsthal's *Das Gerettete Venedig: Trauerspiel In Fünf Aufzügen* (1904).*

75. Tanner, *Venice Desired*, 4.

76. Edith Wharton, *Italian Backgrounds* (New York: Scribner, 1905), 202.

77. Venice had by Otway's time already been understood as a weakened empire of "Empty Magazines, / A tatter'd Fleet, a murmuring unpaid Army, / Bankrupt Nobility, a harrast Commonalty, /A Factious, giddy, and divided Senate." See *Venice Preserv'd*, II.iii.267–70.

78. George Gordon Byron, *Childe Harold's Pilgrimage*, in *Lord Byron: The Major Works*, ed. Jerome McGann (New York: Oxford University Press, 1986), 4.2.10; *Marino Faliero*, in *Complete Poetical Works*, ed. Jerome McGann (Oxford: Oxford University Press, 1980), 5.3.98–99.

79. Benjamin notes that "[i]n 1851 there was still a regular stagecoach line between Paris and Venice"). See *Arcades*, 429.

80. Pathbreaking acts of historiography that distance themselves from the pervasive "myth of Venice"—extended by such redoubtable works as James Morris's classic *Venice* (London: Faber and Faber, 1960)—include Mario Isnenghi and Stuart Woolf, eds.,

Storia di Venezia: L'Ottocento e il Novecento (Rome: Istituto della Enciclopedia Italiana/ Marchesi Grafiche Editoriali, 2002); Alessandro Bettagno, ed., *Venezia da stato a mito* (Venice: Fondazione Giorgio Cini/Marsilio, 1997); Carlo Ossola, ed., *Venezia nella sua storia: Morti e rinascite* (Venice: Fondazione Giorgio Cini/Marsilio, 2003), and John Martin and Dennis Romano, eds., *Venice Reconsidered*. An essential, encyclopedic introduction to the cultural and political history of Venice in the post-Republican period was provided in English by Margaret Plant in *Venice: Fragile City, 1797–1997* (New Haven, CT: Yale University Press, 2002). John Julius Norwich turned to the history of nineteenth-century Venice through portraits of illustrious visitors in *Paradise of Cities*. As Gherardo Ortalli puts it, the critic's task should not be to chart a single rise and decline but "to understand which different Venices . . . are patiently constructed or nobly or vulgarly killed off, as they are invented, built and destroyed." "Storia e miti per una Venezia dalle molte origini," in Carlo Ossola, ed., *Venezia nella sua storia,* 82.

81. Tanner, *Venice Desired,* 4; Margaret Doody, *Tropic of Venice* (Philadelphia: University of Pennsylvania Press, 2007), 17.

82. Mary McCarthy, *Venice Observed* (San Diego, New York, and London: Harcourt, 1963), 35.

83. *Works* 10:6.

84. Ibid., 10:6–7.

85. Ibid., 9:57–58.

86. Marinetti, "Discorso futurista ai veneziani" (Futurist Speech to the Venetians), in *TIF* 30–31.

87. Ruskin, *Works* 24:216; Marinetti, "Contro Roma passatista" (Against Passéist Rome), in *TIF* 285–86.

88. *TIF* 50. For the full English translation, see "Technical Manifesto of Futurist Literature," in Filippo Tommaso Marinetti, *Selected Poems and Related Prose. With an Essay by Paolo Valesio*, ed. Luce Marinetti, trans. Elizabeth R. Napier and Barbara R. Studholme (New Haven, CT: Yale University Press, 2002), 79.

89. For a complete argument regarding the support for the unification of Italy by English literati, see Harry W. Rudman, *Italian Nationalism and English Letters: Figures of the Risorgimento and Victorian Men of Letters* (New York: AMS Press, 1966). For examples of Anglo-American sympathy with the Italian Risorgimento, see the laudatory account of Venetian independence movements by Edmund Flagg, *Venice the City of the Sea: From the Invasion by Napoleon in 1797 to the Capitulation to Radetzky in 1849; with a Contemporaneous View of the Peninsula* (New York: Charles Scribner, 1853). For more on French engagement with Venice at the turn of the twentieth century, see Sophie Basch, *Paris-Venise, 1887–1932. La "folie vénitienne" dans le roman français de Paul Bourget à Maurice Dekobra*, Travaux et Recherches des Universités Rhénanes (Paris: Honoré Champion, 2000).

90. Simmel, "Venice," 44–45.

91. Ibid., 44.

92. "Futurist Speech to the Venetians," in *TIF* 32.

93. Thomas Mann, *Death in Venice*, trans. Clayton Koelb (New York and London: W.W. Norton & Company, 1994), 47. Like many set-piece characterizations of Venice, this one revises another: Gautier's "unreal" Venice of the melodramatic "Romanticist stage-setting." See Theophile Gautier, *Travels in Italy*, in *The Complete Works of Theophile Gautier*, trans. and ed. F.C. DeSumichrast (London and New York: Postlethwaite, Taylor & Knowles, Ltd., 1901), 4:48.*

94. Zanzotto, *Poesie e prose*, 1056.

95. For concise surveys of the new modernist studies, see Douglas Mao and Rebecca L. Walkowitz, eds., *Bad Modernisms* (Durham, NC, and London: Duke University Press, 2006) and their introduction to "The New Modernist Studies," *PMLA* 123, no. 3 (2008): 737–48. These writings trace the expansion of scholarly attention to modernism in temporal, spatial, and cultural (or "vertical") terms, a revitalization of the field roughly coinciding with the founding of the Modernist Studies Association in 1999. Other key meditations on alternative modernities and the uneven development of modernism include Andreas Huyssen, "Geographies of Modernism in a Globalizing World," *New German Critique* 100 (Winter 2007): 189–207 and Arjun Appadurai, *Modernity at Large: Cultural Dimensions of Globalization* (Minneapolis: University of Minnesota Press, 1996). Asymmetry in the critical record has begun to be redressed by volumes such as Mark A. Wollaeger and Matt Eatough, eds., *The Oxford Handbook of Global Modernisms* (New York: Oxford University Press, 2012). In defining modernism broadly as the expressive dimension of modernity, I am in agreement with the definition articulated by Susan Stanford Friedman in "Periodizing Modernism: Postcolonial Modernities and the Space/Time Borders of Modernist Studies," *Modernism/Modernity* 13, no. 3 (2006): 432.

96. Recent writings, seeking terms with which to do justice to the transnational turn in humanistic discourse, re-theorize cosmopolitanism as participation in a network of social obligations that does not elide cultural differences. See, for example, Pheng Cheah, Bruce Robbins, and Social Text Collective, eds., *Cosmopolitics: Thinking and Feeling Beyond the Nation* (Minneapolis: University of Minnesota Press, 1998); Homi Bhabha et al., "Cosmopolitanisms," *Public Culture* 12, no. 3 (2000): 577–89; Anthony Appiah, *Cosmopolitanism: Ethics in a World of Strangers* (New York: W.W. Norton & Co., 2006).

97. Contarini, trans. Lewkenor, qtd. in Platt, 131.*

98. For more on immigrant influence in the sphere of the arts, see the account of Venetian *cittadini*, or wealthy immigrant merchants, in Blake de Maria, *Becoming Venetian: Immigrants and the Arts in Early Modern Venice* (New Haven, CT: Yale University Press, 2010).

99. Henry Lefebvre, *The Production of Space*, trans. Donald Nicholson-Smith (Oxford and Cambridge, MA: Blackwell, 1991), 76.

100. For the way cholera contributed to an othering of nations regarded as unsanitary, see Pamela K. Gilbert, *Cholera and Nation: Doctoring the Social Body in Victorian England* (Albany: State University of New York Press, 2008).

101. John Ruskin, *Ruskin's Letters from Venice, 1851–1852*, ed. John L. Bradley (New Haven, CT: Yale University Press, 1964), 37.

102. See William Hardy McNeill, *Venice: The Hinge of Europe, 1081–1797* (Chicago: University of Chicago Press, 1974).

103. Walter Benjamin, *Il mio viaggio in Italia: Pentecoste 1912*, trans. Lucia A. Petroni (Messina: Rubbettino Editore, 1995), 54. Grateful acknowledgement goes to Petra Kuppers for help resolving ambiguities in the original German text.

104. Henry James, *Italian Hours* (New York: Grove Press, 1909), 76. Hereafter cited as *IH*.

105. In this way, Venice resembles the Edinburgh described by Ian Duncan in "Edinburgh, Capital of the Nineteenth Century," in *Romantic Metropolis: The Urban Scene of British Culture, 1780-1840*, ed. James Chandler and Kevin Gilmartin (Cambridge and New York: Cambridge University Press, 2005), 45–64.

106. "With its tradition of skepticism or at least of disenchantment, Venice sought constantly to dampen the excesses of Mussolinian rhetoric." Enzo Di Martino and Paolo Rizzi, *Storia della Biennale 1895–1982* (Milan: Electa, 1982), 40. The Fascist dictatorship commissioned a new façade for the Italian pavilion in the Public Gardens in 1932, so that the central theme was Italy, "not *arte* or Venice." Matthew Affron and Mark Antliff, eds., *Fascist Visions: Art and Ideology in France and Italy* (Princeton, NJ: Princeton University Press, 1997), 205–6. However, Venice remained unusually open to foreign influence; many countries requested and were conceded national Biennale pavilions during Fascism's twenty-year reign.

107. Zanzotto, *Poesie e prose*, 1061.

108. For identification of Italy as Europe's "internal other," see George Van den Abeele, *Travel as Metaphor* (Minneapolis: University of Minnesota Press, 1992).

109. "Futurist Speech to the Venetians," *TIF* 34.

110. Mann, *Death in Venice*, 4.

111. Ibid., 3, 13.

112. Ibid., 3, 4, 5, 18, 50, 51. These ambiguities actually constitute the radicality of Mann's depiction. With more space, one could pursue an extended argument surrounding the way that the stagnant city of *Der Tod in Venedig* nevertheless constitutes a polycultural cauldron through Mann's depiction of the amalgamated and deracinated cultures pooling in Venice.

113. "The Stranger," in Georg Simmel, *The Sociology of Georg Simmel*, trans. Kurt H. Wolff (New York: Free Press, 1950), 402. *Ghetto* derives from the verb *gettare*, "to cast," given that the city's Jewish ghetto, established to isolate the Jewish community from the rest of the populace in 1516, was initially the site of a foundry.

114. On the hybrid nature of these columns, see Otto Demus and Ferdinando Forlati, *The Church of San Marco in Venice: History, Architecture, Sculpture* (Washington, D.C.: Dumbarton Oaks Research Library and Collection, Trustees for Harvard University, 1960), 22; Michelangelo Muraro, *La vita nelle pietre: Sculture marciane e civiltà veneziana del Duecento* (Venezia: Arsenale, 1985), 12; and Debra Pincus, "Venice and the Two Romes: Byzantium and Rome as a Double Heritage in Venetian

Politics," *Artibus et Historiae* 13, no. 26 (1992): 102–3. For more on Venetians' creative reconstruction of history, made possible by the city's lack of a direct Roman heritage, see Patricia Fortini Brown, *Venice and Antiquity: The Venetian Sense of the Past* (New Haven, CT: Yale University Press, 1997).*

115. Marcel Proust, *On Reading Ruskin*, trans. Jean Autret et al. (New Haven, CT, and London: Yale University Press, 1987), 129.

116. Marcel Proust, *Remembrance of Things Past,* trans. Terence Kilmartin and C.K. Scott-Moncrieff, vol. 6, *Time Regained and a Guide to Proust* (New York: Vintage, 1996), 182, 229. The architectural historian and theorist Sergio Bettini praises the seeker of lost time for having conceived Venice's current atmosphere ("*Stimmung attuale*"): "[Proust] adheres perhaps more than any other author to the singular form of Venice, the most 'current' [*attuale*] city there is: because it was never a 'classical' city . . . but has always been an open form, thrown into '*tempo*,' and thus resolved in color and rhythm." Sergio Bettini, *Venezia: Nascita di una città* (Milan: Electa, 1978), 22.

117. Proust, *On Reading Ruskin*, 129.

118. Ibid., 129. This description serves as an allegory for Proust's experience of reading Dante and Shakespeare.

119. McCarthy, *Venice Observed*, 35.

120. Zanzotto, *Poesie e prose*, 1056.

121. I use the term "textual attitude" in the sense developed by Said, denoting a subject's preference for "the schematic authority of a text" over "the disorientations of direct encounters with the human." Edward Said, *Orientalism* (New York: Vintage, 1979), 93.

122. Ezra Pound, *The Cantos of Ezra Pound* (New York: New Directions, 1993), 26/121. Hereafter cited as *Cantos* with canto and page numbers.

123. Theodor W. Adorno, *Aesthetic Theory*, trans. Robert Hullot-Kentor (Minneapolis: University of Minnesota Press, 1997), 147.

124. Theodor W. Adorno, *Minima Moralia: Reflections from Damaged Life*, trans. E.F.N. Jephcott (New York: Verso, 1978), 151.

125. Bill Brown, *The Material Unconscious: American Amusement, Stephen Crane, and the Economies of Play* (Cambridge, MA: Harvard University Press, 1996), 18.

126. Tafuri, *Venice and the Renaissance*, x.

1. "The Entanglement of Memory"

1. Qtd. in *Works* 9:xxxvi.

2. George Gordon Byron, *Childe Harold's Pilgrimage,* in *Lord Byron: The Major Works*, ed. Jerome McGann (New York: Oxford University Press, 1986), Canto 4, stanza 1, lines 1–4 (hereafter *Childe Harold* with canto, stanza, and line numbers); Ann Ward Radcliffe, *The Mysteries of Udolpho: A Romance, Interspersed with Some Pieces of Poetry* (Philadelphia: J.J. Woodward, 1828), 243.*

3. Letter of November 17, 1816, to Thomas Moore, in George Gordon Byron, Lord, *Byron's Letters and Journals*, ed. Leslie A. Marchand (Cambridge, MA: Belknap, 1973–1982), 5:129.

4. *Works* 10:8.

5. Volume I was published in 1851, volumes II and III in 1853. My research for this chapter is indebted to a series of earlier studies of Ruskin and Venice: in addition to those cited throughout, they include John Unrau, *Looking at Architecture with Ruskin* (Toronto and Buffalo: University of Toronto Press, 1978), and *Ruskin and St. Mark's* (London: Thames & Hudson, 1984); N. N. Feltes, "The Stones of Ruskin's Venice: A Materialist Analysis," *Prose Studies* 3, no. 1 (May 1980): 54–68; Sarah Quill, *Ruskin's Venice: The Stones Revisited* (London: Ashgate, 2000); Sergio Perosa, ed., *Ruskin e Venezia: La bellezza in declino* (Florence: Leo S. Olschki, 2001); and various biographies, the most recent of which are by Quentin Bell, *Ruskin* (London: Hogarth, 1978); Joan Abse, *John Ruskin: The Passionate Moralist* (New York: Knopf, 1980); John Dixon Hunt, *The Wider Sea: A Life of John Ruskin* (New York: Viking, 1982); Wolfgang Kemp, *The Desire of My Eyes: The Life and Work of John Ruskin* (New York: Farrar, Straus, and Giroux, 1990); Tim Hilton, *John Ruskin: The Early Years* (New Haven, CT, and London: Yale University Press, 1984) and *John Ruskin: The Late Years* (New Haven, CT, and London: Yale University Press, 2000); and John Batchelor, *John Ruskin: A Life* (New York: Carroll & Graf, 2000).

6. *IH* 3.

7. John Ruskin, *Praeterita*, ed. Francis O'Gorman, Oxford World's Classics (Oxford: Oxford University Press, 2012), 188.*

8. *Works* 35:156; 35:296.

9. *IH* 3.

10. Walter Pater, *The Renaissance: Studies in Art and Poetry. The 1893 Text*, ed. Donald L. Hill (Berkeley and Los Angeles: University of California Press, 1980), vii.

11. Ibid.

12. *Works* 9:17.

13. Ibid., 35:372.

14. *Stones* distinguishes a first period of nine hundred years (the rise of Venice, and declaration of a doge), then a second, decadent period, following the *Serrar del Consiglio* (the reduction of a Great Council of men who were not necessarily noble into a hereditary aristocratic assembly by decree of Doge Gradenigo, around 1297), marked by oligarchy and the decline of domestic religion. He dates the fall of Venice to the day of Carlo Zeno's death, May 8, 1418, and its "*visible* commencement" with the death of Doge Mocenigo five years later (9:22). *St. Mark's Rest* distinguishes the four periods as "formation," AD 421–1100; "establishment," 1100–1301; "meditation," 1301–1402; and "luxury," 1421–1600.

15. *Works* 9:57.

16. It is a critical commonplace that Ruskin's attention swayed from art to social and political economy around 1859, but that underestimates the degree to which the

aesthetic and the social were always imbricated in one another in his writing. A series of misleading psychoanalytic readings tends to ascribe the increasingly digressive character of Ruskin's works to his nervous illnesses. See, for example, R.H. Wilenski, *John Ruskin: An Introduction to Further Study of His Life and Work* (London: Faber & Faber, 1933); John D. Rosenberg, *The Darkening Glass: A Portrait of Ruskin's Genius* (New York: Columbia University Press, 1986), 186; J.B. Bullen, "Ruskin and the Tradition of Renaissance Historiography," in *The Lamp of Memory: Ruskin, Tradition, and Architecture*, eds. Michael Wheeler and Nigel Whiteley (Manchester: Manchester University Press, 1992), 54–76; Richard Ellmann, *Golden Codgers; Biographical Speculations* (New York: Oxford University Press, 1973); Paul L. Sawyer, *Ruskin's Poetic Argument: The Design of the Major Works* (Ithaca, NY: Cornell University Press, 1985); and Tony Tanner, *Venice Desired* (Cambridge, MA: Harvard University Press, 1992). For a refreshing critique of this line of inquiry that does continue to read Venice as the object of Ruskin's erotic projections, see Robert Hewison, *Ruskin on Venice: The Paradise of Cities* (New Haven, CT: Yale University Press, 2009), 399–428.*

17. Walter Benjamin, *Illuminations*, ed. Hannah Arendt, trans. Harry Zohn (New York: Schocken Books, 1968), 239–40.

18. John Ruskin, *Ruskin's Letters from Venice, 1851–1852*, ed. John L. Bradley (New Haven, CT: Yale University Press, 1964), 60. Republican uprisings had kept Ruskin and his notoriously dissatisfied new spouse, Effie, away from Chamonix and Venice until 1849.*

19. Ibid., 10.

20. Tanner, *Venice Desired*, 81.

21. Letter of September 14 to his father, in John Ruskin, *Ruskin in Italy: Letters to His Parents, 1845*, ed. Harold I. Shapiro (Oxford: Clarendon Press, 1972), 201.

22. Walter Benjamin, *The Arcades Project*, trans. Howard Eiland and Kevin McLaughlin (Cambridge, MA: Harvard University Press, 1999), 831.

23. Jeanne Clegg, *Ruskin and Venice* (London: Junction Books, 1981), 88.

24. *Works* 1:536.

25. Hewison, *Ruskin on Venice*, 32.

26. *Works* 10:257. The "pocket cathedral" quote is from Edward Burne-Jones, describing the Kelmscott Press edition of Chaucer, qtd. in Martin Harrison and Bill Waters, *Burne-Jones* (New York: G.P. Putnam's Sons, 1973), 164; Burne-Jones is paraphrasing *Praeterita*, in *Works* 35:41. For more on the influence of illuminated manuscripts on Ruskin's aesthetics and those of his successors such as William Morris, see Alice H.R.H. Beckwith, *Victorian Bibliomania: The Illuminated Book in Nineteenth-Century Britain* (Providence, RI: Rhode Island School of Design, 1987).

27. See Joseph Forsyth and Issac Forsyth, *Remarks on Antiquities, Arts, and Letters, During an Excursion in Italy, in the Years 1802 and 1803*, 4th ed. (London: J. Murray, 1835), 337. John James Ruskin purchased this book in 1835, when the family made the voyage to Venice.

28. Ruskin, *Ruskin in Italy*, 205.

29. Hewison, *Ruskin on Venice*, 5; Ruskin, *Works* 35:483.

30. David R. Ellison, *The Reading of Proust* (Baltimore: Johns Hopkins University Press, 1984), 63–64.

31. Translation from Donoghue's "Ruskin, Venice, and the Fate of Beauty," in Perosa, *Ruskin e Venezia: La bellezza in declino*, 13.

32. *Works* 35:44.

33. *IH* 82. James's personal use of *The Stones of Venice* and Ruskin's Venetian *Appendix* is well documented; he recommends Ruskin's work as the best reading on Venice in Henry James. See *Letters from the Palazzo Barbaro*, ed. Rosella Mamoli Zorzi (London: Pushkin, 1998), 58–59.*

34. Revising Harold Bloom's reading of Ruskin's Romantic inheritance—first articulated in "Ruskin as Literary Critic," in *The Ringers in the Tower: Studies in Romantic Tradition* (Chicago: University of Chicago Press, 1971), 169–83—Elizabeth Helsinger argues that Ruskin was among the first to react against Romanticism's "sublime egotism." See *Ruskin and the Art of the Beholder* (Cambridge, MA: Harvard University Press, 1982), 66. For a recent analysis of competing strains of Romanticism in Ruskin and Pater, see Kenneth Daley, *The Rescue of Romanticism: Walter Pater and John Ruskin* (Athens, OH: Ohio University Press, 2001).

35. Georg Simmel, *The Sociology of Georg Simmel*, trans. Kurt H. Wolff (New York: Free Press, 1950), 422.

36. Ibid., 413.

37. *Works* 35:151.

38. These call to be read in relation to local revisionist histories of the time such as *Venezia e le sue lagune* (Venice: Antonelli, 1847), a patriotic Venetian effort at rewriting Venetian history with an emphasis on republican values.*

39. Tanner, *Venice Desired*, 25.

40. Byron, *Beppo: A Venetian Story* (London: John Murray, 1818), stanzas 20–21, lines 157–61. Hereafter cited with stanza and line numbers.

41. Byron, *Byron's Letters and Journals*, 5:13; December 5, 1816.

42. Byron, *Beppo*, title page. *Ottava rima* had been recommended to the English public by Ugo Foscolo (who had extensive links to London) in an essay published in *Quarterly Review* 21 (April 1819): 486–556.*

43. The term *dissolute* pervades the *leggenda nera*, and this notion will reemerge in Aschenbach's final soliloquy, where Clayton Koelb has translated *liederlich* as "dissolute": "Do you see . . . that we poets . . . necessarily go astray, that we necessarily remain dissolute adventurers of emotion?" Thomas Mann, *Death in Venice*, trans. Clayton Koelb (New York and London: W.W. Norton & Company, 1994), 61.

44. Alexander Pope, *The Dunciad: In Four Books* (New York: Longman, 1999), book 4, lines 307–10. English pronunciation of "Venice" and "Venus" made no distinction between the two at the time of publication (in 1743).

45. Michel de Montaigne, *All the Essays of Michael Seigneur de Montaigne*, trans. Charles Cotton (A. Murray & Company, 1872), 794.

46. The Grand Tour's entrenched "itinerary of statues and paintings as well as cities unified English visitors in a controlled common experience." See Patricia Meyer Spacks, "Splendid Falsehoods: English Accounts of Rome, 1760–1798," *Prose Studies* 3, no. 3 (December 1980): 206.

47. Pope, *Dunciad*, book 5, lines 329–30.

48. Bruce Redford, *Venice and the Grand Tour* (New Haven, CT, and London: Yale University Press, 1996), 82.

49. *An Essay on Man* (1732–34), in Alexander Pope, *Alexander Pope: The Major Works*, ed. Pat Rogers (Oxford: Oxford University Press, 2006), 272.

50. *Tale of a Tub*, published in 1704, in Jonathan Swift, *Jonathan Swift: The Oxford Authors*, ed. Angus Ross et al. (Oxford: Oxford University Press, 1984), 130.

51. See Laurence Sterne's 1768 *A Sentimental Journey Through France and Italy by Mr. Yorick*, ed. Gardner D. Stout Jr. (Berkeley: University of California Press, 1967), 119. Sterne influenced Italian letters: the Venetian Ugo Foscolo translated *A Sentimental Journey*—and befriended Sterne's successor, Byron, in London.

52. *Childe Harold*, 4.18.158–59.*

53. To John Murray, in a letter of April 2, 1817; see *Byron's Letters and Journals*, 5:203.

54. *Childe Harold*, 4.6.50–51, 4.7.63.

55. Ibid., 4.125.1122; 4.105.945.*

56. Ibid., 146.

57. Ibid.

58. See James Buzard, *The Beaten Track: European Tourism, Literature, and the Ways to Culture, 1800–1918* (Oxford: Clarendon, 1993), 118.

59. *Childe Harold*, 4.4.155; 4.4.32–33.

60. Though they go unnamed, Ruskin must be thinking principally of Gibbon, Voltaire, and Hume.*

61. *Works* 10:221.

62. "Of the Pathetic Fallacy," *Works* 5:201.

63. Patricia Fortini Brown identifies the "eyewitness style" of painting in the age of Carpaccio, whose "note of authentication [is] conveyed to us by the intervening narrator as eyewitness or self-proclaimed authority," and which arises alongside the first city guidebooks by Marcantonio Sabellico (1490) and Marin Sanudo (1493). See *Venetian Narrative Painting in the Age of Carpaccio* (New Haven, CT: Yale University Press, 1988). For Rawdon Brown's contribution to Ruskin's work in Venice, see John E. Law, "'Grubbing in the Archives': Rawdon Brown and Venetian Sources," in *Rawdon Brown and the Anglo-Venetian Relationship*, eds. Ralph A. Griffiths and John E. Law (Stroud: Nonsuch Publishing, 2005), 130f.

64. Bullen calls this Ruskin's "synecdochic method" of cultural history. "Ruskin and the Tradition . . .," 56.

65. M1 Notebook for *Stones* preserved at the Ruskin Library in Lancaster, 76. Reproduced, with editorial changes to paragraph structure and punctuation, in John Ruskin, *The Diaries of John Ruskin*, ed. Joan Evans and J.H. Whitehouse (Oxford: Clarendon Press, 1956), 453–54.

66. See, for example, Jeffrey L. Spear, *Dreams of an English Eden: Ruskin and His Tradition in Social Criticism* (New York: Columbia University Press, 1984); Sawyer, *Ruskin's Poetic Argument*.

67. See Marvin Trachtenberg, *Building-in-Time: From Giotto to Alberti and Modern Oblivion* (New Haven, CT: Yale University Press, 2010), xviii. Mohsen Mostafavi and David Leatherbarrow pursue the implications of such attention to aging for twentieth-century architecture as a fundamental part of construction—identifying the Venetian architect Carlo Scarpa as a paradigmatic example of collaborative design with weathering—in *On Weathering: The Life of Buildings in Time* (Cambridge, MA: MIT Press, 1993).

68. Ruskin's eventual willingness to put even his most confident and coherent early writings at risk is testified to in the revised 1880 introduction to *The Lamps of Architecture*, which had in 1849 attempted "to extricate from the confused mass of partial traditions and dogmata . . . those large principles of right" (8:20).*

69. *Works* 10:15. The "special providence for Venice" that Ruskin claims is also based on the peculiarity of three-foot tides that allow the lagoon to be flushed, but still allow access to boats at low tide. All are permitted by the structure of the mouths of the Brenta and Adige rivers and the "mystery" of the Adriatic, which ministers to Venice "like a gentle nurse" rather than an enemy or tutor. See Ruskin, *Letters from Venice*, 36–37.

70. Ruskin, *Ruskin's Letters*, 40.

71. Ruskin, *Diaries*, 370–71.

72. John Dewey, *Art as Experience* (New York: Capricorn, 1958), 19.

73. On "Venetotropism," a comparative tendency or tic expressing ambivalent English attitudes toward Venice during the eighteenth century, see John Eglin, *Venice Transfigured: The Myth of Venice in English Culture, 1660–1797* (New York: Palgrave, 2001).

74. Giovanni Arrighi, *The Long Twentieth Century: Money, Power, and the Origins of Our Times* (New York: Verso, 1994), 174.

75. The artists met on Tuesday evenings at the residence of Mrs. Kibblewhite; see J.J. Wilhelm, *Ezra Pound in London and Paris, 1908–1925* (University Park, PA: Penn State Press, 2008), 80.

76. "The Nature of Gothic," in *Works* 9:196.

77. For Pugin's influence on Ruskin, see Robert Hewison, *The Argument of the Eye* (Princeton, NJ: Princeton University Press, 1976), 128–29.*

78. Hewison rightly notes that beyond the visual and historical contrasts that structure *Stones* stands the destabilizing contrast between "the language of technical description, and the richer rhetoric of religious exhortation." "Ruskin and the Gothic Revival: His Research on Venetian Architecture," in *Ruskin's Artists: Studies in the Victorian Visual Economy* (Brookfield, VT: Ashgate, 2000), 56–57.

79. The inclusion of "buffoons, drunkards, Germans, dwarves, and the like fooleries" in Veronese's *Last Supper* led the painter to be called before the tribunal

of the Inquisition, which led him to change its title to dodge charges of irreverence, decorum, and even heresy.*

80. For affinities between Ruskin and Romantic theorists of organicism, see James Clark Sherburne, *John Ruskin; or, the Ambiguities of Abundance: A Study in Social and Economic Criticism* (Cambridge, MA: Harvard University Press, 1972).

81. William Wordsworth, *The Prelude: 1799, 1805, 1850* (New York: Norton, 1979), 7.696, 699, 700.

82. Ibid., 7.702–05.

83. Gasparo Contarini, *De Magistratibus & Republica Venetorum* (Paris: Michael Vascosani, 1543), as translated by Lewis Lewkenor in 1599; qtd. in Peter G. Platt, "'The Meraiulouse Site'," 130, 132.

84. Thomas Coryate, *Coryats Crudities* (London: Scolar Press, 1978), 173.

85. Wilenski goes on to attribute the incidentals as "branches from the main trunk of his personal psychosis." *John Ruskin: An Introduction*, 185.

86. Helsinger shows how Ruskin plied his way between the seer's visual arrest and the unfolding perception of ordinary beholdership in space and time in *Ruskin and the Art of the Beholder*, 67–110.

87. *Works* 10:80.*

88. John James Ruskin to John Ruskin, ALS; December 9, 1852; Ruskin Library at Lancaster University.

89. The Venetian cultural heritage lends itself peculiarly well to such strategic circuitousness and myopia. Ekphrasis itself was popularized by Guarino of Verona as an antique trope imported from Byzantium by the Greek humanist Manuel Chrysoloras during the Quattrocento (see Brown, *Venetian Narrative Painting*, 120). In the narrative painting tradition of *istorie* Ruskin treasured, typified by Bellini and Carpaccio, "the ambient is so richly—even so verbosely—elaborated" as to obscure the ostensible center of attention (Brown, 2). Written Venetian histories likewise held to the genre of *cronaca*—with its emphasis on the anecdotal, "multiplication of facts," and dependence on the "gratuitousness of the event"—long after other major cultural centers had turned to humanist historiography (qtd. from historian Antonio Carile in Brown, 90).

90. Jonathan Crary, *Suspensions of Perception: Attention, Spectacle, and Modern Culture* (Cambridge, MA: MIT Press, 1999), 30.

91. Régis Debray, *Against Venice,* trans. Philip Wohlstetter (Berkeley, CA: North Atlantic, 1999), 6.

92. The letters making up these eight volumes were published at regular monthly intervals from January 1871 until Ruskin's breakdown in February–March 1878 and appeared at irregular intervals from 1880 until 1884.

93. For a thorough account of the material changes wrought on Venice and their relationship to cultural tourism, see John Pemble, *Venice Rediscovered* (Oxford: Clarendon, 1995), especially chapter 1.*

94. Leslie Stephen wrote of the work in 1874, "One seems almost to be listening to the cries of a man of genius, placed in a pillory to be pelted by a thick-skinned

mob." "Mr. Ruskin's Recent Writings," *Fraser's Magazine* 9 (June 1874): 689. *Fors* had few subscribers. O'Gorman's analysis of this text stresses its aspiration to locate "patterns beneath the surface of things" and "a greater fate, a higher Fors." Francis O'Gorman, ed., *Late Ruskin: New Contexts* (Aldershot, UK: Ashgate, 2001), 86. See Birch's "Ruskin's Multiple Writing," in *Late Ruskin,* 175–89, for a general defense of *Fors Clavigera*'s structural integrity (countering many critical dismissals of the work), argued from a poststructuralist standpoint.

95. Compare Rosenberg's early characterization of *Fors*'s "peculiar suspension of time and absence of motion" in *The Darkening Glass,* 188.

96. Ruskin's conception derives from Horace's 35th Ode of the first book: "And grasps empaling nails [*clavos trabales*]." See Horace, *A Poetical Translation of the Works of Horace,* ed. Philip Francis London: A. Millar, 1750), 1:129.

97. *Fors* provoked a range of contemporary reactions, from the *Spectator*'s condemnation of its "watery and rambling verbiage" (October 1871) to Thomas Carlyle's initial praise, voiced in a comment to Emerson about "those fierce lightning-bolts Ruskin is desperately pouring into the black world of Anarchy all around him." *The Correspondence of Thomas Carlyle and Ralph Waldo Emerson, 1834–1872* (Boston: Charles Eliot Norton, 1880), 2:352.

98. T.J. Clark, *The Painting of Modern Life: Paris in the Art of Manet and His Followers* (Princeton, NJ: Princeton University Press, 1984), 258.

99. On the Lido's development as a pleasure center, see Giorgio Triani, *Lido e Lidi: Società, moda, architettura e cultura balneare tra passato e futuro,* 1 ed. (Venice: Marsilio, 1989).

100. T.J. Clark, "Modernism, Postmodernism, and Steam," *October* 100 (Spring 2002): 158.

101. Wordsworth, *The Prelude,* 13.560–85.

102. For a thorough study of mythical and apocalyptic imagery in Ruskin, with particular attention to Turner, see Raymond Fitch, *The Poison Sky: Myth and Apocalypse in Ruskin* (Athens: Ohio University Press, 1982).

103. Benjamin, *Arcades,* 831.

104. "Among School Children" (1927), in William Butler Yeats, *The Collected Works of W. B. Yeats,* ed. Richard J. Finneran (New York: Simon & Schuster, 1997), 1:220.

105. Letter qtd. in *Works* 24:xxxvii.

106. John D. Rosenberg, *Elegy for an Age: The Presence of the Past in Victorian Literature* (London: Anthem Press, 2005), 84.

107. Gertrude Stein, *Writings 1903–1932* (New York: Library of America, 1998), 524–26; 395.

108. Manfredo Tafuri, *Venice and the Renaissance,* trans. Jessica Levine (Cambridge, MA: MIT Press, 1989), 291. Virginia Woolf describes *Praeterita* in terms apposite to these: "the beautiful stream wanders out of his control and loses itself in the sands . . . " "Praeterita," *The New Republic* 53, no. 682 (December 28, 1927): 166.

109. William James, *The Meaning of Truth: A Sequel to "Pragmatism"* (New York: Longmans, Green, 1909), 140.

110. Tafuri, *Venice and the Renaissance*, x.

111. *IH* 82.

112. Henry James, *The Aspern Papers and the Turn of the Screw* (New York: Penguin, 1986), 78. Hereafter cited as *Aspern Papers*.

113. *IH* 11.

2. Nearer Distances and Clearer Mysteries

1. Henry James, "Letter of September 25, 1869," in *Letters from the Palazzo Barbaro*, ed. Rosella Mamoli-Zorzi (London: Pushkin, 1998), 57. Hereafter cited as *LPB*.

2. Henry James, *Aspern Papers*, 31.

3. *LPB* 68.*

4. I have used the 1909 Grove edition of *Italian Hours*, cited throughout as *IH*. As Auchard points out in his introduction to the Penn State edition, guidebooks to Italy began to provide a "Table of Italian Hours" for travelers in 1815, as the long-divided Italian peninsula had not yet adopted standardized time: even into the twentieth century, "time in Italy was considered a local phenomenon." "Introduction," in *Italian Hours* (University Park: Pennsylvania State University Press, 1992), x.

5. Henry James, *The Letters of Henry James*, ed. Percy Lubbock (New York: Scribner's, 1920), 2: 77.

6. "Casa Alvisi," in *IH* 82.

7. Henry James, *The Wings of the Dove*, ed. J. Donald Crowley and Richard A. Hocks, Norton Critical Editions (New York: Norton, 1978). Hereafter *Wings*.

8. Here I deploy a term from contemporary experimental poetics that designates a practice of boring through or otherwise manipulating the language of preexisting texts—"writing through"—to describe the intertextual approach to Venice taken by James as post-Romantic author.

9. Ali Behdad argues that nineteenth-century travel accounts always position the traveler to exotic sites as belated. See *Belated Travelers: Orientalism in the Age of Colonial Dissolution* (Durham, NC: Duke University Press, 1994).*

10. *IH* 5. Venice had been linked by rail to Vicenza in 1846, after two decades of planning; by 1857 the line was complete to Milan, but after the opening of the Mont Cenis tunnel in 1871, thousands arrived annually. When the Austrians withdrew in 1866, and Venice joined the Kingdom of Italy, its vitality as a cultural destination was reinstated. These developments made the place a harbor of cosmopolitanism once again, but now open to masses of tourists, spurring a crisis of the very category of the cosmopolitan.*

11. For a history of these developments in tourism, see Lynne Withey, *Grand Tours and Cook's Tours: A History of Leisure Travel, 1750–1915* (New York: William Morrow, 1997).

12. For more on these relations, see Hugh Honour and John Fleming, *The Venetian Hours of Henry James, Whistler, and Sargent* (Boston: Little, Brown, 1991); Anne McCauley et al., eds., *Gondola Days: Isabella Stewart Gardner and the Palazzo Barbaro Circle* (Boston: Isabella Stewart Gardner Museum and Antique Collectors' Club, 2004); and John Julius Norwich, *Paradise of Cities: Nineteenth-Century Venice Seen Through Foreign Eyes* (London: Viking, 2003), 261–82.

13. The critique appeared in *Fors Clavigera*, in a review of Whistler's 1877 show of paintings at the Grosvenor Gallery in Bond Street London. See *Works* 39:160. James writes disapprovingly of Ruskin's commentary and of the trial in general, noting that while he finds Whistler's paintings imperfect, his etchings are "altogether admirable." Henry James, *The Painter's Eye: Notes and Essays on the Pictorial Arts*, ed. John L. Sweeney (Madison: University of Wisconsin Press, 1989), 174.*

14. Qtd. in Margaret F. MacDonald, *Palaces in the Night: Whistler in Venice* (Berkeley: University of California Press, 2001), 70.

15. Qtd. in ibid.

16. William Dean Howells, *Venetian Life; with Illustrations from Original Water Colors*, 2 vols. (Cambridge, MA: Riverside Press, 1883). Howells was hiding out from the American Civil War as U.S. Consul to Venice.

17. Qtd. in Linda Merrill, *After Whistler: The Artist and His Influence on American Painting* (Atlanta: High Museum of Art; Yale University Press, 2003), 34. James was in London during this period; see volume 2 of Leon Edel's 5-volume biography, *Henry James: The Conquest of London, 1870–1881* (Philadelphia: Lippincott, 1962) and the more recent biography by Fred Kaplan, *Henry James: The Imagination of Genius* (New York: William Morrow & Company, 1992), chapters 7 and 8.

18. "Whistler's Wenice; or, Pastels by Pastelthwaite," *Punch* 80 (February 12, 1881): 69.

19. See "On Whistler and Ruskin" (1878) and "On Art-Criticism and Whistler" (1879), in James, *The Painter's Eye*, 172–77.*

20. See ibid., 143; James's early rejection of Whistler's paintings as "ghostly" succumbs to a gradual embrace of the "votary of 'tone'" whose "manner of painting is to breathe upon the canvas." See his 1882 reassessment, qtd. in Viola Hopkins Winner, *Henry James and the Visual Arts* (Charlottesville, VA: University of Virginia Press), 26.

21. *The American Scene*, in *Collected Travel Writings: Great Britain and America* (New York: St. Martin's Press, 1987), 465.*

22. For more on the developments of cultural tourism over the course of the nineteenth century to accommodate the touring masses, see Margaret Plant, *Venice: Fragile City, 1797–1997* (New Haven, CT: Yale University Press, 2002), 99–105.

23. This is the description Miss Evans offers of Venetian waters in Henry James, "Travelling Companions," in *Complete Stories 1864–1874* (New York: Library of America, 1999), 515.

24. Caroline Porter adopts the anthropological term in addressing the detached visionary's "combined complicity and impotence" in James's late fiction. Caroline Porter, *Seeing and Being: The Plight of the Participant Observer in Emerson, James, Adams, and Faulkner* (Middletown, CT: Wesleyan University Press, 1981), 127.

25. See Martin Jay, *Songs of Experience: Modern American and European Variations on a Universal Theme* (Berkeley and Los Angeles: University of California Press, 2005), 96.

26. In his preface to the 1946 edition of *The American Scene*, W.H. Auden wrote, "Of all possible subjects, travel is the most difficult for an artist, as it is the easiest for a journalist. For the latter, the interesting event is the new, the extraordinary. . . . The artist, on the other hand, is deprived of . . . the freedom to invent; successfully to extract importance from historical personal events . . . free only to select and never to modify or to add, calls for imagination of a very high order." Quoted in Henry James, *The Art of Travel: Scenes and Journeys in America, England, France, and Italy from the Travel Writings of Henry James*, ed. Morton Dauwen Zabel (New York: Doubleday, 1958), 26.

27. John Carlos Rowe, *The Theoretical Dimensions of Henry James* (Madison: University of Wisconsin Press, 1984), 193–94.*

28. William James, *The Principles of Psychology* (New York: Holt, 1890), 1:609–10.

29. Edith Wharton, *Italian Backgrounds* (New York: Scribner, 1905), 178.

30. Ibid., 177–78.

31. Edith Wharton, *The Valley of Decision: A Novel* (New York: Scribner, 1902), 53.

32. *Henry James: Letters*, ed. Leon Edel (Cambridge, MA, and London: Belknap, 1984), 4:235–36.

33. From a dialogue embedded in "Mr. Henry James's Later Work," included in the Norton Critical Edition of *Wings*, 485, 486.

34. Walter Pater, *The Renaissance: Studies in Art and Poetry. The 1893 Text*, ed. Donald L. Hill (Berkeley and Los Angeles: University of California Press, 1980), 121. Hereafter cited as *The Renaissance* with page numbers.

35. Henry James, "Preface to *A Little Tour of France*," in *Collected Travel Writings: The Continent* (New York: Library of America, 1993), 3.

36. Henry James, *Essays on Literature: American Writers, English Writers*, ed. Leon Edel (New York: Library of America, 1984), 46.

37. Pater, *The Renaissance*, 110–11. In concluding the seventeen-year project of *Modern Painters*, Ruskin attempted to salvage, by engraving in fine lines, a fragment of the damaged Giorgione fresco, "more like a sunset than a painting," on the façade of the Fondaco dei Tedeschi before the building was destructively "restored" (or notoriously reconstructed, according to the principles of Ruskin's opponent, Viollet-le-Duc). *Works* 3:212n.

38. The mobility of the city bodied forth by Giorgione's portable painted scenes reflects a more recent development: in the wake of the maritime republic's dissolution, the scattered trophies of the Venetian cultural aggregate had begun to travel as far and wide as the leisured class. By James's age, spoliation, impoverishment, and

attempts at modernization had led to the dispersal (if not the destruction) of many artworks that had been created for viewing within structures of worship and political congregation in the Venetian cityscape. James refuses to turn a blind eye to this dispersal. Instead, he punctuates his fiction with the displaced stones and canvases of the fallen Republic. The resultant conditions of viewership compel perceptual dislodgments that James taps strategically.*

39. Psalm 68:13, with the fragment in italics employed as Pater's epigraph.

40. See, especially, Henri Bergson, *Matter and Memory*, trans. Nancy Margaret Paul and William Scott Palmer (New York: Macmillan, 1912), 170–81; James, *The Principles of Psychology*, 1:605–42.

41. Quoted in James, *The Art of Travel*, 20.

42. James actually calls for a literature mediated by previous literary imaginations: he says of Hawthorne, "He looks at things as little as possible in that composite historic light which forms the atmosphere of many imaginations." *Essays on Literature: American Writers, English Writers*, 309.

43. "Two Old Houses," in *IH* 65–66.*

44. *The Princess Casamassima,* in Henry James, *Novels, 1886–1890*, The Library of America (New York: Viking Press, 1989), 351–52.

45. Ibid., 352.

46. Theodor W. Adorno, *Negative Dialectics*, trans. E.B. Ashton (New York: Continuum, 2000), 203.

47. James's enthusiasm for Sargent was immediate and enduring; his 1887 essay on Sargent for *Harper's* introduced the artist's work to the American public. Barry Maine relates James's Venetian interiors to the private and obscure Venetian scenes of Sargent in terms of sexual anxiety in "Picture and Text: Venetian Interiors by Henry James and John Singer Sargent," *Henry James Review* 23, no. 2 (Spring 2002): 136–56.

48. Henry James, *Autobiography: A Small Boy and Others, Notes of a Son and Brother, the Middle Years*, ed. Frederick W. Dupree (New York: Criterion, 1956), 4.

49. A comparison of the original and New York editions of *Portrait of a Lady* proves instructive in this regard; James changed all recurrences of the word "picturesque" to read "romantic," underscoring his historical remove from that aesthetic.

50. Ca' Cappello, an edifice along the Rio Marin, provided James with a basis for the fictive palace; he sent photographer Alvin Coburn there in 1906 in preparation for the production of the *Aspern* frontispiece.*

51. The likening of *calli* to corridors can be traced back at least as far as Chateaubriand; the comparison of the Piazza San Marco to a salon resonates with an apocryphal statement by Napoleon. See Jules Lecomte, *Venise, ou coup-d'oeil littéraire, artistique, historique, poétique et pittoresque sur les monuments et les curiosités de cette cité* (Paris: 1844), 40.*

52. James, *Aspern Papers,* 63.*

53. James, *The Painter's Eye*, 117.

54. Ibid., 117–18.

55. This tendency bears an oblique relation to other representational traditions in Venice, including Grand Tour portraiture. Redford demonstrates that unlike the rhetorical portraiture of Rome, which always incorporates the city as explicit backdrop to the Grand Tourist, portraits by Venetian artists such as Rosalba Carriera "have internalized . . . the place of execution: the Venetian milieu is captured and communicated through medium, format, color, texture, dress, and physiognomy." See Redford, *Venice and the Grand Tour* (New Haven, CT, and London: Yale University Press, 1996), 85.

56. Pound, *Literary Essays*, 200.

57. Henry James, *The Portrait of a Lady. The Novels and Tales of Henry James*, New York Edition (New York: Charles Scribner's Sons, 1908), 3:v–vi. Hereafter cited as *Portrait.*

58. Henry James, *The Spoils of Poynton, A London Life, The Chaperon*, in *The Novels and Tales of Henry James*, New York Edition (New York: Charles Scribner's Sons, 1908), 10:xxi.

59. *IH* 73.

60. Preface to *Portrait*, vi.

61. Aldo Rossi, *A Scientific Autobiography. With a Postscript by Vincent Scully*, trans. Lawrence Venuti (Cambridge, MA, and London: MIT Press, 1981), 72.

62. Pound, *Literary Essays*, 302.

63. Preface to *Wings*, 13.

64. "Travelling Companions," 515.

65. James, *The Spoils of Poynton, A London Life, The Chaperon*, xxi.

66. In "Travelling Companions," the narrator says of Leonardo's *Last Supper* that "The mind finds a rare delight in filling each of its vacant spaces . . . and repairing, as far as possible, its sad disorder" (495).

67. *The Golden Bowl*, in *The Novels and Tales of Henry James*, New York Edition (New York: Charles Scribner's Sons, 1909), 19:138. Hereafter *GB.*

68. For an analysis of the reification of persons as well as thought through images in *The Golden Bowl*, see Bill Brown, *A Sense of Things: The Object Matter of American Literature* (Chicago and London: University of Chicago Press, 2003), 169–73.

69. For the relation of this novel to the debates surrounding the gold standard, see Brenda Austin-Smith, "The Counterfeit Symbol in Henry James's *The Golden Bowl*," *The Henry James Review* 25, no. 1 (2004): 52–66.

70. See James, *The American Scene*, 508.

71. The suicide of James's friend, the writer Constance Fenimore Wilson, in January 1894 is widely understood as a backdrop to *Wings*. See, for example, the discussion in Rosella Mamoli Zorzi, ed., *"Gondola Days": Isabella Stewart Gardner e il suo mondo a Palazzo Barbaro-Curtis* (Venice: Edizioni della Laguna, 2004), 98.*

72. For a classic feminist reading of the vengeful resurgence of textual "ground," see Barbara Johnson, "Is Female to Male as Ground Is to Figure?," in *Feminism and Psychoanalysis*, eds. Richard Feldstein and Judith Roof (Ithaca, NY: Cornell University Press, 1984), 255–68.

73. See the distinction between realism and romance outlined in James's preface to *The American*, ed. James W. Tuttleton (New York and London: Norton, 1978), 10.

74. James, *The Principles of Psychology*, 1:610, 1:609.

75. For complete characterizations of the late style, see Seymour Benjamin Chatman, *The Later Style of Henry James* (Oxford: Blackwell, 1972); Ruth Bernard Yeazell, *Language and Knowledge in the Late Novels of Henry James* (Chicago: University of Chicago Press, 1976); David William Smit, *The Language of a Master: Theories of Style and the Late Writing of Henry James* (Carbondale: Southern Illinois University Press, 1988); and Ross Posnock, *The Trial of Curiosity: Henry James, William James, and the Challenge of Modernity* (New York: Oxford University Press, 1991).

76. For an argument that this is the "chief (dis)organizing trope" of *Wings*, see Sheila Teahan, "The Abyss of Language in *The Wings of the Dove*," *The Henry James Review* 14, no. 2 (1993): 204–14.

77. Gertrude Stein, *Lectures in America* (New York: Vintage, 1975), 53.

78. She will explore the limits of determinism in *Q.E.D.*, in *Writings 1903–1932* (New York: Library of America, 1998). *Q.E.D.* was published the year after *The Wings of the Dove* and identifiably echoes its tripartite structure, love triangle, and characters.

79. Gertrude Stein, *Narration: Four Lectures by Gertrude Stein* (Chicago and London: University of Chicago Press, 1935), 9.

80. "A Transatlantic Interview, 1946," in *A Primer for the Gradual Understanding of Gertrude Stein*, ed. Robert Bartlett Haas (Los Angeles: Black Sparrow, 1973), 15–16.

81. Gertrude Stein, *Writings 1932–1946* (New York: Library of America, 1998), 173.

82. See his discussion of his reasons for abstract frontispieces in the preface to *The Golden Bowl*. Mark Desiderio points out the limitations of the oft-cited pictorial metaphor in "The Art of Friction: Henry James's Evasion of the Pictorial," *Henry James Review* 23, no. 3 (Fall 2002): 281. However, Desiderio simply substitutes the pictorial metaphor with that of the tapestry.

83. Henry James, "Miss Prescott's *Azarian*," *North American Review* 206 (January 1865): 270, 276.

84. Adeline Tintner claims that in James's fictions, artworks "iconify" dramatic action. See *Henry James and the Lust of the Eyes: Thirteen Artists in His Work* (Baton Rouge and London: Louisiana State University Press, 1993), 76. Such metaphors fall short of James's interest in the disjunctions between literary and discursive experience.*

85. See Miriam Allott, "The Bronzino Portrait in Henry James' *Wings of the Dove*," *Modern Language Notes* 68, no. 1 (January 1953): 23–25.

86. Winner proposes that this is a conflation of *The Feast of the House of Levi* at the Venetian Academy with *The Marriage Feast at Cana* in the Louvre (85), while Tintner argues that it refers to the latter alone (101). As the picture is only Susan's metaphor for the scene, and a somewhat ill-conceived one at that, strict philological approaches have their limitations.

87. Preface to *Portrait*, x. Compare this to Osmond's imprisoning "portrait" of Pansy in the novel itself, 347–48.

88. George Oppen to L.S. Dembo, *The Selected Letters of George Oppen*, ed. Rachel Blau DuPlessis (Durham, NC: Duke University Press, 1990), 241.

89. Max Horkheimer and Theodor W. Adorno, *Dialectic of Enlightenment: Philosophical Fragments*, ed. Gunzelin Schmid Noerr, trans. Edmund Jephcott (Stanford, CA: Stanford University Press, 2002), 61.

90. Theodor W. Adorno, *Minima Moralia: Reflections from Damaged Life*, trans. E.F.N. Jephcott (New York: Verso, 1978), 151.

91. Henry James and Hendrik Christian Andersen, *Beloved Boy: Letters to Hendrik C. Andersen, 1899–1915. With an Introduction by Millicent Bell*, ed. Rosella Mamoli Zorzi (Charlottesville: University of Virginia Press, 2004), 102.

92. Ibid., 106–7.

93. See Millicent Bell's introduction in Ibid., xxxi.

3. ADRIATIC FANTASIES

1. "Against Passéist Venice," in *TIF* 33–34. Translations mine unless otherwise noted, as throughout. The manifesto was co-signed by Boccioni, Carrà, and Russolo.

2. Speeches by Boccioni and Carrà followed Marinetti's; an invitation for the event suggests that Russolo, Aldo Palazzeschi, Paolo Buzzi, Enrico Cavacchioli, and others would participate as well. Details of the *serata* can be gleaned from a review published in *L'Adriatico* on August 2, 1910, while the *New York Times* report appeared on July 24, 1910.

3. These polemics are countered in articles published in the *Gazzetta di Venezia*: "Sarah Bernhardt liquida Venezia," February 2, 1909, and Gino Damerini's "Venezia d'oggi vista traverso il carnevale di Nizza. Le fantasie e le diffamazioni di un letterato francese," December 10, 1909.*

4. The *Gazzetta* riposte was composed by a local journalist—a far cry from Calmette, to whom Proust was to dedicate *Swann's Way*. Arnaldo Fraccaroli, "Il futurismo," *Gazzetta di Venezia*, February 13, 1909.*

5. "Veneziani! Quando gridammo: 'Uccidiamo il chiaro di luna!' noi pensammo a te, vecchia Venezia fradicia di romanticismo!" *TIF* 35.

6. "Founding and Manifesto of Futurism," in *TIF* 10–11.

7. See Margaret Plant, *Venice: Fragile City, 1797–1997* (New Haven, CT: Yale University Press, 2002), chapters 6 and 7.

8. *TIF* 34, 35.*

9. For more on Volpi, a controversial figure central to Venice's cultural and industrial development, see Maurizio Reberschak, "Gli uomini capitali: Il 'gruppo veneziano,'" in Mario Isnenghi and Stuart Woolf, eds., *Storia di Venezia: L'Ottocento e il Novecento* (Rome: Istituto della Enciclopedia Italiana/Marchesi Grafiche Editoriali, 2002), 1255–1311; Sergio Romano, *Giuseppe Volpi: Industria e finanza tra Giolitti e Mussolini*, 1 ed. (Milan: Bompiani, 1979); and Fabrizio Sarazani, *L'ultimo Doge: Vita di Giuseppe Volpi di Misurata* (Milan: Edizioni del Borghese, 1972).

10. Pontus Hultén, *Futurism & Futurisms = Futurismo & Futurismi. Palazzo Grassi*, 1st American ed. (New York: Abbeville Press, 1986), 17. See also Valesio's introduction to Filippo Tommaso Marinetti, *Selected Poems and Related Prose. With an Essay by Paolo Valesio*, ed. Luce Marinetti, trans. Elizabeth R. Napier and Barbara R. Studholme (New Haven, CT: Yale University Press, 2002), 150. For an account in English of Futurism as the first avant-garde, see Marjorie Perloff, *The Futurist Moment: Avant-Garde, Avant Guerre, and the Language of Rupture* (Chicago: University of Chicago Press, 1986).

11. Building on Theweleit's *Male Fantasies*, Blum argues that Futurist misogyny stems from "a profound destabilization of the western ideal of the separate, bound, and autonomous subject." See Cinzia Sartini Blum, *The Other Modernism: F.T. Marinetti's Futurist Fiction of Power* (Berkeley: University of California Press, 1996), ix. Emily Braun traces Futurist relations to both misogyny and feminism, arguing that Boccioni's ouevre establishes a more dynamic dialectic, in *Mario Sironi and Italian Modernism: Art and Politics Under Fascism* (New York: Cambridge University Press, 2000). See also Laura Mattioli Rossi, ed., *Boccioni's Materia: A Futurist Masterpiece and the Avant-Garde in Milan and Paris* (New York: Guggenheim Museum, 2004), 1–21.

12. *TIF* 31.

13. The Republic was in fact constantly trying in vain to re-erect eroding boundaries between social classes by instituting sumptuary laws suppressing the circulation of courtesans, but the myth persisted.

14. Marinetti here taps into what Said calls the "deep rich fund of female sexuality" characteristic of Orientalism. Edward Said, *Orientalism* (New York: Vintage, 1979), 182.*

15. F.T. Marinetti, "Ricostruire l'Italia con architettura futurista Sant'Elia. Divertimento rappresentabile in molte sintesi," in *Teatro*, ed. Jeffrey T. Schnapp (Milan: Mondadori, 2004), 477–531.

16. An important revision or amplification of Benjamin's analysis of Fascism as it relates to the Italian context appears in Emilio Gentile, *The Struggle for Modernity: Nationalism, Futurism, and Fascism* (Westport, CT: Greenwood Publishing Group/Praeger, 2003), 43. See also Part 1 of Paolo Valesio, *Gabriele D'Annunzio: The Dark Flame*, trans. Marilyn Migiel (New Haven, CT: Yale University Press, 1992). I do not mean to posit a causal relation between Marinetti's histrionics and Mussolini's acts, though Mussolini acknowledged his debts to Futurism in the dictum, "I formally declare that without Futurism there would never have been a fascist revolution." See Gentile, *The Struggle for Modernity*, 41. A compact but nuanced summary in English of the collaboration and tension between Futurism and Fascism appears in Lawrence Rainey's introduction to *Futurism: An Anthology*, eds. Lawrence S. Rainey, Christine Poggi, and Laura Wittman (New Haven, CT: Yale University Press, 2009); see especially 12–39. This relationship has been the result of extensive studies and revisions in recent years. Beyond those cited throughout this chapter, see, for example, Günter Berghaus, *Futurism and Politics: Between Anarchist Rebellion and Fascist Reaction, 1909–1944* (Providence, RI: Berghahn Books, 1996).*

17. The *bonifiche* or public-works campaigns of the mid-1930s that produced economic housing in the mainland outpost of Mestre succeeded in displacing working-class Venetians to the mainland and the "New Towns" further south, and thereby began to purge the poor from the historical center. This movement has continued to the present day.

18. For accounts of the New Towns built out of reclaimed malarial marshlands during the 1930s in a late echo of Caesar's agricultural policy, see Diane and Joan Ockman Ghirardo, *Building New Communities: New Deal America and Fascist Italy* (Princeton, NJ: Princeton University Press, 1989); Federico Caprotti, *Mussolini's Cities: Internal Colonialism in Italy, 1930–1939* (Youngstown, OH: Cambria Press, 2007); Mia Fuller, "Tradition as a Means to the End of Tradition: Farmers' Houses in Italy's Fascist-Era 'New Towns,'" in *The End of Tradition?* ed. Nezar AlSayyad (London: Routledge, 2004), 171–86; and Antonio Pennacchi, *Fascio e martello: Viaggio per le città del Duce* (Rome: Laterza, 2008).

19. "La nuova Roma" (December 31, 1925), in *Opera omnia di Benito Mussolini*, ed. Edoardo Susmel and Duilio Susmel (Florence: La Fenice, 1960), 22:48.

20. For accounts of *sventramento*, see Ghirardo, *Building New Communities: New Deal America and Fascist Italy*; Caprotti, *Mussolini's Cities: Internal Colonialism in Italy, 1930–1939*; Antonio Cederna, *Mussolini urbanista: Lo sventramento di Roma negli anni del consenso* (Rome: Laterza, 1979); Paul Baxa, "Piacentini's Window: The Modernism of the Fascist Master Plan of Rome," *Contemporary European History* 13, no. 1 (February 2004): 1–20; and John David Rhodes, *Stupendous, Miserable City: Pasolini's Rome* (Minneapolis: University of Minnesota Press, 2007).

21. For Marinetti's opposition to *romanità*, see the section of the 1915 text *Guerra sola igiene del mondo* (War, the World's Only Hygiene) reproduced as "Contro Roma passatista" in *TIF* 286. *Romanità* had been available as a nationalist stance since 1870, when Rome's status as capital was secured, and developed into an intellectual elitist cult through the 1920s. See Andrea Giardina and Andrè Vauchez, *Il mito di Roma: Da Carlo Magno a Mussolini* (Rome and Bari: Laterza, 2008).

22. James McNeill Whistler, for example, registered his understanding of Venetian aesthetic difference in an 1885 lecture by noting that Tintoretto and Veronese saw "picturesque grandeur and noble dignity in the Jews' quarter" of their native city, without exchanging its "brocaded silks for the classic draperies of Athens." *Mr. Whistler's "Ten O' Clock"* (Boston and New York: Houghton, Mifflin and Company, 1896), 8.

23. For a synthetic account of these developments, see, for example, Franco Mancuso, *Venezia è una città: Come è stata costruita e come vive* (Venice: Corte del Fontego, 2009), 63–88.

24. Various critics have sought to add nuance to the relations of European modernism with Fascism: in addition to those cited here, they include Perloff, *The Futurist Moment*; Braun, *Mario Sironi and Italian Modernism*; Alice Yaeger Kaplan, *Reproductions of Banality: Fascism, Literature, and French Intellectual Life* (Minneapolis: University of Minnesota Press, 1986); Richard Joseph Golsan, *Fascism, Aesthetics, and*

Culture (Hanover, NH: University Press of New England, 1992); Claudia Salaris, *Artecrazia: L'Avanguardia futurista negli anni del fascismo*, 1 ed. (Scandicci [Italy]: Nuova Italia, 1992); and Barbara Spackman, *Fascist Virilities: Rhetoric, Ideology, and Social Fantasy in Italy* (Minneapolis: University of Minnesota Press, 1996). For perspectives on the difficulty of siphoning off a strictly aesthetic "modernism" in Italy, see Luca Somigli and Mario Moroni, eds., *Italian Modernism: Italian Culture Between Decadentism and Avant-Garde*, Toronto Italian Studies (Toronto and Buffalo: University of Toronto Press, 2004).

25. This is part of an overall imperative to "[d]estroy the I in literature." "Technical Manifesto of Futurist Literature," in *TIF* 50.

26. Here I echo the epigraph to Byron's "Beppo." See Celeste Langan, "Venice," in *Romantic Metropolis*, ed. James K. Chandler and Kevin Gilmartin (New York: Cambridge University Press, 2005), 2.

27. Henry James, "Gabriele D'Annunzio (1902)," in *Literary Criticism: French Writers, Other European Writers; the Prefaces to the New York Edition* (New York: Library of America, 1984), 2:941.

28. Later, Fascism explicitly espoused art that resisted abstraction while paradoxically repudiating "materialistic" and sensuous aesthetics; see, for example, Ardegno Soffici, *Periplo dell'arte. Richiamo all'ordine* (Florence: Valecchi, 1928).*

29. Patrizio Ceccagnoli summarizes Venice's status in Marinetti's career as "a polemical object that stands in for (and can be substituted by) other Marinettian-Futurist polemical objects: moonlight, symbolist poets, d'Annunzio, sentimentalism, etc." See "Marinetti e Venezia: Dal romanticismo al feticismo," in F. T. Marinetti, *Venezianella e Studentaccio*, ed. Paolo Valesio and Patrizio Ceccagnoli (Milan: Mondadori, 2013), 156. This volume cited below as *VS*.

30. Visser describes Venetian counters to hegemonic *romanità* in "Fascist Doctrine and the Cult of the Romanità," *Journal of Contemporary History* 27, no. 1 (January 1992): 7.

31. Barrès was the author of the French nationalist trilogy *Cult of the Ego*. See Maurice Barrès, *Un homme libre* (Paris: Imprimerie Nationale, 1988) and *Amori et dolori sacrum: La mort de Venise* (Paris: Emile-Paul, 1903). For an account of Venice's influence on Wagner, and Wagnerism's profound impact on Venice, see John W. Barker, *Wagner and Venice* (Rochester: University of Rochester Press, 2008).*

32. Gabriele D'Annunzio, *Il fuoco*, ed. Niva Lorenzini (Milano: A. Mondadori, 1996), 58. This work was published in English as *The Flame of Life*, trans. Kassandra Vivaria [pseud.] (Boston: L.C. Page, 1900); as *The Flame*, trans. Dora Knowlton Ranous (New York: National Alumni, 1907); and as *The Flame*, trans. Susan Bassnett (New York: Marsilio, 1991). However, all references to *The Flame* in this text refer to my translation of the Italian edition unless otherwise noted. For D'Annunzio's relation to Decadentism and the "rhetoric of sickness," see Barbara Spackman, *Decadent Genealogies: The Rhetoric of Sickness from Baudelaire to D'Annunzio* (Ithaca, NY: Cornell University Press, 1989).*

33. For an account of Mussolini's call to return Rome to the sea, and its influence on aesthetic practices such as those that built the Esposizione Universale of 1942, see Richard Etlin, *Modernism in Italian Architecture* (Cambridge, MA: The MIT Press, 1991), 503–04.

34. Walter Pater, *The Renaissance: Studies in Art and Poetry. The 1893 Text,* ed. Donald L. Hill (Berkeley and Los Angeles: University of California Press, 1980), 189.*

35. *Il fuoco,* 220.*

36. Ibid., 254, 278. Eleonora Duse, under the alias of "La Tragica" in this passage, was D'Annunzio's collaborator, interpreter, lover, and benefactor from 1895 through their definitive break in 1904.*

37. James, "Gabriele D'Annunzio (1902)," in *Literary Criticism: French Writers, Other European Writers,* 2:935.

38. Ibid., 2:939; 2:919.

39. *Il fuoco,* 23, 42, 59, 91.

40. Ibid., 25, 74, 91.

41. James, *Literary Criticism: French Writers, Other European Writers,* 2:931.

42. Ibid., 2:926.

43. Ibid., 2:941.

44. Ibid., 2:930.

45. *Il fuoco,* 9.

46. See Barbara Spackman, "Interversions," in *Perennial Decay: On the Aesthetics and Politics of Decadence,* ed. Liz Constable, Dennis Denisoff, and Matthew Potolsky (Philadelphia: University of Pennsylvania Press, 1999), 35–49.

47. James, *Literary Criticism: French Writers, Other European Writers,* 2:941.

48. See Enzo Di Martino and Paolo Rizzi, *Storia della Biennale, 1895–1982* (Milan: Electa, 1982); Lawrence Alloway, *The Venice Biennale 1895–1968: From Salon to Goldfish Bowl* (Greenwich, CT: New York Graphic Society Ltd., 1968); Adriano Donaggio, *Biennale di Venezia: Un secolo di storia* (Milan: Giunti, 1988). Jeffrey T. Schnapp's studies of the Fascist political exhibitions are essential. See his *Anno X. La Mostra della Rivoluzione Fascista del 1932: Genesi–sviluppo–contesto culturale–storico–ricezione* (Rome-Pisa: Istituti Editoriali e Poligrafici Internazionali, 2003); *Donatello Among the Blackshirts: History and Modernity in the Visual Culture of Fascist Italy* (Ithaca and London: Cornell University Press), 223–40; and "Mostre," in *Modernitalia,* ed. Francesca Santovetti (New York: Peter Lang, 2012), 145–70.

49. *Il fuoco,* 37, 48, 55, 69.

50. This racialized understanding pervades the book, though it ends on the death of the genius Wagner, eulogized in spite of Èffrena's suspicion of Germanic races. Èffrena's xenophobia is captured in his imagining the metropolitan races of the North and New World for whom Foscarina/Duse has performed: "colonies of bastardized races . . . , all the barbarian crowds to whom she had appeared like the sovereign revelation of Latin genius" (89).

51. James, *Literary Criticism: French Writers, Other European Writers,* 2:941.

52. Ibid., 2:934.

53. *Il fuoco,* 177.

54. For a reading of the iconic relationship forged between the author and the nomadic, newly "modern" actress, arguing that Duse influenced D'Annunzio's authorship of more modern theatrical works, see Lucia Re, "D'Annunzio, Duse, Wilde, Bernhardt: Il rapporto autore/attrice fra decadentismo e modernità," *Modern Language Notes* 117, no. 1 (2002): 115–52.

55. For more on the aesthetic turn from symbolism and naturalism to the "convalescence of the spirit," see Luca Somigli, *Legitimizing the Artist: Manifesto Writing and European Modernism, 1885–1915*, Toronto Italian Studies (Toronto and Buffalo: University of Toronto Press, 2003), 96–127. For "Adriatic nationalism," see Renato Camurri, "La classe politica nazionalfascista," in *Storia di Venezia: L'Ottocento e il Novecento*, ed. Mario Isnenghi and Stuart Woolf (Rome: Istituto della Enciclopedia Italiana, 2002), 1356–57.*

56. For more on Andrea Busetto's Venetian interventionist publications, see Willard Bohn, *The Other Futurism: Futurist Activity in Venice, Padua and Verona* (Toronto: University of Toronto Press, 2004), 19–24.

57. Gabriele D'Annunzio, *La nave: Tragedia di Gabriele D'Annunzio* (Milan: Fratelli Treves, 1908), 5, hereafter referred to in body text as *The Ship* for the sake of broad legibility, though I have translated throughout from the Italian text.

58. For an account of the Byzantine revival, see Massimo Bernabò, *Ossessioni bizantine e cultura artistica in Italia: Tra D'Annunzio, fascismo e dopoguerra*, Nuovo Medioevo (Naples: Liguori, 2003).

59. Valesio, who is markedly sympathetic to D'Annunzio, and in this way a revisionist critic, notes that at times, "[t]he preciousness that usually gives particular force to d'Annunzio's poetry acts . . . as an embarrassment or impediment that is not only lexical . . . but also syntactical," hampering certain moments "like an archaeological . . . shadow." *Gabriele D'Annunzio: The Dark Flame*, 58–59.

60. Pound, *The Cantos* 93/650. Pound cited D'Annunzio's line "Non è mai tardi per tentar l'ignoto" ("It is never too late to attempt the unknown") in "I Gather the Limbs of Osiris" (1911–1912), in Ezra Pound, *Selected Prose: 1909–1965* (New York: New Directions, 1973), 25, and again in Canto 93.

61. *TIF* 37. Marinetti's relationship to Nietzsche, in particular to "On the Use and Abuse of History for Life," and to aestheticism is analyzed in the second chapter of Somigli, *Legitimizing the Artist*.

62. Wyndham Lewis, "A Review of Contemporary Art," *BLAST* 2 (1915): 40.

63. *TIF* 37.

64. For more on this period's development of tourism and its effect on the local population, see Plant, *Fragile City*, 256–61.

65. Thomas Mann, *Death in Venice*, trans. Clayton Koelb (New York and London: W.W. Norton & Company, 1994), 53–54.

66. Thomas Mann in a letter to the Hungarian anthropologist Kark Kerényi, qtd. in André von Gronicka, "'Myth Plus Psychology': A Style Analysis of *Death in Venice*," *Germanic Review* 31 (1956): 191.

67. "'Futurists' Desire to Destroy Venice," *New York Times*, July 24, 1910.

68. The conservative curator, Antonio Fradeletto, prohibited the exhibition of a Picasso *Harlequin* in 1909, for example, because "it scandalized the public." Qtd. in Esther Coen, Guido Perocco, et al., eds., *Boccioni a Venezia: Dagli anni romani alla mostra d'estate a Ca' Pesaro* (Milan: Mazzotta, 1985), 141. See also Di Martino and Rizzi, *Storia della Biennale 1895–1982*, chapter 1.

69. Nostalgia for aristocratic rites suffuses the review pages: "Yesterday Venice called to mind the grandiose ceremonies of the *Dominante*, when Princes and Powers came here from every country." Hugo Damerini, "Review of 9th International Exposition of Art," *Gazzetta di Venezia*, April 24, 1910.

70. Qtd. in Hultén, *Futurism & Futurisms*, 555.

71. Arturo Lancellotti, *Le Biennali veneziane dell'ante guerra* (Alexandria: Ariel, 1926), 120–21.

72. Damerini, "Review," 1–2. This ambiguous notation may refer to the call for a democratic-socialist art during the opening ceremonies by Luigi Credaro, then Minister of Public Education.

73. Ibid., 1. Damerini later wrote *D'Annunzio e Venezia* (Milan: Mondadori, 1943).

74. Gino Damerini, "Gustav Klimt," *Gazzetta di Venezia*, April 24, 1910. Marinetti had written to Damerini in September 1909, praising the critic's review of Ugo Valeri's show at Ca' Pesaro. See Coen, *Boccioni a Venezia*, 70, and Bohn, *The Other Futurism*, 22–23, for further details.

75. F.T. Marinetti, "Discorso futurista agli inglesi," in *TIF* 286. The inauguration of the restored campanile in April 1912 unfolded to much fanfare, including a manifesto written for the occasion by the American artist Joseph Pennell and, as the *New York Times* reported on April 25, the presence of J.P. Morgan. For more details on the reconstruction controversy, see Plant, *Fragile City*, 234–38.

76. "Futurist Speech to the Venetians," in *TIF* 36.

77. *The Cantos* 80/529. For more on Pound's negotiations with Italian culture (and Fascism) in the 1930s, see David Barnes, "Fascist Aesthetics: Ezra Pound's Cultural Negotiations in 1930s Italy," *Journal of Modern Literature* 34, no. 1 (2010): 19–35.

78. See Coen, *Boccioni a Venezia*, 141. The museum still exists, as does the supporting Bevilacqua La Masa Foundation, founded by the Venetian duchess.

79. *Boats in the Sun* and *The Grand Canal in Venice* (both 1907) are good examples of this development. For more on Futurist activity in Venice, see the catalog for the Palazzo Grassi exhibit, *Futurismo a Venezia* (Turin: La Stampa, 1986); Dino Barattin et al., eds., *Parole in libertà: Libri e rivisti del futurismo nelle Tre Venezie* (Monfalcone: Laguna, 1992); and Bohn, *The Other Futurism*.

80. Letter to Barbantini in Umberto Boccioni, *Gli scritti editi e inediti*, ed. Zeno Birolli (Milan: Feltrinelli, 1971), 341.

81. Qtd. in Coen, *Boccioni a Venezia*, 85.

82. See the introduction to *Futurismo e fascismo* (1924), in *TIF* 496–97. "Il Secondo Futurismo" is divided by scholars into two phases, from 1918 to 1928 and 1929 to 1938

(distinguished by the "Manifesto dell'Aeropittura" discussed later), and is followed by the so-called Terzo Futurismo.

83. See Bohn, *The Other Futurism*, 11–12, for the text of Marinetti's 1911 speech to the Venetians.

84. Only one page of "Convegno sul Canal Grande" is broadly available, reproduced in Amerigo Fabbri, "La cima della modernità: Il manifesto finale inedito del futurismo," *Yale Italian Poetry* 5–6 (2001–2002): 294.

85. See Marinetti, "Lettera aperta al futurista Mac Dermarle," *TIF* 94.

86. See Luca Pes, "Il fascismo adriatico," in *Storia di Venezia: L'Ottocento e il Novecento*, ed. Mario Isnenghi and Stuart Woolf (Rome: Istituto della Enciclopedia Italiana, 2002), 1315.

87. In 1932 the fliers of a squadron of seaplanes who had made the transatlantic journey from Italy to Chicago on the occasion of the World's Fair returned for a triumphal parade on the Roman Via dell'Impero. See Gioacchino Volpe, *Il Risorgimento dell'Italia* (Fasci italiani all'estero, 1934), 405–06; Plinio Ciani, *Graffiti del Ventennio: Guida al curioso, al comico, all'aneddotico nell'architettura e nell'arte mussoliniane* (Milan: Sugar, 1975), 44–45; and Claudio G. Segrè, *Italo Balbo: A Fascist Life* (Berkeley: University of California Press, 1987), 215–65.

88. Mario Isnenghi, "D'Annunzio e l'ideologia della Venezianità," *Rivista di Storia Contemporanea* 3 (1990): 430. For more on D'Annunzio's appropriation of the myth of Venice, see John Woodhouse, *Gabriele d'Annunzio: Defiant Archangel* (Oxford: Clarendon Press, 1998), 307, and Isnenghi and Woolf, *Storia di Venezia*, chapter 4.

89. Von Hohenlohe was the brother of Rilke's patron, Maria von Thurn und Taxis. For further background in English, see the introductions to the English translations: Gabriele D'Annunzio, *Nocturne and Five Tales of Love and Death*, trans. Raymond Rosenthal (Marlboro, VT: Marlboro Press, 1988), 1–6, and *Nocturne*, trans. Stephen Sartarelli (New Haven, CT: Yale University Press, 2012), vii–xii.*

90. From D'Annunzio's postscript to the work, in *Notturno*, ed. Elena Ledda (Milan: Garzanti, 1995), 320.

91. Ibid. *Notturno* was finally published in 1921.*

92. *Notturno*, 17.*

93. Ibid., 18.

94. Ibid., 22.*

95. "Three Cantos," in *Poems and Translations*, ed. Richard Sieburth (New York: Library of America, 2003), 318; qtd. in Ezra Pound, "Paris Letter. October, 1922," *Dial* 73, no. 5 (November 1922): 553. Pound translates from the following text: "Sono disteso davanti alla finestra. La luna è colma. Non v'è bava di vento. [. . .] / Non s'ode voce, né tonfo di remo, né romore alcuno. La vita sembra esaltata da secoli. / La luna insensibile contempla una bellezza esanime come quella di Angkor e di Anuradhapura."

96. Ezra Pound, "Approach to Paris, V," *New Age* 13, no. 23 (October 2, 1913): 662.

97. Giordano Bruno Guerri, *Filippo Tommaso Marinetti: Invenzioni, avventure e passioni di un rivoluzionario* (Milan: Mondadori, 2009), 178.

98. Renzo de Felice, *D'Annunzio politico: 1918–1938* (Rome: Laterza, 1978), 154–55. For relations between D'Annunzio and the Futurists in Venice, see Jared M. Becker, *Nationalism and Culture: Gabriele d'Annunzio and Italy After the Risorgimento* (New York: Peter Lang, 1994), chapters 5 and 7. For Marinetti's reaction to these events, see Guerri, *Filippo Tommaso Marinetti*, 176–210.

99. William James Bouwsma, *Venice and the Defense of Republican Liberty: Renaissance Values in the Age of the Counter Reformation* (Berkeley: University of California Press, 1968), xiii.

100. Horatio Brown, *Venetian Studies* (London: Kegan Paul, Trench & Co, 1887), 1.

101. Stanislao G. Pugliese, *Fascism, Anti-Fascism, and the Resistance in Italy: 1919 to the Present* (Lanham: Rowman & Littlefield Publishers, 2004), 6. D'Annunzio's *Il fuoco* refers to "the cunning and bravery of Malatesta" (100); it is conceivable that his interest in this figure kindled Pound's.

102. For more on the symbolic support a Venetian imaginary lent to the Fiume occupation, see Damerini, *D'Annunzio a Venezia* and Mario Isnenghi, "Il poeta-vate a la rianimazione dei passati," in *L'Italia del Fascio* (Florence: Giunti, 1979), in particular 60–61. On the development of Venetian fascism, see Giulia Albanese, *Alle origini del fascismo: La violenza politica a Venezia 1919–1922* (Padova: Il Poligrafo, 2001).*

103. "Fiume . . . became the symbol of a moral, political and social refutation of the entire constructed order." De Felice, *D'Annunzio politico*, 28–29.

104. The 1924 Treaty of Rome Mussolini forged with Yugoslavia declared that Fiume be annexed to Italy; it remained Italian until its restoration to Yugoslavia in 1947. For a discussion of the differences between the political outlooks of D'Annunzio and Mussolini, see De Felice, ibid., 160. Dombrowski summarizes as follows: "D'Annunzio's mythical narratives provided a symbolic response to a concrete historical predicament, to which fascism provided a large-scale political and organizational solution." Robert S. Dombrowski, *Properties of Writing: Ideological Discourse in Modern Italian Fiction* (Baltimore: Johns Hopkins University Press, 1994), 68.

105. Dombrowski, *Properties of Writing*, 64.

106. Ezra Pound, "The Revolt of Intelligence, I," *New Age* 26, no. 2 (November 13, 1919): 21–22.

107. Ibid., 22.

108. "Paris Letter," 552–53.

109. "Henry James," in *Literary Essays of Ezra Pound*, ed. T.S. Eliot (New York: New Directions, 1968), 324n.

110. "Paris Letter," 551.

111. Ibid., 552.

112. D'Annunzio's famous flight over Vienna in 1918 resulted in his declaring "the aeronautical supremacy of the aeroplane." For an account of the Brescia air meet detailing the participation of Kafka and Puccini, among others, see Peter Demetz, *Air Show at Brescia, 1909* (Darby, PA: Diane Publishing, 2002).

113. For this background and a history of the aerial aesthetic, see Giovanni Lista, "Gli anni trenta: l'aeropittura," in *Futurismo 1909–2009. Velocità + Arte + Azione*, eds. Giovanni Lista and Ada Masoero (Milan: Palazzo Reale di Milano, 2009), 237–72.

114. Marinetti, "Ricostruire l'Italia," 484.

115. Ibid., 496.

116. Ibid., 530.

117. Ibid., 496.

118. The work was finally published in the Valesio-Ceccagnoli edition, cited as *VS*.*

119. See Carlo Fumian, "Venezia 'città ministeriale' (1943–45)," chapter 8 of *La resistenza nel veneziano: La società veneziana tra fascismo, resistenza, repubblica*, vol. 1, ed. Giannantonio Paladini and Maurizio Reberschak (Venice: Università di Venezia, 1985). For more background on Venetian society of these years, see the following chapters in Isnenghi and Woolf, *Storia di Venezia*: "I fasti della 'tradizione': le cerimonie della nuova venezianità," 1514–1522; "Il 'fronte interno' sulle lagune: Venezia in guerra (1938–1943)," 1685–1740; and "Il '43–45," 1741–1756.

120. Antonio Maraini, introduction to catalogue, *XXII Biennale di Venezia*, 1942 (n.p.).

121. The historical center of Venice was too detached from new ground networks to be a vital part of the partisan movement in this period and had been determined too precious to be bombed.

122. They stayed in the Casa Ravà and left for Salò in August 1944, several months before Marinetti's fatal heart attack on December 2. Valesio provides extensive background in his introduction to *VS*, v–liv.

123. *TIF* 32.

124. Valesio singles this work out as one of the truly rare examples of a modern Italian "experimental novel," even identifying it as "pre-neoavanguardia," in his preface to the text of *VS*, xlvii. Due to its self-declared hybridity between poetry and narrative, I hesitate to describe the work as a novel.

125. See Blum, *The Other Modernism*, xi.

126. Christine Poggi, *Inventing Futurism: The Art and Politics of Artificial Optimism* (Princeton, NJ: Princeton University Press, 2009), xi.

127. Blum, *The Other Modernism*, viii.

128. Benito Mussolini, *Opera omnia*, 26:187.

129. Schnapp, "Mostre," 161. See also the catalog, *Mostra Augustea della Romanità: Catalogo* (Rome: Colombo, 1938), and for an exegesis, Marla Stone, "A Flexible Rome: Fascism and the Cult of *romanità*," in *Roman Presences: Receptions of Rome in European Culture, 1789–1945*, ed. Catherine Edwards (Cambridge and New York: Cambridge University Press, 2007), 205–20.

130. For a reading of Venezianella as Beatrice, see Giusi Baldissone, "Beatrice e Marinetti: Da Dante a 'Venezianella,'" in *Il personaggio nelle arti della narrazione*, ed. Franco Marenco (Rome: Edizioni di Storia e Letteratura, 2007), 131–38. Baldissone characterizes *Venezianella* as Marinetti's "only authentic futurist novel," doing away with the preoccupations of punctuation and syntax, coherent narration of events, and the thread of a story.

131. See the 1944 tractate on aeropoetry, "Aeromusica dell'alfabeto in libertà," reproduced in *Yale Italian Poetry* 5–6 (2001–2002): 301–14.

132. "Decollagio," in Filippo Tommaso Marinetti, *L'Aeropoema del Golfo della Spezia: Vincitore nella sfida ai poeti d'Italia (Festa del premio di pittura "Golfo della Spezia" settembre, ottobre 1933-XI)* (Milan: Mondadori, 1935), 20–21.

133. Ibid., 21–23.

134. Pound, *Cantos* 25/117.

135. "Decollagio," in *L'Aeropoema del Golfo della Spezia*, 20–21. The manifesto's twenty-two terms are recapitulated for those with no access to the Italian in Willard Bohn, "The Poetics of Flight: Futurist 'Aeropoesia,'" *MLN* 121, no. 1 (2006): 209.

136. This approach was later taken up by the post-Futurist painter Lucio Fontana, who privileged airborne perspectives in the *Spatial Concepts* series inspired by Venice and New York in 1961 and 1962.

137. "Decollagio," in *L'Aeropoema del Golfo della Spezia*, 21.

138. This manifesto is reprinted in *Futurism: An Anthology*, 65.

139. See Lista and Masoero, *Futurismo 1909–2009*, 237, 239. Jeffrey Schnapp has demonstrated that the body/machine complex Marinetti transcribes from the "propeller talk" does not conform to the day's Taylorist precepts of scientific management, being driven instead by spurts of embattled effort and expenditure. See "Propeller Talk," *Modernism/Modernity* 1, no. 3 (1994): 153–78.

140. See *Futurismo 1909–2009*, 239.

141. "Aeropittori futuristi" exhibited at the 1934 Biennale, and the 1938 Biennale featured an exhibit titled "Futuristi aeropittori d'Africa e Spagna," celebrating Italy's 1935 invasion of Ethiopia and 1936 participation in the Spanish Civil War. Crali, following Prampolini and Depero, was awarded a solo show at the 22nd Biennale in 1940. Marinetti praised the show elaborately in a pamphlet printed in Venice, whose title declared the exhibit a "*new victory of Italian aeropainting, plastic supremacy surpassing foreign painting, and supremacy in the aeropictorial glorification of aerial warfare's rapid bombardments.*" Qtd. in Bohn, *The Other Futurism*, 50.

142. Rainey notes that one of Marinetti's signature strategies is to push the terms of polarities such as masculine sea and feminine stars "to such extremes that they would collapse back into their antitheses, a maneuver that casts the nature of individuation, or how we draw basic distinctions between figure and ground . . . into a perennial crisis." See his introduction to *Futurism: An Anthology*, 3.

143. *TIF* 253–54.

144. See especially Kaplan, *Reproductions of Banality*; Spackman, *Fascist Virilities*; and Andrew Hewitt, "A Fascist Feminine," *Qui Parle: Literature, Philosophy, Visual Arts, History* 13, no. 1 (Fall/Winter 2001): 29–56.

145. Kaplan, *Reproductions of Banality*, 86.

146. *TIF* 457. For more on this 1482 action by the republic, see the "Ponte delle Tette" (Bridge of Tits) entry in Giuseppe Tassini, *Curiosità veneziane*, ed. Lino Moretti (Venice: Filippi Editore, 1933), 654.

147. *TIF* 9.*

148. See Blum, *The Other Modernism*, 49; Hal Foster, *Prosthetic Gods* (Cambridge, MA: MIT Press, 2004), 118–20; and Poggi, *Inventing Futurism*, 157–58. On the posited opposition between body and machine, see Mark Seltzer, *Bodies and Machines* (New York: Routledge, 1992).

149. Boccioni, who probably came into contact with Bergson's *Matière et mémoire* in 1913, shared Marinetti's obsession with "matter." See Fergonzi, "On the Title of the Painting *Materia*," in *Boccioni's Materia*, 47–53.

150. For visual correlatives, see also *The Street Enters the House* (1911), *Simultaneous Visions* (1911), *Horizontal Construction* (1912), and the photograph of Boccioni's mother in front of the map of Le Tre Venezie, reproduced in Coen, *Boccioni a Venezia*.

151. Marinetti's parody is made explicit through the rewriting of several scenes from *Il fuoco*.

152. Quoted in 240–41 of Giuseppe Dell'Oro, "L'arte decorativa alla XXI Biennale," in *XXI Esposizione Biennale internazionale d'Arte di Venezia. Le Tre Venezie*, ed. Federazione veneziana dei Fasci di combattimento (Venice: Biennale di Venezia, 1938).

153. See Ruskin, *Works* 10:114–15.*

154. See Boccioni's "Futurist Sculpture," April 11, 1912, reprinted in *Futurism: An Anthology*, 117, 114.

155. "Ricostruire l'Italia," 482.

156. Paul Scheerbart, *Glass Architecture; and Alpine Architecture, by Bruno Taut*, ed. Dennis Sharp, trans. James Palmes (New York: Praeger, 1972).*

157. "The Glass Paradise," in Reyner Banham, *A Critic Writes: Essays by Reyner Banham* (Berkeley: University of California Press, 1996), 36–37.

158. *Glass Architecture*, 58.

159. Ibid., 59.

160. Ibid., 67.

161. Mussolini's "Ai gerarchi milanesi" (July 10, 1929) is discussed in Emilio Gentile, *The Sacralization of Politics in Fascist Italy* (Cambridge, MA: Harvard University Press, 1996), 124–25. See also Etlin, *Modernism in Italian Architecture*, 439–47.

162. Giuseppe Terragni, in a double issue devoted to the Casa del Fascio: "La Costruzione della Casa del Fascio di Como," *Quadrante* 35/36 (1936): 5–6.

163. "La Costruzione della Casa del Fascio," 15.

164. See Etlin, *Modernism in Italian Architecture*, 650n.

165. Guerri, *Filippo Tommaso Marinetti*, 255, 252.

166. John Ruskin, *Works* 16:349. An uncannily similar proposal arises in "Ricostruire l'Italia," 497.

167. See "Ricostruire l'Italia," 521.

168. For a useful primary source in English on the aspirations of Futurist theater, see Marinetti's 1933 text "Total Theater: Its Architecture and Technology," in *Critical Writings*, trans. Doug Thompson (New York: Farrar, Straus, and Giroux, 2006), 400–07.

169. See Valesio's postface in Marinetti, *Selected Poems and Related Prose*, 153.

170. James, *Literary Criticism: French Writers, Other European Writers*, 2:941.

171. Valesio elucidates this religious turn in Marinetti, *Selected Poems and Related Prose*, 154.*

172. Blum, *The Other Modernism*, viii.

173. Spackman, *Fascist Virilities*, 5, 6.

174. Tafuri argues that during the Renaissance, architects understood the "return to antiquity" as a "transgression" of laws regulated by taste, not a hearkening to universal laws of beauty or form. See Manfredo Tafuri, *Ricerca del Rinascimento: Principi, cittá, architetti* (Turin: Giulio Einaudi, 1992).

175. Braun, *Mario Sironi and Italian Modernism*, 6.

176. Mark Antliff, *Avant-Garde Fascism: The Mobilization of Myth, Art, and Culture in France, 1909–1939* (Durham, NC: Duke University Press, 2007), 60.

177. Theodor W. Adorno, *Minima Moralia: Reflections from Damaged Life*, trans. E.F.N. Jephcott (New York: Verso, 1978), 151.

178. Lista and Masoero, eds., *Futurismo 1909–2009*, 272.

179. Examples of this phenomenon appear in Gaetano Pattarozzi's "Aeropoema futurista della Sardegna," Emilio Buccafusca's "Aeropoema del Golfo di Napoli," Castrense Civello's "Area madre," Geppo Tedeschi's "Idrovolanti in siesta sul Golfo di Napoli," Dina Cucini's "Aeropoema futurista delle torri di Siena," and Franca Maria Corneli's "Aeropoema futurista dell'Umbria."

180. Qtd. in Enrico Crispolti, *Architettura futurista: Attraverso l'architettura futurista* (Modena, Italy: Galleria Fonte d'Abisso, 1984), 117.

181. Buvoli's attraction to these ephemeral materials, and his description of his work as "Meta-Futurist" and "post-utopian," appear in his interview with Christine Poggi: "A Very Beautiful Day After Tomorrow: Interview with Luca Buvoli," *Modern Painters* 21, no. 1 (2009): 56–59.

182. Ara Merjian argues that Buvoli's work exposes that aphasia, as dissolution of language and sense, is implicit in the Futurist aesthetic: see "'Those Ars All Bellical': Luca Buvoli's *Velocity Zero* (2007–2009) and a Post/Modernist Poetics of Aphasia," *Word & Image* 28, no. 2 (April 2012): 101–16.

4. From Passéism to Anachronism

1. Pound first traveled to Venice in 1898 with his aunt. "That I was interested in CIVILIZATION from the age of 12 when I first saw Venice. . . . Anyhow, I came to Europe to git kulchur all right, and to a great extent got it." Transcribed text of radio broadcast no. 39 (May 18, 1942): "With Phantoms," from Rome, in *Ezra Pound Speaking: Radio Speeches of World War II*, ed. Leonard William Doob (Westport, CT: Greenwood Press, 1978), 137.

2. John Gery offers a compact summary of Pound's trips to and relationships formed in Venice in Ira Bruce Nadel, Sabine C. Carey, and Mark Gibney, eds., *Ezra Pound in Context* (Cambridge and New York: Cambridge University Press, 2010), 221–30.

3. Dante Alighieri, *Purgatorio. La divina commedia*, ed. Natalino Sapegno (Florence: Scandicci, 1988), canto 3, lines 130–32. Translation mine.*

4. For more background on the activity of these authors in the early teens, and on the influence Marinetti's publicity tactics had on Pound's career, see Lawrence S. Rainey, *Institutions of Modernism: Literary Elites and Public Culture* (New Haven, CT: Yale University Press, 1999), 10–41.*

5. "Scriptor Ignotus: To K.R.H., Ferrara 1715," in Ezra Pound, *Poems and Translations*, ed. Richard Sieburth (New York: Library of America, 2003), 38. Throughout I will refer to this volume where possible, as it constitutes one of the few widely available and reliably edited collections of Pound's verse outside of *The Cantos*, shorter works that themselves have complicated publishing histories; it will be cited as *PT*.*

6. See "A Few Don'ts by an Imagiste," *Poetry* 1, no. 6 (1913): 200–06. Pound's relationship to Fascism is complicated, as Marinetti's was, though cultural distance seems to have permitted Pound's ideals for the regime in particular to obscure reality. For a more straightforward and syncretic assessment of this relationship than I can provide here (though it is explored in greater detail later in the text), one can begin with Burton Hatlen's "Ezra Pound and Fascism," in *Ezra Pound and History*, ed. Marianne Korn (Orono: University of Maine Press, 1985), 145–55, and Chapter 4 of Vincent Sherry, *Ezra Pound, Wyndham Lewis, and Radical Modernism* (Oxford: Oxford University Press, 1993). More extensive treatments of the subject are cited as pertinent.

7. Bembo's intensive textual editing involved transcribing by hand a fourteenth-century manuscript of the *Commedia* that Boccaccio had given to Petrarch.

8. Giorgio Agamben, *Categorie italiane: Studi di poetica* (Venice: Marsilio, 1996), 53; for an English edition (which translates the phrase rather differently), see *The End of the Poem: Studies in Poetics*, trans. Daniel Heller-Roazen (Stanford, CA: Stanford University Press, 1999), 47.

9. Ezra Pound, *The Selected Letters of Ezra Pound, 1907–1941*, ed. D.D. Paige (New York: New Directions, 1971), 38; 37.

10. Giorgio Agamben, *Nudit* à (Rome: nottetempo, 2009), 63–64. For a different translation in English, see *Nudities*, trans. David Kishik and Stefan Pedatella (Stanford, CA: Stanford University Press, 2010), 40.

11. See Friedrich Wilhelm Nietzsche, *Untimely Meditations*, trans. R.J. Hollingdale, Cambridge Texts in the History of Philosophy (Cambridge and New York: Cambridge University Press, 1997), 59–60.

12. To cite an example, Louis L. Martz writes of poems such as the 1909 "Praise of Ysolt" as the voice of a "tormented, lonely genius crying for release from a faded idiom, seeking a way in which his song can emerge into a sort of naked clarity, free of archaic diction and dead poetical properties." See his introduction to Ezra Pound, *Collected Early Poems of Ezra Pound*, ed. Michael John King (New York: New Directions, 1976), xvi, hereafter *CEP*. Thomas Jackson's approach to the influence of late Victorian lyric in Pound is similarly embarrassed: see *The Early Poetry of Ezra Pound* (Cambridge, MA: Harvard University Press, 1968). Vincent Sherry, however, argues in

nuanced fashion for the way that Pound builds on the Decadents: "in bringing decay and morbidity along as the dominant conditions of cultural practice, [he] establishes these conditions in the program and personality of modernist poetics." See Nadel, Carey, and Gibney, *Ezra Pound in Context*, 17–18. Valuable extended readings of the early poems appear in Niclas Christoph de Nagy, *Ezra Pound: The Pre-Imagist Stage* (Berne: Francke Verlag, 1960); Hugh Witemeyer, *The Poetry of Ezra Pound: Forms and Renewal, 1908–20* (Berkeley and Los Angeles: University of California Press, 1969); and Thomas F. Grieve, *Ezra Pound's Early Poetry and Poetics* (Columbia, MO: University of Missouri Press, 1997).

13. Ezra Pound, 1964 foreword to *A Lume Spento and Other Early Poems* (New York: New Directions, 1965), 7.

14. Marjorie Perloff, "Pound Ascendant," *Boston Review* 29, no. 2 (February–March 2004): 52.

15. Pound presages recent developments surrounding "unoriginality" in conceptual and other experimental contemporary poetics, but with instructive historicist/comparatist commitments. For more on this contemporary development, see, for example, Marjorie Perloff, *Unoriginal Genius: Poetry by Other Means in the New Century* (Chicago: University of Chicago Press, 2010) and Kenneth Goldsmith, *Uncreative Writing: Managing Language in the Digital Age* (New York: Columbia University Press, 2011).

16. *Literary Essays of Ezra Pound*, ed. T.S. Eliot (New York: New Directions, 1968), 75. Hereafter cited as *LE*.

17. "Scriptor Ignotus: To K.R.H., Ferrara 1715," *PT* 38.

18. Ezra Pound, *The Cantos of Ezra Pound* (New York: New Directions, 1996), 1/5. The modern edition of Pound's epic will be cited hereafter as *Cantos*; due to the infinitely complicated publishing history of this unfinished epic, other editions will be cited as necessary. Divus first made an appearance, along with Elpenor, in the "Ur-Canto" 3, published in *Poetry* in July 1917. Pound's literal translation of the Nekuia episode from *The Odyssey* was incorporated in 1923, and this poem became Canto 1 of the 1924–1925 *A Draft of XVI. Cantos*. Pound's copy of Divus, found in Paris between 1906 and 1920, also included Aldus's *Batrachomyomachia*. For Pound's theory of the possible dialogue between Divus and Aldus, see "Early Translators of Homer," in *LE 265*.

19. See Jerome McGann, *The Textual Condition* (Princeton: Princeton University Press, 1991), 147, 140, 124. See also Lawrence S. Rainey on the decorative capital and headpieces for *A Draft of XVI. Cantos*, in *Ezra Pound and the Monument of Culture: Text, History, and the Malatesta Cantos* (Chicago: University of Chicago Press, 1991), 159–209; Vincent Sherry on the Malatesta Cantos' relation between initials and text in *Ezra Pound, Wyndham Lewis, and Radical Modernism* (Oxford and New York: Oxford University Press, 1993), 143–62; George Bornstein's reading of Hynes's incorporation of modern iconography in the decorative initials for *A Draft of Cantos 17–27*, echoing current events such as World War I and the Russian revolution, in "The Book as Artefact: Historicizing Ezra Pound's First Thirty Cantos," *Variants* 4

(2005): 151–64; and Miranda B. Hickman on the Vorticist values of *A Draft of XXX Cantos* in *The Geometry of Modernism: The Vorticist Idiom in Lewis, Pound, H.D., and Yeats* (Austin: University of Texas Press, 2005), 89–132. While scholars are still to recover the process of illumination for the second and third volumes, Lawrence Rainey has demonstrated convincingly that Pound collaborated with Slater on the symbolism and meaning of his initials for the 1925 edition, suggesting that the poet would have worked closely with Hynes and Dorothy Pound as they illuminated subsequent deluxe editions.

20. Ezra Pound to Kate Buss, in a letter from Paris of May 1923, reprinted in *The Selected Letters of Ezra Pound, 1907–1941*, 187.

21. *Works* 5:132.

22. "Scriptor Ignotus," *PT* 38–39.

23. Ezra Pound, *Diptych Rome-London* (New York: New Directions, 1994), 10.

24. *Guide to Kulchur* (Norfolk, CT: New Directions, 1952), 83.

25. See Daniel Tiffany, *Radio Corpse: Imagism and the Cryptaesthetic of Ezra Pound* (Cambridge, MA: Harvard University Press, 1995).

26. Pound was living at Calle dei Frati n. 942. *A Quinzaine* contains a poem entitled "Fortunatus," after Rolfe/Corvo.*

27. *PT* 69.

28. Jürgen Habermas, "Modernity—An Incomplete Project," trans. Seyla Ben-Habib, in *Postmodern Culture*, ed. Hal Foster (Trowbridge, England: Pluto Press, 1983), 5.

29. *TIF* 8.

30. *PT* 35.

31. "Aube of the West Dawn," *PT* 72.

32. "To Whistler, American," included in *Personae,* and reprinted in *PT* 608. For more on Whistler's influence on Pound, see Rebecca Beasley, "Ezra Pound's Whistler," *American Literature* 74, no. 3 (September 2002): 485–516.

33. For an argument surrounding Pound's dissatisfaction with impressionism, his search to see "more," see Rebecca Beasley, *Ezra Pound and the Visual Culture of Modernism* (Cambridge and New York: Cambridge University Press, 2007), 46–47.

34. "Cavalcanti," in *LE* 154.

35. Ibid.

36. The canonical contrast between the performative and the constative modes appears in J.L. Austin, *How to Do Things with Words*, The William James Lectures (Cambridge, MA: Harvard University Press, 1962).

37. *IH* 32.

38. Ezra Pound, "Approach to Paris, V," *New Age* 13, no. 23 (October 2, 1913): 662. See Eugene Jolas's "Transition's Revolution of the Word Dictionary," which attributes the neologism "constatation" to James Joyce, defining it as "statement of a concrete fact." "Transition's Revolution of the Word Dictionary," *Transition* 21 (March 1932): 323.

39. "Approach to Paris," 663.

40. Charles Altieri recognizes this critical distinction implicitly: "the ego is another kind of fact that requires attending not to what we see but to how we constate our worlds." "The Pound-Stevens Era," *Wallace Stevens Journal* 26, no. 2 (Fall 2002): 229. In a 1931 essay published in *L'Indice*, Pound speaks of his overall attempt to "constatare la tradizione della letteratura in totalità" ("to constate the literary tradition as a whole"). See Ezra Pound, *Carte italiane 1930–1944*, ed. Luca Cesari (Milan: Archinto, 2005), 166.

41. "Approach to Paris," 664.

42. For more on citation in Pound, see Rainey, *Monument of Culture,* 57–72; Michael André Bernstein, "History and Textuality in Ezra Pound's Cantos 15–22," in *Ezra Pound and History*, ed. Marianne Korn (Orono, ME: National Poetry Foundation and University of Maine, 1985), 15–36.

43. In this way Pound continues to address the impasse of experience (as *Erlebis*) highlighted at this juncture in the tourism capital's history; such jolts are immanent as opposed to pre-reflective or "immediate."*

44. F.S. Flint, "Imagisme," *Poetry* 1, no. 6 (1913): 199.

45. *IH* 32.

46. William Shakespeare, *Shakespeare's Sonnets*, ed. Stephen Booth (New Haven, CT: Yale University Press, 1977), 86.

47. Ibid., 86–87.

48. "Channeling Guido," qtd. in Perloff, "Pound Ascendant," 52.

49. William Shakespeare, *Much Ado About Nothing*, in *The Riverside Shakespeare* (Boston: Houghton Mifflin, 1972), 1.1.271–72; translation by H.T. Lowe-Porter from Thomas Mann, "Death in Venice," in *Death in Venice and Seven Other Stories* (New York: Vintage, 1954), 72.

50. Richard Aldington et al., *Some Imagist Poets: An Anthology*, vol. 2 (Boston: Houghton Mifflin Company, 1915), preface; T.D. Hulme, *Speculations: Essays on Humanism and the Philosophy of Art* (London: Routledge and Kegan Paul, 1924), 113–40.

51. "Art Notes: Processes," on the Royal Society of Painter-Etchers and Engravers show (1918), qtd. in Harriet Zinnes, ed. *Ezra Pound and the Visual Arts* (New York: New Directions, 1980), 47.

52. Ezra Pound, *Selected Prose: 1909–1965* (New York: New Directions, 1973), 21; 25; *Cantos* 93/649.

53. "The Revolt of Intelligence, I," *New Age* 26, no. 2 (November 13, 1919): 22.

54. "Paris Letter. October, 1922," *Dial* 73, no. 5 (November 1922): 549, 553.

55. *PT* 562; *Cantos* 1/4.

56. Robert Creeley, "A Note on Ezra Pound," in *The Collected Essays of Robert Creeley* (Berkeley: University of California Press, 1989), 26.

57. Ibid.; John Ruskin, *Works* 5:132.

58. From his definition of the epic in Ezra Pound, *ABC of Reading* (New York: New Directions 2010), 46.

59. Eliot's lecture notes from a 1933 course on modern English literature at Harvard; qtd. in Ronald Schuchard, "Burbank with a Baedeker, Eliot with a Cigar: American Intellectuals, Anti-Semitism, and the Idea of Culture," *Modernism/Modernity* 10, no. 1 (2003): 15. Schuchard argues that for Eliot, "Venetian Italy was symbolic of the post-Versailles diaspora . . . in which hotly contested lands and ethnic-religious dislocations and antagonisms would ensure the further disintegration of European unity" (8).*

60. T.S. Eliot, *The Letters of T.S. Eliot*, ed. Valerie Eliot, 1st ed. (San Diego: Harcourt Brace Jovanovich, 1988), 351.

61. T.S. Eliot, *Selected Essays*, New ed. (New York: Harcourt, 1950), 247.

62. T.S. Eliot, *Collected Poems 1909–1962* (New York: Harcourt, Brace, and World, 1965), 32–33.

63. Ibid.

64. See "The Stranger," in Georg Simmel, *The Sociology of Georg Simmel*, trans. Kurt H. Wolff (New York: Free Press, 1950), 402.

65. Eliot, *Collected Poems 1909–1962*, 32. Above, I echo Pound's parodic line, "These fragments I have shelved (shored)" in *The Cantos*, 8/28.

66. Scholars refer most often to Cantos 25 and 26 as the "Venetian Cantos." I intend to clarify why the characterization, and limitation of Venice to these cantos alone, is insufficient.

67. William James Bouwsma, "Venice and the Political Education of Europe," in *A Usable Past: Essays in European Cultural History* (Berkeley: University of California Press, 1990), 272.

68. Leopold Ranke, cited in John Pemble's account in *Venice Rediscovered* (Oxford: Clarendon, 1995), 77.*

69. Qtd. in ibid., 74, 73.

70. Walter Benjamin, *Illuminations*, ed. Hannah Arendt, trans. Harry Zohn (New York: Schocken Books, 1968), 255.

71. See Rainey, *Monument of Culture*, 68. Rainey's study illuminates the historicist influence on the composition of the Malatesta Cantos in extraordinary detail. For a synthetic account of Pound's relationship to Italian archives, see Caterina Ricciardi, "Archives," in Nadel, Carey, and Gibney, *Ezra Pound in Context*, 148–58.

72. Pound's "periplum" (from *periplus*) is defined in the Pisan Cantos: "Periplum, not as land looks on a map / But as sea bord seen by men sailing." *Cantos* 59/83.

73. *Purgatorio* canto 6, line 63; *Aeneid* book 1, line 405. James quotes Virgil in *Complete Stories, 1892–1898*, ed. David Bromwich and John Hollander (New York: Library of America, 1996), 592.*

74. "Henry James," in *LE* 308; "How to Read," in *LE* 26.*

75. J.J. Wilhelm's biography of Pound between London and Paris notes that Pound had been attending Hulme's salons, housed at the former Venetian embassy and "Venetian-palace home" of Mrs. Ethel Kibblewhite. *Ezra Pound in London and Paris, 1908–1925* (University Park, PA: Penn State Press, 2008), 80.

76. See Davie's contribution to Massimo Bacigalupo, ed., *Ezra Pound: Un poeta a Rapallo* (Genoa: Edizioni San Marco dei Giustiniani, 1985), 92. Pound hosted many artists in Rapallo—making his own, far less political Fiume—and did editorial work regularly from his Riviera home, producing four issues of *Exile* in 1927–1928, the Literary Supplement of *L'Indice* in 1930–1932, and the Rapallo weekly *Il Mare* in 1932–33.*

77. Letter to Charles Eliot Norton of November 28, 1899, in Henry James, *The Letters of Henry James*, ed. Leon Edel (Cambridge, MA: Harvard University Press, 1984), 4:125.

78. "Henry James," in *LE* 300–01.

79. Ezra Pound, *The Selected Letters of Ezra Pound, 1907–1941*, 180.

80. *Indiscretions: or, Une Revue De Deux Mondes* (1920), reprinted in *Pavannes and Divagations* (New York: New Directions, 1958), 3.

81. Ibid., 3–5.

82. Ibid., 6.

83. Ibid.

84. For a chronology and detailed index of Pound's residences in Venice, see Massimo Bacigalupo et al., *In Venice and the Veneto with Ezra Pound* (Venice: University of Venice and Supernova, 2007), 14–16.

85. "Henry James," *LE* 302; Pound, *Pavannes and Divagations*, 5.

86. Oscar Wilde, *The Picture of Dorian Gray*, Oxford World's Classics (New York and Oxford: Oxford University Press, 2006), chapter 14.

87. Pound, "Paris Letter," 551.

88. "Henry James," in *LE* 324*n*.

89. "Sordello," in Robert Browning, *The Works of Robert Browning*, ed. F.G. Kenyon et al., vol. 1 of 10 (London: Smith, Elder & Co., 1912), Book III, line 676.

90. *LE* 51.

91. Pound, "The Revolt of Intelligence, I," 550.

92. Louis Zukofsky, "An Objective," in *Prepositions: The Collected Critical Essays of Louis Zukofsky* (Berkeley: University of California Press, 1981), 12.

93. Plant, in her historical survey, argues that against the "history and bathos" that cramp the Venice of most moderns, such as T.S. Eliot, "the Venice of Ezra Pound is exceedingly complex, both more contemporary and more historical than that of any other writer of his time." Margaret Plant, *Venice: Fragile City, 1797–1997* (New Haven, CT: Yale University Press, 2002), 290. Given that Plant presents thumbnail sketches of virtually every representation of post-Republican Venice in *Fragile City*, the claim is a striking one, albeit left unsupported.

94. Charles Olson, "This Is Yeats Speaking," *Partisan Review* 13, no. 1 (1946): 139–42.

95. Charles Olson, *Mayan Letters* (Bañalbufar, Mallorca: Divers Press, 1953), 26–27.

96. Robert Creeley, "Why Pound!?!" in Creeley, *The Collected Essays of Robert Creeley*, 30.

97. Pound, "The Revolt of Intelligence, I," 549.

98. *Cittadini originari* were a second-tier group of elites peculiar to the Venetian Republic. As descendents of early inhabitants of Venice, these citizens were ineligible for political office but enjoyed a certain social mobility.

99. Morrison reads the city of Dioce in Canto 74 as nothing but "a local habitation and a name that are translated into an airy nothingness, a thoroughly poeticized vision of the fascist city of man." Paul Morrison, *The Poetics of Fascism: Ezra Pound, T.S. Eliot, Paul De Man* (New York and Oxford: Oxford University Press, 1996), 37.

100. Rainey draws the connection between Malatesta and Mussolini, pointing out that Pound's second visit to the Tempio Malatestiano in 1923 for research coincided with his first significant experience with members of the Fascist Party, and recounts Pound's rummaging through Fascist-curated libraries in the 1920s. See *Institutions*, 107–45.

101. Horatio Brown, *Studies in Venetian History* (London: John Murray, 1907), 2:152. Pound met Brown in Venice in 1913.

102. Letter from Venice of October 11, 1888, in Rollin van N. Hadley, ed., *The Letters of Bernard Berenson and Isabella Stewart Gardner, 1887–1924, with Correspondence by Mary Berenson* (Boston: Northeastern University Press, 1987), 27. Berenson sends D'Annunzio's *Le vergini delle rocce* and *Allegoria dell'autunno* to Gardner in December 1895. See Ibid., 45.

103. Reading patterns in the poem follow suit. As Donald Davie describes the process of poring through the Malatesta Cantos, "'reading' is an unsatisfactory word for what the eye does as it resentfully labors over and among these blocks of dusty historical debris. We get lost in ever murkier chaos, an ever more tangled web of alliances, counter-alliances, betrayals, changing of sides, sieges and the raising of sieges, marches and countermarches; it is impossible to remember whose side Malatesta is on at any time or why." *Ezra Pound: Poet as Sculptor* (New York: Oxford University Press, 1964), 126.

104. Lewis Mumford, *The Culture of Cities* (New York: Harcourt, Brace, 1938), 438.

105. See Gaudier's "Vortex," championed by Pound, in *Gaudier-Brzeska* (New York: New Directions, 1970), 20.

106. From Pound's translation of Cavalcanti's "*Canzone: Donna mi Priegha*." Ezra and Marcella Spann Pound, eds., *Confucius to Cummings: An Anthology of Poetry* (New York: New Directions, 1964), 94.

107. "Art Notes," qtd. in Zinnes, *Ezra Pound and the Visual Arts*, 94.

108. Henry James, *The Aspern Papers and the Turn of the Screw* (New York: Penguin, 1986), 133.

109. Wallace Stevens, *The Necessary Angel: Essays on Reality and the Imagination* (New York: Vintage, 1951), 11.

110. Rosalind Krauss, "Sculpture in the Expanded Field," *October* 8 (Spring 1979): 34. Krauss diagnoses modern sculpture's failed monumentality, or stifling self-reflexivity.

111. Umberto Boccioni, "Futurist Sculpture" (1912), as translated in *Futurism: An Anthology*, ed. Lawrence S. Rainey, Christine Poggi, and Laura Wittman (New Haven, CT: Yale University Press, 2009), 117.

112. Charles Altieri, *Painterly Abstraction in Modernist American Poetry: The Contemporaneity of Modernism* (New York and Cambridge: Cambridge University Press, 1989), 300.

113. Pound once again recasts the Palazzo Venier de' Leoni moment he translated from D'Annunzio's *Nocturne* (in "The Revolt of Intelligence, I," 551–52).

114. Michael North and Lawrence Rainey have read the Tempio Malatestiana in the Malatesta Cantos as Pound's attempt to exemplify "the apex of a culture." Michael North, "The Architecture of Memory: Pound and the Tempio Malatestiano," *American Literature* 55, no. 3 (October 1983): 152. See also *The Final Sculpture: Public Monuments and Modern Poets* (Ithaca, NY, and London: Cornell University Press, 1985); Rainey, *Monument of Culture*. Michael Bernstein, valuing the first-person viewpoint, laments that in the first thirty cantos, "there is not yet established a consciousness authoritative enough to guarantee the validity of the work's startling juxtapositions." *The Tale of the Tribe: Ezra Pound and the Modern Verse Epic* (Princeton, NJ: Princeton University Press, 1980), 177.

115. Rainey, *Institutions*, 144.

116. Georg Simmel, "Venice," *Theory, Culture & Society* 24, no. 7–8 (2007): 44.

117. Aldo Rossi, *The Architecture of the City*, ed. Peter Eisenman, trans. Diane Ghirardo and Joan Ockman (Cambridge, MA, and London: MIT Press, 1984), 18.

118. North overstates the role of a Vorticist stress on stillness (gleaned largely from the writings of Hulme and Lewis) in Pound's conception of monumental sculpture (see *The Final Sculpture*, chapters 5 and 6).

119. "Fragmenti," *CEP* 248.

120. In the good city, "patriotism, dedication to the common good, justice must take the place of *Eros*." Leo Strauss, *The City and Man* (Chicago: Rand McNally, 1964), 110–11.

121. This manuscript at the Beinecke Library is reproduced in a transcribed conference talk by Mary de Rachewiltz in Rosella Mamoli Zorzi, ed., *Ezra Pound a Venezia* (Florence: Leo S. Olschki, 1985), 47.

122. Davie, *Poet as Sculptor*, 129.

123. Augustine, *Enarrationes in Psalmos* 147.26–27; Flavius Merobaudes, "Carmen Ii," in *Flavius Merobaudes: A Translation and Historical Commentary*, ed. Frank M. Clover (Philadelphia: American Philosophical Society, 1971), 11.

124. Andrea Palladio, *I quattro libri dell'architettura* (Venice: D. de' Franceschi, 1570), 1:7. Accessed as pdf on June 1, 2011, at http://lccn.loc.gov/47044047.

125. See Marvin Trachtenberg, *Building-in-Time: From Giotto to Alberti and Modern Oblivion* (New Haven, CT: Yale University Press, 2010).

126. Donald Davie, who in several pages first elucidates a general affinity between Stokes and Pound, provided a springboard for this section: see Davie, *Poet as Sculptor*, 127–32. Stokes met Pound many times from 1927 to 1929.

127. Adrian Stokes, *Stones of Rimini*, in *The Critical Writings of Adrian Stokes* (Plymouth: Thames and Hudson, 1978), 196.

128. Ibid., 214.

129. The city of stone in water forms the source for Pound's theophanies and *paradisi terrestri*, as in "Gemistus's theogony." See Pound, qtd. in Zinnes, *Ezra Pound and the Visual Arts*, 168.

130. Stokes, *Stones*, 185, 200.

131. Ibid., 186.

132. Ibid., 208.

133. See Pound, in Zinnes, *Ezra Pound and the Visual Arts*, 168.

134. Ezra Pound, ed., *The Chinese Written Character as a Medium for Poetry* (San Francisco: City Lights Books, 1963), 22.

135. *Cantos* 7/25; "Liu Ch'e," *Personae* 108; Stokes, *Stones*, 289–90.

136. Eva Hesse, ed., *New Approaches to Ezra Pound: A Co-ordinated Investigation of Pound's Poetry and Ideas* (Berkeley: University of California Press, 1969), 39.

137. "Portrait d'Une Femme," *PT* 233.

138. Pound, *Gaudier-Brzeska*, 20.

139. For more complete accounts of Pound's identification with Fascism than can be provided here, see Tim Redman, *Ezra Pound and Italian Fascism* (Cambridge and New York: Cambridge University Press, 1991) and Morrison, *The Poetics of Fascism*. On Pound's anti-Semitism, see Leon Surette, *Pound in Purgatory: From Economic Radicalism to Anti-Semitism* (Urbana and Chicago: University of Illinois Press, 1999) and the highly polemical Robert Casillo, *The Genealogy of Demons: Anti-Semitism, Fascism, and the Myths of Ezra Pound* (Evanston, IL: Northwestern University Press, 1988). For an excellent case study written through the lens of the Pisan Cantos, see Ronald Bush, "Modernism, Fascism, and the Composition of the Pisan Cantos," in *Modernism/Modernity* 2, no. 3 (1995): 69–87. For an earlier account, see also Peter Nicholls, *Politics, Economics, and Writing: A Study of Ezra Pound's Cantos* (London: Macmillan, 1984).

140. "The Idea of Order at Key West," in Wallace Stevens, *The Collected Poems of Wallace Stevens* (New York: Vintage, 1990), 128.

141. Ruskin, *Works* 5:207–8.*

142. From a 1927 letter to his father in Ezra Pound, *Letters of Ezra Pound* (London: Faber & Faber, 1951), 285. For more on this phenomenon, see Leon Surette, *A Light from Eleusis: A Study of Pound's Cantos* (Oxford: Oxford University Press, 1979).

143. Pound offers this last image as a figure for poetic force in Pound, *Guide to Kulchur*, 190.

144. Critics have, of course, proposed any number of models for understanding the structure of *The Cantos:* fugue, fresco, Odyssean return, and *Commedia*-like descent, circling and ascent, to name some major examples. Envisioning Pound's monument in the form of a sculpted *space* fashioned by a collective, compelling internal crossings in a plurality of directions, allows the poem its difference, discontinuity, and mobility in a way that former models do not.

145. A resurgence of federalism in Italy since 1993 has made the post of mayor much more prominent—in many cases more powerful than the political party. After some years out of office, Cacciari was re-elected in April 2005.

146. Massimo Cacciari, *L'Arcipelago* (Milan: Adelphi, 1997), 13.*

147. Ibid.*

148. Ibid., 16.*

149. Pound explicitly praised Henry James's production of a "communication [that] is not a leveling . . . not an elimination of differences, of the right of differences to exist." *LE* 298.

150. Cacciari, *L'Arcipelago*, 21.

151. Ibid., 20.*

152. Hugh Kenner, *The Pound Era* (Berkeley: University of California Press, 1971), 423, 420.

153. Pound, "Paris Letter," 550. In 1927, Olga Rudge was invited to give recitals at Bernard Berenson's Villa I Tatti, D'Annunzio's estate, and Mussolini's estate, attention that enhanced the poet's sense of a socio-aesthetic vortex brewing.

154. Yale Collection no. 745, qtd. in Rachewiltz's contribution to Zorzi, *Ezra Pound a Venezia*, 47.

155. *The Selected Letters of Ezra Pound, 1907–1941*, 239.

156. Ibid., 210.

157. Dante Alighieri, *Inferno,* canto 21, lines 7–18—duly noted by Pound in *The Spirit of Romance* (New York: New Directions, 2005), 135.

158. Letter 18, *Works* 27:313–19. For the definitive account of medieval and early modern Venetian finance, as well as the bubble of currency speculation it dominated and consequent crises, see Frederic C. Lane and Reinhold C. Mueller, *Money and Banking in Medieval and Renaissance Venice: Coins and Moneys of Account* (Baltimore: Johns Hopkins University Press, 1985). See also its companion volume, Reinhold C. Mueller and Frederic C. Lane, *The Venetian Money Market: Banks, Panics, and the Public Debt, 1200–1500* (Baltimore: John Hopkins University Press, 1997).

159. *St. Mark's Rest*, in *Works* 24:232.

160. For accounts of Social Credit in Pound's thinking, see James J. Wilhelm, *Ezra Pound: The Tragic Years, 1925–1972* (University Park: Pennsylvania State University Press, 1994), 56–68; Redman, *Ezra Pound and Italian Fascism*, 17–75.

161. *A Draft of the Cantos 17–27*, 7; 17/76 of modernized New Directions edition.

162. Stokes, *Stones*, 185.

163. *Cantos* 25/115.*

164. This phrase is the formulation of Jean-Luc Nancy, the title of an essay in his *The Inoperative Community*, trans. Peter Connor et al. (Minneapolis and Oxford: University of Minnesota Press, 1991), 43–70.

165. Bernstein stresses Pound's poetics of co-created meaning in *Tale of the Tribe*, 170. Ian F.A. Bell argues that *The Cantos* assumes patterns of correspondence between objects that deny the unruly range of discourse in the service of a hidden unity in *Critic*

as Scientist: The Modernist Poetics of Ezra Pound (London: Methuen, 1981). Christine Froula argues that Pound's poetics gestures toward "the partiality and contingency of every effort to write history" in "The Pound Error: The Limits of Authority in the Modern Epic," in *Modern Critical Views: Ezra Pound*, ed. Harold Bloom (New York: Chelsea House, 1987), 153.

166. *A Draft of Cantos 17–27*, 41; in modern edition, *Cantos* 25/115.

167. *Stones*, 289–90.

168. Nancy, *The Inoperative Community*, 91.

169. Daniel D. Pearlman, *The Barb of Time: On the Unity of Pound's Cantos* (New York: Oxford University Press, 1969), 30.

170. *L'Arcipelago*, 20.*

171. Tanner provides provocative analyses of Venice's relation to Eros, as expressed by a lengthy and variegated genealogy of authors, throughout *Venice Desired* (Cambridge, MA: Harvard University Press, 1992).

172. Charles Altieri, "The Concept of Force as Modernist Response to the Authority of Science," *Modernism/Modernity* 5, no. 2 (1998): 89.

173. James, preface to *Wings*, 13.

174. *Cantos* 41/202. Mussolini finally acceded to Pound's numerous requests for an audience in 1933.

175. Ezra Pound, "Introduction to the Economic Nature of the United States," in *Selected Prose* (New York: New Directions, 1973), 217.

176. *Jefferson and/or Mussolini; L'Idea Statale; Fascism as I Have Seen It* (New York: Liveright, 1936), 73.

177. See Klaus Theweleit, *Male Fantasies*, vol. 1, *Women, Floods, Bodies, History*, trans. Stephen Conway (Minneapolis: University of Minnesota Press, 1987).

178. Remy de Gourmont, *The Natural Philosophy of Love*, trans. and with a postscript by Ezra Pound (New York: Boni and Liveright, 1922), 207–08.

179. Ibid., 208.

180. Qtd. in Bonnie Kime Scott and Mary Lynn Broe, *The Gender of Modernism: A Critical Anthology* (Bloomington: Indiana University Press, 1990), 361.

181. For the wave pattern, to which Pound referred repeatedly, and context for the visit to Excideuil, see Kenner, *The Pound Era*, 336–37.

182. See *The Stones of Venice*, in *Works* 9:379. Pound traveled to Verona in 1911 to see this signed column capital, making it clear that he had read Ruskin: see Kenner, *The Pound Era*, 323, and Tanner, *Venice Desired*, 271–72. Both Ruskin and Pound praise Dante's precise verbal description, and relate this precision to a definition of political economy as one of production and distribution rather than mercantile accumulation; see Alison Milbank, *Dante and the Victorians* (Manchester: Manchester University Press, 1998), 235–37.

183. Andrew Hewitt, "A Fascist Feminine," *Qui Parle: Literature, Philosophy, Visual Arts, History* 13, no. 1 (Fall/Winter 2001): 31–2. Introducing Theweleit's *Floods, Bodies, History*, Barbara Ehrenreich emphasizes a dread of dissolution at the heart of

Fascism: "Women's bodies are the holes, swamps, pits of muck that can engulf." *Male Fantasies,* 1:xiii.

184. See selections of *Mother Right: An Investigation of the Religious and Juridical Character of Matriarchy in the Ancient World*, in Johann Jakob Bachofen, *Myth, Religion, and Mother Right: Selected Writings of J.J. Bachofen*, trans. Ralph Manheim (Princeton, NJ: Princeton University Press, 1967), 69–209.

185. Pound, in de Gourmont, *The Natural History of Love*, 219.

186. "Hugh Selwyn Mauberley," *PT* 550.

187. I only provide a brief summary of this logic, in order to parse its relation to the place of Venice in Pound's work; for a full treatment of Pound's economic poetics or poetic economy, see Redman, *Ezra Pound and Italian Fascism*; Surette, *Pound in Purgatory*; and Vincent B. Sherry, *Ezra Pound, Wyndham Lewis, and Radical Modernism* (New York: Oxford University Press, 1993).

188. See Luca Somigli and Mario Moroni, eds., *Italian Modernism: Italian Culture Between Decadentism and Avant-Garde*, Toronto Italian Studies (Toronto and Buffalo: University of Toronto Press, 2004), 22.

189. Pound, in de Gourmont, *The Natural History of Love*, 208–09.

190. Michael Tratner, *Deficits and Desires: Economics and Sexuality in Twentieth-Century Literature* (Stanford, CA: Stanford University Press, 2001), 165.

191. "Cavalcanti," *LE* 154.

192. Ibid.

193. For an argument that this passage may reveal the influence of Jeffrey Mark's analysis of usury, see William M. Chace, *The Political Identities of Ezra Pound & T. S. Eliot* (Stanford, CA: Stanford University Press, 1973), 88–90.

194. Ezra Pound, "Law and the Merchant of Venice," *Der Querschnitt* 4, no. 4 (Fall 1924): 237.

195. Ibid., 238.

196. William Shakespeare, *The Merchant of Venice*, in *The Riverside Shakespeare* (Boston: Houghton Mifflin, 1974), 4.1.89–102. For more on Shakespeare's relation to Venice, see Shaul Bassi and Laura Tosi, eds., *Visions of Venice in Shakespeare* (Burlington, VT: Ashgate, 2011).

197. Pound, "Law and the Merchant of Venice," 238.

198. Ibid.

199. Pound, "Kublai Khan and His Currency," *New Age* 28, no. 3 (May 20, 1920): 175.

200. For more on the plight of the Venetian Jews during this period, see Renata Segre, *Gli ebrei a Venezia 1938–1945: Una comunità tra persecuzione e rinascita* (Venice: Il Cardo, 1995).

201. Pound, *Guide to Kulchur*, 60.

202. Ernesto Laclau, "Fascism and Ideology," in *Politics and Ideology in Marxist Theory: Capitalism, Fascism, Populism* (New York: Verso, 1977); see also Alice Yaeger Kaplan, *Reproductions of Banality: Fascism, Literature, and French Intellectual Life* (Minneapolis: University of Minnesota Press, 1986).

203. See Roger Griffin, ed., *Fascism* (Oxford: Oxford University Press, 1995); quote is from Jared M. Becker, *Nationalism and Culture: Gabriele D'Annunzio and Italy After the Risorgimento* (New York: Peter Lang, 1994), 201.

204. See Catherine E. Paul, "Italian Exhibitions and Pound's Move to the Imperial," *Twentieth-Century Literature* 51, no. 1 (Spring 2005): 64–97.

205. Pound, "Introduction to the Economic Nature of the United States," 145–46.

206. Pound, "Alma Sol Veneziae (Baritone)," *PT* 64.

207. Shakespeare, *The Merchant of Venice*, 1.1.78–79.

208. That trope, repeated in Jaques' soliloquy in *As You Like It*, persisted all the way through Simmel's 1907 analysis of the city: "The way they . . . buy and sell, observe and talk—to us, all that appears to be merely two-dimensional." "Venice," 44.

209. Richard Sieburth's excellent edition of the eleven Pisan Cantos contains a helpful synthesis of these events: Ezra Pound, *The Pisan Cantos*, ed. Richard Sieburth (New York: New Directions, 2003), ix–xliii.

210. Simmel, "Venice," 46.

211. Ibid., 42, 43.

212. "The City as Essay," in Massimo Cacciari, *Architecture and Nihilism: On the Philosophy of Modern Architecture*, trans. Stephen Sartarelli (New Haven, CT, and London: Yale University Press, 1993), 37.

213. Maria Caterina Federici, *Lo sguardo obliquo: Dettagli e totalità nel pensiero di Georg Simmel* (Perugia: Morlacchi, 2004), 255.

214. "The City as Essay," in Cacciari, *Architecture and Nihilism*, 95.

215. Casillo, *The Genealogy of Demons*, 235.

216. Jean Michel Rabaté, *Language, Sexuality, Ideology in the 'Cantos'* (London: MacMillan, 1986), 175.

217. This (not always accurate) translation from Pound's (not always accurate) Italian is Pound's own. His translation of Canto 72, somewhat flawed and omitting select racially offensive lines, was finally included in *The Cantos* after 1989; no Pound translation of Canto 73 has been found.*

218. See Jared M. Becker, *Nationalism and Culture: Gabriele D'Annunzio and Italy After the Risorgimento* (New York: Peter Lang, 1994), 201. Becker expands upon the thinking of Emilio Gentile to argue against the progressive aspect of Fascism as contrasted with Nazism. See also Renzo De Felice, *D'Annunzio politico: 1918–1938* (Rome: Laterza, 1978), and Michael Arthur Ledeen, *D'Annunzio: The First Duce* (New Brunswick, NJ: Transaction Publishers, 2002).*

219. Andrew Hewitt, *Fascist Modernism: Aesthetics, Politics, and the Avant-Garde* (Stanford, CA: Stanford University Press, 1993), 7.

220. Massimo Pesaresi identifies these dialectal features in "Pound's Admirable Presenza in the Italian Language," in *Ezra Pound and Europe*, ed. Richard Taylor and Claus Melchior (Amsterdam and Atlanta: Rodopi, 1993), 217.

221. See Kenner, *The Pound Era*, 469.

222. Translation mine. In spoken Tuscan dialect, "c"s are pronounced as "h"s.

223. *Marina Repubblicana* I, no. 2 (January 15, 1945), qtd. in Massimo Baci-galupo, "Ezra Pound's Cantos 72 and 73: An Annotated Translation," *Paideuma* 20, nos. 1–2 (1991): 21. The original publication included only lines 9 to 35 of Canto 72.*

5. FABULOUS PLANNING

1. *Saggi* 2:2688. "Avvenire" functions as both noun and verb, increasing the sense of Venice's potential. Calvino's reflections were first published in *Il Gazzettino* in an interview in April 1968 and appeared in 1974 as a formal essay in the German peri-odical *Merian*; my citations come from the later text. Roberto Favia notes that Calvino returned to Venice on numerous occasions from the mid-1950s through 1981. See his essay in Alessandro Cinquegrani, ed., *Cartoline veneziane: Ciclo di seminari di lettera-tura italiana. Università Ca' Foscari di Venezia, 16 Gennaio–18 Giugno 2008* (Palermo: Officina di Studi Medievali, 2008), 57–58.*

2. *Saggi* 2:2690. "Aerial" habitation is regarded as a Venetian innovation in historical terms; in constricted areas such as the ghetto, the first "high-rises" in Europe sprang up as high as eight floors.

3. Original is found in Levi's preface to Laurence Sterne, *La vita e le opinioni di Tristram Shandy, Gentiluomo. Prefazione di Carlo Levi*, trans. Antonio Meo (Torino: Einaudi, 1958), viii, xiv. Later qtd. in Italo Calvino, *Lezioni americane: Sei proposte per il prossimo millennio* (Milan: Garzanti, 1988), 46, and in translation as *Six Memos for the Next Millenium*, trans. Patrick Creagh (New York: Vintage, 1993), 47.*

4. From 1973 forward, it would be clear that the refineries at Porto Marghera could no longer compete with the polycentric industrial development of Northeastern Italy. Dow Chemical's abandonment of the site in 2006 was considered Marghera's defini-tive death knell.

5. *Saggi* 2:2692.

6. Ibid., 2:2691, 2692. Sant'Elia's "Messaggio" and later "Manifesto dell'Architettura Futurista" imagine a similar scene of catwalks, underground traffic paths, and moving sidewalks. See *Futurism: An Anthology*, ed. Lawrence S. Rainey, Christine Poggi, and Laura Wittman (New Haven, CT: Yale University Press, 2009), 198–201.*

7. Ibid., 2:2689.

8. Henry Lefebvre, *The Production of Space*, trans. Donald Nicholson-Smith (Oxford and Cambridge, MA: Blackwell, 1991), 93.

9. Henry James, *The Portrait of a Lady. The Novels and Tales of Henry James*, New York Edition (New York: Charles Scribner's Sons, 1908), 3:ix–x.

10. It is clear that Calvino was reading Mumford; in "Elio Vittorini: Project and Literature," discussed later, he cites an article by Mumford that discusses the automo-bile's influence on the rationalization of all communication. See Calvino, *Saggi* 1:176.

See also Letizia Modena, *Italo Calvino's Architecture of Lightness: The Utopian Imagination in an Age of Urban Crisis* (New York: Routledge, 2011), 60–62. Modena provides a crucial account of Calvino's active engagement with problems in contemporary urbanism as reader, author, and editor at Einaudi.*

11. Lewis Mumford, *The City in History: Its Origins, Its Transformations, and Its Prospects* (San Diego, New York, and London: Harcourt, 1989), 324.

12. Calvino, *Saggi* 2:2692.

13. Lefebvre, *The Production of Space*, 76.

14. This modernist conception of Venetian "zoning" fails to recognize the fluidity and interlacing of the city's functions.*

15. Mumford, *City in History*, 321.

16. Le Corbusier, *When the Cathedrals Were White: A Journey to the Country of Timid People*, trans. Francis Edwin Hyslop (Cornwall, NY: Reynal & Hitchcock, 1947), 7.

17. Le Corbusier, *The Radiant City*, trans. Pamela Knight, Eleanor Levieux, and Derek Coltman (New York: Orion Press, 1967), 269, 268.

18. Ibid., title page.

19. Mumford, *City in History*, 322.

20. Ibid.

21. Ibid., 563.

22. Ibid.

23. The peculiar Venetian lexicon, amalgam not of streets and avenues but of *calli*, *fondamente*, *sotoporteghi*, *rio terà*, includes a circus of toponyms indexed painstakingly in the popular history *Venetian Curiosities* (1863, 1887), which undertook to document the origins of every place-name: see Giuseppe Tassini, *Curiosità veneziane*, ed. Lino Moretti (Venice: Filippi Editore, 1933).*

24. Calvino, *Saggi*, 2:2690.

25. Guy Debord, "Psychogeographical Venice," a preface written for a project by Ralph Rumney that was never published, 1957. As announced in "Venice Has Vanquished Ralph Rumney," in *Internationale Situationniste* 1 (June 1958).*

26. Guy Debord, *In girum imus nocte et consumimur igni* (We Spin Around the Night Consumed by the Fire) (Carlotta Films, 1978), 35 mm film.

27. Cage performed on "Lascia o raddoppia?" Eco's 1962 volume *L'Opera aperta* was translated as Umberto Eco, *The Open Work. With an Introduction by David Robey*, trans. Anna Cancogni (Cambridge, MA: Harvard University Press, 1989). See also Bruno Zevi, *Saper vedere l'architettura* (Turin: Einaudi, 1948), translated as *Architecture as Space; How to Look at Architecture* (New York: Horizon Press, 1957).*

28. Calvino, *Six Memos for the Next Millenium*, 71.

29. Henry James, *The Golden Bowl. The Novels and Tales of Henry James*, New York Edition (New York: Charles Scribner's Sons, 1909), 19:136.

30. "La sfida al labirinto," in *Saggi* 1:106. On "internal colonialism" see Federico Caprotti, *Mussolini's Cities: Internal Colonialism in Italy, 1930–1939* (London and Youngstown, NY: Cambria Press, 2007).

31. For a thorough discussion of this exhibition and its relation to the urban fabric of Venice, see Aaron Levy and William Menking, *Architecture on Display: On the History of the Venice Biennale of Architecture* (London: Architectural Association, 2010), especially 35–48.

32. Henry James, *Italian Hours* (New York: Grove, 1909), 5.

33. A documentary film by American expatriates Carole and Richard Rifkind presents the increasing challenges to daily life for ordinary Venetians, and the decisions by the city council that threaten to multiply them: "The Venetian Dilemma: City or Theme Park?" (New York: Parnassus Works, 2004), film. Cardin's plan was abandoned in June 2013 after two years of resistance.

34. This development is rendered the more ironic by its history: it was the site of a notorious instance of class conflict—the assassination of "Cavaliere" Giovanni Stucky by a night-shift worker that occurred in May 1909, just a month after "Against Passéist Venice" was launched. See "L'orribile assassinio del Cav. Giovanni Stucky," *Gazzetta di Venezia*, May 22, 1909.*

35. Stuart McLean, "Stories and Cosmogonies: Imagining Creativity Beyond 'Nature' and 'Culture,'" *Cultural Anthropology* 24, no. 2 (2009): 227.

36. See Joseph Brodsky, *Fondamenta degli Incurabili*, trans. Gilberto Forti (Venice: Consorzio Venezia Nuova, 1989); Derek Walcott, *Il levriero di Tiepolo*, trans. Andrea Molesini (Venice: Consorzio Venezia Nuova, 2004); Sergio Bettini, *Forma di Venezia* (Venice: Consorzio Venezia Nuova, 2005); Guido Moltedo, *Welcome to Venice: Replications, Imitations and Dreams of an Italian City* (Venice: Consorzio Venezia Nuova, 2007).

37. See Margaret Plant, *Venice: Fragile City, 1797–1997* (New Haven, CT, and London: Yale University Press, 2002), chapters 11 and 12.

38. Margaret Doody, *Tropic of Venice* (Philadelphia: University of Pennsylvania Press, 2007), 302.

39. See Guy Nordenson, Catherine Seavitt, and Adam Yarinsky, *On the Water: Palisade Bay*, 1st ed. (New York: Museum of Modern Art, 2010).

40. The text appears on the schema for the work held by *MAXXI*. For more on Superstudio, see Peter Lang and William Menking, eds., *Superstudio: Life Without Objects* (Turin: Skira, 2003).

41. Nicolas Roeg, "Don't Look Now," screenplay by Allan Scott and Chris Bryant (London and Rome: Casey Productions/Eldorado Films, 1973).

42. On the postwar art scene, see Luca Massimo Barbero, ed., *Venice 1948–1986: The Art Scene* (Modena: Fondazione Cassa di Risparmio di Modena, 2006). While standard tourism attracts twenty million tourists annually, the Biennale and strategically revived Carnival have been cited as bringing in an additional 900,000. For an impassioned polemic outlining the conflict between culture and industry from the perspective of the working class, defending Marghera industry, see Wladimiro Dorigo, *Una legge contro Venezia: Natura storia interessi nella questione della città e della laguna* (Rome: Officina, 1973), 73.*

43. See Régis Debray, *Against Venice*, trans. Philip Wohlstetter (Berkeley, CA: North Atlantic, 1999); Robert C. Davis and Garry R. Marvin, *Venice, the Tourist Maze* (Berkeley: University of California Press, 2005).

44. Mumford, *City in History*, 562.*

45. For more on these unbuilt projects, see Lionello Puppi and Giandomenico Romanelli, *Le Venezie possibili: Da Palladio a Le Corbusier* (Milan: Electa, 1985).*

46. Tudy Sammartini, "Masieri Foundation, Venice," *Architectural Review* 174, no. 1038 (August 1983): 61.*

47. Sergio Bettini, "Venezia e Wright [Venice and Wright]," *Metron-archittetura* 9, nos. 49–50 (January–April 1954): 29.

48. A design by Scarpa for the *Casa dello Studente* was finally built after his death, but his design was realized only in part.

49. See Guillermo Jullian De La Fuente, "The Venice Hospital Project of Le Corbusier," *Architecture at Rice* 23 (1968): 9. A complete account of Le Corbusier's project appears in Hashim Sarkis and Pablo Allard, *Case: Le Corbusier's Venice Hospital and the Mat Building Revival* (Munich and New York: Prestel, 2001).

50. Peter Eisenman, "Three Texts for Venice," in *Cities of Artificial Excavation: The Work of Peter Eisenman, 1978–1988*, ed. Jean-Francois Rédard (Montreal: Centre Canadien d'Architecture/Rizzoli International Publications, 1980), 47. This text hails from Eisenman's project for *10 Immagini per Venezia* (1978), commissioned by Gregotti. For the other commissioned projects, see the catalog edited by Francesco Dal Co (Venice: Officina Edizioni, 1980).

51. For more background, see the notes to the 1972 Biennale exhibit "Four Projects for Venice" in *36ª Biennale di Venezia. Esposizione Internazionale d'arte* (Venice: Biennale d'Arte, 1972), 17–19.

52. Scarpa is upheld as an architect who designs to display, not deny, "the life of the building in time" in a "creative reinterpretation of the fact of weathering" in Mohsen Mostafavi and David Leatherbarrow, *On Weathering: The Life of Buildings in Time* (Cambridge, MA: MIT Press, 1993), 103.

53. Exhibition text supplied to Jennifer Scappettone by the artist in private correspondence, August 2012.

54. See Patrizia Montini Zimolo, in Gino Malancarne and Patrizia Montini Zimolo, eds., *Aldo Rossi e Venezia: Il teatro e la città* (Milan: UNICOPLI, 2002), 83.

55. Qtd. in *Aldo Rossi: Tutte le opere*, ed. Alberto Ferlenga, Documenti di Architettura (Milan: Electa, 2000), 422.*

56. See Manfredo Tafuri, *Architecture and Utopia: Design and Capitalist Development* (Cambridge, MA: MIT Press, 1976).*

57. See Fredric Jameson, *Postmodernism, or, the Cultural Logic of Late Capitalism*, Post-Contemporary Interventions (Durham, NC: Duke University Press, 1991), 60–61. The Tafuri quote is from *Architecture and Utopia: Design and Capitalist Development*, ix. Jameson compared *Architecture and Utopia* in importance to Adorno's *Philosophy of Modern Music* and Barthes's *Writing Degree Zero*. For an account

of the political power of historiography in Tafuri's thinking, see Carla Keyvanian, "Manfredo Tafuri: From the Critique of Ideology to Microhistories," *Design Issues* 16, no. 1 (Spring 2000): 3–15.

58. Manfredo Tafuri, "Toward a Critique of Architectural Ideology," trans. Stephen Sartarelli, in *Architecture Theory Since 1968*, ed. K. Michael Hays (Cambridge, MA: MIT Press, 2000), 15.

59. Eisenman, "Three Texts for Venice," 47. K. Michael Hays points out that Le Corbusier's hospital is not so much present as "hallucinated" in this work, and that Eisenman's "Cities of Artificial Excavation" actually *invent* archaeological content. *Architecture's Desire: Reading the Late Avant-Garde* (Cambridge, MA: MIT Press, 2010), 63–72.

60. Jürgen Habermas, "Modernity—An Incomplete Project," trans. Seyla Ben-Habib, in *Postmodern Culture*, ed. Hal Foster (Trowbridge, England: Pluto Press, 1983), 5.

61. Manfredo Tafuri, in an interview with Richard Ingersoll, " 'There Is No Criticism, Only History,'" *Casabella* 619–620 (1995): 97.*

62. See Tafuri, *Architecture and Utopia: Design and Capitalist Development*, viii.

63. Giancarlo De Carlo expresses this sentiment about the "outsiders" of the IUAV as transcribed by Isnenghi, 1916. For a condensed history of this institute through the year 2000, see Guido Zucconi's chapter in Mario Isnenghi and Stuart Woolf, eds., *Storia di Venezia: L'Ottocento e il Novecento* (Rome: Istituto della Enciclopedia Italiana/Marchesi Grafiche Editoriali, 2002), 1913–25. In recent years, the pathbreaking academic outcast Giorgio Agamben taught at the IUAV, continuing the tradition.*

64. Manfredo Tafuri, *Theories and History of Architecture*, trans. Giorgio Verrecchia (New York: Granada, 1980), 11.

65. Walter Benjamin's importance to this school is made evident in Massimo Cacciari, "Di alcuni motivi di Walter Benjamin," *Nuova corrente* 68 (1975): 209–43.

66. Pier Vittorio Aureli, *The Possibility of an Absolute Architecture* (Cambridge, MA: MIT Press, 2011), xi.

67. John Ashbery, *Reported Sightings: Art Chronicles, 1957–1987* (Cambridge, MA: Harvard University Press, 1991), 335.

68. Aldo Rossi, *The Architecture of the City*, ed. Peter Eisenman, trans. Diane Ghirardo and Joan Ockman (Cambridge, MA, and London: MIT Press, 1984), 21.

69. *A Scientific Autobiography. With a Postscript by Vincent Scully*, trans. Lawrence Venuti (Cambridge, MA, and London: MIT Press, 1981), 1.*

70. See *The Architecture of the City*, 164–67.*

71. Rossi uses the local expression "repubblica veneta" rather than "Repubblica di Venezia"; he adds gnomically, "Sarà d'altra parte il destino dell'architettura palladiana." *Aldo Rossi: Tutte le opere*, 118.

72. Henry James, *The American Scene*, in *Collected Travel Writings: Great Britain and America* (New York: St. Martin's Press, 1987), 508.

73. Ibid.

74. Ibid., 507.

75. In Malancarne and Zimolo, *Aldo Rossi e Venezia: Il Teatro e la città*, 17.

76. Ibid., 19.

77. Robert Coover, *Pinocchio in Venice* (New York: Grove, 1991), 176.

78. Rossi, *A Scientific Autobiography*, 18.*

79. Ibid. Rossi calls upon Benjamin in defining the difference between the modernist model and this form of urbanism, in which the individual artifact is "deformed" through connection to surrounding environs: "There no longer exists purity of design which is not also a recompositioning." Ibid., 19.

80. Catalogue essay by Peter Eisenman for *Aldo Rossi in America: 1976 to 1979*, a show of Rossi's drawings at Max Protech Gallery and the Institute for Architecture and Urban Studies in New York, qtd. in Ashbery, *Reported Sightings*, 334. See also Eisenman's introduction to *The Architecture of the City*, n.p.

81. Qtd. in Ashbery, *Reported Sightings*, 335.

82. Manfredo Tafuri, *History of Italian Architecture, 1944–1985*, trans. Jessica Levine (Cambridge, MA: MIT Press, 1989), 136. Teresa Stoppani speaks of "the tensions, conflicts and mutual references, attacks and collaborations" that animated the IUAV in "*L'histoire Assassinée*. Manfredo Tafuri and the Architecture of the Present," (paper presented at "The Role of the Humanities in Design Creativity," Lincoln, UK, 2007). See http://gala.gre.ac.uk/3035/1/Stoppani.pdf, 5.

83. Tafuri, *History of Italian Architecture, 1944–1985*, 137.

84. Ibid., 187, 186.

85. Ibid., 187.

86. Ibid., 186.

87. The chapter, reworked from a 1976 essay, "*Ceci n'est pas un ville*," is called "'The Wicked Architect': G.B. Piranesi, Heterotopia, and the Voyage." See Manfredo Tafuri, *The Sphere and the Labyrinth: Avant-Gardes and Architecture from Piranesi to the 1970s*, trans. Pellegrino D'Acierno and Robert Connolly (Cambridge, MA: MIT Press, 1992), 25–54.

88. Ibid., 35. The Campus, filled with republican monuments, was subjected to propagandistic renovation by Augustus.

89. Eisenstein, qtd. in ibid., 56.

90. Qtd. in ibid., 87.

91. Ibid., 54.

92. *Confessions of an Opium-Eater*, in Thomas De Quincey, *The Collected Writings of Thomas De Quincey*, ed. David Masson, New and enl. ed. (New York: AMS Press, 1968), 3:438.

93. Manfredo Tafuri, *La sfera e il Labirinto: Avanguardie e architettura da Piranesi agli anni '70* (Turin: Einaudi, 1980), 37. Translation mine.

94. Marguerite Yourcenar also discusses the relation between Piranesi's youth and his design practice in *The Dark Brain of Piranesi and Other Essays* (New York: Farrar, Straus, Giroux, 1984), 88–128.

95. *The Sphere and the Labyrinth*, 29.

96. See Manilo Brusatin's introduction to *Venezia e lo spazio scenico: Carnevale del teatro. Catalogo della mostra a Palazzo Grassi* (Venice: Edizioni "La Biennale di Venezia," 1980), 16.

97. Ibid.

98. Tafuri, *The Sphere and the Labyrinth*, 40–41.

99. Giovanni Battista Piranesi, *Parere su l'architettura,* qtd. in ibid., 42.

100. Heterotopias are "a kind of effectively enacted utopia in which . . . all the other real sites that can be found within the culture, are simultaneously represented, contested, and inverted." Michel Foucault, "Of Other Spaces," trans. Jay Miskowiec, *Diacritics* 16, no. 1 (Spring 1986): 24.*

101. Michel Foucault, *The Order of Things: An Archaeology of the Human Sciences,* trans. A.M. Sheridan-Smith (New York: Vintage, 1973), xviii.

102. Tafuri, *The Sphere and the Labyrinth*, 41.

103. Ibid.

104. Herman Melville, *Clarel: A Poem and Pilgrimage in the Holy Land* (New York: G.P. Putnam's Sons, 1876), Book II, Canto XXXV, lines 4271–84.

105. Manfredo Tafuri, *Ricerca del rinascimento: Principi, cittá, architetti* (Turin: Einaudi, 1992), xxi. *Ricerca* was translated as *Interpreting the Renaissance* but could be rendered as *Research of the Renaissance* to stress the "search" implied by the title. For an introduction to *il pensiero debole* in translation, see Gianni Vattimo and Pier Aldo Rovatti, eds., *Weak Thought* (Albany: State University of New York Press, 2012).

106. Rossi, *A Scientific Autobiography*, 65.

107. See ibid., 68. An elaborate critical discourse surrounds this structure; see Manlio Brusatin and Alberto Prandi, eds., *Aldo Rossi, Teatro del Mondo* (Venice: CLUVA, 1982).

108. See *Aldo Rossi: Tutte le opere*, 153.

109. Rossi, *A Scientific Autobiography*, 29.

110. Ibid., 67. The importance of typology within Rossi's work is a mark of the influence of structuralism within the School of Venice at this time.

111. See Aldo Rossi, *Opera completa,* vol. 1, *1959–1987,* ed. Alberto Ferlenga, 3 vols. (Milan: Electa, 1987), 153.

112. Rossi, *A Scientific Autobiography*, 153.

113. Ibid., 65.

114. *Aldo Rossi: Tutte le opere*, 88.

115. In Brusatin and Prandi, *Aldo Rossi, Teatro del Mondo*, 146.

116. Rossi, *Opera completa,* 1:153.*

117. Rossi, *A Scientific Autobiography*, 29.

118. Ibid., 66.

119. *Aldo Rossi: Tutte le opere*, 154.

120. See Lucia Re, "Calvino and the Value of Literature," *MLN* 113, no. 1 (1998): 126, and Calvino, in a preface to *Le città invisibili* (Milan: Mondadori, 1993), ix. Re defends Calvino from the now-disparaging term "utopian." For an early reading of

Le città invisibili as an example of intellectual detachment, see Pier Vincenzo Mengaldo, La tradizione del Novecento: Da D'Annunzio a Montale, 1 ed. (Milan: Feltrinelli, 1975).

121. Calvino, Saggi 1:116–17; 1:122.

122. Ibid., 1:107; 1:122. He cites as examples of literary "labyrinths" the phenomenological consciousness of Butor, the linguistic stratification of Gadda, and the cultural imaginary of Borges.

123. Calvino, Six Memos for the Next Millennium, 48.

124. See Saggi 1:169. I have translated this differently than Patrick Creagh has in Calvino, Six Memos for the Next Millenium, 71.

125. Polo reports that the unicorn of Java "does not at all resemble the idea that we have of it, nor what we speak of when we describe it as an animal that would allow a virgin to embrace it; it is exactly the opposite." Marco Polo, Il Milione, trans. Maria Bellonci (Rome: Mondadori, 1990), 251.

126. Ibid., 43. Another typical utterance within the work is "This is the truth of the salamander; all other things said are fables and lies" (102).*

127. Italo Calvino, Romanzi e racconti, eds. Claudio Milanini, Mario Barenghi, and Bruno Falcetto (Milan: A. Mondadori, 1991), 3:509–86.

128. Le città invisibili, viii. Original English talk to Columbia students was published as "Italo Calvino on Invisible Cities," Columbia 8 (Spring/Summer 1983): 37–42.

129. Marco Paolini and Francesco Niccolini, Quaderno del Milione, Stile Libero DVD (Milan: Einaudi, 2009), book and accompanying digital video disc, 74.

130. Sterne, La vita e le opinioni di Tristram Shandy, gentiluomo, x.

131. Italo Calvino, Invisible Cities, trans. William Weaver (New York: Harcourt Brace Jovanovich, 1974), 88. I have used the William Weaver translation in this section's quotations from Invisible Cities (hereafter IC) but will include the Italian where appropriate.

132. Saggi 1:689–90.

133. Calvino, Six Memos for the Next Millenium, 37.

134. Calvino, Le città invisibili, 86. The Italian reads, "devo partire da una prima città che resta implicita."

135. Calvino, Saggi 2:2925.

136. Ibid., 2:2690.

137. Ibid., 1:426.

138. IC 89. Kerstin Pilz points out that the text ultimately destabilizes the opposition between the Khan's order and Polo's disorder. "Reconceptualising Thought and Space: Labyrinths and Cities in Calvino's Fictions," Italica 80, no. 2 (Summer 2003): 232.*

139. Alessia Ricciardi, "Lightness and Gravity: Calvino, Pynchon, and Postmodernity," MLN 114, no. 5 (1999): 1064.

140. Ibid., 1070. Scholars have launched well-founded critiques of Calvino's emblematic brand of "Il postmodernismo nazionale" as writing caught in a purely intertextual labyrinth that shirks the gravity of historical circumstance. See, for example,

Carla Benedetti, *Pasolini contro Calvino* (Turin: Bollati Boringhieri, 1998), 56–57 and *The Empty Cage: Inquiry Into the Mysterious Disappearance of the Author*, trans. William J. Hartley (Ithaca, NY: Cornell University Press, 2005).

141. Wolfgang Scheppe goes so far as to claim that Venice, with its increasing dependence on a westward sprawl into the industrial Veneto region, is indistinguishable from the shapeless cities with which it is normally contrasted. See his *Migropolis: Venice / Atlas of a Global Situation* (Comune di Venezia: Hatje Cantz and the Fondazione Bevilacqua La Masa, 2010), 1:25.

142. On the "Disneyfication" of Venice, see Denis Cosgrove, "The Myth and the Stones of Venice: A Historical Geography of a Symbolic Landscape," *Journal of Historical Geography* 8, no. 2 (April 1982): 145–69.

143. Rossi, *A Scientific Autobiography*, 65.

144. From his essay on "Multiplicity," in Calvino, *Six Memos for the Next Millenium*, 116.

145. Calvino, *Le città invisibili*, 11 (my translation).

146. For a survey of schemas that chart Calvino's work as an "epistemological puzzle," see Carolyn Springer, "Textual Geography: The Role of the Reader in *Invisible Cities*," *Modern Language Studies* 15 (1985): 289.

147. In the essay originally titled "Which Utopia?" Calvino specifies that this etherealization results from a collision of new interior and exterior circumstances. The 1986 English translation reads "a utopia of fine dust," but Calvino uses the term "*polverizzata*." Italo Calvino, *The Uses of Literature: Essays*, trans. Patrick Creagh, 1st U.S. ed. (San Diego: Harcourt Brace Jovanovich, 1986), 255.*

148. Judith Butler, *Bodies That Matter: On the Discursive Limits of "Sex"* (New York: Routledge, 1993), 49. Teresa de Lauretis notes that *Invisible Cities* performs the paradigmatic subtraction of woman from history and cultural process, given that she is the ground for narrative, "the foundation and the very condition of representation." Teresa de Lauretis, *Alice Doesn't: Feminism, Semiotics, Cinema* (Bloomington: Indiana University Press, 1984), 13.

149. Jeanette Winterson, *The Passion* (New York: Grove Press, 1987). For Winterson's brief commentary, and her relation to Calvino and Morris, see "My Passion for Venice," *London Times*, May 5, 2007. Seaboyer presents the darkly psychic Venice of *The Passion* as "a figure for Kristevan abjection: all border." Judith Seaboyer, "Second Death in Venice: Romanticism and the Compulsion to Repeat in Jeanette Winterson's *The Passion*," *Contemporary Literature* 38, no. 3 (1993): 485.

150. The island of San Servolo is now, however, being developed for private education initiatives, artists' residencies, and other programming. For an outline of these developments, see Studio Philipp Oswalt, Caso Studio Venezia/Case Study Venice, 2006–2007 (Berlin: Shrinking Cities Working Papers, 2007), at www.shrinkingcities.com/fileadmin/shrink/downloads/WP_Venedig071021.pdf.

151. This tendency is certainly due to the fact that "[t]he idea of Venice as it was—a self-governing city-state prosperous (relatively) and free, the tourist center and mart

of pleasure as of goods for East and West—this idea is last embodied in the city of the eighteenth century." See Doody, *Tropic of Venice*, 57.

152. Frederick Rolfe, *The Desire and Pursuit of the Whole. The First Complete Edition*, ed. Andrew Eburne (New York: George Braziller, 1994), 35. The macaronic strategies at work throughout the narration of Rolfe's novel (not only between Italian and English, but between English and Venetian dialect) are of considerable interest, in line with its trouncing of gender boundaries; they warrant further study.

153. Ibid., 122.

154. Winterson, *The Passion*, 114, 150, 152.

155. Ibid., 5, 13, 40, 69, 139, 160.

156. Aureli, *The Possibility of an Absolute Architecture*, xii.

157. Georg Simmel, "Venice," *Theory, Culture & Society* 24, no. 7–8 (2007): 44.

158. Coover, *Pinocchio in Venice*, 20.

159. Biographical detail supplied in correspondence by electronic mail with Jennifer Scappettone, dated July 13, 2012.

160. Interview of October 1985 with Italo Calvino conducted by Maria Corti, qtd. in Rebecca West, "The Persistent Puppet: Pinocchio's Heirs in Contemporary Fiction and Film," Fathom Archive, University of Chicago Library Digital Collections, last modified 2002, http://fathom.lib.uchicago.edu/2/72810000.

161. Robert Coover, Reading from *Pinocchio in Venice*, University of Pennsylvania, February 23, 2009 (Philadelphia: PennSound, 2009), sound recording.

162. I refer once more to the "sguardi che si incrocino da tutte le dimensioni" of which Zanzotto writes. Andrea Zanzotto, *Le poesie e prose scelte*, eds. Stefano Del Bianco and Gian Mario Villalta, I Meridiani (Milan: Mondadori, 1999), 1056.

163. *Pinocchio* was composed in the early years of Italian unification. For an extensive analysis of its role in the making of Italians, see Suzanne Stewart-Steinberg, *The Pinocchio Effect: On Making Italians, 1860–1920* (Chicago: University of Chicago Press, 2007).

164. As Foucault argues, every book is "a node within a network." Michel Foucault, *The Archaeology of Knowledge* (Abingdon: Routledge, 2002), 26. I cannot hope to chart here all the intertextual links in Coover's novel, which refers obliquely or directly to virtually every literary work discussed in this book (and many others). For this type of genealogy, I refer the reader to Judith Seaboyer's discussion in "Robert Coover's *Pinocchio in Venice*: An Anatomy of a Talking Book," in *Venetian Views, Venetian Blinds: English Fantasies of Venice*, ed. Manfred Pfister and Barbara Schaff (Amsterdam and New York: Rodopi, 1999), 236–55. For a useful account of how the novel fits into classical definitions of postmodernism, as well as a mediation on its Oedipal reverberations, see Thomas J. Morrissey and Richard Wunderlich, *Pinocchio Goes Postmodern: Perils of a Puppet in the United States* (New York: Routledge, 2002), 177–86.

165. Robert Coover, "The End of Books," *New York Times*, June 21, 1992.

166. Ibid.

167. Ibid.

168. Ibid.

169. Calvino, *Saggi* 2:2689.

170. Steven Spielberg's *A.I.*, the incarnation of what was originally to be a Stanley Kubrick film, was conceived as a robotic version of *Pinocchio.**

171. Textual refrain from Judd Morrissey, "RC_AI," *Judisdaid: Electronic Literature/ Data Poetics/Performance & Installation*, June 4, 2010, http://faulttacticalnetwork.org/ rcai.

CODA

1. See Frances Anderton, "Put It on the Ceiling and Call It High Art," *New York Times*, October 14, 1999.

2. Qtd. in Michael Specter, "A Sinking Feeling," *The New Yorker* (July 12, 1999): 40.

3. The views forged at The Venetian more than any other Vegas casino call up the typological "arsenal" of urban public space while being controlled by private interests: here *carabinieri* function as security guards, and the pigeons released across the Piazza San Marco at timed intervals are trained. An account of the fabrication process, supervised by Bob Hlusak's Treadway Industries, which produced 80,000 ornamental pieces, appears in Guido Moltedo, ed., *Welcome to Venice: Replicas, Imitations and Dreams of an Italian City* (Venice: Consorzio Venezia Nuova/Marsilio, 2007), 53–65. The hotel was to commemorate Adelson's honeymoon in Venice; his second wife thought Venice "the most romantic place in the world" (55). See also Wayne Curtis, "Belle Epoxy," *Preservation* 52, no. 3 (May/June 2000): 32–39 and Richard Kadrey, "History Lite, No Chaser," *Wired* 6, no. 7 (July 1998): 136–39, 169. Giovanna Franci offers the most incisive reading of The Venetian and other virtual "Italian" spaces as late manifestations of the Grand Tour's imaginary Italy in *Dreaming of Italy: Las Vegas and the Virtual Grand Tour* (Las Vegas: University of Nevada Press, 2005).*

4. Bruce Bégout, *Zéropolis: The Experience of Las Vegas*, trans. Liz Heron (London: Reaktion Books, 2003), 20.

5. Kevin Lynch, *The Image of the City* (Cambridge, MA: Technology Press, 1960); Joel Garreau, *Edge City: Life on the New Frontier* (New York: Doubleday, 1991), 10.

6. Robert C. Davis and Garry R. Marvin, *Venice, the Tourist Maze* (Berkeley: University of California Press, 2005), 292.

7. Wolfgang Scheppe and the IUAV Class on the Politics of Representation, *Migropolis: Venice / Atlas of a Global Situation* (Comune di Venezia: Hatje Cantz and the Fondazione Bevilacqua La Masa, 2010), 1:63.

8. Henry Lefebvre, *The Production of Space*, trans. Donald Nicholson-Smith (Oxford and Cambridge, MA: Blackwell, 1991), 73–4.

9. Andreas Ruby, "Transgressing Urbanism," in *Transurbanism*, ed. Arjen Mulder (Rotterdam: V2 Publishing/NAI Publishers, 2002), 24.

10. Keith Alan Biederman and Judi Deutsch, "Venice Comes to Vegas: The Grand Canal Shoppes," *E.S.P.* (May 1999), n.p. For a detailed, celebratory outline of this project from the perspective of the designer (nonetheless tinged with irony), see WATG and The Stubbins Associates, "The Venetian," *Verb: Conditioning: The Design of New Atmospheres, Effects and Experiences* 4 (2005): n.p.

11. See Chris Hastings, "The Merchant Moves from Venice to Vegas," *The Telegraph*, August 7, 2005, http://www.telegraph.co.uk/news/uknews/1495691/The-Merchant-moves-from-Venice-to-Vegas.html.

12. Quote taken from "Hermitage Guggenheim, Las Vegas, Nevada, 2001," OMA, http://www.oma.eu/projects/2001/hermitage-guggenheim. See also Robert Venturi, Denise Scott-Brown, and Steven Izenour, *Learning from Las Vegas: The Forgotten Symbolism of Architectural Form* (Cambridge, MA, and London: MIT Press, 1972), 34–47.

13. See Rem Koolhaas, Jeffrey Inaba, et al., eds., *The Harvard Design School Guide to Shopping: Harvard Design School Project on the City 2* (Taschen, 2002), jacket text. The Benetton family bought the complex from the Italian postal system for 50 million euros.

14. Henry James, *Henry James: Letters*, ed. Leon Edel (Cambridge, MA, and London: Belknap, 1984), 4:329; 4:389.

15. See Francois Weil, *A History of New York*, trans. Jody Gladding (New York: Columbia University Press, 2004), 67–94.

16. Henry James, *The American Scene*, in *Collected Travel Writings: Great Britain and America* (New York: St. Martin's Press, 1987), 507.*

17. Lawrence Halprin, *The RSVP Cycles: Creative Processes in the Human Environment* (New York: G. Braziller, 1970), 86–87; *Freeways* (New York: Reinhold, 1966), 114–17.

18. The Consorzio Venezia Nuova commissioned a collection of journalistic accounts of these Venices—twenty-two in Brazil, twenty-three in Columbia, and so on: see Moltedo, *Welcome to Venice*.

19. Rem Koolhaas, *Delirious New York: A Retroactive Manifesto for Manhattan* (New York: Monacelli Press, 1994), 125.

20. Ibid., 123.

21. Ibid., 55.

22. The philosophers quote from Friedrich Nietzsche, *Aurora e scelta di frammenti postumi, 1879–1891*, volume 5 of *Opere complete*, ed. Giorgio Colli and Mazzino Montinari, trans. F. Masini and Mazzino Montinari (Milan: Adelphi, 1964).

23. Manfredo Tafuri, *The Sphere and the Labyrinth: Avant-Gardes and Architecture from Piranesi to the 1970s*, trans. Pellegrino D'Acierno and Robert Connolly (Cambridge, MA: MIT Press, 1992), 291. The latest effort to compare these metropolises appears in Teresa Stoppani, *Paradigm Islands: Manhattan and Venice: Discourses on Architecture and the City* (New York: Routledge, 2011).

24. Tafuri, *The Sphere and the Labyrinth*, 291. See also *Venice and the Renaissance*, trans. Jessica Levine (Cambridge, MA: MIT Press, 1989), xi.

25. Tafuri, *The Sphere and the Labyrinth*, 291. Tafuri is citing the dichotomy between forms of social bonds developed by German sociologists Ferdinand Tönnies and Max Weber in the late nineteenth and early twentieth centuries.

26. Massimo Cacciari, "Viaggio estivo," in *Venezia Vienna*, ed. G. Romanelli (Milan: Electa, 1983), 127. Cacciari bases this interpretation on a Venice that pervades Nietzsche's *Twilight of the Idols, Beyond Good and Evil, Daybreak*, and uncollected aphorisms in "subterranean" fashion.

27. Koolhaas, *Delirious New York*, 123.

28. Langan goes on to present Venice as a symbol of the new world order: its citizen "a *canalized* subject, traversed by flows of power that originate elsewhere." Celeste Langan, "Venice," in *Romantic Metropolis*, ed. James K. Chandler and Kevin Gilmartin (New York: Cambridge University Press, 2005), 2.

29. James, *GB* 478.

30. F.T. Marinetti, "Discorso futurista agli inglesi, pronunciato al Lyceum Club di Londra," in *TIF* 285.

31. "Democrazia futurista," in *TIF* 433.

32. "Distruzione della sintassi/Immaginazione senza fili/Parole in libertà," in *TIF* 65–80.

33. Scheppe, *Migropolis*, 1:107.

34. See Janet Adelman, *Blood Relations: Christian and Jew in* The Merchant of Venice (Chicago: University of Chicago Press, 2008), 66–98.

35. Miwon Kwon, *One Place after Another: Site-Specific Art and Locational Identity* (Cambridge, MA: MIT Press, 2002), 157.

36. Fredric Jameson, *Postmodernism, or, the Cultural Logic of Late Capitalism*, Post-Contemporary Interventions (Durham, NC: Duke University Press, 1991), 25.

37. While a prolonged meditation on this critical history would far overreach present constraints, it is summarized and challenged by editors Virginia Jackson and Yopie Prins in their work on *The Lyric Theory Reader: A Critical Anthology* (Baltimore: Johns Hopkins University Press, 2014).

38. For the canonical account of time-space compression, see "The Experience of Space and Time," in *The Condition of Postmodernity: An Enquiry Into the Origins of Cultural Change*, ed. David Harvey (Oxford and Cambridge, MA: Blackwell, 1989), 201–326.

39. Henry James, "The Grand Canal," in *Italian Hours* (New York: Grove, 1909), 45.

40. "Worsening Situation," in John Ashbery, *Self-Portrait in a Convex Mirror* (New York: Viking, 1972), 4. The next poem, "Forties Flick," surveys a movie set's street scene containing "Things too real / To be of much concern, hence artificial, yet now all over the page" (5).

41. O'Hara curated the Seymour Lipton and Mark Tobey sections of that Biennale. See Frank O'Hara, *Art Chronicles: 1954–1966* (New York: George Braziller, 1975), 159.

42. Susan Rosenbaum reads Ashbery's affect through the reanimation of cliché in "Mixed Feelings: Ashbery, Duchamp, Roussel, and the Animation of Cliché," *Genre* 45,

no. 1 (2012): 87–119. For a refreshing historicist take on Ashbery's use of the cliché, see Jasper Bernes, "John Ashbery's Free Indirect Labor," *Modern Language Quarterly* 74, no. 4 (December 2013): 517–40.

43. Jean-Paul Sartre, "Venice from My Window," in *Modern Times*, ed. Geoffrey Wall, trans. Robin Buss (London: Penguin, 2000), 24.

44. Robert Duncan, *The First Decade: Selected Poems 1940–1950* (London: Fulcrum Press, 1968), 90.

45. Ibid., 107. Christopher Nealon's proposal surrounding "queer tradition" as a type of lineage that "is neither linear nor progressive" and that reckons with "our radical dependence on the past" could provide a provocative framework for thinking about the alternative lineage of Venetian writing I briefly sketch here. See his "Queer Tradition," *GLQ: A Journal of Lesbian and Gay Studies* 14, no. 4 (2008): 617–22.

46. John Ashbery, *The Mooring of Starting Out: The First Five Books of Poetry* (New York: Ecco, 1997), 3.

47. Marjorie Perloff, *Poetry On & Off the Page: Essays for Emergent Occasions* (Evanston, IL: Northwestern University Press, 1998), 115.

48. Harry Mathews, *The Sinking of the Odradek Stadium* (Normal, IL: Dalkey Archive Press, 1999), 101.

49. Harry Mathews, *Tlooth* (Urbana-Champaign, IL: Dalkey Archive, 1998), 132.

50. John Ashbery, *Flow Chart* (New York: Alfred A. Knopf, 1991), 3.

51. The first definition of "lagoon" in the *Oxford English Dictionary* actually reads, "An area of salt or brackish water separated from the sea by low sand-banks or a similar barrier, *esp.* one of those in the neighbourhood of Venice."

52. Qtd. in John Ashbery, *Reported Sightings: Art Chronicles, 1957–1987* (Cambridge, MA: Harvard University Press, 1991), 328.

53. From a review of the Knoedler Gallery show, in ibid., 11. He cites a detail from the Saint Ursula cycle in which "a stranded ship in the middle distance seems to be part and parcel of the distant mountain behind it."

54. Ibid.

55. William Shakespeare, *Othello*, ed. Saunders Norman (Cambridge: Cambridge University Press, 2003), 5.2.354–72.

56. Vladimir Nabokov, *The Stories of Vladimir Nabokov* (New York: Alfred A. Knopf, 1996), 558. The story's addressee, "V.," is clearly a doubled double for Nabokov himself.

57. Ibid., 568.

58. Ezra Pound, *Cantos* 76/461.

59. Marcel Proust, *Swann's Way*, in *Remembrance of Things Past*, vol. 1, *Swann's Way, Within a Budding Grove*, trans. Terence Kilmartin and C.K. Scott Moncrieff (New York: Vintage, 1982), 424–25. Adorno's reading stresses the delusional promise of happiness embedded within Proust's "place-name." See Theodor Adorno, *Notes to Literature*, trans. Sherry Weber Nicholsen (New York: Columbia University Press, 1992), 373.

60. Frank O'Hara, *The Collected Poems of Frank O'Hara*, ed. Donald Allen (New York: Knopf, 1971), 252.

61. James E.B. Breslin, *From Modern to Contemporary: American Poetry, 1945–1965* (Chicago: University of Chicago Press, 1984), 242.*

62. Marjorie Perloff, "Watchman, Spy, and Dead Man: Jasper Johns, Frank O'Hara, John Cage, and the 'Aesthetic of Indifference,'" *Modernism/Modernity* 8, no. 2 (2001): 18.

63. Charles Altieri, *Enlarging the Temple: New Directions in American Poetry During the 1960s* (Lewisburg: Bucknell University Press, 1979), 111.

64. O'Hara, *The Collected Poems of Frank O'Hara*, 257.

65. Breslin, *From Modern to Contemporary*, 218.

66. Jameson, *Postmodernism*, 25.

67. Andrea Zanzotto, *Peasants Wake for Fellini's Casanova and Other Poems*, ed. and trans. John P. Welle and Ruth Feldman (Urbana: University of Illinois Press, 1997), 87. Hereafter cited as *Peasants Wake*, though I have often altered the English translations.

68. Marjorie Welish, *The Annotated "Here" and Selected Poems* (Minneapolis: Coffee House Press, 2000), 45.

69. Qtd. in Zanzotto, *Peasants Wake*, 5. See also Umberto Eco, *Travels in Hyperreality: Essays*, 1st ed. (San Diego: Harcourt Brace Jovanovich, 1986).

70. Marinetti, "Argument Against the Venetians," in *TIF* 33.

71. Qtd. in Zanzotto, *Peasants Wake*, 5.

72. Costanzo Costantini, ed., *Conversations with Fellini*, 1st U.S. ed. (San Diego: Harcourt Brace, 1995), 91. Sutherland also played the father figure in Nicholas Roeg's *Don't Look Now*, filmed five years prior in Venice.

73. For a cogent argument surrounding Fellini's interpretation of Casanova as a performer and literary "void," see Millicent Joy Marcus, *Filmmaking by the Book: Italian Cinema and Literary Adaptation* (Baltimore: Johns Hopkins University Press, 1993), 204–24.

74. Edith Wharton, *Italian Backgrounds* (New York: Scribner, 1905), 213–14.

75. Andrea Zanzotto, *Le poesie e prose scelte*, ed. Stefano Del Bianco and Gian Mario Villalta, I Meridiani (Milan: Mondadori, 1999), 1070.

76. See Aldo Palazzeschi, "Il Doge," in *Il Doge; Stefanino; Storia di un'amicizia*, ed. Anna Nozzoli (Milan: Mondadori, 2004), 3–151.

77. See Darius Spieth, "Giandomenico Tiepolo's *Il Mondo Nuovo*: Peep Shows and the 'Politics of Nostalgia,'" *Art Bulletin* 92, no. 3 (September 2010): 188–210. On the *Rückenfigur*, see Joseph Leo Koerner, *Caspar David Friedrich and the Subject of Landscape* (New Haven, CT: Yale University Press, 1990).

78. For further details surrounding the commissioning and sonic montage of these elements of the film, see Andrea Zanzotto, *Il cinema brucia e illumina: Intorno a Fellini e altri rari*, ed. Luciano De Giusti (Venice: Marsilio, 2011), 13–15.

79. Qtd. in Zanzotto, *Peasants Wake*, 5.

80. Andrea Zanzotto, *Sovrimpressioni* (Milan: Mondadori, 2001), 104, 108.

81. Qtd. in Zanzotto, *Peasants Wake*, 6.

82. Andrea Zanzotto, *The Selected Poetry and Prose of Andrea Zanzotto: A Bilingual Edition*, ed. Patrick Barron, trans. Patrick Barron et al. (Chicago: University of Chicago Press, 2007), 400. The linguistic roots of "infancy" are explored in Giorgio Agamben, *Infancy and History: Essays on the Destruction of Experience*, trans. Liz Heron (London and New York: Verso, 1993).

83. Zanzotto, *Peasants Wake*, 10.

84. Ibid., 87. Zanzotto notes that the phonological palette of a dialect is often maintained while appropriating terms from panterrestrial languages such as English. See "On Minimal and Maximal Languages," in *Selected Poetry*, 398.

85. Zanzotto, *Poesie e prose*, 1061.

86. Zanzotto, *Selected Poetry*, 400–401.

87. Derek Walcott, *Sea Grapes* (New York: Farrar, Straus, and Giroux, 1976), 4. I have cited from the bilingual edition commissioned by Consorzio Venezia Nuova: *Il levriero di Tiepolo*, trans. Andrea Molesini (Venice: Consorzio Venezia Nuova, 2004). Hereafter *Tiepolo's Hound*, and cited parenthetically.

88. Derek Walcott, *What the Twilight Says: Essays*, 1st ed. (New York: Farrar, Straus, and Giroux, 1998), 4.

89. Ibid., 16.

90. *Tiepolo's Hound*, 176.

91. In an eloquent study, Rei Terada describes Walcott's "pantomime" of the European canon as pointed and displacing: "for Walcott mimicry, with all its ambivalent freight, replaces mimesis as the ground of representation and culture." *Derek Walcott's Poetry: American Mimicry* (Boston: Northeastern University Press, 1992), 2.

92. From an unpublished section of an interview with Jennifer Scappettone at the American Academy in Rome, March 27, 2011.

93. Édouard Glissant, *Poetic Intention*, trans. Nathanaël Stephens with Anne Malena (Callicoon, NY, and Lebanon, NH: Nightboat Books, 2010), 11.

94. Ibid., 14.

95. James Clifford, "Mixed Feelings," in *Cosmopolitics: Thinking and Feeling Beyond the Nation*, ed. Pheng Cheah, Bruce Robbins, and The Social Text Collective (Minneapolis: University of Minnesota Press, 1998), 362.

96. Zanzotto, *Selected Poetry*, 417.

97. Published in Giuseppe Dall'Arche et al., *Molo K Marghera: L'altra Venezia* (Vicenza: Terra Firma, 2007), n.p. Translation, here as elsewhere, mine.

98. "Venezia, forse," in Zanzotto, *Poesie e prose*, 1053.*

INDEX